1994

LIKENESS AND PRESENCE

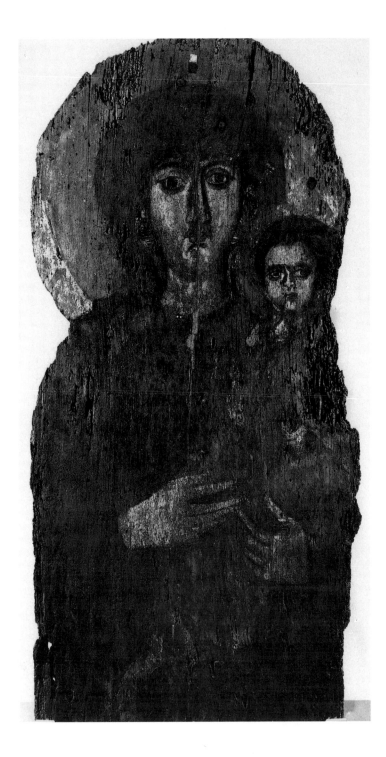

HANS BELTING

LIKENESS AND PRESENCE

A History of the Image before the Era of Art

Translated by Edmund Jephcott

The University of Chicago Press

Chicago and London

Frontispiece: Rome, Pantheon; icon of the Madonna and Child, A.D. 609.
Repeated in color at front of color gallery, following page 264 (see also fig. 8).

Hans Belting is professor of art history and media theory at the School for New Media at
Karlsruhe. He is the author of several books, including *The End of the History of Art?* also
published by the University of Chicago Press.

The University of Chicago Press, Chicago 60637
The University of Chicago Press, Ltd., London
© 1994 by The University of Chicago
All rights reserved. Published 1994
Printed in the United States of America

01 00 99 98 97 96 95 94 5 4 3 2 1

ISBN (cloth): 0-226-04214-6

Originally published as *Bild und Kult—Eine Geschichte des Bildes vor dem Zeitalter der
Kunst,* © C. H. Beck'sche Verlagsbuchhandlung (Oscar Beck), Munich 1990.

This book is printed on acid-free paper.

Library of Congress Cataloging-in-Publication Data

Belting, Hans.
 [Bild und Kult. English]
 Likeness and presence : a history of the image before the era of
art / Hans Belting ; translated by Edmund Jephcott.
 p. cm.
 Translation of: Bild und Kult.
 Includes bibliographical references and index.
 1. Christian art and symbolism—Medieval, 500–1500. 2. Icons.
3. Saints—Cult. I. Title.
N7850.B4513 1994
704.9′482′0940902—dc20 93-3389
 CIP

Contents

Illustrations

Foreword

The aims of the present book require some explanation, as it is not intended to follow the usual directions taken by a history of art but to focus on the history of the image. But what is an image? The term means as much and as little as the term *art*. I therefore would like to clarify that, in the framework of this book, the image I am considering is that of a person, which means that I have chosen one of several possibilities. The image, understood in this manner, not only represented a person but also was treated like a person, being worshiped, despised, or carried from place to place in ritual processions: in short, it served in the symbolic exchange of power and, finally, embodied the public claims of a community. The reader, by now, will have realized that I am speaking of the 'Holy Image.' The latter was rooted in religion—but I would be making a tautological statement if I were to stress this obvious fact. In the era under consideration, most images were religious even if they served political or economic purposes.

My choice of the Holy Image as the subject of this book necessitated the omission of the other major image which came down to us from the Middle Ages: the narrative image, which presented sacred history and was usually perceived in a way that was more like an act of reading than that of simple viewing. I have treated this other type of image, at least in part, in a book which I edited together with Dieter Blume on late medieval painting and culture, *Stadtkultur und Malerei der Dantezeit*. In that work, the narrative image, both in its public and private, or its religious and profane, variety, is discussed under the heading "The Image as Text."

The subtitle of this book, which speaks of "a history of the image before the era of art," is still in need of explanation, as the reader may be puzzled by the uncommon notion of an "era of art." Art, as it is studied by the discipline of Art History today, existed in the Middle Ages no less than it did afterwards. After the Middle Ages, however, art took on a different meaning and became acknowledged for its own sake—art as invented by a famous artist and defined by a proper theory. While the images from olden times were destroyed by iconoclasts in the Reformation period, images of a new kind began to fill the art collections which were just then being formed. The era of art, which is rooted in these events, lasts until this present day. From the very beginning, it has been characterized by a particular kind of historiography which, although called the history of art, in fact deals with the history of artists.

But what about a history of the image? When we leave the common ground of a history of styles, we have as yet no suitable framework for structuring the events which shaped the image in the era before the Renaissance. If one consults David Freedberg's book on *The Power of Images,* one even finds a warning against attempting to devise a history of the image at all, as the author considers the image to be an ever-present reality to which mankind has responded in ever the same way. I nevertheless have opted for some kind of history, as before the era of art, the image

had a social and cultural significance of an altogether different kind, which thus requires a different type of argument. I do not, however, aim at "the" history of the image, but consider this narrative as a means of introducing my topic in a deliberately "open" way.

The story of the iconic portrait opens in late antiquity when Christianity adopted the cult images of the "pagans," in a complete reversal of its original attitude, and developed an image practice of its own. The center of the story is in the Middle Ages, both East and West, when images of God and the saints underwent many significant changes either as icons or as statues. The third part of my narrative concerns the period of transition between the Middle Ages and the era of the Reformation and Renaissance, when the images reemerge with a new face as works of art.

In my confidence in the practical use of such a narrative I may be accused of naivete and the lack of a proper "method." I am well aware of advances in current research on images, both in anthropology and in psychology. But the results are not yet such as to offer a safe guide through the sequence of history. I therefore still believe in the usefulness of historical narrative, which makes available the materials and the respective stories and other sources for further use by a wide range of methods and disciplines. This book is meant to offer a service to forthcoming research on images by bringing together as much information as there is. As a result, it aims at overcoming the narrow treatment of the topic that is prevalent today: a research restricted to a few examples which are to illustrate a fashionable "theory" for theory's sake.

My book does not "explain" images nor does it pretend that images explain themselves. Rather, it is based on the conviction that they reveal their meaning best by their use. I therefore deal with people and with their beliefs, superstitions, hopes, and fears in handling images. This context, whether social, religious, or political, in the German title of the book is summarized by the term *Kult*. The individual cultures in which images played their role are given more importance than an overall view on the permanent features of the image. It was, however, not possible to examine them in full detail, as it seemed more important to connect them with one another and to mark changes as well as continuities. This history of the image, as a result, cannot be confused with simple storytelling, but takes a conceptual attitude toward history. The image, in the end, appears as paradoxical as does the human being him- or herself who made use of it: along with the sequence of societies and cultures, it changes all the time, but on another level, it remains always the same—an observation which allows for both distinctions and comparisons.

The era of the image which is discussed in this book is in fact only one chapter in the long history of images which, on the one hand, reaches back into prehistorical times and, on the other hand, goes on until the present day and will last as long as mankind survives. The images may never have had more importance than they had in prehistorical practice, of which we know so little: practice in the midst of preverbal cultures when the religious and the social were one and the same. Anthropology will hopefully provide answers to the most interesting question of all: why images?

The present book is only concerned with European culture, both East and West, and only with the era ranging from Antiquity to the Renaissance (at the time of the

Renaissance, two kinds of images, the one with the notion of the work of art and the other free of that notion, existed side by side). The period "in between," the limited scope of my project, was nevertheless a topic which almost exceeded the powers of a single author who wanted to address his colleagues as well as a general audience. The latter received the book favorably in Germany, where the book soon became an issue within a lively debate on the role of images, as opposed to art, in our present culture, and where it even was commented on by many artists. Against the idealism of art appreciation for its own sake, represented by George Steiner's book on "Real Presence," it was used as a source of information on the historical usage of images. In France, Laurence Kahn introduced a reading of the book under the heading "Adorer les images" into the topics of the "Nouvelle Revue de Psychoanalyse" (no. 44, Paris, 1991). It is hoped that the book will continue to offer its services to a widening range of people and disciplines in search of a general view on the role of images in human culture.

It is a pleasant duty to acknowledge the manifold assistance which I received while writing this book. First of all, I have to mention the Dumbarton Oaks Center of Byzantine Studies (Harvard University) where Giles Constable, the former director, accepted the topic as a research project and thus offered me a long series of unforgettable visits at this wonderful refuge of research. As a token of gratitude, in 1990, I codirected a symposium there, on a topic related to the book, together with Herbert S. Kessler, from Johns Hopkins University. I also have to single out the Bibliotheca Hertziana of the German Max Planck-Institute, where I actually started the writing of the book during an undisturbed year of leisure in the midst of the resources, both of monuments and books, at Rome. The two directors, Christoph L. Frommel and Matthias Winner, were my hosts, to whom I owe the granting of a fellowship.

I profited in many ways from the encouragement and help of friends and colleagues with whom I could discuss my findings and my open questions. Christa Belting-Ihm, who has herself engaged in related research on the role of images especially from early Christian times, accompanied the progress of the text with unfailing assistance. Victor Stoichita, at Fribourg University, the author of a companion volume to my own, called *L'instauration du tableau*, offered me long and fruitful hours of talk while he still was at Munich. I owe inspiration of the same importance to David Freedberg with whom I taught side by side for a while at Columbia University in New York. Georges Didi-Huberman, whom I first met in the gardens of Villa Medici in Rome, opened for me doors to my topic whose existence I had not even noticed before. Herbert S. Kessler, himself an authority in the field, took a vivid interest even in the English translation of my text and proved to be a rare friend when he read the first draft of the English version. Anna Kartsonis and Nancy Patterson Ševčenko, each in her own special way, introduced me into the true secrets of Byzantine sources. My friend Henk van Os, now director of the Rijks-Museum at Amsterdam, shared my experience with images at Siena, on which he is the living authority. Richard Krautheimer, who generously received me in his beautiful office facing the Ss. Trinità dei Monti, had a watchful eye on the progress of my work at Rome. Ernst Kitzinger, Oxford, my former supervisor in America proved to be a faithful adviser

in all matters of images. Peter Brown, Princeton, whom I would have liked to meet more often, shared with me the authority and enthusiasm which are his own. Finally, my special gratitude goes to Renate Prochno who contributed so much to the completion of the book.

I am indebted to many colleagues for offering me access either to usually inaccessible images or to photographic materials difficult to obtain. First of all, Kurt Weitzmann opened the rich resources of the photographs from Mount Sinai to me with a rare generosity. G. Mancinelli accompanied me to the private quarters of the pope, where I could inspect what I regard the oldest Christ icon in existence. M. Andarolo made the Marian icon at Spoleto descend from the huge baroque altarpiece for me. Valentino Pace opened many doors for me which otherwise would have remained closed. The memories related to all the unusual events which happened before and during the encounter of famous images would fill several pages. I wish to thank all the people who participated in such events, and beg their pardon for not naming everybody at this place with due attention.

At Munich, precious assistance came from members of my department at the university, particularly from Gabriele Kopp-Schmidt, Gabor Ferencz, and Sonya Nausch, but also from the publishing house C. H. Beck and its member Karin Beth. At the University of Chicago Press, I would like to thank Karen Wilson for her true devotion in making this book possible despite the countless obstacles. Craig Noll, the final copyeditor, offered real support in a difficult time.

1. Introduction

a. The Power of Images and the Limitations of Theologians

Whenever images threatened to gain undue influence within the church, theologians have sought to strip them of their power.[1] As soon as images became more popular than the church's institutions and began to act directly in God's name, they became undesirable. It was never easy to control images with words because, like saints, they engaged deeper levels of experience and fulfilled desires other than the ones living church authorities were able to address. Therefore when theologians commented on some issue involving images, they invariably confirmed an already-existing practice. Rather than introducing images, theologians were all too ready to ban them. Only after the faithful had resisted all such efforts against their favorite images did theologians settle for issuing conditions and limitations governing access to them. Theologians were satisfied only when they could "explain " the images.

From the earliest times, the role of images has been apparent from the symbolic actions performed for them by their advocates, as well as against them by their opponents. Images lend themselves equally to being displayed and venerated and to being desecrated and destroyed. As surrogates for what they represent, images function specifically to elicit public displays of loyalty or disloyalty. Public professions of faith are part of the discipline that every religion requires of its faithful. Christians frequently harassed Jews, heretics, and unbelievers by accusing them of secretly desecrating sacred images. To such desecration the "injured" images, as Leopold Kretzenbacher has called them, reacted like living people by weeping or bleeding. Whenever miscreants laid hands on such material symbols of faith as image, relic, or Eucharist, they proved themselves to be saboteurs of the unity of faith, which in principle tolerates no infringement. Thus as soon as a cult of images began to flourish, minorities had to live in fear of being denounced as its assailants. Examples extend well beyond the Reformation; Joseph Roth recently described such events in Galicia.

Images aroused a different kind of controversy when the parties were arguing about the "correct" or "incorrect" presentation of the images they had in common. Here the issue was the purity of the faith. The Eastern and Western churches were sometimes as much at odds over the iconography of images as they were linguistically in the *filioque* dispute. When he proclaimed the schism of the church in Constantinople in 1054, the papal legate criticized the Greeks for presenting the image of a mortal man on the cross, thereby depicting Jesus as dead. Equally, when the Greeks came to Italy for the Council of Ferrara-Florence in 1438, they were unable to pray before Western sacred images, whose form was unfamiliar to them. Thus Patriarch Gregory Melissenos argued against the proposed church union: "When I enter a Latin church, I can pray to none of the saints depicted there because I recognize none of them. Although I do recognize Christ, I cannot even pray to him because I do not recognize the manner in which he is being depicted."[2] Reservations about associat-

1

ing with the central images of a religious sect other than one's own reveal a fear of contamination.

Reformation-period theology had difficult issues to contend with when the Calvinists abolished images and the Lutherans modified them (chap. 20). What was fundamentally at stake was church tradition, but as also happened in a different context at Nicaea in 787, the tradition did not speak with one voice on the issue of sacred images. Part of the church saw itself in its visible images, and part saw itself as needing to reject these same images. In the eighth century as in the sixteenth, both sides laid claim to unspoiled tradition, which is generally seen to encompass the identity of a religion. Since no attitude toward images could be established for earliest Christianity, it became necessary to define the tradition itself before proceeding. The debate about images likewise provoked a controversy concerning the true nature of spirituality, which seemed threatened by the "materialism" of the image cults. Later, when the point at issue was whether justification was by faith or by works, the cult and donation of images were included among works.

From the point of view of Catholicism, Protestants no less than Turks were adversaries on the issue of images, as both groups dishonored the images with which Catholicism was identified. Fear of losing the institutional power that the images represented also was apparent. The Albigenses and the Hussites both opposed images, although their real target was the institution behind the images. Conversely, the Counter-Reformation's cult of images was an act of atonement toward them, each new image being intended symbolically to fill the place from which another had been expelled. This polemical use of images culminated in the figure of Mary, because Mary made it possible to present in visible terms the doctrinal differences between Catholics and Protestants. Older icons of the Virgin, now newly revered, served in their fashion to validate a tradition on the strength of their age. Publicly erected Marian columns, like paintings in other times, also were monuments to the church as an institution and to its triumph. The state, as the defender of the church, likewise associated itself with images and their cult. Thus, when revolutionaries in 1918 toppled the Marian column in Prague, they were acting more against the Hapsburg power they identified with it than against the religion it represented.

In the foregoing we have isolated a few aspects of the historical roles of images, since theology alone cannot encompass the image. The question facing us, therefore, is how to discuss images, and which aspects of them to stress. As usual, the answer depends on the interests of the person discussing the subject. Within the specialized field of the art historian, sacred images are of interest only because they have been collected as paintings and used to formulate or illustrate rules governing art. When battles of faith were waged over images, however, the views of art critics were not sought. Only in modern times has it been argued that images should be exempt from contention on the grounds that they are works of art. Art historians, however, would fail to do justice to the subject if they confined their expertise to the analysis of painters and styles. Nor are theologians as well qualified as they might seem. They discuss past theologians' *treatment* of images, not the images themselves. What interests them, when they enter the debate, is the study of their own discipline. Historians,

finally, prefer to deal with texts and political or economic facts, not the deeper levels of experience that images probe.

The mantle of competence displayed by each academic discipline is thus insufficient to cover this field. Images belong to all of them, and to none exclusively. Religious history, as embedded in general history, does not coincide with the discipline of theology, which deals only in the concepts with which theologians have responded to religious practices. Holy images were never the affair of religion alone, but also always of society, which expressed itself in and through religion. Religion was far too central a reality to be, as in our day, merely a personal matter or an affair of the churches. The real role of religious images (for a long time, there were no other kinds of images) thus cannot be understood solely in terms of theological content.

This view is supported by the way theologians have discussed images and continue to discuss them. Their concept of visual images is so general as to exist only on the level of abstraction. They treat the image as a universal, since only this approach can yield a conclusive definition having theological significance. Images that fulfilled very different roles in practice have been reduced for the sake of theory to a single common denominator, shorn of all traces of their actual use. Every *theology* of images possesses a certain conceptual beauty, surpassed only by its claim to being a repository of faith. This claim distinguishes it from the *philosophy* of images, which since Plato has concerned itself with the phenomena of the visible world and the truth of ideas; in this perspective, each material image is the possible object of a linguistic or mental abstraction. The theology of images, however, even if it engaged extensively in this discussion, always had a practical end in view. It supplied the unifying formulas for an otherwise heterogenous, undisciplined use of images. When it achieved its aim and defined a tradition, the polemical dust settled to leave a compromise masquerading as pure doctrine, in which everything appeared, retrospectively, clear and simple.

Only occasionally, when the polemics were in process, did the contending parties admit that they were arguing over a special kind of image, and a special use of images that they identified as "veneration" to distinguish it from the creature's "adoration" of God himself. Reference here was not to the commemorative paintings on church walls but to the images of persons that were used in processions and pilgrimages and for whom incense was burned and candles were lighted. These were deemed to be of very ancient or even celestial origin and to work miracles, make oracular utterances, and win victories. Although they were bones of contention or touchstones of belief, they had no special status in any theological doctrine of images. Only cult legends granted them their respective status. Even their opponents could attack them and refute them theologically only in general terms; they could not attack the specific images themselves.

We can therefore consider these cult images, or "holy images," as Edwyn Bevan has called them in his book of that title, only if we adopt a historical mode of argumentation that traces them back to the context in which they historically played their part. These images represented a local cult or the authority of a local institution, not the general beliefs of a universal church. When the Virgin's statue in the Auvergne, or

her icon on Mount Athos, was greeted and accompanied like a sovereign, it was act-
ing as a local saint and the advocate of an institution whose rights it upheld and
whose property it administered. Even in modern times, symbols of the local commu-
nity have lost little of their psychological power. A few years ago the Venetians cele-
brated the return of the Virgin *Nicopeia* to S. Marco, from which it had been forcibly
removed. In the old republic the icon had been publicly honored as the true sovereign
of the state. The prehistory of its cult in Venice leads back to Byzantium, where in
1203 the icon was seized from the chariot of the opposing general. For the Byzantines
it was the embodiment of their celestial commander, to whom the emperors gave
precedence at victory celebrations. The Venetians took home this palladium, which
they gained as a fruit of victory and which in turn brought them victory, as a part of
the "transfer of cults." They placed their community under the icon's protection just
as the ancient Greeks had once done with the image of Athena from Troy.

The icon was soon known in Venice as St. Luke's Madonna. It was seen as an
original from the days of the apostles, and Mary herself was believed to have posed
for it. This "authentic" portrait was naturally preferred by the Virgin, as it showed
her "correctly" and had been made with her cooperation; special grace thus accrued
to this one painting. It led a unique existence, even a life of its own. At state ceremo-
nies, it was received as if it were an actual person. The image, as object, demanded
protection, just as it in turn granted protection as an agent of the one whom it de-
picted. The intervention of a painter in such a case was deemed something of an in-
trusion; a painter could not be expected to reproduce the model authentically. Only
if one was sure that the painter had recorded the actual living model with the accuracy
we today tend to attribute to a photograph, as in the case of St. Luke or the painter
whom the Three Kings brought with them to Bethlehem to portray the Mother and
Child, could one verify the authenticity of the results.

This concept of veracity makes use of a testimony by tradition, otherwise invoked
by Christianity only to prove the authenticity of *texts* of revelation. As applied to
images of Christ, the legends of veracity either asserted that a given image had a su-
pernatural origin—in effect, that it had fallen from heaven, or affirmed that Jesus'
living body had left an enduring physical impression. Sometimes both legends were
used alternately for the same image. The cloth with an impression of Christ's face,
which made the Syrian city of Edessa impregnable, and the sudarium of St. Veronica
in St. Peter's in Rome, to which the Western world made pilgrimages in anticipation
of a future vision of God, are important examples of images that such legends have
authenticated.

Besides the legends about origins, there were legends about visions, when a be-
holder recognized in an image people who had appeared to him or her in a dream, as
according to the legend of St. Sylvester, Emperor Constantine identified the images of
the apostles Peter and Paul. At the same time Constantine acknowledged the pope,
who owned these painted images and who also knew their names as these apostles'
rightful earthly representative. In this case the proof of authenticity lay in the corre-
spondence between dream vision and painted image.

A third kind of cult legend, that of miracles, stressed the supratemporal presence

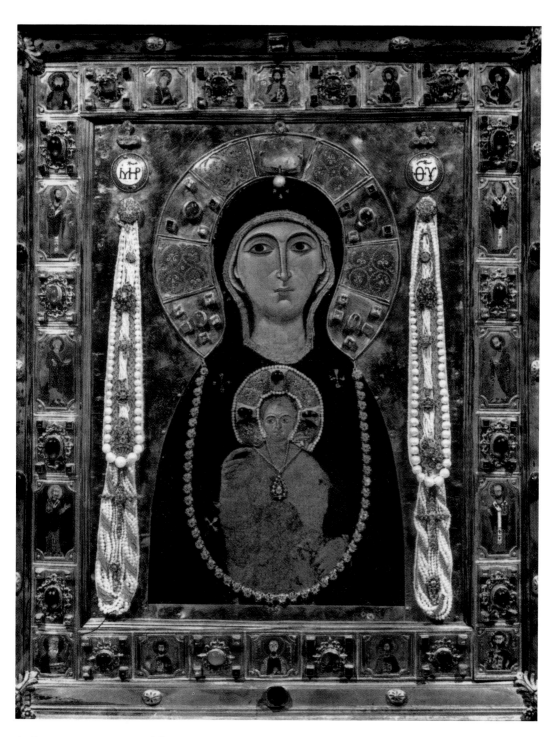

1. Venice, S. Marco; icon of the Nicopeia, 11th century

of saints, who worked miracles through their images after their death, thus demonstrating that they were really still alive. These legends also reinforced the double value that any religion emphasizes, that of age and permanence, history and timelessness.

Authentic images seemed capable of action, seemed to possess *dynamis*, or supernatural power. God and the saints also took up their abode in them, as was expected, and spoke through them. People looked to such images with an expectation of beneficence, which was often more important to the believer than were abstract notions of God or an afterlife. Worshipers lost many advocates for their times of need when the Christian state closed the temples and rural shrines of Asclepius and Isis. Although theologians may view religion primarily as a set of ideas, ordinary worshipers are more concerned with receiving aid in their personal affairs. The new, universal mother figure of the Virgin easily fit into this context. When the Pantheon was consecrated as the church of Mary and all martyrs in 609, it was given a "temple image" of its new patron, whose gilded hand conjured up the aura of the healing hand of Asclepius. The right of asylum, we also learn, was similarly transferred to this icon.

Such images possessed charismatic powers that could turn against church institutions as long as they were excluded from such institutions. They protected minorities and became advocates of the people, since by their nature they stood outside the hierarchy. They spoke without the church's mediation, with a voice directly from heaven, against which any official authority was powerless. Another icon of the Virgin, which later was transferred to S. Sisto, forced the pope to do public penance because he had inappropriately attempted to move it to his residence in the Lateran. It returned in the dead of night to some poor nuns, whose only possession it had been. This Virgin's hands, held up in the supplicant posture of an advocate, also are covered with gold to signify their function as expectant carriers of supplication. The making of many replicas of icons in the Middle Ages reflects the belief that duplicating an original image would extend its power.

Such images, whose fame derived from their history and the miracles they performed, have no proper place in a theology of images. They represent the typical images that were kissed and venerated with bended knee; that is, they were treated like personages who were being approached with personal supplications. In Byzantium it was understood how to honor them so as to distinguish them from other images. In 824 the emperors wrote to tell the Carolingians that they had "removed the images from the low sites" at eye level, where their devotees would "set up lamps and light incense." During the second iconoclastic controversy, therefore, the believers were deprived of every opportunity to practice a cult of images. Left intact, however, were "those images placed in higher locations in churches, where painting, like Holy Scripture, narrates [the history of salvation]." At that time the Frankish theologians understood neither the subtleties of the one party nor the aggression of the other, both of which were fixated in their different ways on the veneration of images. Therefore, the Franks condemned both the "superstitious cult" and the removal of images from the access of the faithful. By the late Middle Ages, however, Western European iconoclasts, even the theologians among them, had long since been confronted with the same problems as their Byzantine precursors and respected the dis-

tinguishing traits that removed particular images from the abstract doctrine of images as such.

Only images that were lifted by an aura of the sacred out of the material world to which they otherwise belonged could take on real power. But what enabled an image to distinguish itself from the ordinary world and be as "holy" as a totally supernatural sign or agent of salvation was? It was, after all, precisely such a quality of "holiness" that originally was denied to images when they still bore the stigma of being dead, pagan idols and that was reserved for the sacraments. But the sacraments too consist of *things* (bread, wine, oil) transformed by priestly consecration. In principle, anything could be consecrated, a fact that would deny any higher status to images; if they depended on being consecrated, they relinquished their power to the consecrating institution. The priests would then not only be more important than the painters but also be the true authors of the holiness of the images. Unlike the hierarchy of the church, however, the miracle-working saints had not been consecrated either. They were the voice of God, either on their own account or by a spontaneous act of grace. Their merit lay in their virtue. Wherein did the merit of images lie? This is where the cult legends, which explained everything by the will of God, came in. If God created images himself, he did not make use of the established hierarchy. But to argue thus was clearly to touch upon a delicate issue.

The theologians, unable to achieve their demand for consecration, pointed to the "archetype" that was venerated in the copy, thus making use of a philosophical argument. It was protested that, while it was one thing to represent a saint, who had had a visible body, in an image, it was quite another to try to present the invisible God in a visible image. This objection was answered by the formulation of the dual, divine-human nature of Jesus, of which, however, only his human nature could be depicted. An indirect image of God was conveyed by depicting a historical human being who implied the presence of God. The task now remained only to postulate the indivisible unity of the invisible God and the visible human being seen in a single person. Once God was visible as a human being, it was possible to make an image of him as well, and indeed to use the image as a theological weapon. In the seventh century Anastasius thus posed the trick question as to who or what was to be seen in a painting of Christ being crucified. The death that the image was supposed to attest could be neither that of God nor, if one was to believe in the death's redemptive power, that of the human being called Jesus (cf. chap. 7f).

In this way the Christians picked their way between the graven images of polytheism and the ban on images imposed by the Jews. For the Jews, Yahweh was visibly present only in the written word. No image resembling a human being was to be made of him, since it would then resemble the idols of the neighboring tribes. In monotheism, the only way for the universal God to distinguish himself was by invisibility. His icon was the Holy Scripture, which is why Torah scrolls are venerated like cult images by the Jews. But the regional conditions in Palestine could not be extended to the Roman world empire. The conflict with the Jewish Christians was decided in favor of the "heathen church." With the adoption of images, Christendom, once an Oriental church, asserted its claims to universality in the context of Greco-Roman culture.

In so doing, however, it came up against a rival in the form of the emperor, who symbolized a unity that transcended the multiplicity of religions and cults. It is not without reason that war was declared on the Christians only when they refused to make the state image of the emperor an object of cult worship. Before Christianity became the state religion, the emperor was the living image of the one god, the sun god. In his dream vision Constantine saw the sign of the God in whose name he would triumph, and he heard, "In this sign [*signum*] shalt thou conquer." The emperor himself wished to be victorious, not through the aid of an image of a god, but under the sign of the invisible God. He would therefore remain the living image of God, while putting to military use the cross, which served as a sign of the sovereignty of the Christian God. This separation of image and sign is reflected in imperial coinage. From the sixth century the image of the emperor continued to be shown on the face of coins, while the reverse showed the triumphal sign of the cross, which had now become the banner and weapon of the emperor. For a long time the only public image cult that was tolerated in the Christian Roman empire was that of the emperor's image.

81 It was therefore a turning point of major significance when the image of Christ displaced that of the emperor from the face of coins at the end of the seventh century. The emperor, now titled the "servant of Christ," takes in his hand the cross, which had previously adorned the reverse. A few decades earlier, the emperor had made his troops swear their oath of allegiance on the battlefield not to his person but to a painted image of Christ. Such an event makes it apparent that, at the end of antiquity, the unity of the Roman state and its people was clearly no longer sought in the person of the emperor, but in the authority of religion. From then on, the emperor exercised his rule in the name of a painted God.

56 By the same process the cross became the support for an *image*, not of the crucified Christ, but of the Christian God placed in a tondo above it. Whereas in Constantine's day images of the emperor had been fixed to the imperial cross-standard, now the cross was crowned with the image of Christ. During the iconoclastic controversy, the emperors reversed this tendency. The same emperors, not the theologians, then banned Christian images in the name of religion, even if they did so for their own purposes. If the unity of the state resided in the unity of faith, one had to decide for or against the images, which (depending on the time) promoted or endangered such unity.

90 The ensuing dispute was played out between the image of Christ and the image-less sign of the cross. With each political change, one replaced the other over the entrance to the imperial palace, accompanied by polemical inscriptions. Although we might see in this controversy a mere substitution of labels, in this dispute on the threshold of the Middle Ages a conflict was coming to the surface that had its roots far back in the use of images during antiquity. The Christian cult image had forced its way into the preserve of court and state, where the ancient image cult still survived, and it had adopted the latter's rights. The *one* God suddenly became no less a subject for images than the *one* emperor had been up to then. But the understanding of the nature of images in general was also involved. In an image a person is made visible. It

is a different matter with a sign. One can make one's appearance with a sign but not with the help of an image, which implies both appearance and presence. Where God is present, the emperor cannot represent him. It is "the ancient antithesis between representing and being present, between holding the place of someone and being that someone" (Erhart Kästner). It is therefore no accident that the battle between image and sign was fought above the palace gate, through which the emperor presented himself to his people.

It is difficult to encapsulate the conflict over the image in a simple phrase. The theological disputation at the Council of Nicaea, however, was undoubtedly of secondary significance. Like any committee of experts, the theologians could communicate only in their specialized language, but essentially they used the language of theology to ratify decisions that had already been made at a different level. At that level, religion and its images mirror the role of the state, as well as the identity of a society that would either remain a part of antiquity or break with it.

b. Portrait and Memory

It is difficult to evaluate the significance of the image in European culture. If we remain within the millennium with which this book is concerned, we are everywhere obstructed by written texts, for Christianity is a religion of the word. If we step outside this millennium into the modern period, we find art in our way, a new function that fundamentally transformed the old image. We are so deeply influenced by the "era of art" that we find it hard to imagine the "era of images." Art history therefore simply declared everything to be art in order to bring everything within its domain, thereby effacing the very difference that might have thrown light on our subject.

To avoid being unhistorical despite these obstructions, one might quote documentary sources that refer to images. But the authors of these were theologians, whose interest in images was confined to the question of whether images had any right to exist in the church at all. They frequently quoted each other, making it easy for us today to pick out the main strands of what is called the doctrine of images. Modern criticism in the field of the arts is repetitive, whether from presumptuousness or its opposite; it believes it can provide the necessary explanations merely by repeating the old arguments. If we leave the old explanations behind, we lack firm ground to stand on; if we hold on to them, however, we lose the chance of seeing things in their true light. We might escape into anthropology, studying the basic features of human response to an image. But we have such a firmly established perception of our own culture's history that anthropological discoveries continue to be treated like arbitrary intrusions into an already-cohesive system. This book therefore follows the well-tried course of narrative, gathering material sequentially for an analysis of the historical perception. I would like to preface the narrative with a few observations on the problems that threaten such a framework.

In all the medieval sources the watchword *memoria* occurs over and over again. What kind of memory or recollection does it imply? According to Gregory the Great, painting, "like writing," induces remembrance. "To call back to memory" is, first of all, the task of the Scriptures, with the image able to play only a supporting role.

Image and Scripture together recall what happened in the story of salvation, which is more than a historical fact. The same Gregory states concisely in his famous Ninth Letter that one should venerate him "whom the image recalls to memory as a new-born child or in death, and finally in his heavenly glory [*aut natum aut passum sed et in throno sedentem*]."

This statement gives a foretaste of the problems our subject will present. People are disposed to venerate what is visibly before their eyes, which can be only a person, not a narrative. Images contain moments from a narrative, although they themselves are not narratives. The child on its mother's lap and the dead man on the cross recall the two focal points of a historical life. The differences between them are the outcome of historical factors and consequently make possible remembrance *within* or *through* the image. The image, however, is comprehensible only through being recognized from the Scriptures. It reminds us of what the Scriptures narrate and secondarily makes possible a cult of the person and of memory.

Besides images of God, however, there are images of the saints, a simpler subject for recollection. The exempla of their virtuous lives are what is really remembered, but that is only part of the truth. Saints were remembered not only through their legends but also through their portraits. Only the portrait, or image, has the presence necessary for veneration, whereas the narrative exists only in the past. Moreover, the saint is not only an ethical model but also a heavenly authority whose aid is sought in current earthly need.

In the pictorial history of Christ and the saints, the portrait, or *imago*, always ranked higher than the narrative image, or *historia*. More so than with the biblical or hagiographic history, the portrait makes it hard to understand the function of memory and everything connected with it. It is not enough to see the cult portrait as a symbol of *presence* and the narrative picture as a symbol of *history*. The portrait, too, derives power from its claim to historicity, from the existence of a historical person. Remembrance, we may say, had different meanings that we must bring together, since they are not self-evident.

The mnemonic techniques of antiquity, which were further extended in the Middle Ages, are of little help. The "art of memory" (*ars memoriae*) was developed in rhetoric but was extended in the Middle Ages to the practice of virtue. To assure a functioning technique of recollection, this method used inner, or invisible, images that were memorized in order to retain the thread of memory. They were supplemented by visible memory aids, however, which in turn served only as means to the end of memory training.

The cultic sphere is concerned not with the *art* of memory in this sense but with the *content* of memory. The present lies between two realities of far higher significance: the past and future self-revelation of God in history. People were always aware of time as moving between these two poles. Memory thus had a retrospective and, curious as it sounds, a prospective character. Its object was not only what had happened but what was promised. Outside of religion, this kind of consciousness of time has become remote to us.

In the medieval context the image was the representative or symbol of something

that could be experienced only indirectly in the present, namely, the former and future presence of God in the life of humankind. An image shared with its beholder a present in which only a little of the divine activity was visible. At the same time, the image reached into the immediate experience of God in past history and likewise ahead to a promised time to come. Thus a prayer quoted by Matthew Paris refers to the icon of Christ in Rome as a memento (*memoriale*) left behind by Jesus as a promise of the vision of God in eternity (see text 37E in the Appendix). 16

The theme of portrait and remembrance can be encompassed neither by Aby Warburg's concept of "mnemosyne" nor by C. G. Jung's "archetypes." The kind of cultural recollection that includes artworks and artists has a different profile. Ancient images and symbols in our cultural repertoire were, for Warburg, evidence of the survival of antiquity. However, the continuity of symbols within a discontinuity in their use is a theme that transcends his field of study, the Renaissance. In our context, the use of pictorial motifs from antiquity that could not claim any religious significance during the Renaissance actually may have been a means of emancipation from the icon images that concern us. As for C. G. Jung's archetypes, they are located in the collective unconscious and are thus exempt from the claims made by the images of our study. It is quite possible that stereotypes from our natural stock of images could also be discovered in the official icons of the church (e.g., Mary as mother), but here we cannot pursue such an argument.

The attraction of our subject lies in the fact that as a theme of religious history it is as present as it is absent: present because the Christian religion extends into the present, and absent because it now has a different position in our culture. Only occasionally, in the Mediterranean Catholic area, do we now come across popular practices that had ceased to be universal customs by the end of the Middle Ages. One such occasion was the proclamation in November 1987 of a new saint who lived in Naples and is venerated in the church of Gesù Nuovo in that city. The canonization of the doctor Giuseppe Moscati (d. 1927) was celebrated in Naples with liturgical pomp and with a monumental ceremonial image, a modern icon, displayed on the altar above the tomb.

The larger than life-size photograph fills a Baroque altar-tabernacle that had pre- 2
viously held a painted image. The suit worn in the photo shows that the saint was a layman; in other pictures distributed at the time, he was wearing a doctor's smock. The location of the image makes clear its cultic claims. The authenticity inherent in a photo supports the claims of authentic appearance always raised by icons; the image was to give an impression of the person and to provide the experience of a personal encounter. In this case, the enlargement of the Moscati photo was dictated by expediency. It had to fit the altar format and thus be different from ordinary photos. By contrast, an icon in the Middle Ages was typically life-size. Its origins were often surrounded by legend, so that it could not be unequivocally identified as a man-made object: Seen in this light, the photo in Naples, particularly with its special aura, was a practical solution. The portrait keeps the saint present in the general memory at the site of his grave and is easily seen by those visiting the tomb in order to pray to the saint. (There is no need to pray *for* him, as for an ordinary mortal.)

2. *Naples, Il Gesù Nuovo; photograph-altarpiece of St. Giuseppe Moscati, 1987*

In this case the pictorial propaganda was supplemented by verbal propaganda having two themes that also followed the old practice of the cult of saints. Printed leaflets contained the remarkable biography, always regarded as a guarantee of sanctity, and a prayer asking for the grace to imitate the life portrayed. The saint thus as model for imitation is one theme. The other theme—of the saint as helper in times of need—was only implied. Moscati had treated the sick without charge even during his lifetime. Finally, visitors took souvenir pictures away with them, thereby multiplying the locations of the official photo.

Usually the historical person fulfills a preexisting ideal of the saint. The Neapolitan doctor is an example of this pattern. But sometimes the relationship was reversed. If the person of the saint did not fit the traditional patterns, there was a need to formulate the ideal that the person did embody. This could be a laborious process, which can be illustrated by a famous example. After his death St. Francis of Assisi received one new look after another because he had to represent *in effigie* the latest version of his order's ideal. His image was used in conjunction with his biography (chap. 18a). *228* New biographies corrected previous ones to such an extent that the older versions had to be destroyed to hide the discrepancies. Ceremonial images were likewise replaced by new ones because the official ideal had to be without error. The images, after all, had to be not only looked at but, more, believed in. Thus the "corrected image" was a consequence of the "correct" perception one was supposed to have of the saint.

The relationship between the painted image of St. Francis and the normative idea that one had of his person leads us to problems of analysis that we would not necessarily expect with portraits. Our modern concept of portraiture gets in the way. With the repeated changing of the appearance of St. Francis (his beard or lack of it, the stigmata, his posture, attributes, and associations with the appearance of Christ), the "image" that people had of his person was successively corrected. The function of the portrait in the propagation of a *person-ideal* is thus made apparent to us.

The icon of St. Francis was enlarged, as had been done previously in Byzantium, by pictorial citations from his biography, which surround the portrait like a frame or a painted commentary. They supplement the *physical* portrait of the likeness with the *ethical* portrait of the biography, and with the miracles attesting to the saint's divine approbation. Finally, an important experiential aspect of the icon was its ceremonial display. It was exhibited on Francis's feast days, when readings from his biography were also part of the ceremony. The memorial feast provided the congregation with the memory exercises of the texts and had its focus and culmination in the memorial image. When the image was venerated, a ritual memory exercise was thus performed. Often, access to an image was permitted only when there was an official occasion to honor it. It could not be contemplated at will but was acclaimed only in an act of solidarity with the community according to a prescribed program on an appointed day. This practice we identify as a *cult*.

The image had several functions. Besides defining the saint and honoring him or her in the cult, the image also had a function relating to the place where it resided. The presence of the local saint was, as it were, condensed in a corporeal image that

had a physical existence as a panel or statue and a special appearance as an image type, an appearance that distinguished it from images of the same saint in different places. Images of Mary, for example, always distinguished themselves visibly from each other according to the features attributed to local copies. Likewise, the old image titles have a toponymous character: they name the place of a cult. The connection between image and cult therefore has, as we see, many aspects. The memory an image evoked referred both to its own history and to that of its place. Copies were made in order to spread the veneration of the image beyond the local place, even as they reinforced the connection between the original and its own locality. The memory tied to the original therefore remained undivided. The copies recalled the original of a famous local image, which in its turn recalled the privileges that it had acquired in (and for) its own place during its history. In this sense, image and memory become an aspect of legal history.

The legends surrounding the origins of famous images helped to clarify the memory value they ultimately acquired through their history. These legends concerned more than the historical circumstances that guaranteed the authentic appearance of the person depicted. The myth of origin also vouched for the rank of a particular image, which was inferred from its age (or its supernatural origin). Age was a quality to be read in the image's general appearance. Its form therefore also had a (real or fictitious) memory value. Archaism as a fiction of age is one of the marks of identity that new cult images simulated (chap. 19d).

c. The Images' Loss of Power and Their New Role as Art

The account of the power of images given so far in this Introduction remains incomplete as long as the other half of their history has not been told. It concerns the images' *loss* of power in the Reformation. As this is to be discussed in detail later (chap. 20), a few general reflections will suffice here. The successful opposition to images in the Reformation might be taken as evidence that the images in fact lacked power, at least relative to the written word and the interpretations of the preachers. In reality the late seizure of power by the theologians confirms the latters' earlier impotence. The toleration of images, whose function formal theology had repeatedly rationalized, now ended.

Many factors played a part before this revolt of the theologians against images occurred. A simple explanation is not possible. In what they say, the theologians merely repeat the principles of a purified doctrine, leaving out whatever does not fit neatly into their theology. But in what they do, the theologians give us an idea of the privileges enjoyed by images that stood in their way. From the criticism of images in the Reformation, therefore, we are able to draw conclusions about the prior use of images. What is now condemned as abuse was accepted custom earlier.

Emancipation from the old institutions was one of the most important motives behind the leaders of the Reformation becoming iconoclasts. Their program envisaged a new church made up of the preacher and his congregation. Luther's liberal attitude still left room for images, but they were images used for didactic purposes, to reinforce the revelation of the word (text 40). This limitation divested the images of

the very aura that was a precondition of their cult. It followed that they could and should no longer represent any institution. They were, in any case, discredited in conjunction with the previous doctrine of the justification of Christians by means of their works. The new doctrine of justification by faith alone made pious donations of or for images superfluous. The whole concept of the votive image collapsed, and with it the Roman church's claim to be an institution that dispensed grace and privileges visibly embodied in its relics and images. What the new doctrine left in place was theologians without institutional power, preachers of the word legitimated only by their superior theology. Where everything was based on truth and unambiguity, no room was left for the image with its equivocalness.

The idea of tradition, on which the Roman church had always prided itself, now became the church's handicap. Tradition no longer consisted of the great age of church institutions and the long history of textual interpretation; instead, it was seen to reside in the original condition of the founders' church, which was to be restored by purifying it of later accretions. The rebirth of the early church in the Renaissance period, after many unsuccessful attempts in the Middle Ages, provided the necessary retrospective justification for modern reformed religious practices. Thereby, an imageless church was defined that, in the person of Paul, had opposed the image worship of the heathens.

The link to the early church is evident in the fixation on the authentic word of God. The preacher interprets the biblical text solely on the basis of faith, without needing to refer to prior church exegesis. In the Gutenberg era the divine word was in theory made available to everyone by means of Bibles printed in the vernacular. God's word was thus constantly accessible, which permitted a check on interpretations. The direct presence of the biblical word, however, also allowed the preacher to exert control over the people of his congregation, who were expected to live according to its pure doctrine. The purity of doctrine was determined by the letter of the text, as understood through the guidance of the Spirit of God. Against such an authoritative text, the image lacked force; when substituted for the word, it always posed a threat because of its imprecision and the possibility of misunderstanding.

The word is assimilated by hearing and reading, not by seeing. The unity of outer and inner experience that guided persons in the Middle Ages breaks down into a rigorous dualism of spirit and matter, but also of subject and world, as expressed in the teachings of Calvin (text 41). The eye no longer discovers evidence for the presence of God in images or in the physical world; God reveals himself only through his word. The word as bearer of the spirit is just as abstract as is the new concept of God; religion has become an ethical code of living. The word does not depict or show anything but is a sign of the convenant. God's distance prohibits his presence in a painted representation, sensually comprehended. The modern subject, estranged from the world, sees the world as severed into the purely factual and the hidden signification of metaphor. But the old image rejected reduction into metaphor; rather, it laid claim to being immediate evidence of God's presence revealed to the eyes and senses.

In the meanwhile, the same image suddenly appears as the symbol of an archaic

mentality that still promised a harmony between world and subject. Into its place steps *art,* which inserts a new level of meaning between the visual appearance of the image and the understanding of the beholder. Art becomes the sphere of the artist, who assumes control of the image as proof of his or her art. The crisis of the old image and the emergence of the new concept of art are interdependent. Aesthetic mediation allows a different use of images, about which artist and beholder can agree between themselves. Subjects seize power over the image and seek through art to apply their metaphoric concept of the world. The image, henceforth produced according to the rules of art and deciphered in terms of them, presents itself to the beholder as an object of reflection. Form and content renounce their unmediated meaning in favor of the mediated meaning of aesthetic experience and concealed argumentation.

The surrender of the image to the beholder is tangibly expressed at this time in the emergence of art collections, in which pictures represent humanistic themes and the beauty of art. Even Calvin accepted the use of images for these purposes. Although he believed that they could represent only the visible, this did not preclude a reappraisal of the visible world by the meditative subject. The Protestant Reformers did not create this change of consciousness vis-à-vis the image; indeed, in this respect they were themselves the children of their time. What they rejected in the name of religion had long since lost the old substance of unmediated pictorial revelation. I do not say this with any nostalgic intent, but only to describe the fascinating process whereby the medieval cult image became the artwork of the modern era.

This process also took place in the Catholic world, and not only as a reaction to Reformation criticism. In the Netherlands the Reformation was not officially introduced until 1568. By then, however, the transformation of the image that we have described had long since been completed. To uphold the claims of the cult image in an era of art, the Roman church needed to establish new attitudes toward images. The old claims now tended to be reserved for ancient images that appeared as relics of a bygone age. They were always thought of as images from the earliest stage of Christianity, and thus intended as a visible refutation of the Reformation's concept of tradition. In these cases contemporary art was given the task of providing the effective presentation of the old image. This was an important program during the Counter-Reformation.

As is to be expected, all such presentations of history contain an element of exaggeration. Humankind has never freed itself from the power of images, but this power has been exerted by different images in different ways at different times. There is no such thing as a historical caesura at which humanity changes out of all recognition. But the history of religion or the history of the human subject, both of which are inseparable from the history of the image, cannot be narrated without a schema of history. Certainly, it is impossible to deny that the Reformation and the formation of art collections changed the situation. The aesthetic sphere provided, so to speak, a kind of reconciliation between the lost way of experiencing images and the one that remained. The interplay of perception and interpretation that is pursued in the visual arts, as in literature, demands the expert or connoisseur, someone who knows the rules of the game.

2. The Icon from a Modern Perspective and in Light of Its History

This book is concerned not only with icons but with statues and relics—and indeed every kind of venerated image. Unlike medieval cult images in the West, the Eastern icon has always enjoyed a special place in modern thinking. The origin of its unique status is to be sought in the curious history of its rediscovery. Romantic utopias played a part in the mystique of icons but soon were dominated by issues of identity in Eastern Europe, for the East used the icon as a means of self-assertion against the established culture of the rest of Europe by placing the icon outside the realm of historical thought. Today, emigrants from an Eastern Orthodox background and religious souls yearning for a pure, "original" art vie with each other in their cult of the icon itself, a cult satisfied willy-nilly by any example. This book is not written for them.

The theme of the Christian cult image between antiquity and the Renaissance, overshadowed as it is by the Eastern icon, has no secure place in intellectual history and in fact gives rise to nothing but misunderstanding. The modern panel painting is seen as having emerged, as if from nowhere, in the form of the devotional image, which developed in the context of late medieval mysticism and simultaneously as the initial concern of Renaissance collectors. The medieval cult statue is included in the historical study of sculpture as such. The early panels in Rome are simplistically said to reflect Byzantine "influence," and the Eastern icon, perceived in isolation from medieval panel painting, has always been of more interest to theologians and poets than to art historians, if only because it does not seem to fit into any pattern of a true historical development. We can clear a way for our study only by reconstructing the history of the modern perception of the icon, since it is the continuing influence of this perception that blocks a new approach to the subject.

a. The "Painter's Manual of Mount Athos" and Romanticism

In 1839 the Frenchman Adolphe Napoléon Didron was traveling on Mount Athos in Greece, just as the independent Kingdom of Greece was formed under a member of the House of Wittelsbach.[1] He was one of the first Westerners to take an interest in the religious art of the Eastern church. Discovering that Eastern images always turned out so similar to one another, he wondered how this dogmatically fixed iconography, which did not reveal any historical change, had come into being.

Didron's excitement grew when he observed a number of painters on Mount Athos who were painting a fresco freehand, without preparatory drawings, and doing so with such precision that the issue of their training became a concern for him. The answer seemed to lie in a manual of religious painting that was presented to him, the now-famous *Painter's Manual of Mount Athos*. Didron published the text in French, after having the original transcribed by a scholar of Greek. He also presented a copy to the Greek king, who deposited it in Munich, thus providing Godehard Schäfer with

the basis for his German translation of 1865. The discovery was a sensation, as a letter of congratulation from Victor Hugo makes apparent.[2]

While the manual did give instructions on technique, it was more concerned with themes, addressing their proper placement and representation. Both the subject matter and the technique of painting seemed thus to be fixed in advance. Everything that Didron had wondered about was now explained, and he wrote in his preface: "The Greek painter is the slave of the theologian. His work is the model for his successors, just as it is a copy of the works of his predecessors. The painter is bound by tradition as the animal is by instinct. He executes a figure as the swallow builds its nest, the bee its honeycomb. He is responsible for the execution alone, while invention and idea are the affair of his forefathers, the theologians, the Catholic Church."[3]

Didron was confirmed in this view by the introduction of the work, which described the "consecration" that awaited painters at the end of their training. The text of this ceremony describes the activity of the painters as a service to God, and painting as an instrument of divine salvation. Besides the talent bestowed by God, a pure heart and piety were required, being asked for in the prayer spoken by a priest.[4]

Such statements were to fall on fruitful soil among the last exponents of Romanticism. They had the ring of a programmatic appeal to the secularized art world, and Didron made sure to dedicate his work to the author of *Notre Dame de Paris*, Victor Hugo. The first publication gave rise to many misunderstandings, and the dogmatic assertion of a virtually sacred art that the manual seemed to contain was seen in a less favorable light as the situation in Europe changed later on.

The main misunderstanding lay in the belief that the key to an understanding of Byzantine art had now been discovered. The manual had been compiled only at the end of the eighteenth century, however, less than two generations earlier, by the monk Dionysios of Phurna. While there were certainly earlier practices reflected in the work, and although fragments of earlier writings were found later, none of these goes very far back.[5] It does not seem likely that manuals of this kind existed in Byzantine times. The whole structure of the work gives the impression of being a codification of a tradition no longer living and therefore endangered, written to prevent the tradition from being further distorted. Perhaps one might venture a comparison with the situation in Florence about 1550, when plans for founding an academy were circulating and young artists were to be brought into line by Vasari's *Lives*.[6] In a word, the *Painter's Manual* as a type is a post-Byzantine product.

The technical part, however, may well go back to Byzantine times. Similar workshop manuals always existed. One need think only of Cennino Cennini, whose guidelines are the best equivalent of the technical section of the *Painter's Manual*. Techniques in themselves, however, do not establish a style. The manual actually contained no *pictorial* patterns of the kind found in the Russian *podlinniki* with their fixed picture forms.[7] But the combination of practical instruction in technique with the mere naming of the themes left painters to their own devices in composing their forms. That this workshop tradition had ceased developing is not directly related to the existence of the *Painter's Manual*. The one is as much a symptom as the other.

Of course, there is a kernel of truth in Didron's comments. But he is mistaken

when he says that painters are responsible only for the execution while theologians take care of the idea and invention. In Byzantine art there was no such thing as a separation of invention and execution, any more than there was in the medieval workshop. The models were taken from painters and not from theologians. But the theology of the image elevated the work to a quasi-sacred status and sought to remove it from the control of the artist. That it was produced by a painter was secondary as far as theology was concerned, which saw the image as a vehicle of revelation. What Didron calls "execution" is in fact the material of a long history of styles. The theological demand for "truth" did, however, limit the scope of artistic production. "Truth" was meant not in the sense of the art itself or of its imitation of nature but in the demand for authentic *archetypes*. An archetype requires repetition, which thus explains the conservative dogmatism of icon painting. When an authentic form seemed to have been found, whether for a religious truth or for a "genuine" portrait of Christ, there could be no other "correct" solution. Of course, there was not always unanimity over the authentic form. The artist's hand sometimes had to wither away before it found its way to the correct type. But a particular form became a norm, the authentic became a type, as soon as theology insisted on repetition.

What Didron did not realize was that he had seen hardly a single icon from Byzantine times. German art historian Heinrich Brockhaus learned of this limitation, however, when he visited Mount Athos in 1888. In 1891 he published an exemplary study on the art of the Eastern church, the basic ideas of which are still valuable. In it he noted with resignation that it was practically impossible to visualize panel paintings from the Eastern church, since they had all been destroyed.[8]

b. The Rediscovery of the Icon in Russia

About the same time, Russian icon painting, which up till the present has shaped our perception of the icon, came to public notice for the first time. Russian scholars also began to study Greek icon painting systematically. At the Seventh Archaeological Congress in 1890 a couple of early icons were presented that had found their way to Russia in an unusual fashion. Bishop Porphiri Uspenski had acquired two sixth-century icons on two journeys to Mount Sinai, in 1845 and 1850. He then bequeathed them to the ecclesiastical museum in Kiev on his death in 1885. Though his travel reports had originally attracted little notice, the originals aroused widespread interest when they appeared in a public collection.[9] Josef Strzygowski, who taught in Prague at the time, published both panels, which remain among the oldest known icons today.[10]

40, 22

In the following years the circle around N. P. Kondakov took the first steps in exploring this new world of icon painting. The interest in icons is explained not least by the national situation. Russia's relationship to its own traditions, which since the foundation of St. Petersburg had been almost abolished by law in favor of a *dirigiste* Europeanization, was again being debated. This crisis of identity fostered reflection on the Russian past in the nineteenth century, including specifically attention on the icon, which, before the country had come under Western influence, was its only form of panel painting.[11]

At first, public opinion even in Russia took little notice of these investigations. The public interest was not generated until the Great Exhibition of 1913, celebrating three hundred years of rule by the House of Romanov, which gave pride of place to the antiquities of Russian icon painting. It opened the Russian public's eyes to the aesthetic value and the historical importance of a genre of painting that had been known hitherto only as church furnishings. The impact of the exhibition was reinforced by the fact that the long-closed churches of the so-called Old Believers were being reopened at the time and were found to contain old icons in their pristine state.[12]

As early as 1873 Nikolai S. Leskov had already published his famous novel *The Sealed Angel,* in which the romantic image of old Russian icon painting was presented to a broad public for the first time.[13] In the icons of the Old Believers, who were excluded from the official church, he saw an authentic tradition of the religious nature of the Russian people. We read in the story that the official seal of a governor had dishonored an icon of an angel who was the patron and protector of a group of Old Believers. They tried to recover the icon, which had been confiscated, by substituting an exact copy for it. Their salvation depended on owning the genuine icon, an angel with golden hair, the image of which filled the soul of the beholder with peace. The angel was blinded by the seal imprinted on it. According to its owners the icon was their irreplaceable protector "because this angel was painted by a pious hand in troubled times and consecrated by a priest of the old faith in accordance with the breviary of Piotr Mogila. Now we have neither priests nor the breviary." For the Old Believers the icons become symbols of their oppressed faith, and for literary figures like Leskov, of a lost Russian identity. "The picture of our traditions as preserved by our ancestors has been destroyed . . . so that today it is as if the entire Russian race was hatched only yesterday." "Holy Russian icon painting," a truly divine art, not only touches the soul of simple people but depicts the "transfigured divine body," which "material man cannot even imagine." Modern art, by contrast, is worldly and shallow. The old art contains the "spirit of which our fathers' traditions tell." That too is why it is a kind of worship, with established rules, "but with its execution left to a free art and to an inspired artist." Here the romantic concept that continues to govern our view of Eastern art is aptly formulated. Unfortunately, it distorts our view of the actual history of the Greek icon.

Patriotism and religion were not the only factors that fed the public's enthusiasm; the discovery of the "primitives" had been in the air ever since modern artists had begun to herald them as their forebears. Kandinsky, Chagall, and Jawlensky drew inspiration from the glowing colors and delight in invention found among Russian naive artists. Vladimir Tatlin, like Goncharowa, apparently began as an icon painter. Kazimir Malevich, who in a new form of icon was himself trying to capture the absolute ideal without taking the detour through objective realism, saw the indigenous icon as an alternative to the artistic tradition of the West. In his own words, it communicated to him a higher truth than nature. Non-Russians, too, swore by this "primitive" art, as when Matisse declared in Moscow in 1911 that better models for

artists were to be found there than in Italy. Viennese Jugendstil and, earlier, symbolism likewise reflect the Russian icon; connections that need fuller investigation.[14]

The Russian icon was to continue to shape the general view of icon painting. In 1926 Oskar Wulff, who had acquired Russian panels for the Berlin Museum well before the First World War, with Russian colleagues prepared two large exhibitions, which laid a firm foundation for the German public's continuing attachment to Russian icons.[15] The work on icon painting that Wulff published with Kondakov was based primarily on the contents of Russian collections, a fact important for the history of scholarship.[16] Meanwhile, Russian icons were being collected in Germany. The Winkler and Wendt collections formed the backbone of the icon museum in Recklinghausen that opened in 1956, which now holds more than one hundred panels.[17] That they are mainly late and Slavic examples is explained by the conditions under which they were purchased. We must be understanding of these limitations, even as we recognize that the enthusiasm of such museums also in the United States slants the general public's view of the Middle Ages because of the overrepresentation of postmedieval works of Slavic origin.

The history of the discovery of icons mirrors the romantic and historical concepts of the nineteenth century, which often led to a misunderstanding of the historical icon. Once the Enlightenment had relegated the icon to a folk practice and thus to a marginal position, the study of the cult of icons became equivalent to invoking a lost world. In opposition to classicism and the secularized art of the academies, icons became glorified retrospectively as an ideal art form of medieval origin. Considering icons as "light from the East" made apparent the degree of their alienation from their traditional basis and their claim to cult status.

c. Italian Panel Painting as the Heir to the Icon

Meanwhile, scholars discovered icons in an entirely different area: the Italian Middle Ages. Pursuing the early history of the European panel painting, they traced its origin to early altarpieces and devotional painting; in the process, the hypothesis became established that most types of altarpieces and private devotional paintings owed their existence and their appearance to the influence of Eastern icons.

One of the early forms of the retable, known as the dossal, is as broad as the mensa of the altar to which it is attached; as an example at Pisa shows, it links together a number of half-length saints framed with Gothic arches.[18] There can be no doubt that this is a new application of the Byzantine icon beam, or *templon*, that surmounted the iconostasis in the Eastern church.[19] There are no altarpieces in Byzantium, whose function is assigned instead to the iconostasis beam at the entrance of the altar area. The pediment-shaped top of the Pisan retable indicates its function as the upper part of an altar, holding together the frieze of icons. Beyond its similarity as a collective icon, it is thematically parallel to the Eastern iconostasis in being a deesis, in which various saints accompany Christ as intercessors.

Other types of altarpieces were also derived from icons, for example, the vertical-format retable with a pedimental top. One might say that the retable with the full-

3

4

3. *Pisa, Pinacoteca; altarpiece from*
S. Silvestro, 13th century

4. *Mount Sinai, monastery of St.*
Catherine; icon beam with deesis,
13th century (detail)

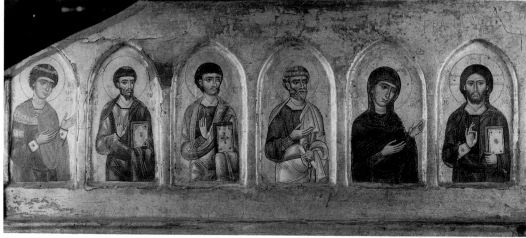

length portrait of the titular saint between accompanying scenes has absorbed the character of the so-called vita icon. A comparison of the St. Catherine retable in the 6, 226 Museo Nazionale of Pisa with an icon of St. Catherine from the Sinai monastery 227 makes the connection clear.[20] The vita icon, so called because of its framework show-ing scenes from the life of the saint, is clearly recognizable in the Italian derivative, despite the fact that the latter has been designed for display on an altar and so has been monumentalized (cf. chap. 18a).

Just as remarkable was the icon's success in the West as an archetype of the new genre of half-length panels of the Madonna, which, in their intimate atmosphere, went beyond the stiff and haughty images of the Romanesque period. The icon, usu-ally thought to embody hieratic distance and rigidity, inaugurated what seemed to be its exact opposite in the West—the emotive, approachable image of the Virgin. In the second quarter of the thirteenth century a small domestic altar from the Berlinghiero 212 school in Lucca introduced the tender embrace of Mother and Child, a pictorial idea anticipated by icon painting as early as 1100 in panels such as the famous Madonna of Vladimir (chap. 17c).[21] 175

There is still disagreement whether some panels are Byzantine imports, works by Byzantine masters in Italy, or Italian replicas of Greek originals. The Kahn Madonna, part of the Kahn Collection in the National Gallery in Washington, is one of these. It 225 shows the technique of an Eastern icon painter but was produced for a patron in Tuscany. It adopts not only the full-length figure of the Tuscan enthroned Madonna panel, which did not exist in the East, but even the engraved ornament of the halo, such as was common only in Tuscany. Here the young Duccio may have met an itin-erant Greek artist about 1280 and received an important new stimulus for an art of lifelike expression. His early work, the *Crevole Madonna* in the Opera del Duomo at 224 Siena, is a kind of "translation" of the icon style into that of Sienese painting.[22]

The influence of icons was not confined to Italy in the thirteenth century, al-though it was strongest there. A number of Italian panels from that time are so close to Greek icons in form and execution as to be hardly distinguishable from them. A saint's icon at Nocera Umbra has taken over the semicircular inner frame and the 5 gold hatching of the robe. Only the Latin bishop's miter shows its Western origin.[23]

Icons also began quite early to have an impact on German art. An illuminated book from Saxony, now in Donaueschingen, reproduces on a double page an icon in diptych form with half-length images of Christ and the Virgin.[24] The Augustiner-museum in Freiburg has a drawing from a model book derived from a Greek icon showing a saint on horseback from the late twelfth century, such as has been discov-ered among holdings of Crusaders' images at Mount Sinai. On the back of the page is a catalog of images showing seventy-five subjects, including a considerable number of icons (chap. 16a).

The influence of icons remained a matter of reconstructing lost models until matching finds were made among Eastern material. Such a find was made by the art historians George and Mary Soteriou. They revealed to scholars a large stock of icons at the monastery of St. Catherine on Mount Sinai,[25] thus putting the study of icons on a firm basis for the first time. The 1956 book by the Austrian Walter Felicetti-

5. *Nocera Umbra, museum; icon of a saint, Umbrian, 13th century*

6. *Mount Sinai, monastery of St. Catherine; vita icon of St. Nicholas, 13th century*

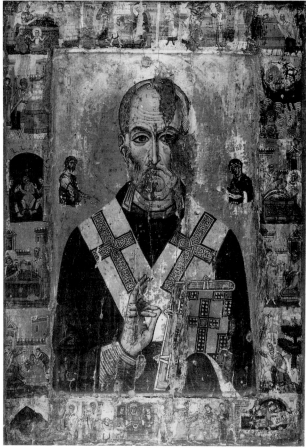

Liebenfels, which offered a "history of Byzantine icon painting," was a somewhat ill-starred publication, since the Soterious were at the same time publishing two hundred previously unknown icons from Mount Sinai, which now make up the most important material available for the history of icons, at least for the period between the fifth and thirteenth centuries.[26]

d. The Discoveries in Rome and at Mount Sinai

The chance discovery in the Sinai desert monastery has now put scholars in a position to write a history of Byzantine icon painting. The catalog of the Mount Sinai icons will prove to be a compendium of Byzantine panel painting. After the hoard of icons became known, Princeton University and the University of Michigan formed an expedition that worked at the monastery for several months each year for almost ten years, with a staff of scholars, photographers, and restorers. Their finds are estimated to number about three thousand items. The first volume of the catalog, compiled by Kurt Weitzmann, has appeared.[27]

These icons include few panels of local or of Egyptian-Palestinian origin. The overwhelming majority, particularly of the panels produced since the ninth century, come from the central provinces of the Byzantine empire and from Constantinople itself, with a number of panels from Cyprus. They reflect stylistic developments in the Byzantine motherland and are entirely free of features such as we would expect in eastern provinces under Arab rule. They came to the monastery as donations from pilgrims; some are products of "Crusader art" (chap. 16c).

The Greek monastery was a station on the route taken by these pilgrims to the Holy Land. Their goals were the mount of Moses above the monastery and the site of the burning bush, where Moses met his God. Founded with funds from Emperor *160*
Justinian in the sixth century, the monastery retains its original fortifications. The basilica within them and the now-famous mosaic of the Transfiguration of Christ in the apse, both from the time of the monastery's foundation, are completely intact. The treasure of icons discovered here indicates how enormous the loss of material elsewhere must be. That they should have been preserved here is explained by a number of factors, including the remote location, the fortified character of the monastery, which was never destroyed, and not least the climate. We have here a parallel to the mummy portraits and the other panel paintings from classical Roman times found in Egypt, which are the only surviving representatives of the genre of ancient panel portrait painting (chap. 5e).

Another series of discoveries, this time in Rome, is almost the equal of the Sinai find in terms of artistic quality and historical importance, if not of quantity. It also came to light in the 1950s and is one of the major achievements of Carlo Bertelli and the Istituto Centrale di Restauro in Rome.[28] The complex of finds includes examples going back to the sixth century, among them pieces imported from Byzantium and local Roman replicas. These discoveries certify that Rome in late antiquity and the early Middle Ages must be considered a Byzantine province as regards the veneration of icons. This is significant insofar as Rome was the center of Western Christendom. This is certainly also a major reason why the influence of icons in the thirteenth cen-

25

tury was greatest in Italy, since we can assume that icons were produced in Italy in every prior century of the Middle Ages. This recognition grants the study of icons and their influence a new significance (chap. 15).

With such spectacular discoveries, scholarship is at a new starting point after the finds in Rome and the Sinai, even if nothing definitive can be said until the Sinai material is fully explored. Important studies remain to be written, at least as regards the history of the icon, which was the most important if not the only branch of European panel painting for a period of almost a thousand years. Today, with the aid of surviving examples, we command a view of the icon's history from the fifth to the fifteenth century. The history of its influence in the West extends far beyond that.

e. Problems with a History of the Icon: The Deficiency of a History of Styles

Did the icon actually have a history? If we are to believe Didron, it did not develop; it was set apart from the life of Byzantine society. If we listen to Byzantine theologians, the icon appears as almost a divine revelation. The theologians, however, tell us only what the icon was supposed to be, not what it really was.

The icon's inner history is manifest in its forms and content. Its external history begins in the fifth century. It was first permitted in private, then admitted into the church, and finally accepted into the realm of the state. Its popularity soon plunged it into a crisis, however, since it had many opponents, especially among the theologians. In the early eighth century the icon was banned by law. A long civil war followed, which ended with the icon's official reinstatement in Byzantine society. At this point, one would expect the end of the icon's historical development with its reintroduction in the ninth century. That this was not the case, however, can be seen from the surviving panels, which show new forms and themes, despite the theologians' assertions to the contrary. Style can be viewed as an expression of historical change, which links the icon to the society that produced it.

The significance of the icon was different in each of the three ages of Byzantium. Initially in antiquity, Byzantium was the eastern part of the Roman Empire,[29] and the Middle East and Egypt would long continue to remain in Christian hands. From Rome, the popes opposed Byzantine administration only after the last western Roman emperor. In the Mediterranean area, cooperation was more important than frontiers, which came only later. The icon drew to itself all the controversy surrounding cult images that would long remain alive in Christianity. It was nothing but a late classical panel picture that inherited the divine image, the imperial image, and the portrait of the dead. Thus the icon adopted a multiplicity of formal devices, each coming from a different tradition and from different genres. It had not yet evolved a style or an aesthetic of its own. It embraced the conflict between the desire for commemorating an individual's likeness and the wish for obtaining an imperishable ideal. Eastern and Western ideas and practices still went hand in hand.[30]

The second age began in the ninth century, as the schism of the Eastern and the Western churches was approaching. The city of Constantinople was the center of a reorganized Eastern empire whose administrative language was no longer Latin but Greek. Although the Middle East had been lost to Islam, the Balkans and Russia

remained, as satellites, in the orbit of Byzantium, whose church reached further than did its secular power. After being reintroduced with new premises, the icon was given an official role in the church for the first time.[31] Other genres of art now became dependent on it. A standardized iconic art, which set the tone in all areas of religious painting, became an instrument of church doctrine. After the icon had divided every-one during the iconoclastic controversy, now all were called on to unite in its name. It was to be a guarantor of the true tradition in which medieval Byzantium sought its identity. In the West, however, where an empire had existed since 800, a different doctrine of images had been advanced against that of Byzantium.

The next break came in the year 1204, when Constantinople was conquered by an army of Crusaders controlled by Venice.[32] The Greek resistance that soon followed led to the reconquest of the imperial city in 1261. In the third age Byzantium fought externally against the Turks and internally for its own identity. A kind of cultural restoration emphasized the Greek inheritance. But the pretensions and the reality of the shrunken empire increasingly diverged.[33] The icon, which now experienced an-other flowering, became a reflection of the crisis. It was open to a personal manner of viewing, but one that sought a different, inner reality through the visual experience. The visual aspect, which kept alive the legacy of Hellenism, was only a means to the end of making the invisible visible. In 1453 the Turkish conquest put an end to the existence of Byzantium. The art of the icon had no further development, but it had an afterlife, especially in Russia and Crete. As of the thirteenth century it had a second history, but now in Western art.

The stylistic history of the icon begins firmly embedded within the framework of the art of late antiquity and Byzantium.[34] What is true of Byzantine art in general is true, in terms of style, of the icon in particular. The style of the icon, however, also expresses historical changes in the way the cult image was understood during the different epochs. The early icon clearly reveals the lack of a fully developed doctrine of images. It competes through its subject matter with the contradictory conceptions of nature and image found in late antiquity. The antitheses between space and surface, movement and rest, corporeality and abstraction, also testify to the contradictions between existing perceptions of the world and traditions of culture. Since the Chris-tian cult image does not yet have a tradition of its own, it borrows its forms from other genres. Only the three-dimensional, sculptured image is proscribed.

In the Middle Ages the icon symbolized rigid concepts of order that enforced a standardization of its appearance. The open structure of painting of late antiquity gave way to precise definition, to which lines on a surface always lend themselves. The diversity of visual experience was reduced to a canon that suited the church-controlled cult image. The face of figures abolished the natural spontaneity that had existed earlier, to become the stereotyped mask, which also served to keep distance between saint and beholder. The physical form was given less emphasis. It was a schema that could be filled with new life, for the intention was not to preserve an earthly form but to communicate the archetype that alone justified the cult of images itself. Beauty was so standardized that it resisted any materialistic use of the image and opened up a spiritual world, called "noetic" by the Byzantines to distinguish it

6

from "physical" experience. The reduced but universally valid canon of forms reflected, in the icon, a superordinate canon of values, which was safeguarded by the centralized church of the diminished empire.

From the eleventh century, however, a countervailing tendency set in. In competition with church poetry an "animated" painting was developed that celebrated ethical roles and ideals through the traditional icon. Another function of the new rhetoric was to resolve the paradoxes within the divine "economy" of salvation.[35] The emotions that are portrayed, which appear to permit a private access to the saints, actually denote elements of dogma. Liturgical practices opened up new "speech roles" for the icon.

178

The saint was portrayed as filling a particular role, both ethically and ecclesiastically. The interchangeable facial type, one of a limited range of formulas, pointed to the exemplary person, just as the robe pointed to a group within the church community. One and the same type of face denoted the prophet Jonas or the evangelist Luke or the early church father John Chrysostom. The type of robe (taken from antiquity for apostles and from liturgical dress for clerics) ruled out any confusion.[36] All that usually makes up a story was couched by the narrative icon in the timeless language of the ritual reenactment of a myth. Beyond the historical narrative of the Bible, the underlying mystery to be revealed in it was made apparent. In this narrative variant too the icon now took on a scriptlike clarity. While showing events from the life of Christ and the Virgin (being the only narratives allowed), it always depicted the topic of a church feast day. The veneration of the image was based on the meaning and content of a feast.

159
160

164

In the late period, when Byzantium's existence was constantly being threatened, the appearance of the icon changed radically yet again. On one hand, it now allowed a personal way of experiencing its meaning, stimulated by the affective means of mime, gesture, and color. On the other hand, all was now removed into the unattainable world of the beyond. This effect was fostered by the use of light that seemed to come from a world beyond. The debate whether the light of Christ's Transfiguration on Mount Tabor was created or uncreated (i.e., divine) pointed to the devaluation of the visible world. Dissonance and fragmentation destroyed the harmony between the figures and their setting in the icon. The image expressed a contradiction between the beholder's personal experience and the "objective" ideals of faith. It pointed the way to a personal escape into another world, a transcendental one that was now the only world intact.

Seen in this way, style becomes the expression of a mentality that changes fundamentally several times. Stylistic development comes to an end only when the icon has become merely a means of remembrance. The maintenance of a given form was to express a desire to hold on to a lost tradition. The late Byzantine icon actually was ill suited to be canonized insofar as it expressed not a timeless order but an ecstatic experience. It was the last form to be handed down, however, and so it alone was preserved as "correct."

Any history of style shows how difficult it is to distinguish the icon as a genre of painting separate from other genres, such as wall painting or book illumination. In

the early period, during late antiquity, its formal characteristics had not yet solidified. In the late period of Byzantium it accepted motifs such as landscape or emotions, which called into question the idea of a peaceful, timeless existence, on which it had long depended. Only in the centuries following iconoclasm was the icon so clearly in the foreground that other genres, such as fresco painting, mosaics, and ivory, benefited artistically from it. Only this period allows us to speak in general terms of an aesthetic of the icon.

If such a claim is accepted, there can be little point in writing the history of the icon solely as a history of style. But equally, an iconographic study of themes and motifs soon reaches its limits when we realize that we must study not only the icon itself but the other arts as well. In the eleventh century a Crucifixion looked no different in a panel painting from how it appeared in a wall mosaic. The icon also cannot *164* be defined simply as panel painting, since it is also found in other branches of painting or in relief sculpture, and in the applied arts. The icon thus is not a particular tech- *108* nique of painting but a pictorial concept that lends itself to veneration.

3. Why Images? Imagery and Religion in Late Antiquity

a. The Virgin's Icon; Icon Types and Their Meaning

Only a person or a "mystery" of the faith can be venerated. The image derives its authority in the first case from the authentic appearance of a holy person, and in the second case from its "correct" treatment of an event in the history of salvation.[1] In both cases a general consensus is needed. Icon painting therefore centers in given types that refer back to real or alleged archetypes as their first formulations. The first task of icon scholarship therefore appears to be to define icon types and to identify them by means of the inscribed names. For a long time this indeed was a common exercise that intended to produce a fixed catalog of immutable types rather than tracing the history of changes and new inventions. But difficulties arose as soon as one took the legends as they were told by the icons' sources literally or adopted a simplistic view of the course of events.

The name inscribed on an icon indeed coincides with its type far less often than post-Byzantine catalogs suggest. In the early period an icon had no title, at most the name of the saint it portrayed. For polemical reasons, after iconoclasm the icon of the Virgin adopted the theological title of the Mother of God (first *Theotokos*, then *Mētēr Theou*), which at the time amounted to an official proclamation of the Virgin's status in the history of salvation.[2] It also bore the name of the church in which its "original" resided, or a title referring to its origin, its function, or a conspicuous quality (e.g., intercession, or *paraklēsis*, by the Virgin). Sometimes the name of an image alludes to a dogmatic theme, as for example *Platytera* (i.e., "wider [than the heavens is the womb that encompassed the Creator]").[3] The case is similar with the *Eleousa*, or Our Lady of Mercy, who performs her part of the work of salvation. It has been proved that such a name does not match a fixed image type but adds a general denominator to quite different types of images.[4]

The Virgin's icon, in particular, became an inexhaustible source of new inventions and allusions. If it is true that the types and names of images were freely interchanged, each bringing its own meaning into play, then a new field of historical inquiry opens for scholars. First, one must learn to understand allusions that can invoke different and even contradictory ideas in a single image, both by the way the figure is shown and by the name appended to it. One must also ask which types were current at a given time in a given place, and for what reasons. The original invention needs to be explained. Migrations from one cult to the other can be verified through the transfer of "temple images"; poetic and theological themes can be elucidated by means of the adopted shapes, which differ significantly in the eleventh century, for example, from those of the earlier period or of the late Middle Ages. It thus seems an obvious task to view the history of the icon in the wider historical context within which the icon's use underwent changes, in such a way as to make apparent the interaction between its continuing tradition and its varying context.

This is a difficult program to pursue. The situation is more favorable for late antiquity and the early Byzantine period because the context has been far better researched. The late Byzantine period (mid-thirteenth to mid-fifteenth century), for its part, is so close in time to the post-Byzantine history of the icon that what is known of later practice often can be applied in retrospect. What is least known is the history of the icon in the middle centuries, for which we must adopt a different perspective. In doing so, we are helped by liturgy and church poetry, since they provided the functional context within which the viewer of the time saw the icon.

The hymns that were sung and the sermons that were preached at that time were usually more than half a millennium old. Texts by the early church fathers were still read in the original language; hymns to the Virgin were handed on in the form they had taken in the sixth century. The mysticism of the early period had already created the main symbols that continued to be used in the high Middle Ages, often with deliberately archaic language. All the same, such themes and motifs served the needs of an ever-changing society, or were made relevant in ever-new ways by changes of emphasis. It is often difficult to distinguish the timeless features of liturgical poetry from those that are modern, and we encounter a similar difficulty when we try to see the icon within the changing context of Byzantine society, necessary as it is to make the attempt.

One example is the rhetorical development that took place within the Virgin's icon, whether it alludes to the lament of the grieving mother or to the knowing mel- *172* ancholy of the compassionate mother. Such a development transformed the appear- *173* ance of the icon after the tenth and eleventh centuries, but the change was carried along by an argumentation and intoned in a language that went back to well-tried models. When these patterns of thought and speech originated, however, such images did not exist, nor was it conceivable that icons could ever express such rhetorical matter in the sixth century. At the time of Romanus the Melodos, the icon as a form was ill adapted to absorb impulses from poetry. It was necessary for such hymns to take on a new liturgical function, and for the icon to have a secure existence in church life, before it could take on such complex significatory roles. The same applies to the time lag between the Christological debates and the much later decision to symbolize them in the icon. A persistent disparity obliges us, when thinking about the icon as a social phenomenon, to consider it within its own tradition as well as to situate it in the society that it served in its varying roles.

This twofold attention to constant and variable features is especially necessary after the icon's crossing of the frontier to the Western hemisphere, which led to an expansion of the genre after about 1200. After this date imported icons were often put to such new uses, or Italian replicas so exactly replicated Byzantine models, that it is difficult to distinguish a familiar form in a new function from a new form in an existing function (chap. 17a).

Different, yet also similar, are the problems arising in late antiquity, during the transition to Christian culture. Clear distinctions are often impossible, since Christian cult images appeared in borrowed forms. Lineages between the non-Christian and Christian usage of images, are not always easy to discern. Christians were reluctant *7, 8*

to acknowledge the analogies, and they were also drastically reducing, and if possible eradicating, the physical stock of pagan "idols," while borrowing from it at the same time. This was especially true of the images of the gods, with which the next stage of our discussion is concerned. Matters are somewhat simpler regarding the portrait of the dead and the image of the emperor, because in these cases the private and state spheres formed a buffer zone between Christian imagery and the tabooed objects of "heathen" religion. On the level of popular religious practice, however, there was an urgent need to provide a substitute for the confiscated cult images, from which the people had sought help in times of need.

These problems culminated in the icon of the Virgin, which we shall now consider. The Marian icon may also help to throw light on the question why icons were needed at all—which gap they filled in the way society represented itself. Of course, we cannot go beyond questions and conjectures in discussing such a topic. It will be appropriate to begin by talking about the person embodied in the Marian icon, for although she made her appearance late in the art of the icon, she soon became the favorite subject.

b. The Virgin's Personality in the Making: The Mother of God and the Mother of the Gods

Isidore of Pelusium (d. ca. 435) replied in a letter to a question from a theologian as to how the Christian belief in a Mother of God (*Theou Mētēr*) related to the polytheism of the Greeks, who talked of a mother of the gods (*Mētēr Theōn*).[5] This was a reference to the Great Mother, or Cybele, who was venerated at Pessinus in Phrygia but who had also had a cult center in Rome since about 200 B.C.[6] Emperor Julian the Apostate (A.D. 361–63), writing at a time when Christianity was already the state religion, composed a speech on the "motherless virgin who sits beside Zeus" and is "the mother of the thinking gods." Constantine restored her temple in Constantinople and donated a new cult image.[7]

Isidore admitted that the two situations bore a superficial resemblance but insisted all the more emphatically on the differences. He claimed the paradox of the virgin mother exclusively for Mary—ironically, the very status on which the divinity of many prior goddess-mothers had been founded. Isidore might have argued that Mary's virgin motherhood was without parallel because it alone was claimed to have arisen from a human pregnancy. This did not, however, dispose of the question of who Mary was. The three persons of the Godhead had already caused enough problems for the monarchical principle of the single God; now a woman had also to be accommodated within the definition of God. For the theologians a human mother was indispensable, since only she could guarantee the human life of Jesus. But she must have conceived the Child through God within her body if the unity of Jesus as a person was to be valid. For this reason the Alexandrian theologians at the Council of Ephesus in 431 insisted on the title "Mother of God" (*Theotokos*).[8] Isidore's letter was written in this context.

But centuries later, when the problem seemed long since to have been resolved, we still find John of Damascus speaking of the distinction between Mary and "the

mother of the so-called gods," to whom many children are fancifully attributed, "whereas in reality she had none." For how could an incorporeal be impregnated by means of sexual intercourse, and how could there be an eternal God who had to be born? The writer therefore assumes a first, timeless birth of the divine Logos from the Father alone, distinguishing it from "a second birth" in which he who "is without beginning or body" was born in the flesh from the human body of a mother. "Thus he remained wholly God and became wholly man." In this sense one could speak of the Mother of God. "Nevertheless, we do not call her a goddess (far be such hairsplitting Greek fables from us) and also recognize her death."[9] In fact, John was preaching on the feast of the death of the Virgin, but now he stressed that her tomb (like that of Christ) had been found empty, as she too had been taken up into heaven corporally. Just as her human motherhood was, if not canceled, at least raised beyond ordinary human experience by her virginity, so likewise was her human death by her transportation to heaven.

The two texts quoted here prove at the least that it is no modern error to speak of the role of goddess-mothers in the history of the veneration of Mary, as the possible (or real) analogies were early regarded as a problem. Perhaps the fear of creating a goddess was one reason for the noticeable reticence of the very early theologians vis-à-vis the figure of Mary. It was only when the public debate on the definition of the person of Christ in the fourth century preoccupied the whole Roman Empire that Mary began to feature more and more prominently in Christological arguments, creating a need to define her life and person as well. This circuitous way in which her role came to be defined within the church explains why all utterances about her up to the Council of Ephesus lead away from her as much as they focus attention on her son. This reaches a peak in her telling designation as a "virginal workshop" set up by the Logos in order to become man therein.[10] Her femininity, indeed her person, was regarded as secondary to her primary service as an instrument of salvation. Here the theologians not only were thinking about the Judaic heritage of the one God the Father and the doctrine of the Logos but also were concerned with concrete problems raised by the doctrine of the Docetists, who ascribed to Jesus only the "appearance" of a body and no human nature. For this reason all similarities of Mary to a goddess, which might have cast doubt on the human aspect of Jesus, were avoided, and even Mary's human frailties were celebrated.

While the theologians were neutralizing Mary's possible role as the heavenly mother by disputing her role in the birth of Christ, many cults of goddess-mothers still persisted, at least at a popular level. In the eastern part of the Roman Empire this was true particularly of Cybele, the "mother of the gods," who has already been mentioned, and of Diana of Ephesus (the virginal all-mother), whose cult reached its zenith in the third century A.D.[11] She was a mother figure who could bestow salvation like Isis, described by Plutarch as "the justice which leads us to the divine because it is wisdom." Isis, "the one who is all," with her "thousand names," was endowed by myth as mother to the boy Horus, with whom she appears on an Egyptian mural—with qualities that could readily be transferred to Mary, in that they inspired the trust of those in need of protection. Some of the temples of Isis that had been

7

closed at the end of the fourth century (as late as 560 in the case of the temple at Philae) were reconsecrated as churches of the Virgin.[12] The heavenly mothers were the focus of mystery religions, whose initiates sought redemption and practiced a personal piety. These figures also acted as oracles, rainmakers, and protectors of crops.

Apart from its saints, Christianity had little to offer in place of such practical protectors and the multiplicity of local cults. Hence the oversensitive reaction of Bishop Epiphanius of Salamis, about 370, to a cult of the Virgin practiced by women who offered Mary loaves made from a dough called *kollyris*.[13] It was, he proclaimed, a relapse into heathenism; although Mary could be honored, only God should be prayed to. From then on, a cult of the Virgin developed within the church on the pattern of the saints' cults already existing. The Council of Ephesus met in a church of the Virgin, and a short while earlier Proclus had preached in the capital on a feast of the Virgin. When the council met at Ephesus in 431, the construction and decoration of S. Maria Maggiore in Rome was almost complete.[14]

It was only the council's decision to recognize Mary as having given birth to God, however, that set in motion the autonomous and general veneration of the Virgin. The theological definition was no longer a problem, having been reduced to a formula that the majority accepted. Now the new figure could be endowed with all the stereotypes of a universal mother that were known from the mother divinities. An oration given by Cyril of Alexandria in Ephesus on the day after the condemnation of his opponent Nestorius laid the foundations of a Marian mysticism that culminated two generations later in the poetry of Romanus.[15] The theologians now seemed to have no hesitation about ascribing to Mary almost "godly honors," taking over metaphors from texts on the mother divinities to make her seem more familiar, and even favoring the celebration of new feasts of the Virgin on the feast days of the old goddess-mothers.[16]

The new literature on the Virgin pursued three different aims. First, the biography of the real person had to be "completed," since Mary's life is hardly mentioned in the Gospels and played a significant part only in apocryphal texts.[17] In this context icons and clothing relics were needed in order to add concrete historical proof. Naturally, the absolute perfection of this person was no longer in question, nor was her purity, beginning with her immaculate conception in the womb of Anne. A second aim, often difficult to reconcile with the first, was to popularize the "mystery" of Mary's cosmic role as the greatest miracle of creation, which tended to blur the outlines of the real person. The metaphor of the bridge to God helped meet this aim, as did the whole repertoire of Old Testament prophecies, which were now used to support the idea of the Virgin as a key figure in universal history. From this perspective followed Mary's role as universal intercessor with God, and this third aim of the literature also embraced the idea of a new mistress of the world, apart from whom no way led to God. Refuge was now taken "in the heart" of a compassionate Mother, as Mary now accrued the anthropomorphic features of many former protective divinities and miracle workers.[18]

About A.D. 450 the new cult of the Virgin met with the energetic support of Empress Pulcheria in the capital, but it is difficult from the later sources to determine the

exact outlines of the empress's activity. Pulcheria had taken up the regency for her brother Theodosius II (408–50) at an early age, and after his death she became empress as the wife of Marcian (450–57). She clearly played a part in the preparations for the Council of Chalcedon, which reaffirmed a unity of faith that now embraced the Mother of God.[19] Later sources attribute to her the building of three famous churches of the Virgin in Constantinople that were subsequently much enlarged.[20] Mary's mantle, however, seems to have found its way to the church of the Virgin in the Blachernae quarter only in the reign of Leo I (457–74).[21] One would like to know more about the early history of this relic, for it later provided a palpable symbol for the idea of Mary's motherly role, just as it offered concrete evidence to support the legend of the empty tomb, in which the mantle had been left behind.[22] As Mary's tomb, the location of which was disputed between Jerusalem and Ephesus, could not be brought to the capital, the palpable relic of the mantle was substituted for it, according to the account given later by a popular text.[23] The empty tomb was a stimulus to the universal veneration of the Virgin, since it ruled out any local claims to her presence and also fostered belief in the miraculous appearances of one whose body sojourned in heaven.[24] The interest in transferring cult centers from the Holy Land to Constantinople, however, where no biblical tradition existed, had become far too important after the moving of the apostles' bodies there in the fourth century ever to allow any shortfall in the cult of the Virgin.

Clothing relics and, as we shall see, authentic portraits took the place of missing body relics as evidence of a historical life. Such relics effectively turned some churches of Mary into cult centers, both as mausoleums and as successors to the pilgrim churches in Jerusalem and Nazareth. Other churches became sites of miraculous healing in the pre-Christian tradition. The foremost of these was the church of the Virgin at the healing spring, situated in a cypress grove outside the city, which was included among the many existing or new buildings in which Emperor Justinian I (527–65) promoted the Virgin's cult.[25] The "spring of miracles," or "life-giving source," was henceforth surrounded by many legends.

A new and decisive phase of the Virgin's cult began when the capital and the hard-pressed empire needed her support in the age of wars against the Avars and the Persians, and ultimately against Islam. Hopes of encouraging divine aid were directed toward her, as she also acted as a symbol of unity for the empire's population. This era, which began with Justinian's death in 565 and reached its first climax with the Avars' siege of the city in 626, is so well documented by contemporary sources, and has now been so thoroughly researched, that we can clearly trace the extension of Mary's role as city deity and army leader through changes in the practice of her cult.[26] In the same era the cult of icons had its first flowering under the direction of the court (texts 2 and 3).

Upon the coronation of Justin II in 565 the poet Corippus composed a prayer to the Virgin for the empress that mentions a dream visitation in which Mary reveals his fate to the emperor, just as Venus had once done to Aeneas.[27] Under Maurice (582–602), who also introduced the Assumption as a universal feast, the image of Nike was replaced on seals by that of the Virgin.[28] Soon after, when the beleaguered

city was fighting for its life, Mary took over, through appropriate visions and exhortations, the role of Athena Promachos, whose statue still stood in the city.[29] As a sermon describes, during the siege by the Avars in 626 she appeared, brandishing a sword in her hand and admonishing the desperate citizens to dye the sea red with the blood of their enemies.[30] A new preamble to the old *Akathistos* hymn, with which the Virgin was thanked for the final deliverance, made explicit her role as city goddess and general.[31] Emperor Heraclius (610–41) attributed his accession to the throne to Mary's help and commended the city to her protection when he went to war with the Persians in 622.[32] At that time the mantle of the Virgin in the Blachernae was the city's palladium, even more than were the Marian icons; encased in a threefold reliquary, it still bore traces of the milk with which Mary had stilled her Child.[33] The clergy of this church were so numerous that for economic reasons Heraclius had to reduce them to seventy-five priests.[34] The relic chapel, as we know from inscriptions, was rebuilt by Justin II (565–78); in two later inscriptions she "who bore Christ and vanquished the barbarians" is praised as the protectress of the imperial house.[35]

Such information makes it clear that we are no longer moving in the realm of speculation if we see the change in the cult of the Virgin as a consequence of the turning toward the universal mother, which by the early seventh century had reached a pitch that could hardly be surpassed. The Mother of God, whose figure had by now become as polymorphous as the demands made on her were multifarious, appeared as an actual sovereign, in whose name even the emperor acted. As the unity of the Roman people was now sought in the unity of religion, personal piety and state religion merged seamlessly into a patroness accessible to all, enlivened by the human features of Greek religion and endowed with unlimited power. This history throws a different light on the reaction by the court in the eighth century, when the iconoclasts under Constantine V finally repudiated not only the icons but the oppressive status of the Virgin. The iconoclasts' position unites the claim for an autonomous representation of the Roman emperor with the adoption of a purified, spiritual religion. The link between the cult of the Virgin and the cult of icons again became clear when the supporters of images endowed the reinstated Marian icon with the official title "Mother of God."[36]

The cult of the Virgin, which looked very different to the populace than it did to the theologians, took a fixed place in the political sphere, its third manifestation, from the late sixth century on. This was expressed in the official addresses prescribed for the feast of the Assumption in the imperial Book of Ceremonies,[37] which begged protection "on the wings" of Mary's intercession and praised the Virgin and Mother as the "eternal river" and the "living spring of the Romans." She was entreated to aid the emperors, who had received their crowns from her and who in war bore her image as their invincible shield.

c. Pagan Images and Christian Icons

The continuity between the pagan and Christian use of images has naturally become a subject of controversy among scholars, as the early Christians' opposition to the idols of polytheism was only too obvious. The early theologians too had entered the

fray, putting forward entirely new arguments to support the idea of discontinuity as regards paganism, in terms of theory if not in terms of practice. Where connections did exist in the use of images, they were veiled and hidden as far as possible, so that the sources yield little on the question. Only through the functions the images took over, first in the private sphere and then in the public, can we infer connections. These can be presented here only in the form of conjectures. Edwyn Bevan, like Ernst von Dobschütz before him, has made this continuity the subject of his study.[38]

Christianity's public use of images was hampered not only by its former opposition to the state cults of Rome but also by the Mosaic ban on images. St. Paul (Rom. 1:23) charges the pagans with having changed the glory of the incorruptible God into an image of corruptible human beings. In his defense of Christianity, Tertullian accuses the heathens of doing no more in the cult of their gods than they did to honor their dead; the alleged miracles performed by statues served only to "confuse stones with gods."[39]

Tertullian touched here on a sensitive spot that was also a contentious issue among the Romans, for consecrated images inhabited by the Godhead raised expectations of supernatural powers and miraculous healing. In his *Interpretation of Dreams*, Artemidorus contended that it made no difference whether one saw "Artemis herself . . . or her statue" in a dream, for even "perishable statues" had "the same meaning as if the gods were appearing in the flesh."[40] The idea of the image as the "seat of the divine being" and the idea of the "spirit animating the statue" both led, according to Otto Weinreich, to the conviction that the image possessed the same powers as its divine model and shared its capacity for response.[41] In the cult image "the divine *noumenos* was present and active," so that if one had a petition to make, one sought out its presence.

This use of images had very ancient roots going back far beyond Greco-Roman culture and needs no special explanation. Nor should it be mistaken for a popular aberration among the lower classes, no matter how glibly the enlightened upper classes may have distanced themselves even then from such practices. The desire, in times of public or private need, to have a divine intercessor present at a cult site and in an image was only too understandable. At such times the idea of a religion was always less important than the direct meeting with its representative. This is why cult sites quickly became centers of pilgrimage, where the meeting with the intercessor was staged in a way that promised success. Given the overcrowded pantheon of gods, such places also permitted the experience of the community of the local cult. The public cult was continued in private by the protection offered by household deities and genii. Where private expectations of salvation were involved, the use of images took on a multiplicity of forms and content that had little in common with the rigid patterns of an official pantheon. Heroes and healing gods like Asclepius, below the rank of the Olympian gods, offered direct access or a locally accessible partner during times of personal need.

The transfer of a cult from one place to another usually involved the god's image. At the new site, the latter was introduced in a carefully managed ceremony at which the original was first removed from public view and then allowed to "appear" during

the rites of a feast day. The likeness that existed between a god and the god's cult image could be confirmed by dream apparitions in the temple; here the god appeared to the dreamer in the same form "as he is seen in the temple." Thus Ovid describes Asclepius assenting to leave Epidauros for Rome, although Asclepius chose to appear in the shape of his attribute, the snake.[42] Images of the gods were also donated as votive offerings, for which replicas of the official cult image were chosen. If these were not seen in their contexts, it was often far from obvious whether they really were the official images of gods. In the fourth century the famous orator Libanios was unsure whether he had before him a portrait of the writer Aristeides or—because of the long hair—a cult image of Asclepius. He claimed that the figure resembled Asclepius, who was to be seen as a votive image beside Apollo on a "large panel picture" in a temple in Antioch.[43] Here, then, is evidence of the image of a god in panel form.

In view of this multiplicity of religious concepts and their pictorial symbols, it is unlikely that the introduction of Christianity as the state religion marked a sharp break in the use of images, despite the official line of the church. One might well do without the temple image in the parish church and yet maintain the household gods and domestic intercessors. The functions of such gods were gradually transferred to Christian saints with hardly any noticeable change, except of name. Demetrius, the patron saint of Thessalonica, provides a revealing example of this process.[44] When he appeared in dreams in the form he had in his icons in that city, the dreamer in his church was cured, just as had happened with the vision of Asclepius. Demetrius was clearly a kind of Christian Asclepius, who in the fifth century turned his city into a new Epidauros. The same is indicated by the golden hands that distinguish the saint in a mosaic in his church, much like those of St. Stephen in a chapel in Durazzo (Albania).

The healing hand of the miracle worker Asclepius (Hera, Artemis, and Serapis are also known to display it) is the subject of a study by Otto Weinreich, which continues to be of particular interest in our context.[45] In his sanctuary on the Tiber in Rome, where Asclepius was worshiped as "redeemer and benefactor," were to be seen the votive gifts of those who had been "saved by his hands." According to Emperor Julian the Apostate, Asclepius appeared at Epidauros in simple human form; he grew up there, and on his wanderings he held out his beneficent right hand. Hera Hypercheiria similarly healed with a raised hand held above the sick person.

Demetrius, the Christian saint, could heal only if he prayed to God, but his prayer was so effective that his praying hands were highlighted by means of their gold color. This both honored the saint and indicated the feature for which he was honored. In antiquity the gilding of a statue was often a way of giving thanks for a rescue. In Rome, for example, the statues of the Dioscuri were gilded for this reason.[46] In the Middle Ages the aura of the healing hand passed to rulers and leaders of spiritual movements. In the ninth century the head of the Paulicians thus was called "Golden Hand" (Chrysocheir).[47]

The motif of the golden hand provides a sure link between icons and pre-Christian cults (although it did not change Demetrius, who was a mortal saint, into a god). The motif reappears in two early icons of the Virgin in Rome, which do,

7. *Karanis, Egypt; Isis as house patron*

8. *Rome, Pantheon; icon of the Madonna and Child, 609 (repeated in color at front of color gallery, following page 264)*

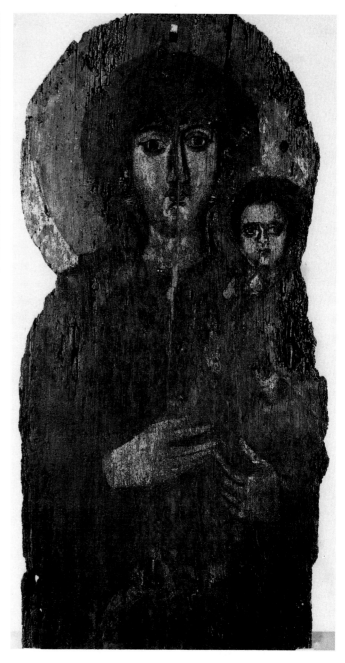

of course, contain an image of God in the form of the Son of God. In the Pantheon icon (609), the hand that Mary uses to intercede for the praying person is gilded (chap. 7b). In the icon of Our Lady the Advocate, both hands have golden sheathings (chap. 15c).

There is also evidence for such a gold covering for seventh-century wall icons in S. Maria Antiqua in Rome. Here too we must distinguish between applications that are not votive offerings on the part of clients, and those that symbolize the "responding" part of the saint. In this church, for example, Demetrius's mouth, not his hand, once was covered in gold, the mouth being emphasized as the organ of prayer and the source of the response.[48] One is reminded of votive gifts in pre-Christian temples, which often consisted only of the large ears of the deity.

The motif of the miracle-working hand points to a continuity in the use of the cult image, which assumed precisely the functions left unaccounted for upon the abolition of the old healing gods. It is therefore not a question of Artemis becoming Mary or of Asclepius becoming Demetrius but of which traditional functions the new Christian images assumed. One need only recall the cult legends about the heavenly origins, the inviolability, and the miracles of speaking and bleeding images to be aware of the transfer of familiar ideas to the new cult images. This does not mean that Christendom had now become "heathen," although it cannot be denied that it did open itself to the culture of the Roman Empire, which, as supporting a mystery religion, it had once so steadfastly opposed. This means that general ideas and practices deeply rooted in human nature became established in Christianity as soon as it had ceased being on the defensive and had become the religion of the whole empire. Of course, open references to images of the old gods were bound to be controversial, and we hear of a sixth-century painter whose hand withered when he painted a Christ too obviously resembling a familiar type of Zeus.[49] But allusions did not need to go so far, as in general the formal assimilation of the image of ancient gods into the Christ image was long since completed (cf. chap. 4).

The continuity of image use can be seen in the mysterious bronze votive image at Caesarea Philippi (or Paneas), at the source of the Jordan.[50] It depicted a healing god with raised hand, perhaps Asclepius, and a woman client seeking protection; local people, however, spoke of it as representing Christ and the woman with the issue of blood, who according to the Gospels was healed by touching the hem of his garment. The woman was said to have had the statue cast and placed outside her house in gratitude. Eusebius (d. ca. 339–40), the bishop at a nearby town, passed on this version without commentary in his famous *Ecclesiastical History*. This gave rise to countless legends, in which, as they developed, the sick woman was called either Martha, the sister of Lazarus, or Berenice, and finally became Veronica. A Christian origin for this sculpture in the fourth century is out of the question, although scholars disputed the matter for a time. It was therefore all the more necessary at the time to assert a Christian origin, to justify the continuity of the image cult of the Christian era. The healing herb growing up to the hem of what was supposed to be Christ's robe and the rediscovered dedicatory inscription to a "God and Healer" were also used as evidence.

But how did the Marian icon fit into this continuity? As we have seen, it first

served to provide Mary with a "face" and to substitute for the lack of physical relics. The inscription "Blessed Mary" on the early images verifies the association with the long-established image of the saint (cf. chap. 5). But the depiction of the Christ Child on the icon, which was the original reason for painting it, brought the mother's image into the proximity of the God image. One might call the Marian icon a saint image that contained a God image (although, as the discussion of the images attributed to St. Luke will show [chap. 4b], matters were more complicated). The transformation of Mary into a universal mother facilitated the assimilation of pictorial formulas of mother-deities such as Isis. Sometimes the Virgin's image gave the impression of hold- 7
ing out the God image like a weapon against attackers.[51]

The icon of the Virgin is a striking example of the continuity in the use of images between pre-Christian and Christian times that is at issue here. This is true of both the public and the private spheres. In the public sphere, the cult of the Marian icon culminated in Constantinople in the period after 600 (text 2). As we saw, Heraclius ascribed his ascent to the throne to the help of an icon of the Virgin, whose image he emblazoned on his ships' banners.[52] When the capital was under siege in 626, the patriarch had Marian images (perhaps again reproductions of the same icon) painted on the city gates, where they filled the same role of the old god images, guardians of the gate (propylaioi), which protected a town and also warded off sickness.[53]

By then the Marian icon had long been at home in the private sphere. Lamps burned before it as before the old household gods. It was found in monks' cells and even in prisons. In a work on the life and ideals of hermits, John Moschus (d. 619) recounts a number of episodes involving the monks' use of Marian icons. For example, before leaving on a journey, a hermit asked that his icon itself take care that the candle burning before it not go out in his absence.[54] Private persons, who did not yet understand the official church's opposition to the consecration of images by professional magicians, asked Patriarch John IV (d. 595) to bless an icon of the Virgin in order to heal a sick woman with it.[55] When the patriarch refused the request, the image performed the miracle on its own when it was hung in the sick woman's house. In the home, the icon fulfilled functions similar to those of the earlier domestic images of Isis.[56] The church sought to separate the icon's miraculous powers from magic 7
incantations, ascribing them instead to the Virgin herself and making them dependent on the prayers of the icon's owner. In the West (and for the Byzantine iconoclasts), a different view was taken; what mattered was precisely that the image be consecrated by a priest, since only the blessing was valued.[57]

d. Why Images?

It has been asked again and again why Christianity finally did adopt the veneration of images, and why it happened in the sixth century.[58] The question does not, of course, refer to ordinary pictures, but to images that were venerated as idols had been by the heathens. Whose interests did this veneration serve, and what were these interests? The question can be approached from different directions—from the viewpoint of religious history or that of political history, to name only two possibilities. The theologians produced the theory for a practice they found already in place. The state

provided image veneration with a public pattern and so gave certain signals to society. The icon cult was different as practiced by monks and pilgrims, and different again as pursued in private. The answers have usually been sought in the concrete historical context, but the question can be given a further dimension by posing it on a wider plane: Why were there images at all?

We are concerned here with material images, of course, but ones that are invested with mental images. They came into being because they were to provide a visual likeness of what they stand for. In our case they represent persons who cannot be seen because they are absent (the emperor) or invisible (God). If they were visible, veneration of their image would not be necessary. The absent emperor present in the image is an old tradition. But for Christianity the depiction of the invisible God (though he may have become visible in Jesus) posed a problem that escalated in the conflict over iconoclasm and taxed the minds of theologians for a century.

It had not been forgotten that Yahweh was present only in the written word of revelation, which was venerated in the Torah as his sign and bequest, as the two rabbis do in figure 9. Here the icon of God is the Holy Scripture housed in the Torah shrine. No visible image could do justice to the idea of God. An image of Yahweh that resembled a human being could be confused with the idols of polytheism. Monotheism always tended toward an imageless concept of the one and universal God. It was in competition with a multitude of cults distinguished among themselves not least by their idols—cults that gave their gods precisely the anthropomorphic features that Christianity allowed only in the special case of the historical Jesus, but that Judaism could not accept at all.

In Christianity the need for local cults was answered by the cult of the saints, whose relics—and then icons—suited the purpose.[59] Only Christ—whose painted image was a physical likeness of God in human form (cf. chap. 8)—and the Mother of God could claim a universal cult. But it was precisely their images that provoked the controversies that prevented a universal cult of images; the problem of visibly depicting God exacerbated the theological differences that had been contained with such difficulty.

Why images? The question cannot be separated from a further question: Who used them, and in what way? We can see how this question applies to the private sphere, where domestic patron saints were invoked to ward off every kind of danger. Their physical presence was needed to allow people to address vows or thanks to a visible intercessor by placing garlands around the image or lighting candles before it.[60] In the public sphere, the only way to represent saints after death or outside the immediate vicinity of their graves was by means of images, in which they could be venerated at many other sites after their death. The images met the same demands that were made of the saints while they were alive: to give aid and perform miracles.[61] In the state sphere up to now, unity had been represented by the emperors, who embodied victory or prosperity in their self-display. These functions were now taken over by images of God, which embodied the unity of the empire on a supernatural plane.[62] The icons now became victors, especially over foes of a different faith, who

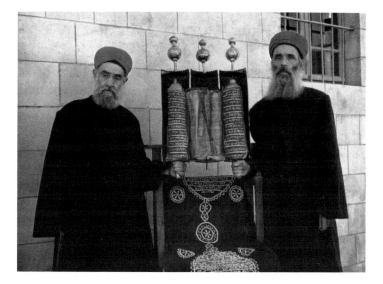

9. *Jerusalem, two Rabbis with Torah rolls*

10. *Buenos Aires; Virgin of Amparo, Peronist election campaign demonstration in 1972*

could be vanquished not only in the name of the empire but in the name of faith as well.

Here too images were called upon to play an active part where nothing else was available. Images thus filled gaps on a social level. They were given roles that society no longer handled by itself; in this way, extraterrestrial forces were given power and responsibility. It would therefore be a mistake to see images—as theologians were later to do in the iconoclastic controversy—only as objects of religious contemplation, since they were constantly used for very tangible purposes, from the repulsion of evil to healing and the defense of the realm. The authority they acquired through such functions enabled them to become the focus of a society's aspirations (whether that society was a town or an entire empire) and to symbolize the ideal community envisaged by that society. In this way images helped in the creation of a collective identity, what Peter Brown calls "civic patriotism,"[63] when a group or a city was threatened.

This was a weapon, however, that could turn against its owners. If the local saint was credited with more power than the central authority of the state, images could foster centrifugal, regional tendencies. The emperors in fact seem to have joined in the iconoclastic controversy in order to counter these tendencies (chap. 8b). When the religious unity of the empire was at issue, images, as soon as they became associated with theological definitions, could widen the breach instead of strengthening unity. This possibility perhaps explains why images were first used as symbols of state and of religious unity but then, when they were seen as causing disunity, were abolished.

This was especially the case when images were given a role that we do not readily associate with them, since the theologians do not mention it, that of giving protection and success in war. After assuming this role in the late sixth century, the images' failure to prevent the Arab onslaughts of the eighth century discredited them and caused the emperors to remember God's wrath against the Israelites when they lapsed into idolatry.[64] This recollection fostered a desire for a united people of God, with purified religious forms on the Old Testament model. But the wheel of history could not be turned back, the more so because the Roman Empire was subject to conditions different from those of the Israelites. The tradition of image use was too deeply entrenched to be eradicated now. However, a pruning and ordering of the excesses in the use of images was needed, and it was here that theology after iconoclasm had its finest hour (cf. chap. 9).

The part that images played in the experience of that time can perhaps be illuminated by two modern examples, however problematic such analogies may be. Religious images played a part in the Spanish civil war of 1936–39, as we read in the autobiography of the film director Luis Buñuel.[65] He tells us that the republicans and anarchists actually "executed" statues of Christ because they symbolized the enemy cause. Buñuel also tells of an abbess who cut the Christ Child away from a statue of the Virgin, telling the Madonna that she would return him when their side had won. Simply owning a religious picture at that time could cost one his or her life. There is an obvious difference between this situation and the one in the Middle Ages, since the opposing parties in the modern war had decided for or against religion itself, though

admittedly a religion with specific Spanish traditions. Political identity included religious identity; opposition to one thus meant hostility to the other. Allowing for the obvious differences, this situation offers analogies to our theme. It would be artificial to draw a distinction between religious, patriotic, and political convictions. Images symbolized questions of identity to such an extent that they became the objects of symbolic actions (to which they lend themselves in any age) and were treated by the opposing party as enemies.

The other example comes from South America and illustrates the state's usurpa- 10 tion of popular forms of belief. During the election campaign of 1972 in Argentina, a propaganda poster in the form of an icon gave the Virgin of Mercy the features of Evita Perón, the dead wife of the former president, whom the Peronists were projecting as an idol for the masses. The prayer attached to the image, alluding to the cult of the *Virgen del Amparo,* reads: "Protect us [*Ampáranos*] from on high." [66]

It will be objected that such a case would have been unthinkable in late antiquity and that the situation in South America is a special case, since that continent has two superimposed cultures. Christian images there often have pre-Christian elements, as in the case of the Madonna of Guadalupe and her predecessors in the cults of the Indians.[67] But, as we noted in the last paragraph, does not that very situation present analogies to our subject? More important than these, however, is the interaction of official use and popular cults, which cannot be neatly distinguished, no matter how much one would like to do so.

In the case of early Byzantium there is no less disagreement among scholars about the role of the people in the cult of images (the "pressure from below") than there is about the role of the court.[68] However, the argument loses its point if one bears in mind that it was the cult of the emperors that first provided the pattern in which the public cult of icons was enacted, and that the latter only adopted cult practices that already existed.[69] The emperor later fell victim to his own strategy of delegating his authority to a higher sovereign in heaven, since later it was no longer he, the emperor, who appeared as that sovereign's living image on earth but an icon.

One may object that the actual religious functions, after all, were the images' primary and most obvious feature. However, the religion to which the Byzantine images bear witness not only has timeless features (as do all religions) but also embraces temporal features that locate it in a given society and culture. Many religions are concerned to make visible an object of veneration, to protect it and to approach it with the same piety that they would like to lavish on the higher being; symbolic acts toward the image thus reveal one's inner attitude. Theologians always harbored the suspicion that such a cult would lead simple folk astray, in that they would mistake the image for what it represents. All the same, they took advantage of the opportunity to make the object of religion tangible and visible to the people, since the realm of theology properly speaking was alien to them.

But the problem has deeper layers. Once the object of religion is made visible in the image, the purity of a concept that only the true initiates can know is called into question. The visible image of God is adapted to a human perception that is no more than a means to an end, since neither Judaism nor Christianity has an anthropomor-

45

phic conception of God, as was the case with the gods of Greco-Roman myth. The visible painted image does not reveal any true attribute of God but contradicts his essence; we thus can understand the care devoted to the theological definition of Jesus' dual nature.

As actually happened, the problem of invisibility can be solved in two different ways. Either any visible image of God can be proscribed as blasphemous, or the very idea of visibility can be questioned and thereby extended to the entire visible world, which then would pose much the same problems as the painted image. If one had to live in the physical world, one could also live with a painted image. Both the world as a whole and the image of a part of that world pointed to an invisible reality, and for both, material conditions were secondary. The worldview of late antiquity could be roughly summarized in such a fashion, and its system is still best described as Neoplatonism. But this brings about a contradiction inherent in an icon's representing God in human shape; namely, it invests the anthropomorphic figure with a meaning that its visibility cannot support: the idea of the invisible and the incomprehensible. The contradiction was resolved in principle by theologians in the definition of Jesus, but (precisely because his *dual* nature cannot actually be depicted) it persisted nevertheless.

A society as bound to religion as that of early Byzantium was bound to pay special attention to the visible presence assumed by the sacred in this world.[70] Icons were of particular interest because they claimed to embody higher or transfigured beings and to deserve the veneration due to the holy. The iconoclasts later argued that icons could not themselves transform the ordinary (*koinos*) into the sacred (*hagion*) unless they were consecrated, like the Eucharist. But resistance to icons was older than this. Indeed, the early legends about the age and celestial or apostolic origin of icons probably arose as a reaction to the reluctance to accept icons. Veneration and rejection of icons had a common root in the absolute rank assigned to the sacred; they differed, however, in their views on where it was to be found on earth. The Eucharist was "administered" by the official church; the cross, by the court and the military—if one may reduce the matter to such a simple formula. Initially, icons were alien to the official institution, just as holy hermits and miracle workers stood outside the church hierarchy, properly speaking. Both posed the question whether the social hierarchy (essentially the court and the official church) could or should be the *sole* representative of the sacred on earth. Perhaps because this question itself was explosive enough, icons were quickly and completely taken into the service of court and church.

4. Heavenly Images and Earthly Portraits: St. Luke's Picture and "Unpainted" Originals in Rome and the Eastern Empire

In the early stage of the icon there was no theory to explain the nature of images and to justify their veneration. But the legends about supernatural origins and miraculous powers of images give us an idea of the perceptions that accompanied them. We are here entering the gray zone of the transition between ancient culture and late antiquity, when Christian society was assimilating more and more practices and ideas from the paganism it had so fiercely opposed. Common to the most diverse of attitudes is a recognition of the cult image not as an aesthetic illusion or as the work of an artist but as a manifestation of a higher reality—indeed, as an instrument of a supernatural power.

In the theory of images that emerges later, the form, or, to put it differently, the verisimilitude, of a portrait icon was not tied to a particular example but was interchangeable and repeatable. Theologians aimed at neutralizing the abuse of images, at democratizing the image; nonetheless, the existence of privileged images continued. One reason is to be found in the early history of icons, which includes images that had acquired special reputations. All cult practices, as well as cultural practices generally, have a peculiar capacity to survive. This was particularly true for practices associated with such privileged icons as they continued pre-Christian image cults.

The granting of privileges to certain icons is paradoxically inherent in the theory of icons itself, for the ontological relation between likeness and model made the portrait subject to the criterion of authenticity. What mattered was not whether the depiction of a saint was beautiful, but whether it was correct. Therefore, there could not be several authentic portraits, but only one. It was then necessary to establish which was the true one.[1]

This made it desirable for images to declare themselves authentic by performing miracles, the classic proof of authenticity. If a particular image performed a miracle, it thereby revealed itself as an instrument of heavenly intervention and assumed special powers. The cult history of the icon begins with miraculous images that seemed capable of passing on supernatural favors. The paradox inherent in the religious image of making visible the invisible seemed to be validated in cases where images legitimated themselves as receptacles of God or a saint, that is, by revealing the direct intervention of heaven. The difference between the image and what it represented seemed to be abolished in them; the image *was* the person it represented, at least that person's active, miracle-working presence, as the relics of saints had previously been.

Etymologically, the term "icon" comes directly from *eikōn* and so means any image or portrait.[2] All the same, it may be appropriate to link it to a movable, autonomous image of any material, whether cloth or stone and metal, for example. The image of a single figure, because it stands by itself, is perceived in a particular way. This happens not only because in the picture the individual beholder meets an individual partner. The suggestive power of the autonomous image also derives from the

encounter of its physical existence, which is dramatized whenever the image is set in motion, when it moves from place to place like a living person, or when, on ceremonial occasions, it appears like an honored individual from behind a normally concealing curtain. Processions played an important part in the presentation techniques of venerated images. In such cult stagings the moving image took on a quasi-personal life; it functioned like an individual and thus could not be confused with all the other images. Legends surrounding its origin and its miracles created a kind of biography and thus an aura of its own. Almost all of the early icons had this kind of development.

11 The veneration of icons in the Eastern church is illustrated by a photo of a procession leading from the main church on Mount Athos, the Protaton, out to visit the neighboring monasteries.³ At its center was a miraculous image whose name, *Axion estin,* alludes to the Magnificat: "Verily, *it is worthy* to praise thy name." Legends date it from the era of iconoclasm and tell how it bled after being wounded by an imperial soldier. The miracle-working Madonna normally reposed "on the stone seat of the abbot under a baldachin, enjoying the veneration appropriate to princes. At the millennial celebrations of Mount Athos she was received in Athens like a ruling sovereign amid the ringing of all the bells of the city."⁴ The Christ Child bears a ribbon inscribed with a text from Luke 4:18: "The Spirit of the Lord is upon me. . . . He hath sent me to heal the brokenhearted, to preach deliverance to the captives and recovering of sight to the blind." These words now refer to the icon panel and identify its miraculous works.

On Easter Monday the monks accompanied the Virgin to the neighboring convents. The icon was borne beneath a canopy, a sign of sovereignty since before Christianity. Here the veneration of the Virgin had taken on highly material forms. Other miraculous images of the Virgin were also carried in the procession, likewise as patrons of the monasteries. Although they all depicted the same person, it is right to speak of "patrons" in the plural, as the icons had themselves taken on personal qualities once the boundary between the image and the person was blurred. The images, like the cult objects of pagan antiquity, were garlanded, crowned, or even dressed like

12 real people. The covering in gold falls into the same category. Murals of the thirteenth and fourteenth centuries illustrating the Marian hymn *Akathistos* or showing the

111, 112 funeral processions of kings make it clear that cult practices in the form of image-bearing processions have changed little in the course of centuries.⁵

The image of the Virgin at Mount Athos represents an early category of nonliturgical images, which continued to exist in Byzantium beside liturgical images. In the twelfth century the rule of the monastery of the Pantocrator in Constantinople lists all the images before which lamps were lit during the liturgy.⁶ This repertoire of images was a complete one. It is therefore surprising to read that on anniversaries of the ruling family a famous icon of the Virgin was brought from the Hodegon church to stay near the tombs of the donors. There were Marian images enough in the monastery, so why was it necessary to bring in another one from elsewhere? Were greater miracles expected of it? The answer to these questions is to be found in the reputation of the miraculous image known as the *Hodegetria* (chap. 4e).

The existence of privileged images bearing the names of the churches in which they resided is reflected in an eleventh-century icon showing a number of single figures at the top.[7] The Virgin appears five times: once enthroned at the center with the donor at her feet, and four times half-length at each side. This curious multiplication of the same person is explained by the inscriptions. They not only refer to Mary but associate her with the name of a church: the icon of the Blachernae and the icon of the Hodegon church on the left, and on the right the icon of the Hagia Soros, the shrine in the Chalcoprateia, and of the little-known *Cheimeutissa.* The figures are named after famous churches of the Virgin in which the original icons were kept. The donor of this panel assures himself of their collective support by assembling them all around him. Even the change in scale points to a collection of individual pictures, icons within an icon. In the case of the Blachernae icon the artist made a mistake, which is not surprising with this plethora of figures. Even the central figure reproduces a given type. Her frontal posture and her manner of presenting the Child go back to the so-called *Nikopoia,* or Bringer of Victory. The manner of depiction testifies to the existence of rival icons that perpetuated, to an extent, the function of the old temple images.

a. Unpainted Images of Christ and Relics of Touch

From the point of view of their origins it is possible to distinguish two kinds of cult images that were publicly venerated in Christendom. One kind, initially including only images of Christ and a cloth imprint of St. Stephen in North Africa, comprises "unpainted" and therefore especially authentic images that were either of heavenly origin or produced by mechanical impression during the lifetime of the model. For these the term *a-cheiro-poiēton* ("not made by hand") came into use, in Latin *non manufactum* and in Russian *ne-ruko-tvorenii.*[8] As one might guess, the term justifies Christian cult images as opposed to the human artifacts that served as idols in non-Christian cults. It also tries to relate the new species to the wonder-working images of pre-Christian cults. Besides images in the strict sense, acheiropoietic items include, for example, the traces that Christ's body left on the pillar where he was scourged. Its measurements were taken and were transformed into amulets, which the faithful used to wear around their necks.

The second kind of cult image, which appears to include only icons of the Virgin, is also traced back to apostolic times but is believed to be the work of a painter. But this was no ordinary painter, being no less a person than St. Luke the Evangelist, for whom it was believed that Mary had sat for a portrait during her lifetime.[9] Here authenticity was no less guaranteed, if by different means. Luke, who is known to have been a doctor, qualified as a painter of Mother and Child through his exact description of Jesus' childhood in his gospel. Admittedly, this natural origin, and even the holy painter's authentic eye, were soon thought insufficient, and the Virgin herself was made to finish the painting, or a miracle by the Holy Spirit occurred to grant still greater authenticity for the portrait. Not all images of the Virgin were attributed to St. Luke; later on, the legend of St. Luke was questioned by the legend about the painter whom the three Magi commissioned to paint a likeness of the Child and his

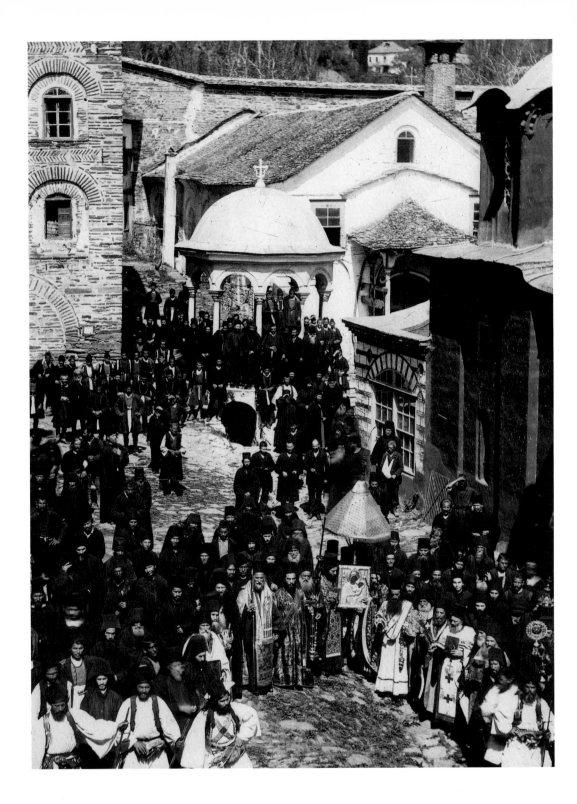

11. *Mount Athos, icon procession, around*
1900

12. *Markov monastery; icon procession*
(Akathistos) *as depicted on a Serbian*
fresco, 14th century

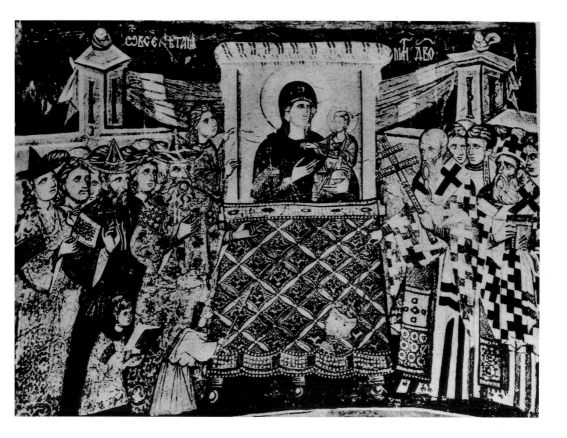

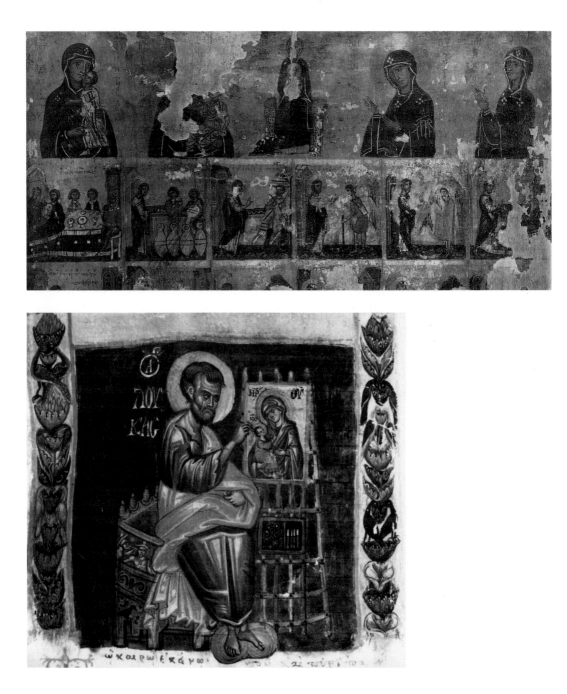

Mother, a version that gains credence in terms of the age of the Child in Marian icons. The portrait sitting commissioned by the Magi, which John of Euboea describes in a sermon, is illustrated as an episode in miniatures of the eleventh century.[10] But the legend of St. Luke remained an important argument to support the icon's claim to be a historical portrait. At the same time, it removed the icon out of the sphere of controversy by making it dependent on the will of the model, or even of heaven.

Precisely the same thing happens through the legend of the unpainted image, one that came into being either through a divine miracle or by direct contact with the body it reproduced. The visual impression thereby also became a relic of physical contact. Moreover, the mechanical reproduction would continue by the multiplication of such images in the same way as they had been first produced. Now it was not the original body but an authentic imprint of it that propagated itself. The contact between image and image, like the original contact between body and image, became a retrospective proof of the first image's origin. It also transferred miraculous power to the copy, as happened with the relics that continued to perform miracles through the substances that had come into contact with them. When the miraculous image duplicated itself of its own accord, it acted like its original: Christ's wish to make an image of himself was passed on to the image when it made a copy of itself.

The analogy of today's photography seems appropriate. Priority was given not to art itself or to the artist's invention but to the utmost verisimilitude. This attitude takes us to the heart of the early use of images. The beholder was in touch with the real presence in, and the healing power of, the image. These could be guaranteed, however, only by an exact match between likeness and original, the intervention of an artist being unwanted. The oldest examples of such privileged images have been demonstrated to date from the sixth century. At their head is the sacred *Mandylion*, a cloth bearing Christ's portrait that saved the Syrian city of Edessa from the Persians. In the Middle Ages it was kept as imperial palladium in Constantinople. The Veronica, or *vera icona*, in St. Peter's in Rome, traced back to a similar legend, later displaced the *Mandylion* from its position (chap. 11).

In the early period a different miraculous image of Christ was venerated in Constantinople. The legends surrounding its origin exemplify those of the entire genre. In his famous book *Christusbilder* (Images of Christ), Ernst von Dobschütz describes it at length.[11] The earlier legend tells of a pagan woman who refuses to believe in Christ because she cannot see him. She lives in a village in Asia Minor, the name of which is handed down as Kamuliana. One day she finds an image of Christ imprinted on linen in a garden well, which she immediately recognizes. Its heavenly power is attested first by the fact that when drawn out of the water, it is dry, and second, that when hidden in the woman's dress, it at once leaves an exact duplicate of itself there. Churches were built at two sites for the two images, and soon after 560 one of the images was taken in procession through the country to collect money for a new church building. Everyone wanted to see the image, and even paid to be allowed to. Previously, the ceremonial procession of an image had been reserved for the effigy of the emperor, which served to represent him in the provinces (chap. 6). These rites were now for the first time usurped by a religious image.

53

*15. Rome, Vatican, Capella
S. Matilda; Mandylion from
S. Silvestro in Capite, 6th
century*

*16. Rome, Lateran; Sancta
Sanctorum icon; the Veronica
(detail)*

*17. Sperlonga, Villa of
Tiberius; recovery of the
palladium, 1st century A.D.*

In 574 the image was brought to the imperial capital. There it soon became one of the "supernatural defenders of Constantinople"[12] and was used as imperial palladium in the wars against the Persians of the seventh century. As early as 586 it was among the furnishings of the field headquarters at the battle on the River Arzamon in Mesopotamia. In 622 it accompanied the armies in the Persian war of Heraclius, which was fought as a holy war. On this occasion the icon was celebrated by the poet George the Pisidian.[13]

The emperor, says George, took with him to the war the "divine . . . figure," the "unpainted image, not painted by [human] hands." Just as the Creator of the universe was born of the womb of woman without a man's seed, in the icon he created a "figure painted by God" (*theographos typos*). Being made man without human conception and becoming an image without the painter's intervention are placed in parallel. The image is a kind of visible proof of the central dogma of God's incarnation as a man, which is repeated in God's becoming an image in the earthly material of the printed cloth. In an eleventh-century miniature the portraits of Christ stand as living, "spiritual tablets," to use the language of theology, opposite the tablets of the law of Moses; icons are now seen as the tablets of the New Testament.[14] Iconoclasts, however, objected to this formulation by arguing that only in the sacramental transformation of bread into the body of Christ can a human product (one made with hands) become a supernatural one (one that is acheiropoietic).[15]

Dobschütz studied the sequence of heathen and Christian miraculous images as a topic of religious history in a way that reveals both connections and differences.[16] In antiquity, cult images of celestial origin, like the stone idol of the mother of the gods (apparently a meteorite) and the ancient wooden figures of Pallas Athena and the Artemis of Ephesus were called *diipeteis*, things cast down by Zeus. The utterances of living people were ascribed to them, as was the quality of being invulnerable. Usually they were not to be seen, and they punished those who did see them. In the role of palladium they exercised protective power over a town. The city that possessed a miraculous image of its protectress was impregnable. Troy could be conquered only by means of the theft of its palladium, which then became a historical power contested by the Greek cities. Since it was Homer who described Troy, the cult image of Pallas Athena there, even if not mentioned by him, gained the greatest fame. It was thought to have been moved to Rome, and later even to Constantinople, where Constantine was alleged to have hidden it under the porphyry column bearing his statue.[17] The rationalist critique of this legend was countered in late antiquity by a Neoplatonic philosophy of images, which provided a retrospective theological justification for pious popular belief. Like the image theories of the Christians, it did its best to level the difference between privileged and ordinary images.

When Cicero describes a miraculous image of Ceres as "not made by human hand, but fallen from heaven" (*non humana manu factum, sed de caelo lapsam*), he paraphrases the Greek concept of the *diipetēs*. He also contrasts it to human work, much as did the Christian concept of the *acheiropoiēton*.[18] This idea is present in ancient literature, even if the term is absent. Emperor Julian the Apostate (361–63), for example, in a speech on the mother of the gods, freely adapted Livy's account of

17

the transfer of her stone idol to Rome in 204 B.C. and disputed the view that it had been a "lifeless statue" (*xoanon apsychon*). It had proved by means of a miracle that it was "not a human but a divine work" and as such possessed a *dynamis* that endowed it with life and soul.[19]

The Greek term for "not made by human hand" seems to have emerged in the Judeo-Christian vernacular and refers to anything that is not a lifeless object or artifact, including a human being.[20] In the Acts of the Apostles, St. Paul objects to the image of Artemis at Ephesus on the grounds that something made by human hand cannot be divine. This was countered by the argument that Ephesus possessed an image of heavenly origin, a *diopetēs* or a *Iovis proles*[21]—meaning the gold-clad sculpture of dark wood that was washed on feast days and, as the mistress of the city, went down to the sea, visited the land owned by the city, and presided over the festival performances at the theater. Each morning the curtain that concealed it was drawn aside in the adytum of the temple, where the sculpture stood.[22]

The Christian concept of the work not made by human hand was a reaction both to the early Christian taboo on graven images and to the later criticism that Christians were worshiping the works of human beings and believing in wooden gods on painted panels. God himself, they now claimed, had in his philanthropy provided a visible proof of his incarnation in the form of the miraculous image, and also had thereby permitted the making of images.[23] Thus Evagrius, in his history of the church written about 600, calls the true portrait of Christ in Edessa (chap. 11a) "a God-made image [*theoteukton eikona*] that is not the work of human hands."[24]

According to Dobschütz the unpainted cult images were a direct continuation of the images that the ancients believed to have come from heaven; Christianity took over this idea when paganism, though a spent force, left behind its practice and theory of the image for the new faith.[25] Christian cults of this kind first appeared in Hellenized regions where images sent from heaven were especially venerated: in Asia Minor and Syria. What the older legend of the image of Kamuliana—novel in that it was painted on canvas—had especially in common with non-Christian legends was the idea that "not only the image but the material was of supernatural origin." Thus the legend here provides substantial evidence "that it is really a case of ancient beliefs being transferred into Christian concepts."

But the unpainted image like that of Kamuliana, says Dobschütz, was not the primary witness of the holy image, as distinct from ordinary artifacts. "In the veneration of the miraculous portrait," Christianity added "a new element of decisive importance. It was the religion of historical revelation," a revelation involving a historic personality. Thus "a twofold argument" entered the Christian belief in images: "the miraculous origin through contact with the person depicted, and simultaneously an origin during the life of the person." The idea of the imprint was the means of establishing a link to the original model. In subsequent polemics the miraculous images were used "almost exclusively to prove age." Since they were "synonymous with the ancient and apostolic," they also could be put "on the same level as the images painted by Luke the Evangelist."

15

Miraculous images thus were documents in a double sense. They proved the historical existence of the person who had left a bodily imprint while alive, and they demonstrated that person's extratemporal presence, since the images continued to work miracles. The image's age and its miraculous powers were two different qualities, but they complemented each other. Often it was not complete images that were venerated but bodily impressions left behind on columns (the scourging pillar) and walls where Christ or Mary had leaned. Their impressions, which could be touched, signified that they had been physically present, even if they had left no bodies in graves. In the Holy Land, such impressions, by which Christianity constantly reaffirmed the historical reality of its own beginnings, gave rise to local cults and centers of pilgrimage. This is also true of the Virgin's image of Lydda (Diospolis). According to legend, the apostles built a church in honor of Mary there, and she left an impression of her body on a column as she leaned against it during the church's consecration.[26]

Such impressions are more like relics, and different in kind from the unpainted cult images represented by the Kamuliana portrait. That image was carried in procession through the land like the official effigy of the emperor and was surrounded by much the same legends as the earlier images of the gods. Its counterpart, the true portrait in Edessa, was attracting attention at about the same time, being thought of as a personal gift from Christ, which had healed King Abgar just as if it had been Christ himself (chap. 11).

b. St. Luke's Images of the Virgin and the Concept of the Portrait

The origins of the legend that St. Luke was an artist are still shrouded in obscurity.[27] The evidence provided by one document from the sixth century, in which it may appear to be mentioned, is open to doubt. The church history compiled by Theodorus Lector can be trusted in its account of the three churches of the Virgin founded by Empress Pulcheria (about 450). But the statement that Pulcheria had received an image of the Virgin by St. Luke from her sister-in-law Eudocia in Jerusalem is likely to have been added later.[28] Two of Pulcheria's three churches by then possessed famous relics of garments. The third, in which the icon of the *Hodegetria* was later venerated, may have initiated the legend of the icon painted by St. Luke, which would likewise serve as a relic. After all, this image, the legend claims, also came from Jerusalem in the same way as Mary's mantle and girdle.

By the end of the sixth century, images of the Virgin were no longer uncommon. Surviving panels in Rome and Kiev appear to date from this time, if not older still *21* (chap. 7). But we do not know to which of them the legend of St. Luke was linked, or when the link was made. By the early eighth century the legend was so well known that prominent Greek theologians referred the iconoclasts to an image in Rome that St. Luke had painted.[29] The three Eastern patriarchs did the same in 836, when, in a letter to Emperor Theophilus, they included five icons of the Virgin among twelve miraculous images.[30] Only later are images by the hand of St. Luke said to exist in Constantinople, but an early example may have been lost in the turmoil of the icono-

clast controversy. The legend of the unpainted image and other cult legends seem to have distinguished particular icons of the Virgin prior to the emergence of the St. Luke legend.[31]

This legend focuses entirely on the concept of the authentic portrait. The concept was a justifiable one, since most of the early icons were recognized as portraits. But the true portrait originated as a portrait of the dead and retained this function within the cult of the saints as well (chap. 5). Here, where the grave itself was primary, the portrait was always secondary. But Mary's empty grave, as we saw, offered no opportunity for the portrait of a deceased saint. The image of a mother and her child similarly can serve no such function if its biographical content is taken seriously. Moreover, the schema of mother and child rather recalls images of maternal deities but was so alien to portraits properly speaking that the legend was needed to stress the quality of portrait, which, in its origins, the schema did not have. The legend invented an apostolic origin by making an apostle's pupil the portrait painter, thereby conferring the status of a portrait to an image formula not familiar for portraits. If one takes the legend literally, one may wonder how St. Luke could have portrayed the Child Jesus, who was a child before Luke even was born. Perhaps this inconsistency explains why the legend gained only late acceptance. But then, one could point to the Gospel of St. Luke, which gives so much emphasis to the childhood of Jesus.

The St. Luke legend clearly indicates the existence of a picture that it comments upon a posteriori. The icon of the Virgin actually originated as a convincing reference to the Child. In presenting a visual image of God's becoming human, there was no alternative but to show him as a child and to place him on the arm of his human mother. There is no early image of the Virgin without the Child. The role of mother was determined even before it was filled by any distinct person. The "unpainted" images of Christ also showed the "divine-human being," as he was called then,[32] but the image of the Virgin puts the emphasis on his childhood, that is, on the portrayal of Christ's human nature. It thus follows that every image of the Virgin by definition included an image of God. In 626 Patriarch Sergius presented on the walls of Constantinople "the holy icons of the Mother of God, in which the Redeemer is shown as a child, borne in the arms of his mother."[33]

For the image of the divine child, a tomb portrait was totally out of the question. It could not be a portrait for the reason alone that only a person who died as a child was portrayed as a child. Rather, the child belongs to the pictorial tradition of the divine Child. One need only think of the boy Horus at the breast of Isis.[34] The tension between two totally antithetical pictorial concepts cannot be eliminated from the image of the Virgin. The image seemed to repeat the divine appearance of the heavenly Child, and yet it was dependent on the human circumstances of his being made flesh. The variants of the early image of the Virgin therefore sometimes put the accent more on the divine aspect, and sometimes more on the human aspect, of the selfsame Jesus. As an exalted, enthroned figure, the Mother of God resembles the empress-mother who presents the new sovereign. When she holds a shield bearing his image instead of the Child himself (chap. 6d), she resembles a Nike/Victoria displaying the imperial

portrait. If the Child in this "image within an image" is enthroned above a rainbow in a blue sky, then the dual theme is condensed into a surprisingly concrete concept: namely, the human mother is presenting the heavenly God before he takes on human form in her body.[35]

If this was the spectrum of the early images of the Virgin, the legend of St. Luke—if we may bring its later examples to bear—was associated primarily with the half-length depiction of Mother and Child, which most resembled the format of a portrait, even if it was not. The legend served to justify a preexisting image as document and relic. In so doing, it seized on an idea latent in the image and emphasized the reality of Jesus' human childhood by claiming that the image was an authentic portrait. In its own way, it laid claim to the same degree of authenticity to which "true likenesses" of Christ laid claim. It therefore perhaps originated around 600, when the legends about unpainted portraits of Christ had just become established, and answered the need for an equal in terms of the Virgin's image. The more the cult of the Virgin increased, then, the more the legend emphasized her active role. Thus, as early as the ninth century, the three patriarchs asserted that Mary had authenticated and verified this type of image.[36] Ultimately, the legends about unpainted impressions and about St. Luke as painter came to be valued similarly, to such a degree that they were combined with increasing frequency.

c. Relic and Image in Private and Public Life

An early reference to the miraculous images of Christ is found in a sixth-century double icon of SS. Sergius and Bacchus in Kiev.[37] The memorial image of the two saints depicts them *en buste* wearing officers' uniforms. The medallion image above them clearly represents Christ and depicts him as the *vera icon,* in the format of the early miraculous images. Whereas the reality of the saints was affirmed by the existence of their graves, where their miracles occurred, the historical reality of Christ's earthly life was attested by the presence of his authentic portrait, which performed miracles such as were otherwise performed only by the remains of saints. The miracles performed by the image were a virtual continuation of those worked by the God-man while he was on earth.

This gives us an indication of the early status of images. They became equivalent to relics. Although Augustine spoke disparagingly of heathens as worshipers of images and graves (*adoratores imaginum et sepulcrorum*), the cult of graves and images soon became a characteristic of Christianity.[38] The fascination attaching to a saint's grave or bodily relics was transferred to images. A link between one and the other was provided by the relics of touch, or *brandea,* which acquired miraculous powers through contact with holy remains. Finally, images emerged that behaved in exactly the same way as relics. The image, both in its physical reality and as a testimony to authenticity, inherited the functions otherwise characteristic of the relic. It became a carrier of the highly actual presence of a saint.

About 600, Leontius of Cyprus defended the Christians against accusations of religious materialism that were being directed against both images and relics. In the

40

cross and the images, he argued, Christians did not venerate wood or stone, or even gold, or the perishable images, relics, and caskets, for their own sake.[39] He gives us here a virtual catalog of cult objects and the materials of which they were made.

The amulets, or *eulogia*, that pilgrims brought home from holy sites were special forms of image relics. They contained healing oil from a saint's tomb or a replica of a wonder-working icon. In the sixth century an amulet of the Syrian Symeon the Stylite hung over every shop door in Rome.[40] The links between image and relic are manifold. They point toward a range of signification for the icon that was to be especially important in the West. The visual presence of an image elicited the fascination normally attaching to relics (which lacked such a presence), and in turn derived an enhanced reality from them.

Amulets were containers for relics of touch whose healing powers were trusted. On their outside they bore the image of the saint or of the holy place from which their contents came. Often image and relic grew so much together that images of the saint whose aid was sought were made of edible material that could be taken as medicine. In these cases the image had no autonomous existence but was a sign of the saint to which the saint's healing power seemed to be transferred. It cannot be assumed that people had the same confidence in the power transmitted by images as in that transmitted by direct physical contact, but often one was hardly distinguishable from the other—for example, when mass-produced pocket-sized pictures of saints were brought into contact with the living saints or their graves, or with their cult image. Such practices confirm that images did represent saints themselves, and also that replicas multiplied the original image.

But the relation of relic to image is not properly described by special cases. It is possible to demonstrate that public cult images and private devotional images took over more and more of the qualities or powers of saints and relics, but this does not explain why it happened. The introduction of a general cult of images in the late sixth century is one thing, and the use of images as relics, which we are discussing here, is quite another.

With increasing frequency the same claims were made for images that customarily had been made for saints and their graves: they emitted healing oil, performed miracles, and punished those who failed to respect them.[41] In the cult of saints there was always an original image, the one that resided at the center of the cult, in the burial church. It was the burial site that granted the image its power. In dream apparitions around 600 Demetrius, the patron saint of Thessalonica, was said to ask people to go to his church in order to be healed. Arriving there, they recognized the saint by his "temple image," that is, the likeness of the saint as he had appeared in the dream.[42] The place of a saint's presence, where the saint's special favors were expected, was usually by the tomb, but in the case of Demetrius it was by an icon that dwelt in a special cella within the church (chap. 5c) and was visited by those who sought the saint's aid. The city too sought it out in the turbulent times of the invasions around 600. The public cult of the city's patron saint escalated, then, as he came to be relied upon more than the emperor and the city's own military defenses. It had its

focus in an image, whose cult was indistinguishable from a relic cult but that actually spurred the imagination more.

In a penetrating study, Peter Brown has thrown new light on the connections between the cults of saints and those of icons in the public and private life of this period. He draws attention to Daniel Stylites (d. 493) in Constantinople, whose corpse, fixed to an upright panel, was venerated "like an icon."[43] As the "living icon" of a man pleasing to God and as a powerful intercessor, the "holy man," often a hermit and miracle worker, possessed an aura that was passed on to his icon. He was not a member of the church hierarchy but had a personal following within the city's society that turned to him for advice and aid even during his lifetime. Miracles were expected even more at his grave site as proof of his continuing presence. The bodily presence of a patron saint now in heaven could also be sensed as one stood before an icon, in which the saint's features were preserved so that he or she could be recognized and perceived as reality. Thus the individual saint was as much the object of piety as was the icon, which received the prayers directed at the saint. Unlike a relic, the icon represented the saint even during his or her lifetime; like a relic, it filled the gap left by the saint's death, the more so as it was a portrait of a real person.

In city life too, according to Brown, the icon became "the visible expression of the invisible bond" that linked the individual town to its patron saint. The local patriotism that revived old cults in times of general insecurity found a symbol of unity and protection not in the imperial capital but in the cult of local saints, a cult that developed centrifugal tendencies. In their temples, at their tombs, and before their icons, to which people came to pray, the urban saints ensured that the population remained loyal to their Christian town.

The protection of the community was placed in the hands of a heavenly authority that was present in its relics or its image. In the legends of Demetrius, the saint refuses to flee the town that venerates him when urged to do so by heavenly messengers and intervenes vigorously in the course of events. The patron's physical presence makes the town as impregnable as the palladium had once made Troy. Evidence of the same idea is found two generations earlier in Edessa, Syria (chap. 11). When the Persians were about to storm the town in 544, they found inscriptions on all the gates with the text of a letter from Christ promising the town his personal protection; the letter was kept as a relic in the town at the time. Soon afterward the letter was joined by an image. This true portrait, too, had been received personally from Christ. It was therefore also a relic, but of a different kind that initiated a new valuation of the image.

About 600, in a third community, Constantinople, the presence of relic and image as guarantors of heavenly protection is just as clearly expressed. The unpainted image of Christ, the relic of the True Cross, and the Virgin's mantle were mounted conspicuously on the walls, singly or together, as if they were defensive weapons to ward off attackers, and icons of the Virgin also played their part.[44] Mary's mantle, a touch relic in place of the unobtainable body relics, was enclosed in a threefold reliquary, as we learn from a sermon of 620. This kind of reliquary is known from surviving sixth-century examples in Varna, which contained genuine relics. Inside a stone box was

placed a container of silver, and inside this a container of gold and enamelware.[45] The preacher mentions a stone box, one made of "gold and silver," and a third, though in a different order.[46] When the innermost box was opened, "there arose a fragrance so powerful that it filled the whole church."

This is a familiar pattern from descriptions of the opening of sacred tombs. But the preacher adds a further analogy from the tomb cult when he describes the opening of the reliquary as a crime. Those who were charged to protect the treasures in the Blachernae church against the invaders "even dared to lay hands on the divine reliquary and to bring into the light that which had hitherto been hidden from all eyes." This is an allusion to the palladium, the heavenly image that protected Troy and its successors, which was kept invisible in its cella. Once again we see demonstrated the closeness of relic to image, which even included the public function of guaranteeing security. The function assigned in Troy to an image, and in Rome to a shield of the gods that came from heaven, was transferred to a touch relic representing the Mother of God.

Heraclius, the emperor at that time, attributed the overthrow of his predecessor in 610 to the help of a Marian icon that he had brought to Constantinople; it was to play a part in the events that followed.[47] Heraclius found in the capital the already-existing cult of an unpainted image of Christ, which he made his own. When he set off on a campaign against the Persians in 622, he took the miraculous image with him, treating it as a sovereign in whose name he hoped to be victorious, especially as his foes were unbelievers.[48] He made the patriarch governor of Constantinople in his absence and left behind icons of the Virgin, which were then engaged in the defense against the besieging Avars in 626. From the city wall, the patriarch confronted the invaders with "the awe-inspiring image of the unpainted painting," crippling them with the visage's "paralyzing gaze."[49] This account seems to refer to an image of Christ, but the victory is attributed to the Virgin alone. We hear in a contemporary sermon, for example, that the patriarch had shown icons of the Virgin, saying that the attack was "against these very images." He told the enemy, "A woman, the Mother of God, will at one stroke crush your temerity and assume command, for she is truly the mother of him who drowned Pharaoh and his whole army in the Red Sea."[50] Like the Virgin's mantle, therefore, icons became signs and guarantors of protection. Relic and image both represented the same person, Mary the mother and champion (chap. 3b). Perhaps on the icons she was shown holding her son aloft on a portrait shield, as we see on seals of the time. Such a configuration would help to explain the reference to the paralyzing gaze of the icon.

At that time the public cult of relics and images was finally installed. Both were acknowledged as supernatural defenders of city and empire; they represented the state authority in its absence, assuming supreme command. This protective function of the images was later exported to the vassal states, of which Russia provides a graphic example. A fifteenth-century panel shows the saving of the city of Novgorod from the invaders from Susdal.[51] Redemption came through the miraculous icon of Our Lady of the Sign (*Znammeny*), who carried the Child and presented him before the enemy exactly as we suppose the seventh-century icons in Constantinople to have done.

When the image appeared on the city walls, the enemy's arrows bounced off it. Holy warriors entered the fray as allies, annihilating the foe.

d. Early Icons in Papal Rome

The propaganda waged with images, which reached a first high point in Constantinople around 600, soon spread to the old Western Roman Empire as well; indeed, it even reached theologians such as Gregory of Tours in Gaul, who already knew of the Virgin's mantle and began to tell of miracles worked by images in his homeland.[52] By that time, Rome had become a Byzantine province. Its most famous icons, an image of the Virgin attributed to St. Luke and an unpainted image of Christ,[53] represent the two basic types of the new miraculous image. At the time of iconoclasm Rome became the asylum for miraculous images from Constantinople, at least in the minds of the Greek theologians, who were unwilling to admit that their revered images had been disposed of by the iconoclasts. One image of the Virgin, Patriarch Germanus claimed, fled to Rome unaided, covering the distance in twenty-four hours, standing upright on the water. It was a replica of the unpainted image of Lydda, and Germanus himself had sent it on its way. Later it was called Our Lady of Rome (*Rhomaia*), and an inscription on the image stated the day and hour of its departure, while an appended prayer ran: "Save thyself and us."[54]

The purpose of such legends is evident. They postulate an interrupted continuity by describing both the saving of images in this Roman exile and their joyous return when the crisis was over. Rome was a plausible destination for the images, as the arm of the Byzantine state was not long enough to compel the pope to destroy them. In this way early traditions survive in Rome that in Byzantium were dislocated by iconoclasm and the rigorous theologizing of image practices.

The early history of the cult of the Virgin in Rome is still obscure, so that the East seems to have priority in the cult as a result. The surviving evidence concerning images in Rome, however, is as old as that found in Byzantium. The images may even antedate the liturgical developments of widespread celebrations of feasts of the Virgin, since they were produced as temple images for some of the oldest Marian churches. The situation confronting us is therefore the following. From the first half of the fifth century Marian churches existed in Rome in which Marian images can be shown to have existed before the year 600. In contrast, in Constantinople at the same time the most noted churches of the Virgin displayed garment relics that were venerated in mausoleumlike circular buildings, resembling sacred tombs (chap. 3d).

There could be no question of corporeal relics once belief in the physical assumption of the Virgin into heaven was widespread. About 600, Emperor Maurice made his subjects swear acceptance specifically of this belief when he established 15 August as the feast of the Assumption.[55] At that time the liturgy of the Virgin reached its first peak. Soon afterward the new Marian feasts were introduced in Rome as well. Finally, Pope Sergius (687–701) made the ceremonial procession (*letania*) between St. Hadrian's on the Forum and S. Maria Maggiore a fixed custom on feasts of the Virgin, thereby bringing this liturgical development to a conclusion.[56] The Roman liturgy relating to the Virgin clearly followed close on the heels of the Eastern practice.

Does this also apply to the cult of images? After all, the surviving panels in Rome do seem to have come into being independently of this liturgical development.

A test case on this point is the reconsecration of the Pantheon as a church of the Virgin, on which occasion it also received an icon. Pope Boniface had asked the emperor to let him have the ruined temple. On 13 May 609 he consecrated the former shrine of all the gods as a church of the Virgin "and all the martyrs."[57] The reason for dedicating the church to all the saints seems obvious, but placement of the Virgin at the head of this new pantheon is less readily justified, particularly as she was not a martyr and there were older churches of the Virgin in the city. But it was precisely in these years that Rome was adopting the Eastern liturgy of the Virgin, so that the dedication to her was most appropriate. The form of the building also fits this context, since the first sites of the Virgin's cult in Byzantium were rotundas or centralized buildings with ground plans similar to the Pantheon's. But there, we should note, the building type was connected with the cult of relics.

8 The Pantheon contains a Marian icon preserved only in the most ruined condition (chap. 7b). It is the only item from the time of the church's consecration about which we know anything. The wonder-working intercessor with the golden hand (chap. 3c) was soon also renowned as a guarantor of asylum. Under Stephen III (768–72) a Lombard priest clung to the panel when seeking refuge from the papal militia.[58] The question we must consider is whether the panel was a substitute for a garment relic of the Virgin, which the church lacked, or whether it had been a Byzantine custom to venerate "house images" in famous relic chapels. It is not of critical importance whether the icon was painted in Byzantium, which even experts find difficult to decide. But one would like to know whether the idea of producing house images came from Byzantium and thus was an import in Rome.

Whatever the answer may be, what is clear is that the custom was not new in Rome at that time. The oldest churches of the Virgin, dating from much earlier, all have their own temple images, and it is these surviving examples whose dating must provide the basis of all other considerations (chap. 7, b and c). Among the most famous cult images in Rome in the Middle Ages were a pair of icons, one of which came to visit the other in its home temple. This visiting underscores the idea of a local residence, in the sense that images took up permanent abode in their churches and so could receive visitors. In addition, the two icons in question represented, perhaps
18 from the outset, the archetypes of the unpainted image in the case of Christ and of the
21 portrait by St. Luke in the case of the Virgin. We shall now consider these icons in somewhat more detail.

The Christ image resided in the papal residence of the Lateran and was displayed in the pope's personal chapel, in the Sancta Sanctorum.[59] Before the chapel's completion, it had been the property of the Lateran Basilica, which in fact was dedicated to Christ the Redeemer. The first information we have dates from the eighth century (text 4B). Even then the image was carried in procession, specifically for the then-pressing need to defend the city against the Lombards. In that connection the Book of the Popes referred to it as an *acheropsita*. As a corruption of *acheiropoiēton*, the word also indicates the image concept to be one originally developed in the East

(sec. a above). There too it had already played a role as a Christian palladium, defending the city against its enemies.

About this image the medieval legends tell us that the apostles had appointed Luke, "who as a Greek was a good painter," to paint a portrait of Christ, so that they would at least retain a likeness of him after his ascension into heaven. Once begun, however, the picture had completed itself, "not by human agency but by divine intervention" (text 4F). This version therefore synthesizes the St. Luke legend with that of the divinely created unpainted image. The author adds that God stipulated that the image have as its residence the palace of his representative on earth.

The painting, on canvas fixed on a panel of Italian walnut with a format of 142 × 58.5 cm, today is a ruin. As a full-length portrait of an enthroned figure, it falls outside the pattern of early icons. Consulting the replicas that dioceses commissioned in Latium in the high Middle Ages, we still can conceive a rough idea of its original appearance (text 4I and chap. 15d). At the beginning of this century Josef Wilpert was allowed to view the original once. Our knowledge thus rests on what he tells us. By the tenth century the *ycona,* as the Book of the Popes otherwise calls it, had already been disfigured by nocturnal processions and cult washings to a point where it had become unrecognizable. At that time, as an inscription reveals, John X had it covered in silk cloth and its head repainted on a new canvas. Under Innocent III (1198–1216), the new face, which had become identified with the image sent from heaven, was left visible through a window when the pope donated a silver casing for the icon. In keeping with this treatment, the icon was henceforth called a half-length portrait, the main interest being in the authentic physiognomy.

The new silver casing stresses the Passion of Christ in its figure program. An Easter Sunday ceremony described by Cencius Camerarius explains the purpose of the folding doors (the present ones are a later replacement) at the bottom of the image, which stood behind the pope's private altar.[60] On this feast the pope kissed Christ's feet after opening the doors, calling out three times, "The Lord is risen from the grave!" This rite reaffirmed the historical reality of the person depicted on the panel and served as homage paid by the earthly representative to his heavenly sovereign. It was complemented by another rite during the nocturnal August processions on the Forum, when the feet of the figure were washed with water from basil, the small folding doors again being opened for the purpose (text 4E).

The silver case of the ancient image was part of a program by which Innocent III was trying to give new splendor to the Lateran. At the same time the altar before the icon was fitted with expensive bronze doors showing the Prince of the Apostles within a tondo and marking out the altar as a papal reliquary. In St. Peter's, Innocent was fostering the cult of Veronica's veil (chap. 11c), so that it was only an act of even-handedness to refurbish the house image in the papal chapel. At that time yet another miraculous image was also attracting attention in the Lateran.[61] It was the half-length image of Christ in the apse, which was believed to have appeared miraculously when the Basilica was consecrated. The legends involving this image of the True Face (cf. chap. 6c) explain why, like a relic, it was "restored as the Holy Countenance unharmed to its old place" when the apse was rebuilt by Nicholas IV (1288–92).

18. *Rome, Lateran; Sancta Sanctorum icon, ca. 600; silver chasing, ca. 1200*

19. *Rome, Lateran; Sancta Sanctorum icon, ca. 900 (detail of fig. 18)*

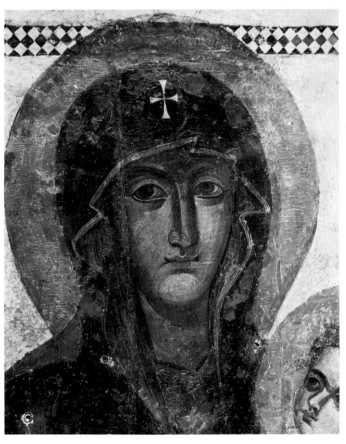

20. *Rome, S. Maria Maggiore;* Salus Populi Romani *icon (detail of fig. 21)*

The Sancta Sanctorum icon, which was venerated as an old palladium already in the eighth century, likely dates from about 600. In both Constantinople and Edessa at that time, we hear of unpainted miraculous images of Christ that were gaining reputations as divine protectors of their respective cities (sec. a above and chap. 11a). The Roman icon, the third of the group, therefore fits into a larger context of the time. The cult of Christ's true visage was also not uncommon in Rome at this time. Evidence of it are the mosaics in S. Venanzio in Laterano and the frescoes that a certain Gaudiosus had painted in the Pontian catacomb.[62] But they are limited to half-length figures, as was usual for icons then. The full-length icon shows Christ enthroned, which may have seemed appropriate for the site where the pope's throne was to be found, thus bringing together the two thrones.

On the year's most important feast of the Virgin, the unpainted image in the Lateran went to S. Maria Maggiore to meet an image of the Virgin that was held to be a genuine portrait by the hand of Luke. It is as old as the Christ icon, if not older—at least in its original state. If it is not mentioned in documentary sources until some centuries later, this is not surprising, as it was not carried about in processions. Since 1613 it has been preserved in the altar tabernacle of the Cappella Paolina built especially for its cult,[63] and since the nineteenth century it has borne the official title "Salvation of the Roman People" (*Salus Populi Romani*). From the thirteenth century it had "lived," usually not on public display, in a marble tabernacle erected by "the Senate of the Roman people" opposite the older tabernacle containing the relic of Jesus' crib.[64] In this way the authentic portrait of the Mother and the historical crib from Bethlehem, the most venerated relics in the Basilica, each called to mind the other. The first lay confraternity in Rome—later called the *Gonfalone* after its flag, which bore an image of the Virgin—was founded in front of the icon.[65] At that time it was given the title "Queen of Heaven" (*Regina Caeli*).[66] After the mid-twelfth century a cleric who helped to prepare the August procession reported that on the evening before the feast of the Virgin "the image of the Virgin began to stir," evidently to prepare itself for the meeting with the icon from the Lateran.[67]

Our sources go no further back. In the ninth century there is a mention of a "Chapel of the Crib," for which Gregory IV donated a "golden image of the Virgin with the Child on her arm."[68] This must have been a votive image, which could not compete with the privilege of the Lucan original but did reinforce the idea of motherhood in the context of the commemoration of Christmas. Even before then the image by St. Luke had not been the only Marian icon in the church. In the eighteenth century, painted Greek inscriptions with the names of angels and of St. Demetrius were found on the boards of the crib relic; the crib had evidently been made of parts of dismantled icons.[69]

The fame of the icon attributed to St. Luke can be reconstructed from the early production of replicas,[70] and from the part it played in the ritual on the feast of the Virgin's Assumption. The *achiropiite* (unpainted image) and St. Luke's Marian icon met on the feast of the Assumption. As in the ancient apotheosis, the mother remained present in the portrait she left behind on earth after she had reached heaven. The Christ panel was brought to this portrait, to which everyone turned for maternal

intercession, so that it could receive her intercessory pleas. The titular icon was obviously linked with the cult in the church on the Esquiline. In this Christmas church the earthly birth of the Son of God called attention to the supernatural motherhood of the Virgin as the "Mother of God," as she was theologically known since the time when the Basilica was being constructed (chap. 3d).

The *Salus Populi Romani* icon, on cypress wood (117 × 79 cm), expresses such *21, 20* ideas through the rulerlike pose of the woman, who looks out of the picture, while the Child, turned toward her, seems to confirm her status as Mother of God. The present painting is a montage of various layers that are seen simultaneously, as in a palimpsest. The image has yet to be technically investigated and cleaned,[71] so that the chronology still is an open question. The "Pompeian" quality of the first layer is visible in the modeling of the Child's hand for instance. The areas of linear stylizations seem to go back to the eighth century. The process of "restoration" seems to have been taken up again around 1100 and may have come to an end in the thirteenth century. As in the robes in a very early icon of Elijah at Mount Sinai, the Child's garment consists of drapery rendered lively in golden hatching, producing a flat effect in both cases. The Virgin's blue mantle, wrapped over her purple dress, is severely altered in the outline as visible at her shoulder and neck. The red halos at the top overlap the bevel of the raised edge awkwardly and, like the frame ornamentation, cannot be part of the original image.

But the image concept is still the original one. It consists of the pose of the Virgin, which is unique among all icons and was reproduced with great difficulty in the replicas of the twelfth century because it was not a medieval pattern. The folded position of the hands, which also hold the consul's *mappa* cloth, is based on direct observation. The same motif distinguishes a Mount Sinai icon in Kiev dating from the fifth *22* century, which has the same vivid contrapposto as the two bodies of Mother and Child turn toward each other.[72] By contrast, the Mother in the Pantheon icon already *8* subordinates herself slightly to the Child by her imploring gesture and the turn of her head, and the interaction of their bodies exists only in a flat plane. In the image we are discussing the majestic quality is conveyed by the frank outward gaze of the figure, combined with her upright posture. The image concept, in the final analysis, dates from antiquity, not from the Middle Ages.

The procession on the night before the feast of the Assumption on 15 August carried Christ's "unpainted" image from the Lateran to meet the Virgin's icon. With the introduction of the feasts of the Virgin, the Basilica had become a "station church" in which the pope celebrated Mass—as the patriarch of Constantinople also did at the same time, going in procession between the Marian churches in the imperial city.[73] In Rome the pope passed along the Via Sacra of the Forum Romanum to the former senate house and then to the Virgin's church, with the whole populace in attendance. The August ceremony, which ultimately took up the whole night, soon overshadowed the rituals performed on all the other feasts of the Virgin. It always involved a procession of supplication to the Mother of the Romans and could be staged at other times if there was a need for it (text 4B). In the ninth century, divine help was called down against the plague during the procession, and about the year

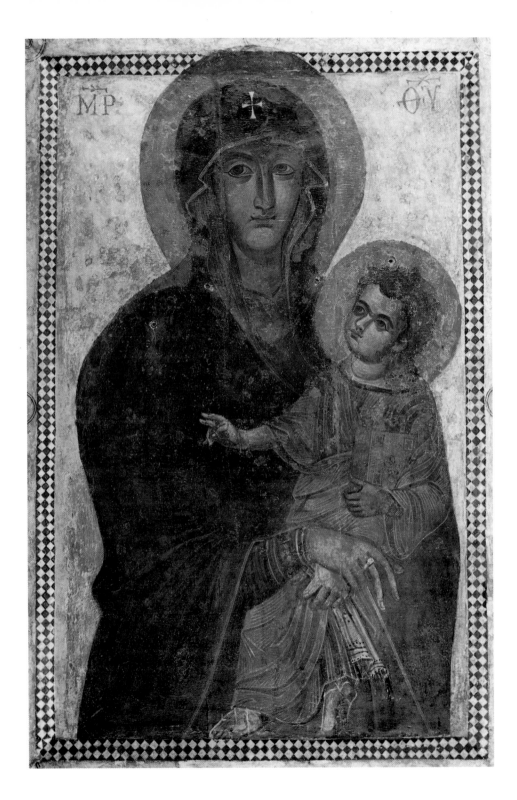

21. *Rome, S. Maria Maggiore;* Salus Populi Romani *icon, 6th century (?)*

22. *Kiev, Museum of Occidental and Oriental Art; Marian icon from Mount Sinai, 6th century*

1000 the occasion was used to make the assembled Roman people swear allegiance to the German emperor (texts 4C and 4D).

Gradually the procession's route lengthened to give the various social groups the opportunity to appear before the icon. Initially the city prefect and the representatives of the urban districts joined in (text 4B). Then a confraternity took on special roles in the procession (text 4G). The order of precedence of the guilds, which mirrored the social hierarchy, was a sure source of conflict that sometimes had to be resolved by the magistrate (text 4H). During the Renaissance, the rites that gave an official framework to civic displays in Rome awakened memories of the old Roman triumphal procession (texts 4G and 4H). In 1347 Cola di Rienzo took advantage of the August procession to have himself crowned tribune in front of S. Maria Maggiore.[74] In 1566 the procession was banned, partly because it no longer matched the prevailing religious ideals and the idea of a universal papacy. The procession goes back to late antiquity, when images evoked the immediate presence of divine intercessors and thereby gained more prestige than the earthly institutions of the church.

The role of these images in the August procession was not confined to a meeting of two icons but involved a visit of two persons, Christ and his Mother, who were embodied in the icons. The festival in fact commemorated an event involving an imagined visit by Christ to the Virgin's deathbed. Recorded at Tivoli is the ceremony of the so-called Inchinata, which calls for two icons to bow to each other at the climax of the procession (text 4I).

As the sources tell us, the procession also included intermediate stops where other Marian icons were visited and, we may suppose, taken along with the procession from then on. In the twelfth century there was a ceremonial pause in front of S. Maria Nova on the Forum Romanum, now called S. Francesca Romana (text 4E). A very old Marian icon was kept there, the original parts of which, in encaustic paint, were cleaned of extensive overpainting in 1950.[75] It must have come from S. Maria Antiqua, whose title and inventory were moved to this church in the ninth century. As early as 735 the pope had "crowned" the "ancient image" (*imago antiqua*) in that church with a new silver mounting. In the thirteenth century an inscription on its frame stated that the image had come to Rome from "Troy in Greece," that is, from the city that was the birthplace of Rome's progenitor and that had also harbored the ancient palladium. A fuller account of this once-monumental icon of the Virgin, whose head alone measures 53 cm, will follow later (chap. 7b).

Just as S. Maria Nova was not the only stopping point, so the titular icon of that church was not the only image of the Virgin to take part in the procession. It is probable that the Madonna of S. Sisto served in the procession from the tenth century on (chap. 15b). About 1100 it was the first Marian icon in Rome to be declared explicitly an original portrait painted by St. Luke, and as such invited the making of numerous replicas. Great hopes were placed in it, since it had intervened against excessive power of ecclesiastical institutions. Possibly the icon was an early import from the East that had stayed in private hands before it belonged to a Roman church. A hymn sung during the procession around A.D. 1000 hints at this icon's involvement when it men-

tions the halt made by the Christ icon on its thronelike socle (*solium*), and adds that the Mother of God stood on a similar plinth (text 4D).

The involvement of the S. Sisto icon is evident from the replicas that were used in the same procession throughout the dioceses of Latium (chap. 15d). Also the replica from S. Maria in Aracoeli (texts 4G and 32) later took part in the procession. (Through the efforts of the Franciscans, this replica in the end outranked the original icon of S. Sisto.) Finally, we have the evidence of the apse mosaic of S. Maria in Trastevere, since it borrows the type of the S. Sisto icon for the Virgin crowned in heaven, in the context of her Assumption.[76]

We thus gain an unexpected insight into the way in which form and function interrelated in such images. By its pose and gesture, the icon of S. Sisto also qualified especially well for taking a role of its own in the August ceremony. The sideward turnout of the picture, together with the intercessory pose of her two gilded hands, expresses the figure's partnership with the procession's Christ image more compellingly than did the depiction of Mother and Child together that waited at the end of the procession. Throughout the procession, the Advocate of the Romans could be placed into dialogue with the image of the Redeemer, until the ceremony ended before the image of the Mother of the Romans. There is therefore a certain logic to considering both icons as originals by St. Luke, for they complement each other instead of competing.

In the Marian Year 1988, all the icons of the Virgin in Rome were brought together in an exhibition for the first time.[77] Seeing them side by side in S. Maria Maggiore, one could only marvel at their variety of format, style, and type. Only in one aspect were they identical: they were all half-length figures. The only exception was the panel from S. Maria in Trastevere (chap. 7c), which differs from the others in the size of the figure (not of the image). The icons of S. Maria Maggiore and the Pantheon match in their size, but not in their image type. The icon from S. Sisto diverges from the rest by its small format, and that from S. Maria Nova by its gigantic dimensions. Only two of the five icons are painted on canvas. The S. Sisto icon is the only one to have an original gold ground, the Pantheon panel having a light yellow background and the one from S. Maria in Trastevere a blue sky above a green lower area. The Madonna of S. Sisto's nimbus is engraved in the gold ground, while that of the Madonna from the Trastevere church is sculpturally fluted. In other words, each work was a unique entity of its own, not part of a series.

e. The Image of the "Hodegetria" in Constantinople

The question of where the legend of St. Luke originated, bearing in mind the disparity between East and West as regards the respective works and legends, is still unsettled. Ernst von Dobschütz suggested that the idea about St. Luke might be "a Western counterpart of the Greek belief in acheiropoietic images," arguing that "if the East was apt to stress a supernatural origin, Rome always put special emphasis on apostolic tradition in the faith and its mysteries."[78] This simplified view is no longer tenable, however. While early original works like those in Rome are lacking today in the

23. Rome, S. Maria Maggiore; icon exhibition, 1988

East, Eastern sources speak of images painted by St. Luke as early as the eighth century (sec. b above). That these name Jerusalem and Rome as their locations can be explained by the apostolic tradition linked to the two places. They were also beyond the reach of the Byzantine state, which was destroying images at that time.

In Constantinople only one Marian icon of which we have any notion lays claim to have been an old original by St. Luke. It was also one of the few images in the imperial city that we know by name. The others were titular icons in the leading Marian churches in the city (chaps. 3d and 13f). But this icon was kept in the former home for the blind run by the guides (*hodēgoi*) on the present-day Seraglio Point and was called after it the *Hodegetria,* or Guide, icon.[79] The *Hodegetria* icon has been lost since the Turkish conquest of the city, but its appearance can be inferred from innumerable replicas, as it was probably the most-reproduced icon of all. The half-length presentation, like that of the oldest icons in Rome, showed the Mother with the Child on her left arm. The medieval variants were at pains to make the Mother's intercession with the Child obvious by her look and gesture. A Greek miniature of the thirteenth century, now in Berlin, gives us an idea how the icon was displayed at its cult site.[80] The family that owned the Psalter had themselves depicted on the title page praying before the famous icon. The icon is behind a lattice under a baldachin, supported by a frame. The curtain normally concealing it is drawn back.

177

24

The origin of this icon is lost in obscurity. In the early Middle Ages importance was attached to its provenance from Jerusalem, and it was included with the Marian garment relics among the sacred objects obtained by the Empress Pulcheria from biblical sites in the Holy Land and transferred to Constantinople (sec. b above). In the ninth century, the church of the Hodegoi was restored, and Caesar Bardas went there to take leave of the Mother of God before departing for a war. In the tenth century this image, which by then ranked among the highest in the list of icons, was the object of weekly processions for which a special confraternity was responsible (chap. 10b). A recently discovered thirteenth-century fresco in a church at Arta in Greece depicts the icon procession passing through the main streets of the city.[81] In the twelfth century the emperor asked "the divine icon of my most holy mistress and Mother of God," which by then essentially had become the city's palladium, to pray with him on anniversaries of the deaths of his ancestors (text 20). During a revolt in 1187, Emperor Isaac displayed it atop the city walls to warn the enemy and encourage the citizens. After the reconquest of the city in 1261, the emperor followed the icon barefoot at the head of the triumphal processions. Thereafter, it was moved to the palace during the Easter holy days and venerated by the emperors there, having been retrieved from the Latin conquerors.

111

After the Latin occupation of Constantinople in 1204 the Venetian patriarch Thomas Morosini had taken possession of the icon and had it moved from the palace chapel to Hagia Sophia. He turned down the Greek population's request to be allowed to celebrate the traditional Tuesday rites with the image. The Venetian podesta was drawn into the argument. He could have the icon if he could find it, was the patriarch's terse challenge. The podesta called in troops to have the icon transported to the Pantocrator monastery, at that time Venetian. Morosini, finding himself de-

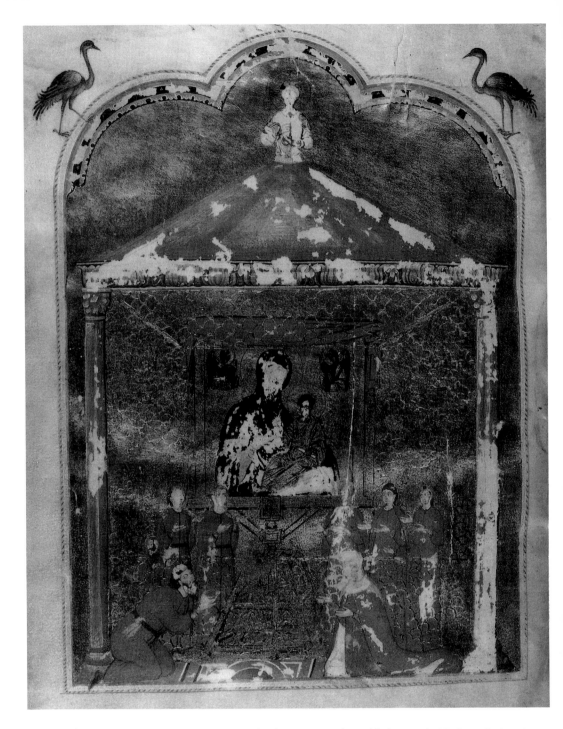

24. *Berlin, Staatliche Museen Preussischer Kulturbesitz, Kuperferstichkabinett; the* Hodegetria *icon in Constantinople, as depicted in a miniature of the Codex 78 A 9, fol. 139, 13th century*

feated, hurled down an anathema on the icon raiders from the church roof and even appealed to the pope to have the anathema confirmed.[82]

Pope Innocent III assented, also confirming that this original icon by St. Luke was the most venerated image in all *Graecia*. He could not share the Greek view, however, that the Virgin's spirit inhabited the image, and he rejected any exaggerated venera-tion as superstitious. Even in Byzantium different views on this point circulated. Rus-sian pilgrims reported that during the weekly processions the Holy Spirit came down to settle on the image, just as the Virgin's icon in the Blachernae church received "the divine spirit" at the weekly veil miracle. This was countered by a less spectacular version, according to which Mary had been so pleased with the finished portrait that she had bestowed her "grace" (*charis*) on it. As late as the seventeenth century the scholar Lambeck referred to it in order to justify the miraculous aura of an image in Vienna. It was left to the Enlightenment to recall Innocent III's stricture. According to Ludovico Antonio Muratori, "The Greeks held in exceedingly high honor a picture of the Mother of God which they believed to have been painted by St. Luke, for this foolish, stupid people imagined that the spirit of the divine Mother lived in the image; which nonsensical opinion was speedily damned by Pope Innocent III. For all I know, such errors may be entertained by others of the faithful who pay such inordinate heed to such images."[83]

Legends tell us that icons fell from heaven, not handmade but born of miracles. History gives us a different account. Legends are rooted in culture and have a reason of their own, which historians may explain. Upon close examination, existing icons from late antiquity prove their origin from panel painting of Roman times. As Christianity was a religion of antiquity that lived into a new era, so the Christian icon was nothing but a branch of ancient panel painting that, unlike other branches of ancient art, became predominant in the era to come. It profited from Christianity's rise to universal recognition and, in the long run, served new ends. Nevertheless, the icon is, in short, clearly the heir of the portrait of the ancients.

Examples from ancient portrait painting and Byzantine icon painting are evidence of a continuity that persisted long beyond the end of antiquity as well as evidence of a change that was caused by new demands and functions. A mummy portrait such as that of a young woman (Louvre) has many features in common with an eleventh-century icon of Philip the Apostle and thus allows for unexpected comparisons, despite the gap in time and despite the difference in function, the former being a pagan portrait and the latter a Byzantine icon.[1] Physical space is excluded from both of them, and in both cases the head stands out against an ideal, flat picture plane.

The icon nevertheless has a character of its own and presents not just a common person but a saint. It is not simply a portrait but a *venerated* portrait, representing a person to be worshipped by the beholder. Indeed, it was the cult of saints that prepared the way for the development of the icon, in form and function. Being the earliest and most significant cult image that Christianity brought forth it raises the question of how it came about and to what extent its ritual function led to its formal properties.

a. Pagan and Christian Cults of Images

We should ask first about the early use of icons and their functions before raising the question whether they developed an aesthetic of their own. The realm of the funerary portrait proves to be the source of the cult of the saint's icon. Here, the memorial image at private tombs became transformed into the cult image of a public saint. The icon is the result of this change from pagan to Christian, from private to public use of the image.[2]

From early on, icons make it evident that they demand worship on behalf of the faithful. A seventh-century icon of St. Irene includes a tiny figure in prostrate pose that is not simply a visual signature of its donor but defines the situation of cult: the monumental saint receives veneration by a living person.[3] Much the same situation is repeated by an icon in Rome that was painted as a mural. Here the prostrate figure of an individual who enters the saint's image has not shrunk to the size of a mere attri-

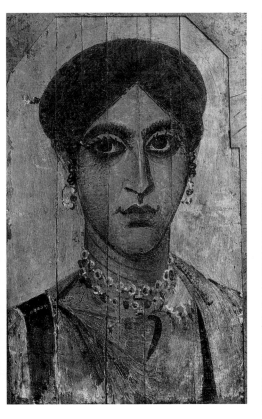

25. Paris, Musée National du Louvre; *mummy portrait from Fayum (Egypt), 4th century* A.D.

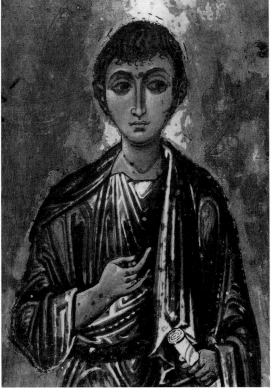

26. Mount Sinai, monastery of St. Catherine; *icon of the apostle Philip, 11th century (detail)*

bute but matches the scale of the saints. We may identify him as the papal functionary Theodotus, who is holding burning candles in front of St. Julitta and her brother Quiricus,[4] whose chapel Theodotus dedicated about 750 (chap. 7a). The two saints' figures, which have not survived in full, may be reconstructed on the model of the icon of St. Irene. In both cases, whether panel or mural, we are facing a single image of a saint accompanied by a donor—in other words, a specimen of the early icon.

In both cases, the main figures make it clear that they embody saints and not just ordinary individuals. They are shown in a frontal, fixed stance, an attitude that demands our veneration. The depicted donor assumes the same gesture of subjection that he chose in front of the real icon during his lifetime. He addressed the saint, who no longer was present in person, in front of the saint's substitute—the image. The Roman mural refers to a living practice as it distinguishes the space of the contemporary person from the space of the saint by assigning them different picture planes. It therefore makes it explicit that the donor, with his candles, is kneeling not in front of the saints themselves but rather in front of their image, as he did in real life. The image thus contains the visible proof of its use as the cult image of a saint.

b. The Origin of Saints' Images

29 A Roman wall painting from the late fourth century takes us back to a time when images of saints made their very first appearance. It is situated beneath the church of SS. Giovanni e Paolo and decorates the walls of a cult chamber that is attached to the tomb of saints, the tomb being no longer part of a public cemetery but an integral part of the respective church.[5] Relics of the martyrs Cyprian, Justina, and Theoctistus, whose names appear in a graffito, seem to have been venerated there. According to Greek legend, the relics were offered to the Greek matron Ruffina, the sister-in-law of Pammachius, who built the basilica on the site of the old titular church. Ruffina's cult of relics, the first of its kind inside the city walls of Rome, not only involved the veneration of Eastern saints but was a practice itself originating in the East.

Two features of the fresco indicate that its portrait commemorated not a private person but a public saint: the curtain and the prostrating figures at the feet of the 27 orant figure of the saint. The motif of prostration recurs in the icon of Irene. But there 30 it denotes an individual donor, as it does on a cell wall in the Egyptian monastery at Saqqara.[6] There the monk who owned the cell added a portrait of himself in the act of prostration before St. Apollo, thus indicating the personal relation of patron and client. In the Roman mural mentioned above, by contrast, the prostration does not signify the veneration of a particular believer but serves to define the status of the saint and to prevent the saint's icon from being confused with a private portrait.

In the catacomb of Callistus in Rome, praying frontal figures represent dead people in paradise, as the inscriptions prove.[7] The central figure in the fresco in SS. Giovanni e Paolo accordingly was first a depiction of a deceased person. The curtain and the prostration, however, are means of distinction that qualify him as a saint.[8] In the cult of heroes preceding the cult of saints in the same sphere of the tomb, the curtain served to conceal or reveal statues. Use of the curtain also formed an

27. *Mount Sinai, monastery of St. Catherine; icon of St. Irene, 7th century*

28. *Rome, S. Maria Antiqua; donor portrait in the Theodotus chapel, 8th century*

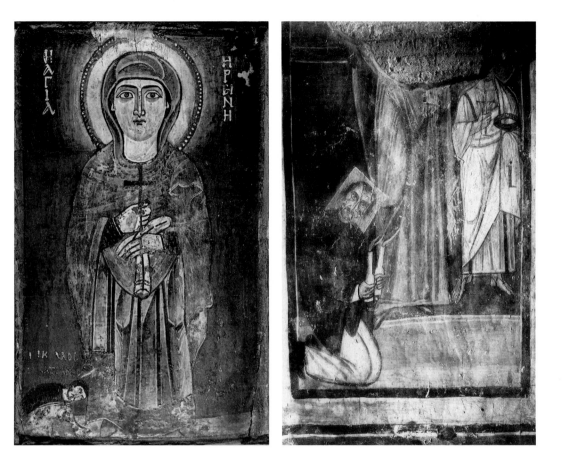

indispensable part of emperor worship. It could create a special aura and change a mere appearance into an epiphany, the ritualized act of appearance.[9]

Images of saints could emerge from the context of sepulchers because Christianity allowed memorial images of the dead to remain on tombs. The portrait of a woman at prayer in the Thrason catacomb or a similar portrait in the Vigna Massimo is thus no longer an anonymous symbol of salvation, as the praying figure had been originally in the pagan tradition.[10] The woman in figure 31 is wearing her best dress and her own ceremonial jewelry, all of which individualizes the deceased as a private person whose portrait was used on a Christian grave. The mass influx of new believers into the new state religion undoubtedly contributed to a relaxation of restrictions, including those on the private veneration of the dead. The cult of saints emerged at the same time. Whether a *memorial* image could be understood as a *cult* image depended on the person of the deceased, not on the image per se.[11]

Family members hung flower garlands and lighted lamps by the grave, as witnessed in an image from a tomb in the San Gennaro catacomb in Naples. The inscription reads, "Here lies Proculus."[12] From his costume we may infer that the deceased person was a presbyter. Perhaps he was a popular cleric whose burial place was honored not only by his family but, as happens with priests' graves today, by women of the parish. When this happened, then the first step toward an official cult had been taken. Private honoring of the dead developed into public veneration of saints. This process was in the hands of the parish and could be justified by miracles if the deceased did not already have a claim to veneration by virtue of being a martyr. The image itself could also undergo a similar transformation. Along with the dead person it depicted, the image itself received the veneration that it fostered. Flowers and lamps are also known to us from images on other tombs in the Naples catacomb, and the recipients of such attention are identified as saints.[13] A further step had been taken. The commemorative image of a saint now could be replicated. It was no longer tied to the actual grave—indeed, it could appear on the graves of others to assist in their salvation. The image of the saint now had a new role to play.

c. Cult Image and Votive Image

In the church built over the tomb of St. Demetrius in Salonika, we meet not just one portrait of the local saint but the same image multiplied all over the church.[14] This is a new situation, as there is no longer the one image that denotes the one tomb. The repeated image serves a new function that may be called the ex-voto, or votive, function. The votive images are meant to present private individuals or public figures as the saint's clientele. A sixth-century mosaic on the west wall introduces people who, approaching from both sides to the central figure, seek protection of the saint or are presented to him by others.[15] A specific concern now takes shape in the image. St. Demetrius, in the costume of a high official honored by a niche of distinction, no longer is praying for his own salvation but intervenes on behalf of others. His tomb no longer attracts simply the care of relatives and friends but has become a focus of expectation where the community asks for the saint's favor. The burial place of the dead did, in the end, become the hope of the living. If we compare the new votive

29. *Rome, SS. Giovanni e Paolo; saint's image before the Confessio, ca. 400*

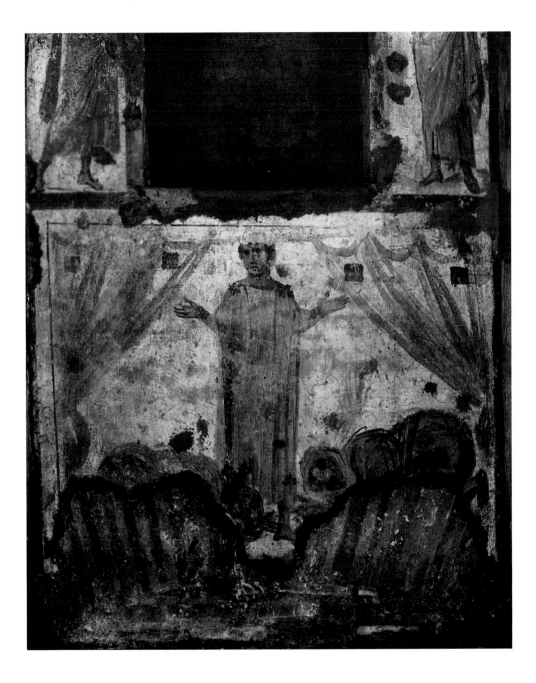

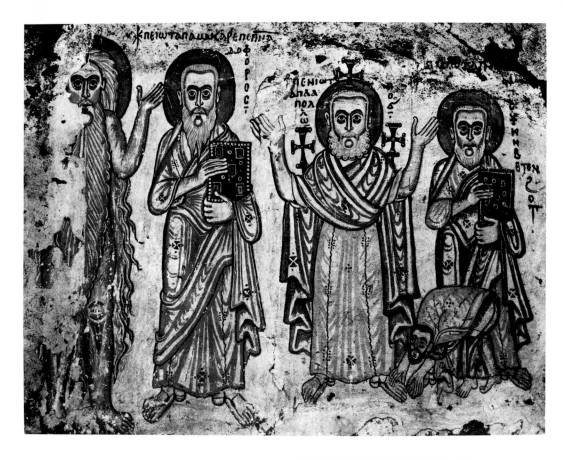

30. *Saqqara (Egypt), monastery of Jeremias; cell wall, 7th century*

31. *Rome, Thrasone Catacomb; portrait of the deceased, near her grave, 4th century*

84

images with the Roman mural mentioned earlier, we discover the new meaning of the prostrate figures, which, though in a similar position within the image, now have assumed the identity of individual clients who make requests of the saint. The local saint's praying hands, on which they pin their hopes, in one case are emphasized by gilding.

The votive images that accumulated on the pillars of this Greek church around 600 present the archetype image of the local saint in a certain number of variants that were dictated by the individual donors. Unlike the ex-votos of pilgrimage places today, they stand out by their life size and by their quality as works of art. The frontal figure of the praying saint, dressed in an officer's cloak, stands in the center of the picture resplendent in the beauty of timeless youth, in accordance with the visions recounted at the time. Visions confirmed the authenticity of the saint's appearance in the image, while the image in turn confirmed the reality of the saint's personal intervention in the visions.

This type of image seems to reflect the main icon of St. Demetrius, which has been lost but once was kept in a silver canopy inside the church, as we learn from old descriptions.[16] But the votive images introduce variants that respond to the requests put forward by the donors. The saint no longer raises both hands in the gesture of prayer but places one hand around the shoulders of the person commended to his protection, like a patron acknowledging a client. The votive images, which are a variation from the single icon at the tomb, define the role of the saint for the demands of the saint's clients. We are reminded of the votive gifts that once were placed in the temples of pagan antiquity. They expressed the wishes of the faithful while embodying the local god in the form of his temple image that they repeated. The case under discussion is different in meaning in that the reality of the physical tomb places the main icon in the lineage of the funeral portrait.

Within the church of St. Demetrius, the mosaics destroyed by fire in 1917, which had covered the walls of the north aisle, are a case apart.[17] They formed a long frieze of images that had been paid for, section by section, by various people according to a practice that also had been in use for floor mosaics in churches. The donors, in this case, selected an ever-changing image formula to present their request either to the local saint or to the Virgin. Since they could not choose the type of the local main icon and since they could not use the general scheme of the single icon, people commissioned every possible type of portrait that was current at the time, to honor the local saint. They made him appear either as a full figure in front of a niche or beneath a canopy, or they chose the medallion with his bust. The variations in the pattern allowed differences in what was essentially the same context. In one case, where a mother carries her child to the saint, varying formulas were used even within one and the same picture. Enthroned before the canopy that sheltered his main icon, St. Demetrius passes on the request of the mother to Christ, who bends down from his medallion to answer the petition of the saint. The Virgin completes the sequence to the right by supporting the request in her turn. The doors of the ciborium, where the icon was kept on a thronelike support, were shown open, as if the icon had come to life and emerged from its cella. The concept of the living image could not be phrased

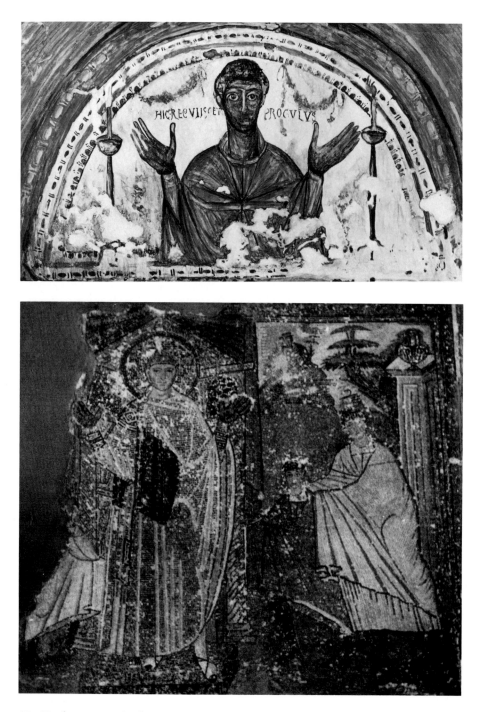

32. *Naples, catacomb of S. Gennaro;
portrait of the deceased Proculus, 5th
century*

33. *Thessaloniki, church of St.
Demetrius; mosaic on entry wall,
6th century*

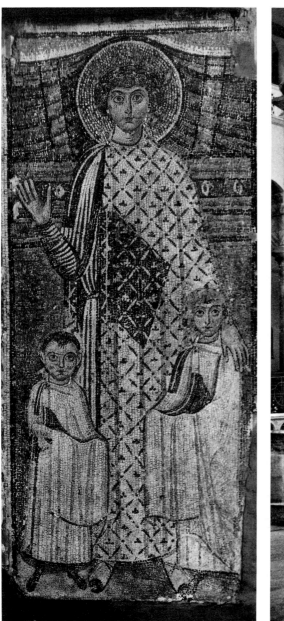

in a better way. The ciborium, which long since has perished, may be viewed with the
help of a similar construction that still exists in the church of St. George in old
Cairo.[18]

37

The formula of the saint in prayer also was chosen for the main icon of St. Menas
at his famous desert shrine in Egypt, where he was buried. A stone relief, now in
Vienna, may well be an exact replica of this icon with St. Menas standing between
two camels.[19] The two figures in a pose of veneration are added to the figure of the
saint much like attributes or afterthoughts. The icon of St. Menas is quoted by a large
number of pilgrims' ampullae.[20] Murals from the sixth century excavated in the
neighborhood of the Menas shrine confirm the appearance of this cult image.[21]

38

The development that brought about the saint's icon may be summarized by com-
paring a funeral image in Antinoë (Egypt) with the main icon of St. Demetrius as
witnessed by the votive mosaics at Salonika.[22] In a mural painting at the private tomb
in Antinoë, a woman by the name of Theodosia, the owner of the tomb, is flanked by
two saints who are identified as such by their halos and by the suffix "holy" added to
their names. The deceased, shown in a praying gesture, addresses the two holy advo-
cates on her own behalf. The saints intervene for the dead woman in their midst. At
Salonika, the meaning of the image is reversed. Here, it is the saint who performs the
prayer on behalf of the living. He is dead, but he does not receive protection. Rather,
he grants protection at the site of his tomb. The change from funeral portrait to saint's
icon, from a memorial image for private use to a cult image for public ritual, took
place in the realm of tombs, much as the cult of saints itself grew out of the funeral
practices of the previous age.

39

d. Funerary Portraits and Icons

The memorial portrait of the dead, which preceded the icon and determined its early
development, is best known today from the mummy portraits in Egypt. It was widely
used in many different shapes, however, with the foremost being in independent pan-
els that were hung on the walls of tomb chambers and also in public buildings. Once
again, examples—rare as they are—come from Egypt, where the so-called Brothers'
Tondo, a large double portrait from Antinoopolis, is a good illustration of the genre.[23]
The two men in a frontal pose in the picture are identified as dead, as the painter adds
two figures of gods who were called upon in the funerary rites: Hermes, who accom-
panies souls on their journey in the afterlife and who in this case also is Anubis, as his
tripartite crown tells us; and the deified Antinous, who by his attributes here is un-
derstood as Osiris, the lord of the realm of the dead.

41

An early icon of the Syrian martyrs SS. Sergius and Bacchus, today in Kiev, offers
a telling comparison with the Brothers' Tondo. The analogy of the pair of brothers
with the pair of saints (chap. 4c) is obvious, despite the choice of frontal types and
the use of halos for the icon. Even the small attributes of pagan gods have an equiva-
lent in the icon. It is a small bust of Christ, who promises eternal life and who will
reward with eternal glory the brave combatants, who have offered their life for their
faith. In his medallion, he is shown in the guise of a "true image," which has to de-

40

36. Thessaloniki, church of St. Demetrius;
side-aisle mosaic as depicted in a watercolor
by W. S. George, 6th century

37. Old Cairo, church of St. George;
image cyborium

38. Karm al-Ahbariya (Egypt), fresco of
St. Menas, 7th century

39. Antinoë (Egypt), grave painting,
6th century

velop as a portrait icon of its own (cf. chap. 4c). Icons such as that of the two martyrs must have circulated along with the growing cult of their relics in Syria. The surviving example was meant to be carried around and once could be closed by a protective cover, as a notch in the edge of the panels indicates.

There is a stereotyped manner of portraying a person that links the Brothers' Tondo to the majority of surviving examples of ancient portraits, including the mummy portraits. As a mummy portrait representing the boy Eutyches particularly well illustrates,[24] this manner of portrayal is manifest in the shifting of the shoulders with regard to the picture plane and also in the emphasis given to the gaze, which is directed outward and receives more attention as a result of the body's movement.

It is no mere coincidence when we rediscover this very same manner of ancient portraiture in images of Christian saints in the West of the Roman Empire, such as the mural of a catacomb in Naples that represents the apostle Peter.[25] Again, we are in the sepulchral sphere but have reached the time of the cult of saints. The chosen portrait type nevertheless does not change. It now can easily be identified when we see the slight turn of the head to the left and the opposite movement of the shoulders. The light comes from the left, as the deep shadow on the neck and in the folds of the garment indicates.

This specific way of portraying a deceased person and, then, a saint may be easily contrasted with a fourth-century image of Christ that dominates the so-called Leo Chamber in the Roman catacomb of Commodilla and seems to be the earliest surviving single image of Christ as Pantocrator.[26] Though it too is related to the portrait tradition in general, it does not use the scheme of the contrasting movement of both gaze and body and therefore avoids the intimate effect of the exchange of glances with the spectator. In fact, it belongs to the different tradition of showing emperors and heroes in apotheosis, which indicates a heavenly context and uses the emphasis on divinization. A telling comparison is the apotheosis portrait of the Roman emperor Titus that is placed in the apex of the vaulting surmounting the opening of the arch of Titus at Rome and therefore matches the position of the Christ image at the vaulting of the catacomb room.[27]

We are now in a position to identify the image of private individuals who were commemorated after their death as in fact the origin of later icons. Such images appeared, to quote yet another example, in a mural of the Oceanus crypt in the Roman catacomb of Callistus, where it even uses the materials of actual panel painting.[28] The head was painted on a separate piece of canvas that was inserted into the surrounding wall paintings and thus must have been entrusted to a professional portrait painter who delivered a separate piece of painting, much as the painters of portraits in Egypt contributed to the outfit of the mummies.

The most striking instances of the private portrait are the gold-glass portraits, of which we have many examples from Roman catacombs. These include all the varieties of the private portrait, and also the earliest saints' portraits, especially of Peter and Paul.[29] Seen against this background, the transition from the private commemorative portrait to the venerated saint's image is easier to understand. Unfortunately, we possess few examples of panel paintings from the transitional period. Most of

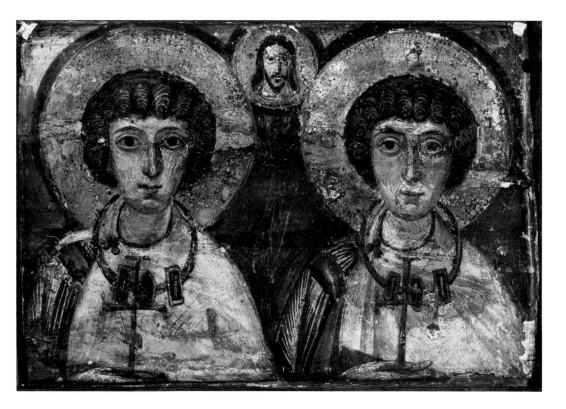

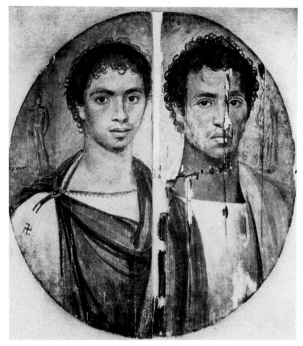

40. *Kiev, Museum of Occidental and Oriental Art; icon of Sergius and Bacchus from Mount Sinai, 6th century*

41. *Cairo, Egyptian Museum; Brothers' Tondo from Antinoopolis, 3d century*

91

42. *New York, Metropolitan Museum of Art;
mummy portrait of Eutyches*

43. *Naples, catacomb of S. Gennaro; bust
portrait of St. Peter, 5th century*

44. *Rome, Vatican Museum; gold-glass
portrait, 4th century*

those we do have come from Egypt, where the climate happened to be favorable to their preservation.

An early Coptic icon in Berlin represents "our father Abraham, the Bishop," as 45 the inscription reads. Though the circular nimbus appears to indicate a saint, the inscription identifies the person represented as the abbot of the local monastery of St. Apollo in Bawit, Egypt, where it was found.[30] What at first sight seems to be the icon of a saint, in fact proves to be the memorial image of a member of the monastic community. Whether the memorial image became a saint's icon depended on the person represented and much less on the scheme of portraiture, as the latter served both functions. The use of a similar type of image is best explained when we keep in mind that the concept of sainthood at that time was in transition. One who must have been a beloved and well-remembered fellow monk could easily become an acknowledged saint. His portrait as a departed monk, without any need of change, then became his icon as a saint.

A panel now in the possession of the Cabinet des Médailles in Paris closely re- 46 sembles the Abraham portrait in Berlin and also represents an abbot or bishop, as is shown by the costume and by the gospel book that the cleric holds in front of him.[31] But it lacks the circular halo or nimbus, which we usually take to distinguish a saint. The inscription, however, reads, "Our father Mark the Evangelist," thereby denoting what seems to be a regular portrait as a saint's icon, while the Berlin panel, despite its attributes of a saint's icon, immortalizes a local cleric. Clearly, the borderline between portrait and icon was blurred at the time, and the image is no reliable guide when we wish to differentiate the one from the other. The portrait of St. Mark also may give us an idea of the official portraits of church dignitaries, which written sources of the time mention. As we learn from John of Ephesus, in the sixth century the newly elected patriarchs of Constantinople had their official portraits hung in a special gallery. They also sent portraits of this kind to their diocese to be commemorated in liturgy. They usually chose the diptych, as a seventh-century example from Brescia clearly testifies.[32]

From the early fifth century we have literary evidence of the simultaneous use in churches of portraits of the living and the dead, including saints. Bishop Paulinus of Nola, who resided near Naples, was asked by his colleague Sulpicius Severus for a portrait to be hung in the baptistery next to that of the recently deceased Martin of Tours.[33] Paulinus had misgivings, which he voiced in Platonic terms. The "divine person" (*homo coelestis*—the *noēton* of the Platonists) could not be copied, and the "earthly person" (*homo terrestris*) should not be copied, he said. To prevent his image from being misunderstood or even misused next to the icon of St. Martin, Paulinus composed inscriptions reminding the beholder that Martin was an example to be imitated, and he an example to be shunned. Martin, he wrote, offered the "perfect pattern of a proper life" (*perfecta regula vitae*), whereas he was a lesson for sinners who had to do penance. He could not have expressed more clearly the fact that the distinction between portrait, memorial image, and cult image had become problematic. Care had to be taken lest images using the same convention be confused; the wrong image could too easily become an object of veneration.

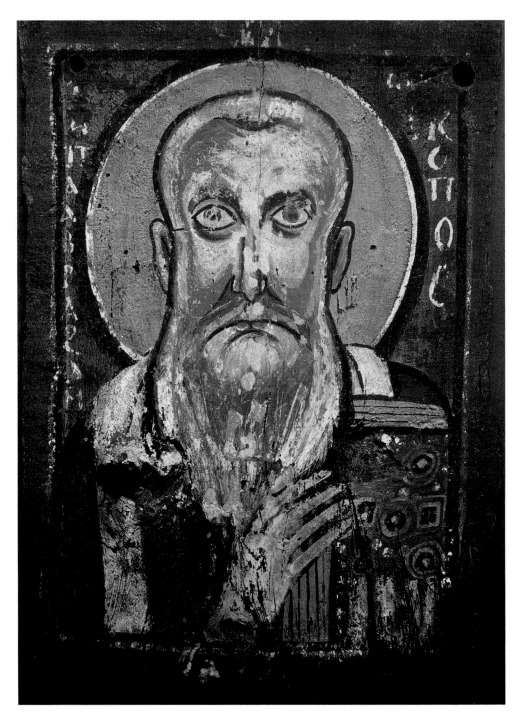

45. *Berlin, Staatliche Museen; portrait of Bishop Abraham of Bawit (Egypt), 6th century*

94

46. *Paris, Cabinet des Médailles; Egyptian panel of St. Mark, 6th century*

47. *Paris, Cabinet des Médailles; Egyptian panel of the archangel Michael, 6th century*

45, 46 The Berlin and Paris panels illustrate the problem in their own way. Only from
the inscriptions do we know which panel represents the saint and which the local
abbot. To contemporaries the difference may not have been very evident. The image
at the grave of the revered abbot may actually have received more veneration than
that of the Evangelist; both ultimately were memorial images, certified as such by the
existence of body and tomb.

The extension of such iconic conventions to other beings represented an impor-
47 tant stage of development. In the Cabinet des Médailles a companion panel to the
St. Mark panel has been preserved.[34] The bust of a youthful dignitary with a ribbon
in his hair, wearing an officer's uniform and displaying a circular nimbus, has been
identified as that of an archangel. This identification is aided by the stumps of wings
on the shoulders. In this image of an incorporeal, nonhistorical being, the line of
tradition from the memorial image to the saint's portraits is broken. The iconoclasts,
and foremost among them the Jews, took the Christians to task for this inconsistent
use of portraiture. They were rebutted by the argument that since God had given the
angels a visible body in order to make them appear to humankind, angels could well
be represented in images.[35] What had been manifested by an act of heavenly revelation
could also be the subject of images. Moreover, the image included the immortal being
and was not confined to just the physical likeness of a body.

Given the open transitions between different schemes and functions of the image,
it sometimes is difficult to decide how to read the message of a group image where
48 figures are introduced to others. A sixth-century Egyptian icon in the Louvre, which
comes from the same monastery of Bawit as the Abraham panel mentioned above, is
a case in point.[36] St. Apa Menas, a local monk, seems to be an independent saint's
image, as he is shown with a halo and with a gesture of benediction. But his frontal
position is contradicted by his introduction to Christ. In fact, Christ performs the old
gesture of the patron who shields his client by placing his protective arm around
Menas's shoulders. It may be true that, in the image, Christ "raises the abbot among
the saints and presents him to the people," as Klaus Wessel once remarked. But the
gesture has a history of its own, which defines the motif with the meaning of protec-
tion.[37] In this case the image does not succeed in fusing the different notions both of
receiving and of granting protection in a convincing pictorial formula.

When the Egyptian monastery of Bawit, the home of two icons mentioned above,
was excavated, several cells of monks were found that were painted in the seventh
49 century. In one case, the walls were covered all over with icons of saints that repre-
sented a nearly complete list of all the images that were current at the time.[38] The
heterogeneous collection of images included half-length and full-length saints, some
in prayer and some giving a blessing, as well as busts in the medallion form that stems
from the sacred type of the *clipeus,* or consecration shield. It seems that the monk
who commissioned the murals wanted to surround himself with every type of image
he knew about, thereby honoring all the saints he knew of with a specific type of
image.

36 The mosaics in the aisle of St. Demetrius in Salonika offer a similar collection of
types of images, but in this case, the situation is reversed.[39] Here, despite the variety

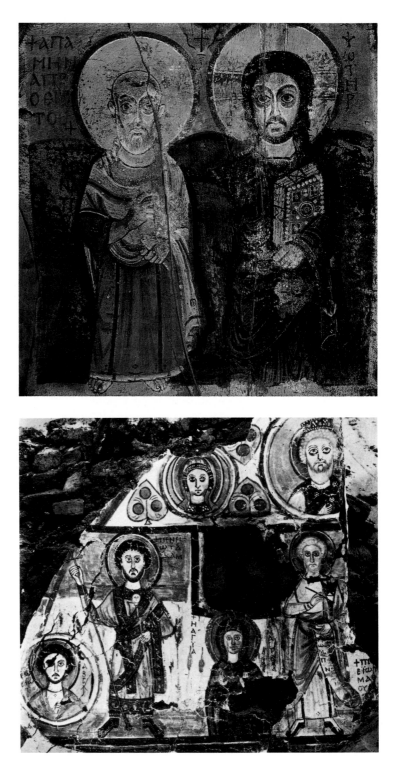

48. *Paris, Musée National du Louvre; St. Apa Menas from Bawit (Egypt), 6th century*

49. *Bawit (Egypt); cell wall in the St. Apollo monastery, ca. 600*

97

of image formulas, they address the same saint—St. Demetrius—and here, they are commissioned by a great number of individuals, who vie with each other by the image type chosen. Through inscriptions, the mosaics specify the requests of the donors. In one case, parents pray for themselves: "And thou, my Lord [*Despota*] St. Demetrius, help us, thy servants [*doulois*] and thy servant Mary, whom thou hast given us."[40] The votive images sometimes also include the figures of the donors; in one case, the portraits of two church benefactors are even placed as busts in a medallion beside the medallion of the local saint. Except for the golden halo that distinguishes the saint, it would be hard to single out the icon of the latter from the portraits of private individuals.

Like the imperial image and the image of the gods, the funeral portrait that we have studied has received a special cult that made possible the emergence of the icon. The cult of tombs promoted the cult of saints, which in turn became manifest in the cult of their images. Both private persons and saints were commemorated with their images. In the case of the saints the difference was the kind of commemoration that transcended the private sphere and, in the end, became a public cult that was sanctioned by the church. The saint's icon was a product of the cult practiced at the saint's tomb. It initially resembled the private funeral portrait to such an extent that it was virtually indistinguishable from the latter. Later on, the range of types of images narrowed down when funerary portraits of private individuals went out of use and icons of saints adopted conventions of their own. Even then, they made use of the aesthetics that had been developed in ancient portraiture.

e. Idealism and Realism in the Ancient Portrait

42 The painted mummy portrait that emerged only in Roman times reflects three different concepts of portraiture that converged in Egypt—the Greek, the Roman, and the Egyptian traditions.[41] As a result, the surviving mummy portraits differ among themselves to a considerable degree. In function, however, they all depend on the belief in an afterlife, from which the idea of preserving the portrait is derived. The portrait serves to preserve the physical likeness of the person for the afterlife. In Egypt, the entire body is preserved for the other world by embalming it, and the mummy, in turn, carries a panel portrait of the person, which is placed on top of the face.

This portrait, independently of its use in Egypt, adopted two different concepts of portraiture, of which the Greek one, in accordance with Greek philosophy, "not so much emphasized the likeness of a unique individual . . . as an idea of man that transcends the limits of physical likeness. Significantly, the death mask never became common in Greece" but emerged in Rome. The Roman death mask, which so much influenced the Roman portrait, "served to preserve the body" in its own way. "It was not so much the eternal form, destined to serve in the other world . . . as the actual likeness of a physical body which became important for representing the real existence of an individual."[42]

The transformation of the old Egyptian death mask, with its rigid smile, into the Roman portrait, with its physical likeness, is best illustrated by a cardboard mask

from the so-called Kaufmann Tomb in Havara, dating from the early days of the Roman Empire.[43] With the exception of the gilding that was customary in Egypt, the influence of realism, which developed in republican Rome, is evident.[44] The painted panel of the portrait, in chronological sequence, followed the use of the cardboard mask. Two mummy portraits from Havara indicate the parallel use of the cardboard mask and the painted panels for Egyptian mummies in the time of Emperor Hadrian, that is, in the second century A.D.[45] The mask is now the only part that became gilded, while the hair is colored black and the robe white. The increasing Romanization gradually changed the appearance of the old mask.

The painted portrait, on a panel, marks the last stage in the appearance of the mummy in Roman Egypt. It is inserted in the sculptured bust relief that covers the second of the two mummies from Havara. Allowing the highest degree of likeness with the help of a fairly simple technique, it is nothing but a funeral portrait in the ordinary sense as it was used by the Romans. In some cases, it must have been a reused example whose use for a mummy did not affect its appearance at all. The painted portrait, as a result, reflects both the Greek concept of idealizing a person and the Roman concept of recording his or her real likeness.

A male mummy portrait in Dumbarton Oaks in Washington seems to anticipate the saint's icon, as it appears to look beyond the present world.[46] Its ideal face, the opposite of an individual face with its inherent realism, reflects beauty in a general, spiritual way. The gilding, here confined to the full lips of the man and the background of the panel, takes up motifs of the Egyptian tradition. The heroization by means of a golden wreath in the dark hair, as part of a Greco-Roman tradition, increases its dignity, which distinguishes the new status of the deceased in the world beyond.

Within ancient portraiture the *memorial portrait,* which records the reality of a single life, contrasts with the *heroic image,* which represents an ideal beyond physical reality. The surviving examples either satisfy one ideal of portraiture at the expense of the other or strike a balance between the two, as they refer both to the temporal existence of a person and also to a realm beyond where the deceased dwell. The new existence of the afterlife requires the care and respect of the living.

The icons of saints soon make use of the possibilities of the funeral portrait, their predecessor, as they too represent an individual in a most specific, Christian heroization, and as they too look backward at a human life as well as forward to a suprahuman reality. The choice between memorial image and ideal image was no matter of a simple alternative such as recording a historical body versus inventing an ideal appearance. The study of nature by necessity involves the question of how nature is understood in a given age. If nature is dismissed as a lesser, or negative, reality, then it will be set aside and subordinated to forms that are both ideal and of an abstract, general quality. The cult, finally, needs an ideal that may be worshiped. As Walter Benjamin once remarked, "The definition of the aura is a unique manifestation of something remote, no matter how close it may be." Remoteness, as the opposite of nearby reality, reaches the climax in the image of the saint, who, as a saint, remains

50

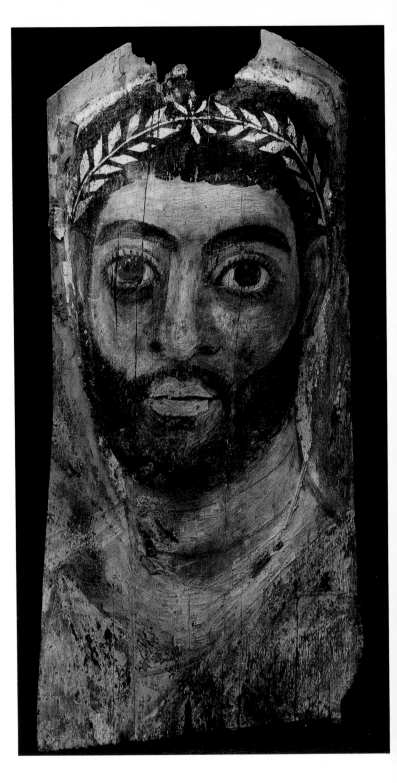

inaccessible for the faithful. "The physical presence" that such an image conveys to us is counterbalanced by the immaterial "appearance" that distinguishes the person represented.[47]

As the most important source of the icon of the saint, the funeral portrait developed at the tomb, where family and friends performed the rituals of memory. But the image of God cannot be derived from this tradition. The divine images of the pagans, which were the object of sacrifices, were long opposed by Christianity and, in the end, were replaced by images of Christ. Surviving examples of panel images of the gods again come from Egypt, where the climate favored the preservation of panel paintings.[48] Finally, the state rituals surrounding the cult of icons of Christ leads to the third source of the Christian icon: the imperial image.

6. The Imperial Image in Antiquity and the Problem of the Christian Cult of Images

The third pictorial genre of antiquity that was associated with fixed cult practices is the imperial image. A Byzantine miniature in a Psalter of 1066 serves to introduce the subject.[1] It tells the story of the three companions of Daniel who refused to worship the cult image of King Nebuchadnezzar. Their refusal was dangerous, since the king had proclaimed that "whoever does not fall down and worship shall immediately be cast into a burning fiery furnace" (Dan. 3:6). Nebuchadnezzar indeed threw them into the furnace, but the three steadfast young men were saved by the angel of the Lord.

Given these circumstances, the depiction in the miniature of the cult image described by Daniel is surprising. Although the text refers to a golden statue, the book illuminator represents the offensive image as a contemporary imperial portrait. It hangs as a panel painting suspended from a hook on a wall.

a. The Worship of the Imperial Image

It is hard to determine whether the monk who painted the miniature was merely illustrating the biblical story of the three Hebrews with a certain freedom of detail or was making a polemical allusion. But he clearly assumed that imperial icons of this kind were familiar to the beholder. At that time the emperor was still the object of ritual veneration; at public receptions he sat stiffly on his throne receiving prostrations, like an icon concealed and revealed by a curtain in a fixed ritual.[2] In the ceremonies following military triumphs the prostrate position signified subjection to the "living statue," as is shown by the miniature in a Psalter of Emperor Basil II (976–1025) in Venice.[3]

It is uncertain how far veneration of the imperial image persisted in the Middle Ages, but the surviving examples or those of which we have descriptions are the only portraits that present the person in a frontal position and thus demand worship for the emperor, as had been the case for his pagan predecessors. The mosaic of Emperor Alexander from the year 913 in the church of St. Sophia bears a striking resemblance to the painted imperial image in the Hebrew story, as do two large stone tondi now to be found in Venice and at Dumbarton Oaks.[4] The reliefs were once set into an exterior wall. A painted version is reported by an eighth-century source describing the city of Constantinople. The painters, it tells us, admired a "colored stele" of Emperor Philippicus (711–13) at the baths at Zeuxippos.[5] Here the notion "stele" indicates that the painted image had the same function as the earlier memorial statue.

The much-debated veneration of the image of Christ had been explicitly justified by the undisputed worship of the imperial image. The Council of Nicaea (787), which dealt with such questions, decreed: "When the population rushes with candles and incense to meet the garlanded images and icons of the emperor, it does not do so to

honor panels painted with wax colors, but to honor the emperor himself."[6] Such a practice was evidently quite old.

From the earliest days of the icon, state worship of the imperial image is abundantly documented. When Christianity became the state religion, the Christians had to deal with this worship as a possible source of conflict. What they refused to the pagan god-emperor, however, they willingly granted to the Christian representative of the state. The imperial ceremonies in the Christian Roman Empire had their origins in the late third century, in the time of Diocletian.[7] The great reformer had introduced a fundamental change in the law on imperial portraits, laying down firm constitutional norms that remained valid over the following centuries. Breaking this law would therefore have meant a clear breach of the constitution.

Even in the early Christian period, imperial images consisted mainly of statues, usually monuments to the monarch that were erected in public squares. These continued a genre of monuments from pagan times. In the fifth century Philostorgius described the institutionalized cult of the statue of Constantine on a column in the Forum at Constantinople, a cult that continued the genre in a new context. There is a gigantic surviving bronze statue of a fifth-century emperor that was moved to Barletta in southern Italy.[8] The emperor, in the armor of a general, probably held an enormous cross in his right hand, as a sign of the victory promised by heaven and as an emblem of the one whom, as the *basileus,* he represented on earth. On the ivory of Probus a similar emperor figure holds up a standard with the inscription "In Christ's name you shall conquer."[9]

The imperial statue was not the only cult image in which the emperor appeared at the time. The text from Nicaea quoted earlier refers to panel paintings that the emperor sent out into the provinces as symbols of his legal presence. Such pictures had the double advantage of being transportable and of not recalling pagan images. We see them in an official calendar of the fifth century, the so-called *Notitia dignitatum.*[10] Here the various ranks of state officials are listed and represented by their respective insignia. The page on the praetorian prefect shows a portrait of the emperor that had been issued to him because of his rank. It is displayed between burning candles on a table in his office, which meant that the official always administered justice in the emperor's name. The image appears again on a stand nearby, a position it also has in an ivory of the Roman prefect Probianus.[11] Official authority is represented by the emperor's image, especially at judicial proceedings and court sessions. We find a different form of picture stand in a sixth-century gospel book in Rossano.[12] Here, at Christ's interrogation, the Roman governor Pilate sits between two stands bearing portraits of the coemperors. The imperial image was not only an official symbol but simultaneously an object of cult worship.

b. The Emperor's Person and the Legal Status of His Image

The imperial cult of images equated the person represented with the portrait. This identification led to granting the images almost all the honors and rights due the emperor himself. The emperor's status in state law was extended to his portrait, which

53

103

51. London, Cod. Addit, 19 352, fol. 202; the three youths before Nebuchadnezzar, Byzantine miniature, 11th century

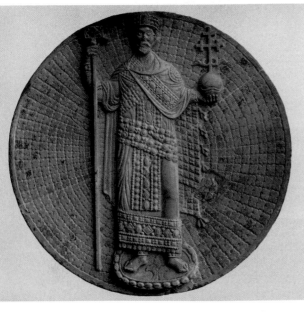

52. Washington, D.C., Dumbarton Oaks; relief depicting a Byzantine emperor, 11th century

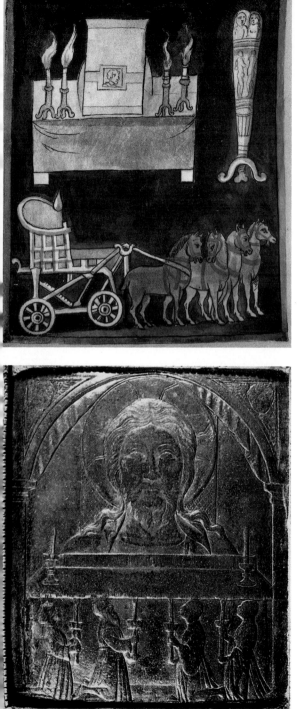

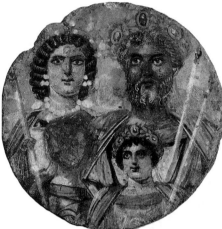

53. *Munich, Bayerische Staatsbibliothek; clm. 10 291, fol. 178; ceremony of homage to the emperor, late antique official's calendar of the* Notitia Dignitatum

54. *Berlin, Staatliche Museen Preussischer Kulturbesitz; family portrait with Emperor Septimus Severus, ca.* A.D. 200

55. *Rome, Lateran; door covering in a silver chasing depicting homage paid to an icon, ca. 1200 (detail of fig. 18)*

could be used effectively to represent him in the provinces only if its status was exactly defined by law. Two important legal customs make clear the position of the imperial image. First, it was ostentatiously displayed at the time of the emperor's accession to the throne, an act intended to prove the subjects' acceptance of the authority of the new emperor. Second, it was violently removed as a sign of rebellion or secession, and sometimes as part of a *damnatio memoriae* decreed from above. A surviving example of this extinguishing of images is a family portrait of Emperor Septimius Severus, produced about 200, now in Berlin.[13] It witnesses the important type of the *imago imperialis* known as the *imago clipeata,* or circular shield portrait. Geta, one of Sep-timus's two sons, had fallen victim to *damnatio memoriae* when his brother, Cara-calla, came to power. The latter's order to remove all images of Geta has been followed in the picture; Geta's face has been effaced and covered with a foul-smelling substance.

I shall recapitulate here the most important findings of Helmut Kruse and Thomas Pekary, who have studied the imperial image and its legal status.[14] While the imperial portraits had initially been erected by citizens or officials, following Diocle-tian they were also sent out by the emperor himself to all the provinces. This practice is confirmed by an important ceremony that increased the aura of the image and at the same time demonstrated the loyalty of the subjects. The image was sent out to receive the homage of the new emperor's subjects, a procedure that could be called the publication of the image. The Byzantine Book of Ceremonies contains an example of this ceremony in its description of the reception of the laurel-wreathed portrait of the Western Roman emperor Anthemius in Constantinople in 467.[15] Acceptance of the portrait meant the acceptance of the Western Roman emperor as coemperor. It demanded the setting up of joint images in the empire.

The object of sending out images was the *proskynēsis* of the population. Any rejection of the image or even any incorrect reception would have been lèse-majesté. Like the ruler himself, the image was officially met several miles from the city. The welcoming of the image was followed by festivities that included a ceremony per-formed with the imperial image. Paying of homage (acclamation) by the populace and the officials was always required. A ritual of congratulations of the ruler alternated with invocations of God. Descriptions of such receptions are known to us from Rome, where the imperial icons of Byzantium were displayed, surrounded by candles and incense, in the oratory of Caesarius on the Palatine.[16]

In Rome too the Christian icon soon became the object of elaborate rituals clearly derived from those associated with the imperial icon. The same process must have taken place earlier in Constantinople. As early as the sixth century we hear of a state cult of the icon of Christ at Kamuliana clearly based on the worship of the imperial image. At that time the icons of Christ and of the emperor were even worshiped side by side, with more or less the same rituals (chap. 4a).

The state forms of image worship are best documented in the case of the old Savior icon in the Sancta Sanctorum, the papal chapel in the Lateran (chap. 4d). The metal mounting of the icon had a double door that was opened when the feet of the icon were kissed or washed. The new fourteenth-century doors have depictions of the

Savior bust, which is displayed between candles on the chapel altar and is venerated by a confraternity. The analogy with the display of the imperial icon shown in the late Roman calendar of the *Notitia dignitatum* is self-evident. One can understand the misgivings of some North African clerics in the fifth century who were waiting official envoys carrying imperial images on the occasion of the consecration of a church built with imperial funds. They were afraid that the images might be set up on the church altar, which would have abolished the necessary distinction between state and church premises.[17]

By their form, the laurel-crowned imperial images clearly resembled the portrait shields that were used in the military sphere. These imperial images became known as *laurata,* after the laurel, which was the sign of an official image. In military usage the portrait shield (*clipeus*) was attached to the standard.[18] In a relief dedicated to Trajan on the Arch of Constantine, the *imaginifer,* a standard with the imperial images, takes part in the battle. On a triumphal arch in Leptis Magna in North Africa, the imperial image is hung around the neck of a high military personage in the form of a bulla.[19] The army signaled a change of rulers by replacing the imperial image, which, as a rule, was used in conjunction with the military standard, the *signum*. In principle, the image on the standard represented the emperor vis-à-vis the troops. The possibility of speedy production made the metal medallions appropriate for the proclamation of a new emperor via his portrait. In view of all these developments, it is significant that the image of Christ was also taken into the battlefield shortly after it had been given civil legal status. We thus may conclude that it was also connected to the military status of the imperial image. Whereas previously the imperial image had been carried ahead of the army, it was now the turn of the image of Christ.

c. The Military Standard and the Cross as Bearers of Images
Against this background we can explain the curious practice of fixing a portrait shield of Christ to the cross. At the beginning, the cross, as Christ's triumphal sign, had been entirely devoid of images. Later, it became customary to affix a *clipeus* to the top of the cross showing Christ as ruler and God, even before a figure of the Crucified was placed on the cross. We have evidence of this custom from the Holy Land. Pilgrims' souvenirs from the Holy Land and a Roman mosaic from the seventh century both show the memorial cross of Mount Golgotha in this form.[20] Surviving portrait tondi with fixing pins are further proof of this use of the Christ image. It is no accident that the earliest evidence dates from the late sixth century, when the civil and military cult of Christ icons is first documented. The most important witness is a painted wooden tondo from Egypt in the Kunsthistorisches Institut of the University of Mainz.[21]

The *signum* of the Christian God under which Constantine won his victory was apparently also affixed to his imperial standard, the labarum.[22] As is well known, Constantine's decision to put his trust in the Christian God was the result of his vision on the eve of the decisive battle. With the sign (*signum*) he saw in the sky, he was said to have been given the message, "Under this sign you shall conquer" (*In hoc signo victor eris*).[23] The *clipeus* of Christ attached to his standard as yet carried no portrait, only the first two letters of *Christos—chi* (X) and *rho* (P), which, if combined with

56. Rome, S. Stefano
Rotondo; mosaic with
Golgotha cross, 7th century

57. Washington, D.C.,
Dumbarton Oaks; lead
ampoule with Golgotha cross,
ca. 600

58. Mainz, Kunsthistorisches
Institut; image superstructure
of a cross from Egypt, 7th
century

the cross, produced the Christogram, or chrismon. Here Constantine was no doubt drawing on the emblematic tradition of military standards. Next to the new sign that was borne ahead of the army, the imperial portrait tondo could remain in its old place, performing its old function.[24]

Two centuries later we hear of images of Christ being introduced into the civil and military cult of the *imago imperialis*. This coexistence clearly gave rise to a crisis of which we now have no clear idea. Almost two more centuries were to pass before the emperor and the church emerged as antagonists in the iconoclastic controversy. The *imago Christi* first appears as a *clipeus*, that is, in the most important form taken by the imperial image. Even the cross, seen as a standard and a trophy, had become *58, 59* associated with imperial triumphs on the battlefield. Attached to the standard, the *clipeus* of Christ was referring to the imperial image. Christ appears on the cross first as emperor and general, not as the Crucified.

The emperor's image and the Christ icon both use the official type of the tondo portrait. In an illustrated Psalter from the ninth century (in Moscow), the iconoclasts are shown in the act of painting over a Christ icon in tondo form (chap. 8d).[25] In a *88* church calendar from the tenth century, Empress Theodora, who in 843 reintroduced the veneration of images, is shown demonstratively holding a roundel with the portrait of Christ.[26] The surviving examples go back to a time before iconoclasm. The apse in the small church of Castelseprio near Milan, probably painted during iconoclasm by Greek exiles, quotes a Pantocrator icon in medallion form.[27] The accompanying scenes narrating Christ's infancy are essentially a commentary on the historical life of Jesus; they certify the portrait as genuine, even though it represents Christ—according to his divine nature—in the sacred mode of divine or imperial images.

The *clipeus* portrait was not only in use by living emperors. Also as a portrait of the dead, it expressed the idea of apotheosis. The consecrated emperor could demand that his image be worshiped as it was carried in triumphal processions. On a small arch honoring Emperor Galerius (305–11), from his palace in Thessaloniki, this *59* practice is alluded to as the imperial image is carried in triumph by a Persian. A third-century source underscores the official nature of such worship: "By a unanimous decision of the Senate a golden *clipeus* showing a bust of Emperor Claudius Gothicus [268–70] was set up in the curia and is still to be seen."[28]

d. Images of Christ in State Iconography

We are now in a position to consider the introduction of images of Christ as state images. The first known example dates from 540 and is part of a so-called consular diptych. The consuls used to send such diptychs on their inauguration on 1 January, as official gifts from Constantinople. Because they carried portraits of the representative of the state, the double panels of ivory had the stamp of a true state ideology; any change in their iconography had the meaning of a virtual state proclamation.[29]

By 540 the consul was no more than a figurehead on the ship of state, which the emperor himself steered. But the former could still perform ceremonial duties, such as opening the games at the circus. In an ivory now in Paris, Anastasius (517) is en- *60* throned on the *sella curulis* above the arena.[30] With the mappa, or handkerchief, in

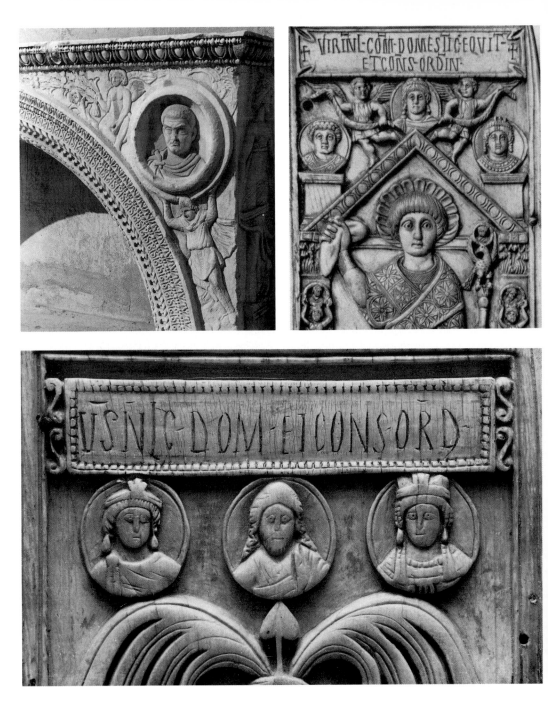

59. *Thessaloniki,*
Archeological Museum;
small commemorative arch
of Galerius, 305–11

60. *Paris, Cabinet des*
Médailles; ivory of the consul
Anastasius, 517

61. *Berlin, Staatliche Museen*
Preussischer Kulturbesitz;
ivory of Consul Justinus, 540
(detail)

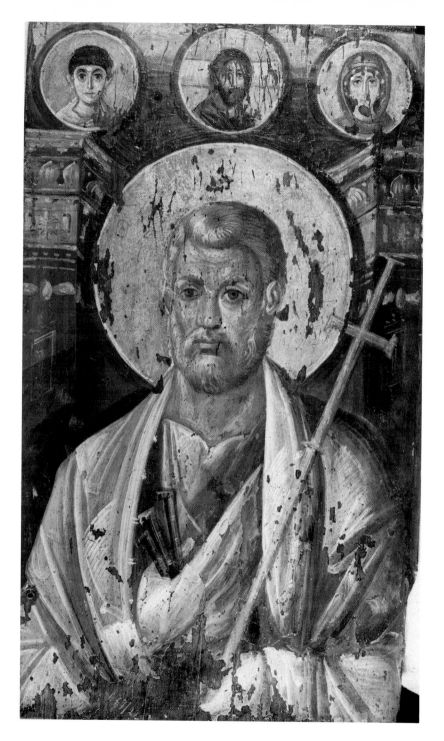

62. Mount Sinai, monastery of St. Catherine; icon of St. Peter, 6th century

63. *Formerly Bawit (Egypt), fresco in Chapel*
28 of the St. Apollo monastery, 7th century

64. *Mount Sinai, monastery of St. Catherine;*
Madonna icon with Clipeus Christi, *7th century*

his right hand, he gives the signal for the games to start. Imperial authority is present in the scepter with the eagle bearing the emperor's *clipeus* between its wings. Still more important is the presence of Emperor Anastasius and his wife in the portrait roundels at the top.

Above Consul Clementinus (513), in an ivory in Liverpool, the *clipei* of Emperor Anastasius and his empress flank the cross of Christ, representing the origin of imperial rule and imperial victory.[31] The Christian God is present in the symbol of the cross in the midst of the traditional imperial images.

It was therefore an event of utmost importance when the cross was displaced from this position by the portrait tondo of Christ on the diptych of Consul Justinus 61 (540), now in Berlin.[32] While everything else has been kept in place, the decisive change is brought about in the area of the imperial *clipei*. The symbol of the cross is being exchanged for a further portrait, whose central position shows its rank above the imperial portraits. There is a reciprocal reference between the divine and imperial images that the eyes of contemporaries must have caught immediately. As the imperial images circulated as real objects and were used in actual rites, an image of Christ that is treated as their equal must also have been understood as a real image. The central portrait, in fact, reproduces an icon of Christ that held a legal and cult position analogous to that of imperial images. It is inconceivable, moreover, that an icon of God, once introduced, would have been denied the ritual of cult already in use by the imperial icon. Indeed, the literary sources of the sixth century give us plentiful evidence of the existence of cult images of Christ.

This opens up the possibility of seeing a number of early icons as arguments in favor of such a practice of the image. They adopt the image of Christ, much as the imperial image was adopted on the consular diptychs. The sacred *clipeus* that they use for Christ denotes higher rank, as compared with the ordinary portrait of saints. Perhaps there is even an allusion to a particular example, when the icon of SS. Sergius and Bacchus in Kiev quotes the miraculous image of Kamuliana. 40

The early icon of John the Baptist (46.8 × 25.1 cm) in Kiev shows the forerunner 85 and herald of Christ in a full-length portrait.[33] With his right hand he is pointing to a portrait tondo of Christ, saying, in the text of the scroll, "Behold the Lamb of God, who takes away the sins of the world." The prophet announces the Messiah to the new age. John the Baptist's image is subordinated to that of the God-man, which in turn is accompanied by the image of the Virgin, according to the scheme of the three-figured deesis. St. John visibly plays the role of intercessor, answering the requests of the faithful and presenting them to God himself. The change of portrait type is significant, as Christ is shown with the formula of the divine (and imperial) *clipeus*.

Messages of this kind also characterize the early icon of St. Peter (92.8 × 53.1 62 cm) in the monastery on Mount Sinai, which may have been produced in the sixth century.[34] The analogy with the Justinus diptych is clear in the upper part of the panel. The three *clipei* in the diptych are taken up, with Christ again at the center. One might ask whether they are not secondary in the icon, simply borrowed from state images, since they look less authentic in the new context. The icon contains a portrait of Peter, who resembles an imperial official, with the keys of his apostolic power and the cross

of his sacrificial death as his insignia. God's representative on earth invokes the divine ruler. Peter assumes the position of the state official, while Christ, flanked by the images of the Virgin and St. John the Evangelist (?), functions as Peter's sovereign in heaven. The portrait shield is reserved for the divine Ruler and thus denotes a distinction in rank, much as it distinguishes the emperor from his consuls in the state iconography. The apostle administers the sacred image as the sign and legitimation of his official mission.

The sacred images stand out from the blue background of the icon by their golden background, which matches the nimbus of the main figure. They are thus "bathed in another light." This difference also determined the choice of portrait type. The apotheosis medallions meet the requirement of timeless ideality. Peter's face, however, with the realism of the strong flesh color, meets the demands of a corporeal reality whose continued presence is attested by his tomb. Funeral portrait and the divine image (the latter including the image of the divine emperor) are both present in this panel by quotation.

A half-length icon of the Virgin in the Mount Sinai monastery (40 × 32 cm), which dates from the seventh century, again borrows the portrait shield for a very specific reason.[35] The Mother of God introduces her divine son by way of an image on an oval shield, just as Victoria presents the image of Consul Basilius (Rome, 480) on an early ivory.[36] In a seventh-century fresco in the monastery of St. Apollo at Bawit, such a "visual proclamation" of the divine sovereign is borrowed quite literally from the state image, as the enthroned Virgin holds the oval shield before her body.[37] Even in the panel in the Mount Sinai collection, the displaying of the consecrated shield remains the theme. It retains the echo of an elevated official rite that has passed into the format of the icon. The "image within the image" is nothing other than a reminder that the beholder should see the icon as a cult image.

7. Image Devotion, Public Relations, and Theology at the End of Antiquity

The long prehistory of the icon, which we have been studying so far, may explain the variety of artistic and technical features that were available when icons were first produced. Icons drew heavily on the plentiful resources of ancient painting and borrowed from existing types and media of images before evolving forms of their own. The genre still lacked a common iconography and an aesthetic at that stage, and each surviving panel differs from the other, as it followed its own models and offered its own message, not having general norms of icon painting to draw on. Admittedly, the surviving examples are diverse in origin, making comparisons difficult, but this, again, is another matter. We are not yet in a position to assign places of origin to extant works and cannot even confidently distinguish Western from Eastern examples in the early period preceding iconoclasm. The exhibition of early icons of the Virgin available in Rome, which we mentioned above (chap. 4d), provided visible proof of the wide diversity of the panels, even in one place. To sum up, early icons were different from each other not only because of their different painters and places of origin but also simply as a result of their arising in an early stage of development when their prehistory was still influencing their character.

We nevertheless would like to raise the question whether icons began to generate an interrelation of form and content, or form and function, which would establish an aesthetics of their own and distinguish them from other genres of painting. This question, however, does not promise easy answers. The doctrine of images is no obvious help, as it was developed "after the fact" by theologians during iconoclasm (chap. 8c) and not with the intention of guiding the production of actual icons. It is therefore uncertain whether there existed an initial congruence between the theory and the form of the icon.

a. Wall Icons in a Roman Church

We may enlarge our basis of observation when we include icons in other materials or icons reproduced in wall paintings of the time. The latter, in addition, survive in their original situation and thus provide us with an insight into their function, which surviving panels rarely can offer. Only in Rome is it possible to gain an idea of the original context for which icons were produced. It is therefore appropriate to start our inquiry in Rome, where actual panels have survived along with replicas of icons in mural painting. Such replicas are to be found in what was formerly S. Maria Antigua, the church of the Greeks on the Forum Romanum.[1] The church flourished in the seventh and the eighth centuries and was abandoned as early as the ninth century. It therefore offered an excellent idea of the early state of things when it was excavated in 1900 and when its walls, unaffected by the work of later centuries, were found in the condition that they had reached by the eighth century.

For our argument, a few single "icons" of saints that are situated at eye level and

often bear traces of a former cult practice devoted to them are of the greatest interest. Usually representing an individual saint, they seem to have been commissioned by private individuals for their private devotion, especially since they do not form part of the overall program of church decoration. The saint whom they represent was obviously the personal choice of the donor, who was granted a private place of worship in a public church. Given these circumstances, we may safely identify these unusual murals as replicas of icons that survive in their original location. Not until late in the Middle Ages do we come across similar votive images in the West.

65 The votive icons in S. Maria Antigua are mostly situated at the entrance of the chancel area (see the plan in figure 65). The image of St. Anne, Mary's mother, was spared at the time when the choir was redecorated with new paintings in the eighth century (fig. 65, C),[2] as it must have been protected by donors' rights. A lamp once hung beside the image of Mary, who is depicted as a child carried on her mother's arm. The girl's earrings underscore the private nature of the donation. Saints Deme-

66 trius and Barbara (fig. 65, E and B) originally were both given lips of gold; the fixings of these metal coverings are still visible.[3] As was the case earlier with pagan oracles, it was expected that the saint would listen and answer the requests of the faithful. The

67 series continues with a group portrait of a whole family of martyrs (fig. 65, A),[4] the seven Maccabees from the Old Testament, who were venerated in the Greek church. Their mother, Solomone, who is emphasized by her position at the center and also by her nimbus, once had a metal brooch on her breast. Such a votive gift confirms our view of these wall paintings as private icons.

 In addition to private images we also find private chapels in the adjoining rooms, such as are otherwise known to us only from the late Middle Ages. Theodotus, the papal administrator of this church, secured the largest chapel for himself (fig. 65, I) and had it painted ca. A.D. 750 with a series of votive icons in which he usually ap-

28 pears in person.[5] Next to the entrance the titular saints of the chapel, Quiricus and Julitta, receive the patron Theodotus, who is consecrating burning candles to their image (chap. 5a). Indeed, lamps were situated in the chapel on the frames of the saints' images. Theodotus appears twice more as a donor, each time with a different function. A group portrait of saints "whose names are known to God" repeats a variant of the collective icon. The chapel's main image in a deep niche within the east

70, 71 wall, a Crucifixion measuring 229 × 139 cm, repeats an icon pattern that we know from contemporary panels from Mount Sinai.[6] We shall come back to the meaning of this icon quotation.

69 Before doing so, we shall visit another private chapel in the main nave (fig. 65, III) that, this time, is only provisionally divided off;[7] it has a single painted wall with a small niche for worship. In the lower zone the donor, a cleric, had himself painted beside a depiction of Daniel in the lions' den. The niche, which was lined with marble and had room for a lamp to illuminate the images, probably housed a *sepulcrum*

68 containing a relic. On its back wall a half-length image of the Virgin and her Child (36 × 35 cm) deserves special attention because, unlike the other votive images, it is stylistically a true copy of an icon. Using a very early image formula from the fifth century, as is shown by the portrait convention chosen for the Virgin and the colorful

65. *Rome, S. Maria Antiqua; plan with chapels and individual images*

 I. *Chapel of Theodotus*
 II. *Chapel of Saints of Medical Healing*
 III. *Open private chapel*
 A. *The Maccabees, see fig. 67*
 B. *St. Barbara, see fig. 66*

 C. *St. Anne*
 D. *Female saint*
 E. *St. Demetrius*
 F. *Madonna and Child, see fig. 68*

66. *Rome, S. Maria Antiqua;*
votive image of St. Barbara,
7th century

67. *Rome, S. Maria Antiqua; votive image of the seven*
Maccabees, 7th century

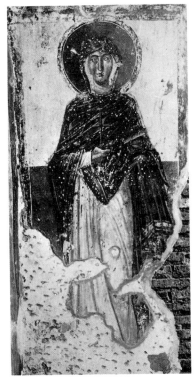

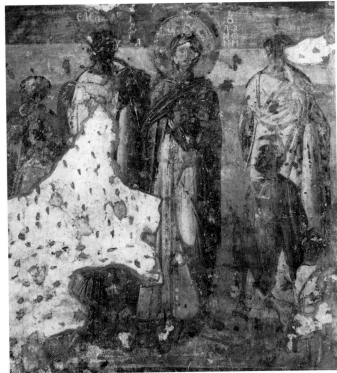

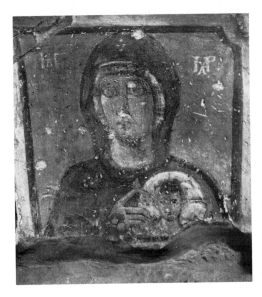

68. *Rome, S. Maria Antiqua; Madonna icon in a*
wall niche, 705–7

69. *Rome, S. Maria Antiqua; private chapel with icon, 705–7 (see fig. 68)*

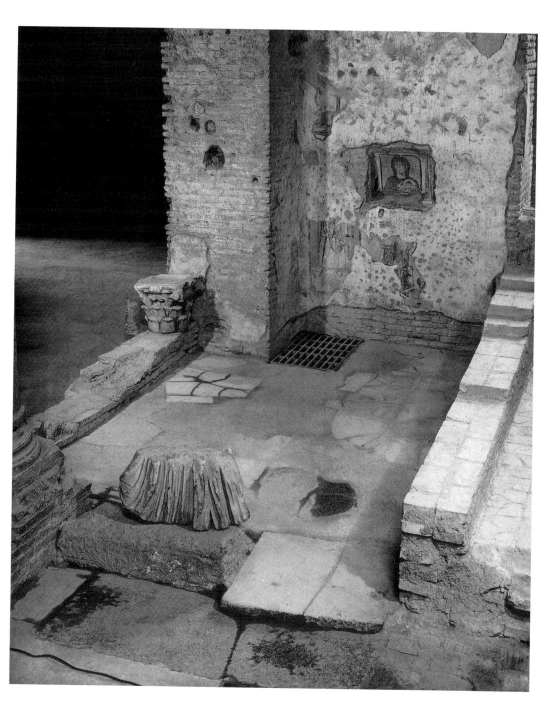

modeling of the face, the image was, in terms of style, antiquated by the eighth century, when it was actually painted.[8]

The Virgin, who, like the former mummy portraits, is placed without a nimbus against a background resembling gold, follows an ancient portrait convention of a shoulder-length bust. The antiquated notation of her name in the form of a monogram is also based on early models. The asymmetrical position of the Child recalls Roman family portraits, and the angle of view, which shifts between the Mother and the Child, reflects the tradition of the private image. Shrouds from Achmim, dating from late antiquity and reproducing a *tabula picta* with an early portrait, offer an analogous disposition of the shoulder-length bust and also use the nose shadow for modeling the one side of the face.[9] The Roman fresco contains a further indication of an old tradition, as the Mother's hand is holding the transparent blue nimbus of the Child (which, itself, alludes to the iconography of the pagan gods) as if it were a

63 portrait tondo. We have already come across examples of this motif, which signifies the epiphany of the divine Child in his image (chap. 6d). The Roman replica is an allusion to such an icon.

The small niche painting is undoubtedly a special case, as it not only is an icon in function but also reproduces an icon's style, using an old and perhaps famous model. In the case of the other votive images it is not totally clear how far they take over the formal properties of the panel paintings to which they refer. Most of them no doubt simply adopt the current style of fresco painting, as the spontaneous, sketchy brushwork that builds up the body from light and shadow contrasts with the neutral background and the frontal figure characteristic of icons at the time. The "Pompeian"

67 qualities of pictures in the style of the Maccabees caused much confusion when the paintings were discovered. Scholars did not expect to find the painterly vigor of antiquity in such works of the seventh century. It seems to have been Greeks who brought this "perennial Hellenism" to Rome[10] and who conjured up their own vision of ancient art as they reproduced icons in the medium of mural painting. Clearly, icons did not yet involve formal properties of their own that would make an iconic style compulsory. In the case of the large public icons of this period in Rome, however, we shall discover medium-specific conventions as soon as we turn from replicas to surviving originals.

Before leaving the church of the Virgin on the Forum Romanum, we must return

70 to the Crucifixion in the Theodotus chapel, which alludes to a contemporary Eastern icon while making a significant deviation from the model. The theme of the Crucifixion was particularly topical in the East, since it served to distinguish the various church positions in the conflict over the definition of the person of Christ (cf. chap. 13d). Who was it who hung on the cross? The man Jesus, or only God, or both in one? And who, if anyone, died on the cross? In the seventh century the Greek theologian Anastasius of Sinai brought a picture of the crucified Christ to Alexandria in order to refute his opponents. Early panels of the Crucifixion, in fact showing Christ as a dead person with eyes closed,[11] have been recently discovered in the Mount

71 Sinai monastery. Such an icon, I believe, was known to the donor Theodotus, who wanted the Roman painter to repeat a prototype from the Holy Land. The niche

above the altar, where the picture is displayed, was conceived to display an image that could receive liturgical veneration and could provoke theological discussions. This was particularly apt at a time when the Roman curia, to which the donor belonged, rejected the Byzantine ban on the representation of Christ (chap. 8d). There is, in fact, a significant detail that makes the theological position of the donor apparent. The image of Christ deviates from the surviving icons in the East: his eyes are wide open, thus polemically emphasizing not human death but the life of divinity.

b. Early Panels in Rome and the Problem of an Iconic Style
Among surviving panels in Rome, there is one whose origin in the Holy Land, where the Greeks lived under Arab rule, is certain. It comes from the Santa Sanctorum in Rome and is a painted wooden box dating from about A.D. 600 that contains samples of earth and stone replicas from pilgrimage routes of the Holy Land.[12] The lid of the box itemizes its contents in pictures representing sites of events from the life of Christ. For example, the Crucifixion, which incidentally is the "Semitic type" (sec. e below), indicates the sacred site of Golgotha. These images depict biblical places and perhaps also the icons that were venerated at the sacred sites. 72

The treasury of the papal chapel Sancta Sanctorum includes two small portraits of the Princes of the Apostles, which were venerated as relics.[13] According to the leg- 73
end of St. Sylvester, the pope had shown such portraits to Emperor Constantine.[14] Recognizing the visitors of his nightly dreams, Constantine is said to have been converted to Christianity. As a matter of fact, the small panels pretend to be originals from the time of Constantine, though they date from the early Middle Ages. What seems to be an act of forgery amounts to nothing less than the visible proof of a claim made by the church of Rome that it owns the authentic portraits of its founders by divine will. God himself, so the argument goes, made Constantine identify the two apostles from their icons and thus, in principle, justified the cult of images from the very beginning.

Each icon that we can trace back to an early time in Rome makes a most specific claim, which becomes part of the general framework of theories of images. Such is the case with the large icon of the full-length Savior, again owned by the papal treasury *18*
of the Lateran (chap. 4d). It goes back to the years around 600 A.D. and, from the eighth century on, is mentioned as a miraculous image that was produced without human intervention. Once again, this origin justifies the cult of this particular image and, in the long run, the veneration of all images. Christ was believed to be present with this image in Rome, and as a result the image could "visit" the church of Christ's Mother on the eve of 15 August.[15]

The most important cult images in early Christian Rome were titular icons or temple images, which survived in the oldest churches of the Virgin. In one case it is certain that the icon was produced at the time of the church's consecration. The Virgin entered the temple, so to speak, along with her icon, to take up residence there. *8*
This occurred in A.D. 609, when the former Pantheon was consecrated as a church of the Virgin and all the martyrs.[16] By this time, it had become an established custom in Byzantium to distinguish memorial churches of the Virgin by depositing garment rel-

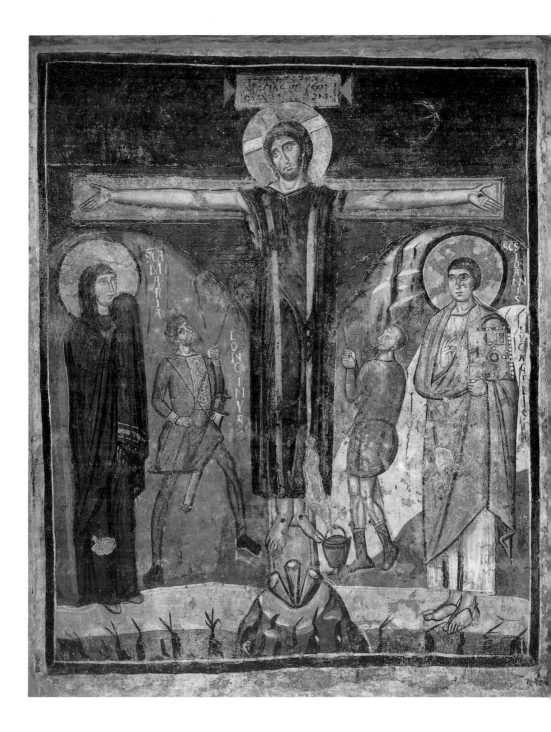

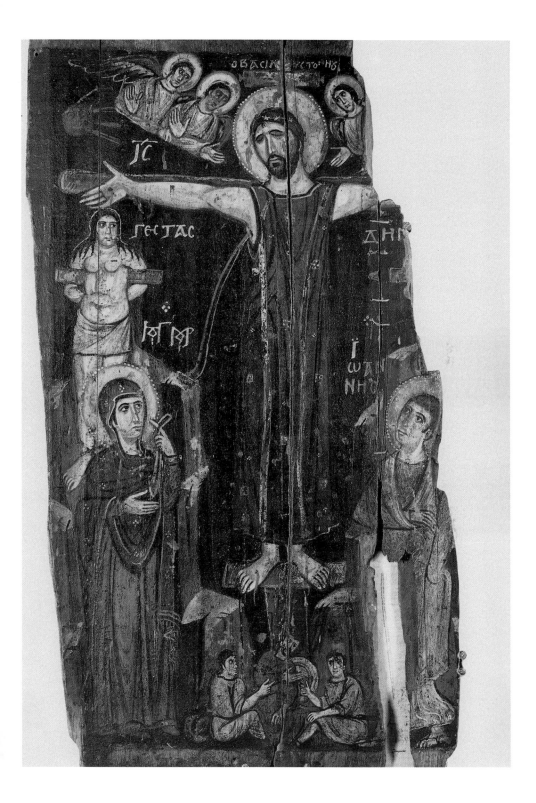

ics and icons.[17] One therefore wonders whether the cult of icons in Rome took its impetus from Byzantium or had older roots in Rome itself.

By the time the Pantheon icon was produced, however, the practice had become standard in Rome as well. Restoration of the icon's original appearance has made apparent its early date, which corresponds with its destination. The elm panel (100 × 48 cm) was cropped when it was fitted into the Baroque tabernacle. Today it is displayed on the altar of the Chapel of the Canons and therefore has disappeared from the sight of the Pantheon visitors.

8 & front of color gallery 74

The Pantheon icon uses the most delicate devices to express the human relation of mother and child. The Mother, whose face is dominated by her dreaming eyes, bends slightly toward the Child, while the Child, whose body is close to hers, turns around with his head and looks at us with the dignity of a pagan god-child such as the young Dionysus. The Mother's self-absorption vividly contrasts with the activity of the Child, whose presence indicates a divine being. The deep bonding of the two persons, who are in complete harmony, appeals to the emotions of the spectator.

We as viewers are included by the argument that the two figures convey, as the latter also manifest two distinctive roles. The Mother asks the Child on our behalf, and the Child answers her petition on her behalf, since, as the Mother, she can expect his answer. As the tool of mediation, her right hand, which touches the Child's knee to beg his protection, is in fact gilded. This distinctive device which identifies the gesture of salvation, ultimately is of pre-Christian origin. In Rome it was used for

190

33

both hands of the Virgin of S. Sisto, and in Salonika it sets off the interceding hand of St. Demetrius.[18]

V

The vivid effect produced by the Virgin contrasts somewhat with the firmness of the drawing. As in the S. Sisto panel, the oval face has a sharp outline, yet within this contour the spherical surface of the face is emphasized. And as in the other panel the subsidiary forms have almost geometric patterns. The Child's head, by contrast, is much more open in form and far more freely rendered.

I

These observations raise the question whether there was a single icon style at the time, or whether different conventions were used, one beside the other. We shall keep this question in mind while considering another early icon of the Virgin that poses similar questions. It comes in all probability from S. Maria Antiqua, the church that had already been called "the old" in the seventh century. In the ninth century, its title, its rights, and probably its belongings were transferred to the very same church that houses the icon today, S. Francesca Romana. Its original name—Maria Nova— served to distinguish it from its predecessor.

The nineteenth-century overpainting covered not only a layer of tempera from the thirteenth century but also the remains of the original heads painted in encaustic technique on canvas.[19] In the Middle Ages the two heads of Mother and Child were cut out and physically incorporated into the new painting. In this way the medieval icon retained a material as well as a historical link to the original from late antiquity. It was certainly the importance of the old Greek church that accounts for the largest of all the icons that survive in Rome. The face of the Mother, measuring 53 × 41 cm, indicates the giant size of the original panel. Unfortunately, the outline of the head

72. *Rome, Vatican Museum; reliquary shrine from Sancta Sanctorum, ca. 600*

73a, b. *Rome, Vatican Museum; portraits of the apostles Peter and Paul, 8th century*

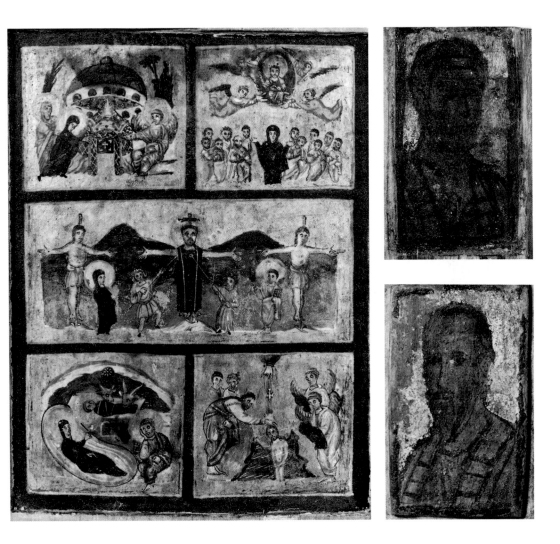

has been distorted by its modern completion, and its inclination toward the Child, which can be seen from the angle of the neck, has been ignored. The church of S. Maria Antiqua certainly existed by the second half of the sixth century, as Richard Krautheimer has demonstrated.[20] The icon may be as old as this and thus may antedate the seventh-century frescoes in the church, to which it has been so often compared.[21]

In style, the icon is related to a group of famous frescoes in its home church that have been painted at considerable intervals.[22] The bottom layer, from the sixth century, includes an enthroned Virgin who matches our icon by her truly monumental appearance, though here she is frozen in a rigidly frontal posture. In the top layer an angel from an Annunciation, called the "beautiful angel" by art historians, comes close to the icon both in the spatial three-quarter view and in the vigor of its colorful modeling. And yet this very comparison makes it clear that, in its aesthetics, the icon follows an ideal of its own. On the one hand the modeling is of an almost unimaginable perfection, having a kind of floating transparency in its chromatic richness and its imperceptible, glazed transitions. On the other hand, all movement is arrested. The smooth surface is of a crystalline, almost icy coolness. The expression is focused on the huge eyes, whose melancholy remoteness is reinforced by the slight turn of the head. Immobility via the arresting of bodily forms and ideality via choosing the most general forms were clearly required to produce the aura of the cult image. Portraits in sculpture of emperors and empresses from about A.D. 500 anticipate the icon's choice of a *typos hieros* that transcends any individual feature (sec. d below). The Neoplatonic philosophy of people like the so-called Dionysius the Areopagite at the same time proclaimed an intelligible, suprasensuous truth.[23] But the mentality of the time cannot be connected with a painting style on the basis of just one work. What matters here is the discovery that a new conception of the cult image was in the making.

c. Image and Politics at the Papal Curia

II A third icon of the Virgin became the titular image of the church S. Maria di Trastevere, which is even older than S. Maria Antiqua.[24] The panel, painted on canvas in encaustic, may not, however, be the original icon displayed here. The donor, who bends over the foot of the divine mistress, appears to be Pope John VII (705–7), whose veneration of the Virgin is recorded elsewhere as well. The mutilated inscription on the original frame speaks of the "awestruck princes of the angels" (*stupentes angelorum principes*), who are equipped with long ceremonial staffs behind Mary's throne, like a guard attending a monarch.

II The Madonna della Clemenza, as this icon usually is called, also was cleaned from its thirteenth-century restoration. The panel, 164 × 116 cm, differs from the other icons in Rome by virtue of the large throne, such as one might rather expect in monumental painting. It repeats an Eastern pictorial schema that can be seen in the sixth century in the minor arts and in a mosaic in the church of St. Demetrius in Thessaloniki.[25] The frontal immobility of the columnlike woman who bears her Child on her knees comes from this model, together with a pair of angels emerging behind

her, and may reflect a lost icon in the Byzantine imperial palace that the pope had reproduced in Rome.

In the Roman replica, however, new motifs introduce a different political meaning. As on a silver reliquary in Grado,[26] the Madonna holds a costly jeweled cross in her right hand, which was probably once a metal attachment but was later added in tempera into the original encaustic painting. This is the gesture of the Roman emperors when they presented the cross as the official sign of the Christian Roman Empire. The imperial iconography explains why the Virgin is dressed in the vestments of an empress and wears the tall crown of an empress with shield-shaped ornaments and long strings of pearls. In Byzantium, where the emperors were present in person, such analogies usually were avoided, since they might give the impression that the emperor wished to relinquish power to heaven. But in the West, where the Eastern empire was a constant source of difficulty, the investiture of the Virgin's image with the insignia of power had already become a tradition.

Pope John VII commissioned not only this icon but also mosaics in the chapel of the Virgin he had built in Old St. Peter's, where the Virgin is shown with the same purple vestment and the same crown.[27] When the narrative mosaics were removed in the seventeenth century, the central figure was isolated like an icon and transferred to S. Marco in Florence. But even in her original context she had been conceived as a separate image. The same pope who in the icon performs the ceremonial kissing of the Virgin's foot, in the mosaic approaches her, as the inscription reads, with the title of "Servant of the Holy Mother of God" (*Sanctae Dei Genitricis Servus*). There is no reference to the earthly emperor, while the bishop of Rome subordinates himself directly to his heavenly queen. The title he chose in St. Peter's in a polemic way refers to the "Servant of Christ," a title that the emperor had adopted only ten years before (sec. e below). This antagonism may demonstrate how icons, like murals before, provided an instrument of official propaganda. The pope at that time was still de jure a Byzantine vassal. But de facto he was now ready to exert his power independently, at the command of the Mother of God.

The panel in Rome not only has an official theme; it also phrases its theme in an official tone. Part of this style of presentation is the way the figures express their differing status in the world order by differences of form. The agitated angels, for example, are in marked contrast to the immobile main figure. Mary's upper body is like a column, while the lower part seems like a plinth beneath the Child. Her face wears an expression of unapproachable aloofness. These formal implications go beyond the scope of a painter's choice. We have to ask which were the stylistic devices that the work borrowed from the art of late antiquity, and what purposes they served.

The panel conveys a unique message that previous interpretations have hardly touched upon. The angels, whose tunics reflect the color of the sky, represent the timelessness of *eternity,* while the figures of Mother and Child manifest God's epiphany in the time of *earthly history.* The figure of the pope introduces yet another time: the *present.* In keeping with this conception of the theme, the panel of S. Maria in Trastevere stands out as the only surviving icon that provides an internal topography.

76

II

74. *Rome, Pantheon. The Child, in the Madonna and Child icon, 609 (detail of fig. 8)*

75. *Rome, S. Maria Antiqua; choir wall, "Beautiful Angel," 7th century*

76. *Florence, S. Marco; mosaic from Old St. Peter's, Rome, 705–7*

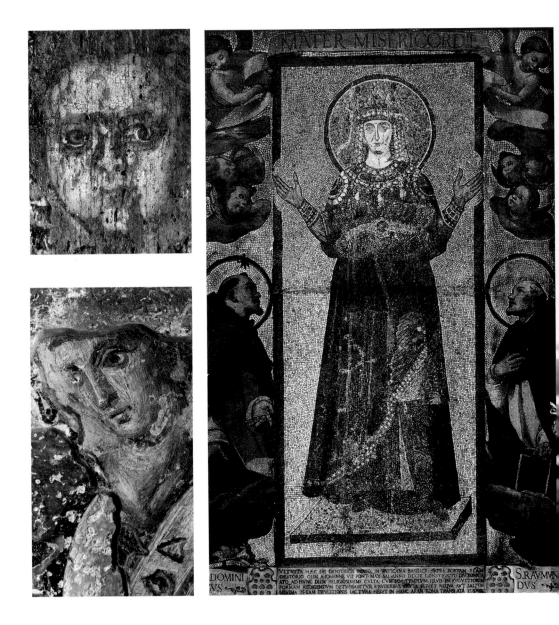

The low-set green ground on which Mary's throne rests below the horizon signifies the terrestrial world, in which God's Son has taken on a human body. For this reason the corporeal presence of Mother and Child strongly contrasts with the floating, incorporeal angels. The theological statement about the mystery of the Incarnation coincides with the political statement about the rule of the pope, who presents himself as the Virgin's regent on earth. His face in its full frontality breaks abruptly with the posture of the forward-bent body, so that the head appears unnaturally dislocated. This device serves to distinguish the living portrait by granting it features of its own, in much the same way as the spirits of angels are kept distinct from the bodies of Mother and Child.

d. Styles and Conventions of the Early Icon

In his book *Art Forms and Civic Life in the Late Roman Empire,* archaeologist Hans Peter L'Orange examines a new type of portrait sculpture, which he explains in terms of its function. The portraits of individual rulers are replaced by a general *typos hieros,* or sacred type, whose stereotypes qualify the imperial majesty as a higher order of being.[28] The *typos hieros* exerted a decisive influence on the formal devices used by the early icon, apparently through the connecting link of the painted imperial portrait. Such an influence would explain the "abstract style" of early icons analyzed by Ernst Kitzinger in 1958, a style characterized by its immaterial, akinetic forms, which transform the appearance of the figures represented.[29] It may seem significant, as Kitzinger insists, that contemporary philosophers emphasized the transparency of material images (as vessels containing the supernatural substance) to reveal their archetype. Accordingly, painters may have chosen an "iconographic style" or "stylistic mode" to make visible the icon's reference to a reality otherwise invisible. It is apparent, however, that the wide range of devices used in icons calls for additional arguments.

Even in one and the same panel, different "styles" or devices can coexist. The Madonna della Clemenza surprises us by contrasting the immobile, frontal face of the Virgin with the lifelike movement of the Child's head. The main figure, with the fixed gaze of her enlarged eyes, makes the claim of ideality. Her aloofness emphasizes the inaccessible aura of the imperial Virgin. It is open to question, however, whether the painter used these different styles deliberately, which would imply a stock of alternative styles with given meanings. It is obvious that the painter was in command of every stylistic convention available within the tradition of late antiquity, but it is not certain whether these conventions were used according to strict rules and whether they provided a consistent meaning.

An icon of the Virgin at Mount Sinai lends itself to pursuing this question further. Though small in size, it matches the Roman panel from S. Maria in Trastevere by using a similar pictorial scheme: a Madonna enthroned, with two angels guarding her throne.[30] But two saints, clearly the Roman army officers Demetrius and Theodore, are added. On closer inspection, we again notice the simultaneous use of different styles, but they have not the same meaning as in the Roman panel. Here the "abstract style" characterizes not the main figure but the accompanying male saints.

129

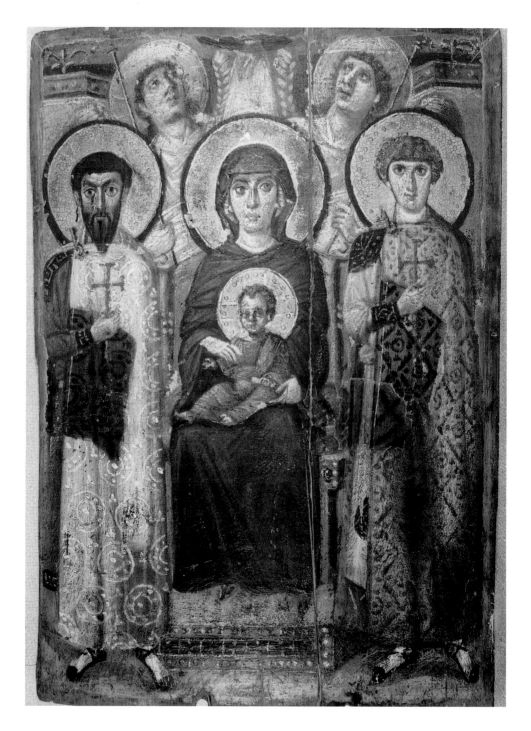

77. Mount Sinai, monastery of St. Catherine; Madonna icon with angels and saints, 7th century

Ernst Kitzinger has chosen this icon as an example in order to develop an explanatory model for the simultaneous use of different stylistic devices. "The two saints, tightly and rigidly aligned on either side of the Virgin and possessed of regularized features, fixed gazes and strangely insubstantial bodies," which the author compares to the Demetrius mosaics in Thessalonika, and from which the "lively brush work" of the main figure diverges. The three-dimensional angels with their spatial movement are "in striking contrast to the solemn and immobile array in the foreground." As in the illusionist painting of Pompeian tradition, "impressionistic technique combines with lively action."[31]

In his subsequent argument he identifies the "Hellenistic pictorial technique" as an "iconographic attribute" of the incorporeal (*asōmatoi*) angels, an attribute that distinguishes spiritual from physical existence.[32] However, he also calls the two saints "insubstantial," giving rise to new questions. Kurt Weitzmann also relates the "impasto technique" of the angels to their celestial nature but sees in the "sunburnt face" of Theodore and the pallor of George a "lifelike" effect that contrasts with Mary's supernatural appearance.[33] The interpretation is clearly open to controversy.

What is evident is the difference between the angels and the two saints in the foreground, the angels representing open forms and movement in space, the saints representing a closed surface with linear and neatly circumscribed forms. The Virgin makes use of both devices, while the Child tends toward the angels. These "gradations of form" might offer a theological meaning, in Kitzinger's terms, as distinctions between spiritual and physical substance. The angels, who are distinct by their transparent or translucent white nimbi, are painted white on white, with the beam of white light falling from heaven thus forming a supernatural aura that surrounds the Mother and her Child. Their mid-air presentation contrasts with the firmly standing (or seated) postures of other figures, who all have an earthly, physical existence.

The difference between the saints and the central figure undoubtedly implies a hierarchical difference. The Virgin, with the free treatment of her figure, is raised above the saints, who with their fixed gazes and their schematic oval faces clearly represent the "normal" portrait convention current at the time, as they had been human beings with a real life on earth (chap. 5). We come across the same convention in the early icons in Kiev, which once belonged to the Mount Sinai collection. The icon of St. Peter at Sinai, the next work we shall consider, in the medallions contrasts the freedom of the Christ figure's pose with the flat, schematic figures of Mary and John.

It may be more appropriate to speak of conventions than stylistic modes, a term first used in seventeenth-century art theory. Unlike Poussin, icon painters did not operate within a highly developed conception of art that allowed for a set of variations or for a set of styles available for quotation. Rather, they were concerned with one icon at a time, for which they used different conventions to distinguish one figure from the other in terms of reality and nonreality. There was no need to use such means consistently from one icon to the other, since consistency within one and the same picture seemed sufficient. "Real" portraits served to set their figures apart from mere appearances of heavenly beings. Though the surviving material hardly allows for a

34

40
62

general statement, we may venture the view that icon painters used stereotype or topi-
cal conventions of style that could nevertheless be applied according to various needs,
without being bound to a standard meaning in each case. The device of free illusion-
ism, for example, did not differ from the device of abstraction in the sense that free-
dom differed from convention but was a convention of its own that could be freely
chosen along with other conventions.

The use of figure types that implied a certain manner of style may be illustrated
with the Mount Sinai apse mosaics of the sixth century, which include a pair of fig-
ures—the Virgin and St. John the Baptist—with a striking contrast of their treatment
of face.[34] The Virgin, who is higher in rank, uses a general ideal or "sacred type" of
figure, while St. John, with the wild movement in both face and hair, makes use of
another figure type, which has been identified as that of the tragic variant of the the-
atrical mask. The artist chose ready-made formulas for presenting the figures, much
as an actor performed with the help of a mask.

Pictorial formulas, as L'Orange has demonstrated, may be understood like the-
atrical masks.[35] Masks conceal the individual actor and reveal the role that the actor
performs on stage. Universal types, according to Neoplatonic philosophy, conceal the
singular phenomenon of nature and reveal a general truth beyond such particulars.
In the third century A.D. the philosopher Plotinus rejected the custom of portraying
individuals, using the argument that, in such a procedure, the pure idea of the
absolute would be obscured, since it would not survive as such in any condition of
physical matter. Pseudo-Dionysius took this argument further in the era of the early
icon. The devaluation of individual likeness, a product of nature, soon included the
preference for symbolizing an individual being in terms of the "truth" of a general
type of image. Already, then, the Middle Ages was coming in sight.

A second icon in the Mount Sinai collection that stands out by its quality as work
62 of art represents a half-length figure of St. Peter on a large panel measuring 92.8 ×
53.3 cm.[36] The round niche in the background transforms the simple appearance of
the saint to the event of a ritual epiphany. At the top of the niche, three golden medal-
lions are set against a background of deep blue. St. Peter, who is identified as such by
his keys and the cross, follows an established portrait type that characterized him
since the fourth century A.D. There is a difference in treatment of the clothing, painted
freely in broad brushwork, and of the head, enclosed in a firm outline and detailed
with compact motifs, so that it seems almost too heavy for the loosely painted body.
This discrepancy confirms our view that painters selected portrait types, derived from
given models, without conceiving a figure as a whole. In this case, the portrait, which
strikes a balance between a general type and an individual likeness, also may have
involved a given manner or convention of style.

In terms of style, the mosaics in the apse of SS. Cosmas and Damian in Rome
(526–30) come closest to the portrait scheme used in the icon.[37] They may well be an
echo of the Eastern monumental painting of the period. The same era also provides
the best parallels to the layout of the three medallions at the top of the icon (chap. 6d).
61 The diptych of Consul Justinus confirms the formula's role in official state images of
the time.

The medallions above the apostle, in addition, represent a different stylistic convention. Though they surely vary among themselves (the head of Christ, turned away from the edge of the picture, is set apart), they all do reflect an ideal type to which individual features are irrelevant. Thus St. John may be compared to a prince's portrait from Constantinople representing Arcadius (Berlin).[38] In both cases the canon strives for an ideal appearance, which is based on general forms.

The most famous of the early Mount Sinai icons, a panel of the Pantocrator, in all likelihood originated at Constantinople. It apparently reproduces a well-known original of the time that determined the type of Christ preferred in Byzantine painting. Measuring 84.5 × 44.3 cm, it is only slightly smaller than the icon of St. Peter. It was published only in 1967.[39]

The powerful figure dominates the entire picture and seems to fill a real space in front of the narrow niche, which is pushed backward. The body appears at an angle, as arms and shoulders indicate, and thus leaves the mere surface of the picture plane. The sling, which includes the blessing hand, reinforces the impression of a free movement in space. By contrast, the face, which keeps the strictly frontal view, seems to turn toward us, as if Christ decided to become visible for us in an active way. The smooth ivory surface of the flesh contrasts vividly with the ruddy-hued, solid face of the St. Peter icon.

Encaustic icon painting here appears at its best. The face comes to life by virtue of the eyes, which are not symmetrical, and the soft lips. Though the nose keeps a center position in the face, its shadow seems to shift the face in our direction. The brushwork closely follows the bodily features in the relief of the face. The eyes express aloofness, while the mouth allows for the effect of a rather human melancholy. Even in mummy painting of earlier centuries, the quality achieved by the Christ icon occurs only as a rare exception. In a panel now in Brooklyn, the shading of the face and the angle of the body help us to trace back the devices used by the icon painter to a much earlier convention.[40] A mummy portrait now in Stanford shares the strong lights and smooth flesh of the Christ icon.[41] The portrait of Eutyches mentioned above, however, comes closest to the icon in every possible device of portrayal.[42] It also emphasizes the ethos of the person represented by the alert gaze and the sensitive mouth.

The icon's general appearance, in fact, is derived from a concrete model whose identity still is an open question. For all its spontaneity of expression, it was not invented by its painter but seems to reproduce a famous image of Christ that, for this purpose, was replicated for a given commission. The lost archetype, to judge from the existing copy, achieved the synthesis of divine image combined with the ideal of a human portrait representing a philosopher as teacher. This hidden dualism of divine and human features beautifully alludes to Christ's dual nature, which was so much discussed in the theological debates of the time.

We have to distinguish the age of the surviving panel from that of the model it reproduces. In the sixth century the model was known even in Rome, since a votive image in the Pontian catacomb (chap. 4d) even repeats the turn of the body and the position of the hand in the garment as it gives blessing, as well as the Gospel book. We can estimate the fame of the model from the fact that it was chosen later (at about

78

42

79

81 the time the Mount Sinai replica was produced) to represent Christ on the state coins of Byzantium under Justinian II (685–95).

e. Icons and Politics at the Imperial Court: The Christ Coin

The model for these coins must have been one of the very famous icons whose names we know from texts of the sixth century when they first made their public appearance. However, we cannot safely identify it from the surviving replicas. The icons named in these early texts are reported to have been images of Christ that, being an innovation at the time, needed a legitimation, for which authenticity was the obvious choice. As soon as "true" images of Christ, in terms of portraits produced by heaven, came into use, they required a public cult, the precedence for which was the cult of the imperial image, with its legal status.

81 James Breckenridge once proposed that the coin image of Christ, which came into use at the end of the seventh century, was a section of a full-length figure that, he conjectured, might have decorated the throne room in the imperial palace.[43] In his view, the concept of a heavenly emperor that would have been in place at the site of the throne of the earthly emperor is alluded to by the resemblance of the coin figure to the Zeus iconography. The coin inscription, which refers to Christ as "Ruler of rulers" (*Rex regnantium*), indeed clarifies the relationship between Christ and the emperor, whose place on the coin the heavenly Ruler assumed.

Whatever the model of the Christ icon (and of the coins) may have been, the allusion to Zeus certainly became a controversial issue in relation to such early icons. An excerpt from the lost church history of Theodorus Lector tells of a fifth-century painter who painted a Christ icon "having a resemblance to Zeus" for a pagan patron in Constantinople,[44] whereupon his hand withered. The theologian John of Damascus, who quotes the legend, adds: "The hair on the painted panel was parted so that it did not cover the eyes. This is how the Greeks paint Zeus."

The original version of the legend continues: "The other [portrait] form, with the short crinkled hair, is the authentic one." It is precisely this latter form that Justinian 82 II took up when he came to the throne for the second time after various upheavals in 705.[45] Was he seeking success by means of a more effective prototype? Two extremes, which seem mutually exclusive, successively represent Christ in the coin portraits. The two portraits—the "Hellenic" and the "Semitic"—compete on the first coins bearing an image of Christ. The two concepts, Hellenic and Semitic, however, are very different in meaning. In its physiognomy and hair the Semitic portrait has racial features, and its ordinariness—even ugliness—suggests a private portrait of ethnic origin. The Hellenic portrait, in contrast, does not embody a Hellenic person but recalls the images of gods in the Hellenic tradition.

Breckenridge rightly sees behind the Semitic type an original from the Syria-Palestine area, possibly a miracle image, or *achiropiite*. Its claim to authenticity, together with an attractive cult history, may have led to the selection of this type for the coin. While the popularity of the Semitic type was restricted to the time before iconoclasm, the Hellenic type, in contrast, had a profound influence on the subsequent images of Christ. We can only conjecture what the reasons may have been. They cer-

tainly were not guided by aesthetic judgment, but by confidence in a successful arche-type that may have played the role of original for the ruling dynasty.

The change from the Hellenic portrait type to the Semitic on the coins of the same emperor is sufficient indication that in both cases famous originals—which means icons—were involved. Unfortunately, we are no longer able to identify the location or name of the icons in question.

The icon could hardly have been given a more significant promotion than to be introduced into the official iconography of coins, the preserve of the imperial image and the indicator of imperial rule. Now the icon itself became a kind of insignia of power, but it was the power of a heavenly ruler. The emperor adopted another sov-ereign's insignia in order to claim the support of supernatural authority.

In this way the continuity of state and religious imagery is preserved, though eventually with inverted roles. In the beginning the religious image profited from the imperial image, including its legal status and the state rituals of cult and, in a second stage, took the lead by replacing the imperial image. If Justinian invoked particular icons, they may have been the same ones that had conferred victory and protection on his ancestor Heraclius (610–41), the founder of the dynasty. The icon now dis-placed the emperor from the obverse, or front side, to the reverse, even though in fact it took the place of the triumphal cross which had been on the reverse. The previous themes of obverse and reverse were amalgamated as the emperor himself took the cross into his hand.[46]

State iconography exchanged its imperial-antique connotations for religious-ecclesiastical ones. The emperor redefined himself as "representative of Christ" who was, at God's command, to administrate the Christian realm on earth. His portrait, therefore, in relation to the icon of the heavenly sovereign, obeyed a hierarchical order.

André Grabar's book *L'empereur dans l'art byzantin* made us aware that the emperors heavily engaged in a cult of images, which involved both court and state icons.[47] Usually such images were miraculous icons owned by the dynasty and distin-guishing the dynasty (like, later on among the Hapsburgs) and as such also playing the role of personal patrons or palladia. In the reign of Justinian II they also assumed a propaganda function in the "war of ideologies." As the coins testify, they confirmed the emperor's orthodoxy both inside and outside the empire, foremost against Islam, his rival in the struggle for world hegemony.

"There is a change in both iconography and legend [of the coins]. The initial inscription on the back, previously VICTORIA AUGUSTORUM, was a vote of success vouched for first by the goddess of victory . . . and then by the palladium of the empire, the cross as a triumphal sign . . . the [new] legend departing from the Roman tradition by using the inscription REX REGNANTIUM. . . . If the solidus is turned over, we read DOMINUS JUSTINIANUS SERVUS CHRISTI. . . . The new legend . . . links the image of the emperor to that of Christ, indicating that the emperor is Christ's repre-sentative. The emperor can mint coins by virtue of Christ's authority, just as he signs in Christ's name . . . emperor by the grace of God." The emperor's image is given a ceremonial instead of a military emphasis, his garment now being the *loros*. "In the

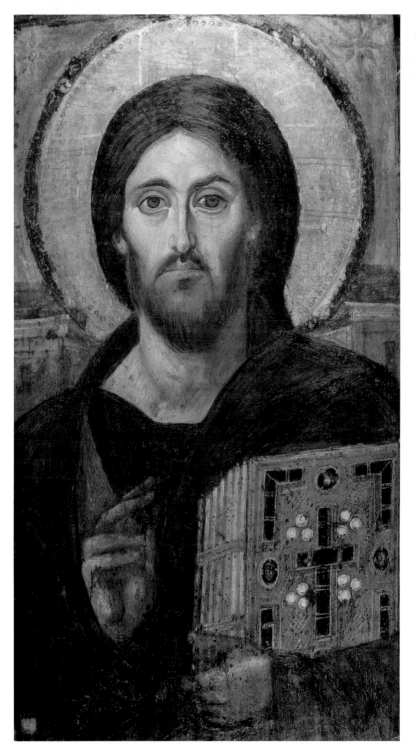

78. Mount Sinai, monastery of St. Catherine; icon of Christ Pantocrator, 6th/7th century

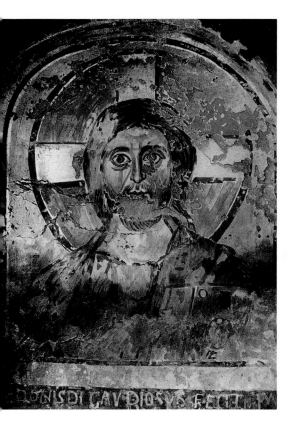

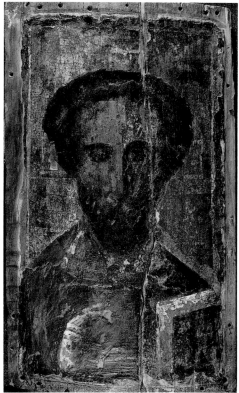

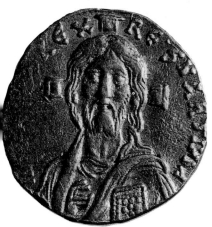

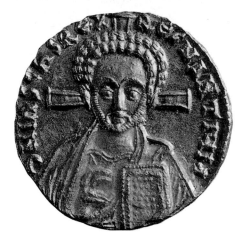

79. *Rome, Pontian Catacomb; votive image of Gaudiosus: Pantocrator, 6th century*

80. *Mount Sinai, monastery of St. Catherine; icon of "Semitic Type" Christ, 6th century*

81. *Washington, D.C., Dumbarton Oaks; coin (obverse) from the reign of Justinian II, 685–95*

82. *Washington, D.C., Dumbarton Oaks; second coin from the reign of Justinian II, 705*

same way, even under Justinian I the globe with a cross replaces the spear and shield as the symbol of the emperor of the world. The helmet also disappears, being replaced by the crown."[48]

According to Breckenridge, these changes represent "a subtle transition from the previous iconography, in which Christian symbols were the instruments of imperial power in achieving an essentially secular triumph, to a new conception, in which the emperor himself is but the instrument of the Divine will in achieving Its own victories. . . . The emperor, standing before his Master, appears to men both as the image of the Divine Pambasileus on earth, and as the apostle of the true Faith, of orthodoxy itself."[49] This legitimation, however, often had more short-term motives. The emperors were particularly eager to invoke heaven when their power on earth was threatened by usurpers. During iconoclasm, the emperors reverted to the old convention of depicting themselves together with their ancestors rather than with the image of Christ. The depiction of the son, who also was crowned as Augustus, was to secure his succession. Later on, the iconoclasts were accused of having replaced Christ's image with their own.[50]

When Justinian II, after a ten-year interruption, returned to the throne in 705 and introduced the Semitic type of Christ on his coins, in Kitzinger's view he used not merely a different *type* of portrait but an authentic likeness of Christ, which was characterized by a geometric portrait *style*.[51] The emperor's "Christomimesis" implied the return to a half-length image. He "no longer turns to Christ, but speaks to men." His globe with the cross proclaims the peace (*pax*), referred to in the inscription, a peace that the legitimate dynasty again confers on the world. Thus his subjects greet him with the suitable appeal that he may "hold dominion for many years" (DN IUSTINIANUS MULTUS AN).[52]

Seen from the perspective of foreign policy, the Christ coin possibly contradicts the coinage of Caliph Abd el-Malik, on which he proclaimed himself "lord of orthodox believers" and "representative of Allah." Grabar interprets the new cult of icons as a means of religious propaganda in the struggle between different empires and systems.[53] The coin inscriptions enforce the Byzantine intention to meet the challenge of the theocracy of the neighboring empire. After 695 the Arab coins even abandoned the image of the ruler and chose aniconic inscriptions to invoke the one and only God by name.[54] Before 695 the Christ image and the holy lance had been opposite symbols integrating the two respective systems. In the following years the two theocratic empires continued to be locked in ideological rivalry. The "static, traditional insignia of rule" retained their aura in the Greco-Roman world.[55] The symbols corroborated convictions that were respectively honored and opposed. Image and Koran verse were irreconcilable.

Byzantium, however, was soon to begin its own crusade against images, only a few years after Caliph Yazid I had issued his first ban on images in Christian churches of the Arab empire (721).[56] It is worth noting that Leo III, "the Isaurian" (717–41), who started the controversy of iconoclasm, himself came from Syria and was familiar with the Arab mentality. He persecuted, however, only the images of God and the

82

saints, while in the Arab realm the depiction of any living creature by using a "dead" image was regarded as an offense against the Creator.[57]

The exaggerated cult of images, followed by the equally exaggerated destruction of images, may have been stimulated by the proximity of Islam. Justinian II's coins with the Semitic type of Christ may give us a clue in this respect. The Semitic portrait type is best documented in such regions as were already under Arab rule. We find it in a Syrian book miniature from 586, in frescoes in Abu Girgeh (Egypt), and in the temple of Baal in Palmyra.[58] A Sinai icon that Weitzmann considers a sixth-century 80
work gives the best idea of the lost "original."[59] The knowledge that such an image had its home in regions now lost to Islam could only foster its cult in the capital. From there the fame of the image even spread to the Western part of the empire. As soon as the coins had been minted in Byzantium, Pope John VII (705–7) used the Semitic type in the next year for an Adoration of the Crucified, in S. Maria Antiqua in Rome 83, 87
(chap. 8d).

f. Icons and Theological Argument

The early icons are so much a part of the portrait tradition that one forgets how often they were directly involved in disputes that started in theology but ended in politics. It is therefore useful to examine a number of icons that, whether by written inscriptions or simply pictorial means, advance a theological argument. As we might expect, they refer to the ever-present doctrine of the two natures of the incarnate Logos, even when the object was to deny the doctrine.

Thus the Mount Sinai icon of the Mother of God enthroned[60] reduces the dis- 77
tance between heaven and earth to a white beam of light that falls from the hand of the invisible God onto Mary, on whose lap the visible God appears in the flesh. The martyrs flanking the Mother and Child group have suffered death for the true faith. In another Mount Sinai icon the soldier-saints Sergius and Bacchus appear with their 40
heavenly sovereign, who confirms his earthly, historical presence in the medallion of the true image (chaps. 4a and 5d).[61]

The image of Crucifixion by necessity insisted on the question of who actually 71
died on the cross (or, as the other party contended, did not die, because he had no body that could die). The reality and meaning of the Crucifixion continued to stir up controversy well into the Middle Ages (chap. 13d). In the seventh century the subject was central to the discussion of Christ's identity, which explains the fact that the theologian Anastasius introduced icons of the Crucifixion into theological debates, where his opponents were asked to identify the single figure on the cross.[62] It is hardly surprising that the manner of presentation in such icons, was carefully planned, since they visually promoted a doctrine of faith. When icons depict Christ with his eyes closed, they offer an argument in favor of his death, which he suffered by virtue of his human nature (cf. sec. a above). Such panels do not, therefore, simply narrate an episode from the Passion of Christ but take up the discussion of the God-man as the Crucified.

Inscriptions in the form of prayers sometimes invited the beholder to see things

83. *Rome, S. Maria Antiqua; crucifix from the choir screen, 705–7*

84. *Trevi near Spoleto, Temple of Clitumnus; St. Peter, 8th century*

140

85. Kiev, Museum of Occidental and Oriental Art; icon of St. John the Baptist from Mount Sinai, 6th century

theologically. An inscription of this sort on the frame of a small Sinai icon of the Crucifixion asks: "Who does not shake with fear to see you, my Savior, hanging from the cross? You wear the garment of death, but you are also clothed in the robe of the everlasting."[63] Later, after Theodore of Studion, verse inscriptions for icons developed into a literary genre of their own.[64]

85 A remarkable sixth-century icon from Mount Sinai, which ended up in Kiev, uses St. John the Baptist as a theological witness.[65] He is not just represented for his own sake but serves to proclaim the divine nature of Jesus by speaking the famous words "Behold, the Lamb of God" (John 1:29). The prophet, who speaks these words with the help of the text on a long scroll, in addition points upward to a medallion of Christ, by which gesture he visualizes his prophecy. It is with the motif of the outstretched index finger that the painter relates the two figures of the one who sees, and the one who is seen, thereby forwarding the argument that is central to the icon.

 Whereas St. John spoke in a metaphor when proclaiming Christ as the Lamb of God, the painter did not paint a lamb but depicted the Man who was called the Lamb. Theologians had discovered that part of the argument was lost when the painters just represented a lamb. After all, John was the only prophet who had actually seen Christ with his own eyes and had not merely foretold him with metaphors. For this reason, at a council held in 692, the theologians called the metaphor an aberration that detracted from the reality of the Incarnation and that failed to take into account Christ's visible manifestation in human form (chap. 8d). Since icon painters made Christ visible in his human body much as he had revealed himself on earth, they were now obliged to exploit this advantage.

62 The icon of St. Peter that has already been discussed also uses a pictorial language for making its theological statement.[66] It borrows a pictorial scheme that the consuls had used in state iconography up to A.D. 540 to qualify them as representatives of the emperor, who occupied the central medallion above their heads. Much as the consul represented the state in the name of the emperor, so St. Peter represented the church on earth in the name of Christ. The central medallion bears witness to Christ's divine nature as ruler, while to his left and to his right the historical witnesses of his death complete the affirmation of his human nature.

 St. Peter's role as Christ's representative on earth was not so contentious an issue between the Eastern and Western churches at that time as it may appear later. Otherwise it would not have been possible for a seventh-century Greek icon to reinforce the argument by its inscription. The *igona* of Peter was formerly kept in S. Pietro in Cielo d'Oro, the principal church of the Lombard royal residence at Pavia, where a pilgrim noted its inscription in the eighth century.[67] The inscription was Greek, as was, therefore, the icon itself. It was mutilated early, for our witness could read only a reference to "God the Logos," to whom Peter was clearly pointing in the picture. In the further text the beholder was invited to see "in the gold the rock formed by God [*theoglyptan petran*]," a rock "on which I truly stand firm [*ou klonoumai*]." The portrait of Peter, which also incorporated the *theos logos,* was thus a suitable vehicle for a theological and ecclesiastical argument. The pun Peter–*petra* ("rock") goes back to Matthew 16:18, where Christ proclaims, "Upon this rock I will build my church." The

statement that the apostle should be seen in "the gold" no doubt refers both to the gold background on the panel and to the title of the church in Pavia where the icon was kept. The Greek panel may therefore have been a commission by the Lombard court.

In Rome, for reasons already discussed, the double portrait of Peter and Paul was preferred at that time; only together were they allowed to represent the church of Rome (sec. b above). They also appear jointly in eighth-century murals in the unusual 84 templelike church at Trevi near Spoleto. That this conjunction originated in a pair of icons is clearly proclaimed by the picture frames of the murals and by the choice of a reddish background.[68] The Roman "twins" were originally designed for the apse of St. Peter's, where they flanked the figure of Christ. In the meanwhile it became important, even in an apse painting, to show the two apostles within two framed panels, which must have had a famous prototype in Rome.

The very fact that a civil war was waged over the icon is reason enough to inquire more closely into the cultural and religious significance that the public use of the icon had developed up to the eighth century. It was, after all, not the icon as such but its veneration that brought about the long conflict of iconoclasm and divided Eastern society. In order to understand the issues that were involved in such debates and caused events of bitter hostilities, we must analyze both the practices and the theories, which had had a long history before they produced the open conflict. The icon, though ultimately an heir of ancient panel painting, in the end became the symbol of religious conflicts, which were not just the concern of the theologians as such but touched those matters of ethnic and cultural identity that constantly endangered the fragile unity of the Eastern empire.

a. The Image in Christendom

We should always keep in mind that in the beginning, the Christian religion did not allow for any concession in its total rejection of the religious image, especially the image demanding veneration.[1] The religious community did not approach a cult image but assembled around the altar, or mensa, where sacrifice addressed an invisible God. The church did not house a divine image, as the cella of the pagan temple had done, since such images were vigorously opposed as idols, which had led the pagans into error. Refusal to worship the emperor's image had become the basis for persecuting the early church. Finally, images in religious use were in open contradiction to the Mosaic law of the ancient Jews. Jewish monotheism conceived of the one God as the invisible One who stood apart from the many gods of heathens and from their images.

Given all these circumstances, the final acceptance of cult images by the church seems to be an unexpected change from very early and very important convictions. The church, to be sure, resisted this change for a long time but, in the end, admitted images, though with the exception of sculpture in the round, as the object of worship. The new attitude was backed by a theory that, in retrospect, justified the worship of images within the context of the theological debate over Christ's dual nature.

Modern books sometimes repeat the old arguments with the same awe that inspires their authors in front of the old icons. They thereby give the impression that the old arguments had a genuine Christian origin and displayed a truly intellectual vigor, differing totally from pagan antecedents. We should, however, not be taken in by a doctrine that, in an attitude of self-defense, merely sublimates existing practices with icons and retrospectively lends them a theoretical sanction. The doctrine of images, as will be apparent at once, was an answer to a preexisting controversy.[2]

The first statements on the image date from the fourth century, when Christianity became the state religion of the Roman Empire. Bishop Eusebius (d. 339), the theo-

logical adviser of Constantine I (306–37), in a letter refused the request made by the emperor's daughter to procure for her a portrait of Christ, which seemed to her the obvious way to embrace the core of the new religion.[3] Another Christian woman, the owner of the miraculous image of Kamuliana, was to ask two centuries later: "How can I worship him if he is not visible, if I do not know him?" (chap. 4a). The church had to deal with the needs that newcomers had of being shown in images what they were to believe. But these needs raised the problem of purity and identity. To put it in the terse formulation of Bishop Epiphanius of Salamis (d. 403), "Set up images, and you will see pagan customs do the rest."[4] Eusebius, in his letter to the emperor's daughter, expressed himself more circumspectly. Had Constantina, he inquired, ever seen anything of the kind in a church? He, Eusebius, had taken images of Paul and the Savior from a woman to avoid giving the impression that Christians carried their God about with them in effigy as idol worshipers did. Finally he asked the princess which of the two natures of the God-man she would expect to find in the image: the divine one was inaccessible to visual representation, and the human one was unworthy of it.

The legend that Pope Sylvester brought two images of the apostles Peter and Paul to Emperor Constantine in order to convert him thus cannot be of such early date. In fact, the St. Sylvester legend achieved currency only in the eighth and ninth centuries, though its beginnings may go back to the sixth century. Its later success rested on its alleged evidence for the so-called Donation of Constantine, the pope's claim to imperial power over the Carolingian kings. The two small portraits of the apostles (from the treasury of the Sancta Sanctorum chapel) discussed earlier (chap. 7b) date from the same time. In the fourth century the church certainly did not yet use such icons.

The strictures of Eusebius and Epiphanius are not unique. A general council of the church that met in Elvira in A.D. 306 stated in its thirty-sixth canon that "the hanging of paintings in churches shall be forbidden, since the object of veneration and worship does not belong on a wall."[5] The concern about the power of the image over the viewer was still widespread at that time. The unwitting beholder might mistake the image for what it depicted. A few centuries later, John of Damascus, the first theologian of images (ca. 680–749), officially insisted on an idea that in fact should have been self-evident: "The image is a likeness that expresses the archetype in such a way that there is always a difference between the two."[6] Clearly, even this difference between representation and the person represented had in the meantime become unclear.

We first hear of the church's use of religious images in the sixth century. Significantly, the imperial family played an important part in this development, as when it donated votive images to the Blachernae church or when it had an image of the Virgin sent from Jerusalem to Constantinople, which, in fact, represented a new genre of image. It was reputed to have been painted by Luke the Evangelist after the living model (chap. 4d).[7]

As soon as the cult of images could no longer be ignored, theologians began to take a position for or against the value of images, which still were not generally permitted in the sixth century. It was for pedagogical considerations that Bishop Hypa-

73

145

tios of Ephesus conceded the use of images only for those who had need of them—that is, for simple, uneducated people.[8] This idea that images were the Bible of the illiterate eventually became the official teaching of the Roman church.[9] Seventh-century legends of saints contain the first justifications of the new cult of images practiced in the East. The Greek legend of St. Pancras of Taormina alludes to a portrait icon of Christ that St. Peter, who had commissioned it, handed over to the saint to take to Sicily, together with illustrated manuscripts of the Gospels and image panels to be used as models for the decoration of churches.[10]

b. Byzantine Iconoclasm

The exaggerated use, and misuse, of icons in one part of the empire and the rejection of icons in another part soon led to the explosion of iconoclasm. The feverish promotion of images may have divided church and society even before, but the conflict began in the open when the state officially banned the images and thus opened hostilities that were to last more than a hundred years and at times amounted to a civil war. The public debate, which was the immediate result of the first acts of violence, was the hour of the first doctrine of images, which up to then had mattered only for Greeks living outside the frontiers under Arab rule. It needed the crisis to introduce the question of the image into the debate of theologians, whether they supported or attacked the icon. The debate, rich in subtle and even hairsplitting definitions, often was more an occasion of polemics than a sincere attempt at solving the problem. The supporters of images did not hesitate to forge an old tradition where there was not, and could not be, such a continuous tradition of image worship. The writings of the defeated party, which was defamed as the "enemies of images" (*ikonomachoi*), survive only in the quotations of their opponents, which served to contradict them and to make them appear ridiculous. Also the scope of the acts of violence was distorted by the opponents. We do know, however, that images were forceably removed from public places (sec. d below).

Iconoclasm, certainly the most-discussed chapter in the history of the icon,[11] has produced a modern literature with controversial evaluations of the events that do not allow for any monocausal explanation. Often images were merely the surface issue for deeper conflicts existing between church and state, center and provinces, central and marginal groups in Eastern society. The court and the army struggled against the monks along a constantly shifting front. Heretical movements joined the fray, particularly those from the Anatolian border provinces, which threatened the unity of the empire, causing the center now to be conciliatory, now to be repressive. Economic factors also influenced both the outbreak and the course of the conflict. Finally, the military, which always supports the winning party, was involved in the events from the start. Reading the sources, one often wonders why it should have been images that unleashed or at least exposed the conflicts. We can only conjecture about these reasons, since official explanations tend to refrain from treating them.

The primary theme of the images—the figure of the God-man—was naturally at the center of theological considerations, so that the image was perceived either as a

symbol of, or as an obstacle to, the purity and unity of the faith. Images lend themselves to such a role, as they are visible to all and thus can be venerated or reviled, officially displayed or officially removed from public view. Consensus and dissent are more easily manifest from the general use of images than from the use of writings, which, in those times, were accessible to only a few. The icon furthered the unifying discipline of a faction, whereas sophisticated argumentation often obfuscated differences and conclusions. The power of proprietors of local images and the impotence of the emperors, who saw themselves degraded to vicars of divine images, were further problems in the outbreak of iconoclasm. The collapse of the big cities in the seventh-century wars against the Arabs demanded a strong central authority that, if need be, would put the unity of the church above all potentially divisive symbols such as icons. Only the cross, as a sign of the empire's military success, was immune both to theological dissent and to charges of idolatry such as that which had brought down God's wrath on the Israelites. The subject of iconoclasm clearly transcends the boundaries of a history of the icon as a pictorial genre.

Even an attempt to outline the mere course of events proves to be difficult enough. The events started in 726 with what was apparently an edict against images and with the destruction of the icon of Christ on the palace gate (sec. d below),[12] which caused Patriarch Germanus, an advocate of images, to resign in 730. Emperor Leo III (717–41), who was born in the Syrian hinterland, apparently represented the majority of the army when he initiated iconoclasm. Success in war seemed to depend on the observance of the true faith. Overtly present was the model of the caliph, whose armies had brought the decentralized empire to the brink of ruin. With the example of the caliph in mind, Leo therefore preferred to see himself as the representative of the one, united "people of God," following the prototype of the Old Testament. In a letter to the pope, he stated his intentions, as the one emperor of the one God, to break with the centrifugal forces of diverse cultures and local authorities.[13] His son, Constantine V (741–75), who would later suffer extensive vilification, injected overtly theological considerations into the struggle. He sympathized with the Monophysites, who believed in the single, divine nature of Christ; images, which necessarily emphasized Christ's human nature, thus were necessarily suspect.[14] A first climax of the incipient image doctrine was reached with the Synod of Hiereia, over which Constantine presided in 754 and which issued definitions of faith on the subject of images.[15]

Iconoclasm nevertheless came to a preliminary end by the death of Leo IV in 780, when his widow, Irene, became regent in place of his son, who was still a minor. In league with the patriarch Tarasius and with the support of important circles in the imperial capital, she abruptly changed course and began to reinstate the cult of images. In 787 an "ecumenical council" met in Nicaea, where the first general council of the church had met under Constantine the Great in 325. This council condemned all the resolutions of the preceding synod[16] but was unable to prove the early use of images from the traditions of church literature, for "we do not find it said in the ancient books that images should be worshiped," as the opposing party was to point

out later.[17] As a result, the council—which also issued a number of general canons—with philological vigor made every possible effort for demonstrating its case from the sources (text 8).

The interlude did not last long, however, and iconoclasm broke out again in 813. The emperor who brought about this new change of direction had again been proclaimed by the army and again came from one of the eastern border provinces, this time Armenia. It is no accident that even his name, Leo V (813–20), revives the memory of his eighth-century predecessor.[18] His biographer tells us that he wished to emulate those emperors whom heaven had proved right by granting them a long life and success in war.[19] The resistance Leo faced from the clergy was powerful. Among the emperor's opponents, who had all risen to prominence in the interval, the leading figures were the patriarch Nicephorus (806–15, d. 828), who was dismissed, and the abbot of the monastery of Studion, Theodore (759–826), who also went into exile. A courtier, Theodotus, was placed on the patriarchal throne. His successor, the "grammarian" John (837–43), who was given the derisive nickname Jannis, was from the beginning the leading theoretician of the new iconoclasm. The synod, which met in the church of Hagia Sophia in 815 and proclaimed the desired theology, already bore his stamp.[20]

Another, and final, change of course occurred when a woman again came to power—the widow Theodora, who became regent for her minor son on 20 January 842. By 4 March 843, a once-persecuted advocate of the image cult, Methodius (843–47), was appointed patriarch. Within the same month, a synod restored the previous theological position; the Sunday when the images were reinstated was proclaimed the Feast of Orthodoxy.[21] However, the most radical elements among the monks, the Zealots, were not satisfied. They demanded still greater autonomy for the church, which in their eyes had been greatly dishonored by the emperors. To provide a hero, the patriarchy therefore pronounced the former patriarch Nicephorus a saint and victim of the emperor. His remains were transferred to Constantinople, and his vita was commissioned.[22]

The two rival authorities, the emperor and the patriarch, now became the focus of the conflict, and the events that followed flowed from this tension rather than from the question of images. In the following years the imperial court took the lead by publicly reinstalling the images. The emperors even took over the patriarchs' role in preaching at the consecration of new churches (chap. 9a). Both sides sought to limit each other's rights. For overextending his powers, the patriarch Photius was dismissed a first time in 867 and again in 886, this time under an emperor of the new Macedonian dynasty.

The weapons of the polemics were not only texts but derisive images and caricatures in book illumination. When Photius was deposed the first time, forged synod records directed against his adversary, the patriarch Ignatius, were found among his books.[23] Polemical illustrations by the hand (*autourgia*) of his supporter Asbestus, bishop of Syracuse, disfigured Ignatius and called him by nicknames such as "Devil," "Brood of Simon the Sorcerer," and "Antichrist."

The same methods had been used against the iconoclasts in editions of the

Psalms, whose marginal glosses in the form of pictures, rather than words, effectively relate the texts to contemporary events. They were probably first produced in the years 845–47, when there was cause for retrospective celebration of the heroic resistance of the patriarch in the person of the "martyr" Nicephorus.[24] In a Psalter from the Chludov collection, now in the Historical Museum in Moscow, the illustration to Psalm 51:7 chooses a verse that could be applied to the enemy: "God shall cast you down for ever. You speak not truth but untruth."[25] Two illustrations, similar in their typology, compare the posthumous victory of the patriarch over his archrival from the other camp with the triumph of St. Peter over Simon Magus, whom the apostle, says the inscription, "destroyed for his covetousness [*philargyria*]." This is an allusion to simony, or the selling of church offices. In the parallel picture below, the rehabilitated patriarch stands in the ancient Roman pose of the victor, with his foot on the shoulder of the "second Simon and iconoclast," who is caricatured as a foul monster with a tangled mane of hair. The new saint holds a tondo icon of Christ, which has won the day, as a visible proof of orthodoxy. The analogy with Peter and with the triumph over the heathen generates a pictorial antithesis to denounce the iconoclast enemy and to assure the victorious party a place in the history of salvation.

86

Such polemical images, which use the verses of the Psalms as if the psalmist had predicted the events, are repeated several times. In Psalm 25:4, for example, "once" and "now" are made to refer to the iconoclastic synod of 815 and the patriarch who had been expelled at that time but who was now restored to power.[26] *Once,* the illustration says, the icon of Christ was whitewashed over, causing blood to flow as from a bodily wound. *Now* the same icon is conspicuously restored. The prelate holds it in the fold of his surplice, where we would expect the Gospel book, while drawing our attention to it with the other hand. At the close of the long history of iconoclasm, we again are reminded of the fact that the image of Christ, as testimony to the True Faith, was at the center of the debate.

c. The Theory of Images and Its Traditions

The theory of images properly speaking, which, as a weapon against the iconoclasts, is different in aim and character from all the texts produced previously, began with writings by the patriarch Germanus (text 6), who was forced to resign in 730.[27] Earlier than this, there are relevant texts starting with the work of John of Damascus (ca. 675–749), who grew up in territory dominated by Islam and who entered the Saba monastery near Jerusalem. His theological writings relevant to our theme (text 7) are, above all, his three books "against those who attack the divine images."[28]

In the three phases of the image doctrine referred to by Paul J. Alexander, this first stage was dominated by traditional arguments.[29] Against the Jews, they justify the Christian use of images with Christ's visible appearance in the flesh, of which they are a visual record. The christological debate that was to dominate the second phase of the development of image theory, once the Council of Nicaea had raised the subject in 787, was launched by a brilliant theological argument from the other side, the chief exponent of which, significantly, was an emperor, Constantine V (741–75).[30] His radicalism had a clearly spiritual cast and was soon also directed at the "materialism"

of religion. The mimesis, or imitation, of Christ was not, he asserted, the business of the painter or of images; rather, it was an achievement of virtue that accepted only the cross and the Eucharist as physical signs of the spirit and the truth of the faith.[31]

When iconoclasm broke out again in 813, the old debate, which the two parties had dominated alternately, needed an additional effort such as the discovery of unknown patristic sources in order to find the desired support. The pro-image argument in the third phase was dominated by the exiled patriarch Nicephorus, who in his three monumental "counterarguments" (*antirrhētikoi*) addressed to an imaginary interlocutor, and also in the book *Apologeticus,* favored the case of the images.[32] Theodore, the abbot of the Studion monastery, had time in exile to compose similar works.[33] The two theologians often clashed over matters of church politics, but on the subject of images they were close together. Nicephorus debated in the Scholastic fashion, by argument and counterargument, with an opponent who is none other than the former emperor Constantine V. The discussion is conducted in an abstract style in the manner of Aristotle's peripatetic philosophy.

The author makes every effort to reject the claim of his opponent that Christ cannot be verbally described (he is *a-perigraptos*) and therefore cannot be visually depicted either (he is also *a-graptos*). He maintains that the human life of Christ had a reality that the image, as a likeness, witnesses. This statement is backed by the old doctrine that says that image and word, the media of eye and ear, are equal in age and rank. *Graphē* means both writing and painting. Nicephorus even insists that he had consulted "ancient manuscripts" that proved that script and image enjoyed the same status.[34] Theodore of Studion, who was more concerned with the veneration than with the image, argued by tracing the image back to the truth of its archetype. While different in nature, the image matches the hypostasis and individual appearance of the person represented.

After this brief survey of the history of the debate, the arguments now may be put into context. A pronouncement of the synod of 869 introduces us to the final form of the terms under debate:

> We prescribe that the icons of our Lord . . . are to be venerated and shown the same honor as is accorded to the Books of the Gospels. For just as all attain salvation through the letters of the Gospel, so likewise do all—the knowing and the ignorant—draw benefit from the pictorial effects of paint. . . . If, therefore, a man does not do homage to the icon of Christ, he also shall not be able to recognize His Form at the Second Coming.[35]

A modern person will hardly appreciate how daring and dangerous a claim was advanced here for the image, given the fact that the Holy Scriptures, as the authentic word of God, had been the sole medium of revelation. As a doctrine of redemption, Christianity linked salvation to revelation, which in turn rested on the written word of God. It therefore was an unusual proposition to extend this sacred privilege to an image of God and thereby to confront the difficult question of whether and how God revealed himself to humankind by images in addition to his word. The theology of images had to meet the challenge of such questions. Its task was to upgrade the image

86. *Moscow, Historical Museum; Cod. 129, fol. 51v; defamatory images of iconoclasts in a Greek Psalter, after 843*

as a medium of salvation, an image that, according to church tradition, was made of dead matter—wood and paint—and had been produced by human painters imitating God's nature. The word was revealed by God, whereas the image was created by artists (and, according to Mosaic law, initially was even interdicted by God).

Theologians who ventured to justify the images from the tradition of the ancient church thus found themselves in a delicate position. They nevertheless had to draw on the authority of the church fathers, who had not cared about images for their own sake but had referred to images for elucidating the two natures of Christ by way of an example. Such texts therefore were an obvious choice, since the most important image, the image demanding veneration, was the image of Christ. Was it possible to represent Christ at all? If so, which of his two natures was involved in the image? The identity of Christ, including the relation of the Son to the Father, in fact had preoccupied the old Fathers like nothing else.

This argument, which had shaken the church to its foundations, hinged on the premise that God, in monotheism, was *one* and that he was *invisible*. Who, then, was Christ? Was he merely *similar* (i.e., *homoi-ousios*) to God, or was he *equal* (i.e., *homo-ousios*) to God? The old theologians had dealt with the basic question by referring to the common experience of the image and its relation to the person represented. They argued that God had become visible in Christ, as in an image, while the new theologians, as advocates of the image, contended that Christ could become visible in his image. If the invisible God, they said, had become visible in the man Jesus, then the latter could be made visible in images. The reality of Christ's incarnation, a dogma still widely discussed, thus was linked to the possibility of Christ's representation, and the image was thereby promoted to a criterion of orthodoxy.

But it was not sufficient to claim for the image the right of representing a human being called Jesus, for images always rightly represented persons existing in a human body. After all, the image of Christ demanded veneration and thus invited for itself an argument familiar in the long history of Platonism. If Christ as a man could be portrayed, the image was not limited to his human nature, since he was himself, like everyone else but in a way different from other human beings, an image of God. The fact that the Christ-image included its own archetype had been cited as a way to illuminate the issue. God, as the archetype, was materialized in the Son of Man as in an image. As the book of Genesis explained, man had been created *according* to the image or likeness of God. From this, the Fathers concluded that man was not the image himself but followed the image, or model, which they identified with Christ the God-man and thus the archetype of creation. Basil the Great (ca. 330–79) summed up the argument by the famous definition that the resemblance brought about in an image by its form was brought about in the relation of Son and Father by the divine nature.[36]

In order to explain his argument, Basil drew on the well-known experience of the imperial image, which at the time received honors on behalf of the emperor and, in his place, even presided over judicial proceedings. "Just as no one who looks at the imperial image in the marketplace and acknowledges the emperor would deduce the

existence of two emperors, first the *image* and then the real emperor, that is the situation here, too. If the image and the emperor can be one (for the image does not cause a multiplication of the emperor), the same holds true of the divine *Logos* and God."[37] Athanasius (295–373) takes this argument further, saying: "In the image the features of the emperor have been preserved unchanged, so that anyone who looks at it recognizes him in the image. . . . Thus the image could say: 'I and the emperor are one.' . . . He who honors the imperial icon, therefore, honors in it the emperor himself."[38]

Two conclusions could be drawn from this comparison. The first concerns the theological implications of the *person* of Christ. While the image and its model are to be distinguished, this does not mean that they separate into two persons. Therefore, Father and Son are also to be distinguished, without separating into two gods. The second conclusion concerns the veneration of the person of Christ. Since the person of Christ contained the Father as in an image, the Father could be honored in the Son. This line of thinking was later applied to the icon, the painted panel, which lent itself to honoring Christ himself. Here too the old formula applied; namely, the honor of the image refers to the archetype (Basil). The likeness is not honored in the name of the image but in the name of the person represented, the image being only a means to an end.

But the argument did not rest there, since it also had to fight against the iconoclasts. They had objected that the issue had been the image of the Father in the Son, that is, an image created by *nature*, whereas now it was an image created by an artist. They thus distinguished between the image generated by nature (by means of *physis*) and the image generated by imitation or art (by means of *thesis* or *mimēsis*), which were not interchangeable.[39] The advocates of the images therefore had to wheel out the old Platonic doctrine and to assert that the painter's image also had its place in the cosmic sequence of images. Every image, no matter of what kind, originated in a prototype, in which it was contained in essence (by *dynamis*) from the outset. As an impression belonged to a seal and a shadow or reflection to a body, so a likeness belonged to a model.[40] The image was thereby taken away from the caprice of the painter and related to its archetype, which it mirrored in form according to the cosmic principle of similitude. Seen in this way, the image was not the mere invention of a painter but was more or less the property—indeed the product—of its model. Without the model, the image could not have come into being. By adopting the essence of the archetype, the image borrowed the supernatural power that justified its worship.

The argument was carried to an extreme when it was no longer the incarnation of God that became elucidated by the image, but the image explained with the help of the Incarnation, culminating in the assertion that the image of God had been overshadowed by the Holy Spirit as the Virgin had been at the conception of Christ. The image was held to be the incarnation of the form in matter. The Holy Spirit now took the place of the painter, as he had taken the place of a human father at Christ's conception.[41] In the end, the argument, as it were, retraced the pagan philosophy and declared the cult image to be the seat of the divinity. Images had been promoted to quasi-personal beings and as such were explained by a metaphysics that had its roots

in pagan Neoplatonism. It only was left to their advocates to secure their practice against excesses and misuse. The *adoration* of God was distinguished from the mere *veneration* of the image. When translated without distinction into Latin, these concepts were misunderstood by the Carolingians, who promptly rejected the entire image doctrine of the Greeks (text 33).[42]

These deliberations ultimately are rooted in Plato's view that the products of nature are reflections of primal images, in which they exist in a purer form. There is no biological evolution from primitive to more developed forms but a dependence on a preexisting and everlasting world of ideas or archetypes that is reflected in the transitional variety of physical nature. Nature indeed is generated by the law of likeness and reproduction, not by the law of development—in short, as an *image*. The image thus became a cosmic agent in the emergence of the physical world. It is this universal significance of the image as agent or principle that is mirrored in its use in the controversy over the nature of the person of Christ.[43]

In the Middle Ages, images of God were usually images of Christ, since Christ was thought to resemble God in his divine nature and to have made God visible in his human body. His body in the flesh thus provides the likeness of God the invisible. The law of likeness, as it exists between model and image, offers the analogy for explaining the person of Christ. As a model and his or her image are one and the same person, the model in life and the image in representation, so also God and Christ, the model and the living image, are one and the same God (though, for matters transcending our argument, not the same person). The theologians therefore never tired of pointing out the resemblance of model and image. The painter, they insisted, can produce a work only by virtue of the model that generates an image of itself via the painter (or, directly, via the mirror). The painter does not create the image but depends on the model. And since the image bears witness to the person represented, it follows that it can receive the honor reserved for the person.

The theologians who advocated the case of the image were fighting on two fronts: against their opponents they defended the legitimate veneration, as much as they were forced to argue against the abuse of veneration. The reference to Christology, in addition, raised the debate on images to a very high level of theology, where a fully developed theory was meant to provide the necessary control over the image and also over its use by the faithful. As art theory had become the business of the church, we may ask in what way, and whether at all, this doctrine determined the formal appearance of images.

There is, to start with, the "proof of reality" that was expected from the image. As everything, according to Platonic beliefs, was created from a preexisting image and, in turn, could generate an image of itself, nothing could claim to be real that did not lend itself to be represented by an image. Theodore of Studion, who equated body and shadow to archetype and image, continued: "If that which is absent can be contemplated by the mind and cannot be also seen in a visual representation, then it denies itself also to the mind's eye."[44] The image, in fact, refers to a reality that is called into question as soon as the image is rejected. Whoever objects to the possibility of representing Christ indeed doubts the reality of Christ's life as a human being.

This line of thought, which had so much importance in the debate, will be illustrated by three examples that apply the idea to pictorial practice.

d. Image and Sign, Icon and Cross

It is well known that the early church used signs and symbols based on biblical metaphors as visual references to Christ. A general council that met in Constantinople in 692 dealt with this subject and issued a pronouncement on the question of whether the figural speech of the Bible should actually be presented by images.

> On some venerable images is depicted a lamb at whom the Forerunner points with his finger: this has been accepted as a symbol of Grace, showing us in advance, through the Law, the true Lamb, Christ our Lord. While embracing the ancient symbols and shadows inasmuch as they are signs and anticipatory tracings handed down to the Church, we give preference to the Grace and the Truth which we have received as the fulfilment of the Law. Consequently, in order that the perfect [to teleion] should be set down before everybody's eyes even in painting, we decree that [the figure of] the Lamb, Christ our God, who removes the sins of the world, should henceforward be set up in human form on images also, *85* in the place of the ancient lamb, inasmuch as we comprehend thereby the sublimity of the humiliation of God's Word, and are guided to the recollection of His life in the flesh, His Passion and His salutary Death, and the redemption which has thence accrued to the world.[45]

This deliberation, which was resumed at the time of iconoclasm, relates explicitly to the reality of the image. If Christ is real, there is no alternative to his portrait. The image thus takes on the status of a confession of faith. The one who acknowledges Christ also acknowledges his image. The New Testament signifies that Christ appeared bodily on earth. Therefore the term "truth" can also be translated "reality." The image makes the claim of reality for whatever it is representing. The symbol, by contrast, is regarded as obsolete as soon as it can be replaced by the image, that is, by the original.

The so-called Cross of Emperor Justin in Rome clearly antedates the historical *92* change in the evaluation of the image of Christ that has been described.[46] At the intersection of the cross's arms, where one would expect to find the crucified Christ, there is a medallion showing the Lamb of God. By contrast, the Crucifixion in the chapel of Theodotus in S. Maria Antiqua in Rome (chap. 7f), by representing a bearded man *70* dressed in the purple vestment, emphasizes the full reality of the death on the cross. To qualify as proof of the official theology, therefore, the Crucifixion had to show the dead Christ on the cross. The fresco in Rome does not go so far, but a number of *71* early icons take this very step.[47]

On the wall above the apse of S. Maria Antiqua, the adoration of the historical Crucified in heaven appears significantly, in a position previously reserved for a de- *87, 83* piction of the Lamb of God from the Apocalypse.[48] The Roman beholder, therefore, would have noticed the change of introducing into the adoration of the Lamb the figure of the Crucified. As this innovation happened at the time of John VII (705–7),

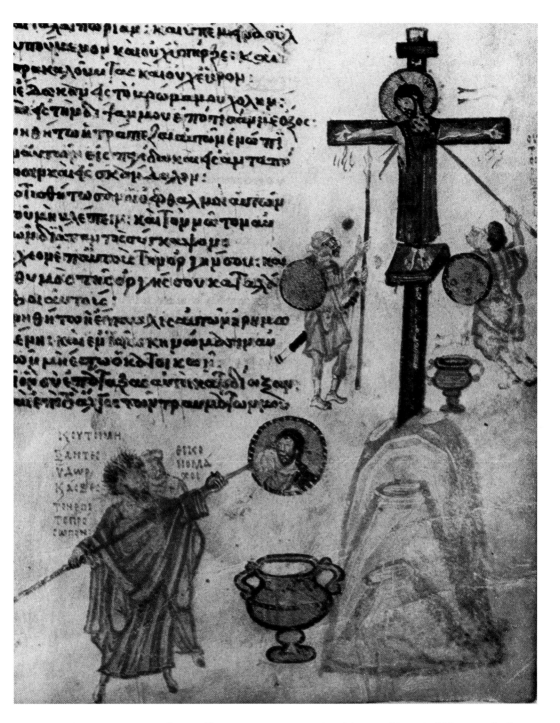

87. *Rome, S. Maria Antiqua; choir wall,*
705–7, after W. Grüneisen

88. *Moscow, Historical Museum; Cod.*
129, fol. 67; the enemies of Christ and the
iconoclasts, after 843

only a few years after the Constantinople council of 692, the reference to the new image theology is undeniable. The *adoratio crucis,* in reality an *adoratio crucifixi,* is neither a historical Crucifixion nor the usual apocalyptic adoration of the Lamb in heaven. It combines the two themes in a new, synthetic presentation that pointedly suppresses the Lamb and replaces it by the human Christ. The appended quotations from the Old Testament relate typologically to the Crucifixion and emphasize its reality.

A second test case for the new understanding of the Christ image is the equation of the Crucifixion of Christ with the damaging or destruction of the Christ icon. In the writings of Patriarch Nicephorus we read that both are the same.[49] It is not surprising, therefore, that the equation is also expressed in pictorial form. Among the polemical miniatures in a Psalter from the Chludov collection already mentioned (sec.
88 b above), the degradation of the Crucified, who is offered a sponge soaked in vinegar, is equated with the desecration of his image, which is being whitewashed with a similar sponge.[50] In the legends of the saints, images that have been pierced by the Jews bleed, just like the historical Jesus, whose side was opened by a lance. Such bleeding was reported, for example, by a converted Jew, who claimed to have experienced such a miracle.[51]

The miniature in this Psalter serves as a polemic against the iconoclasts by illustrating Psalm 68:22: "They mix my food with gall, and give me vinegar for my thirst." The equation of the Crucifixion with the mistreatment of an icon in fact identifies the image with the person it depicts.[52] The inscriptions support this argument: "And they mix water and vinegar upon his face." The pictures compare the Jews who raise the sponge to Christ with the iconoclasts who paint over his icon.

A third test case for understanding the Christ image is the decision of the iconoclasts to replace it—whether at the palace gate, in the apses of churches, or on state coins—with the cross. Unlike the image, the cross is a sign and thus is not to be identified with what it symbolizes. It was sanctioned in the eyes of the iconoclasts by the authority of the church fathers, who venerated it, and by Christ himself, whose return, according to Matthew, would be anticipated by the cross. Furthermore, it had been the victorious standard in the hands of the emperors. As a sign, it diverts attention from itself as an object to the intended meaning. Not an image but the cross was the instrument of salvation. This was the view of the theologians on the iconoclastic wing, and the Carolingians, who deliberated on these matters in the *Libri Carolini* and at the Frankfurt Synod of 794, thought likewise.[53] In iconoclasm, the conflict involved the contrast of image and counterimage, of icon and sign. In a church of the
89 Dormition in Nicaea on the Sea of Marmara, where the council of 787 met, three subsequent apse decorations went along with the changes in image policy. As can be seen from an old photograph, an initial image of a standing Madonna and Child was replaced in iconoclasm by a cross, which after iconoclasm in its turn had to give way to another image of the Madonna.[54] In the apse of the church of St. Irene in Constan-
90 tinople, the pure cross from the time of iconoclasm was maintained.[55] At Nicaea, however, the opposing parties hastened to replace what offended them with what they considered its antithesis. The iconoclasts were offended by the *image,* while their op-

ponents considered the *sign* an insult to the image. Image and anti-image reveal a basic difference in interpreting creation.

The one position rejected the image as an obstacle on the path to God and held the Eucharist to be the only proper image of the God-man. The other position took the image to be part of the created nature that was redeemed by the Son of God; it therefore understood the reality of the image as a guide to the reality of redemption by the God-man. The image (*eikōn*), in the words of Patriarch Nicephorus, was more worthy of veneration than was the *typos* of the cross because it resembled the appearance of Christ and alone possessed the substantial and also essential "similarity" (*homoiōma*).[56] Only if a historical man hung on the cross was salvation accomplished in reality. In the mosaic at Nicaea, above the human mother who held out the Child as a visible proof of God's incarnation, the Hand of God signified the invisible God by way of a symbol. The image itself, however, was a proof of visible creation. The apse therefore contained a bipolar statement about the effect of salvation. In Islam the human figure, the most important subject of ancient art, was taboo in places of worship. Thus the image in Byzantium gained all the more status as a profession of faith, a testimony to the True Faith.

In an annex in the church of Hagia Sophia, once part of the patriarchate,[57] all the figures were destroyed and replaced by crosses. The impending loss of cultural continuity led to a new consciousness of what was true identity. The history of the church included two conflicting traditions, which forced the faithful to choose. Iconoclasm initially concerned only the Christ icon, the first to be removed and the first to be reinstated. It had been installed above the palace gate in Constantinople, the so-called *Chalke*, or Bronze Gate, and was destroyed as early as 726 in a violent encounter that gave the images' cause its first martyrs.[58] When the first phase of iconoclasm was past, Empress Irene had the cross replaced by the figure of Christ, adding the inscription: "The image that the tyrant Leo destroyed has been restored by the empress Irene."[59]

On his ceremonial entry to the city in 813, Leo V still paid homage to the image. But shortly before Christmas 814 his soldiers stoned the icon. The second removal of the figure was justified as a precaution to prevent further desecration. Again it was replaced by a cross. The inscription explains the measure as follows: "Emperor Leo and his son Constantine held it to be a desecration of the divine Christ that he should appear even above the palace gate as a lifeless, dumb image of wood (on a wooden panel). They have therefore replaced what the Holy Scriptures prohibit by the cross as the sign of salvation, and a pledge of faith."[60]

After the triumph of orthodoxy in 843, the last act of the drama was played out. The third image of Christ to appear at this spot was a full-length mosaic, said to have been made by a victim of the iconoclasts, the mutilated painter Lazarus. For it, the patriarch Methodius (843–47) composed an epigram of twenty-nine lines:

> With your immaculate image and your sculpted cross before my eyes, O Christ,
> I honor your true flesh with pious trembling. Although you were of timeless nature as the word [*Logos*] of the Father, through your birth of a temporal mother you took on a mortal nature. . . . As I make visible your flesh capable of suffering,

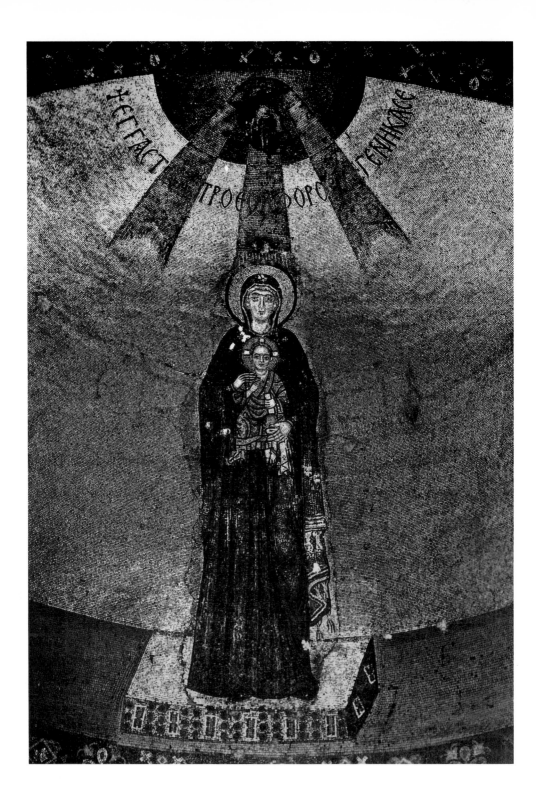

I confess that you are invisible in your nature as God. But the adherents of Mani, who [see] your incarnation as a phantom . . . could not bear to behold your image. . . . In opposing their unlawful error Empress Theodora, the guardian of the faith . . . in imitation of the pious emperors whose piety she has outdone, has restored this image with pious intent to its place over the gate of the palace, to her own fame and glory, to the honor of the whole church, to the benefit of the human race, and to the perdition of all malign foes and barbarians.[61]

An important issue was the relation of the image cult to orthodox faith. Thus pictures of the Sixth Ecumenical Council (680) were the object either of destruction or of an equally vehement reinstatement. They were didactic pictures intended to influence decisions on matters of faith. In 711 the Monothelitic emperor Philippicus Bardanes refused to enter Constantinople until the picture of the Sixth Council in the palace vestibule had been replaced in the *milion* by depictions of the first five councils alone.[62] Later the bishop of Naples had council pictures painted that were directed pointedly against Byzantium.[63]

As we read in the life of Stephen the Younger, Constantine V went to the *milion*, where "the Six holy Ecumenical Councils had been depicted by the pious emperors of olden times and were conspicuously displayed so as to proclaim the orthodox faith to country folk, foreigners and the common people." The emperor had these paintings "smeared over and obliterated, and portrayed in their stead a satanic horse-race and that demon-loving charioteer whom he called Ouranikos [heavenly]," whom he honored more than "the holy Fathers [of the Church]."[64] Profane art was clearly the domain of the emperor and depicted various ancient themes that religious painting had suppressed. The emperor himself, as the true icon of God, wanted to have pride of place, to celebrate his victory in the theater of Constantinople. This explains the invocation of the "mystique of the hippodrome" (Brown) as a sign of the unity of the centralized empire against the divisive symbols of religious definitions and icon cults.

The dispute was taken a stage further as soon as the public veneration of icons was demanded by the emperor in 787. An anecdote found in a polemical biography of iconoclast emperor Leo V (813–20) produced by the opposing camp reports that during the first two years of his reign the emperor tried to hide his true intentions from the higher clergy.[65] At an official reception he had pulled "a cross with an image" from his robe in order to pay public homage to it. At Christmas in 814 he even had gone to the church of Hagia Sophia and, as was customary, had venerated a cloth with an image of the birth of Christ. Two weeks later, at the feast of the Epiphany in 815, he again stepped before the same image but this time openly refused to honor it. The connection of image and cult is clear, as is the fact that icons were taken to include not only panel paintings and portraits but also other depicted deeds of Christ that were commemorated by feast days. The iconoclasts thus could complain that the image of Christ's descent into hell (*anastasis*), which showed Hades and the Devil, was venerated at Easter.[66] Whether attacked or defended, however, the cult of images was treated as a practical demonstration of faith, a conclusion that the examples re-

ferred to prove conclusively. The portrait (icon) and the symbol or sign (lamb and cross) were mutually exclusive in terms of proving the reality of Christ's incarnation.

We can still form an idea of the appearance of the altar hanging that Emperor Leo V so conspicuously failed to venerate. The papal treasury in the Lateran includes two fragments of a large silk cloth that the *Liber Pontificalis* from the time of Leo III (795–816) describes as "Syrian medallions [*rotas*] showing the Annunciation to the Virgin and the Nativity."[67] These are the very themes that appear in the medallions on the red cloth. The theme of Christmas is reduced schematically to a view of the newborn Child in the crib, flanked by the figures of Mary and Joseph. The picture is an icon that depicts what really happened and thus demanded both veneration of the Child in the image and, simultaneously, meditation on the event celebrated by the feast of Christmas. The Epiphany of Jesus in the world, as shown by the cloth icons, in fact was the appropriate icon for the respective feast on 6 January.

<div align="right">93</div>

9. The Holy Image in Church Decoration and a New Policy of Images

After iconoclasm the program of *anastelosis,* or restoration of images, was intended to deliver the material proof that a good tradition was being continued. Reinstating an image to its former place left no doubt that a real tradition was being restored. The unveiling of new images was accompanied by official rites, with state and church dignitaries participating. The process began in 843 with the Christ icon on the palace gate. The mosaics in the main throne room of the palace, the *Chrysotriklinos,* followed in 856. Not until 864 do we hear of the decoration of a church with images (mosaics), and then only in a chapel within the confines of the palace itself. It took until 867 before exponents of the icon dared to move into a more public sphere with the restoration of the apse mosaics in the patriarch's church, Hagia Sophia.

a. The Role of the Imperial Court in the Reintroduction of Images

The fact that the propagation of icons was mainly in the hands of the court is evident from the imagery on coins. The second coinage that the orthodox Empress Theodora and her son Michael III (842–67) minted soon after 843 repeats the Christ figure that Justinian II had used on his coins between 685 and 695.[1] As early as 711, even before the advent of iconoclasm, it had again been displaced by the former cross. But its rediscovery now was to convey the impression that it had been in use for a long time and was the victim of the iconoclasts. What mattered, after all, was the evidence of the "true tradition," which one pretended to renew. The Christ coin therefore served both as a piece of historical evidence and as a demonstration of the new official policy on images. The orthodox emperor who on his coins honors Christ's *image* makes the imperial initiative in reinstating images quite clear. The old coin is reintroduced with a message different from the one it originally had.

Basil I (867–86), Michael's successor and founder of the Macedonian dynasty, in addition used the old legend from the coins of Justinian II.[2] The legend *Rex regnantium,* "Ruler of rulers," placed the icon of Christ and the portrait of the emperor in a relationship that justified imperial rule by invoking the divine sovereign in the form of his image.

Basil's coins, however, combined the old inscription with a new image. They no longer appeared with a bust portrait but used a full figure, seated on a lyre throne, which does not follow any previous formula. It was anticipated, however, on a mosaic in the throne room of the palace. Since 856 "the image of Christ [once again] shines above the imperial throne and confounds the murky heresies," as we learn from an old inscription recorded in the *Anthologia graeca* (text 11).[3] It continues: "Hence we [now] call 'the new Christotriklinos' that which aforetime had been given a golden name [*Chryso*triklinos], since it contains the throne of Christ . . . and the image [*eikona*] of Michael whose deeds are filled with wisdom." Here the enthroned

ruler, as a person, was the living likeness of the enthroned *Christ,* who appeared above him in an image. What corresponded on the obverse and reverse of coins was here related vertically as heaven and earth by the icon and its living representative below. Only an *enthroned* Christ could, as an image, make this relationship to the ruler visually apparent. The mosaic of the throne room was later reproduced in Hagia 94
Sophia, during a dramatic conflict between church and state, but in a revealing change of iconography and with an opposite meaning. In this case, the emperor no longer was the likeness of the ruler in heaven but appeared before him as a prostrate penitent. In quoting the mosaic "icon" from the throne room, the former argument now could be inverted all the more effectively. It now carried the message of the unconditional submission of the earthly ruler to the divine one.

These observations help to understand the pictorial propaganda of the state coinage. While Theodora's Christ coin quoted the historical coin of Justinian II, Basil's 95, 81
Christ coin adopted, in addition, the legend from the same model, though changing 96
the figure in order to emphasize the iconic analogy of the heavenly and earthly rulers. This device served to equate the new mosaic in the throne room with the old coin of Christ. It was a clear reference to the site where the figure of Christ on the lyre throne was known to be: above the throne of the emperor. But that was not all. The equation of *coin* image and *monumental* image of Christ in the throne room (both being seen as icons) had the purpose of presenting both of them as replicas of an old model. If the latter had an old model, the former had a predecessor no less real. Seen in this light, the introduction of the icon was the restoration of an "authentic" tradition.

The throne room was followed in 864 by the consecration of the new Pharos palace chapel, which was given a complete program of wall icons.[4] The throne room, which rather looked like the interior of a church, according to the inscription mentioned earlier, also showed the Virgin, who was accompanied by the emperor and the patriarch as "victors over the heretics," and figures of angels, apostles, prophets, martyrs, and priests. In the palace chapel, called the "new" (*nea*) chapel, similarly "a choir of apostles and martyrs, yea, of prophets, too, and patriarchs fill and beautify the whole church with their images [*eikones*]." These are the words of Patriarch Photius (858–67), who gave the inaugural speech at the time of the chapel's consecration.[5] The text of his address, as far as the new policy on images is concerned, was to prove the alliance that existed then between court and patriarchate.

The Temple of the Virgin at the center of the palace is "a truly praise-worthy work of imperial magnificence." This "second palace," which outdoes the earthly palace surrounding it, is of such beauty that "thou mightest say that it is not the work of human hands," but seems to be heaven itself. One is constantly "carried and pulled away from one thing by another." On the vaulting of the dome "is painted in coloured mosaic cubes a man-like figure bearing the traits of Christ. Thou mightest say He is overseeing the earth, and devising its orderly arrangement and government," so surely has divine inspiration guided the artist's hand. All around, angels escort the Pantocrator. The apse behind the altar "glistens with the image of the Virgin, stretching out her stainless arms on our behalf and winning for the emperor safety and exploits against the foes." The text supplements the *historical* justification of images with a

94. *Istanbul, Hagia Sophia,*
atrium; mosaic with Leo VI,
10th century

95. *Washington, D.C.,*
Dumbarton Oaks; coin from
the reign of Theodora and
Michael III, after 843

96. *Washington, D.C.,*
Dumbarton Oaks; coin from
the reign of Basil I, 867–86

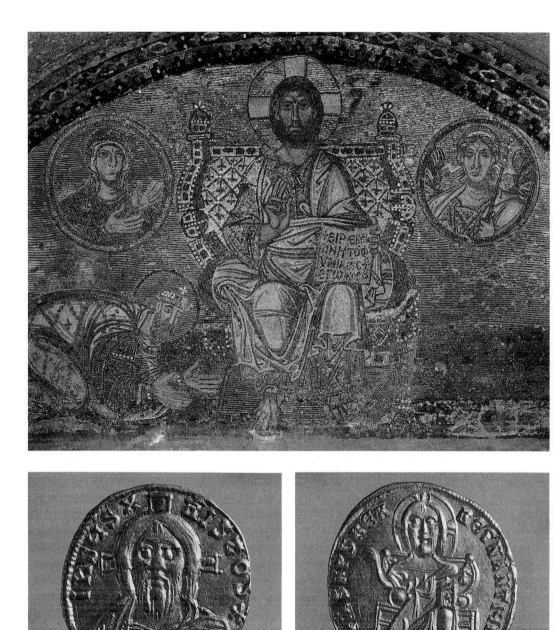

divine sanction. Not only tradition but heaven itself desires these images to be made, hence the reference to the acheiropoietic images (chap. 4a) and the passage about divine inspiration. In its images the church interior reflects the heavenly court. The description takes on a programmatic ring, as if the program should apply henceforth to other churches of the empire as well.

b. Patriarch Photius in Hagia Sophia

Three years later, in 867, images were installed outside the confines of the palace. In the patriarchs' cathedral the restored mosaics were unveiled in the presence of the emperor.[6] In the apsidal niche of Hagia Sophia, the Mother of God (*Theotokos*) 97, 98 reigns monumentally as a figure almost five meters high, with the gold-clad Child on her lap. The cross, which had previously been mounted in her place, left visible traces at her sides. The dedicatory inscription stresses the emperors' will to reinstate the images. "The images [*eikones*] that the erring [iconoclasts] had removed from this place were again restored [*estelōsan palin*] by the pious emperors."

The apse vaulting with its gold surface gives the enthroned figure a bodily appearance—without, however, emulating the effect of statues, which were still taboo. The female figure in her dark robes sharply contrasts with the gold-clad Child, whom she serves as a kind of human throne. The postures of the two figures, whose bent knees and feet extended as if to receive a kiss, match each other in their frontal poses and in their gazes directed out of the picture. Mary, despite her youthful appearance, has a powerful, imposing presence. Her motherhood is underlined by the motif of the Child seated before her womb in a majestic pose. The archangels contribute to the impression of a ruler in the heavenly court, whose likeness the temporal court celebrates on earth.

The day of consecration, 29 March, had been carefully selected. It was the anniversary of the Feast of Orthodoxy in 843, when the reinstatement of images had been proclaimed. The sermon by Patriarch Photius, in celebrating the completion of the new "form" (*morphē*) of the Mother of God, became a synopsis of the official doctrine on images.[7] In the figure a "splendid piety [was] erecting trophies against belief hostile to Christ." The "art of painting, which is a reflection of inspiration from above, set up a lifelike imitation," in which both virgin and mother can be recognized. Her lips' "silence is not at all inert [a criticism that was sometimes made of painting] neither is the fairness of her form derivatory, but rather is it the real archetype." It had been "the daring deed of a wretched Jewish hand" that had deprived the church of such beauty. God's incarnation "is seen and confirmed and proclaimed in pictures, the teaching made manifest by means of personal eyewitness." To reject the images would be to reject the Gospels. "Just as speech is transmitted by hearing, so a form through sight is imprinted upon the tablets of the soul." Before our eyes "stands motionless the Virgin carrying the Creator in her arms as an infant, depicted in painting as she is in writings and visions." The contemplation of her physical beauty lifts our spirit "to the intelligible beauty of truth" (*eis to noēton tēs alētheias kallos*).

These are the central ideas in a long speech, in which the patriarch also demonstrates his rhetorical brilliance. It treats the iconic mosaics as if they were themselves

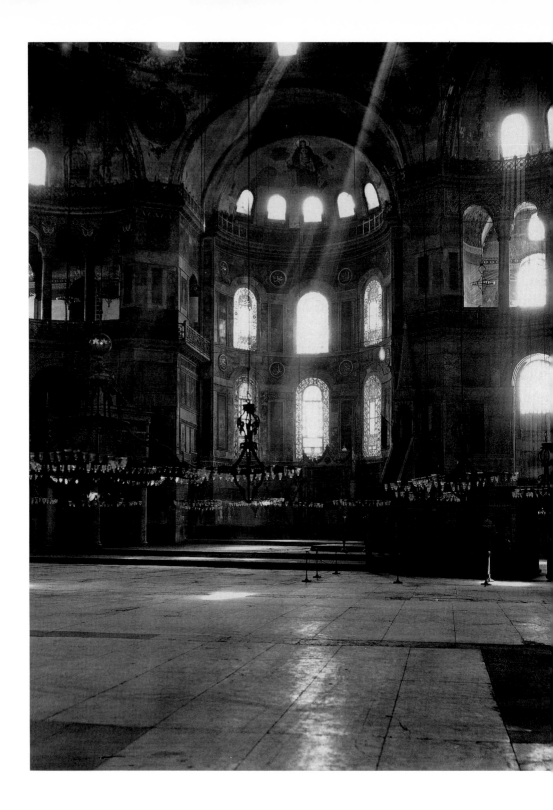

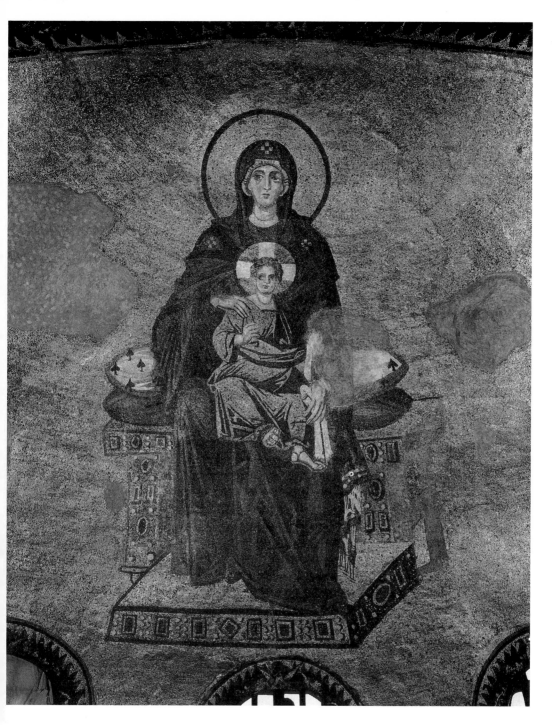

97. *Istanbul, Hagia Sophia, interior facing east*

98. *Istanbul, Hagia Sophia, apse mosaic, 867*

icons and thus makes no distinction between panel pictures and mural pictures of heavenly persons. The physical reinstatement of images that had been violently removed was presented as an act of atonement. At the same time, there was a massive invocation of a tradition whose very existence had been denied by the iconoclasts. After all, something could be *restored* only if it had *existed* previously. The decision about the *true* tradition was now final. In the face of the new images, the public was exposed to the visible proof of orthodoxy. In addition, the unity of church and state was demonstrated by the very ceremony of unveiling the images.

When this unity was broken in 906 by the fourth marriage of Leo VI (886–912), reconciliation was sealed in 920 by a pictorial document that made official the emperor's penitence before his heavenly sovereign. The famous mosaic above the Emperor's Door records not just Leo VI, who provided the immediate occasion for it, but any subsequent emperor, who must also assume a prostrate position as servant before the throne of God in the church of the patriarch.[8] Mary is interceding for the remorseful emperor, while the somber punitive angel on the other side reminds the initiate of the angel to whom David confesses his repentance in Psalm 51. The enthroned Christ, who reproduces a model from the throne room (sec. a above), is cited like an icon. In the text of his open book he extends a conciliatory greeting to the emperor. His face, with its long, parted hair, a lock of which falls across his forehead, and the three-dimensional rendering of the hair about the neck follow the type of the icon already reproduced on the first Christ coin after 843. It is the official portrait of Christ that the victorious party prescribed for general veneration at the court. From now on it determined the appearance of the Pantocrator in Byzantium.[9]

Our account of the events that gave rise to the mosaic may not be generally accepted. The emperor might also be Leo's father, Basil, who was defeated by Patriarch Photius.[10] But whatever the answer, one cannot but speak of a unique image that was possible only in the short period of church dominance over the emperor. The image contradicts the usual representations of the emperors and thus makes a statement of true political significance. After 843 the emperor had presented himself as the guardian of orthodoxy in word and image. Among the profane decorations of the Great Imperial Palace under the new dynasty, one could admire group portraits of the imperial family in which even the children of both sexes held scrolls bearing texts from Holy Scriptures.[11] This made it plain, as the chronicler notes, that they "shared in divine wisdom." In an inscription the children thanked God for having raised their father "from Davidic poverty and hast anointed him with the unction of Thy Holy Ghost." The emperor's victories were related to the life-giving cross on the ceiling, which had clearly kept its right to appear in such contexts.

c. New Pictorial Programs in Churches of the Court

The emperor's policy toward images was manifested above all in the new pictorial programs for church interiors, which were clearly designed with the backing of the court. The current view, according to which the church programs appear truly spiritualized and a pure expression of theological visions, will hesitate to ascribe an active role to the state in bringing them into being. Nevertheless, both the chronology of

events and the preaching activity of the emperor point in this direction, so that both will need to be considered further. In my opinion, the state had a solid interest in expressing the religious unity of God's realm on earth both by way of liturgy and by the visual appearance of churches, in which the icons played an important part. It was a welcome result when the layout of images in churches reflected the everlasting hierarchy of the heavenly court and thus strengthened the central authority. Wherever programs were described, it was the universal ruler Christ with his retinue of angels that dominated the pictorial history of salvation. Only much later did the emphasis shift to ecclesiastical interests and the programs include canonized bishops and depictions of liturgical subjects.[12]

It is no accident that the account of the pictures made for the throne room reads like a description of a church interior representing the whole Christian cosmos. The images not only celebrated the triumph of orthodoxy but also integrated the emperor and the earthly hierarchy (including the patriarch) in the context of the cosmic order. While narrative pictures were conspicuously absent, a well-balanced hierarchy of single figures—that is, icons—together made up a large "group image" of the church as a whole. The program was in a way completed by living people, who filled the actual space in front of the images. Images (of holy people) and living people mirrored each other, thereby confirming the icon's claim to represent reality.

The heavenly hierarchy corresponded conceptually to the one empire (and its church) on earth. According to his biography,[13] Emperor Basil (867–86) sumptuously restored or rebuilt twenty-five churches in Constantinople, eight of which were in the palace.[14] Whereas we seldom learn anything about their decoration, the so-called New Church (*Nea Ekklēsia*) in the palace is an exception. Consecrated in 880, it had five domes resplendent with gold mosaics, whose rich decoration impressed the emperor's biographer more than did the icons, of which he says nothing.[15] In reference to another church in the palace, consecrated to Christ, he mentions only the icons, painted in glowing enamels and mounted on costly silver chancel screens.[16]

Icons, as a rule, are celebrated by sermons delivered at the occasion of the consecration of churches and providing a welcome opportunity to defend the policy on images. Two such sermons were given by Emperor Leo VI (886–912) in person, one in a monastery church built by Patriarch Kauleas,[17] and the other in a church founded between 886 and 893 by the emperor's father-in-law, Stylianos Zaoutzas (text 12).[18] Leo gives special attention to the Pantocrator in the dome, taking the opportunity to consider the dual nature of Christ. In the church of Stylianos, the figure is surrounded by the hierarchies of angels, which the emperor uses to draw an analogy to his own court. In the other church he emphasizes the imperial character of the gold in the mosaics.

This survey may elucidate the active part played by the court in restoring the images to the church interiors, whether in alliance or in rivalry with the activities of the patriarch. It is therefore appropriate to consider the practice in more detail and to analyze the role that the restored images played in contemporary society. The icon, after all, symbolized the new unity of the empire. When peace came, the two conflicting traditions in the church, one with images and one without, required an unequivo-

cal decision *for* or *against*. Even during the short interlude of iconoclasm, the search for the religious and cultural identity necessitated a philological search for authentic sources. In this situation the image became an effective symbol on which the issue of the unity of faith could be focused. It was in the name of the image that the conflicting parties had to come to terms. The oath of allegiance was required for the image, whose justification was supplied both by the theory of images and by the practice or function of images in church decoration and liturgy.

d. Church Decoration: An Applied Theory of Images

The theory of images, as we have said, had to deal with two very different issues. It first had to discredit iconoclasm with theological argument, and it also had to prevent an abuse of images and their exaggerated veneration by exercising a disciplinary control, again on a theological basis. The church was confronted with existing images that were credited with miraculous power. In order to control their effect and to distract attention from magical expectations, images had to be explained rationally, emphasizing the immaterial presence of the archetype and devaluing any material presence of the image as object.

Such theological efforts, however, certainly were no powerful weapons against the danger of idolatry and, in addition, were far from being understood by the common people. The church therefore resorted to the practical solution of taking the images under firm control and using church decoration as what we might call an applied theory of images. There always had been churches with images, but now images were presented both in the framework of a well-devised program and in a function that allowed for a carefully guided, and strictly limited, kind of worship.[19]

To achieve this goal, images were offered for veneration under well-defined conditions. They had a predetermined location in the churches and also were given a specified function in church ritual. The church thereby expected to direct the attention of the faithful first and foremost to official liturgy, which was the primary means of ecclesiastical self-representation. Image and liturgy related to each other in such a way that the liturgy contributed to the control of the image and prevented any para-magical excesses.[20]

The priest himself took charge of the veneration of the image by displaying and kissing it according to a liturgical order. This practice openly sanctioned the veneration of images but at the same time strictly regulated it. Icons were daily exchanged with the saint of the day, as we learn in a rule (typicon) composed in 1136 by Emperor John II for the monastery of the Pantocrator in Constantinople.[21] Murals, according to this rule, sometimes were treated as icons and, as a consequence, were honored in the same way with lighted candles when their turn arrived in the liturgical sequence. The place of the individual image was defined both by the many images around it and by the equalizing effect of the common liturgical usage (cf. text 20).

The equality of the icons was ensured by including them in the church's calendar of feasts and saints.[22] The church decided *which* icons were to be venerated and *when* their turn came. Only the images of Christ, the Virgin, and the titular saint of the church were given a permanent place at the entrance to the sanctuary (chap. 12d).

Wall paintings had to be arranged in such a way that the temporal (liturgical) rota was converted into a spatial sequence of paintings, which in addition marked out the hierarchy of the feasts and saints. The commemorative image was linked to the commemorative liturgy, regardless of whether the image concerned was a portrait of a saint or a depiction of the event or concept of a feast day.

e. Liturgy and Images in Church Interiors

Middle Byzantine church decoration, which introduces us to images in their original location, in theory made no distinction between the different media of panel and wall painting. The frescoes in St. Sophia at Ohrid in Macedonia, dating from the mid-eleventh century, give us a clear proof of the equation of wall painting and icon. The portraits of the saints are set within painted frames complete with hooks, as if they were an actual gallery of movable pictures.[23] They do not obey the usual laws of wall decoration but represent individual pictures in a closed system and in a given space. The location in space as well as the formal presentation of the individual image governed how the individual interpreted it. Church decoration was thus given the consistent iconic character that distinguishes it both from the window illusion of classical interiors and from Oriental tapestry.

The gaze of one entering a Byzantine church will be directed upward to the central dome and forward to the cult niche behind the chancel, the two poles of the decoration. The dome is inhabited by the figure of Christ, who looks downward as the ruler of the universe from the apex of the church, symbolizing the vault of heaven—as if through a window, as Byzantine texts express it.[24] The apse is inhabited by the human Mother, who, by holding out the Child to whom she has given birth, emphasizes the idea of the incarnation of God, a paradox of faith. Her virginity as a mother, expressed by her youthful appearance, adds a second paradox to the paradox of a human mother of God and thereby deepens the mystery of faith.

Otto Demus has described how the murals are so closely tied to the church interior they occupy that they become, so he argues, "spatial icons," which in turn transform the church interior to a "picture space."[25] The beholder is deliberately drawn into the pictures, which seem to belong to a common space that allows one to meet the saints without respect to time and place. The gold foil of the background avoids any specific setting that would remove the picture from the beholder. In addition, the lack of picture frames avoids the usual "window experience" by which we are kept at a distance from the reality of the picture. The saints, so the faithful viewer believes, are "here" right where the viewer is; their frontality allows the beholder to exchange glances with them and to worship them. The beholder loses, as a result, the feeling for the so-called aesthetic boundary that usually contrasts the reality of the picture with the viewer's own reality.

Besides the portrait, also the narrative of the story of salvation is fitted into the order of feasts in such a way that it seems to take place not in a remote historical time but, like the liturgy, in the present time of the beholder. Also the narrative images exist nowhere else than in the very church interior—that is, the site of the liturgy. They usually single out the few protagonists of the story represented, who, like the

portraits, appear against the uniform gold foil of the whole interior. This "deconcre-
tization," as Kazhdan calls it,[26] paradoxically brings about an enhanced sense of re-
ality. The liturgy also tends to perform the historical event in the present. The
Communion of the Apostles in the apse of St. Sophia in Ohrid (Macedonia), a
fresco from the mid-eleventh century, does not portray the historical event of the Last
Supper in Jerusalem, but a contemporary ritual, which reenacts the event every day.[27]
The communion of the faithful, which took place in the room before the image, is
literally prefigured in the apostles' communion.

The Ochrid painting does not actually depict the offer of both bread and wine, as
is represented in the thirteenth-century apse of Sopoćani (Serbia);[28] rather, it chooses
the consecration of the unleavened bread, which is emphasized in Christ's hands.
This, as a controversial issue of the time, underscores the liturgical meaning of the
image, which also alludes to the liturgy by showing a contemporary altar with a bal-
dachin behind the chancel screen where two angels assist Christ the priest in the
manner of deacons. In the lower zone, holy bishops perform as representatives of
the Greek church in the newly established archbishopric in the Balkans. In Sopoćani
the same bishops, carrying liturgical texts, take part in the actual liturgy and thus
complete the symmetry with the apostles' communion above.[29]

The liturgy created its own experience of time, which embraced both the revela-
tion of God in the past and the fulfillment of time in the future. The present was only
a transition to timelessness, which had already begun in the liturgical sphere of the
icons. In this way the image took on a social function. It made visible the world that
the prevailing worldview had defined as the only true reality.[30]

The image cycle in churches matched the calendar cycle of the feasts in that both
form a variable scheme with a few fixed elements within a given frame. The given
frame was the church interior, built according to a unified plan with a central cupola,
four arms in cruciform layout, and a tripartite choir extending to the east. This
space, which also was the site of liturgy, housed the recurring elements, namely, the
portraits of the saints and the narratives of the church feasts. This arrangement varied
in detail from church to church but in principle was a canon based on generally re-
spected rules.

Two monastic churches in central Greece clearly illustrate the aesthetics of church
decoration. The older one, dedicated to St. Luke (Hosios Lukas) in about 960 by
Emperor Romanus II, was enlarged to form the existing main church in the early
eleventh century.[31] The other one, the monastery of Daphne, was built near Athens
about 1100 and still provides a good idea of a mosaic church interior, despite the loss
of parts of the mosaic surface and the marble facing.[32]

The saints as well as the narratives were separated by architectural features, such
as cornices, corners, and windows, and became further emphasized as autonomous
images by their ornamental frames. The individual image was more closely linked to
the church interior, where it "inhabited" a kind of niche, than it was to its immediate
neighbors. The Annunciation, for example, is set apart first by a vaulted squinch and
then by a decorative frame. In the wall paneling below, niches for individual images
or, as in the case of the Crucifixion, broad frames of polychrome marble isolate the

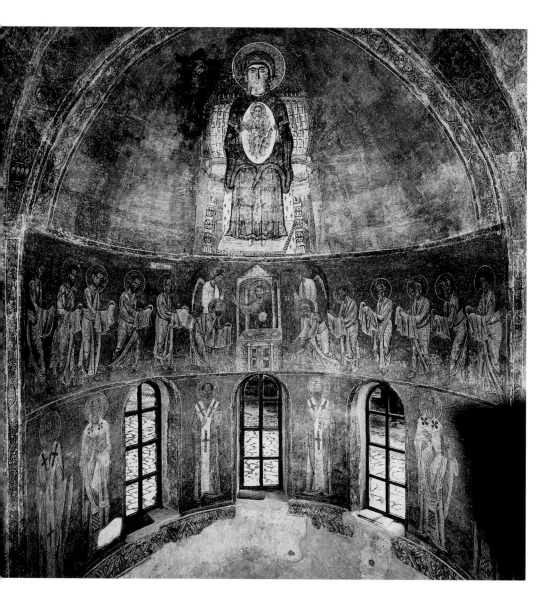

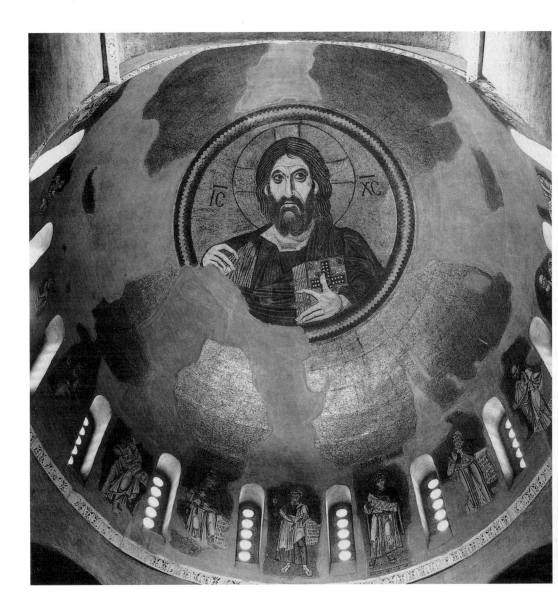

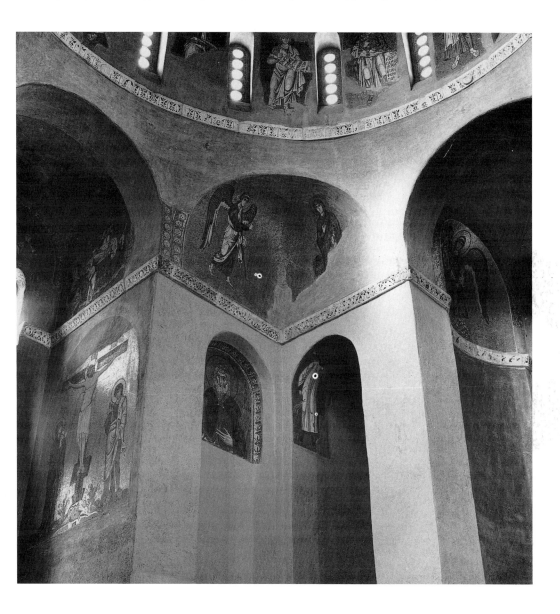

images from their neighbors. Good examples of this device survive in the late Byzantine church of the monastery of Chora (Kariye Camii) in Istanbul.[33] In Hosios Lukas the niches in the vestibule frame the icons by broad, meander-like patterns.

The decoration of Daphne and Hosios Lukas provides the best model for analysis of church interiors of the time. Nea Moni, a third eleventh-century church, situated on Chios, varies the scheme by adapting it to a different type of interior.[34] The spatial configuration of the interior, with its dome above the quadrature and its sequence of spaces from vestibule to chancel, was not merely an architectural framework but also a symbolic setting that conditioned the experience of the images and defined their particular message.

The image of the Universal Ruler appears at the zenith of the principal dome (i.e., in heaven) either among the angels as spiritual beings or above the prophets, who had announced the manifestation of God in the flesh and hence comment on the theological reality of the dome image. The vertical sequence, which is also an order of rank, is supplemented from below by a horizontal sequence (in an east-west direction) of saints' images, often arranged according to status (bishops, martyrs, confessors, virgins). In Daphne, we recognize in figure 101 a deacon-saint beside the high priest Aaron.

The dome is divided from the saints' region by a cycle of feast images, running in two zones around the whole church. These images mark the stations of Christ's life, from annunciation to ascension into heaven. They are preceded by scenes from the life of the Virgin that prepare for the events to come and are extended by the death of Mary, representing, as it were, the opposite pole to that represented by the Virgin mother in the apse. The arrangement of narrative events repeats the anamnesis of the life of Christ in the liturgy, as it also marks the content of the high feasts of the church year. In the vaulting, interrupted only by the chancel, we find the feast images, either mounted on the window walls, like the Birth of the Virgin, or presented in squinches, like the Annunciation. In the transepts further images are added below them, such as the Crucifixion.

The composition required visibility from a distance. Equal dimensions, a symmetrical arrangement, and the overall gold background together with the standard size of the figures create a sense of internal order. The images are conceived as single icons and at the same time form part of a sequence following the architectural structure, as if the scenes depicted were taking place within the same space and against a common horizon, an impression then familiar to everyone by the liturgy.

The saints were sometimes shown in three different portrait formulas—as standing figures, as busts, and as medallions in the vaulting. In Hosios Lukas, where there was little space available, the vestibule was incorporated into the pictorial program, and in the "chapels" in the transepts, large half-length figures in the wall lunettes and medallions in the vault extend the program further. The symmetrical distribution of portraits in each "chapel" creates a spatial unity that suggests a community among the figures.

In the vestibule a monumental bust figure of the Pantocrator above the entrance door communicates with the portraits of the Virgin, John the Baptist, and two angels

in the vaulting. This group portrait, the so-called deesis, which usually forms an icon frieze, in this case is distributed in a spatial arrangement connecting the *spatial* order with the *thematic*. The saints on the vault are meant to appear before the divine Judge as advocates of humankind.

In the movable panel pictures the deesis is one of the two main themes of the icon beam at the entrance to the chancel. The interceding saints on the iconostasis form a frieze of individual icons whose common intercession also creates an internal order, which is well in keeping with the spatial order (chap. 12d). *145, 154*

The iconostasis, which also carries the cycle of high-church feasts, repeats the program of the wall images on a smaller scale and in the different medium of panel paintings. The two cycles are related even more closely to one another when the movable panel paintings are permanently set up on the iconostasis beam. *137*

One can speak of a liturgical art of the icon that retains its characteristic features regardless of setting, genre, and technique. The liturgical space is the functional context of both wall painting and movable panel painting. It thereby takes on the quality of an immense, universal pictorial space in which all the individual images participate. The analogy with the liturgy, which also takes place within this space, is evident. The two levels of reality—the historical event and its liturgical reenactment within the church—are virtually inseparable. This is best illustrated by a twelfth-century miniature in a manuscript of the sermons on the Virgin by a certain James. Here the Ascension of Christ takes place within the interior of a Byzantine church.[35] The church, with its calculated array of icons, is a visible expression of the theory of images. *105*

The conflict over iconoclasm was brought to an end by an official doctrine of images, which, in addition, were given a calendar (the ecclesiastical year) and a stage (the church interior) for their veneration. The liturgical commemoration of feasts and saints and the veneration of the respective images were parallel acts of performing the duty of the church. Liturgy, which the church administered on behalf of the faithful, had a well-defined form, at once official and tightly regulated, thus becoming the opposite of private piety. When its characteristics pass over to the images, the latter become liturgical images. The ritual, too, with its never-changing sequence of ceremonies and prayers, transforms the objects of memory into the experience of events that take place in the present time. The images evoke the past events from salvation history, bringing them to life within the timeless reality of the liturgy.

The liturgy, which was performed at the same place and revolved within the same annual cycle, shares with the images both the place and the same time sequence of veneration. Finally, the arrangement of the images duplicates the general hierarchy that made up the community of saints. In this respect no saint's image could have a rank equal to the images of Christ and the Virgin. Only the titular saint had a place of honor as the patron of the church in question. A kind of pictorial topography assigned particular areas of the church to canonical images—for example, the cupola to the Pantocrator. The iconostasis, composed of movable paintings installed between the congregation and the sphere of the priests, repeated the program on a small scale where panel painting performed its most important task. Here the icons themselves

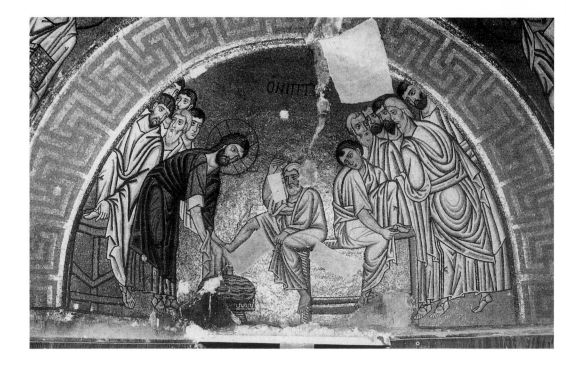

102. Hosios Lukas, *monastery church; atrium mosaic, 11th century*

103. Ohrid (Macedonia), St. Sophia; wall *icon, ca. 1050*

104. Hosios Lukas, *monastery church; atrium, vault mosaics, 11th century*

180

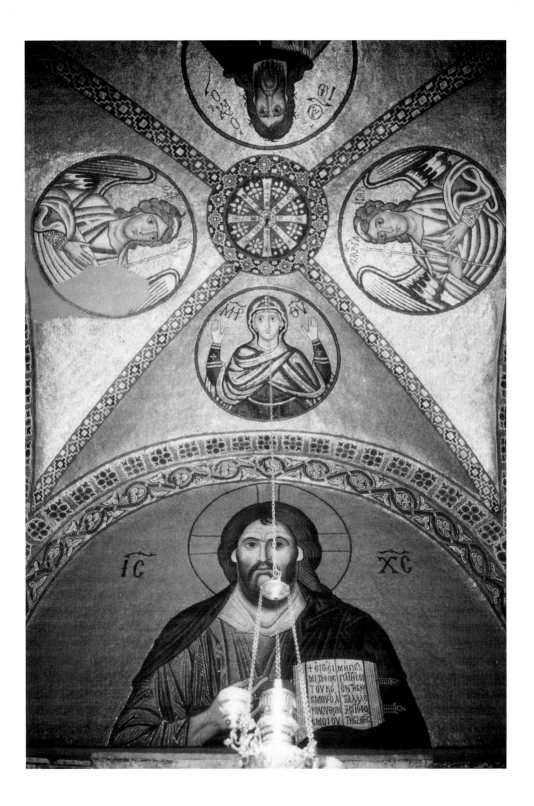

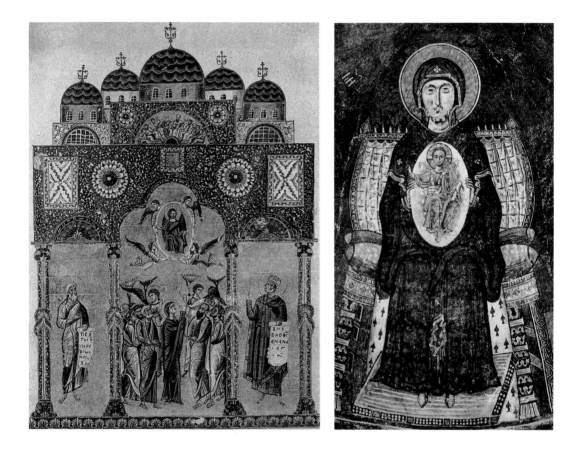

became an object of liturgical actions, as they were displayed and addressed with hymns. The so-called *proskynēseis,* or icons of the day, were set out on a given day for veneration on a special stand, the *proskynētarion.* Even in the reports of Maximus the Confessor from the seventh century (text 7B), we hear of the kissing of the icons of Christ and the Virgin, though only on special occasions. After iconoclasm the icons of the iconostasis began to be kissed during the liturgy of the so-called *proskomidy,* and on the Sunday of Orthodoxy the kissing of Christ's icon is mentioned in the prayers.[36]

In this way the church gained control of a medium that had once threatened its authority. An activity that had been carried on outside the official church now was incorporated within it, its features controlled by the church. The same state authorities who had banned religious images at the outset of iconoclasm now, jointly with the church or in its name, introduced images firmly into church practices.

The effects of the new practices involving images were considerable. As an obligatory part of the church inventory, images were given a fixed *place* and a precisely defined *function.* By elevating *every* image to the same rank, where it qualified as a representative of the person depicted, the doctrine of images sought to dispel the magical fascination that certain images exerted as physical objects. The philosophical explanation denied the image's miraculous power and defined the image with a pictorial type that could be duplicated at will. It was to be of no importance which example of the image one used to appeal to a saint. The theory of images was thus as much an attempt to rationalize the image as the church practices were an attempt to regulate it. The objective was to forestall any cult of the image as such, for according to liturgical practice and theory there were no cult images in the sense of privileged images. The theologian Konrad Onasch therefore speaks of *Kultusbildern* ("cultic images"), as against *Kultbildern* ("cult images"), to accentuate their role in church worship as against the private cult.[37]

The *form* of the image, or, more precisely, the *resemblance* of the image to its original, was not tied to a particular example but was interchangeable and repeatable. In principle, one image was as good as another, and none was privileged. Nevertheless, privileged images that received special veneration continued to be worshiped, as their cult already had a long tradition. The persistence of religious practices favors the survival of early customs. The cult of privileged icons in Byzantium is the subject of the next chapter.

The distinction drawn between miraculous icons and images according to their liturgical functions cannot, however, always be maintained. A telling example is the Virgin in the apse of the cathedral at Ohrid in Macedonia (cf. earlier in this sec.). It has a common place within the program, but it is not a common type of image. The Mother of God here holds out her son on an image shield,[38] reproducing the archaic icon of the *Nikopoia,* the example used being the one discovered in 1031 in the Blachernae church of Byzantium behind brickwork dating from the time of iconoclasm.[39] Archbishop Leo (1037–56), who commissioned the frescoes, thus symbolized the triumph of the victorious Byzantine church in the Balkans by quoting a famous icon, though integrating it in the standard type of liturgical church decoration.

106
63

10. Pilgrims, Emperors, and Confraternities: Veneration of Icons in Byzantium and Venice

After the iconoclastic controversy church interiors typically contained a fixed arrangement of liturgical images, although many places had some striking exceptions. Pilgrims continued to flock to shrines with famous miracle-working images. Beginning around 1200, accounts of Russian pilgrims tell of the numerous relics and icons they encountered on their pilgrimages to the imperial city of Tsargrad, or Constantinople.[1] Because some of the precious objects there came from the Holy Land, Constantinople seemed to the pilgrims like a New Jerusalem.

Not only the pilgrims traveled. The icons themselves moved about in weekly ceremonial processions, turning Constantinople into a huge stage for their worship. Confraternities took responsibility for staging the various ceremonies. Tuesdays, for example, belonged to the *Hodegetria*. On the anniversaries of the icons, people visited an icon's "home" temple, where they would listen in wonderment to legends about the icon's age and supernatural origin and about the miracles the icon had performed in battle or in punishing unbelievers. Sermons delivered on such occasions helped to reinforce the aura of the icons, which were treated much like dignitaries who received visitors and who themselves paid ceremonial visits. Constantinople, as home for the icons, was thus a community unified under God's protection.

The unity of the city was further enhanced by a third kind of public worship: one administered by the court. The so-called Book of Ceremonies compiled by Emperor Constantine VII in the tenth century contains the rituals surrounding the imperial visits made on the church's major holy days and the feasts of the various Marian churches.[2] These visits provided the public with their only chance for seeing the emperors in person. Officially representing the state and all of society, emperors would perform their personal veneration in front of the icons. Emperors thus could display openly their personal piety, which their office required. Forsaking their otherwise secluded life in the palace, emperors appeared publicly before the city's heavenly patrons according to a sequence of processions governed by the liturgical calendar. The practice probably had its origin in the stational liturgy performed by the head of the church, apart from the imperial rituals of late antiquity. Even in the Middle Ages the patriarch proceeded with his clergy to the different stational churches in the city, following the calendar of feasts. Such movement embraced and unified the local worship of the entire city.[3]

Finally, the awe-inspiring "history" of these icons and relics, as reported by chronicles and legends, seemed to guarantee the continuity and identity of the Byzantine empire. The emperors counted on the support of miraculous images that in bygone days had granted the city heavenly protection and stunning victories. While the outside world was bound to face change, Byzantium seemed unaffected by it. The city thus consciously ignored the rupture that iconoclasm had caused, being interested in the controversy only insofar as one could demonstrate that a particular icon

had survived the turmoil unscathed through a miracle or through exile. The icons both reinforced collective memory and were a focus of it. The exercise of this memory both within Constantinople and throughout the empire assured collective continuity and identity. Their age could guarantee not only their own authenticity but also that of the shared history of both icons and believers.

a. The Emperors

In examining the threefold context of pilgrimages, processions organized by confraternities, and visits by the court, we learn of the existence of icons that were not like the others but had a character of their own by virtue of their pedigree, their place of residence, and their miraculous feats. The practices associated with such icons trace back to the early centuries of Byzantium, when these images reputedly originated. In them a magic rooted in the object itself continued to operate, despite all rationalizing theology and regulated piety. As a divine pledge, icons embodied their owners' hope for salvation and worldly success. The owner of a divine pledge was protected, come what may. Such a belief led to icons' being taken into battle as early as 600, a practice that continued in the Middle Ages. From early times, the empire thus was eager to bring in to its capital miraculous images that were housed in outlying areas (chap. 4a). In 944, for example, the emperor rescued the True Face of Christ from Edessa in northern Syria and brought it to his palace chapel (chap. 11b). Finally, icons, like relics, were used as oracles that could miraculously approve or disapprove a planned undertaking. In the eleventh century, for example, Empress Zoe possessed a small icon of Christ that "responded" (the Greek word referring to it is *antiphōnitēs*, or "one who answers") by turning pale when disaster threatened (text 16).[4]

When Emperor Romanus III (1028–34) was trying to rally his forces after their defeat at Antioch, "someone came up with the icon of Theometēr [the Mother of God], the image which Roman emperors habitually carry with them on campaign,"[5] as a "guide [*stratēgos*]" and "guardian [*phylax*]" of all the army." The emperor at once took new heart and "embraced it," weeping, recalling "those many times when She, his ally, had rescued and saved the Roman power in moments of crisis."

In the tenth century Emperor Tsimisces captured a miraculous icon of the Virgin as booty in the Balkans and mounted it, together with the royal insignia of the Bulgars, on his chariot in the triumphal procession, as shown by an illustration in the Madrid codex of the Chronicle of John Scylitzes.[6]

In the war against the Normans in 1107, Emperor Alexius left the city in a state of unrest, as the Mother of God in the Blachernae church, which contained the mantle of the Virgin, "had not performed the usual miracle" on his departure.[7] This miracle involved the curtain before the main icon in the church, which allegedly drew itself aside at vespers on Friday, returning to its original position only on Saturday evening (cf. texts 13 and 15).[8] During this "usual miracle" the Virgin spoke like a living person. Emperor Alexius postponed his campaign for four days when the miracle failed to happen. Then he "went back with the empress. They entered the [church] secretly with a few others. He sang the usual hymns and prayed with great fervour. There followed the customary miracle and so with good hope he left the sanctuary."[9]

107

There was a close link between the relic and the image of the Our Lady of Mercy, the first of its kind. The appearance of the icon, which was reproduced on eleventh-century coins commemorating the six-hundredth anniversary of the foundation of the church, we know well from a life-size marble copy found during excavations in the Manganes quarter of the imperial palace.[10] The Virgin, seen frontally, lifts both hands in such a way that her mantle—the same one that was kept in the church—slips back visibly along her arms. As a cult image, the original was concealed from view by a curtain in order to make a stronger impression when revealed on the weekly feast day. The icon, which also was called upon for legal matters, was thus a public oracle, as Empress Zoe's icon of Christ was a private one.

The church of the Virgin in the Blachernae quarter was a prominent stop on the emperor's visitation program. Here the emperors received a cultic washing, or "mystical therapy," in a bath of beneficent water flowing from "the marble icon of the Mother of God which pours out holy water from her holy hands."[11] The report in question offers a glimpse of the topography of the church with its chapels (cf. text 14). It sheltered icons of such different materials and media that there is considerable confusion as to their various names or titles. Apart from the chief icon, which acted as an oracle during the miracle of the curtain, there was a famous fountain icon that dispensed healing water. An old icon in which Mary presents her son on a portrait shield had been rediscovered behind masonry in 1031 (chap. 9e). A Virgin Orans holding a medallion of her son in front of her womb unifies the characteristics of this rediscovered icon and the chief icon.

In their public veneration of icons, the emperors first kissed the image cloth on the altar of the main church, then repeated the same act before the altar of the relic chapel (soros) of the Virgin's mantle, which they entered through the "imperial doors." Then they stopped before the so-called Marian icon of the visit (episkepsis), before which they prostrated themselves. Perhaps the icon took its name from being visited by the Virgin during the weekly miracle.[12] In a kind of private chapel (metatorion), they bowed before "the icon of the Virgin and the silver cross" that were kept there. In a complex ritual, after wrapping themselves in golden towels, they ascended a staircase to an upper level where they entered a "holy bath" (lousma). There they venerated the "silver icons of the basin" (kolymbos) and, in the east concha, the "silver icon of the Mother of God" erected above the fountain (phialē), on whose left "the imprint of the hand of the Mother of God is pressed into the marble and mounted in silver." On the way back they visited the chapel of St. Photeinos "in the inner rotunda" and honored "the marble icon of the Mother of God, from whose hands holy water flows" (text 14).

We have little idea of the layout of the Blachernae church complex, as it was razed after the Turkish conquest. Still less can we judge what were the locations, types, histories, and names of the various icons of wood, stone, and silver. But we gain an insight into the possible reasons for the choice of different materials, such as marble and silver, when icons were placed in baths or on exterior walls. Sometimes there is a direct relation between an icon's form and its function—for example, when a fountain figure dispenses healing water, the water flowing from it as if by its own will. We

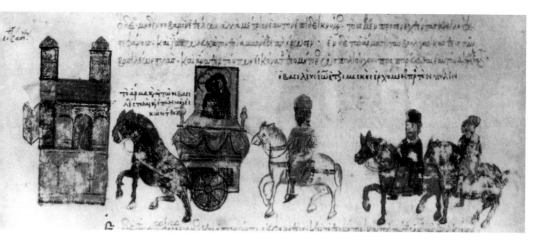

107. *Madrid, Biblioteca Nacional; Cod. Vit. No. 2, fol. 172v; depiction of a triumphal procession with a Marian icon, Chronicle of Scylitzes*

108. *Istanbul, Archeological Museum; marble icon of the Mother of God, 11th century*

109. *Istanbul, Archeological Museum; fragment of Marian icon in marble, 11th century*

hear of similar properties attributed to metal figures of saints mounted over their tombs, dispensing healing oil from openings in their faces or hands. Here, relic and image were inextricably linked.[13]

108 The relief from the Manganes quarter, mentioned earlier in this section, illustrates the form of such marble icons in the eleventh century. An extremely thin layer of relief, rising from the flat ground and centered at the face and limbs and in the folds of the garment, conveys an impression of bodily presence. This very modest relief did not violate the taboo against three-dimensional forms but yet sufficed to convey the suggestion of a living image. The name of the icon is inscribed on two small tablets that look like appliqués.

The polished surface has been destroyed in the region of the head. We can judge
109 the appearance of this Virgin, however, from a fragment in the Archeological Museum of Istanbul that, as far as I know, has never been published.[14] Although this museum piece belongs to a different type of Virgin figure, its turning head nevertheless indicates that in artistic conception, it is closely related to the large relief in the Manganes quarter. The surface, with its delicate shifts and soft transitions, strongly resembles that of a painting. Besides this genre of icons in relief, other icons retained their flat surfaces but used colored cut stones. A large number of such marquetry works were excavated in a monastery church in Constantinople founded by a certain Constantine Lips in the tenth century. A St. Eudoxia—the empress who was said to have introduced icons from Jerusalem—comes close to being a painted icon in its polychromy, which stands out against a white marble background.[15]

The "silver icons" mentioned in the description of the Blachernae church survive in items that have a silver sheet covering the painted parts while leaving exposed just the head and hands of the figure.[16] Such metal icons with covered surfaces are rare, surviving only in the Caucasus in Georgia, starting with early items from the eighth century. They have been published in their entirety in a work of several volumes.[17] They also include triptychs with wings that close over the cult image, one example being an icon two meters high donated by the king to the monastery of Kachuli in the twelfth century.[18] This icon is one of the Virgin as advocate, named after the Hagia Soros, or holy shrine, in Byzantium. It is mounted in enamel and jewels and inlaid with a combination of colored stone and another material, now missing.

110 Two eleventh-century icons of St. Michael in the treasury of S. Marco in Venice, clearly booty from the conquest of Constantinople in 1204, stand out from surviving works by the quality of their combined embossed work and enamel.[19] They are variants and copies of original icons, which overshadowed them by their wealth of material embellishment. Though, as a norm, the old icons were still painted panels, the rich variety of techniques in which later icons were made, such as those in the Blachernae church, is entirely fitting for such icons' being objects of veneration by the emperors.

b. Confraternities and Processions
Not only the emperors but also the patriarchate exercised control over the cult of icons in the capital, as did the monasteries that owned famous "originals." The em-

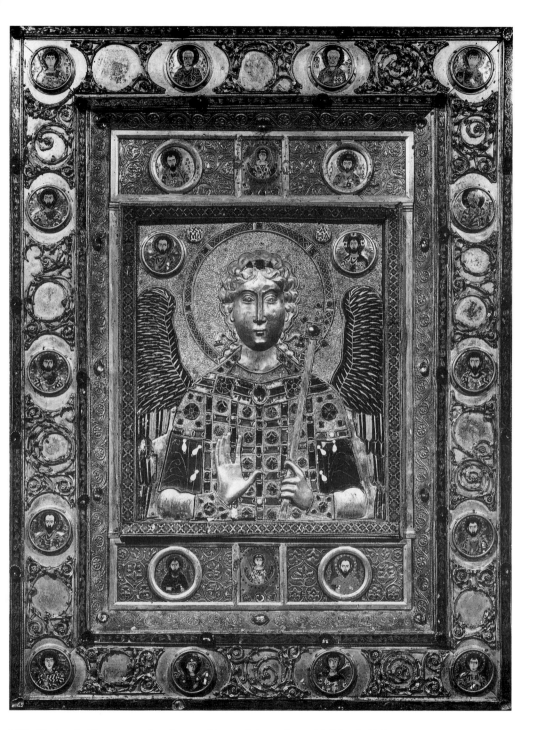

110. Venice, S. Marco; metal and enamel icon of the archangel Michael, 11th century

perors, for example, called upon images that resided outside their private domain (such as the *Hodegetria;* chap. 4e) and in turn lent out images belonging to them. Within the monasteries lay confraternities had taken over part of the management of the cults, which in A.D. 1000 were already known as an old tradition. A ceremonial sermon referred to such a tradition in its mention of the Marian icon called the Roman Virgin, which was kept in the famous Marian church near Hagia Sophia in the Chalcoprateia quarter, so called because it was home of the smiths who worked in bronze and silver.[20] This virgin was turned sideways in intercession. This same church housed the Virgin's girdle in a relic chapel, or *soros,* hence the icon was also known as the Soros Virgin. There is also evidence from as early as 1027 of a long-standing confraternity for the church of the Virgin in the Blachernae quarter.[21]

The icon referred to in the sermon was called Roman because it had survived iconoclasm by traveling miraculously to Rome by sea. It was said to be a replica of an acheiropoietic image from Lydda in the Holy Land. After its voluntary return from exile, the image was given a new home in the Chalcoprateia church, where a confraternity (*diakonia adelphōn*) was formed to ensure that the icon took part in the Tuesday procession of the *Hodegetria.* The sermon also tells of miracles performed by the icon. We learn that it was customary to drink holy water (*hagiasma*) and holy oil that the icon, like a relic, either dispensed or consecrated through contact. The invocation (*epiklēse*) of its name could drive out demons.

A recently discovered fresco in Arta in northern Greece depicts the procession of the famous *Hodegetria,* whose story has already been touched upon (chap. 4e). The image is carried on a wooden structure covered by costly materials (*podea*) in a procession of laymen (whom we can take to be the relevant confraternity) along the main street (*mese*) of the city, which is lined with shops occupying several stories behind and above arcades. In a Berlin miniature that has been mentioned above, the icon appears under a kind of ciborium or canopy behind a grating, where it had its permanent location.[22]

The emperors also promoted its cult, as the rule of the imperial monastery of the Pantocrator indicates. The founder, Emperor John II Comnenus, decreed that the *Hodegetria* should take part in the liturgy on anniversary days for the members of his family buried there.[23] He wrote, "The divine icon of my most holy mistress and Mother of God, the *Hodegetria,* shall be brought into the monastery." It would be part of the supplicatory liturgy and "shall be left standing at our graves," where the whole monastery must spend the night in prayer. Mass the next morning was to be said before the icon. On its departure money was to be given to the bearers of the icon and "the other servants of the holy icon"—clearly meaning the members of the confraternity (text 20).

Such practices were taken over by the neighboring states of Byzantium. In Serbia, King Stephen (1114–1200), the founder of the Nemanja line, who had taken the monk's habit on Mount Athos, had the "very holy icon" of the Virgin, before which he had sworn to die, brought to him on his deathbed.[24] Accompanied by the icon, his remains were taken in procession to the Serbian monastery of Studenica. In the presence of the corpse or at the graveside, the image was asked to intercede for the de-

111

24

112

11. Arta (Greece), church of the Blachernae; fresco depicting a procession of the Hodegetria, *13th century*

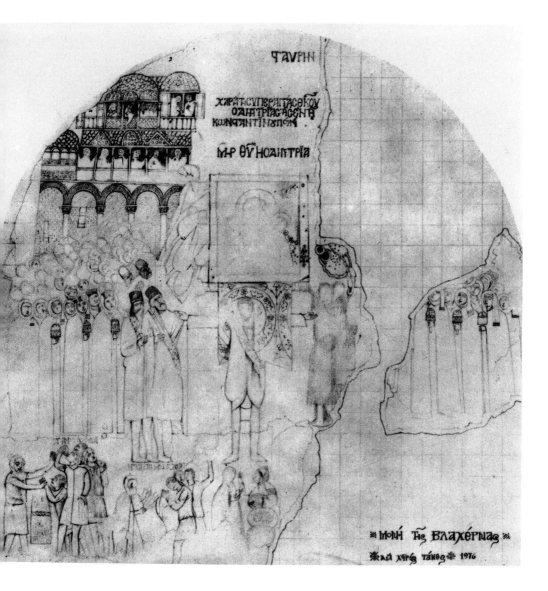

parted, being treated as though it was a person. Much the same situation happened in Constantinople whenever the *Hodegetria* went "into the city."[25] It and other images were taken to the very place where help was needed, which is consistent with their role as intercessors. An invocation (*epiklēsē*) to the *Hodegetria* leads to Mary's addressing a letter to her Son (chap. 12d), much as the invocation of God in the liturgy of the Eucharist leads to the transubstantiation of the bread.

113 A similar icon of the Virgin, though without the letter, forms the frontispiece of a book of statutes of a confraternity dedicated to Marian service. Since its foundation in 1048 as a confraternity of prayer, this association of merchants in the region of Thebes and Corinth had venerated a Marian icon that had its residence (*stasis*) in the monastery of St. Michael at Naupaktos.[26] There the confraternity gathered once a month before taking the icon in procession, accompanied by hymns, to the house of one of the members (*adelphotēs*), where it took up residence for the month. The surviving document, now in the Cappella Palatina in Palermo, was produced on the occasion of the renewal of the statutes in the twelfth century. It was signed by the members, who called themselves "servants of the most holy Mother of God of Naupactus." We possess no clearer view of the life of a confraternity and can only regret that no such statutes have survived from Constantinople itself. There too Marian icons received pleas for protection and mediation. Here, as later in Italy, lay society was given its first real opportunity to take an active part in the cult practices of the capital.

c. Pilgrimages and the Program for Visitors to Hagia Sophia

The large churches of Constantinople, where they survive at all, have lost their original appearance with the removal of the relics and icons that once filled them. In centuries past, outside the hours devoted to the liturgy a constant stream of pilgrims from all parts of the known world filed past the famous treasures, and local guides instructed the pilgrims on addressing the icon or relic, which would answer their particular concern. The relics on display in the city ranged from the bodies of the apostles in the Apostles' church of Constantine to the actual cross of Golgotha and the instruments of Christ's passion in Hagia Sophia.[27]

The scene of salvation history, which had taken place in the Holy Land, seemed in the meantime to have shifted in its entirety to Constantinople, where all its material traces and relics survived. Thus the city could claim to be called the new center of the Christian cosmos. There the True Faith was observed, the Orthodox patriarch presided over the church, and the emperor acted as God's earthly representative. Not only were the icons and relics the legacy of an earlier, apostolic era that Byzantium now administered, but they also bore witness to the continuing, visible presence of the divine in the Byzantine centuries. Turning points in the history of the empire had always been linked to the icons' own history. The idea that the city was impregnable (a confidence not shattered until 1204) was founded on the miraculous icons and relics, which were thought to have averted internal and external catastrophes. The pilgrims' visit to the churches of Constantinople thus not only provided a substitute

112. *Studenica (Serbia), main church; fresco depicting the funerary procession of King Nemanja, 13th century*

113. *Palermo, Capella Palatina; title page of the Statutes of the Confraternity of Naupaktos, 1054*

for a pilgrimage to the Holy Land but offered a living history lesson that made palpable the significance of the empire.

The countless churches and chapels in the imperial palace played a special role, but they were seldom accessible to the common pilgrim. We can gain an idea of the wondrous works that were hoarded there (including speaking and weeping images, relics of Christ's garments, and remains of the saints) from two descriptions of the palace chapel near the Pharos (texts 26 and 27). The authentic canvas portrait of Christ from Edessa and its imprint on a brick (chap. 11b) were kept there. On the eve of the catastrophe of 1204 the custodian of the chapel, Nicholas Mesarites, drew up an inventory of the collection,[28] and after the conquest by the Latins a French eyewitness, Robert de Clari, listed everything he saw there.[29] Soon after, the treasures were scattered to the winds. The lion's share went to the Sainte Chapelle of King Louis IX (Saint Louis) in Paris, as the palace chapel was conceived as successor to the Byzantine one.[30] The doge of Venice secured his own portion, however; what he did not want to keep, including Christ's crown of thorns, he sold to the French king for enormous sums.

Apart from the palace chapel in Constantinople, the greatest number of cult objects from the apostolic and Byzantine periods were assembled in Hagia Sophia, where the emperor and the patriarch regularly made joint public appearances. Cult practices therefore were enacted before the population, which represented both empire and city. Both leaders took part, for example, in the September feast of the Raising of the Cross, when the relic of the cross, normally kept in the vault, was displayed to the public from the pulpit. Most of the sacred objects preserved here were constantly on display, however, and pilgrims filed past them according to an established ritual, about which the reports of Russian pilgrims provide a vivid account.[31]

The visits began in a southern outer vestibule. There a mosaic icon of the archangel Michael "officiated" as guardian of the church. The angel would intervene actively if needed, and stories of his spectacular appearances were told. In the inner vestibule, next to the emperor's portal, one could confess those sins one would not wish to confess elsewhere, doing so before a marble icon of Christ that was willing to forgive even the most scandalous sin. On the other side of the portal was a mosaic icon of the Virgin, reported to be an image relic from Jerusalem that reportedly denied access once to the holy sepulcher to a sinful Egyptian woman named Mary until she mended her ways. The icon was thus a reminder of Jerusalem and a warning to pilgrims that they should fear a similar fate if they entered the church in a state of sin.

After entering the church interior through one of the side doors, one would see, on looking back toward the main portal, a full-length icon of Christ, "of which the books write." This may have been the miraculous icon from the palace gate called chalke, which had played a famous part in the critical moments of iconoclasm (chap. 8d). In the left part of the church "the image of our very pure sovereign, the Mother of God," which had healed many sick people, was sheltered by a "ciborium of great artifice." The icon was said to have "wept when the Franks conquered Constantinople." Near the relics of Christ's passion, which were stored in the treasury, was a painted image of Christ crucified, and "from the wounds of his feet ran holy

water that healed many people." Behind the apse, in the chapel of St. Nicholas, one could see an icon of Christ that had bled when pierced by a Jew and that apparently still showed the traces of blood. It may have been identical to an icon of the Virgin and Child, into whose throat a Jew had once stuck a knife. The blood that had flowed was preserved on another altar.

At the entrance of a chapel flanking the sanctuary stood an icon of the Virgin whose tears often flowed together with those of the Child in her arms. Near the main altar was an icon of Christ that the patriarch Germanus had rescued from the iconoclasts by throwing it into the sea and bidding it make its way to Rome. Now it had returned to the city where the True Faith was restored. A similar legend was attached to the icon of the Roman Virgin (sec. b above). The wooden panel of an icon of Christ came, it was said, from the table at which Christ and his disciples had eaten the Last Supper, thus uniting inseparably image and relic. In the southern aisle of Hagia Sophia an icon of the Trinity hung over a table made from the grove of Mamre, where the three angels had appeared to Abraham as a visualization of the Trinity. This icon was no doubt the archetype of the related late-Byzantine icons that repeat the same subject, and so, indirectly, of the world-famous icon of Andrey Rublyov.[32] We now may understand why the table is given such emphasis in this icon once we realize that it was kept as a relic in Constantinople. The image therefore also served as a visual commentary on the relic. It was, finally, a manifestation of the True Faith, which differed from Islam (which also acknowledged the Old Testament) precisely in its recognition of the Trinity.[33]

It is impossible to identify most of the images the pilgrims reported seeing. But their reports convey a clear message. Hagia Sophia offered a real panorama of the empire's history and its instruments of grace. The empire had clearly become the heir to the Holy Land when God's dominion on earth passed to the Roman Empire. Hagia Sophia also appeared as the spiritual center of the empire, whose sacred physiognomy was mirrored in its holy objects. No significant distinctions were made between image and relic, since cult images were by nature relics, even if they were not actually parts of bodies. Finally, the icons assembled here provided tangible proof of all the famous legends in which they played so spectacular a part.

d. San Marco in Venice and Its Icons

After the Turkish conquest Hagia Sophia lost its entire collection of images and relics. Today, however, S. Marco in Venice continues to give us a significant idea of the appearance of such an Eastern pilgrimage church.[34] In its main functions, moreover, this doges' church was based directly on Byzantine models. As a shrine of the remains of the apostle Mark, it emulated the Apostles' church in Byzantium and apparently also duplicated its architecture. At an early date the Venetians ordered liturgical vessels and furniture for their St. Mark's from Byzantium, the most famous of which is the *Pala d'Oro* over the saint's tomb, acquired from Constantinople in the early twelfth century.[35] After 1204 the Venetians imported a large quantity of icons and other spoils from Constantinople, which they had helped to conquer. Only the *Hodegetria* icon of the Virgin eluded them. In the imperial city it was the subject of a

bitter dispute between the Venetian patriarch and the Venetian governor (chap. 4e).
1 The Venetians did, however, succeed in seizing the Marian icon of *Nicopeia,* as they called it, from the chariot of the commander of the Greek army.

The facade of S. Marco, in its present form, is a monumental stage for the columns, reliefs, icons, and the famous bronze horses acquired at that time. In the thirteenth century their collective magnificence expressed the lagoon city's new imperial claims over Byzantium.[36] The marble icons of Gabriel and the Virgin Orans reflect Venice's foundation, which was on the feast of the Annunciation.[37] The pair of icons of two military patron saints, Demetrius and George, consists of an imported original and a Venetian copy.[38] Such "icons of invocation"[39] had their functions even on the
114 exterior of the building, as is evident from the mosaic image of the orant Virgin on the south facade, before which oil lamps still burn today. She received the pleas of those who were to be executed in the Piazzetta.[40]

115 The icon of Demetrius, an eleventh-century stone relief from Constantinople,[41] shows the patron saint of Thessalonica as a monarch on his throne and as a general in armor. He is about to brandish his sword in support of the emperor. This gesture, which fits the enthroned posture badly, shows the icon to be a synthesis of different types, expressing not only the saint's power to win victories but also his heavenly role at the earthly court of the emperor. For this reason the saint wears a diadem like that of an imperial prince. In all these features the relief follows an early Russian icon from
116 the twelfth century, which in turn repeats the painted original from Constantinople, which had clearly been inspired directly by the court.[42] How much the court was attached to this heavenly "ally" is shown by the emperors' attempt to secure Demetrius's remains for the monastery of the Pantocrator in Constantinople. When the attempt failed, they contented themselves in 1149 with secondary "relics of touch" and a part of the lid of the tomb, which would produce oil. These were accompanied by an image that visitors had to kiss and venerate on the anniversary of the "translation" of the relics from Constantinople to Venice. A prayer begged for protection of the monastery "in which you have resolved to let your sacred image be harbored." Although this was not the original, the preacher nevertheless would assert that "if you, Demetrius, are one yet divided by many, your miraculous power [*charis*] is not thereby diminished."[43] Soon afterward, the Russian princes at Vladimir made this cult their own. When the Venetian doges had the relief icon of the saint mounted on the facade of S. Marco, they also became part of this cult tradition, the prerequisites for which had long existed in Venice.

In Venice relics initially enjoyed greater popularity than icons, but cult legends soon lent images the same aura because of their divine origin or their miraculous powers, which people hoped to see exercised. After 1204, with the transfer of cult objects and practices from Constantinople, notwithstanding the dubious aspects of this pillaging of a Christian city, the Venetians were seeking to perpetuate a tradition that had apostolic origins. A religious object could have no greater proof of its power than to come from Constantinople, a source that was readily asserted, even in cases where it was patently untrue. Thus the Venetian replicas and forgeries are to be ex-

plained as efforts to meet the highest criteria of quality. In every way possible, S. Marco was made to resemble a Byzantine pilgrims' church.

It was therefore catastrophic when a fire broke out among the church's treasures in 1231, hardly two decades after they had been assembled. The most important relics were rescued, however, which led to talk of the "miracle" that had spared them. In 1265 Doge Raniero Zeno sent his envoys to the pope with a letter demanding recognition of the miracle. A contemporary stone relief displays the most important relics—including two fragments of the cross and an ampulla containing Christ's blood—as if they were being listed in a document or in a legal protocol.[44] The ampulla in the treasury of S. Marco was traced back to the blood that had flowed from an image of the Crucified in Berytus, or ancient Beirut.[45]

That incident, too, had been a miracle, proof for which was provided when it was repeated in Venice. A painted panel cross, which had stood on the piazza in front of S. Marco "near the first standard in the direction of the Orivolo," was pierced with knives in 1290, the marks still being visible. As a result, the chronicles tell us, it was moved inside S. Marco and placed below the pyramidal ciborium, called the *capitello*, where it has stood on its own altar ever since.[46] The "blessed cult image," as Kretzenbacher calls this genre,[47] responded to the assault with a miraculous flow of blood from its wounds, as if it had been a living person. The blood was preserved on the altar associated with the icon, as is already mentioned in Barbaro's chronicle. In this way the miraculous crucifix illustrated and confirmed the old legend connected to the ampulla of blood owned by the church. The ciborium is a kind of shrine or cella for the painted cross, rather like the canopy of the ancient icon of Demetrius (chap. 5c). For this reason it also bears an image of the Annunciation, recalling the anniversary of the foundation of the Venetian state.

Venice now itself clearly owned a bleeding cult image such as had been worshiped in Hagia Sophia in Byzantium. Magno's chronicle soon was to assert that it had been part of the spoils of 1204. In fact, even the type of panel cross makes it clearly an Italian work. A Latin inscription speaks of the *Vic[tor] mor[tis]*, "victor over death." Copies in Zadar, with the bust of the archangel Michael at the top of the cross, prove it to be a Venetian type.[48] All the same, its origin was asserted to be in Constantinople. The function it was to perform required such fictions.

Asserting a Byzantine provenance was not the only way to construct an otherwise missing tradition. A marble icon of the deesis type, which actually comes from Byzantium and bears Greek inscriptions, was ironically traced back to Aquileia instead.[49] Again the reason is obvious: The Venetian church saw itself as the heir to the apostolic seat of Aquileia. Legend held the relief, which in fact was produced in Constantinople in the tenth century and revised in Venice in the thirteenth, to be the work of an artist-saint of the early Christian period. Emperor Decius, the legend ran, had commissioned figures of Zeus, Juno, and Mercury. When the sculptor instead supplied him with stone icons of Christ, the Virgin, and John, Decius martyred him.

Icon and relic are coupled in yet another way in a stone icon of the "invincible" (*anikētos*) Virgin[50] commissioned by a Greek named Michael and his wife Irene. The

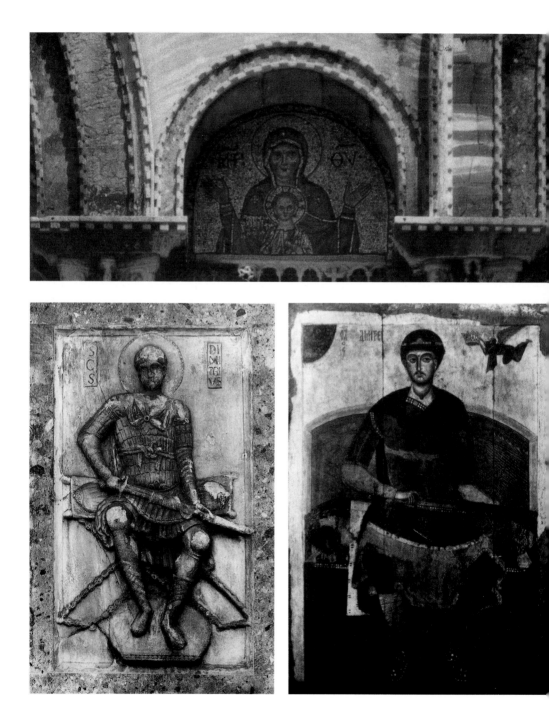

114. *Venice, S. Marco; mosaic icon on the south facade, 13th century*

115. *Venice, S. Marco; Demetrius icon on the main facade, 11th century*

116. *Moscow, State Tretjakov Gallery; Demetrius icon from Vladimir, 12th century*

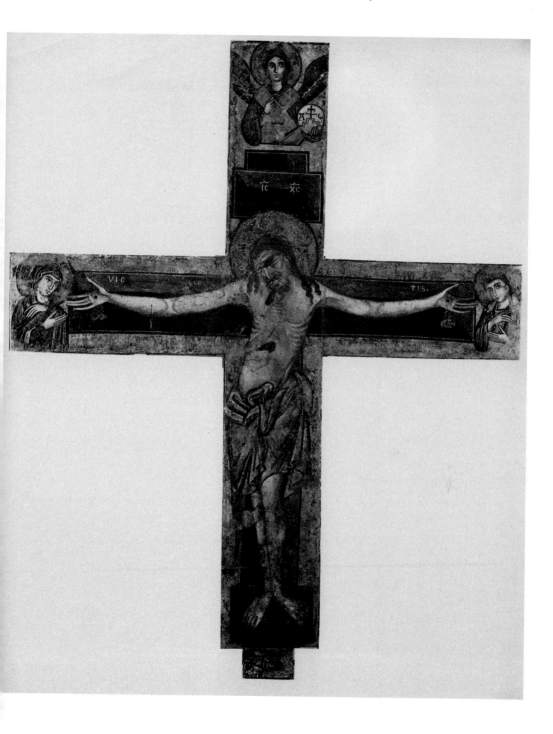

original inscription became the source of the Venetian legend that the image was carved on the stone that Moses struck to procure water for the thirsting Israelites. It reads: "The water that once flowed miraculously from the rock was drawn forth by the prophet Moses' prayer. Now we owe it to the zeal of Michael. May You, O Christ, protect him along with his wife Irene." Evidently Michael had sunk a well and celebrated himself as a new Moses on the accompanying icon. The Venetians adopted a different interpretation. Four holes at the bottom, where a metal cross had originally been affixed, now served as proof that the icon had been hewn from the stone from which Moses had drawn water. In the fifteenth century the Virgin's icon, in which the Old and New Testaments, stone and image, formed a visible unity, was mounted "over the portal" of the church. After 1503 it was integrated into the marble panels of the chapel erected by the procurators of the legacy of Cardinal Battista Zen. At that time the Greek inscription was repeated in a humanistic Latin translation. The name "Michael" now was boldly identified with that of Emperor Michael VIII Palaeologus (1259–82). A relief of Michael, mounted opposite the icon, was to complete the circumstantial proof of the icon's Constantinopolitan and courtly provenance. In its new context the icon looks like one of the old images inserted into the center of a post-Renaissance altarpiece. Its title, the Invincible, was especially apt in the church of the senate, where the imported icon the Bringer of Victory (*Nicopeia*) was also kept.

Not all the icons in S. Marco can be so clearly pictured in the context in which they were once venerated, but many still bear the visible traces of a centuries-old cult. In the right transept a half-length *Hodegetria,* a Greek original with an animated expression, is mounted at eye level with a projecting socle for lamps and flowers. It has been worn away by much touching and is rightly called "Madonna of the Kiss" (*Madonna del Baccio*).[51] In the other transept there is a Madonna now called after the gun (*schioppo*) fixed beside it as an ex-voto. This Gothic counterpart of Byzantine marble icons was the commission of a confraternity that, under its later name of the *Mascoli,* built the adjoining chapel in the fifteenth century but reaches back as far as 1221.[52]

Among the stone icons inside the church a prominent position is held by the Virgin in prayer, embodying the idea of Our Lady of Mercy. The orant Mother with the cloak spread around her raised arms is directly linked to the archetype in the church of the Blachernae in Constantinople, the home of the cloak relic (chap. 17b), and thus transfers the meaning of the archetype to that of the replica. Fragments of the relic also found their way to S. Marco after 1204.[53] Western pilgrims delivered reports about the miracles in the Byzantine church of the Blachernae, near which the Latin emperors of Constantinople took up residence after 1204. But the icon's fame extended even further back. In neighboring Ravenna, a stone icon of the Blachernae Virgin from Constantinople (still venerated today in the church of S. Maria in Porto) worked a miracle that gave rise to a public cult. A confraternity called Sons of Mary (*Filii di Maria*) immediately took charge of the cult. In 1112 the stone image was reproduced as part of the new apse mosaic in the cathedral of Ravenna, complete with inscriptions in which the Holy Mother begs the help of her divine Son for those commended to her protection.[54]

118. Venice, S. Marco; Marian icon of Aniketos, *in Renaissance frame, 13th century*

119. *Venice, S. Marco; Madonna del Baccio, 12th century*

120. *Venice, S. Marco; Madonna delle Grazie, 11th century*

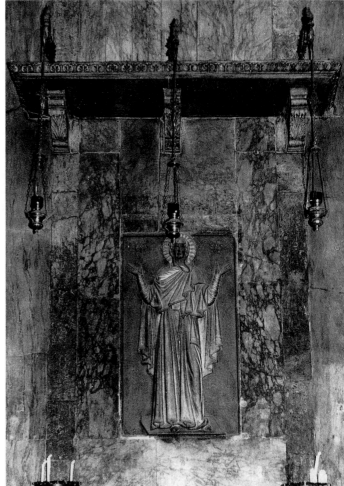

202

This digression gives an idea of the importance of the Blachernae icons in the interior of S. Marco. Their large number suggests that they served various authorities and groups. Among the four examples in the transept and the west wing of the church, the so-called Madonna of the Graces (*Madonna delle Grazie*), near the northern west portal, is especially distinguished. It is a piece imported from Byzantium and has been set into the wall and completely gilded. A baldachin mounted on corbels supports the lamps hanging in front of it.[55] 120

The multiple images resisted the stereotype of serial appearance, since each image had its own history and its own area of competence. In this individual role it was not interchangeable with others, even if they looked similar. Through the transfer of Eastern sacred objects to Venice, S. Marco became a pilgrimage church of the Byzantine kind. The miraculous images and relics assembled there lent authority to the state and protection to its representatives.

The icon, to be sure, was developed in a new, Western way as soon as it was placed on an altar. Since Byzantium, for liturgical reasons, did not use altarpieces (chap. 17a), imported panels from the East were ill suited, both by their small size and by the lack of a kind of socle piece, for being mounted on an altar table. This led to ad hoc adaptations that can be recognized in two Venetian examples from about 1300. A painted panel of the Madonna has a monumental shape that matches the 121
setting of an altar.[56] A painted corbel entablature at the bottom, however, an anomaly for an icon, reveals that the image was previously hung and serves as a transition between the image and the surface of the altar. In her emphasis of the act of suckling her Child, the Madonna follows Western taste. But the frame, composed of full-length saints, corresponds to the conventions of icon painting.

A relief of St. Peter, which still sits on its original altar in the left side chancel, 122
reveals another transformation of what formerly was a marble icon into its new function as an altarpiece.[57] The panel has been enlarged at the bottom to make room for two figures of officials who represent the church's administration in the pose of donors. The top is formed by a pediment, as by now was the custom in Tuscan panels of the Virgin and St. Francis, and carries an angel medallion, like the miraculous cross in S. Marco. It thus merges the features of heterogeneous prototypes into a new form that makes sense for its new placement on the altar.

This survey of the icons of the Venetian pilgrimage church has yet to mention movable panels—painted icons and costly metal artifacts, of which only a very few have survived. They include the enamel icons of angels as well as the famous Madonna of St. Luke, the *Nicopeia*, the artistic and historical importance of which 1
justifies a detailed analysis.[58] As we know from the sources, it had the rank of a patron saint of the state in Venice. Admittedly, most of the sources are from the period of the Counter-Reformation, when the cult of icons had entered a new phase. At that time, in 1618, the icon was moved to the altar in the left transept; in the same year Giovanni Tiepolo published the first account of its history.[59]

The *Nicopeia* (called *Nikopoios* by the Byzantines), measuring 48 × 36 cm, is a major work of Constantinopolitan painting from the late eleventh century. Within the perfect oval of the face the internal forms are captured with elegant precision. The

eyebrows seem to resonate with the lines of nose and brow, emphasizing the intense gaze of the eyes, a gaze that sharply distinguishes the work from the other Marian images of the time.[60] The effect of the figure results, above all, from the diverging angles of head and gaze. The subtle delineation of lips and cheeks reinforces this effect. The metal sheathing, with its enamels and precious stones, culminates in the magnificent nimbus, where gems alternate with fields of enamel showing scrolls and palmettes, as appears on an icon of Christ in Jerusalem.[61]

The surviving icon is probably the same one that was thought in the twelfth century to be the "original" of "Bringer of Victory," or *Nikopoios*. The Mother presents her Son before her body as if she wanted to fend off the attacks of an enemy and at the same time to invite the veneration of believers. In an early variant it was not the Child himself but a portrait shield that she held out before her (chap. 6d). The shining eyes, which have none of the intimacy and melancholy of other Marian icons of the period, are well suited to the role Mary was performing here. She was the unconquerable general at the side of the emperor. In the twelfth century, in fact, not the emperor but the Virgin's icon was carried in triumph into the city (text 18).

And the "victorious Virgin" did indeed go to war. This is why the Crusaders made a point to seize this icon (*ansconne*) in 1203, "together with the *capel imperial* and the general's chariot, on which the Greeks had abandoned it." These words are taken from an eyewitness account, which also says that the icon was made "entirely of gold and jewels, more rich and beautiful than anything seen before."[62] The Venetians were aware of its role and called the image that had brought them victory the *Nicopeia*. The new palladium was also carried in public processions (*andate*) of the representatives of state and society.[63] They had been unable to seize the *Hodegetria*, since the population of Constantinople had strongly resisted its capture (chap. 4e).

Since the sources on the *Nicopeia* in Venice begin only in the sixteenth century, it may be useful to turn our attention to the Venetian colony in Crete, where the icon is mentioned as early as the fourteenth century. Here the Venetian state was represented by an icon attributed to St. Luke: the much-overpainted Madonna in the cathedral of Titus in Heraklion, which was rescued from Crete and brought to Venice in 1669, residing since then in the votive church of S. Maria della Salute.[64] Though unlike the *Nicopeia* in type, it resembles it in function, permitting us to draw inferences about Venice, where the senate conducted a similar icon cult.

In 1379 the records of the senate refer to a conflict between the Latin and Greek clergy over the privilege of carrying the Cretan icon by St. Luke in the procession through Heraklion. The Greek population swore an oath of eternal allegiance before the icon. As a sign of submission to Venice, the icon was handed over to the Latin clergy. The Venetian senate had it carried every Tuesday from the cathedral to the Cretan Piazza S. Marco, as seen in an engraving by Clonza.[65] There it accepted the official homage (*laude*) on behalf of the authority of the state. This state-operated ritual allows us to draw conclusions about the practices in the Venetian metropolis, where public interest focused on the icon painted by St. Luke that was in S. Marco. An engraving by Marco Boschini of 1644 shows its annual passage, by way of a bridge of ships, to S. Maria della Salute,[66] where the Cretan icon by St. Luke was to

123

124

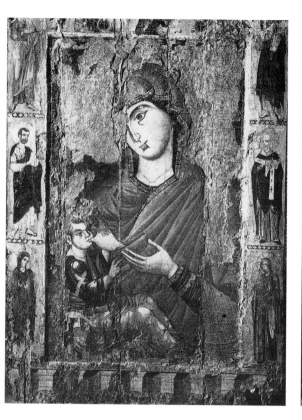

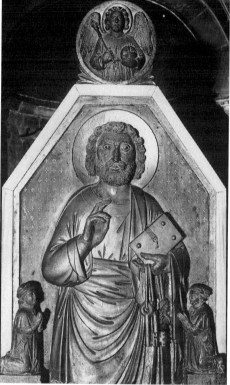

123. *Chaniá (Crete); icon cult on the Piazza S. Marco, after a print by Clonza*

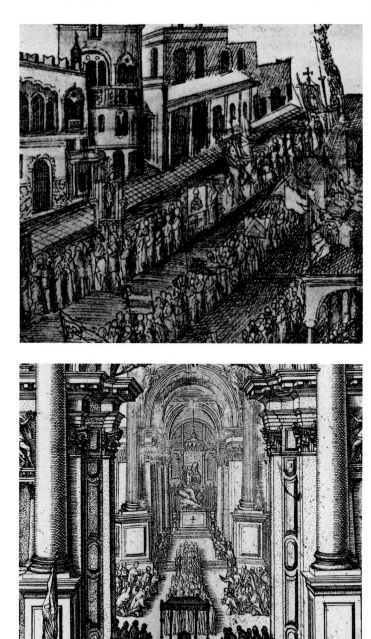

124. *Venice,* andata *of the* Nicopeia *icon, after a print by Marco Boschini, 1644*

find shelter after 1669. Thereafter the two icons painted by St. Luke paid each other annual visits.

Pilgrims and confraternities played much the same role in Venice as they had previously in Byzantium, the origin of the sacred objects venerated in Venice. The role of the emperors was taken over in Venice by the doges and their senate officers, though only within the constitutional framework, which allowed the ceremonial processions crossing the city and also the official cult of relics and icons. As with the image of the Virgin as heavenly general, what we know of Venetian practice must have largely reflected the earlier situation in Constantinople as well. In turn, we can interpret the Venetian sources in light of what we know from Byzantine practices. S. Marco gives us a vivid picture of the outfitting of pilgrimage churches in Byzantium. This cult of icons, which served pilgrims, emperors, and confraternities outside the realm of the liturgy properly speaking, was a significant part of everyday life in Byzantium.

11. The "Holy Face": Legends and Images in Competition

Among the miraculous images kept in Constantinople in the palace chapel among the "authentic relics" of Christ's life, a cloth image known as the *Mandylion,* with the "true portrait" of Christ, held a special place.[1] Brought from the town of Edessa in northern Syria only in the tenth century, it had stirred the general imagination already in the sixth century, when it was first reported. An icon that had survived iconoclasm unscathed was thus brought "home" to the center of the empire from an imperiled frontier post. Constantinople, where its physical presence was of more account than its actual visibility, now possessed the archetype of all images of Christ. Whether or how far the replicas really resembled it was of less importance than their claim to derive from this first example and thus to be genuine and pleasing to God.

We lose track of the *Mandylion* in the West after the sack of the Byzantine capital in 1204. While the East still continued to claim to own the icon, the West promoted a new miraculous image with the genuine features of Christ, against which the imported image from the East had no chance. The new image borrowed its conception from its Eastern rival and in fact was indistinguishable from it. But it had a different legend to explain its origin. The Veronica, or *vera icona,* which was kept in St. Peter's in Rome, made its appearance only in the early thirteenth century, after all trace of the Byzantine cloth image had been lost.[2] It then became in the West what its rival had long been in the East: the undisputed archetype of the sacred portrait. In their respective statements about reality and image, the two icons are closely interrelated.

Although we are dealing with one image that appeared in Syria in the sixth century and another that was venerated in Rome from about 1200, they both may be seen together, since the cult of the old image in Byzantium was transferred to its near successor in Rome. The legends from the portrait of Edessa actively defend the Christian image against the familiar charges leveled at heathen idols but in fact offer two explanations of its origin that contradict each other. They assert on the one hand that King Abgar commissioned an exact portrait from his painter after the living model, and on the other hand claim that the image was miraculously carried out by Christ himself when he pressed his face into the cloth, leaving the image behind.

The purpose of the two explanations is obvious. On the one hand, a portrait after the living model, as distinct from one of invented, fictitious gods, gives evidence of Christ's historical life and of the reality of his human nature, which was a long-disputed issue among Christian factions. On the other hand, the miraculous or, in other versions, mechanical reproduction of Christ's features prevented any equation with the "gods made by human hands" or idols, of the kind for which Paul criticizes the heathens in Acts 19:26. The *achiropiite* (chap. 4a) was an agent of authenticity independent of the talents of a painter. Finally, Christ's intention in sending King Abgar an image of himself would prove that he *wished* to have images made of him-

self. Thus not only the genuineness of the image but also the appropriateness of venerating it were proved legitimate.

That is the gist of a complex tradition of legends that were transferred, with important adjustments, to the Veronica in Rome. The Romans possessed a sudarium or handkerchief, at first devoid of an image, that had been used by Christ on the Mount of Olives or on the Way of the Cross. Later, when it became an image and began to work miracles, it was linked to the legend of the pious woman Veronica, who was said to have offered Christ a cloth, on which his features were imprinted when he wiped his face. The old legend, which now was revised to serve a new purpose, had the plausibility of a kind of historical proof. Its original concern with the image's miraculous origin was dropped, since the Christian cult image was no longer subject to controversy in the Middle Ages and a rational explanation was considered more important than a divine origin. The image as a biographical document now was most significant, particularly as the Lateran already owned an *achiropiite* (chap. 4d).

The desire to see the face of God was inherent in human nature and included the expectation of a personal encounter with the "Other." Christianity offered the hope for a preliminary vision of God, for eternal life was understood as a permanent vision of God. In the "genuine image," the earthly features of Jesus, which could be seen by human eyes, merged with the divine features of God—visible reality with an invisible mystery. This double meaning of a single image invited the production of copies, which became interpretations of an idea rather than mere replicas of a relic. In Byzantium, too, one must distinguish between free re-creations and literal duplications of an original. The very act of viewing in its turn implied the desire of viewers to resemble the One whom they had in view. The image and its beholder, in ultimate terms, related to each other like archetype and copy, like Creator and creature. The material image, as a mediator, thus became the tool for a contemplation of the lost beauty of humankind.

Wilhelm Grimm once described an image of Christ owned by Clemens von Brentano in words inspired by timeless notions of the "true" portrait.[3] He admired in the "noble face with its long and straight nose and parted hair . . . the grandiose impression of highness and purity. There was no trace of pain, but, on the contrary, utter peace and serenity, and an ideal beauty free of passions and remote from the character of a portrait." His words express the awe that all felt in the presence of this image, coupled with the modern nostalgia for religious images, which prepared for the rediscovery of the icon.

a. The "Original" of the Abgar Image and Its Legend

The cloth image, or *Mandylion,* of King Abgar was disseminated in other media in countless copies and paraphrases. While they all agree in their *idea,* to the point of exchangeability, in *practice* they share only a common basic schema that left large scope for variants. The situation can be characterized as follows. While icons generally have the half-length portrait scheme, Abgar images are reduced to an imprint of face and hair on an empty field symbolizing the cloth. They correspond in their ap-

pearance to an original that was not an icon but a cloth. On this cloth the features are, in theory, recorded mechanically, and the hair is spread out, whereas in an image on a panel the hair should hang down. In deviating from the icon scheme and portraying a mechanical imprint, the replicas offer a visible proof of the way in which the original was produced. They are replications of an image relic that, it was believed, had come into being through physical contact with the face of Jesus.

Despite these common features, however, it would not have been possible to identify the appearance of the original without the discovery of a surprising resemblance of two panels that found their way to Italy.[4] One is an icon in the Vatican that, in the Middle Ages, was the proud possession of the nuns of the order of St. Clare in the convent of S. Silvestro in Capite; the other is an icon in S. Bartolomeo degli Armeni in Genoa that the Byzantine emperor John V presented in 1384 to Lionardo Montaldo, the *capitano* of the Genoese colony on the Bosporus.[5] The icons in Rome and Genoa, whose silver casing follows the outlines of head and beard, both are painted on canvas fixed to a wooden panel of exactly the same size (ca. 40 × 29 cm). The lost middle section of a former triptych from the tenth century, in which the surviving wings relate to the Abgar legend, surely matched the appearance of the examples in Rome and Genoa, as it again has the very same size.[6]

This coincidence becomes significant insofar as the surviving panels betray a striking archaism that conceals their true age behind their chosen style. In fact, both panels adhere to a style that is found in eastern Syrian works of the third century, as in a fresco in Dura Europos.[7] This archaism is unusual even within their own genre as Abgar images, which, despite their usually timeless schematism, cannot escape the aesthetic ideal of their time. The copy in the Vatican displays the features of a work of late antiquity whose original painting has survived unscathed under the many layers of varnish, as becomes evident on close inspection. If the Vatican authorities decided to have it cleaned, they would regain what may well be the oldest surviving icon of Christ. The Marian icons in the Pantheon and S. Francesca Romana still retain an echo of a similar age.

In the Genoan example, however, the linear edging of the eyes betrays the characteristics of a medieval replica. But the type chosen totally deviates from other icons of Christ at that time. The oval face with its sparse details eschews all physical and psychic movement for the sake of absolute symmetry. The calm aloofness of the image conveys the effect of *apatheia,* and simultaneously the aura of an extremely old image type. Only the Shroud of Turin, whose lost original was apparently already venerated in Byzantium as Christ's burial cloth,[8] though it is the imprint of a dead man, comes close to this fictitious imprint of the living Christ. What matters for our argument is the observation that a small group of Abgar images qualify in appearance as duplicates of one and the same "original."

It is consistent with this observation that two of the three examples—and the panel in the Vatican may originally well have been the third—carry a kind of seal or "proof" of authenticity. They frame the main image with illustrations of the Abgar legend, a device that otherwise was a rarity. The "Holy Mandylion" in Genoa, as the

<div style="text-align: left; font-style: italic;">

15

III

125

8 & front
of color
gallery; I

III
</div>

respective inscription calls it, has ten small scenes running around the panel's frame of gilt silver, starting at the top left with the sick Abgar commissioning the portrait, and ending with the miraculous cure wrought by the relic in Constantinople. A fourteenth-century scroll retained the memory of the so-called Abgar letter, which was preserved as a relic in the palace chapel up to the twelfth century.[9] Here too, illustrations of the legend serve to "authenticate" the original. The folding wings of the Sinai triptych link King Abgar and the missionary Thaddaeus—through whose *125* mediation, the legend says, the portrait was transmitted to Edessa. As Abgar has the physiognomy of the reigning emperor Constantine VII, who transferred the relic from Edessa to Constantinople in 944, the apostolic and Byzantine eras, the old and the new Abgar, are thus fused, in order to stress the continuity in the legitimate possession of the relic. The Byzantine emperor, the images argue, as much obtained the portrait with Christ's approval as the Syrian king had owned it before him.

According to the legend, after Abgar's messenger failed in his attempt to paint the portrait, Christ washed his own face in order to imprint his features on the cloth. Abgar, who received the letter and the image, in turn was cured by the image. The *126* further history of the portrait opens with a dramatic antithesis. When the icon was mounted on a column, the heathen idol on a companion column crashed to the *127* ground. The subsequent events of the Persian invasion caused the bishop to wall up the icon behind a tile. When it was exposed again, it had left an exact imprint on the tile. The *keramidion*, or tile image, was a further proof of the miraculous powers of the original, which duplicated itself. In the end, the Edessan bishop destroyed the Persians by a fire into which he had poured oil flowing from the image. In this way the miracles of the relic's origin and the apotropaic powers of the image-weapon follow each other in one and the same narrative.

The legend of Abgar was absorbed into a much older legend that Eusebius of Caesarea already knew in the fourth century.[10] Its core was the actual conversion of Abgar IX (179–214), whom the legend, however, considers a contemporary of Christ. Although an alleged letter of Christ that had healed the king was venerated as a relic in Edessa, formerly Abgar's residence, no image was mentioned before the sixth century, when miraculous images became popular elsewhere as well (chap. 4a). As late as 544, Procopius still attributed the recovery of the town from the Persians to the letter, whereas by 593 the chronicler Evagrius gave the credit to the "God-made image" (*theoteukton eikona*), which had not been touched by human hands. Its origin was explained at the time as being the imprint made by Christ's face, without any reference to the Passion.

There were apparently competing cult images held by the different Christian creeds in the city, which no doubt explains the legend of the duplicate on the tile. The rituals of the feast of the cloth image in Edessa are described retrospectively by a writer apparently a court theologian, from Byzantium, who adorns them with mystagogic explanations. The relic, concealed behind a white or purple cover, was usually kept in a shrine and was set up on a "throne" only on special days. On feast days it was approached with water that the people sprinkled on its eyes.

Sinai Genua Sinai

125. Mount Sinai, monastery of St. Catherine; 10th-century Mandylion *from Constantinople (reconstruction)*

126, 127. Genoa, S. Bartolomeo degli Armeni; Abgar legend on silver chasing, 14th century

b. The Abgar Image at Constantinople and a New Aesthetics of the Ideal Portrait

In 944 the emperors negotiated the handing over of the two miraculous images with the emir of Edessa. On the feast of the Virgin's Dormition (*koimēsis*), 15 August, the images were received in the Blachernae church (chap. 10a) in the presence of the whole court.[11] The pageantry metaphorically related the arrival of the images to Christ's appearance to his mother at the hour of her death. In depictions of the *koimēsis*, the divine Son appears on earth to accompany the soul of his Mother (and, as was soon believed, her body as well) to heaven.[12] The welcome of a mortal being in heaven epitomizes in a graphic formula the religious worldview of the Byzantines—death as return and perfection through the approach to God. This event was now reenacted in the feast ritual, which simultaneously "demonstrated" its truth by two pieces of material evidence, the Virgin being present by the relic of her cloak, as Christ was by the relic of his portrait.

The emperors traveled in procession around the capital on a boat with the image (and its imprint on the tile), as if "on a second Ark of the Covenant," and then passed in triumph through the Golden Gate, after which a lame man was healed by the sight of the image. Following a service in Hagia Sophia, it was placed on the imperial throne to receive the veneration of the court, before it found its permanent home in the palace chapel by the lighthouse (Pharos) "in the right part, facing east." A feast commemorated the anniversary of the image's transfer to Constantinople, and poems and sermons elaborated the new concept of a "true portrait." They also mentioned that the original was adorned with the "gold casing that can now be seen [*dia tou nyn phainomenou chrysou*]," which bore the following inscription, allegedly by King Abgar: "Christ, our God. Whoever hopes in you shall not be brought to ruin."[13] The metal casings of the two examples in Rome and Genoa thus stemmed from the "original."

The image, although withdrawn from "sinful eyes" in its adytum, still produced a sense of awe through the miracle that mortals were in principle allowed to glimpse the countenance before which the cherubim hid their faces. In the image, the theological texts proclaimed, the incarnate Logos had left behind "a pledge on earth for mankind of his human-divine properties." The texts spoke of the "divine resemblance [*homoiōma*] to that other resemblance that exists between Christ and God the Father." Thus one could venerate the "likeness [*charaktēr*] of the likeness of the Person of the Father," the "venerable imprint [*sphragis*] of the Beauty of the Archetype, Christ."

In this way the theologians gradually talked themselves into formulations that blurred the distinction, previously meticulously preserved, between the image and the person of Christ. Finally, in a conflict between emperor and church about 1100, the formulations took a truly dangerous turn when the priests were trying to prevent the emperor from melting down some precious cult objects to finance his wars. The Abgar image, which a text of the feast day's canon extolled as partaking in the divine being and as "deified," was used to restrain the emperor from violating ecclesiastical and divine law. When the metropolitan, Leo of Chalcedon, eagerly postulated the unity of divinity and matter, person and image, his position was finally condemned

as heretical. For a time this incident brought the feast and its canon into disrepute.[14]

The literary texts help us to understand why painted copies represent the original image as a quasi-absolute, divine ideal of beauty, even "an archetype" of beauty (*archetypia tou kallous*).[15] Byzantine replicas of the time set out to make visible the idea of a divine beauty in whose image the world was created. Their appearance today can be deduced from a Russian copy painted by an artist from Novgorod in the twelfth century.[16] The panel (76.4 × 70.5 cm), within the approximate ideal of a square, has inscribed the ideal form of a circle. It insists on the unbroken circular halo of Christ, as the theme required only the head's imprint on the cloth. The use of basic forms of geometry extended by analogy to the face itself, relating it to an aesthetic canon. The "Holy Image" of the Divine Archetype with its facial proportions now became what the Vitruvian figure with its bodily proportions had once been: an aesthetic ideal with reference to an aesthetics of the icon, in which only the face counts.

With its golden ground, the Novgorod panel rejects the model of the cloth in favor of a synthesis between cloth relic and panel. The Russian painter's technique has coarsened the style of a model that must have been a Constantinopolitan work, as it is preserved in a Pantocrator icon in the Sinai collection.[17] It seems that the same model had integrated the type of the Pantocrator with the schema of the *Mandylion*. The synthesis between the two most revered portraits of Christ must have been an attempt to express, beyond the individual icons, an absolute ideal of beauty.

The Russian panel schematized the hair and reinforced it by gold lines. The raised eyebrows and the side gaze beneath a furrowed brow are borrowed from the Pantocrator type, which, as a type, also expresses Christ the Judge. The two panels help us to reconstruct how, in the lost work from Constantinople, the type of the Pantocrator was transformed step by step into that of the *Mandylion*. The hair that falls about the Pantocrator's neck is now spread in a flat plane. The woolly beard, distinguished from the hair as in the model, now closes the bottom of the face along a circular line. The tan of the face has been deepened, to suggest the natural skin color of the True Imprint. Thus, in a sophisticated way, a new ideal portrait of Christ comes into being.

The material image—to sum up the aesthetics of the time—is in itself lifeless, but in the face of the person depicted it catches the same life that lives in a person's body like a guest. The physical likeness is as much an "image" of character and virtue as it translates the face into a different order of transcendent beauty. This conception has left its traces even in literary descriptions of living persons. When the emperor's daughter Anna, in her biography of Alexius I (1081–1118), describes the appearance of her parents in detail, she does so in terms that reveal the aesthetic ideals of the time (cf. text 19).[18] In her view, both the image and the living person, both art and the physical body, are related to archetypes and thus can be perfected through imitation. Even the canon of Polyclitus, Anna asserts, looks "utterly inadequate" beside the "incomparable" appearance of her parents, who were "living statues." Symmetry and "harmony" are ranked highest in this aesthetic canon. While the body's conduct is important enough, the expression of the face and the power of the eyes are more so, the latter being in the case of the emperor both "terrible" and "kind," and in the case of the empress graceful and calm. Like that of Anna's sister-in-law Irene, who is rep-

resented in the mosaics of Hagia Sophia,[19] the face of her mother Irene was "not the completely round face of an Assyrian woman, nor long, like the face of a Scyth, but just slightly oval in shape." Such descriptions betray how much attention was paid even to details of form, which thus confirms the aesthetics of the *Mandylion.*

Among the saints, the youthful hero Panteleimon represents another variant of the ideal of beauty.[20] His oval face, below his carefully arranged hair, has a strict formal perfection. The florid cheeks, a similar hue being mentioned for the empress, are signs of the real life that was easily praised in a successful painting. The closed lips, which also are mentioned for the empress, underline the motionless face. Only the eyes are allowed to express the life of the soul. For this reason the gaze is almost always turned aside from the axis of the face. The sensitivity toward an aesthetic ideal, which induced even the rulers to conduct themselves like living icons of themselves, is strikingly similar in both literary documents and visual works. We may therefore suppose that the ideal portrait of Christ, being the True Imprint of his features, was the obvious topic for formulating an aesthetic ideal. As a result, the free re-creations of the idea soon attained more favor than the mechanical replicas of the relic.

When panels of this kind become a topic within the overall pictorial program of a church, they reveal the theological and liturgical ideas that were associated with the *Mandylion.* In the church of the Redeemer at Novgorod, which was decorated in 1199, the *Mandylion* functions as a material proof of Christ's incarnation.[21] Here, indeed, both miraculous images—the cloth image and its duplicate on tile (see above)—are depicted, the one distinguished from the other by their respective backgrounds. In a manuscript entitled *Ladder of Virtue,* by John Climacus, they appear, correctly shown as mirror images of each other, as the tablets of the law of the New Testament, which replace the former shadow by the historical reality of the Messiah (chap. 4a). In a Russian miniature of the thirteenth century the *Mandylion* is adored by angels in heaven.[22] In Russia, as perhaps previously in Byzantium, the motif was placed on military banners to represent the highest sovereign of a Christian army and to put the enemy to flight at the sight of it, like a new Gorgoneion. A flag from the time of Ivan the Terrible (1530–84), on which angels hold the *Mandylion,* continues this genre,[23] which then continued to be used as late as the First World War on banners of the Russian and Bulgarian armies.[24]

In Byzantium the original image relic soon became the occasion for describing an ideal portrait that subsumed a general aesthetic canon. The panel from Novgorod, which repeats a Constantinopolitan model, has on its back a second picture representing the True Cross, which appears with the additional relics of lance and sponge.[25] The cross, by then, had found its way to Hagia Sophia in Constantinople. The bilateral icon thus assembles on its front and back the most important relics of Christ in the Byzantine capital: the True Face and the True Cross.

c. The Veronica in Rome

In the West the *Mandylion* was soon eclipsed by the famous image relic in St. Peter's in Rome.[26] Robert de Clari had seen the former in the palace chapel at Constan-

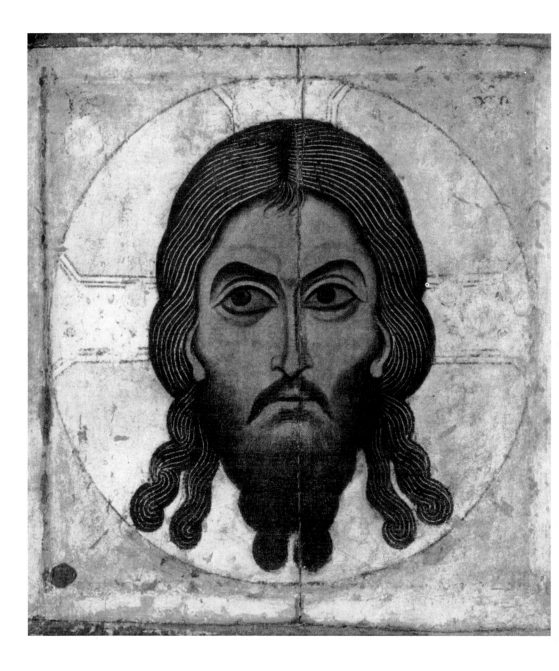

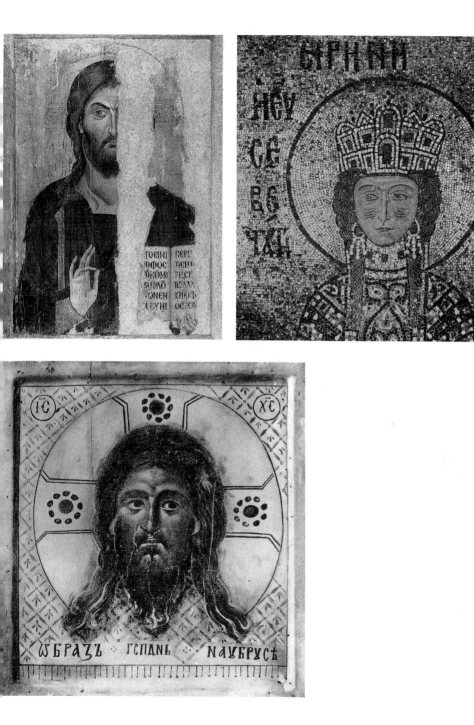

129. *Mount Sinai, monastery of St. Catherine; Pantocrator icon, 12th century*

130. *Istanbul, Hagia Sophia; mosaic of Empress Irene, 12th century (detail)*

131. *Laon, cathedral;* La Sainte Face, *13th century*

tinople in 1204, along with the tile image, in two golden reliquaries hanging side by side on silver chains.[27] Ever since a donation in 1247 of the Latin emperor Baldwin of Constantinople to the French king mentioned the image of the Holy Cloth (*toella*), it was recorded in all inventories of the Sainte Chapelle until 1792.[28] Next to such prestigious relics as the crown of thorns, however, it attracted little notice. Whether it was the *Mandylion* or not, we can no longer ascertain. But it no longer had a real chance for fame, since the Veronica in Rome had in the meantime asserted its claim to be the only True Portrait. This is why also the *Mandylion* from S. Silvestro had little impact in Rome, even though it may be the original itself.

The suppression of the *Mandylion* by the Veronica emerges in a debate over a Byzantine panel in the cathedral of Laon that was boldly proposed in the thirteenth century to be a replica of the Roman Veronica and became venerated as the *Sainte Face*.[29] It is a south Slavic work that the inscription at the bottom describes as the "Face of the Lord on the Cloth" (*Obraz G[o]sp[o]dn na ubrus*). The full, soft features with their free style of painting indicate a date of origin about the year 1200. Soon afterward, in 1249, it is said to have been in Rome and to have traveled to France for reasons that may deserve our special attention.

The abbess of Montreuil-les-Dames, our witness says, had asked her brother in Rome to deed to her convent the Roman icon of the Veronica, which shortly before had become famous throughout Europe. This request put her brother, Pantaleon, in an awkward position. As the papal chaplain and treasurer of St. Peter's, he had access to the relic, but he could not possibly remove it from Rome. He therefore sent her a substitute, an image that his sister might receive, he wrote, "in place of the Veronica." This was not just any work but a portrait that had once been given him by "holy men." Pantaleon justifies the dark complexion of the portrait, which would have seemed unfamiliar to French nuns in the Gothic age, as the sunburn that Jesus had acquired on his wanderings through Palestine. The letter may be an old forgery from that time; nevertheless, its arguments are of interest to us. The local cult legend insists on introducing the Eastern *Mandylion* as exemplar of the Roman Veronica.

It sometimes appears as if the *Mandylion* was simply a variant of the Veronica. Thus in 1287 the Veronica was shown to a Syrian monk and identified as the cloth with the imprint of Christ's features that had been owned by Abgar.[30] But matters were not so simple. We may best understand the Veronica legend if we realize that, while it borrowed some elements from the Abgar legend in the course of the early Middle Ages, it was not linked to a relic in Rome. The Roman relic in fact is not mentioned until the twelfth century, and it is not until the thirteenth that it is characterized as having the image imprinted on it.

The legend of the Veronica "tells of the sickness of Emperor Tiberius, and of the vain search of his messengers until they find Veronica, the woman who had an issue of blood healed by Jesus, and her image of Christ that she had had painted out of gratitude; the story then tells of the healing of the emperor . . . the punishment of Pilate"[31]—and finally of the destruction of Jerusalem as a punishment to the Jews. The image that, as a representative of Christ, had healed the emperor was only later identified as a miraculous image, and later still, about 1300, in the Bible of Roger of

132. *Field banner of the Bulgarian army during World War I*

133. *Pilgrimage procession in the Upper Andes (photo: Barbara Klemm)*

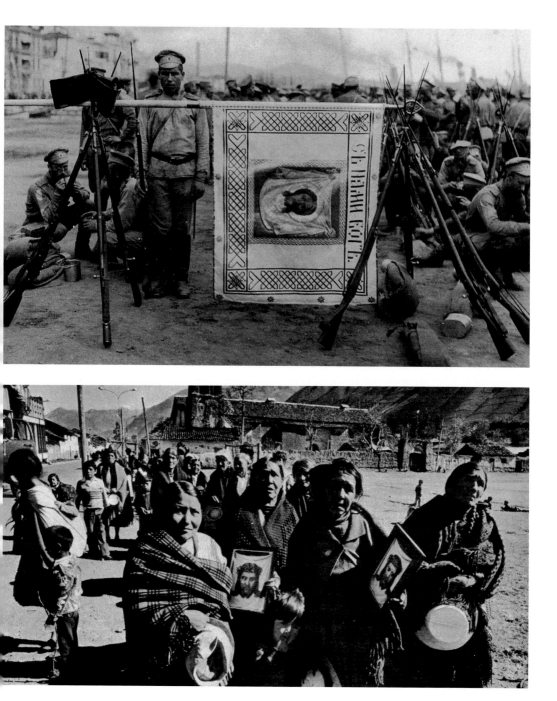

Argenteuil as a motif from the Passion. It was only then that Jesus was said to have pressed his face into Veronica's cloth on the Way of the Cross.[32] From that time on, the replicas of the image adopt the motif of the crown of thorns.

As early as the twelfth century, some people claimed to have seen the sweat of blood that came from Christ's face in the Garden of Gethsemane on the cloth relic in St. Peter's (text 37A). From the time of Celestine III (1191–98), the Veronica was kept locked in the upper part of a canopy with six columns that served both as a barred safe and as a stage.[33] But not until shortly after 1200 was an *image* on the cloth mentioned (texts 37B and 37C). As the new image relic was still overshadowed by the Sancta Sanctorum icon, it needed publicity to establish its cult.

To this end, the cult was inaugurated by means of a suitable miracle. On the second Sunday after Epiphany, Innocent III (1198–1216) was accustomed to go in procession to the hospital of the Holy Spirit, which he had founded, to preach on charitable works and to show to the sick the cloth (sudarium) bearing the sweat of Christ's Passion (text 37D). But in 1216, when it was being brought back to its reliquary after the procession, the image of the face turned itself upside down. Seeing this novelty as an ill omen, the pope introduced a prayer addressed to the image, and ten days' indulgence was granted to those who said the prayer.

So runs the account in the *Chronica majora* of Matthew Paris, which was completed soon after 1245 in St. Albans (text 37E). The chronicler included in his text a picture conveying his own idea of the Roman original, to be shared by the many who themselves would pray to the Veronica. It is an iconic bust portrait as it became popular among devotional pictures, and when it became duplicated as the frontispiece of a contemporary Psalter manuscript, it was commended to the user as follows: "To attune the reader's mind to prayer, the Redeemer's face [*facies*] is honored by the painter's art [*industriam artificis*]."[34]

The English chronicler also quotes the prayer introduced by the pope, which speaks of the image as a "memento" (*memoriale*) that the Lord has left behind. Whoever has seen him only "in the mirror and in similitude" will ask to be allowed one day to see him "face to face." Under Pope Honorius III (1216–27) the image was carried in procession to the hospital in a very costly reliquary and displayed for the veneration of believers (text 37D). Famous hymns were composed, though they hardly assumed their final form until the fourteenth century. The hymn *Ave facies praeclara*, soon to become popular as a private prayer, in order to stress the idea of the Passion, somewhat unconvincingly explains the dark flesh color of the icon as a result of Christ's fear on the Mount of Olives, to which the bloody sweat would fit much better (text 37F). In contrast, the equally famous hymn *Salve sancta facies* emphasizes the "divine radiance" of the holy portrait "on the snow-white cloth" (text 37F).

During the pillaging of Rome in 1527 the Veronica was put up for sale in the taverns of Rome by Lutheran soldiers of the imperial army.[35] It has not been seen since. As frequently happens in such cases, however, it was soon "rediscovered." In the seventeenth century it found its way into the relic chamber that Bernini built into

the southwest pier supporting the dome of St. Peter's.[36] Francesco Mocchi's Veronica statue in the niche below describes the treasure that is guarded there. Josef Wilpert discovered the present relic to be a piece of linen with two rust-brown stains; Paul Krieg describes it as a double linen cloth on which the outlines of a beard appear on a gold ground. The size of the former Veronica (40 × 37 cm) survives in the former receptacle, made of rock crystal and donated in 1350.[37]

The original appearance of the Veronica is recorded in countless pilgrims' rec- 16
ords, amulets, and replicas.[38] In the frescoes of the Spanish chapel in Florence, small Veronica images are shown as "sewn to the hats" of pilgrims as Chaucer has it when he describes his Pardoner with such a "vernicle." The *pictores Veronicarum* (Veronica painters) had a license for producing the pictures, and the *mercanti di Veronichi* (Veronica merchants) had a monopoly for selling them. Hoards of such mass-produced pictures, 7.8 × 4.2 cm in size, have been recently found behind the medieval choir stalls in the German convent of Wienhausen.[39] At times there were up to a million pilgrims in Rome when the Veronica was shown. According to the *Stacions of Rome*, an English pilgrims' guide of 1370, Romans could at such times buy three thousand years' indulgence for their sins, Italians nine thousand years' indulgence, and foreigners twelve thousand years' indulgence. When in 1849 the relic began to shine of its own accord while being shown, sales of replicas enjoyed a new boom. They bore the inscription "Copie authentique de la Sainte Face de Notre Seigneur."

Pilgrims flocked to Rome, as they had earlier to the Holy Land. One of their goals was to visit the Veronica and to take home a reproduction as a souvenir or amulet. A recently published photo from the Andes shows a local pilgrimage among the Indi- 133
ans.[40] Its goal was a regional, South American Veronica, which apparently derives from a Spanish model of the seventeenth century. The women carry framed copies of a picture on which they see their own sufferings prefigured.

Beginning in the fourteenth century, the Veronica was included among the instruments of Christ's suffering (*arma Christi*), which inspired pious meditations on the Passion.[41] The Veronica was well suited to be placed among relics, most of which were venerated in Paris. It too was a relic, and thus more authentic than any work of art, in that it did not rely on artistic imitation. It was as authentic as a photograph. In addition, it ranked as a touch relic (*brandea*), as it had been in physical contact with the Original—with Christ himself.

The mass-produced reproductions agree in their archaic image of face and hair. Even in its dark coloring it resembles the Abgar images—to the point of being confused with the latter. The replicas served to repeat the idea of the imprint. Similarly, the idea of the true portrait initiated a development that would have long-term consequences in Western art.

The reproductions were not confined to pure replicas, any more than they were in the East. Rather, the legendary figure of the female saint Veronica, whom believers credited with the origin of the image, was soon introduced as a figure carrying it. 259, 260
Thus a "proof" of the origin and age of the relic was provided by bringing the first owner into the picture. Finally, in presenting the cloth in her outstretched arms like

the prelates did in Rome, the saint invited cult veneration by her very gesture. This variant in effect staged the original, like an image within an image, by distinguishing the relic from the reliquary, the cult object from its support or presentation.

The introduction in the icon of narrative motifs was in keeping with Western ideas on art, which favored a freer use of images. The history of this variant extends from pictures of the "master of the holy Veronica," a Cologne painter of about 1400 who was given this name by art history,[42] up to the Renaissance and far beyond. The various ideas inherent in the image are, as it were, summed up in an altarpiece that Ugo da Carpi painted for the altar of the relic in St. Peter's in 1525, shortly before the sack of Rome.[43] It shows the female saint called Veronica with the relic standing between Peter and Paul, who represent the Roman church, thus bringing together the former and the present owners. An inscription records that the artist has painted the panel without using a brush (*per Ugo Carpi intaiatore, fata senza penelo*). Vasari and Michelangelo poked fun at this comment, pointing out that the painter must at any rate have used his hand.

Dürer drew on a different tradition when he made the Veronica the subject of a large engraving of 1513.[44] Christ bears the crown of thorns on his head and traces of his suffering in his face. The cloth is held not by Veronica but by angels, who present it as a legacy from heaven to the earthly church. The artist thus succeeds in combining the historicity of the Passion, the material proof of Christ's biography, with the Divine Face, which even the angels are unable to view directly.

Jan van Eyck tried to satisfy yet another claim of the original when he insisted on raising it to the standard of the portrait current at the time.[45] It was, after all, a "true portrait" and ought to highlight this quality. Artists had meanwhile created the modern portrait and defined its premises, including a live model as a sitter. In Christ's case there was the authentic cloth impression in Rome. By taking it as a model, a portrait painter could feel safe in surpassing the traditional schema and reconstructing the appearance of the once-living person by a new act of imitation. For this reason the old hymn of the Veronica (text 37F) was written beside the miniature in the manuscripts that took over the van Eyck type (chapter 19c).

Thus the re-creations and interpretations of the image, in a way both like and unlike that of the icons of Byzantium, revolve around the idea of the ideal portrait, which was developed in ever-different ways and directions in relation to the theme of the Veronica. In the devotional images that are produced alongside the mechanical "vernicles," the idea of the Veronica is subjected to a plethora of applications and interpretations. Sometimes ideal beauty is sought, sometimes a vivid expression of dreadful suffering. One artist endows the features with silent dignity, another with vivid speech, as Christ's eyes meet the beholder's while his mouth is twisted with pain. Thus the Western image fulfills various expectations associated with the sight of Christ.

But the idea of the authentic portrait as an impression on a cloth remained a common feature of the Byzantine Abgar image and the Western Veronica image. Different legends circulated in East and West, but for a long time the images were virtually interchangeable because they expressed the same idea. In *late antiquity* the cloth

134. *Rome, St. Peter's; pillar
with the Veronica, after a print
by Pietro Mallio, 1646*

135. *Rome, St. Peter's; Ugo da
Carpi's altarpiece for the
Veronica chapel, ca. 1525*

136. *Veronica (detail),
engraving by Albrecht Dürer,
1513*

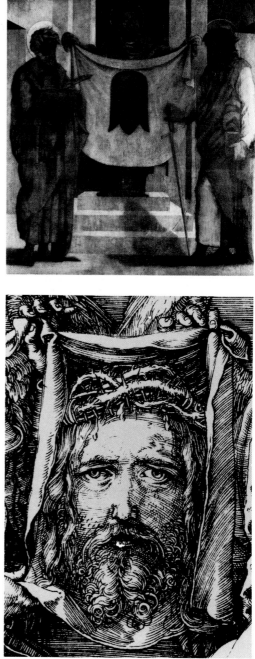

with the "true" imprint of Christ's features for the first time met the requirements for a Christian cult image. It actually was what the miraculous images of the pagans merely purported to be—an image of supernatural origin, therefore sanctioned by heaven. Unlike the heathen images, it was no mere invention but the likeness of a real person and so could bear witness to Christ's incarnation against the doubts of the heretics. In medieval *Byzantium*, once the Christian cult image ceased to be a matter of dispute, the same cloth image served as the archetype of a human image in which the likeness of God was reflected. Its beauty was revealed by free re-creations better than by the original, which itself merely claimed the ideal of perfection. In *Rome* the cloth was first introduced as an uniconic relic that had come into contact with the body of Christ. At a time when the miracle of the Eucharist—the sacramental transformation of the consecrated bread into the body of Christ—was being asserted as dogma, the church was also seeking to gain a direct view of the historical body, the reality of which was the precondition of the sacramental reality.

The sight of the cloth image seemed to anticipate the vision of God, though subject to the conditions of an earthly view of a human face. Petrarch makes an old man set off on a pilgrimage to Rome, "since yearning bade him look upon the likeness [*sembianza*] of him he hoped soon to behold in heaven."[46] In his *Vita nuova*, Dante expresses the antithesis of earthly image and heavenly vision in similar terms. The pilgrims go on their journey to Rome "to see this miraculous image that Jesus Christ has left behind for us as evidence [*essemplo*] of his beautiful *figura*, which my lady Beatrice contemplates in glory [*gloriosamente*]."[47]

12. The Iconostasis and the Role of the Icon in the Liturgy and in Private Devotion

Nothing has received as much attention as the historical development of the iconostasis—the image-bearing screen before the chancel. Today, it is a hybrid accumulation of images forming a closed wall, which was not taken to this extreme until the very end of the Byzantine empire, perhaps first in Russia. The name "iconostasis" too was adopted only at a late stage.[1] It is therefore of interest to inquire what chancel screens, which were common from late antiquity on, looked like in the Middle Ages, and when icons were placed on them. Surviving examples as well as old descriptions are available for reconstructing past screens, though technical questions usually are preferred over those concerning the icons themselves.[2]

Instead of postulating an overconsistent "development," we should be prepared for the discovery that things varied even from one monastery to the next. The term *templon*—first the name for a frieze of icons on the chancel screen and then the *138* general term for chancel screens with icons[3]—seemed to point to a fixed type. But it would have made little sense to mount icons in a permanent position, since the repertory of icons was to be changed according to the feast day. The chancel screen was the site for those parts of the liturgy that took place outside the choir before the eyes of the congregation. The icon of the saint of the day was, as the texts say, "set out" here so that the congregation could kiss it and genuflect (*proskynēsē*) before it.[4] When the occasion demanded, individual panels were removed from the image frieze for special veneration. Liturgical practices governed the kissing of the iconostasis during the liturgy (chap. 9e) and the transformation of the facade of the chancel on particular feast days. It was a kind of wall (before the chancel) *with* images, not a wall *137* *of* images, and changed very often in the interval between the fixed icons of the patron saints. This chapter is therefore concerned not only with the iconostasis but with the use of icons during the hours of daily prayer and during the (Eucharistic) liturgy.

The question of the part played by the icon in the liturgy has given rise to needless controversies. Some have seen the icon as the very essence of the liturgical image. For others, it never had a real place in the liturgy. But by now there can be no doubt that icons gradually became introduced into liturgical practice; in discussing this question, however, one must specify both the time and the kind of liturgy one is referring to. Sources that give us detailed information on the relevant practices come from the eleventh and twelfth centuries. Surprisingly, it was not the strict monastic circles that took an interest in the icon at that time but laypersons, who formed a more personal relationship with it. They disseminated particular examples of icons in order to enjoy their special protection in return. The veneration of images had always been a popular form of extraliturgical participation in church life. In the aristocratic monasteries, which served both as an investment for wealth and as a means of salvation, images now began to take part in the liturgy, which the founders would shape themselves by

the rule (typicon) that they formulated.[5] Although the traditionalists in the high clergy and among the monks resisted for a time, they themselves came under competitive pressure if they wanted to keep pace with the needs of personal devotion and the investment of rich donations.

This is no doubt a simplified view of the matter, which is meant to counterbalance the assertions of the theologians, who raised the icon to a timeless ideal whose history we do not need to discuss. Icons were approached for signing contracts or were used as votive gifts—the value of which increased with the costliness of the material—to heavenly patrons chosen by the donor. Thus they served both as a medium and a recipient of lay intervention in the affairs of the church. Instead of speaking of the liturgical role of the icon in general, we must also pay attention to the institution of private devotion, particularly with regard to the commemoration of donors in the liturgy. In this way, we will gain insight into the mentality of an aristocratic class that, through its members in the ranks of the clergy, also had a major influence on the development of the general liturgy.

a. The Church Interior and the Site of the Images

For Western eyes, the dramaturgy of the Byzantine service, which uses the entire church interior as its stage, is certainly the most striking feature of the Eastern church. What in the Western church is reserved for high feasts makes up the regular practice of the Orthodox church: processions, solemn incantations, and a carefully regulated interaction between the priest (or bishop) celebrating the Mass and the deacons and singers. Within the chancel, which is comparatively small and is often confined to the apse, the only acts that take place depend directly on the altar. There is no choir space in the manner of Western churches. Parts of the service that precede the sacrificial liturgy take place in the main area of the church, below the dome. The preparatory liturgy of the offering of gifts starts in the left choir (*prothesis*), and from there the "Great Entrance" proceeds with the gifts for the altar.[6]

153 At this moment, the clergy pass through the "holy doors," as the doors of the chancel were called, and enter the "inaccessible space," the *adytum,* for the sacrificial act. The priests interrupt the procession before the chancel screen and then pass into the sanctuary, or bema, after kissing the doors that they pass through. As soon as the curtains of the chancel screen are closed, the congregation participates in the liturgy only by listening to what is said or sung or by looking at what they see on the chancel screen—that is, the icons. As the altar is not always visible, the icons are not placed on the altar itself but on the iconostasis. Only the processional cross temporarily rests on the altar and here represents Christ, as does the Book of Gospels when it is placed on the altar.

The "liturgy of the word" actually begins with a different procession, later called the "Lesser Entrance." It was originally the entry of the clergy and congregation to one of the churches in Constantinople that was the "station" for the celebration of a particular feast day. The patriarch proceeded from Hagia Sophia and, after a halt before the Column of Constantine on the Forum, entered the station church.[7] This form of entry remained the custom even when the station disappeared. It began at the

226

main portal, called the "beautiful doors" (*hōraiai pylai*), and ended in front of the "holy doors" of the chancel, which were still closed. The first entry passed through the portal into the church interior, while the second passed through the portal into the altar area. The "word liturgy" took place before the holy doors, but the actual sacrifice of the mass was enacted behind them. The portals thus distinguished three stages of the liturgy: the vestibule (*narthēx*) as the site of the daily hours of prayer, the church interior (*naos*) as the site of the first part of the main liturgy, and the sanctuary (*bēma*) as the location of its conclusion.

This brief summary is intended to make clear the topography of the church in terms of its function for the liturgy. The doors of the chancel screen were just as much a portal as was the entrance of the church itself; even more than the latter, they were a focal point of the liturgical events taking place before or beyond them. A repeated coming and going, dramatized each time by the departure of the priests and their reappearance before the eyes of the congregation, underscored the importance of the boundary formed by the doors (and chancel screen) between the accessible and the inaccessible areas of the church—between the visible and the invisible, no matter what one meant by these terms. The invisible was made visible, in a way, in front of the screen. The image was a representation, a translation of the liturgical reality— that is, the presence of God and the saints. Saints were made visible in their portraits; the feast (e.g., Good Friday) in the event underlying it (e.g., the Crucifixion). With its interchangeable elements, the iconostasis thus became a kind of picture screen whose images summarized the liturgical repertory.

But if, in addition to the permanent icons, there were movable icons as well that were removed from the chancel screen, there must have been other places in the church where they were normally kept and also venerated, at least outside the liturgy. Not only the treasury could be used for this but also chapels, side chancels, rooms in the vestibules, and the tombs of donors. Thus we read in the rules of a twelfth-century monastery that icons were displayed on costly stands beside the founder's tomb.[8] The same text prescribes that after a procession all the sacred relics taken along in the procession, including icons, should be brought back to the "holy places where they belong."[9] Such a description makes us aware of how little we know of the furnishing of the Byzantine church interior with its movable items. The iconostasis may have been the focal point, but it was not the only theater for the veneration of icons.

The texts give the topography of the icons which received ceremonial lighting or the use of incense. The rules of the imperial monastery of Christ Pantocrator in Constantinople are a prime example. The priest is instructed to offer incense first to the titular icon of the main church (Pantocrator), and then to "all the holy places inside the church and the most venerable icons in them."[10] When the founder goes on to mention the lighting of icons, it turns out that by "icons" he means not just panels but also such wall paintings as were found in prominent positions in the monastery and were venerated in the same way as panels. They include feast-day images of the Crucifixion and the Descent into Hell (*anastasis*).[11] In the neighboring church of the Virgin in the same monastery, lights were to be attached to each of the images (*eikona*) above the seven doors inside the church. That is no doubt an extreme case, but

the inclusion of wall icons was not unusual. The icon of Mary's death (*koimēsis*), a wall mosaic above the main doorway in the inner west wall, was illuminated not only here but in another monastery, because "the grace of divine inspiration lies . . . on this icon [*eikonisma*)."[12] In churches of the Virgin the *koimēsis* was the "feast of feasts."[13]

In the monastery of the Pantocrator, on the feast of the Transfiguration of Christ, an especially large candle was placed before "the icon of the Redeemer, which is set up [for veneration]."[14] Clearly the *metamorphōsis*, the transformation of Christ into his divine form, was just as central to the perception of Christ as the death of Mary, her passing into heaven (*metastasis*),[15] was to the perception of his Mother. Both events transcended into a different reality, whose existence too was the premise of venerating the icon in terms of its heavenly archetype that was revealed behind the material image.

The Pantocrator monastery gives us a vivid picture of the different sites of the icons in the monastery's three churches. In the number of candles and the type of candlestick used, the illumination followed a hierarchy both among the icons and in the sequence of feasts. The titular icon in the main church is more richly illuminated than the two genuflection icons (*proskynēseis*) (cf. chap. 12c). In the church of the Virgin two further genuflection icons are given attention. The patron, *Maria Eleousa*, is represented in a procession icon (*signon*) and in a mosaic in the vestibule. Another vestibule mosaic of Christ, the Virgin, and the Baptist together forms a three-figure deesis. Finally, two lights are to be provided "in front of the icon of Christ that stands at the entrance to our tombs." In another monastery the repertory of icons included a stone icon on the bridge leading to the monastery precincts that was to be venerated by passersby.[16] In an imperial convent of the Virgin in the capital, a procession passed through the convent grounds up to a wall painting of the Virgin's Dormition (*koimēsis*) on the outside wall of the nuns' dormitory.[17]

b. Cross, Gospel Book, and Icon in Church Ritual

If we read attentively the rules for processions in eleventh- and twelfth-century monasteries, we notice that in those of the strict monastic orders no icons were carried, but only the cross and the Gospel book, as had been the case in the oldest tradition of the "Great Church," Hagia Sophia. In the old service of stations, the deacon took "the cross that stands before the altar," the patriarch took the "Gospel book that lies on the altar," and the two walked out of Hagia Sophia in procession with them.[18] In the "Lesser Entrance" the Gospel book was kissed by the patriarch in front of the main door and then entered the church as the representation of Christ, while the deacon held it up and invited all to stand in respect for the appearance of "wisdom."[19]

In processions in a convent of the Virgin in Constantinople, during the eleventh century, "the cross, the Gospel book, and the censer" were carried.[20] A hundred years later the imperial prince Isaac took this very monastery as the model for the rules of his own monastery but consistently altered the rules whenever he could introduce icons. In the procession on the main feast of the Virgin (the *koimēsis*), for example, "the abbot shall carry the Gospel book, another the icon of the Mother of God [the patron icon of the monastery], and another the great cross situated at the sanctu-

ary. . . . The procession shall pass around the entire monastery walls to consecrate and preserve the monastery and its land."[21] Clearly the titular saint, in the guise of her image, is here also symbolically called on to occupy the monastery. In Isaac's regulations for the Great Liturgy, wherever the cross alone was mentioned previously, now the founder always specified that the fixed icons on the chancel screen should also be kissed.[22]

In the rule of the Pantocrator monastery of the emperor, whose brother was the Isaac just mentioned, the change is even more striking. Every Friday evening the *presbeia,* or "intercession," vespers of the Virgin included a commemorative procession to the family tombs. In addition to the procession icon of the Virgin of Mercy (*Eleousa*), which otherwise rested on a stand (*signon*) in the monastery's church of the Virgin, "the other holy icons shall take part [in the procession]. It shall also pass by our graves and pause there for a great supplication." During the "entry and exit of the holy icons," all the aisles were to be festively lighted.[23] On the actual memorial days of the dead, even this ceremony was surpassed. Then the original of the miraculous icon of the *Hodegetria* was brought to the monastery from its home and spent the night at the tombs of the dynasty in the presence of the entire convent of monks.[24] The emperor, not satisfied with the power of the monastery's local icons, tied the salvation of his ancestors to the most famous icon in the whole empire. In his own monastery, he was able to integrate the icon's veneration into the official liturgy by a binding rule.

What has been said about the role of the icon in the liturgy (chap. 9e) now needs to be expanded, and to some extent qualified. Images situated within the liturgical space and depicting liturgical themes were not always the ones that had an active part in liturgical practice. They often served, like liturgical poetry, to make the content of the liturgy visible and concrete. After iconoclasm, hymns too became more and more concrete in terms of their narrative and visual content. The images themselves borrowed their own form from the liturgical anamnesis, which did not narrate the biblical events in literal terms but transferred them to the timeless sphere of a revealed mystery. Standardization was to work against the privileging of isolated icons (chap. 9d).

Matters went a stage further when the commemoration of a saint or a feast was firmly linked to the veneration of an image, which, before, had had no place in the liturgy. The liturgical calendar then laid down when a saint's feast icon or day icon had its turn and also made sure that its veneration stayed within the framework of the liturgical order. References to image stands (*stasidion, signon, proskynēma*) show that such icons were displayed in the church interior.[25] It is not clear, however, what place they held within the liturgy. Only those icons of the feasts of Christ (usually fixed to the number twelve) that formed the *templon* or stood on it were by nature 138 liturgical. They were specially illuminated during liturgical prayers and, unless they were painted on a single long panel, could be removed from the series when the corresponding feast arrived.[26] An eleventh-century monastery rule specifies in more detail what was meant by the "feasts of the Lord," naming Easter, Pentecost, the Annunciation, and so forth.[27] The same set of rules mentions an icon of the "redeem-

ing Crucifixion" on the chancel screen. The mosaic of the Virgin's death (*koimēsis*) above the inner main portal was also incorporated into the processions on the appropriate feast day.[28]

The case was different when a founder sought to introduce his or her own favorite icon, where possible, into the liturgy. It represented the legal person of a monastery or was used for personal salvation at the founder's tomb. If such an icon, which had served a personal interest, was incorporated into the liturgy, then it needed a special attempt of the founder to make its veneration acceptable by the monks. Precisely such attempts are reflected in monastery rules of the time that were drawn up by laypersons.

In the public liturgy in the capital, however, which was tied to that of the episcopal church, and in the liturgy of the great monasteries, where laymen had no jurisdiction, the integration of icons into the ritual was a protracted and uncertain process, the stages of which cannot be exactly described as yet. Only occasionally do we get a fleeting glimpse of the process, as when new rites bring with them new images, or images appear with new themes. The liturgy of the Passion is one example by which the process could be revealed, but even here the liturgy of the Great Church followed the innovations of the semiprivate monasteries only after a great time lag.[29] The bilateral icons of the lamenting Virgin and the lamented Christ were suitable recipients for the antiphonies of the Virgin's lament. An eleventh-century will gives two icons the exact names of the liturgical Marian hymns, *Theotokia,* and the inventory of the monastery of Eleousa gives a Marian icon the name of the Friday vespers, *Presbeia,*[30] thereby indicating that these icons had definite liturgical functions. By the end of the Byzantine empire the icon had become so accepted a part of daily liturgical practice even at Hagia Sophia that Symeon of Thessalonica could write at length about the use of icons in the liturgy there.[31]

163, 207

c. Votive Images as Instruments of Salvation and as Commemorations of the Donor

Nowhere is the mentality of a lay founder of a monastery so clearly revealed as in the rule that Prince Isaac conferred in 1152, at the end of his life, on a newly founded monastery where he wished to be buried.[32] The monastery was situated in Thrace, far from the capital, and was dedicated to the Virgin, who here bore the title "World Savior" (*Kosmosōteira*). Isaac called her "my World Savior and manifold benefactress" and honored her in a mosaic icon that, in accordance with his wish, was to take up its residence at the monastery. He had it adorned with a rich covering of gold and silver and designated his own tomb as the place where it was to be displayed. The icon had already been the object of a cult in the region, for Isaac named it after the town nearest the monastery, Rhaidestos. But he wished all to believe that he had inherited it and been allowed to adopt it as his personal icon at the express wish of heaven. He may already have owned it in the capital, where he had originally wanted to be buried in the monastery of Chora, for he sent for a stand for a mosaic icon that had been set up at his tomb there. The icon, which was carried around on festive occasions, was also the visible patron of the monastery and, through its place on Isaac's grave, the personal intercessor for its founder. It therefore received another

image of identical size in the form of a Christ icon. In return for Isaac's devotion, the Virgin was to intervene with Christ as his advocate. To emphasize his personal piety, Isaac finally had a silver copy of an amulet of Mary, which he wore around his neck, fixed to the lid of his tomb.

Isaac's portrait has reached us only through a fourteenth-century replica that survives at his first tomb in the Chora monastery.[33] He forbade the use of a portrait (*eikonisma*) at his new tomb, since his body would not deserve such honor after its decay. If we are to believe the later replica, Mary was turned in an attitude of supplication toward Christ, who in Constantinople was called *Antiphonites,* that is, he who "gave answer." But Isaac's text indicates that Mary is holding her Child in her arms. Isaac was essentially obsessed with obtaining and stipulating by contract all monastic prayers and petitions on his behalf that convention could possibly permit. Therefore he even specified how many poor should be fed and how many prayers they should say for the founder once they had had their fill. Every evening, before the icon of the Virgin on the founder's tomb, and after vespers, the entire chapter of the monastery was to invoke the mercy (*eleos*) of Isaac's patroness. The title *Eleousa* was one associated with numerous Marian icons, but they do not always follow a fixed image type (chap. 13f).

149

139

In the course of his liturgical deliberations Isaac mentioned the festive illumination of two other icons that were situated inside the church proper and so were distinct from the icons on the tomb in the vestibule. He therefore called them *proskynēseis,* or genuflection icons, as they were supposed to be at the center of liturgical veneration, like the icon of the day. Their place was "on either side of the church," which can only mean that they were mounted on the pillars flanking the iconostasis before the chancel. Isaac also called them *eikonismata,* as if they were portable panels, and praised the effect they gave of being living, speaking beings. Finally, he identified them. The monastery's patroness, Mary the World Savior, was complemented by Christ the "most kind" (*hyperagathos*)—kind, that is, to Mary's client Isaac. Lamps burned constantly before these icons, and on the feasts of the Virgin two eight-branched candelabra stood in front of them. The fixed icons of the monastery's patroness and of her partner, probably life-size wall paintings with precious frames, assumed a twofold function. Mary and Christ formed a couple whose dialogue included a permanent intercession for the founder; they visibly reminded the monastery whom the liturgical activity within it was intended to benefit. The Virgin's icon here represented the true holder of rights at the monastery, while the portable icon on the tomb represented her personal intercession for Isaac. Finally, the extraliturgical functions of the two standing icons become clear when Isaac describes the appointing of the monastery officials. The keys of office were deposited before the icons, where the candidates received them after genuflecting three times.

139, 140

This setting provides an explanation for the term "genuflection icons," or "prostration icons" (*proskynēseis*), the meaning of which is not narrowly defined. It doubtless also refers to any icon that was displayed on a given feast day "for veneration [*proskynēsis*]" (sec. b above). As a rule, it also applied to the local or titular icon of a church, which held the highest rank in its particular icon repertory. In the inventory

of the monastery of Maria Eleousa, this icon is distinguished from other Marian icons as *proskynēma*.[34] But if it was a movable panel, it became the custom to duplicate it on the iconostasis in order also to give it a fixed place in a wall image. There it functioned to pass on the petition (*deēsis*) of a founder or a community through its intercession (*presbeia, paraklēsis*) with Christ.[35]

This background explains why two "genuflection icons" are constantly referred to in the two main churches of the Pantocrator monastery, and why they are each time distinguished from the titular icon.[36] A stand for the titular icon in the church of the Virgin is mentioned, so we can be sure that it was a portable procession icon. In the monastery's third church, dedicated to St. Michael, only the icon of the archangel is called a *proskynēsis,* and we are told that the Redeemer was seen opposite it. In this case, then, the main icon was firmly anchored in dialogue within the iconostasis.

In the monastery of Arakas near Lagoudera, Cyprus, the fixed icons in the iconostasis, in the form of a pair of wall images, as well as the movable panels that were occasionally placed on the iconostasis, survive from 1192, the year of the monastery's foundation.[37] The former are full-length figures, the latter half-length. In the iconostasis, the Mother of Mercy (*Eleousa*) addresses a long letter of petition to "Christ who answers" (*Antiphonites*), while on the panel she is identified with the monastery's name, as the "Mother of God of Arakas." On the matching panel of Christ, the founder presents his petition (*deēsis*) as an inscription on the frame. A comparison with these four icons gives us an idea of Isaac's icons. Here too the "genuflection icons" were two permanent images in the iconostasis.

For the main feast of the Virgin, the commemoration of her death in August, Isaac envisaged an important task for the mosaic icon on the founder's tomb. It was borne in procession around the entire monastery as if it were the patroness in person, an activity for which the portable image was well suited. By this procession the Virgin took under her protection the monastery dedicated to her. And by appearing as the possessor of rights, she represented Isaac's rights, since she was under contract with him. As it returned to the church, the portable icon passed the wall image above the west door, which depicted the feast of the day, for which the wall icon was festively lighted. Isaac thus clearly defined the roles of the individual icons and the occasions on which they were to play them. In a twelfth-century manuscript that contains the annual readings for the feast days the frontispiece, with its view of a monastery church as Isaac envisaged it,[38] represents the patroness of the monastery in a mosaic situated above the main entrance. Thus Mary, exactly as Isaac prescribed, holds a prominent position through her icon.

The liturgical commemoration of founders profited from the donation of images, as they were more durable than documents of parchment or paper. The high dignitary Pakourianos, a Georgian by birth, gave a further example of unusual sumptuousness in the late eleventh century by bequeathing his immense fortune to equip the monastery of the Mother of God at Petritsa in present-day Bulgaria "as beautifully and sumptuously as was within my power and as the times allowed."[39] Icons of gold, silver, enamel, and gems played a special part. Elsewhere too, icons with precious casings were treated as a special group distinct from "unembellished" (i.e., merely

painted) panels.[40] In the expense that Pakourianos lavished, a Georgian tradition played a part.[41] As the founder chose no less than three patrons as "guides and advocates"—John the Baptist and St. George as well as the monastery's patroness, Mary—he must have had difficulty in harmonizing his patrons in their various titular icons.

If a monastery lacked a founder who would bring in his own wealth and safeguard the monastery's resources against misuse, then new donors had to be recruited to grant valuable gifts and, in turn, to receive recompense in the monks' work of prayer. In this transaction, icons, holy vessels, and books played a special part. In the rules of the monastery of the Beneficent Virgin (*Euergetes*), they were referred to as votive offerings (*anathemata*), whose divestment was subject to punishment.[42]

d. The Chancel Screen as Iconostasis

The history of the images on the chancel screen began long before iconoclasm. In the early period, single icons, and sometimes also group portraits of intercessors, can be found on the chancel screen. On the occasion of the reconsecration of Hagia Sophia in 563, the poet Paul the Silentiarian describes an altar screen made of silver on which the hierarchy of heaven was depicted, probably in the form of medallions.[43] In another church in the metropolis, Christ was seen between John the Baptist and the church patron Artemios in large icons on the chancel screen, which then was already called the *templon*.[44] About 600 a frieze of stone icons was placed on the screen of the church of Polyeuktos; parts of these icons, which have recently been excavated, represent the Virgin and the apostles in half-length figure.[45]

In Rome, too, the custom of attaching icons to the chancel screen was adopted, and Pope Hadrian (772–95) donated to St. Peter's two sets of three large icons in silver mountings.[46] If we are to believe a report recorded by Bede, as early as 678, Benedict Biscop took painted panels with him from Rome to his convent church of Monkwearmouth in northern England, using them as an entablature (*tabulatum*) above the entrance to the chancel.[47] These figures were repeated soon after on the wooden shrine of St. Cuthbert, in a form that allows a comparison with the stone panels of Byzantium.[48] These scattered indications are enough to prove that attaching icons to chancel screens was an early custom.

After iconoclasm this practice became the rule, and a system was developed that placed the images in an order with a liturgical meaning. The structure of the screens, consisting of supports of stone or precious metal that divided the slabs below and carried an architrave above, guaranteed continuity. A painted icon frieze could be placed on top of the architrave or entablature (epistyle), with the intervals between the columns being filled with painted panels (diastyle icons) and the full-length *proskynēsis* icons being painted on the two outer pillars.

The chancel screen of the cathedral of Torcello gives an idea of such a basic structure.[49] The columns and transennae screens come from the rebuilding of the church in the eleventh century, while the architrave now carries a long frieze of half-figure portraits below arcades, which, as they are in Gothic style from about 1400, are not the first ones in this position. Chancel screens with icons were more common in the

144

137. *Staro Nagoričino*
(Macedonia), monastery
church; iconostasis before
the altar (after G. Babić),
14th century

138. *Mount Sinai, monastery*
of St. Catherine; templon *with*
the epistyle icons of the Feasts
of Our Lord, ca. 1100

139. *Arakas monastery*
(Cyprus); standing icon of
Maria Eleousa, *1192*

140. *Arakas monastery*
(Cyprus); standing icon of
Christ Antiphonites, *1192*

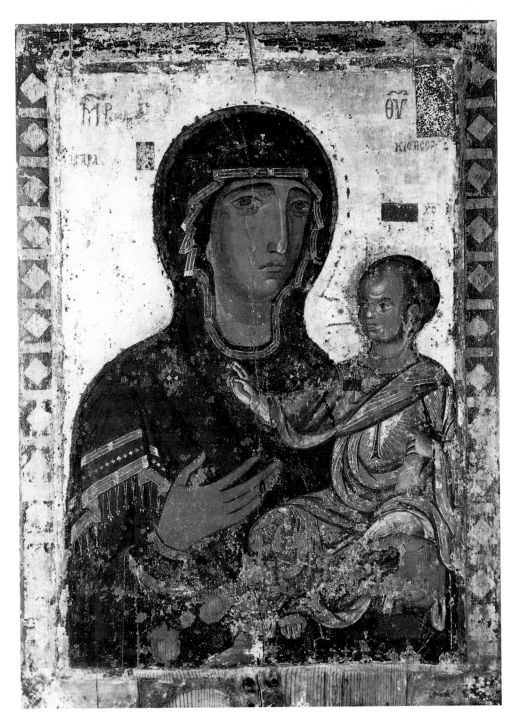

141. *Arakas monastery (Cyprus); diastyle*
icon of the Mother of God at Arakas, 1192

142. *Arakas monastery (Cyprus); diastyle*
Pantocrator icon, 1192

236

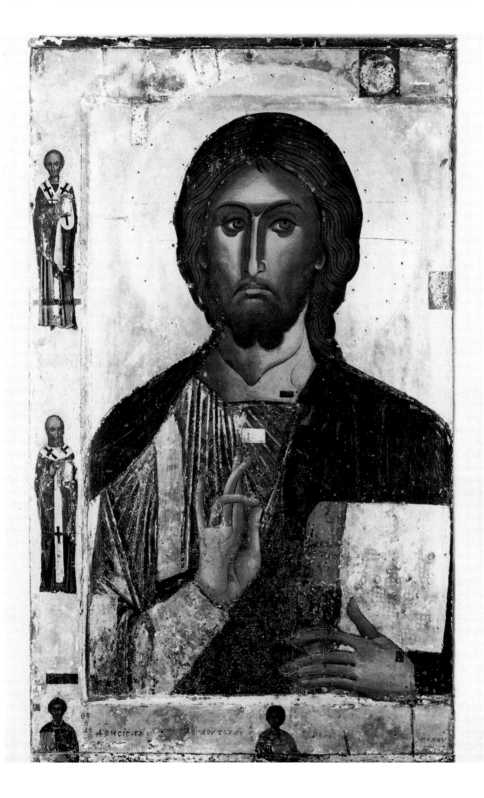

237

West than one might expect today after the purging of churches following the Council of Trent denuded such displays. Two panels in the Museo Correr in Venice, remnants from a similar *templon*,[50] initially were mounted as individual panels on a frieze of apostle figures and divided by inscribed arches that formed a double frame. A thirteenth-century panel in Nocera Umbra, with a comparable structure, is probably of similar origin (chap. 2c).

5

145 The icon frieze over the east door of the baptistery of Pisa, prepared around 1200, repeats a Byzantine model that probably had been part of a lost chancel screen in Pisa.[51] In a piece of adaptive virtuosity, the style of the model, and even its technique of hard-edged metalwork with enamel nameplates, is translated into brittle stone. The theme is the respected one of the great intercession of the saints and angels. It is found

4 in a very similar form in the only *templon* frieze that has survived as a whole, coming from a chapel of the Mount Sinai monastery. The board with thirteen half-length figures of the great intercession, which include St. George and St. Procopius, is almost 1.7 meters long.[52] Italian graffiti indicate that it was used by Crusaders, and the style points to a Venetian painter of the thirteenth century. Examples from the West and works by Western painters in fact enter the history of the Byzantine iconostasis.

A document of 1202 describes the structure of image-bearing chancel screens in Constantinople with welcome clarity.[53] It tells us that the chancel partition consisted of four tall columns of green stone and two sections of screen. The columns supported a marble entablature (*kosmēton*), on which was mounted a further entablature of gilt wood (*templon*) that probably carried icons.

It seems, therefore, that the iconostasis developed from the placing of simple painted icons on top of the old-style chancel screen. Its development after iconoclasm, however, linked up with another tradition and required the provision of screens of costly materials, of which the images, of embossed silver or enamel, were an integral component from the first. This practice is reported of chapels in the imperial palace as early as the ninth century.[54] Here the luxurious nature of the furnishings was more important than the possibility of venerating an icon. Such screens are to be seen as expensive pieces of furniture rather than as iconostases in the true sense. Ivories too found a place in the small chancel screens of the imperial chapels, if we are to follow Weitzmann in tracing back the ivories owned by Bamberg cathedral to a similar arrangement from the tenth century.[55]

We gain an idea of the appearance of such silver and enamel fittings about 900 from an imitation in the form of a marble screen that was excavated in a Phrygian church (Sebaste).[56] The founder's inscription praises the work's novel appearance and the effect of costly materials, which accordingly must have been considered significant. Twenty-one figures on the theme of the Great Intercession are depicted in inlaid medallions recalling real enamel. The program of saints is even continued on the columns. In its concept, this microcosm reproduces the program of church decoration. It identifies this type of screen as a piece of liturgical furniture.

Eventually, however, examples of costly metal screens appeared whose individual elements were true icons. Constantinople even exported experts who erected screens of this kind in places such as Monte Cassino. At the consecration of the screens of the

143. *Rome, Vatican Museum;
Cod. graecus 1156, fol. 1; title
page of lectionary, 12th
century*

144. *Torcello, cathedral; choir
barriers, 11th and 12th
centuries*

145. *Pisa, baptistery; icon
frieze above the east portal,
ca. 1200*

239

abbey church there in 1071, masters from Constantinople are mentioned as being responsible for the work.[57] Six silver-clad columns supported a bronze entablature that supported five shield-shaped icons (*tērētēs*) with silver frames surrounding painted panels "of Greek artistry and skill." Thirteen square icons of equal size stood on a wooden entablature with colored images on a gold ground. From Byzantine sources of the same period we also hear of silver *templa* with figured capitals.[58] In 1204 as spoils of war, the Venetians seized six unusually large enamels with images of Christ's feasts from an iconostasis.[59] Whether they really came from the monastery of the Pantocrator, as a Greek prelate asserted centuries later when he discovered them on the *Pala d'Oro* on the tomb of St. Mark, cannot be verified. It may be correct as regards the dimensions, but the iconostasis of the Pantocrator monastery was of marble, and we know of no other example that mixed marble and enamel in a single screen.

All these examples really belong to a different tradition that synthesized images and ornamentation as a means of enhancing the splendor of the church interior with rich materials. The appearance of such screens was determined by an aesthetic different from that of the icon; the screens were themselves the culmination of the church's decoration. Only works of extraordinary stature give evidence of an attempt to make the screen into a wall of images, a site for the display of icons.

The latent contradiction between the two aesthetic concepts also influenced the appearance of the icon itself when it was given a costly "embellishment," as the metal casing was called at the time. The figure itself could convey the impression of a living person only through the delicacy of its painting. The costly frame surrounding it was an embellishment given as a donation, an additional cloak, that in the end went so far as to leave only the painted face and the painted hands exposed.[60] The *Nicopeia,* now venerated in S. Marco, thus was given an additional nimbus of enamel (chap. 10d), mentioned in inventories of the time as a *phengos,* or "luster," on account of its sumptuousness.[61] Sometimes the embellishment has the character of a votive gift, given to the icon as if to a person, just as the statue of St. Peter in Rome is given festive robes on special occasions. The coronations of icons in Rome show a similar character.[62]

The iconostasis did not need the luxurious furnishings that have been described. Its intrinsic purpose was to provide a kind of architectural frame within which icons were seen, or a stage on which they appeared, but at the same time it was a barrier at the entrance to the chancel, on which fixed and variable icons together formed the changing "face" of the altar area. For this reason its basic scheme hardly changed during the centuries after iconoclasm. Given this stable framework, the individual icons could be varied all the more richly, as could their liturgical interplay.

A small church in Nerezi, south of Skopje in Macedonia, dating from 1164, gives us a good insight into the layout of the iconostasis customary at that time.[63] Only the fixed parts survive, not the movable panels, consisting of the fixed icons on the two outer pillars, on which two almost life-size standing figures make their appearance. They are singled out from anything else in the church by a projecting frame of stucco and stone. It is not only a picture frame but a columnar arcade that, seen in conjunc-

tion with the figures, indicates a canopy appropriate for suggesting a veritable epiphany. As such baldachins (isolated examples are still preserved in Georgia)[64] may originally have been used for the display for movable icons called *proskynēseis,* at Nerezi they enhance the effect of wall icons with the same function as the *proskynēsis.*

The dialogue between images that was possible whenever the patron was Christ or the Virgin did not apply to Nerezi, where the patron saint was Panteleimon ("he who has compassion for all"), who, according to legend, was baptized by a voice from heaven.[65] Such a nature qualified him well for a role in which the first requirement was to intercede on behalf of the founder and of the community. In the picture he is carrying the utensils of the physician he had first been, which inspired confidence in his continuing miraculous powers. The youthful saint with the reddish-brown locks fulfills the expectations of an ideal male portrait that we have discussed elsewhere (chap. 11b). He represents—as painting generally did in the later twelfth century—a gentle and sensible human being, conveyed by a vivid and sensitive use of line that endowed all corporeal elements with spiritual expression.

As we have seen, the fixed icons in the monastery of Arakas in Cyprus present the patroness of the church, Mary, in dialogue with Christ. The usual dialogue between the two icons is enforced as the Virgin unrolls a written petition before her Son. The scroll has the form of an official document, but the text records the words exchanged by Mother and Son, rather than the document's contents. It begins with a question as to what the Mother is requesting, to which she replies that she is begging for the "redemption of mortals."[66] The scroll is thus both a sign of petition and a transcript of the dialogue, which has the quality of a legal document.

In the sideward position of turning toward another icon, that of Christ, the icon of the Virgin follows the famous model that once resided in the church of the Virgin in the quarter of the Chalcoprateia in the capital and carried the name of the relic chapel (Hagia Soros) of Mary's girdle.[67] As the iconoclasts here destroyed an icon of Christ "which gave answer" (*Antiphonites*),[68] we come across the very title of the other icon at Arakas, just as (perhaps as early as the eleventh century) a mosaic icon in a church of the Virgin in Nicaea once carried this title.[69] It therefore seems that the Cypriot painter was alluding to a famous double icon that had its home in Constantinople and that inspired all such formulations, as it also was the model quoted by a Byzantine reliquary in the papal chapel.[70]

The variant with the written petition clearly also had an archetype in the same church, whether it was a modern version of the old icon or a companion piece that now proffered the letter. Two excellent replicas, produced about 1100 by painters in the capital, reproduce this more recent original. One of them, now in the collections of the Mount Sinai monastery, is distinguished by its uncommon use of encaustic paints. The other has been venerated in the cathedral of Spoleto since the thirteenth century.[71] The variant with the letter was therefore not an invention of the Cypriot painter's but a quotation from an original icon, while the title in the inscription, *Eleousa,* underscores its present function in the iconostasis. One must assume in general that the *type* and the *name* of an icon had a fairly free relationship with each other and that they sometimes referred to different archetypes.

148

139, 140

149

146. Nerezi (Macedonia); iconostasis of
the St. Panteleimon church, 1164

147. Nerezi (Macedonia); St. Panteleimon
church, reconstruction drawing (after
G. Bambi)

242

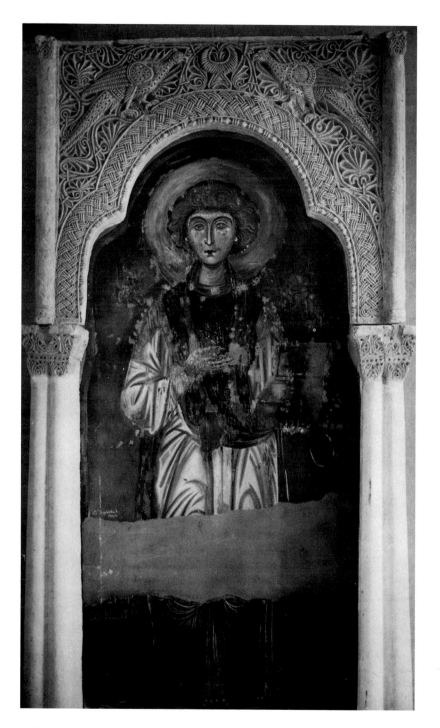

148. *Nerezi (Macedonia); titular icon of St. Panteleimon, 1164*

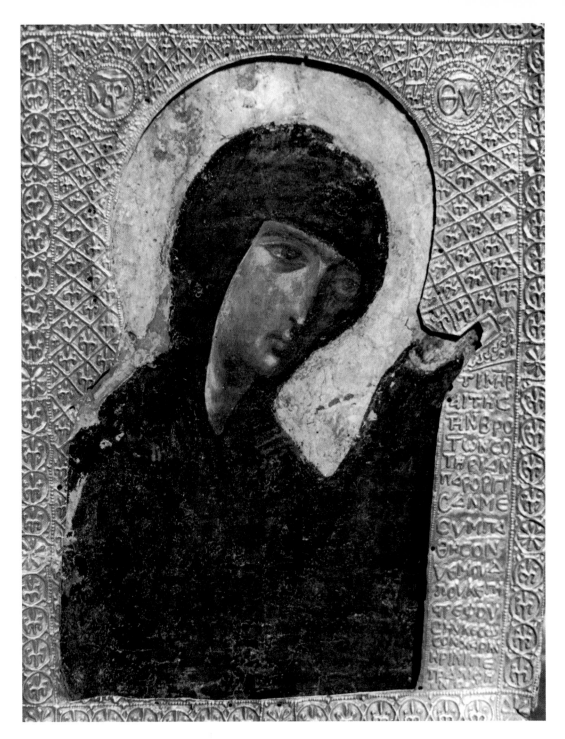

149. *Spoleto, cathedral; icon of the Madonna with Petitionary Letter, ca. 1100*

The portable titular icons, which have been lost in Nerezi, survive in the Arakas *141, 142* monastery. They are half-length images of the "Mother of God of the Arakas monastery" and of the Pantocrator. Because the full-length fixed icons show the dialogue between Mary and Jesus, the portable ones can dispense with it. The theme of intercession was only rarely used in mobile procession icons. It did occur, however, in the late twelfth century, in the hermitage of the unusual Neophytos, also in Cyprus.[72] This example also deserves mention for other reasons. The "merciful" Virgin here *150* appeals to Christ, the "Friend of Humankind" (*Philanthropos*). This was the title of a monastery in the capital, which was next to the monastery of the Virgin Full of Grace (*Kecharitomene*). The feast of the Philanthropos, held on 16 August, one day after the feast of the Assumption, celebrated the Redeemer, who graciously heard Mary's appeal on behalf of city and empire.[73] Again, therefore, the names of the icons invited associations that guided the expectations of the beholder. The dialogue of the icons was enacted by the same two partners, who played a variety of roles.

None of the portable titular icons that formed a second pair in addition to the fixed icons (*proskynēseis*) have been preserved in their original positions. Nevertheless, we may assume that they had their place in the spaces within the chancel screen. We actually find them there in the church at Staro Nagoričino, a royal Serbian foundation not far from Nerezi in Macedonia.[74] Here, in an unusual fourteenth-century pairing, the icons in question are fixed in place. One of the diastyle icons represents *137, 153* St. George, the patron saint of the church, who has the titles of Victor and Redeemer (*Tropaiophoros* and *Diasoritis*), while the other repeats a famous icon in Pelagonia, in which the Mother bends tenderly toward her Son (chap. 13f). Two curtains (*podea*), which usually were fitted to the frames of portable icons, are painted below to allude to mobile icons. The fixed icons on the adjoining pillars show the usual couple presenting and receiving the petition. The Virgin "full of grace" (*Kecharitomene*) and Christ the "compassionate" (*Eleemon*)—who, in the open book, calls to himself all who labor and are burdened (Matt. 11:28)—are only conceptually related, without actually performing the dialogue. The "holy doors" conclude the ensemble with the obligatory theme of the Annunciation, which is seen as the gateway to the story of salvation.

As a rule, titular icons show the church's patron. If that was the Virgin, the icon qualifies her role with reference to a given prototype, which often was a titular icon of a church in the capital. When a church was dedicated to the Holy Cross, which, as a symbol, could not be the theme of an icon, then, in one example, the Way of the Cross was chosen, as is shown by the titular icon of the church of the Holy Cross at Pelendri in Cyprus about 1220.[75] The panel, 112 × 83.5 cm, depicts the preparation for the nailing to the cross, which has already been erected (*helkōmenos*). In this way the cross could be given more emphasis than the Crucifixion allowed, while still focusing attention on Christ, whose biographical reality provided the significance of the image. But since in such a case, there were no firm rules, a church at Monemvasia in Greece that had the very title of the Way of the Cross (*helkōmenos*), was paradoxically given a panel of the Crucifixion as the titular icon.[76]

The one element of the iconostasis that rarely survives only became known in a

150. *Paphos (Cyprus),*
Neophytos monastery; Marian
diastyle icon, 12th century

151. *Palermo, Museo*
Nazionale; fragment of an
icon frieze, 13th century

152. *Mount Sinai, monastery*
of St. Catherine; private icon
with an abbreviated form of
the iconostasis, 11th century
(detail)

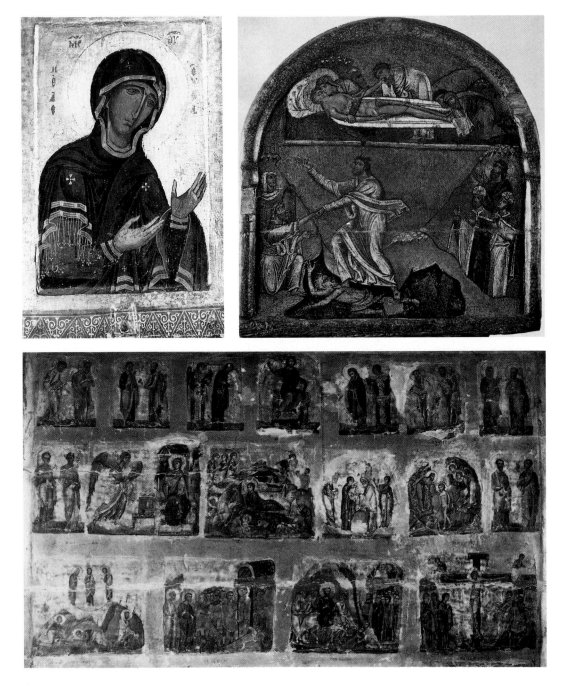

153. *Staro Nagoričino (Macedonia),*
monastery church; iconostasis, 14th
century

154. *Mount Sinai, monastery of St.*
Catherine; templon *with the epistyle icon*
of the feasts of Our Lord, ca. 1200

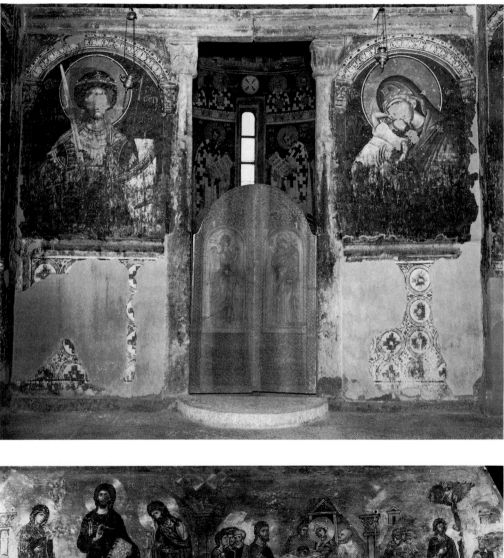

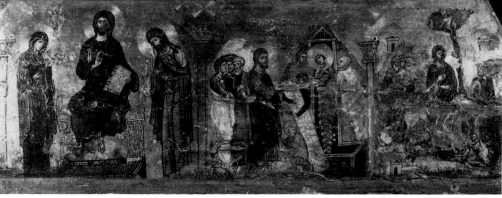

quantity of examples once investigation of the icons in the Mount Sinai monastery
began. It is the icon frieze on the entablature (epistyle), of which only a few examples
in Russian collections and on Mount Athos had previously been known.[77] The new
discoveries confirm that the Great Intercession and the yearly cycle of feasts made up
the main themes of these epistyle icons.

138, 154

152 A small eleventh-century panel contains a résumé of the focal points of the ico-
nostasis.[78] Twelve feasts, from the Annunciation to the Dormition, are arranged in a
biographical sequence like independent "images within images" and like shorthand
versions of individual icons. They are introduced by a Great Intercession with the
twelve apostles and two angels before the enthroned Pantocrator. They should prob-
ably not be called a deesis, as is customary, since this term refers rather to the beholder
and the founder.[79] Perhaps the concept of the "Great Ektene" or of the "Litany" is
more appropriate.[80] But the idea is clear. What the throng of saints assembled on the
church walls expressed by their full number, the frieze of the saints interceding at
God's throne conveyed by the visible unity of their action. Heavenly ceremonies were
best suited to be depicted on the long frieze above the chancel screen. An iconostasis
beam of the thirteenth century, also in the Mount Sinai collection, reconciles the idea
of the series subsumed under a common theme with the idea of the individual icon
(see earlier in the sec.). The *series* is expressed by the common orientation of all the
figures toward the center, the *single icon* by the recessed field in which it is mounted.

4

 If a church had only one epistyle beam but still wanted to include the Great In-
tercession, this theme was shortened to a three-figure group that was placed at the
center of a cycle of festival scenes. Among several examples from the twelfth century,[81]
an arcade of small columns, as a silhouette on a gold ground, divides the icons of
"Christ's feasts" from the petition group at the center. Panel painting here comes to
its best, and concentric grooves in the nimbi and the gold discs between the arcades
catch the light like mirrors. The colors either take on an enamel-like luster, as with
ultramarine and gold, or are used for atmospheric value. Given such a uniform overall
impression, the variety of detail is astonishing. Surviving pieces begin with a strictly
constructed feast cycle from about 1100, the figures of which have a stylistic counter-
part in the frescoes at Asinou in Cyprus (1106),[82] and end with a very dramatic cycle
from about 1200, in which the colors give an effect of unreality, with flowing chords
of vermilion, white, and green. Even though the individual icons in the series look at
first like mere miniatures, on closer inspection they are of extraordinary richness, well
suited to arouse pious empathy.

154

138

154

 In larger churches, either the icon frieze of the *templon* passed straight across all
three chapels of the chancel and thus included the "small *templa*," as they are called
in the Pantocrator monastery,[83] or the three openings were given themes of their own,
such as cycles of the saints who were particularly venerated in them. The examples in
the Mount Sinai monastery include a Life of the Virgin and a Legend of St. Eustratios
that deserve mention.[84] The Life of the Virgin is actually a complete sequence of
the Virgin's feasts that matches the sequence of the homilies and hymns that were
preached or sung on those days (chap. 13). The Legend of Eustratios closely resembles
the biographical icons of saints that will be discussed later (sec. e below).

In the West, too, such epistyle icons or iconic epistyles were more widely adopted than the surviving specimens suggest. The examples from Venice and Pisa have al- *144, 145*
ready been mentioned. A further example in the museum at Palermo comprises two panels with semicircular tops.[85] They show the themes of Lazarus, the Lamentation, *151*
and the Descent into Hell, divided into two zones, as was the case in privately used "miniature iconostases" found in the Mount Sinai monastery.[86] In Venice in the fifteenth century the image friezes above the chancel screens developed into many superimposed registers of carved niches, following a technique similar to that of altar ancons, as a view of S. Antonio Abate by Carpaccio proves.[87] This technique was exported to the East, where the iconostasis now entered a period of development that is no longer our subject.

e. Calendar Icons and Biographical Icons

Another genre of icons, which survives only in examples on Mount Sinai, comprises a complete catalog of the saints of the year, according to their monthly and daily *159*
sequence. They could be called *month icons,* but sometimes three months and in one case six months are compressed into one panel. It is therefore preferable to refer to them as *calendar icons,* as they reproduce the order of the church calendar—the order that has fixed dates and commemorates, as a rule, the saints. Many of the great feasts of Christ depend on the changing date of Easter and so remain outside this fixed order. Nothing more clearly bears the stamp of liturgical thinking than this monotonous compilation of standardized saint figures, and yet the practical liturgical function of the genre is uncertain. It seems to contain lists of icons rather than icons themselves.

Quite different are the *biographical icons* of a particular saint, which surround a *160*
portrait icon on all four sides with a series of scenes from the saint's life. This genre, called "vita icons," was known previously. The narrative frame reproduces the life and the miracles, including posthumous ones, in a kind of biographical celebration of the saint's merits and sacrifices. One might also call them "reading icons," since they offer the pictorial equivalent of the text of a saint's life. While the calendar icons say little about all saints, the biographical icons tell everything about one particular saint.

The two genres have their counterparts in two types of liturgical book, which both serve to commemorate the saints, yet have fundamentally different functions. One type is a feast calendar with a complete list of all the saints and a catalog of the hymns and biblical readings prescribed for their feast days. An example of this type is a lectionary in the Vatican, which supplements the calendar of movable feasts with that of the *155*
immovable feasts.[88] The left column of the page here illustrated names the liturgical commemoration (*synaxis*) of the archangels on 8 November and illustrates the feast *166*
with a shorthand picture of an icon of Michael performing his well-known miracle at his shrine in Chonae (chap. 13e). He is followed on 9 November by the martyrs Onesiphoros and Porphyrios, by St. Eustolia "on the same day," and on the tenth (notice the iota [ι] in the margin, the Greek letter for 10), "our blessed Father Nilos," this time with the appropriate reading "from the [Gospel] of St. Luke." The schema of the figures in principle comprises only the sex and status of the saint, whether

155. Rome, Vatican Museum;
lectionary, 12th century

156. Paris, Bibliothèque
Nationale; Cod. graecus 580;
title page of the November
menologion, 11th century

157. Mount Sinai, monastery
of St. Catherine; diptych of a
calendar icon, 12th century
(detail)

158. Mount Sinai, monastery of St. Catherine;
February panel from a quadripartite calendar
icon, 12th century

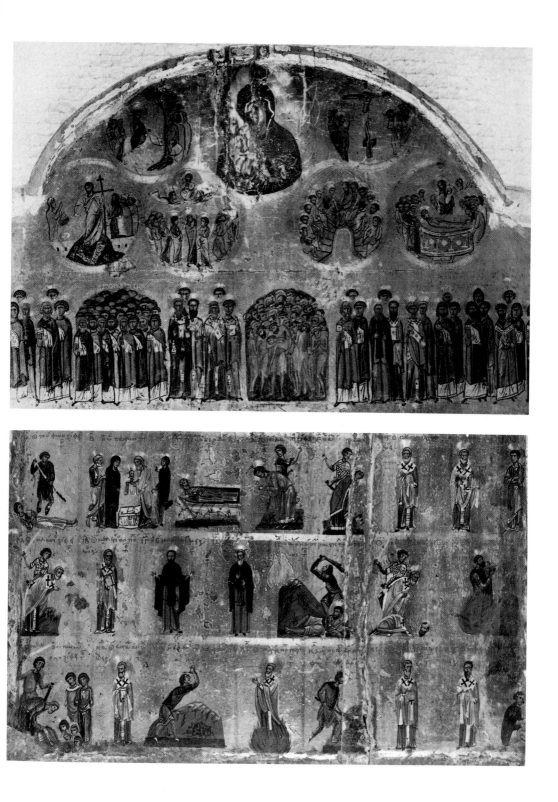

monk, bishop, or layperson. This liturgical compendium was called a *synaxarium*, as it contained the church's commemoration of all the saints in the *synaxis*.[89]

The other type of liturgical book brings together a selection of detailed lives of saints, and only these, in monthly or half-monthly volumes, for which reason it was called a *menologion* ("month book").[90] This book of readings was necessarily selective, if only because not all saints had such biographies. It was probably read at early mass, in the refectory during the communal meals, and also privately. The long readings were a supplement to the feast calendar, which did not contain such texts. In a complete edition of 1056, of which four volumes have survived, the half-monthly volumes have frontispieces that look like calendar icons but serve as a kind of table of contents for the book.[91] We reproduce the frontispiece of the "Saints of the Second Volume of the Month of November," owned by the Bibliothèque Nationale in Paris. The copious illustrations included scenes as well as "shorthand" figures, and sometimes there was an entire biography in pictures, if the book concentrated on the life of a single saint.[92]

Both genres tend to compilation and standardization, which characterizes more than just the ecclesiastical life of Byzantium from the tenth century on. As good traditions were being called for, encyclopedic undertakings became fashionable. In the Great Church the calendar of feast days was firmly laid down, an act that buttressed the centralizing claims of the Byzantine church and provided a universal model for liturgical practice. The unity and authority aimed at in the calendar by the rhythm of time was sought in the texts of the saints' lives by the narrative style. The existing legends about the saints were collected and in some cases adapted in a more elegant and edifying text, for which reason their new editor, Symeon, was called Metaphrastes ("Paraphraser").[93] From now on the church of Byzantium presented itself with a new, unified profile that is precisely the theme of the calendar icons, which express an ideal whole, the church, in the recurring cycle of the year. Large churches did not need the calendar icons, as they possessed the necessary repertory in their wall paintings and the individual feast or day icons that were displayed on different feasts (sec. c above). Outside the churches, in the hands of monks and laypeople who could afford it, the microcosm of all the feasts and saints would have been welcome, since it made the macrocosm of a church's icons privately available.

This idea is nowhere more evident than on a twelfth-century diptych that summarizes all the images that a believer might encounter.[94] Not only the saints—usually several on one day—but the movable feasts of Christ are united here in a grand synthesis. In an inventory of 1143, such an icon is described as "the twelve feasts with the twelve months."[95] The very concordance of the number of feasts with the number of months, and with the apostolic figure of twelve, indicates the tendency to invest the church with an ideal form. The left wing of the diptych is devoted to the first part of the calendar year, which began on 1 September, while the right wing, which we reproduce, continues the sequence in the months up to August. In the top row of saints the eye is drawn to the forty martyrs of Sebaste, who froze to death in an icy lake. Above the rows of saints the feast images of the second half of the year "circle" around the Virgin, who with the Pantocrator forms one pole of the repertory. The

association of the circular images with the motions of the planets is a poetic idea that has a literary equivalent in the dedicatory poem of a Georgian calendar book of 1030 from Constantinople.[96] In it the reader is invited to admire "the art of the painter [*zōgraphou eutechnian*] in the daily commemoration of the feasts of the whole year [*tas kathēmeran mnēmas heortas tou chronou pantos*]." The book, says the poem, is a cosmos in which Christ is the sun, Mary is the moon, and the "choirs of all the just who have truly pleased the Lord are the shining stars."

An exception among the privately used panels is a series of twelve large month icons that today are fixed to the columns of the Mount Sinai basilica.[97] They served in the liturgy of the monastery, being displayed month by month and fulfilling, by means of their shorthand figures, the principle that each saint should be honored in his image. On the back the panels show the Passion as read during Lent as well as other cycles from the life of Christ in their liturgical sequence, the same cycle appearing three times. There were thus three four-part icons (tetraptychs), both sides of which could be used. On the front the cycle of months was shown, while on the back a kind of lectionary in pictures was repeated three times. We reproduce here the front 159 of the February icon, which has several saints for each day. Only the feast of the Presentation of Christ in the Temple (2 February, shown in the top row) and the feast of the Finding of the Head of John the Baptist (25 February, second row from the bottom) interrupt the monotonous lines of saints.

The comparison of the page of the book with the calendar icon makes clear the difference in scope between the complete calendar of saints (*synaxarium*) and the book of detailed legends (menologion). Only the icon has the *calendar* sequence, whereas the book follows the sequence of *readings,* which did, of course, also observe the calendar. Only the icon conveys the idea of the church, as a community of *all* the saints forming "one body" with Christ, and thus, in the medium of panel painting, becomes the equivalent of a church decoration where the saints are arranged not by calendar date but by social rank. The topographical order provided by the space of the building is replaced in the calendar icon by the chronological order of months and days of the ecclesiastical year.

A further variant of the calendar icon survives in a four-part panel painted on only one side, displaying three months on each panel.[98] Two additional outer panels depict the Last Judgment and the cycles of readings on the miracles and the Passion, supplemented by five icons of the Virgin that have already been discussed (chap. 4). A dedicatory inscription on the back by the painter, John, speaks of the "fourfold phalanx of famous martyrs" who are painted here with "the throng of prophets." We reproduce the second panel of this example, the three bottom rows of which cover the 158 month of February. The saints are again reduced to types indicating sex, age, and rank, and in some cases by added scenes of their martyrdom. In this way those who confessed the faith and those who died for it are separated into two groups. This makes the whole image more lively, though the elements are no less standardized.

The identity of the Byzantine church consisted on one hand in the selection of its saints and on the other in the temporal sequence of its calendar. The presence of the saints in the church is symbolized by the presence of a complete list of icons on the

159. *Mount Sinai, monastery of St. Catherine; February panel from a cycle of calendar icons, 12th century*

160. *Mount Sinai, monastery of St. Catherine; biography icon of John the Baptist, 13th century*

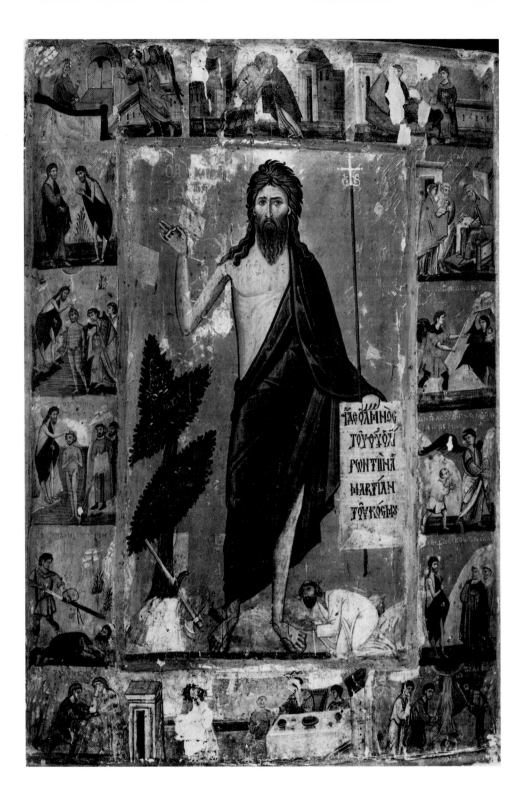

255

panel. Images exist only for those who are real. The depiction and the name thus vouch for the identity of each saint venerated by the church. The order of the heavenly church, reproduced in the mirror of the earthly liturgy, is an ideal model that the Byzantine empire persistently invoked, inasmuch as it continued pretending to be a world empire. What could not be incorporated in the state (e.g., Russia) could still be tied to the Byzantine church. The calendar icons clearly portray the aspirations of the church in an age of expansion.

Just as the calendar icons portray the order of saints within the church, the biographical icons depict the lives of its individual members. The two functions complement each other, the one representing the saint within the community, the other portraying him or her as an individual, proving that he or she perfectly fulfills an ideal both of ethics and of social behavior. In this way both conform to the norms inherent in the concept of the church. In its heavenly perfection the church promised an absolute existence, toward which society was moving in its earthly history. Icons seemed to anticipate this promised perfection as they made the saints available for common sight, though reflecting a supraterrestrial archetype that was to be reached in the future by everyone.

The biographical icons were merely extended by the painted biography but otherwise continued the genre of saints' portraits that had previously existed. In the centuries after iconoclasm this genre underwent a change, as can be studied in wall painting (chap. 2e). Each individual saint represented a given group (e.g., bishop, monk, virgin), which forms with other groups the whole community of the church. Besides the ideal of the man of the church, whether the inspired preacher or the self-mortifying penitent, only the court ideal was admitted: the youthful hero as an elegant officer, whose courage makes him a martyr or an "athlete of Christ."[99] What is at issue finally are social ideals translated into immovable positions in heaven. Hence, heaven was pictured as a synthesis of church and court, institutions that existed side by side on earth. No other social ranks had the right to exist in this ideal state and therefore were not represented by saints, who would have required a different kind of icon.

An official church definition of the saint as one who pursues an ethical ideal and serves the interests of church and court coexists with a more private definition that articulates the hope of salvation to the "miracle worker," or thaumaturge. As an intercessor, the saint has a position of confidant in heaven; as a healer, the saint has miraculous powers on earth. Old and new qualities attributed to saints, popular and theological notions, form a unity in the Middle Ages, although they originated at different times. The radical wing of the iconoclasts not only despised relics but opposed any kind of cult of saints, sensing in them the danger of religious materialism. For this reason biographical cycles of saints played a prominent part, above all in the palace churches, immediately after iconoclasm. They invited the beholder to contemplate exemplary biographies in images in order to act in accordance with them.[100]

The biographical icons, of which little is known before the twelfth century, are on the one hand tied to the texts of the legends of saints that were standardized in collected editions about 1000. On the other hand they are linked to the cycles of

160

103
104
6
148

saints painted in the churches, though these were for a long time confined to chapels or vestibules,[101] where legends of saints seem also to have been read. If the church possessed a tomb, such icons also could explain the saint to pilgrims outside the liturgy.

Cycles of saints were not restricted to wall paintings but were also found on the *templon,* particularly in lateral chapels. Such chapels often had no altars of their own but repeated the model of the church's interior on a small scale. In 1077 we hear of such a *templon* in the monastery of Christ the All-Merciful in Constantinople.[102] Like the icon friezes of the feasts of Christ, it had a deesis with three figures at the center and the "narrative [*diēgēsis*] of the venerable and holy Forerunner," John the Baptist, on either side. A surviving *templon* of this kind was completed by a Cypriot painter about 1100.[103] In the Mount Sinai monastery it probably adorned the chapel of the five martyrs of Sebaste, for it tells the life of St. Eustratios, who was one of them. By a happy chance we have a richly illustrated manuscript with the life of the same saint, which allows for a comparison.[104] The painted scenes on the *templon* celebrate in particular the saint's miraculous cures at his tomb at Sebaste.

Biographical icons combine the portrait and the legend in a way that, despite parallels in ancient cult images of Mithras and Hercules,[105] would seem hybrid, if they did not confirm the tendency to summarize and standardize. The portrait allowed the saint to be viewed as a person, and the accompanying short biography gave an idea of his or her life and miracles. The viewer of the main figure turned into a "reader" of the scenes, which is why we spoke of "reading icons." The small, shorthand scenes are merely an aid to memory; they presuppose a knowledge of the texts that were read aloud. The narrative element, which otherwise has no place in icons, annotates the physical portrait of the saint with the "inner" portrait of his or her virtues. The privileged status of a saint was explained by the miraculous circumstances of his or her life. Sometimes the scenes were not painted on the panel but, as in a lost icon of Panteleimon in Constantinople, incorporated in the costly silver mounting.[106]

The genre under discussion is represented, in the case of St. Nicholas of Myra, by more than twenty surviving icons, mostly of large format, from the Byzantine period.[107] The series began with an eleventh-century icon that assigns the scenes to the wings, making it a triptych.[108] A thirteenth-century panel shows the saint as a high-church dignitary, or "hierarch," with a stern gaze and the forehead of a venerable thinker.[109] In contrast to his robe and the Gospel book, the saint's head and hand are rendered in bodily roundness, as a sign of the living person. His gesture is one of both instruction and blessing. Small half-length figures of Christ and the Virgin invest the saint with the Gospel book and the pallium, the insignia of his teaching office and his sacramental power. Thus the icon becomes a model image of church authority. The same applies to a panel in Leningrad of the wonder-worker St. Gregory, which is almost the same size (81 × 53 cm) but has no surrounding biography.[110] In the icon under discussion the biography consists of sixteen scenes, beginning at the top left with the birth and ending at the bottom right with the entombment. Since the controversial removal of his remains to Apulia, which was done under the Normans, Nicholas was regarded in the West as the saint of Bari, although his Eastern origin was not

6

concealed.[111] In the thirteenth century an Apulian painter adapted the model of the Greek icon to conditions in Bari.[112] The translation of the relics therefore makes up the closing scene.

227 In the Mount Sinai collections, the genre is represented by examples of St. George
160 and by two icons of almost equal size, representing St. Catherine (chap. 18a) and John the Baptist.[113] The panel of St. John (70 × 49 cm) appears to reproduce a twelfth-century model. The fourteen scenes end with the circumstances of his death (the story of Salome) and the rediscovery of the severed head, which was the subject of a feast in February and is also found on the calendar icons. The saint, dressed only in a cloak, alludes to two different key roles in the church community. With his long hair and emaciated body, he is the penitent and hermit in the desert; at the same time he is the great preacher, for the ax lying at the root of a tree next to him repeats the famous metaphor from his sermons (Luke 3:9). First of all, however, John is the Forerunner of Christ. The written text contains the witness to the "Lamb of God" (John 1:29), and his right hand is indeed pointing to where Christ, in the ring of biographical scenes, meets the Forerunner. The donor, a monk, had himself depicted at the saint's feet. The icon of St. George in the Sinai was also a private donation. The monk John introduces himself in the inscription with the same term (*ktisanta*) that was usual for church foundations.[114]

85 Compared with an early panel (chap. 7f), the icon of St. John reveals the complexity of content that icon painting now adopted under the guidance of the church. The simple device, in fact, reveals a hidden wealth of argument. Its rhetoric draws on the legends and the poetic panegyric or encomium, a form that writers such as Psellus were also exploring at the time. The biographical icon thus seems closely bound to the text, particularly in presenting written as well as visual material. Like the comparable texts, it was meant to strengthen the norms of church doctrine. What the calendar icons express through the liturgical order, the biographical icons express through the social order of a role. The former present the church as a social order in heaven, while the latter explain the church by models of a saintly life. Both genres thus have a didactic tendency, which is subordinate, however, to the icon's primary function as an object of veneration.

 A small number of unusual icons at Mount Sinai appear to be biographical but in fact are of a very different kind. They lack any biographical framework, since they introduce the biography in the main image. There are two monumental panels of identical format (130 × 70 cm), both "signed" by the same painter, Stephanus, one
161 of them showing Moses receiving the tablets of the law, and the other the prophet Elijah being fed in the wilderness by ravens.[115] The panels are painted in the brilliant style that came about when the linear style of the twelfth century was breaking down and the figure was regaining a new corporeality. The figure of Moses expresses movement, while that of Elijah assumes the effect of a statue, with a classical garment. The faces have been psychologically refined. Clearly, a long-closed floodgate has been opened, and the enchantment of the natural form was calling into question the formalized syntax of previous icons, a syntax that had implications beyond the painted form.

 These panels arouse our attention by their narrative stance, which appears to be

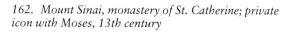

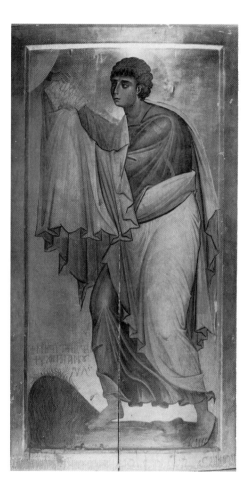

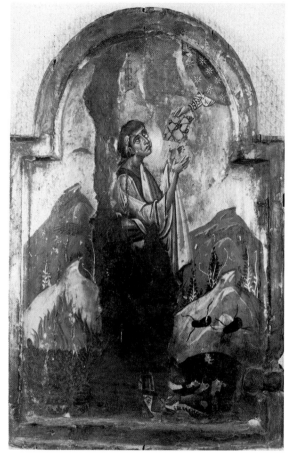

that of biography. In his veiled hands the young Moses is receiving the tablets from the One he may not see, so that he looks only at the tablets that the invisible being is presenting to him. At the same time with his foot he is touching the burning thornbush, which the fire did not consume and from which comes the voice of God bidding him untie his sandals. These two temporally separate manifestations of God (theophanies) were believed at the time to have occurred at the same place. The site of the thornbush is still pointed out in the Mount Sinai monastery today, and the mountain above the monastery is held to be the one on which Moses stood when he received the law. The icon, like that of Elijah, thus really designates a "holy site" (*locus sanctus*), a place visited by God.[116] It was probably donated to the chapel on the mountain by a prominent personage named Manuel (perhaps an emperor), who appeals for salvation in an inscription above the burning bush. The painter Stephanus has written a prayer in Greek and Arabic on both panels, a unique case that indicates his pride in the quality of the painting. He may have lived in Constantinople but did not wish to forgo the opportunity of having an everlasting votive inscription at a world-famous cult site. On the Moses panel he asks the "God-seer" (*theoptēs*), whose "type he has painted," for support in obtaining a "release from sins."

162 The same subject reappears in votive images donated by private persons at the same place for their own salvation. A small panel (27 × 18 cm) even introduces the donor, who is bowing to the ground before the prophet.[117] Here, too, the two theophanies, on the mountain and by the thornbush, are combined in the picture. The landscape plays a greater part in the composition, as it otherwise does only in book painting. But the grandeur that characterizes the titular icon, the almost superhuman stature of the prophet, is missing here. The reason may lie in the difference between the two functions, which are presented to us so clearly in this unique collection. But these functions, which give us a renewed understanding of the icon, were undoubtedly known at other cult centers as well: on one hand, the titular image of a holy place (much like the former temple image); on the other hand, the private votive gift, in the form of icons that repeat the theme of the place and the titular icon on a small scale.

13. "Living Painting": Poetry and Rhetoric in a New Style of Icons in the Eleventh and Twelfth Centuries

From the eleventh century on, the appearance of icons changed as they began to include narrative elements and depict states of emotion, whether of motherly love or of mourning. These transitory features might seem to contradict the claim to timelessness of icons, whose protagonist has departed meantime from human life and its feelings. The transformation of the icon, which now assigned a role or character to the person represented, is striking. New themes—unexpected in this genre—also made their appearance, such as the miracle of the Archangel Michael at Chonae or the 166 monks' Ladder of Virtue. The Annunciation to the Virgin took on narrative traits 165, 167 that could not have been derived from the biblical event alone, indicating new interests that had become attached to the theme. A small Christmas icon contains a whole 168 cycle, up to the flight into Egypt and the murder of the innocent children, thus seeming to transcend the bounds of narrative painting. Another panel placed the en- 178 throned Virgin—a rarity in icon painting—in the context of a choir of prophets and a Pantocrator enthroned in heaven, as if the panel were aspiring to be a theological tract in pictures. Such an icon is mentioned about 1100 in the inventory of an imperial convent in the capital, as an "icon painted in the new style" (*kainourgos eikōn hylographia*).[1]

a. "Icons in the New Style"

This phrase amounts to a catchword for a whole group of images that will concern us in this chapter. Their appeal lies in a narrative mode of depicting emotions, by which the icon begins to speak. It is now "living painting" (*empsychos graphē*), an expression used by Michael Psellus, a famous eleventh-century writer, in a text on the Crucifixion.[2] The term first serves to defend painting against the old charge of being dead matter that in vain pretends to provide the illusion of life. In addition, the term equates painting, which is not mute but capable of speech, with poetry, which touches the feelings by arousing persons and events to life. That which has a soul can speak to the soul. A "live" quality of expression, the goal of poetry, was now expected of the icon as well. In the same text, to which we shall return at length, Psellus describes an icon that not merely reproduces models painted by other artists, as "artless" works had done, but is "full of life and nowhere lacks movement." On the one hand it is so close to nature as to transcend the limits of art, yet on the other hand it exactly fulfills art's task of expressing life, as poetry had done. Psellus therefore describes it according to the pattern of the so-called *ekphrasis,* the literary genre in which ancient writers described works of art.

Not only writers were concerned about the living expression of icons. Private donors who used them as devotional images expected icons to speak to them and to arouse their feelings. Thus Prince Isaac described the icons on the iconostasis of his monastery as "living beings."[3] They "seem to speak graciously with their mouths to

all who look on them." They "seem as if living to the eye and imprint themselves on the heart" (and so the feelings). Isaac, in using commonplaces without literary aspirations, is for this very reason an important witness to a new quality of icons of the time, a quality that needs to be explained. He considers it a miracle that a painting, "which is yet fixed in place and time," appears to be alive. This is an old comment, already used by Gregory of Nyssa when he attributed to paintings the power to "speak" (*lalein*), even while they were "silent."[4] But in Isaac's generation, in the mid-twelfth century, the eloquence of painting becomes an important issue. The poet Theodore Prodromos, for example, puns on the name of the painter whose living work he is praising: Eulalios is *eulalos,* that is, eloquent.[5]

The faculty of speech, which cannot be explained by a power inherent in art itself therefore is explained by Isaac as the inspiration of the "world creator" (*demiourgos*), who has imparted the "wisdom of painting" to the "creator of art" (*technourgos*).

b. Aesthetics, Ethics, and Theology

In the expression of emotions, as in the presentation of theological arguments, but also by their small size, the new icons reveal that they were intended for private contemplation. The very fact that icons were privately owned—Empress Zoe was one such owner documented at this time[6]—is worthy of note. Psellus, too, speaks of his own icon of the Crucifixion. In church ritual, icons took on roles of performance and were staged as sung dialogues. The Virgin's lamentation for her dead Son, sung by the choir for Mary in the first person, was addressed to a double-sided icon on which Mary performs the role of a grieving mother.[7] In the respective texts that celebrate her self-mastery, the Virgin learns to subordinate her personal feelings to the necessity of the events of salvation. The new aesthetics of the icon also served the ethics of a human ideal, as embodied by the Virgin.

These ideas, like the means of their rhetorical expression, were centuries old when they were first applied to the icon. Two factors allowed the icon's eloquence to be extended in this way. First, the icon was no longer controversial but held a safe place in the life of Byzantium that allowed for its free development and awakened new expectations. Second, it was introduced increasingly into both liturgical and private use. The interplay of the two functions has already been discussed (chap. 12c). Private founders—particularly in private monasteries—encouraged the use of liturgical innovations, and mediated old literary texts, which took on a new topical application. Liturgy favored the transformation of icons, which, as inventions of painters, invited a comparison with poetry, since both—icon and poetry—had their common base in liturgy.

Like the authors of church poetry, the painters of icons no longer concealed, but openly displayed, the frequently invoked paradox of Christian dogma. In both cases, the paradox addresses a philosophical mind and serves to explain contradictions as the very proof of a supernatural intervention in the course of nature. Rhetorical antithesis celebrated the union of the irreconcilable, of God and man or Creator and creature, of bodily death and divine life, as the goal and subject matter of devout

163

insight. It was precisely here that the icon, in appropriating such rhetorical practices, found its new attraction for the literary and social elite. The icon of the Mother of God stressed the paradox that a creature could carry her Creator on her arm by showing the Mother kissing her Child or the Child kicking about like an ordinary baby, a visual contradiction that assisted the acceptance of an "educated faith." Contrasts in behavior such as the sleep (death) and animation (life) of the Child in a single figure, or joy and grief in the Mother's expression, serve the same goal. The problem of faith remained the same, but the beholder appreciated its presentation in an educated, philosophical manner.

Seen in this way, the "icons in a new style" were no longer the usual replicas based on old archetypes. Respect for the latter was undiminished, but the new icons acquired extra qualities of poetry that the old ones lacked. In the text mentioned, Psellus thus takes great pains to praise the icon in question as one that is not copied from others but acts as its own model. Its prototype is not another icon but the event itself (the Crucifixion), which the icon reenacts in an inspired and philosophical way. The painted image, by mediating the "appearance of life," not only satisfies the rules of art but transcends external imitation, since it manifests the true spirit. For this reason Psellus refused to equate his icon with others, whether "in the old manner" or "novelties" from recent times.

In a short commentary on the famous biblical passage in which man is said to have been made in the image of God, the same Psellus defines the philosophical meaning of the image as a dynamic concept with ethical premises.[8] By contradicting any static concepts of the *eikōn* as found in the philosophical tradition, he favors man's ethical development toward perfection in the "image" of God. The image has no existence of its own, nor any independent authority interposed between God and man, but reflects the degree of proximity to God that has been reached at a given time. Vice is therefore an "inability to conceive beauty," since beauty is an ethical category. For this reason the figures in icons could be seen as models of a spiritual perfection attained through the mastery of suffering. In the text on the Crucifixion discussed earlier (text 28), Psellus describes Mary at the foot of the cross as a "living ideal image *164* of the virtues. In her grief she has not given up her dignity."

Despite their common views, the writer Psellus introduces the new icon as a mirror of poetic truth, while Prince Isaac sees it as a devotional image. But since poetic literature was to a great extent devotional literature, it is merely the emphasis that is different. The proximity to religious poetry that was now expected of the icon is expressed in the numerous epigrams composed for icons and sometimes written on their frames. The hymnographer John Mauropus, later bishop of Euchaita and a friend and teacher of Psellus, wrote more than eighty epigrams for this purpose.[9] These range from emotive pieces, dependent on feelings, to theological definitions of a theme, and to personal prayers that were used on votive images. Two examples will suffice. In an epigram "on the weeping Mother of God," the poet reflects on the theme of suffering and compassion inaugurated by the "Lady of Mourning" and explains the necessity of her grief, which he shares, as the way to "resolve the cosmic grief."[10] In a long epigram commissioned by the monastery of St. Michael in the Sosthenion

quarter of Constantinople, the monks dedicate a Christ icon to Emperor Constantine IX, whom they show on the icon being crowned by Christ.[11] The verse inscription is itself a dedication; it explains that the dedication has been made in the form of an icon, since one could not make the emperor himself the subject of an icon. Painter and poet compete in enhancing the beauty of the product.

An aesthetic of painting, which applied especially to the icon, was beginning to emerge at this time. Its reasoning was both formal (relating to such matters as symmetry and harmony in a work's composition) and philosophical and theological. It was philosophical in that painters had to capture life in the mirror of their art, and theological in that they partook in the revelation of a higher truth through "grace" (*charis*). In both cases, the argument is rooted in the Neoplatonic distinction between inward and outward, soul and body, spirit and nature. This dual vision also applies to the description of living people.[12] The emperor's daughter Anna claimed that the regularity of her parents' features surpassed even the symmetries of art. But the burning gaze testifies to an inner life, the life of the soul, which is superior to that of the body. This is why, in icons, the gaze is often turned away from the body axis, to express movement and freedom from mere corporeality. Gestures, however, would have distorted the iconic beauty of the body.

In another text Psellus calls himself "a great connoisseur of icons, one of which [a Marian icon] enchants me. Its beauty strikes me like lightning, robbing me of strength and reason. . . . I do not know whether it reveals the identity of the original, but the variations in the paint visibly render the nature of flesh."[13] In the text already cited on the Crucifixion (text 28), Psellus praises the beauty of purely formal means such as "contrast" (*antilogia*) and "harmony" (*euarmostia*) between the parts. Color, too, he has a "wise man" say, contributes to the effect of "living painting." Such rules of art, however, do not in themselves guarantee truth in the higher sense. Nevertheless, they are a part of it, just as physical beauty points to a higher meaning. At this time the ideal image of youthful beauty and courtly elegance was embodied by the

148 doctor and officer Panteleimon, (chap. 11b). The legend of his life not only celebrates his "outstanding beauty" (*to kallos exaisios*) but his calm and majestic gaze.[14] The pagan emperor Maximian had chosen him as courtier on account of his appearance; the saint, however, devoted himself to the service of Christ. In medieval icon painting he represents a social ideal in its heavenly prototype.[15] But the true archetype of

128 beauty was, of course, Christ himself, whose image imprinted on cloth was taken as the basis for an ideal canon of the icon (chap. 11b).

Since the icon does not have a picture space as such but is only figure, it can be "clothed" in gold and silver, provided the figure is left exposed, especially the face and hands. For the figure is supposed to convey a sense of life that only very delicate painting can impart. The figure can be adorned but cannot be replaced by adornments. The inventories of the time thus distinguish between "embellished" and "unembellished" icons. The treatment of the figure is judged by a twofold standard. It must be lifelike to the extent that the dead matter of mere paint is forgotten, and it must also capture something other than physical life and reveal the supernatural existence of the person depicted.

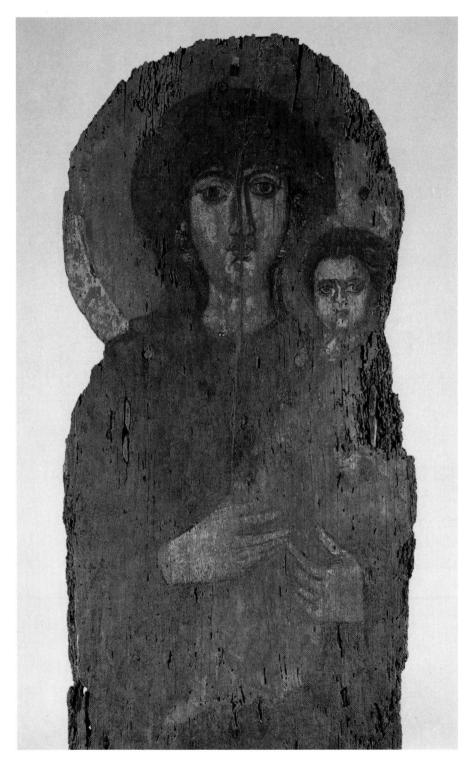

Rome, Pantheon; icon of the Madonna and Child, A.D. 609 (see also fig. 8)

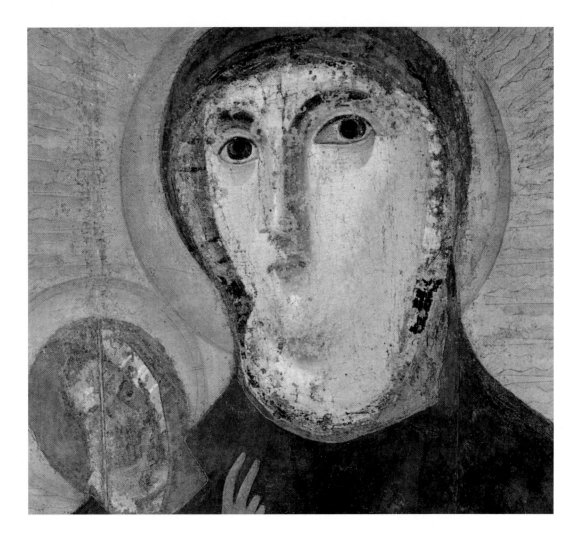

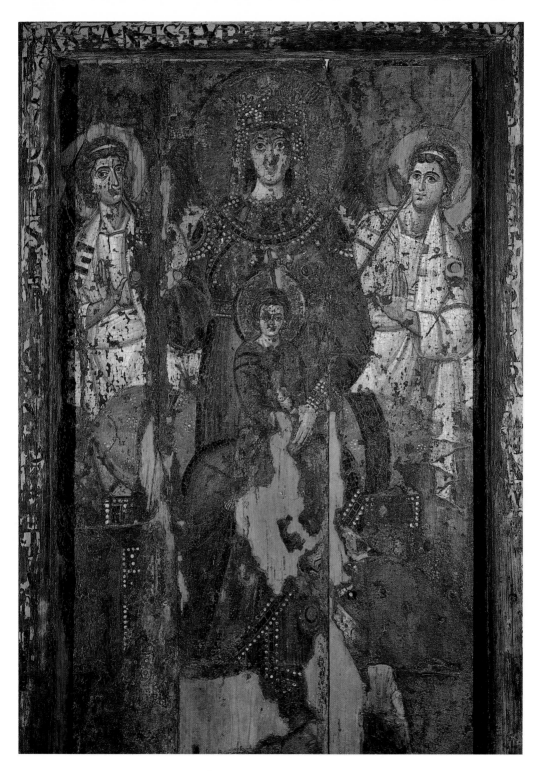

II. Rome, S. Maria in Trastevere; Madonna della
Clemenza, 705–7

III. Genoa, S. Bartolomeo degli Armeni;
Mandylion *from Constantinople*

IV. Conques, Ste. Foy;
Statue of St. Fides, 9th
century and later

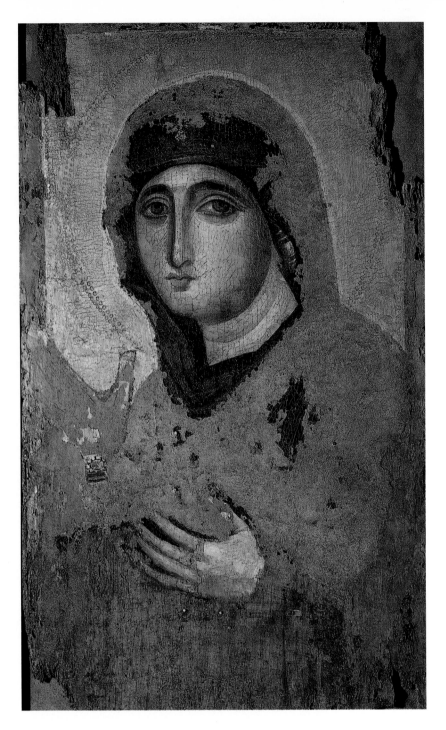

*V. Rome, S. Maria del Rosario; Madonna
of S. Sisto (after restoration)*

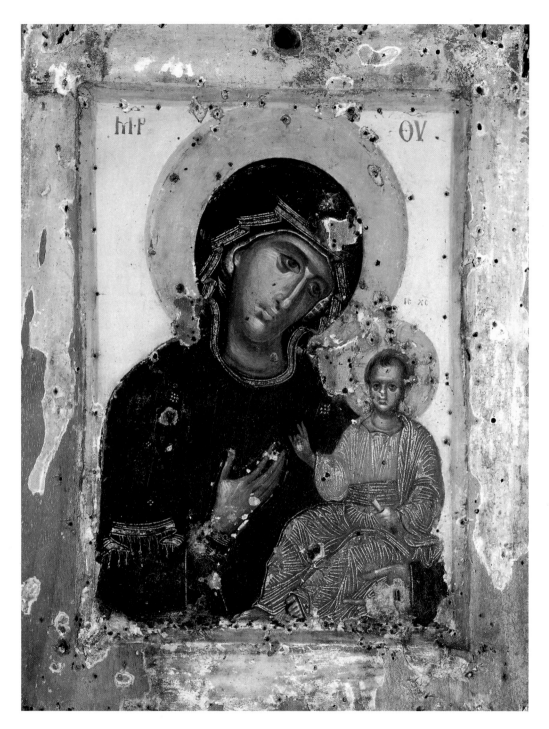

VI. *Siena, Chiesa del Carmine; Byzantine image
of the Madonna and Child, 13th century*

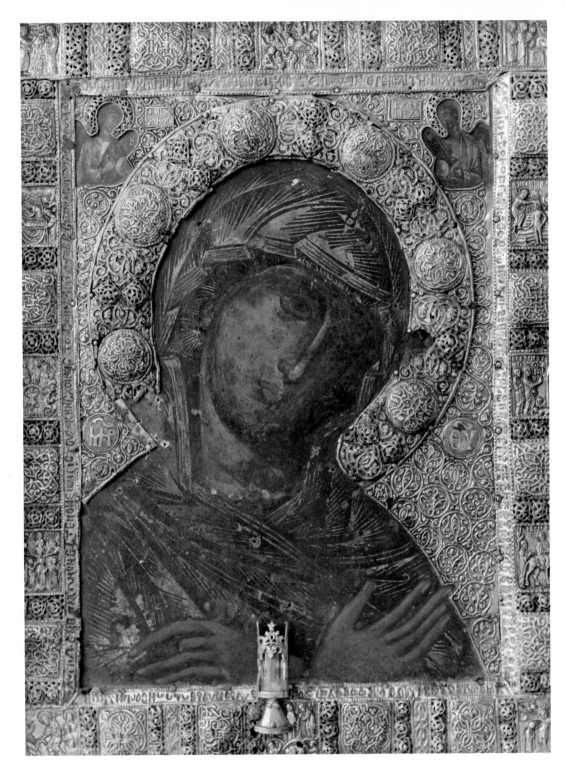

VII. Fermo, cathedral; St. Luke icon, 13th century (hands have been overpainted)

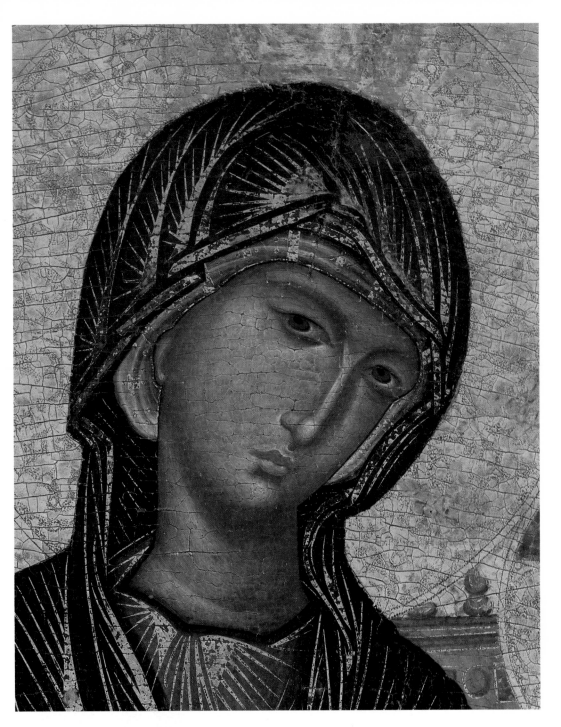

VIII. *Washington, D.C., National Gallery of Art; Kahn Madonna*
(gift of Mrs. Otto H. Kahn), 13th century (detail of fig. 225)

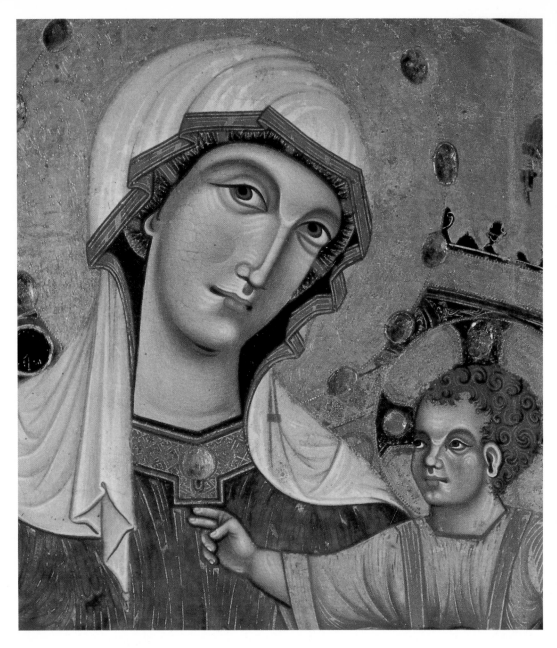

IX. *Siena, Pinacoteca Nazionale; Madonna of*
S. Bernardino, ca. 1280 (detail of fig. 238)

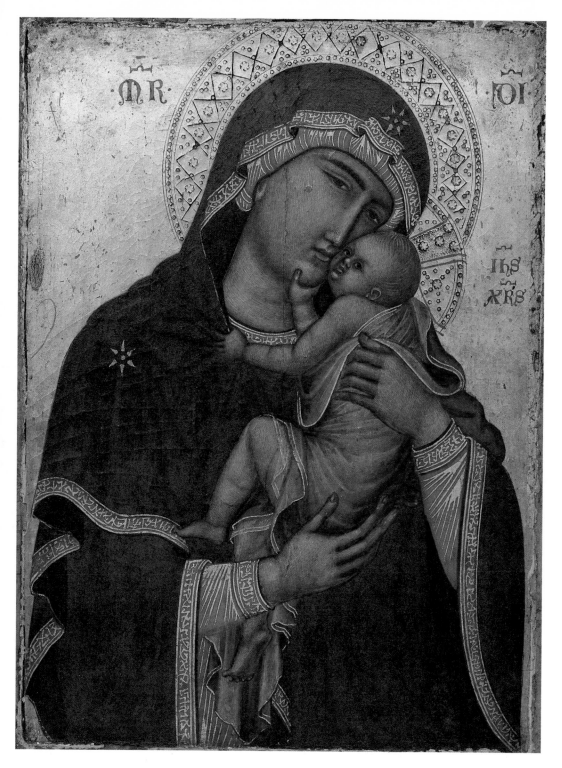

X. *Cambrai, cathedral; Notre Dame de Grâce, Sienese, ca. 1340*

XI. *Rome, Chiesa Nuova; Madonna
of Mercy (detail with old miracle image
exposed), 1608*

This is a high ambition, particularly as lifelike expression, if it includes bodily movement, is incompatible with higher reality. Poetry has often moved between these two poles, vividly tracing human behavior and idealizing it in the same breath. It has constantly departed from the human level in order to translate it into a higher meaning. Painting, tied to the visible unity of one and the same picture, is hard-pressed to convey a double or twofold vision of a single figure. The more complex and less "one dimensional" the expression of its figures, the more closely it approaches the rhetorical ideal of poetry. When the Mother of God sadly holds the happy Child in her arms, beholders are invited to engage in a kind of contemplation that they know from poetry. The sadness relating to a different period of time, one not represented in the image, is the result of Mary's inner vision of the future Passion that her Child will suffer. This complexity matches an old rhetorical exercise in the study of character, in which a person's self-image embraces different time periods through memory (past), perception (present), and premonition (future).[16] Rhetorical descriptions of images at that time emphasize the contradictory feelings in facial expression as being on the same level as poetic truth.[17]

163

But poetic truth is transformed into a theological one if the person represented who suffers gains "insight" into the deeper meaning of his or her suffering. Then the human level of feeling becomes transparent, allowing the central paradox of dogma to show through—the birth and death of God as a human being. The concern for the work of salvation, in which Mother and Son both are involved, focuses the view on the childhood and death of Christ, which icon painting now favors as subjects. What the Virgin, who participates in both events, experiences as a human being is first a means of expressing a theological theme, before it can serve as an exemplary case of Christian behavior. The new emotive aspects of painting may have served humanistic interests and therefore may have appealed to the educated beholder, but they convey first and foremost a theological meaning, which is their reason for being.

172, 173

c. Poetic Continuity in a Changing Society

Icon painting, with its new eloquence and its increased expression of feeling, raises two questions, one of which is easy to answer and the other difficult. The easy one concerns the origin of both ideas and motifs of the new icon that are taken from an old rhetorical tradition of Byzantine literature. Its links with the painting of the eleventh and twelfth centuries have recently been studied in a book by Henry Maguire, on which the following discussion draws.[18] But why did the rhetorical transformation of painting happen at this particular time and within this particular society? This question is much more difficult to answer, as it still seems to be a problem for historians to separate the temporal shifts in Byzantium from the continuities. A book on the society of the eleventh and twelfth centuries, written jointly by the historian Alexander Kazhdan and the art historian Ann Epstein, is revealing in this way.[19] It is as difficult to find a common denominator for the two books as it is to find a common answer to the two questions.

In Byzantium, rhetoric was learned from textbooks of antiquity (and their revised editions), but it was also exercised with the help of the sermons of the Cappadocian

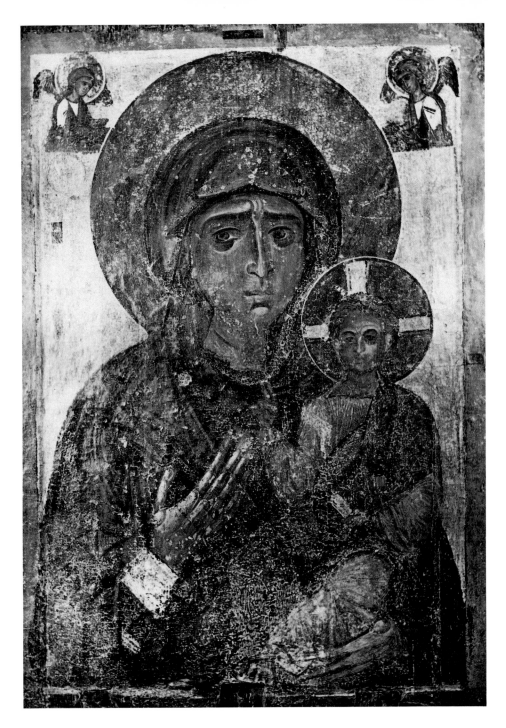

163. *Kastoria (Greece), Archeological Museum; double-sided icon of the Passion,
12th century*

church fathers, who introduced rhetorical devices into Christian literature in the fourth century.[20] Quotations from old models and imitations or elaborations are often hard to disentangle, the more so as the texts in use were very different in date. This, however, was of secondary importance in relation to the linguistic and intellectual synthesis, which mattered most. To preserve the unity of linguistic means (ancient quotations and neologisms used together in a single sentence), the church acted as guardian of the purity of the high or artificial language, which was still the Hellenistic Greek of the Koine, while opposing the influence of the vernacular.[21] The visual and emotional qualities inherent in the mysticism of late antiquity, from Ephraim to Romanus the Melodos, remained a model and a source for medieval hymnographers. The period of iconoclasm, with its spirituality and its conceptual approach, seemed in retrospect to have been an interruption, after which the "true tradition" was restored. In his ninth-century sermons, Bishop George of Nicomedia was inspired by the narrative zest and mystical power of John of Damascus, who for his part went back to mystical texts from late antiquity in his sermons on the Virgin,[22] combining, above all, poetry with the theological tract. Liturgy, too, became more "iconic" after iconoclasm, couching the messages of dogma in narratives or projecting them onto living figures. The sermons of the same Bishop George in the eleventh century were prescribed readings in the liturgy of a convent of the Virgin.[23] Also the early and poetic sermons of the church father Gregory "the Theologian" then became a fixed part of the liturgy—and survive in richly illustrated editions of the time.[24]

Given this context of ecclesiastical literature, one can speak of continuing patterns of rhetoric, as Maguire does in his book. They include, above all, the character study (*ēthopoiia*) and the description (*ekphrasis*).[25] The former depicts types or persons through their verbal or emotive expressions, using direct speech or mime. The latter narrates an event or situation by describing it as vividly and visually as possible; as we know, the technique was first used in antiquity to describe works of art, even fictitious ones, to justify a visual mode of narration. This was continued in medieval Byzantium as an exercise, but now *ekphrasis* narrated the events of the Bible and the lives of the saints more vividly and in more detail than its sources do. The event it described had to be reenacted as if it were to take place in the present, whether it was the murder of the innocent children, which took on aspects of a war report, or the rebirth of nature in spring, which the church fathers had already linked to the Annunciation or the Resurrection of Christ.[26]

168

167

Basic devices of rhetoric are, first, the antithesis (contrasting feelings, situations in time and space, or truths) and, second, the dramatic elaboration of tempo and emotion.[27] Antithesis, arguing by way of contrast, was best suited to emphasizing the paradoxes in the Christian faith. Conceptual contradictions (the Creator as a child, the King of Heaven as an embryo in the Virgin's womb) were enforced by verbal contrasts (then and now, the Child and the corpse, the swaddling clothes and the shroud) or plays on words that are lost in translation.

Such stylistic devices were centered in the old Homeric tradition of the lamentation for the dead, the *thrēnos*,[28] which now readily fitted the theme of the Passion of Christ. In liturgical poetry the lamentations of the Virgin applied the rhetorical prac-

267

tices that were inherited from of old. Their counterpart in painting, the Mother weeping for the dead Son in her lap, was given the ancient name of *thrēnos* or the new one of "entombment," when it was first invented in the eleventh century. Since it was pure narrative, this new theme did not find its way into icon painting properly speaking but nevertheless contributed to the transformation of the current icons of the Virgin, as Mary was now shown as the grieving mother of a young child or simply as a mourner. The epigram on the icon of the "Weeping Mother of God" is an example (sec. b above). A new need for deep feeling and human drama was clearly growing in eleventh-century liturgy, literature, and painting. This raises the question of the social and cultural background, which the Kazhdan and Epstein book discusses.

When this book uses Byzantine literature as a mirror of society, it does so on the strength of parallel developments, or what may be considered as such.[29] The heroes of the historical works and epics, who in the ninth century had been stereotypes of the holy man and the warrior or emperor, were now increasingly individualized. The contradictions within their characters and emotions were brought into the narrative, as were the opinions and feelings of the authors themselves. Ancient literature, which had been collected together only in the tenth century, was now assimilated, to such an extent that by the twelfth century John Tzetzes could attempt an allegorical interpretation of the Homeric myths.[30]

But in what kind of environment did these changes take place? The most obvious answer is provided by the narrow stratum of professional writers and teachers, who were constantly coming under suspicion of rationalism and being involved in conflicts with the church or the theocratic monarchy over questions of orthodoxy, which was so jealously guarded. Psellus belonged to this group, as did John Italus, on whom judgment was passed in 1082.[31] Such people were involved in a struggle for control of the church and higher education, which was important in an increasingly urbanized society. On the other flank the church was clearly fighting against the spread of a popular, private, unorthodox religiosity (the cult of the "holy fools" and the like), which lent weight to the forces tending to disintegrate the established order. This popularization contradicted the aristocratic ethos, which was fostered by the military caste under the Comnenian dynasty from 1081. Perhaps one might conclude from the two authors' thesis that at a time when a previously highly centralized society was, as it were, unfolding and fanning out, individual patterns of behavior and thought took on a new importance. In religious questions, too, different groups began to speak with voices of their own. We shall highlight three typical situations that resulted from this process.

First, there were the outsiders who called not only the church but society into question and were fiercely persecuted. The Bogomils—who did not compromise with their dualist worldview and formed a church without sacraments, relics, or icons, in the Gnostic tradition—after the conquest of their native Bulgaria (1018) grew into such a threat that their head, Basilios, was burned in the Hippodrome in the twelfth century, and Zigabenus was obliged to draw up a dogmatic refutation of their doctrines.[32] Though they may have been a peripheral phenomenon, they did mobilize

opposition and draw attention to all the symbols and implements of orthodoxy, including icons. Society in general here acted as a mirror of orthodoxy.

Next there were the lay theologians, or dilettantes in theology, above all the emperor, who did not leave controversial issues about theological definitions to the church, particularly as these questions excited public opinion all the more passionately as the subtleties of conceptual definition became less comprehensible. Such writers as Psellus were simply ambitious, and knew that they wrote better. But the emperors were tempted to test the monarchy's status against theological questions that they sought to decide themselves on behalf of the church. We hear of such attempts by Emperor Manuel I (1143–80) in the chronicle of Niketas of Chonae, whose character description marks the high point of a long literary evolution.[33] In a Christological debate on the relationship of Christ to God the Father (John 14:28), "he tried to bend the opinions of the church teachers . . . to his will" and to impose legal penalties on any opposition to his views. "Later [1166], on the advice of certain flatterers, he had his dogma carved in stone tablets and placed in the Great Church," Hagia Sophia,[34] where they have survived. He also "composed sermons, and preached publicly." As people looked for theological definitions in the iconography of icons, and as theology interested everybody, innovations in icon painting were bound to receive general attention.

Finally, there were the popular expressions of religion—superstition and belief in miracles on a level below that of church doctrine and scarcely touched by it. Amulets were worn around the neck, spiritualist séances were held on the night of 24 June (the *klēdōn*), and monks sitting by the icons in churches told the future with their aid, like the women soothsayers who read the future in ears of barley (*kritriai*), for which they were condemned.[35] We are told of such goings-on by Theodore Balsamon, who illuminates a scene far removed from the artistic and theological concerns of serious icon painting. By contrast, the "new style of icon" related to values central to contemporary society. On the one hand, it reinforced cultural identity by aspiring to the same level as church poetry. On the other hand, it equated this identity with orthodoxy by using iconographic nuances for defining theological doctrine.

d. The Paradox of the Crucifixion and the Reality of the Image

In a treatise on an icon, Michael Psellus undertook the impossible task of describing, or rather postulating, an art of painting that would make Christ's life visible even in his death, and so would prove the very paradox that lay at the heart of theological definitions.[36] It was not his concern whether an artist actually could paint the paradox of a "living corpse." Rather, he wanted to offer a model for an educated beholder and to advise such a beholder in how to look at such an icon—provided that the painter had achieved a fully lifelike depiction. Psellus does not say what the icon actually looked like but makes clear how it affected a beholder such as himself and, above all, informs us about the use of such an icon as a favorite subject of theological discussion, even in lay society. This cultural exercise explains not only the function of the rhetorical study in question but also the writing of verses that were added to icons of the

Crucifixion (whether they were panels or book miniatures) in the form of epigram-matic inscriptions. Psellus aims at a theological definition—as did the painter—in literary form. On this difficult terrain, literature and painting did now compete with each other.

Depending on one's point of view, the image of the Crucified as dead and yet alive, as both God and man, was either the quintessence of church doctrine or a scan-dal. After the verdict of Islam any painting of a living being came under suspicion of blasphemy (since it simulated Creation); the image of a dead person was even more problematic, particularly if the dead man was simultaneously to represent the living God.[37] Not only could Moslems easily interpret this as an image of a dead God or even of God's death, but Christians, too, were likely to disagree over whether Christ should be shown as really dead on the cross, as this would foster the error that Christ was only a man—or, still worse, that he had died as God. For this reason the papal legate Humbert of Silva Candida, who was looking for grounds for a schism in Con-stantinople in 1054, hurled the reproach at his Greek fellow believers that they placed the image of a dead mortal on the cross.[38] This, he insisted, was as if the Antichrist had occupied the cross to be worshiped as God.

At the same time a controversy between the patriarch and the monks touched on the question of whether the Holy Spirit had preserved the mortal body of Christ from decomposition, that is, had kept it "imperishable" (*aphthartos*).[39] Relevant here was the double stream of blood and water that flowed from Christ's side when he was pierced by the lance after his death. As early as 692 the Council of Trullo had insisted that water and wine should continue to be mixed in the chalice of the Eucharist to signify Christ's two natures: the (baptismal) water as a sign of divine nature, and the wine (blood) as a sign of human nature.[40] Since the sixth century, in the ceremony of the so-called *zeōn*, warm water had been mixed with wine to indicate the life of the spirit (and divine nature) in Jesus' body, even after his death.[41]

These topics, which deserve fuller treatment, are mentioned to indicate the back-ground to which Psellus was referring in his rhetorical piece on the icon of the Cru-cifixion. By then it was hardly possible to describe any element of this theme in simple terms. The issue was inherently complex, and the purpose of the icon was to integrate the different doctrines on this central article of faith in such a way that they could be discussed, or their nature could be contemplated, in terms of the image.

In terms of art, which celebrated this subject, the epigrams that were written on Crucifixion icons encouraged the comparison between poetry and painting.[42] John of Euchaita wrote a poem for a "golden Crucifixion" in which Christ "slept" on the wooden cross,[43] the metaphor of sleep being a formula to reconcile the outward image of death with the inner life of the Deity. In another epigram he wonders at the mys-tery: "To see you, my Creator, killed on the cross: What is this, how can it be? The Savior of the World treated as a criminal. Your appearance has changed, beauty is in you no more."[44] In a Gospel book from the patriarchate of Constantinople, dating from the twelfth century, the image of the Crucifixion carries the verses, "O terrible deed [*ergon*]; o awesome sight [*thea*]. God suffered for us like a mortal man [*brotos*] on the wood of the cross."[45]

Psellus, to whom we now return, sets out in his essay both to compare art to life and to reconcile the contradiction between life and death in the person of the Crucified in a theologically unassailable concept.[46] The icon, he says, which includes the double time of "then" and "now," the event and its depiction, does not merely follow the rules of art but rather attains the breath of life. The painter aims at the all-but-impossible task of representing the Hero as both alive and lifeless (*empsychos* and *apsychos*), impossible in that the body, which is the only thing to be seen in the picture, was the dead part of Christ. He did his best by showing Jesus "living, at his last breath" and by giving him the beauty, the "appearance of life" (*empsychōn eidos*), befitting "living painting" (*empsychos graphē*). All the same, God had to guide his hand to achieve the miracle of showing Christ as much "against the rules of art" as he had once lived in death "against the laws of nature."

A small but exquisite twelfth-century private icon of the Crucifixion, of the type described by Psellus, is preserved in the Mount Sinai collection.[47] In addition to the three figures mentioned by Psellus it has the angels, who, as in a famous sermon of Gregory of Nicomedia, are terrified at the killing of the Creator and express the lamentation of heaven over the event on earth.[48] Jesus, who bends his head in a peace resembling sleep, is neither disfigured nor deprived of the signs of life. The double stream of blood and water that flows from his side—though no lance is to be seen—bears witness to the simultaneity of life and death, divinity and humanity. The Virgin is pondering the event in deep mourning, while Jesus' earlier life "passes once more before her within her soul." At the same time she is speaking with a raised hand, as in the sermon, to her Son, asking him to explain the contradiction between the deity immune to suffering and the pains of the flesh on the cross. In this dialogue, we learn in the sermon, as in John 19:26, Jesus restores a son to her in John, for whom she can "intercede with him. If you can call no one on earth your father, yet you have my mother, whom I give you as your mother."[49] John is shown in the picture not only to witness what has happened but to represent the role of the Virgin's sons in Christ.

The dialogue with the Mother, which in the sermon takes place *after* Jesus has died, in the picture emphasizes the continuation of life, without which the icon would have been heretical. The time scale in the strict sense has been suspended in any case, since the image is intended to be not a narrative but a unity of ideas. This atemporality also explains the series of figures that runs around the frame, which has not yet been mentioned. It begins at the top with John the Baptist flanked by angels and the Princes of the Apostles, and continues with the church fathers, the martyrs and monks, and finally the holy virgins, including St. Catherine as the patron of the icon's monastery. The medallions of the saints are set in the same gold ground that is also the background to the Crucifixion. They form a symbolic frame in that they are a group portrait of the church hierarchy, surrounding the Crucifixion at the center of the church, like the sacrament of the Eucharist in which it is repeated was the center of the liturgy.

The Crucifixion, as the theme of an icon as well as the topic of a learned discourse on the art of painting, through an unusual abundance of contemporary sources, offers us an opportunity to reconstruct the expectations that the "new style of icon" had to fulfill and the part it played in the life of society.

164

271

e. Painted Poetry and Treatises: The Narrative Structures of Four Feast-Day Icons

As soon as the icon had become an object of rhetorical *ekphrasis*, it revealed how much it was at a disadvantage to church poetry and sermons as a narrative medium. All the same, the comparison with literature awakened the desire to develop narrative structures in analogy with church poetry. This desire was met by the four "new-style icons" that are grouped together in the following discussion, each doing so in a different way. They seem to be pure narratives but in reality present a saint or a feast-day topic (i.e., a dogmatic theme) in narrative or metaphoric guise—that is, in a rhetorical style.

Three of them are from the twelfth century, one from the late eleventh. Apart from the Annunciation they are all of modest format, between 30 and 40 cm, and so are likely to have been privately used. All four belong today to a single collection in the Mount Sinai monastery, which gives us an idea of how immense the losses of other material must have been, for with the sole exception of the Ladder of Virtue, they have no thematic connection to the desert monastery.

165 The Ladder of Virtue is, for an icon, probably the most unusual theme, since it appears to be an allegorical narrative that sums up the full content of a long spiritual

166 treatise in a single image. The miracle of Michael at Chonae is not an ordinary icon of St. Michael but narrates a miracle performed by the angel in what seems to be a

168 picture story. A small Christmas icon is not confined to the birth of Christ itself but adds the whole cycle of subsequent events up to the Flight into Egypt. Finally, the

167 large icon of the Annunciation stands out with its dramatic mise-en-scène and with the abundance of its fauna and flora. The four icons, however, agree in making visible the patterns of contemplation and the narrative structures of poetry, which had often dealt with their themes.

165 The Ladder of Virtue is, as a ladder leading to heaven, a metaphor for a textbook on religious asceticism, whose author accordingly was called John of the Ladder (John Climacus).[50] John, whose treatise concludes a long series of ascetic writings, lived in the Mount Sinai monastery about the middle of the seventh century. When Symeon, the "New Theologian," was reviving mysticism in Constantinople about 1000, he once again popularized the old textbook, which describes the unfolding of spiritual life in thirty steps. Richly illuminated manuscripts from this time have,[51] in the ladder leading to heaven, a frontispiece closely related to our icon.[52]

The icon, however, was an independent image of the author and saint, whose feast was on the fourth Sunday of Lent. It integrates the saint as leader of the ascending monks at the top of the ladder, where he is greeted by Christ himself and followed by a certain "Archbishop Antonios," who seems to be the donor of the votive icon that celebrated St. John in his old monastery. Antonios may have been a prelate from the capital, where book painting provided the narrative model used in the panel and invited a comparison between literature and painting by summing up the didactic content of the text in a visual metaphor. Heaven and earth, the striving and struggle for virtue, are presented in a spatial perspective, in which the monks appear as heroes on a truly cosmic stage.

The panel, which unlike miniatures is painted on a gold ground, links heaven and

earth by a ladder with exactly thirty rungs stretching diagonally across the picture. Next to it, black silhouetted devil figures catch in snares those who lapse from virtue, dragging them down to the mouth of hell at the bottom center of the picture. At the top left, a group of angels, representing the inhabitants of heaven, welcome the souls of the victorious athletes of virtue. At the bottom right, a choir of monks look on the drama of virtue, which they have made the program of their lives, in front of the local sign of the Sinai mountain. The rhetorical structure is expressed both in the ordered advance of the rising monks and in the wild disorder of the falling monks. The double movement, couched in a dramatic contrast, fills the space between heaven and earth, which is inhabited, on both ends, by angels and monks—or, to use a metaphor of the time, by heavenly and earthly angels. The author and saint is himself an actor in the scene, not only a commentator as in the corresponding miniatures. The underlying rhetorical structure, based on antithesis and hyperbole, here is transferred into a convincing visual form.

A small icon represents the archangel Michael as the heavenly performer of a 166 miracle on earth that took place at Chonae.[53] The feast on 8 November of the "incorporeal ones" (asōmatōn), as the angels were called, was linked to this miracle, as we saw in a lectionary (chap. 12e). The icon is therefore the feast image of the feasts of *155* Michael and of the archangels, which were celebrated in the capital in the church of St. Michael in Anaplous. The feast in November served the commemoration (anamnēsis) of a historical epiphany of St. Michael,[54] the site of which was a village with healing springs near Colossae in Phrygia.[55] The respective church was tended by the pious Archippus, who appears in the icon in monk's attire. When, according to the legend, the heathens had dammed two rivers in order to destroy the shrine, Michael, the "Prince of Water," guided the water into a cleft in the ground, from which the place took its name Chonae. On the panel the two rivers, one of which encloses the shrine, flow down to the opening made by Michael's staff in front of the steps of the church where they form a whirlpool and vanish.

St. Michael's miracles were also the subject of rhetorical exercises, and Psellus again composed an address "on the miracles of the [heavenly] commander Michael."[56] On the icon, iconographic formulas—such as a common Michael figure (who is usually fighting Satan with his crosslike spear) or the praying monk—are interrelated such as to build up the narrative. On the top frame there was a long explanatory inscription, of which only the name Archippus is legible on the right. The image's syntax reinforces the antithesis between the dramatic angel and the fearful monk, between free action and prayerful patience. The monk, enclosed in the narrower half of the picture, resembles the humble figure of a donor. The archangel, by comparison a figure of superhuman size, performs a beautifully flowing movement in which the minute feet and hands have less importance than the flapping garment, which still holds the motion of his flight from heaven. The strongest colors, light blue and soft yellow in the cloak and vermilion under the wings, are concentrated in this figure. To sum up, we are dealing with an icon of St. Michael that, in this case, has been given a rhetorical structure.

Another visitation by an angel, Gabriel's Annunciation to Mary, is the theme of

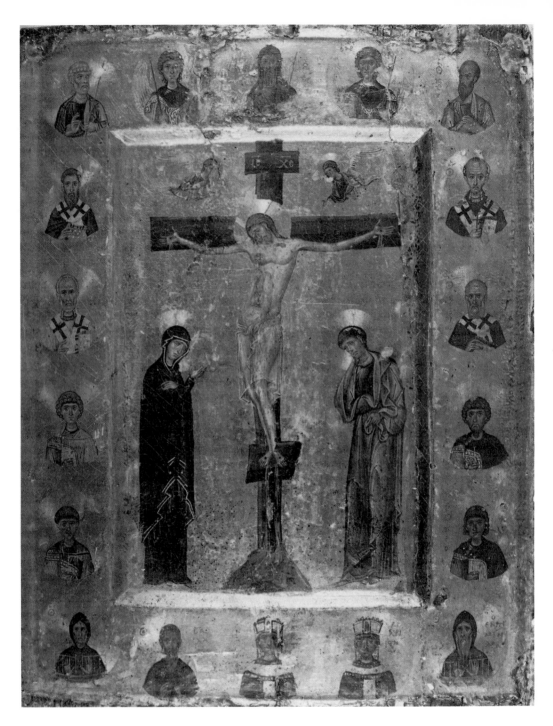

164. *Mount Sinai, monastery of St. Catherine; Crucifixion icon, 12th century*

165. *Mount Sinai, monastery of St. Catherine; icon of the Ladder of Virtue of John Climacus, 12th century*

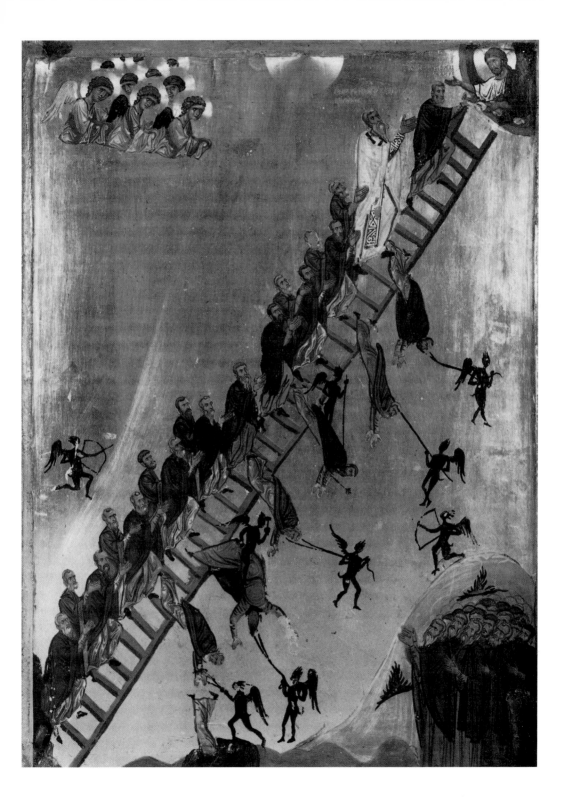

275

166. *Mount Sinai, monastery of St.*
Catherine; icon with the miracle of St.
Michael at Chonae, 12th century

167. *Mount Sinai, monastery of St.*
Catherine; icon of the Annunciation to
Mary, ca. 1200

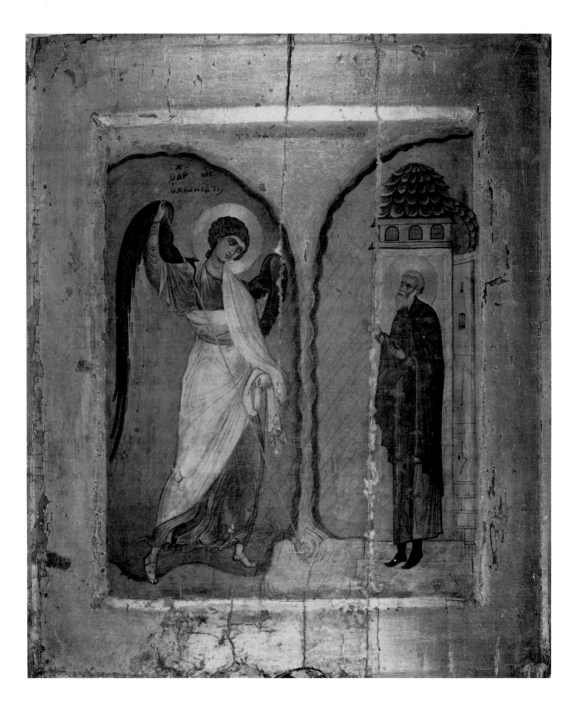

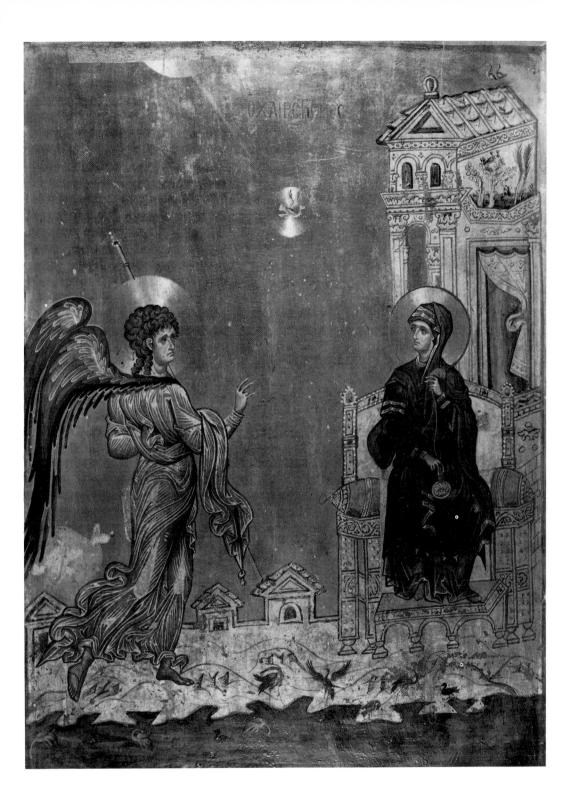

277

167 an unusual panel from the late twelfth century in which the influence of the rhetorical
 device of *ekphrasis* (see sec. a above) clearly is discernible.[57] This time the Virgin is
 the principal figure, for her feast on 15 March was the subject of the picture. Her
 dialogue with the angel, the real theme of the image, contains the agreement to "re-
 ceive the incorporeal one" in her body and thus to assist the process of salvation. As
 understood at the time, the angel does not simply announce the conception but has
 to persuade a reluctant Virgin. The dialogue soon became an occasion for a rhetorical
 tour de force, beginning with the homilies of the church fathers and culminating in
 the famous sixth-century hymn called *Akathistos,* as its twenty-four strophes with
 their 156 forms of greeting were sung standing up.[58] Psellus devoted a rhetorical piece
 to the theme,[59] and in the twelfth century it was chosen for the sermons of the monk
 Jacob, from the monastery of Kokkinobaphos in Bithynia, in whose editions the
179 dialogue between the angel and the Virgin is illustrated in no fewer than eight
 miniatures.[60]

 Apart from the dialogue, the panel has two singular features, as it is painted in a
gold grisaille, and as a river landscape peopled by birds and fish is added at the bot-
tom. Weitzmann explains the river motif by the idea of Mary as the "life-giving
source" (*zōodochos pēgē*),[61] while Maguire sees it as an allusion to the Virgin's feast
as a spring festival celebrating the renewal of nature.[62] The same idea, with elements
of nature panegyric from classical rhetoric, is to be found in a sermon of Gregory of
Nazianzus for the Sunday after Easter, which was often illustrated with bucolic land-
scapes.[63] The riverbank, a Hellenistic motif with a certain significance in early Chris-
tian art, thus would serve as a rhetorical figure embellishing the description, like the
poetic formulas of *ekphrasis* in literature. The motifs of the stork's nest on the roof
and of the roof garden with nesting birds confirm this type of interpretation.

 The synthetic nature of the image's vocabulary includes the house with its orna-
mental columns, a reference to the "living temple," which is a symbol of the Virgin,
while the crenellated wall may refer to the symbol of the "impregnable castle."[64] The
monochrome gold is a metaphor for the supernatural "light streaming from the
ether,"[65] which also permeates the incorporeal angel. Only Mary, who is to give a
body to the "incorporeal Word," has a solid blue and a deep purple-brown on her
garment. She is weaving the temple curtain in the color of blood like a garment
for the Logos, who took on "fleshly existence from the Holy Spirit and from her
blood."[66] Each motif of the pictorial narrative has several levels of meaning. The
spring metaphor refers not only to the feast of the Annunciation but also to the rebirth
of man in the birth of the Redeemer. In an old Christmas hymn, Adam and Eve talk
of the arrival of their new spring, in which the virgin birth reopens paradise.[67]

 The metaphoric decoration transforms the narrative style into a rhetorical one,
which reveals the theological background just as clearly as do the literary associ-
ations. The figures perform their feelings and words like stage roles. Mary looks at
the angel as she answers and lifts her ear "through which she received the Word."[68]
The angel, with his *figura serpentinata,* arrests the powerful movement of his flight
and step in the turn of his upper body, seen from the back. Arriving with the divine
message, he is taken aback by the sight of the mortal woman "whose body is to en-

close the incommensurable" and expresses the bewilderment about her initial resis-
tance in his features. In the contemporary frescoes at Lagoudera in Cyprus (1192), a
similar Gabriel figure is shown in a less complex attitude.[69]

The icon of the Annunciation, with its obvious rhetorical structure, facilitates our
access to a Christmas icon that is the most unusual of the four panels discussed here 168
and may once have been the centerpiece of a triptych, which would accord with the
semicircular top.[70] It is unique in that it narrates the whole story of Christmas in ten
different scenes that take place either on the slopes of the mountain where the cave
was situated or within a panoramic landscape of a type familiar from reliefs of late
antiquity.[71] The story of the Magi, in three scenes, is followed by two scenes with the
shepherds and concludes with the Flight into Egypt and the murder of the innocent
children at the bottom. The narrative detail is so profuse that one might ask how an
icon has come to include such an extensive cycle.

To pose this question is to misunderstand the problem, for the icon does not
narrate the Bible story for its own sake but is, to cut the argument short, a painted
hymn. Like the relevant hymns, it expands on the birth of God as a child in extra
scenes that reflect its miraculous circumstances and answer the question, Who is it
that has been born? The answer is given to the shepherds, to whom angels appear in
the fields, and to the Magi, who are guided by a star. The saving of the Child from
Herod's murderous plans also confirms the mystery. The Virgin, to whom her visitors
reveal the nature of the Child she has borne, is at the center of such hymns. The
beholder of the icon, then, is to worship the Child in the crib, as do the Magi, the
shepherds, and the angels.

In the *Akathistos* hymn, which includes narrative interpolations from the Annun-
ciation up to the Flight into Egypt, the text is centered on Mary and the story of how
she gave birth.[72] The angels, scared as they are about the Incarnation, in the presence
of the shepherds praise the event "in hymns," while the Magi bear witness to it as
"God's heralds," guided by the star of Bethlehem. The most famous Christmas hymn,
composed by Romanus the Melodos, in which the actors from the subsidiary events
conduct a dialogue with Mary,[73] begins with the words "Today the Virgin gives birth
to him who is not of this world, and to the unapproachable one the earth offers a
cave. The angels with the shepherds sing praise unto the Lord, and the Wise Men
follow the star." The Magi, the hymn continues, had been in Jerusalem, "which kills
its prophets," and Mary rejoices over the gifts, which she needs for the flight into
Egypt. The star and the praising shepherds make plain the true nature of the newborn
Child. This sixth-century hymn is the basis of an epigram composed in the eleventh
century by John Mauropus, a friend of Psellus, on a Christmas icon similar to figure
168.[74] The epigram and the hymn differ only in the rhetorical level of dramatization
of the paradoxical mystery (God as flesh). They both invite the reader to hasten with
the shepherds to the "secluded cave" to see "a crib, a Child, and a Virgin" and to
witness the miracle of "the star you see in the sky, which points down to the Child
from up there."

The epigram, composed for an icon by John Mauropus, not only describes the
event in visual terms but also reveals its meaning by metaphors and intricate figures

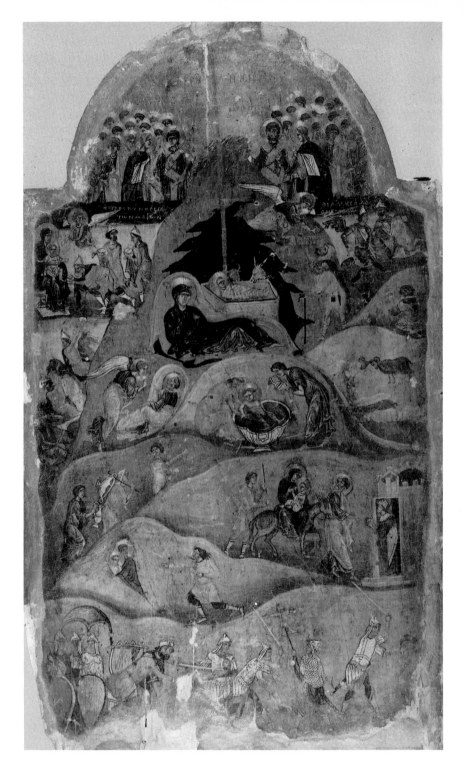

168. Mount
Sinai, monastery
of St. Catherine;
icon with the
Christmas cycle,
ca. 1100

of speech. The icon painter, who was restricted to the visual record of the Bible story, nevertheless took care to arrange the narrative elements so that they would form a framework and a commentary to the event. On the panel the semicircular top with the angels represents heaven, from which the star sends its beam of light straight to the crib, and from which the newborn Child has descended. The "secluded cave" with the crib, the Child, and the Virgin, of whom the poet sings, is the nucleus about which the auxiliary scenes are grouped in a carefully contrived rhythm. As on a single stage, the Magi come on from the left and go off on the right. In a similar strophic structure the shepherds receive the news of the birth at the top right and set off on the road to Bethlehem to the left, where they will come upon the scene of the bathing of the Child. The Flight into Egypt, on the right side, is balanced by a sym- metrical movement of Elizabeth fleeing into the mountains. The killing of the chil- dren, a rhetorical tour de force, closes the poetic structure at the bottom, at the greatest distance from the crib. In its position opposite heaven it represents the mur- derous designs of the world, which, however, cannot prevent salvation from happen- ing. It is this poetic structure that is transformed into the visual structure of the icon, and not a narrative cycle that we come across in this panel.

f. New Images of the Virgin

New images of the Virgin, such as the Virgin of Tenderness or Mercy, have misled scholars into believing that there were icon types with given titles, like those found in late pattern books.[75] Against this view, one must argue that we know almost nothing about the titles or history of such icons in the Byzantine period. The images of the Mother of Tenderness are a case in point. The term *Eleousa,* or "compassionate one," refers to a general theological role and not to a specific type of icon.[76] The title *Gly- kophilousa,* or "tenderly kissing one," is of post-Byzantine date, and the term *umi- lenie,* meaning a feeling of being touched by emotion, which was common in Russia, has no equivalent in Greek.[77] Such terms therefore reveal neither the provenance nor the meaning of icons from the middle Byzantine period.

The theme of the Mother of Tenderness was invented by two famous icons that both had their home in Constantinople but achieved prominence only elsewhere, in two famous replicas. The replica of the first type was taken to Vladimir, the residence of the Russian grand dukes, in 1136.[78] The other type came in a replica to Cyprus in 1080, where it became the titular icon of the Kykkos monastery, founded by the monk Isaias from Constantinople.[79] Ever since, people have spoken of the Virgin of Kykkos, as they were soon to speak of the Virgin of Vladimir in Russia. We can only conjecture about the original icons, whose types are indeed antithetical in meaning. A third type of the tender Mother, probably a synthesis of the other two, became famous by a replica in Pelagonia and then was named after this replica.[80]

Because we know famous icons with new traits only through replicas with a "sec- ond" history, to be distinguished from the history of the archetypes, we may be well advised to consider the problem first in general terms and to outline the possibilities of writing a history of the icon in the middle centuries. The icon of the Virgin as Advocate with the petition in her hand is known from two Constantinopolitan repli-

175
174

cas from the time about 1100, which, as we saw, made their way to Mount Sinai and
149 Spoleto (chap. 12d). In their sideward movement and their suppliant gesture, they
quote the former titular icon of the church of the Virgin in the quarter of the Chal-
coprateia. Their model was probably already a variant and not the original of this
type. In the variant, the Virgin addresses a written petition to an icon of Christ, "who
answered" (*Antiphonites*), a title that also referred to a court official who decided
petitions.[81] The Mount Sinai replica is done in encaustic, like panels in late antiquity,
but the technique was still used in the eleventh century, as we know from an icon
donated to the monastery of the Great Lavra on Mount Athos.[82] The delicate model-
ling of the tender figure, characteristic of the period about 1100, is also found in the
149 small canvas painting in Spoleto, which was cropped at top and bottom when a lady
from the Petralipha (?) family added a metal casing. On the casing the painted text,
which repeats the wording of the original, is replaced by a longer version, in which
the Mother of God submits her petition on behalf of the new owner, Irene. Beams of
light falling onto Mary from the right indicate an affirmative answer.

The only famous icon that we seem to know in the original panel is the Victory
1 Bringer, which was later venerated in Venice as the *Nicopeia* (chap. 10d)—provided
that the Venetian panel is the very icon that was captured by the Crusaders from the
Byzantine general's chariot in 1203. At any rate, the commanding gaze fits the role of
the invincible general. In contrast to this work, the old *Hodegetria*, the favorite icon
177 of the imperial house, which was fought over by various factions among the conquer-
ors of 1204 (chap. 4e), is not known from any replica that gives an artistic clue to the
original, despite the countless repetitions of the type.

169, 170 A double icon of the Annunciation, in a fine replica produced in the capital about
1100, became the titular icon of the church of the Virgin in Ohrid, the archiepiscopal
see in the Balkans.[83] An archbishop called Leon added an inscription on the metal
frame praising the *Kore,* or Virgin, whose type was later called the *Annunziata* in
Italy. The church in Ochrid bore the title of the most important monastery of the
Virgin founded in the capital in the eleventh century, that of the *Peribleptos,* or the
"most famous" Virgin.[84] The original of the icon may therefore have been kept there,
although it would also fit the monastery of the Kecharitomene, of "[Mary] full of
grace," the rules for which were compiled by an empress about 1100.[85]

All these panels, whether originals or replicas, were produced in the decades
about 1100 and are closely related to each other, both in their eloquent expressions
and in their psychological makeup. Most of them were probably toponymous icons,
bearing a place-name and therefore bound not to a particular type but to a particular
church, as we know from an icon inventory of 1077.[86] The "icon catalog" on an
13 eleventh-century panel is another proof of this.[87] Janin's great work on the church
topography of Constantinople lists 139 churches and monasteries dedicated to the
Virgin.[88] They did not all exist at the same time, and some were added only after
1261. Nevertheless, the number is remarkable. Four churches of the Virgin went back
to the fifth and sixth centuries and owned old icons of which we have some idea, apart
from the one in the Virgin's church "at the spring [*pēgē*]." The one in the Chalcopra-
teia quarter was the patriarch's church of Our Lady. Here he celebrated the great

169, 170. *Ohrid (Macedonia), museum;*
double-sided icon of the Annunciation,
ca. 1100

171. *Paphos (Cyprus), Neophytos monastery;*
St. Stephen the Younger, 12th century

283

feasts of the Virgin (the Birth, the Presentation in the Temple, and the Annunciation). The church in the Blachernae quarter was the station used on the feast of the Presentation in the Temple (*hypapantē*) and of the Death of the Virgin (*koimēsis*).[89] In the eleventh and twelfth centuries eight other important monasteries of the Virgin were founded,[90] but we have no definite idea of their titular icons, other than to venture that they were different enough to be distinguished by everybody.

The relation of icon, icon title, and a term from theology may best be illustrated with the example of the *Eleousa*, the "Compassionate" or "Merciful" Virgin, a title that had long been in use in theology and poetry and also became common for icons.[91] A monastery dedicated to the *Eleousa* existed in the capital, and the Virgin's icon in the monastery of the Pantocrator was given the same title.[92] In an *Eleousa* monastery founded in 1085 in the Balkans, a large panel of the standing Virgin is mentioned, with "the Child nestling against her breast [*enkardion*] and babbling sweetly [*eulalaton*] with her."[93] We are well advised to distinguish strictly between a theological concept and the title of a church, if the same term is used for each. It is the site that must have determined the type of an icon.

Zealous iconographers will always be able to trace antecedents for the use of an image type such as that which today is called *Eleousa* to as early as the ninth century.[94] But to conclude that such an image type was in continuous use would not be legitimate. Old types sometimes came back into use when they met new functions or when they were rediscovered under spectacular circumstances (chap. 9e). History and iconography are not to be confused with each other. From all we know at present, the image of the Mother of Tenderness did not become commonplace until the tenth century and then was increasingly popular in the subsequent period.

171 The new importance of this theme is illustrated by a figure of the martyr of iconoclasm, Stephen the Younger. In the twelfth-century hermitage of Neophytos in Cyprus, Stephen holds a single panel of the Mother and Child, in place of the usual double image of Christ and the Virgin.[95] The mutilated inscription speaks of "our Lord" and his "pure Mother," each of whom is "circumscribed in the image." The supporters of images had always taken icons as evidence of the reality of the Incarnation. The "circumscription," a theological concept, here includes the relation of the incarnate God to the mortal woman who was his mother. The icon thus presents the quintessence of Christian dogma. It does not merely depict a tender mother but represents a couple whose relationship was the greatest paradox of Christian faith.

The icon of the Virgin was from the very first a proof of God's incarnation. In late antiquity it served as a theological definition of the Mother of God,[96] thus emphasizing the exalted nature of the divine Child, whose ageless appearance indicated that Mary had not given birth to an ordinary child. In the Middle Ages it was the childlike qualities of Jesus that were now stressed, with the help of rhetorical antithesis, as his divinity was no longer in question, and it was the human aspects of his existence that were seen as miraculous.

The relevant sermons and hymns elaborate on this subject with rhetorical tropes,[97] such as, the creature, Mary, holds her Creator in her arms; or he whose throne is set up above the cherubim sits in the arms of a mortal mother; or the uni-

verse cannot encompass his greatness, and yet he is, as a child, smaller than the human being who has given him birth. These rhetorical tropes, which dramatize a contrast between extremes in order to celebrate their reconciliation as a miracle, also have been introduced into icons, where they are alluded to by signs and metaphors. In depicting the human behavior of Mother and Child as graphically as possible, they are able to emphasize the total contrast with God's true existence. When the Child nestles against the Mother's cheek and the Mother draws close to his lips, the child *175* nevertheless knows about the mystery of the event, and the Mother is trembling in the awareness of kissing God himself.

Her feelings as Mother, surprisingly enough, are described by texts dealing with the Passion, which does not mean, however, that the types of the tender Mother just serve as images of the Passion.[98] The linking of the theme to the Passion had a rhetorical reason as well as a theological one, since the lamentation of the dead, seeking to intensify grief by remembrance of a beloved person, also here allowed for a character study, in suggesting that the Mother, when faced with the corpse of her Son,[99] would have recalled the former joys of his childhood. In the icons, her meditative gaze is anticipating the sorrows to come. The device of anticipation (prolepsis) produces a *173* synopsis of two feelings and two time planes, when, in a text famous at the time, the Virgin addresses Christ: "Then I touched with my lips your lips as sweet as honey and as fresh as dew. Then you slept on my breast as a child, and now you sleep as a dead man in my arms. . . . Once I took care of your swaddling clothes and now of your shroud. . . . Once I lifted you up in my arms when you skipped and jumped like a child, and now you lie [motionless] in them like the dead."[100] In rhetorical tradition the term of the honey-sweet lips goes back as far as the lament of Niobe in ancient literature.[101] In another text Mary talks at the foot of the cross to her "dearest child," whose "motionless limbs, silent mouth, and closed eyes" remind her of the contrast with her former joy[102] but in the end make her realize that this tragedy was needed to carry out the work of salvation.

The Virgin is thus described both in her ethical perfection as a person and in the theological role she plays in the divine work of salvation. This double view already characterizes a hymn of Romanus the Melodos from the sixth century, the archetype of all similar texts,[103] in which Mary first behaves like an earthly mother, uncomprehending, since she will not accept what her Son has done to her. But he counters her complaint with the argument that he could save Adam only by dying himself. "You are called full of grace [*Kecharitomenē*] and must show yourself worthy of the title [*klēsis*] by ceasing to weep."

Such ideas were used in varying degree by icons of the Mother of Tenderness, which, when including the Passion, met the theological requirements by treating a double theme. The Mother, which alludes to the Passion through her facial expression, represents on a single panel the whole of a theological system, which is centered both in the Incarnation and in the death on the cross. As her role of intercession was linked to her role in salvation, the beholder worshiped her hands, which had helped both to bring up the Child and to lay the Son in his tomb.[104]

A wall painting in a cave church in Cappadocia, which repeats the Mother of *173*

285

172. *Nerezi (Macedonia); the Lamentation* (Threnos), *1164*

173. *Göreme (Cappadocia), Tokale Kilise; fresco in the chancel, 10th century*

Tenderness from an icon in the capital in the tenth century,[105] is set up in such a way as to bring the Virgin as intercessor into eye contact with the beholder, while keeping her gaze ambiguous. Mary's inward vision is shown by the way her gaze imperceptibly passes the beholder. The wall image is situated in the sanctuary, directly below a depiction of the Death of the Virgin. There is a rhetorical intention in this arrangement too.[106] On one image the Mother takes her Son's childish body in her arms; on the other, analogously, the Son embraces the soul of his Mother. In the hymn by Romanus he promises, as he leaves her, to call her to him.

The wall painting in Cappadocia is the first medieval example of this theme. The Child is impetuously seeking his Mother's mouth, while her pensive gaze reveals that she knows the mystery. The lyrical expression, which is concentrated below the long lids of her large eyes, together with that of her gestures, matches the direct speech in the texts. The Mother holds the Child on her left arm, perhaps in order to keep her right arm free for the gesture of petition. In this respect the early examples, including those from Georgia,[107] are based on a model different from that of the Virgin of Vladimir. The icon lists of the time often state on which arm Mary holds the Child.

The Virgin of Vladimir,[108] clearly a later version of the theme, intensifies the expression by introducing a sorrow that contracts her brows. The contrast between the passionate tenderness of the Child and the Mother's melancholy detachment has gained importance. Her eyes now look into the distance, where future events are being revealed. The difference between her shaded face, whose glowing cheeks yet represent life, and the lighter skin of the Child, is as much a part of the rhetoric as is the discrepancy between the delicate, almost pointed features of the Mother and the full features of the Child. Light plays a subtle but important part in the contrast. It is difficult to separate the personal interpretation of the painter—who may have been producing a state gift for the Russian prince—from the type he is reproducing, since we lack sufficient comparable material. Unfortunately, we know this panel only with drastic overpainting of the garment done in Russia in the fifteenth and sixteenth centuries. Only the faces (not even the hair and hood) are in the original condition. Mary appears as Psellus describes her, at the foot of the cross, "musing within. Her eyes are fixed on inexpressible ideas, and within her soul" passes what once was, or, in this case, what will be.[109] She presses the Child, who is speaking to her, to her heart, as an icon inventory of the time expresses it.[110] We should like to know what this type was called, but the only replica that has a title, the *Episkepsis,* or "Visit,"[111] is of no relevance to the question. It is a more recent mosaic icon in Athens, which uses coarser means to show Mary looking directly at us.

The allusion to the Passion in the Vladimir panel recalled depictions of the lamentations at the foot of the cross, where the Mother presses her cheek to the corpse.[112] The Passion also was depicted through double icons of the mourning Mother and the Man of Sorrows. A bilateral icon from Kastoria, which played a part in the Lamentations of the Virgin during Holy Week, relates the Man of Sorrows to a Hodegetria whose face is distorted by pain.[113]

The idea of the Passion is developed in an ideographic manner in a wall icon in the Arakas monastery (Cyprus) from 1192.[114] The Child lies in the pose of the

175

172

163

176

174. *Mount Sinai, monastery of St. Catherine; icon of the Madonna of Kykkos, central portion of the Marian panel, 11th century (detail of fig. 178)*

175. *Moscow, State Tretjakov Gallery; Madonna of Vladimir, Byzantine, ca. 1100*

sleep of death (*anapesōn*) on Mary's arm and appears to be teaching her the meaning of the Passion. In the inscription, the donor, Leon, who has had the "immaculate [*achrantos*] icon painted in perishable [*phthartois*] colors," begs the monastery's patroness to shed "countless [*ametrois*] tears" while she intercedes. The theme of the Passion is suggested by the second title given to Mary in the same icon, *Kecharitomene*, or "full of grace." The Passion hymn of Romanus, as we saw, with this angelic address reminds the Virgin of her role in the story of salvation during the dialogue at the foot of the cross. The Child's gesture of instruction can now be explained: it introduced a second level of time, the time of the Crucifixion, with the dialogue. The Passion, also alluded to by the signs in the angels' hands, is echoed on the opposite wall in the rhetorical gestures of the aged Simeon, who foretold it as a prophet, and of John the Baptist, who pointed to the Lamb of God.

In the eleventh century the theme of the Mother of Tenderness was not restricted to the type of the Virgin of Vladimir. In a second type independent of it, the Child's dramatic figure contrasts sharply with the intimacy previously associated with him. This second type became famous in the replica of the Virgin of Kykkos (Cyprus), though this example is so distorted by overpainting that only copies in Cyprus give us an idea of its appearance.[115] A twelfth-century work from the capital, now at Mount Sinai, also refers to the original of the Virgin of Kykkos but enlarges it into an enthroned full-length figure with a framing program.[116] Let us first concentrate on the panel at Mount Sinai and disregard its figural frame for the time being.

The Virgin of Kykkos—as it was to be called, after the replica in Cyprus—reverses the roles of Mother and Child in that the Mother presses the Child to her face, while the Child tries to tear himself free from her with impatient kicking and a violent grab at her veil. The rhetorical figure inherent in the motif of kicking (*periskirton*) occurs in texts on the presentation of Jesus in the temple, which make the Child break away from his Mother to leap into the arms of Simeon. Driven by the *dynamis* of his destiny, he opposes the laws of nature, intending to begin his path toward sacrifice in the arms of Simeon—who presents him as a sacrificial victim—instead of staying with his Mother.[117] The kicking movement is even shown when the Child is already in Simeon's arms, as in the frescoes of the Arakas monastery in Cyprus.[118] The motif should not be interpreted as a child's behavior but as a symbol of Christ's preparation for the Passion, which he accepts as his destiny. If further proof is needed to support this interpretation, it is found in the extended version of the Kykkos icon at Mount Sinai, where, among the Old Testament prophets on the frame, Mary's sad gaze falls on the old Simeon. Thus, in a convincing rhetorical figure, the icon of Kykkos achieves a synthesis of childhood and Passion of Christ.

In light of John 1:1, the motif of the scroll, which is placed in Jesus' hand in this icon, has been a symbol of the divine Logos, or "Word." In Byzantine mysticism, the scroll (which no longer *is* the Word but merely *contains* it) becomes a symbol of the body that Mary bore to the incorporeal one, and so a symbol of Mary herself. The Mother is seen as "Christ's living book, sealed by the Spirit,"[119] and as a "sealed book, the writing of which is known only to him who holds the seal"; she is the text "scroll [*tomos*] in which the logos without writing [*agraphos*] is expressed."[120] On

other icons the scroll is dipped into the color of blood, as on a panel of the *Hodegetria* 177
in Athens, where the Child instructs his Mother on the meaning of the Passion.[121] In
an early version of the Virgin of Pelagonia,[122] the Child holds the scroll, dipped in
Mary's life-giving blood,[123] behind him like a new acquisition. On the Kykkos icon
the scroll was tied crosswise—that is, sealed. In this context it clearly referred to the
body formed of Mary's blood, which the Logos received from his Mother.

In the Virgin of Pelagonia, a third variant of the Mother of Tenderness, the Child 153
turns his face toward his Mother, as on the icon of Vladimir, but at the same time
kicks as wildly as on the Kykkos icon and even pushes his tender Mother violently
away with his hand. The contrast inherent in the double motif expresses a synthesis
or revision of the other two versions. The poetic manner of conveying theological
ideas addresses a beholder versed in rhetoric who enjoyed the subtle alliterations,
analogies, and antitheses, in which a character depiction becomes a theological figure
of speech.

Such rhetorical painting, which competed with the poetry of hymns, culminates
in a Sinai icon that enlarges the Virgin of Kykkos into a complete theological pro- 178
gram.[124] This was not an isolated attempt, as a variant with the same format in the
hermitage at Leningrad proves.[125] The rhetoric that dictates the structure of such pan-
els was not restricted to the expression of living persons but used association, antithe-
sis, and ambiguity to convey theological doctrines through poetic images.[126] Although
these metaphors and figures of speech were visual in nature, they were nevertheless
an attempt to match poetry.

The Virgin of Kykkos, originally a half-length figure, is here enthroned beneath
an arch that signifies a gate. Both the throne and the gate, through which none but
the Logos enters, are central "symbols and types" of the Mother of God,[127] in which
her essential nature is expressed. The throne, now a circumscription of the human
mother, contrasts with the heavenly throne, or "seat above the cherubim," from
which the Logos descended to his earthly throne.[128] The "Lord of Glory" (*Basileus
tēs Doxēs*) is enthroned a second time and below, on the lap of the mortal woman, is
struggling to tear himself free. She is his temple—the garment of his divinity, to use a
common phrase.[129]

The many small figures framing the central figure serve as a theological circum-
scription of the significance of the Virgin and "explain" her to us,[130] just as a con-
temporary sermon addresses the temple in Jerusalem in order to "explain" who is
entering it. She is the ladder to heaven, the burning bush, the bed of Solomon on
which the Word rested (*anapesōn*), the sealed book, and so on. In the icon these
symbols are allocated as attributes to the prophets who wrote about them. In the
second row we recognize Moses by the burning bush and Jacob by the ladder, in
the fourth row Ezekiel by the locked gate and David by the temple or the Ark of the
Covenant. The sermon mentioned before goes on to say that in Mary the oracles
(*chrēsmoi*) of the prophets were fulfilled when the redemption (*lytrōsis*) of the just (of
the Old Testament) was initiated.[131]

Two inscriptions below the Virgin's throne draw the beholder's attention to the
lower frame, at the center of which the foster father Joseph stands between Mary's

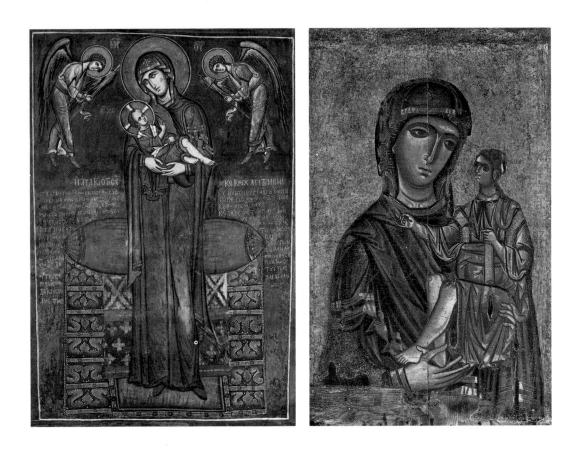

176. *Arakas monastery (Cyprus); titular icon, 1192* 177. *Athens, Byzantine Museum; icon of the* Hodegetria, *12th century*

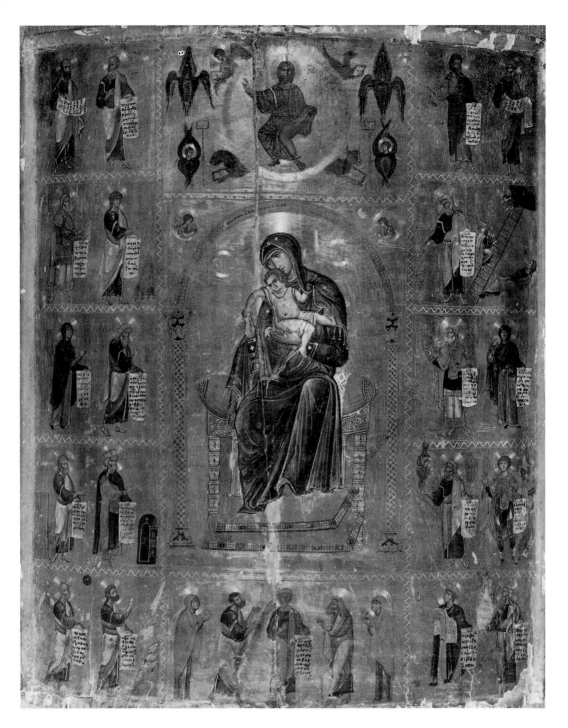

178. *Mount Sinai, monastery of St. Catherine; icon of the Madonna of Kykkos, with prophets,*
11th century

293

parents, Joachim and Anne, and Adam and Eve. The one inscription tells us that "Joachim and Anne had a child" (*eteknogonēsan*), the other that "Adam and Eve were redeemed" (*elytrothēsan*). This brings into play a number of themes that were central to church poetry, especially at Christmas and the feast of the Birth of the Virgin, and in which Mary is called the praise of the prophets, the daughter of David born of Joachim and Ann, who lifts the old curse by bringing forth a child. Born of a sterile mother and giving birth as a virgin, she conquers the true sterility of human history. Joseph witnesses, "in confusion," the pregnancy of a virgin, and Adam and Eve dance for joy at their redemption. One miracle augments the other. The mystery that cannot be explained is at least mirrored in endless reflections, and it is only these that can be spoken of at all.

These themes, well known from all the relevant texts, generate an internal order in the icon in which the signified is distinguished from the sign, the content from the frame, the truth from its allegorical clothing. The Mother with her Child is the object of the *perigraphē,* or explanation through circumscription. Even her appearance is so encoded in the rhetorical trope of the Kykkos icon that anyone who has the key to the code must adopt a theological view. This view is elaborated by the frame, which acts like a scholium (or gloss) to a biblical text and combines different time levels (past and present, curse and redemption) as well as different places (heaven, earth, underworld). The central axis, seen statically, comprises an antithesis between the divine vision (top) and human genealogy (bottom). Seen dynamically, it draws together a falling and a rising line in the central couple of Mother and Child, creature and Creator, within the cosmic event they have produced.

As in church poetry, the chain of associations is in principle unlimited, and the change of time levels is a rhetorical means of indicating that salvation is active in the present. Almost all the texts of the five great annual feasts of the Virgin are interchangeable.[132] In the rules of an eleventh-century monastery of the Virgin, which list the sermons of the great theologians to be read, texts from one feast are often transferred to another.[133] The cycle of miniatures illustrating a cycle of Marian sermons from the twelfth century shows the same mixture of narrative and figurative or allegorical elements as is constantly used in the texts. Thus the text on the Virgin's birth is illustrated not only by the event itself but by a series of cosmic images on the theme of the closing and reopening of paradise; in figure 179, the angels and prophets are venerating the Virgin in paradise, which she has opened once more.[134]

179

The icon in the Mount Sinai monastery that places the complex—indeed, composite—image of the Virgin of Kykkos at the center is not an iconographic curiosity but a fruit of the new rhetoric, in which icon painting strives after the verbal resources of poetry. The abundance of meaning, which is a common trait of icons of the time, is unfolded here in an unusual kind of commentary. But even this extension was not singular. The double panel of the Virgin of the Annunciation in Ohrid places the Mother of God within a metal frame containing all the prophets who have foretold her coming.[135] The inventory of the icons of the monastery of the Virgin Full of Grace (was it perhaps the home of the original of the Virgin of Kykkos?) mentions two panels on which the Virgin is enthroned beneath Christ, likewise enthroned as on the

170

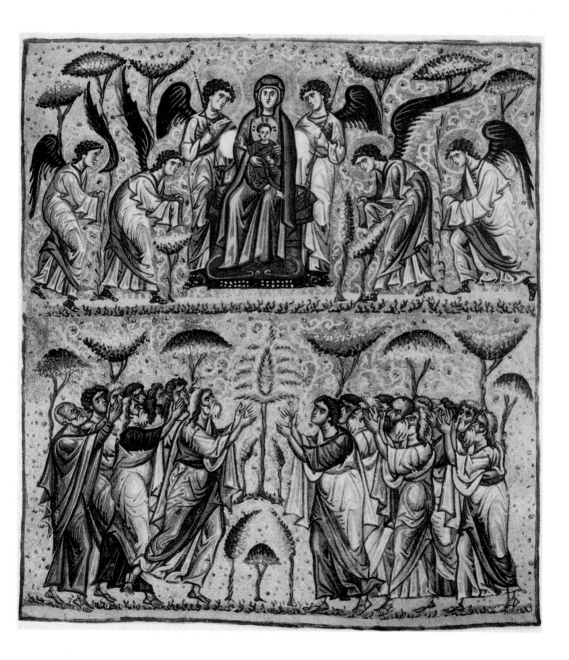

Mount Sinai icon.[136] On one panel she was framed by a series of saints, on the other by a cycle of feasts of the Virgin—though neither variant is represented in the surviving material. One of the panels was the "icon painted in the new style" with which we introduced this chapter. The Sinai icon we described gives us an idea of what it may have looked like.

14. Statues, Vessels, and Signs: Medieval Images and Relics in the West

a. The Different Premises of Image Worship in the West

When in the tenth century the goldsmith Gauzbert made a golden *icona* of St. Martial that was "set upon the altar" in Limoges, he was not producing an icon in the usual sense, but a statue with a skin of gold foil.[1] A reliquary in human shape was often used to restore the appearance of a body to a relic that had lost its shape through decomposition. In the East the practice remained as unknown as the custom of installing the image directly on the altar (chap. 12d). Two traditions here diverged. They did not converge again until about 1200, when Western sculpture in Italy was remodeled after the Eastern icon in a grand synthesis (chap. 17a).

Monumental sculpture seems to have been placed under taboo after the end of antiquity, and for a long time the medieval sculptor was restricted to carving reliefs on buildings. The reintroduction of sculpture properly speaking has been a constant source of discussion among scholars trying to explain it.[2] The thesis of the late emergence of sculpture in the round in the Ottonian period is refuted by written sources that refer to Carolingian works of sculpture, although few such works survive that can be dated with confidence. A few things, however, can be said. Sculptures were always single cult images or figural shrines of relics that, as a rule, were made of a wooden core covered with gold foil, not of marble or bronze. The exceptions are limited to isolated instances. The few rulers' statues from the Carolingian period followed a different tradition, and the bronze castings were used to give Charlemagne's residence a splendor redolent of antiquity.[3]

Early sculpture was produced not on the ancient soil of the former Roman Empire but in regions where the erstwhile barbarians had not forgotten their own traditions and had worshiped idols that Christian missionaries destroyed as late as the seventh century. To be sure, these were trees or stones, not the human figures that were later to replace them under the Christian aegis. The impression that in representing human bodies, medieval sculpture took up a legacy of antiquity is therefore misleading. Eastern culture, which was Christianized much earlier and continued ancient culture much longer, proves the contrary as it decided against the statue, which retained the odor of idolatry about it, in favor of the icon, the painted cult image of antiquity. In the West it was precisely the former idols of barbarian cultures that found a counterpart in Christian sculptures.

But there is another reason for the divergent paths taken by East and West, which illustrates the ineluctable power of historical factors. Byzantium was forced, not least by the proximity of the Orient, into a conflict over images in which it finally had to take an uncompromising stand either for or against (chap. 8). Because of the opposition it aroused, the decision in favor of images was subjected to a pressure that permitted only a standardized image with a precise function, a familiar appearance, and

a firm theological definition. The West had little concern for these problems, and the court of Charlemagne was offended by the calling of a general council on images at Nicaea without Frankish participation.

Charlemagne commissioned a theological report arguing against the Greeks' decisions with regard to images, which became known as the *Libri Carolini*.[4] It had little impact, as it turned out that the pope did not want to take part in a general offensive against Greek theology. At the Synod of Frankfurt of 794, too, the image question took a back seat, but it was taken up when the second wave of iconoclasm at Byzantium forced the Synod of Paris in 824 to formulate some resolutions that were set out in the so-called *Libellus* (texts 33A and 33B). These condemned both the removal and the worship of images.

Despite their limited influence, the books of the *Libri Carolini* are revealing because they follow the didactic line of earlier popes and offer the Franks a free hand in the matter of images. The production of images continues to be allowed, but image veneration is flatly forbidden. An astonishing amount of subtlety is displayed to impress the Greek theologians and to defend a tolerance of images that also was needed in order to calm down disunity in the ranks. The liberal view, which sometimes is nothing but ill-disguised uncertainty, above all is resistance to any dogmatic pressure exerted by the Greeks. The aniconic cross and the iconic Christ, though mutually exclusive in the East (chap. 8d), were both tolerated, but the cross enjoyed greater sympathy, since it was authorized by the Bible. By the end of the ninth century the hour for deliberations was past, and there was no longer a central authority that could issue uniform directives for the West.

Theodulf, who played a key part in the debate, well characterizes the intellectual climate that gave rise to the theological definitions.[5] He loved art for its intrinsic aesthetic appeal but was reluctant to accept the claim of cult images to be worshiped. Where he himself acted as a patron, as he did when commissioning the mosaics in the chapel of Germigny-des-Prés, he rejected iconic subjects that might have favored an image cult and instead had the Ark of the Covenant depicted in the apse.[6] He was probably tolerant of biblical narratives and preferred holy vessels with a high degree of technical perfection, such as finely wrought crosses and beautiful reliquaries, which, as an offspring of a material culture with aniconic origins, were to shape the West's future aesthetics.[7]

Reservations about the venerated image were dropped once the relic came on the scene, and dominated the discussion in the West. Although the argument in iconoclasm had been focused on the icon, the controversy in the West was aroused by the relic and by the danger of religious materialism connected with relics.[8] The relic compensated for the lack of biblical shrines in the West and created a kind of cult geography whose centers attracted pilgrims and outdid each other in their gigantic architecture and their lavish treasures. Here the applied arts were more important than the image, in the ancient sense, which had been supplanted meantime by the relic, the powerful agent of a massive pilgrims' movement in France on the route to the apostle James's tomb in Santiago de Compostella.

b. The Crucified and the Enthroned Statue as Examples of the Bodily Image

The new sculptures that took shape in the ninth century share their tangible, corporeal appearance with the reliquaries and resemble them too in their encasement in gold foil and precious stones. Only their iconic form distinguished them from the aniconic chests of the reliquaries. The practice of displaying them on altars also directed attention to the reliquary, particularly if the altar, as in the case of the Madonnas at Chartres or Vézelay, was situated in the crypt, which had always been the site of the saints' cults.[9] The assimilation of statue and reliquary was carried further when statues were used for containing relics and thereby became figural reliquaries. But the deposition of relics certainly was not the only reason for the emergence of the new genre.[10] More important was the analogy between reliquary and statue, which both were proofs of the physical presence of the saint and resembled each other in appearance.

The relic as *pars pro toto* was the body of a saint, who remained present even in death and gave proof of his or her life by miracles. The statue represented this body of the saint and, as it were, was itself the saint's new body, which, like a living body, could also be set in motion in a procession. The bodylike sculpture made the saint physically present, while the golden surface made the saint appear as a supernatural person with a heavenly aura.

The analogy between relic and image, however, did not apply to Christ and the Virgin, who had left behind no body relics and whose sculptures filled a gap by compensating for this deficit vis-à-vis the cult of saints. At the start there were two definitive sculptural forms: the crucifix and the enthroned statue. In these, both Christ and *180, 181* the Madonna were restricted to invariable image types. There is no statue of Christ sitting enthroned alone; he either sits as the Child on his Mother's lap or hangs on the cross. The crucifix was in a way an elaboration of the preexisting cross, and the motif of the crucified Christ had existed in icon painting (chap. 7) long before it was made *70, 71* into a life-size figure "after the model [*ad instar*] of human stature."[11] These words were written in the ninth century about a sculptured crucifix in Narbonne, and it is surely no coincidence that as early as the sixth century a painted crucifix was venerated in the same place, a figure that once complained about the scanty covering of its loincloth and henceforth periodically was covered by a curtain.[12] In Carolingian times Jonas of Orléans refers almost incidentally in his treatise "On the Cult of Images" to crucifixes of gold and silver that were made "to commemorate the Passion of the Lord."[13] One often tends to forget the early use of statues representing the crucified Christ or the Virgin and the saints. Several life-size crucifixes of silver foil over a wooden core still exist that were produced in northern Italy about 1000, particularly in Pavia and Vercelli.[14] They already enframe the regal figure on the cross by the flanking figures of the Virgin and St. John and provide additional scenes, as was to become customary much later in the painted panels of the Crucifixion.[15] In the treatise already mentioned, Jonas of Orléans also speaks of "brightly painted panels" of the Crucified, by which he means either Eastern icons or a genre that has not survived at all.

181 Like the crucifix, the statue of the Virgin Enthroned recalls a biographical situation, the childhood of Jesus, but elevates it to the timeless dignity of the enthroned image, which was quite logically called *Maiestas* or *Majesté*.[16] It suggests the homage paid by the Magi in the Bible and thereby demands a corresponding veneration from the believer. Any enthroned figure carried along the idea of a ruler, which, in this case, implied the royal rank of the Mother of God,[17] as against heretical movements and their denial of the Virgin-Mother's role. The link with the throne of Solomon provided another useful metaphor, and the inscription on an Italian Madonna of

233 1199 succinctly expresses the theological concept that the invisible God became visible as the Child of a human Mother: "The Father's wisdom shines forth from the lap of the *mater*."[18]

 Like the image of the Crucified, that of the Virgin Enthroned existed from early

II on in icon painting, and in Rome a life-size panel from the eighth century, like the famous Madonnas of Le Puy and Chartres later,[19] makes the Virgin's royalty plain by means of a crown and the other ornaments of a ruler (chap. 7c). The earliest enthroned statue of the Virgin known to us was made around 946 in the cathedral of Clermont-Ferrand, as a reliquary for secondary relics. A contemporary text describes its figural form as being distinguished from that of simple reliquaries, or *châsses*.[20] This early statue was, like the Essen Madonna, covered in gold foil and, like the reliquary shrines, set up behind the altar on a marble column with a figured socle of jasper. Later, such prototypes were replaced by wooden figures painted in gold, such

181 as the Madonna in Tournus, called *Notre Dame la Brune*,[21] whose child addresses the beholder with a teaching gesture, as one might expect of the "Wisdom of the Father." Such figures in the round lent themselves to being incorporated in liturgical reenactments of the story of the Magi. The actors portraying the Three Kings entered the chancel, where the curtain had been drawn aside in front of the Madonna, and "the midwives point out to them an image and say: 'Behold, here is the Child whom you seek.'"[22] The bodily presence invited giving the statue a part in liturgical plays.

 The *Vierges reliquaires* were not yet a familiar sight when a theologian from Chartres, coming across statues in the Auvergne around the year 1000, was surprised that they did not represent the "divine crucifix," which "it is customary throughout Christendom to venerate . . . in sculpture and bronze" (text 34, I). Admittedly, he referred to statues of saints, not Madonnas, but they had adopted the same enthroned type as had the Virgin and were also called *Maiestates*. Such figural reliquaries from early on existed either as statues of the enthroned saint or as "speaking reliquaries," which means that they selected a part of the body, such as the head or an arm, in order to make visible the relic they contained.

 In the case of St. Maurice, King Boso donated a head reliquary, encased in gold and adorned with a crown, to the church of Vienne.[23] In the case of St. Foy (Fides),

IV the abbey commissioned an enthroned statue, although, again, the relic was the skull of the saint. Two monks had stolen the relic from the tomb of the saint, a martyr from early Christian times, in Agen. The full figure increases the iconic presence and suggests the experience of a living person, which culminated in ritual processions when the saint, like a sovereign, was carried about her domains *en majesté*. When in 985 a

blind pilgrim was healed, the miracle made the statue world famous, and the metal casing over the wood core was "entirely renovated," while the ninth-century figure was retained within.[24] The throne of the statue later on served as a safe for relics, while the statue became decorated with precious jewels and metalwork that people dedicated to the saint.

The head, which enclosed the actual relic, had the most powerful impact, because it too—and not just the relic—was spoil from the early days of the church, which increased the desired authenticity. Perhaps it is a late antique or Celtic head of the kind (gold foil over a wooden core) that was to have a lasting influence, both technically and aesthetically, on medieval sculpture. The magical power that was felt at the time to emanate from the inlaid eyes can be seen from a description of the St. Gerald in Aurillac, whose "face was animated by such a living expression that his eyes seemed fixed upon us and the people could read from the luster of these eyes whether their plea had been heard" (text 34, I).

This was written by a cleric from Chartres, Bernard of Angers, who set off in 1013 to find out firsthand proof of the miracles of St. Fides. He came a skeptic and left a convert, not without earning fame of his own with a lengthy book of the miracles of St. Faith, which is one of the most telling sources on medieval sculpture. He wondered about the "old tradition [*vetus mos*]" of the region of making for each saint a statue "of gold, silver, or other metal" and enclosing in it the skull or other relic. This, at first, was rejected by "enlightened people" like him as "a superstition," though one that "cannot be eradicated from the common people." It was enough, he first had thought, to tell the saints' stories in books and paint them on the walls, whereas it was absurd to pin one's hopes on "an object without language or soul," as if it were "an oracle to be questioned or an idol to receive sacrifices."

He repents of his error once he has realized that the statue serves merely as an aid to pious remembrance and is nothing but a reliquary to which "the goldsmith has given a human form in his own way." Above all, he is convinced about the miracles, which depend on the power of the relic and not of the statue. The relic's powers made the abbey of Conques rich, as he was ready to admit, with St. Fides bringing in more and more wealth until the church's treasures, its costly altarpieces and dazzling splendors, could hardly be surpassed (text 34, III). All financial transactions and legal matters of the abbey were decided in front of the statue, which seemed to have a soul and to protect her property. It also represented the abbey at the Synod of Rodez, where it held court in a tent among other relic statues and imageless caskets of equal rank (text 34, IV). What Fides was in Conques, the silver statue of St. Peter was in Cluny—and was even taken along on the Palm Sunday procession.[25]

c. The Relation of Relic and Image

Relics and images were closely related and sometimes were even dependent on each other in their ritual function and veneration. Images assumed the appearance of relics and in turn gained power from their coexistence with relics. In medieval imagination, images and relics were never two distinct realities. The West never developed a theory of images as the East knew it and rarely valued images for their own sake or for

reasons entirely aesthetic in nature. The image, with the bodily appearance of a sculpture, was an agent of religious experience as it represented the reality of the presence of the holy in the world, on terms similar to those of the relic. Image and relic explained each other. In addition, the image, with its coat of gold and jewels, expressed the mentality of an agrarian society with feudal rule, in which gold was valued not merely as an item of exchange but as an expression of power and prestige.

Seen in the framework of religious history, images and relics both confirmed the experience of the living saint, whose tomb became the focus of attention. The saint received the gifts of the faithful, who in return required his or her services. The encounter with the saint could even amount to a kind of legal contract. The saint could disappoint the faithful by not fulfilling their demands, just as the saint could be disappointed by the latter if the faithful did not respect the saint's property. Whenever the saint had reason to feel offended, the saint's relic was taken down from its exalted position and placed on the ground, as if in a mood of sorrow and complaint.[26]

This phenomenon is so general in religious history that it is also found in other religions. For example, the "soul" of a Buddhist statue of Jizo in a Cologne museum recently came to light, having been concealed inside the figure since its consecration in 1249.[27] It consists of relics, reliquaries, and countless votive offerings (e.g., prayer rolls) deposited inside the statue. The identity conferred by this "soul," which distinguished the statue from others, was enhanced by a further identity it acquired as a copy of a wonder-working original. The donation document states that it was copied from an ancient original that had miraculously survived a fire. The text closes with a plea for protection and salvation. This can all be directly applied in our context, as it confirms the existence of a worldwide phenomenon.

The alliance of image and relic was limited by the fact that the cult of saints was secondary to that of Christ and the Virgin, who, as we saw, had not left behind any body relics. As the saints could make such an impressive appearance, the two central figures of Christian faith also required a visual presence, which could be provided by images of the crucifix and the Madonna Enthroned. In this case, however, there was a lack of reality compared to that of the image-relic of the saints. Perhaps this is why relics also were deposited in both types of image, whether this was done at the outset or later; in either case there is an obvious attempt to borrow the status of a reliquary.

While the figure of a saint contained one relic, preferably a major one, a variety of secondary relics were collected in the Marian figures, supplemented by primary relics of other saints. In Chartres the shrine with the Virgin's mantle was clearly distinguished from the statue of *Notre Dame sous terre*.[28] But when a church had less prominent—even if more numerous—relics, they were collected in a small hollow in the figure. This was done in the abbey of St. Pierre in Ghent, where about 1100 a gift of relics from Constantinople was concealed in a theft-proof compartment in the "new image" of the Virgin.[29] Sometimes it was forgotten that a Madonna figure had ever functioned as a reliquary. The wooden image in the crypt at Vézelay did not reveal its function until it was being repaired for fire damage in the twelfth century and a previously unknown relic space was found. But here the Christ Child had

184

openly worn a silk relic pouch around his neck, thereby also displaying a reliquary-like function.[30]

The visibility of the relic was subject to temporal change. The iconic reliquary, unlike the rectangular box, made visible the saint whose relic it contained. It might even show which part of the body the relic was. But the design of reliquaries gradually assumed an aesthetic value of its own, while the concept of what constituted visibility changed as well. Beauty and authenticity ultimately became joined in characterizing the reliquary, with one no longer existing without the other. The reliquary now presented no more than a beautiful frame, at the center of which the relic itself had to be seen—for example, through the "window" of a crystal reliquary.[31]

An intermediate step is represented by the head reliquary of the early pope Alexander, consecrated by Abbot Wibald in Stavelot (Belgium) in 1145.[32] The head, whose silver surface is enlivened by gilded hair, eyes, and lips, is a kind of three-dimensional icon that, like contemporary panels in Byzantium (chap. 12e), gives an idealized image of the prelate. Like the frames or side wings of painted icons, the socle, shaped as a portable altar, contains images that are a kind of theological and ethical commentary. On the front the enamels portray Alexander in the official robes of the pope between his historical companions in martyrdom, while on the sides they show the saint's virtues glorified in the Sermon on the Mount—above all, "perfection." At the time of church reform, the head of this early Christian martyr saint attracted attention, not only because it was known to be an authentic relic, but because it communicated an ethical ideal by means of an image of ideal beauty.

d. A Theological Aesthetic?

This observation leads to questions concerning the whole genre of statuary covered in gold foil. Was it based on an aesthetic of its own that corresponded to the aesthetic of icon painting? Or did it take advantage of a vacuum in which everything was possible? The act of reading, which also addressed narrative paintings and served to decode allegorical images, was here replaced by a different way of visual experience. The cult images, having a bodily presence and a personal life of their own, with their dazzling gold created what we might well call a magical effect. Whenever they contained relics, they overwhelmed the senses of the beholder. What first began in the early Middle Ages probably took on a different meaning in the twelfth century, when the written statements take great pains to dispel any suspicion of crude materialism, lifting all merely earthly connotations to a higher level by an anagogic procedure.

Abbot Suger of St.-Denis, in an inscription on the gilded portals of the abbey, challenged visitors "to admire not the gold and expense but the labor. [Although] the work shines in its noble splendor [*nobile claret opus*], it should so . . . illuminate the [beholder's] mind that he is . . . guided to the true light," that is, to Christ. The "material luster" is only an approach and an introduction to a higher beauty.[33] This light metaphor was applied indiscriminately by the loquacious builder of the new abbey church in the twelfth century to architecture, stained-glass windows, and the enormous gold cross from the Meuse Valley, and so had no special meaning for our genre. Abbot Wibald, Suger's contemporary, did not hesitate in the inscription on the costly

183

6

casing of the shrine of St. Remaclus to point out how much he had spent.[34] Wibald also used the case of the shrine to list the property of the monastery, entrusting it to the protection of its patron saint. Other monasteries and centers of pilgrimage invested heavily in the splendor of the saint who guaranteed their prestige and their property. In such cases the enthroned statue was given the same material, technical, and artistic treatment as the reliquaries, shrines, and other holy vessels owned by a church. The contrast to the aesthetic of the icon, which could be "adorned" with gold but not made of gold (chap. 13b), is evident.

In the West we may ask whether we are dealing with a theological aesthetic properly speaking or with arguments of self-defense to justify the theologians in the use of such sacred art. It certainly is significant that the church reformers of the time repudiated the sumptuous furnishings and mistrusted the images themselves, since the latter threatened the spirituality of religion. While radical movements like that of the Albigenses were totally uncompromising and unwittingly lent strength to the material image cult of the other side, who could claim to uphold the true faith, the reformist orders wanted to strengthen true Christianity within the church. Sometimes, as in the order of Grandmont, the conflict between clerics and lay monks left its mark on the cult objects, as when images on twelfth-century shrines were replaced by mere ornamentation, and vernacular inscriptions were substituted for Latin ones to weaken the monopoly of the clergy.[35]

The Cistercians—whose founder, Bernard of Clairvaux, repeatedly castigated luxurious cult implements as an aberration—prohibited sculptures and paintings in the order's statutes.[36] Initially, only "painted altar crosses" were permitted; later, gold and silver crosses of large format were expressly banned. In the thirteenth century, when painted panels became commonplace elsewhere, the order also banned these. The spiritual interpretation of gold images and shrines thus is revealed as a controversial matter, since the genre seemed too closely bound up with an institution's preoccupation with power and property. The new iconography in the age of Scholasticism, which appealed to theological education, drew one's interest toward higher values, using the goldsmith's art as a means toward another end. The incipient autonomy of artistic creation first enhanced the goldsmith's prestige. But in the long term it brought to the fore a different concept of beauty, the beauty not of the costly materials but that of the form invented by artists.

e. Legends about "Originals" and the Distinction between Image and Person

In the West, the concept of authenticity was initially restricted to relics and their origin from the actual body of the saint. Later on, it was transferred to images, which were treated as relics and distinguished from mere replicas or copies as originals with a history of their own. Such is the case with the carved crucifix in the cathedral of Lucca, which is first mentioned around the year 1100 as the *Volto Santo*, or Holy Face, but dates back to a much earlier period.[37] The surviving sculpture, clearly a Catalan work, replaced a preexisting image that, legend has it, was brought from Jerusalem in the eighth century. In the Middle Ages, the surviving image was crowned and even was vested with clothing and silver shoes. A twelfth-century book miniature

180

illustrating the legends surrounding the image narrates the story of a poor troubadour who had nothing to offer the image but who received a silver shoe that the image had slipped off and thrown to him as a gift.[38] 182

The Lucca image, which was circulating all over Europe in copies such as that of Bishop Imervard in Brunswick,[39] is explained in medieval texts according to the pattern of the bleeding image from Berytus (Beirut), whose legend was adapted to a sculptured work. The famous icon from Berytus, which was brought to Constantinople in 975 but is mentioned as early as the Council of Nicaea in 787,[40] is said to have been left behind by a Christian when he departed from Berytus. Then, the legend goes, it came into the possession of a Jew who pierced the icon of the crucified Christ with a lance in order to avoid suspicion of being a clandestine Christian. When the image began to bleed from the wound, the Jewish community was converted to Christianity and repented of its hostility toward images, which God seemed to reveal to be a sin by this heavenly miracle.

A Latin version of the same legend, which dates from the ninth century, introduces the argument that the Berytus icon had been painted by Nicodemus, who was present at the crucifixion. The legend of the *Volto Santo,* which follows this Latin text, transfers the story to a sculpture and adds the episode of the translation of the image from the Holy Land to Lucca in Tuscany. Nicodemus guaranteed its status as an original, much as St. Luke had guaranteed the original images of the Virgin that he had painted himself. In the fourteenth century, the *Volto Santo* from Lucca ranked alongside images of the Virgin painted by St. Luke (chap. 4b) and the Holy Face at St. Peter's in Rome called the Veronica (chap. 11c) as one of the most famous miraculous images of Christendom.

The Dominican Fra Giordano da Rivalto, preaching in Florence in 1306, attributed "the utmost authority to images imported from Greece," ranking them with the Holy Scripture,[41] as they depicted biblical persons "exactly as they really looked." The crucifix of Nicodemus, who "had been on the spot," seemed a good example. Matthew of Janov, although he wrote against images, admitted in his major treatise of 1390 that the *Volto Santo,* like the Veronica and the image painted by St. Luke, was based on God's own will (text 36, IV). Both the Veronica and the *Volto Santo* 17 were, in their different ways, he wrote, portraits of Christ, one being the portrait of the benevolent Son of Man and the other the portrait of the terrible Judge. Although the author had not seen the original in Lucca, he still was frightened when he thought of the copies he had seen on great flags, warning of the approaching Judge.

Such miraculous images, no matter how powerful their effect, do not really raise the question of the relation between image and person, as they were simply authorized mementos whose authority lay rather in their unusual history than in their ability to be an incarnation of the person. Much as people wanted to venerate the person in the image, the question as to the difference between the image and the person exercised Western theorists very little, as they were not interested in matters of identity. While images were invested with powers necessary to represent a legal person, this custom was not seen as a philosophical problem. Thus there was no theory to explain why the image of the giant St. Christopher was believed to have

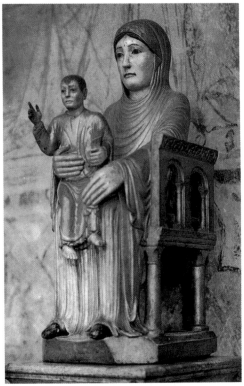

De initione. Reuelacioe ac traslacione sctissimi uultus uenā
bilis leonini. liber inapit.

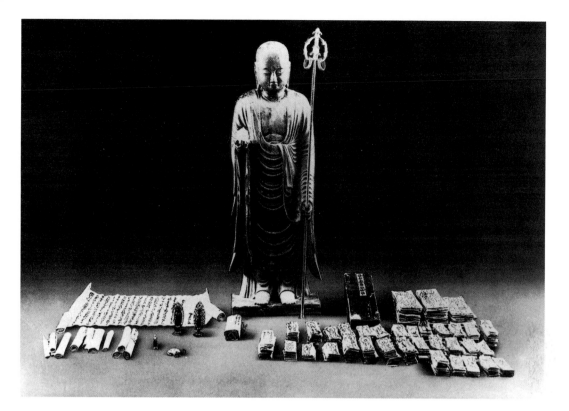

180. *Lucca, cathedral;* Volto
Santo *crucifix, 11th century*

181. *Tournus, St. Philibert;
seated statue of the Madonna,
12th century*

182. *Lucca, Biblioteca
Communale; Cod. Tucci
Tognetti, fol. 2; the* Volto
Santo *crucifix*

183. *Brussels, Musées Royaux
d'Art et d'Histoire; head
reliquary of St. Alexander,
1145*

184. *Cologne, Museum of
East Asian Art; Buddhist
figure with relics, 13th century*

the power to preserve one from death on the day one saw it. Perhaps the reason was the image of Christ whom St. Christopher bore on his shoulders, though, in a northern Italian drawing from the thirteenth century, the beholder is admonished to look at the saint's face.[42]

Statues of the Madonna Enthroned reveal the difference between image and person in the origin of their relics, which often came from a whole variety of saints. This association might raise the question of the priority between image and relic, but it certainly does not justify the inference that special emphasis had been given to the equivalence of image and person. In the East, the difference between them mattered for definitions of the reality of the image (chap. 8c). In the West, images were sometimes treated as if the person were present in them, working miracles through the image. The implications of this view, however, were mainly of a legal nature.

Western legends about miraculous images stress their age and history but seldom refer to their miraculous origin or their authentic reproduction of a model. One exception is the former statue of the Madonna in the crypt of the cathedral of Chartres, where also the relic of the veil was kept.[43] It was said that she had been made even before the birth of Christ and once had stood among heathen idols. Her name, *Virgo Paritura*, or Pregnant Virgin, derives from this legend.

One might wonder now whether the situation of the image changed with the widespread use of panel painting after 1200, when it took on a new importance and achieved far wider dissemination (chap. 17). The cult of St. Francis of Assisi was now spread not by relics but by icons, before which even miracles occurred, just as they had occurred before relics.[44] When relics and images were combined, as in a Sienese devotional image of 1347, their order of rank seems actually to have been inverted.[45] If earlier the relic had been the center and the image its frame, panel paintings now were produced with relics in their frames. In the Tivoli statutes of 1305 the community is to punish anyone who desecrates an image, not only by imposing fines but also by cutting off the hand that has struck it or cutting out the tongue that has spat upon it.[46] This regulation fitted the upgrading of images that was happening everywhere.

In Florence, the panel of the *Donna Nostra* in Impruneta, brought to the city as a rainmaker, created an increasing stir about 1400.[47] The thirteenth-century full-length enthroned image was replaced in 1758 by a replica by the hand of Ignazio Hugford. In the Renaissance era, crimes committed during the *andata* in the "divine presence" were punished with double severity. At that time St. Bernardino warned the Florentines against committing sins "before the eyes" of another wonder-working image, the Virgin from SS. Annunziata.[48] A third image in Or San Michele already in the late thirteenth century was accused by the jealous Laudesi brothers of being used for idolatry.[49] In each case the behavior of living people was attributed to such images.

The analogy with the Eastern cult of icons is obvious, and yet there is no certain link with them, unless it be in the case of privileged images whose cult was fostered by special legends. Meanwhile the production of images, in which the skill of the painter took on increasing importance, spread further and further. While more and more images were prized for their newness and their art, a few were privileged for the very different reasons of their age and their origin in the East (chap. 16).

185. *Escorial; Cod. T.I.1, fol. 50; Cantigas of Alfonso I, 13th century*

186. *Escorial; Cod. T.I.1, fol. 17; Cantigas of Alfonso I, 13th century*

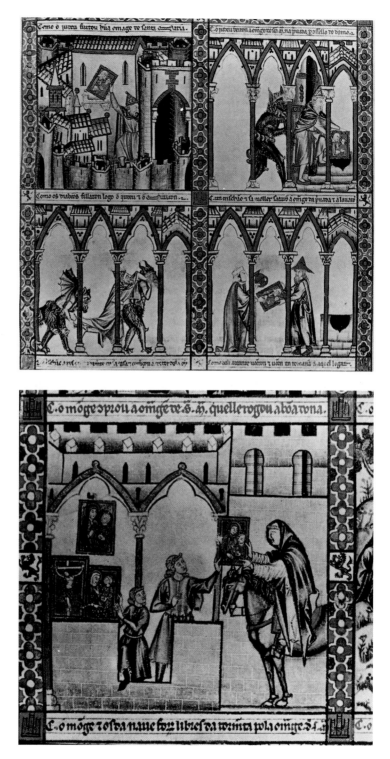

Images play an active part in the West in the texts of the so-called miracles of the Virgin, in which Mary repeatedly acts through her speaking and suffering image. The legends, which were collected by Gautier de Coinci,[50] prefer a matter-of-fact style, which means that the Virgin, embodied in the image, is needed to pardon weak sinners and punish unbelievers. The early sources used by the miracle legends now lost their original purpose of justifying a particular image cult. It is not the image that attracts attention but the Virgin, who can use any image. Often the images are statues. When they are described as panels, the action is often moved to the Near East, where the sources used by the legends have their origins.

The genre in which the image enjoyed such a topical existence was illustrated soon after 1265 in a manuscript of the "Songs of Mary," or *Cantigas* of King Alfonso X of Castile, which are a brief version of the old miracle legends.[51] One of them tells of a Jew who stole a beautiful image of the Virgin in the streets of Constantinople and threw it into a latrine, whereupon he was carried off by the Devil. A Christian, recognizable in the illustration by his Greek hat, finds the image, which is spreading fragrance about it, despite its surroundings, and sets it up reverently, for which it thanks him with healing oil. The motif of the Jew, attributing criminal acts to unbelievers, is an old topos, as is the miraculous reaction of the desecrated image.

Another story, which tells of the "Mother of God of Sardenay" (or Sardenai), also takes place in the Orient and is told in many pilgrims' books. A noble lady living in a hermitage near Damascus asks a monk from Constantinople who is passing through to bring her back from Jerusalem an *ymage de Nostre Dame,* which Gautier de Coinci also calls an *ycoyne.* He forgets to do this, however, and is commanded by a heavenly voice to turn back. In Jerusalem he looks for the loveliest *tavlete* in a shop of images, which the Spanish illustration shows as panels of the Virgin and the Crucifixion. When the chosen image turns out to have miraculous powers, he wants to take it back to his own order but is forced to keep his promise by the image's own numerous interventions. Such stories probably sounded like fairy tales from the Orient, but they also enhanced the fame of Eastern icons at a time when they were becoming a current issue as prototypes or models for Western images (chap. 17).

185

186

15. The Icon in the Civic Life of Rome

a. Images and Institutions in the High Middle Ages

Images played a significant part in Roman civic life and represented traditions that were older in Rome than anywhere other than the Holy Land. They embodied institutions competing for status and power, but they also were called upon by the opposite side, the Roman people, and held out authority for those who lacked it. As they existed outside the social and administrative hierarchy, the latter did its best to turn them to its own purposes. The Roman images, which had their origins in late antiquity (chaps. 4d and 7), were icon panels and remained in use against the medieval preference for sculptures. Thus in Rome the icon had an older and more untroubled existence than even in Byzantium. It first gained recognition as the resident image in the ancient churches of the Madonna and soon served as a means of propaganda by the papal court (chap. 7c). Half a millennium later, in the course of the eleventh century, it entered a new era, which concerns us in the following pages.

At that time, icons representing monasteries, parishes, and deaconries were already a common feature of the cult topography of the entire city of Rome. But the Lateran, where the pope resided, overshadowed any other site by reason of the images and relics hoarded there, surpassed only by the tombs of St. Peter and St. Paul. Our visit to the city, if we begin it here, will profit from a kind of official guide that was written about 1100 as a description of the Lateran and its treasures.[1] "On the altar at which only the Pope may read Mass," it mentions a "wooden panel with the icons of the apostles Peter and Paul as, on his own testimony, they once had appeared to the Emperor Constantine in a dream" (chap. 7b). A golden antependium before the altar allegedly was donated when the church was consecrated. 73

In the pope's private chapel, the Sancta Sanctorum, was the cypress-wood altar of Leo III (795–816), which was crammed with relics; and behind the altar was the "image of the Redeemer, miraculously painted on a panel, that was begun by the Evangelist Luke but finished by God himself through the hand of an angel."[2] At the foot of the panel, relics from the Holy Land were displayed in a precious shrine in such a way that the "unpainted" miraculous image (cf. chap. 4) still seemed to rest on the soil of the Holy Land, even in its Roman domicile. Also around 1100, a canon from the Lateran wrote a separate treatise on the picture (text 4F), which in his view had been among the spoils from Titus's conquest of Jerusalem. Through the "presence of his person in the image," he wrote, Christ had kept his promise to remain always with his disciples in the place where his earthly representative resides. At Easter the pope paid homage to Christ as the real sovereign by kissing the foot of the image.[3] 18 72

There was a division of interests, however, between the Lateran chapter and the papal court, and the old bust of Christ over the cross (chap. 6c) in the apse of the Lateran Basilica, for which the chapter was responsible, was also declared a miraculous image.[4] Dating from the time when the church was consecrated, the bust is said

311

to have appeared without human agency, for which reason it was saved like a relic under Nicholas IV (1288–92) and transplanted into the new apse. There also was competition with St. Peter's, which the Lateran clergy decided in its own favor by acquiring the skulls from the two apostles' tombs. At that time the old panel with the icons of the two apostles was replaced by the silver busts of the skulls (text 35).

21 In the church of S. Maria Maggiore on the Esquiline, which was part of the narrower precincts of the Lateran and was visited more often than just during the stational liturgy held throughout the city,[5] the old icon of the Virgin was the main attraction (chap. 4d), together with the cradle of Jesus. It embodied the church's patron saint and probably was paired with the "unpainted" miraculous panel from the Lateran when the latter was borne to S. Maria Maggiore in the annual August procession. In the thirteenth century it was called *Regina* ("Queen") and became embroiled in the dispute over the "true" icon attributed to St. Luke, when the mendicant orders, with their characteristic energy, struggled for recognition of their ownership of various Lucan icons (sec. c below).

Images also were given an important share with the history of the great miracles that lent additional color to the cult topography of Rome. Thus an icon painted by St. Luke was claimed to have been involved in the procession that conquered the plague under Gregory the Great when it passed by the Castel Sant' Angelo (text 32). This glory was countered in S. Maria Maggiore by the legend of the snow in August, by which Mary wished to indicate the desired site of her church.[6] In the convent of S. Maria on the Capitol the "Altar of the Son of God," on the site of the former temple of Jupiter, commemorated the vision of Augustus, when the emperor had seen the "heavenly altar" (*ara coeli*) announcing the birth of Christ.[7] Such legends were meant to give additional weight to images of the Virgin, which suffered from the inflationary rate of images in Rome (text 35).

The cult of images was first justified within a local framework, until icons imported from the East after 1204, along with their Eastern legends, challenged the local significance on a universal level.[8] Once the imported images had raised the question of their true origin and called the local Roman image cult into question, it was no longer sufficient to cite only Roman legends. The pope apparently first reacted to the new situation in St. Peter's by proclaiming the uniconic cloth of Veronica to be an iconic relic of Christ's countenance (chap. 11c). The Veronica was introduced by a spectacular miracle during a papal procession that could be witnessed by all and was promptly empowered with the remission of penances, the first image to have this

15 power. It thus surpassed the ancient cloth bearing the image of Christ's face in S. Silvestro in Capite, which probably arrived from the East at about the same time (chap. 11a).

In the course of the thirteenth century new images of the Virgin came onto the scene, and legends immediately gave them status among the competing Roman cults.

208 The image painted by St. Luke in S. Maria del Popolo (chap. 16d) is one such icon that came into being after the middle of the century and only later acquired a cult lineage of its own.[9] The Greek abbey of Grottaferrata outside the walls of Rome owned a large icon of the Virgin that, at the end of the century, was enriched with

two painted shutters. Only in the fifteenth century, however, did Cardinal Bessarion inaugurate the veneration of the icon as an image painted by St. Luke.[10] As S. Croce in Gerusalemme had been suffering from the cult explosion in the city, the Carthusians claimed a small mosaic icon from the East (chap. 16c) to be the true *imago* 207 *pietatis* that Gregory the Great had commissioned for recording his vision of the dead Christ,[11] just as he is reported to have seen the *imago* of the crucified Christ, at S. Prisca (text 35). At that time the number of images attributed to St. Luke grew dramatically, increasing the pressure to create ever new legends.

The annual procession with the icon of Christ, which made its way in August to 18 S. Maria Maggiore, was the focal point of the events that highlighted the role of local images. By the eighth century, especially in times of danger when the survival of the city was at stake, it was a well-established custom to march with the icon, led by the pope (text 4B). At the feast of the Assumption of the Virgin, the portrait of the Son was borne to his Mother, who was also the Mother of the Romans. According to a hymn of the time, she asked her Son for an oracle and intervened on behalf of the children of old Roma by shedding tears (text 4D).

From the twelfth century on, the people conducted the procession themselves and were represented by the city prefects and the delegates of the twelve regions of the city, who were received by the pope at S. Maria Maggiore. In the fifteenth century the city population was represented in addition by the guilds, which accompanied the icons in a fixed order (texts 4E and 4G). While the icon was looked after for the rest of the time by a confraternity, it was not in the hands of the whole people. A replica in Trevignano, where a similar procession was held, has Christ speaking in an inscrip- 193 tion as a ruler (*rex*) who has redeemed the people (*populus*) from death.[12]

This procession, however, was not the only public event of the Roman images, as "many other images are carried in processions," in the words of the canon of the Lateran (text 4F). Liturgical decrees for the feasts of the Presentation of the Virgin and the Annunciation prescribed that images were to accompany the processions.[13] They came from the eighteen deaconries and, along with the crosses of all the stational churches visited by the pope, represented the church topography of the city as a whole. While they had their usual abode in their church homes, at such occasions they became part of the itinerant liturgy that manifested the bishop's presence throughout the city. In Milan, too, and even in Fleury, the Presentation of the Virgin was symbolically enacted with an image on the feast of Candlemas.[14] In Rome, the assembly of images reflected the unity of the church of Rome, which existed in the various institutions embodied by the images.

In the August procession, by contrast, an image of Christ—representing, first of 18 all, the authority of the pope, which on this occasion was appropriated by the people—visited an image of the Madonna. According to a guidebook to Rome of 21 1575, the Madonna image returned the visit on the octave of the festival, and even the twelfth-century canon already quoted refers more than once to such a return visit, though he embellishes it into a vision of a heavenly nocturnal apparition.[15] The images represented the church or institution where they resided but could be set in motion for paying tribute to the central church authority. After the Counter-

Reformation the chapter of St. Peter's, on behalf of the pope, assumed the right to crown images of the Virgin.[16] Though they were being venerated for individual, local reasons, as a result all were submitted to the papal authority, which claimed the power to bestow such veneration on them.

In the Middle Ages, however, the legitimate use of individual images was subject to dispute and controversy among the pope, the monasteries, and the people. The images protected and honored those who controlled and worshiped them. The propaganda with images went back to the time when the pope used images to express his dispute with Byzantium. He had himself depicted at the feet of the imperial Mother of God, thereby declaring himself her subject, not the emperor's, in order to be master of his own house (chap. 7c).

In the late eleventh century, the pope again found himself involved in a conflict, this time with the German emperor. At the time of reform, when the right of investiture of bishops was a point of dispute between the pope and the emperor, the politics of images, in which the popes had once excelled, was restored to prominence. This was not confined to polemical picture-narratives defaming adversaries or pinning them down to a one-sided interpretation of the law, as seen in the frescoes in the council room of the papal residence.[17] When the chapel of St. Nicholas in the Lateran received a painted program that served as a monument to a triumphant papacy,[18] the

II frescoes significantly reproduce the early icon of S. Maria in Trastevere, in which the Madonna is enthroned like an empress and receives the homage of Pope John VII (705–7) (chap. 7c). In the chapel's fresco, two popes—one of them the donor of the paintings and the other the builder of the chapel, Calixtus II (1119–24)—kneel at the Virgin's feet as leaders of the autonomous church of Rome. Calixtus bore the name of an early Christian pope who, according to a reliable tradition, had founded the icon's residence, S. Maria in Trastevere. The reference to the icon thus reveals the idea of reviving an old tradition.

The icon of S. Maria in Trastevere is one of four images of the Virgin that were housed in the most famous churches dedicated to her in Rome and in the early Middle Ages is reported to have come into being "by itself"; it was *per se facta*—that is, of supernatural origin.[19] The other images, as we have seen, were the "temple images"

8 & front in S. Maria Maggiore and in S. Maria ad Martyres, formerly the Pantheon (chaps. 4d
of color and 7a). The icon in the Pantheon, on which the interceding hand is gilded, granted
gallery protection in the early Middle Ages to those seeking asylum.[20] The fourth icon is no longer in its old place, S. Maria Antiqua near the Forum, but was moved to the church of S. Maria Nova, which succeeded it. After a fire in the building, only the faces of

I Mother and Child survived, as a fourteenth-century document records (text 35), and as restoration has confirmed.

b. An Old Icon in a New Role: The Madonna as Advocate of the Roman People

In the Middle Ages, the old temple images were challenged by the fame of another icon that, in terms of origin, may be exactly what the legend claims: an early import from the East. We first find the small panel, which often changed its place, in the convent in Tempuli near the Caracalla baths, the ruins of which survive in the park of

Porta Capena.[21] In the thirteenth century it was moved to nearby S. Sisto; later on, in 1575, it arrived in SS. Domenico e Sisto in the city center, where an old copy exists; and in 1931 it ended up on Monte Mario, where it hides behind a grating in the convent of S. Maria del Rosario. We call it the Madonna of S. Sisto, after the site where it resided longest.[22]

A recent restoration uncovered the original encaustic paint on a panel of poplar wood measuring 71.5 × 42.5 cm. The Virgin turns with both hands toward someone outside the picture, whom she addresses on behalf of the beholder, and she turns with her face to the latter, who is requesting the favor of her plea. By these movements of her body, the one directed to Christ and the other directed to the faithful, she convincingly expresses the visual idea of the maternal advocate. The painted surface of the icon ends unevenly at the bottom, as if a curtain had concealed the lower part of the picture during processions. The gold casing of the hands dates from the eighth century at the latest, as does the gold-leaf cross on Mary's shoulder; both, however, may have been part of the original image.

V

Opinions still diverge on the date of the panel, though an origin from the sixth century is now generally favored. The face, with its perfect oval clearly outlined against the dark veil, implies the ideal of the *typos hieros,* attaining the same three-dimensional treatment of the surface as is found in rulers' portraits of the sixth century (chap. 7d). The compassionate eyes, turned toward us beneath heavy lids, enliven the regular features with human emotion. The modeling with colored glazes counterbalances the linear features, in a style close to that of the Pantheon icon, although the image type is different. The old Abgar image of Christ in the Vatican also offers some points of comparison, though it is obscured by many coats of brown varnish (chap. 11a).

8 & front of color gallery

15

The archetype of this icon had its home in Constantinople, in the church of the Virgin where the girdle relic was kept. There the Mother of God addressed her plea to an image of Christ that "answered." The dialogue between the two icons was reproduced repeatedly on Byzantine iconostases (chap. 12d). In Rome, however, there was only the one icon, which had to be taken to an icon representing Christ or which, by the very idea of the image, invited the beholder to reconstruct the second person of the dialogue in his or her own imagination. The precious embellishments of the beseeching hands make clear the healing power, just as they do in the icon at the Pantheon, in keeping with pre-Christian iconographic practice (chap. 3c).

We might wonder how an icon of such rank could have found its way into so humble a domicile, and we might ask why, about 1100 (earlier than any other icon of the Virgin in Rome), it was referred to as an image painted by St. Luke. A text giving the oldest version of the legend reveals that the pope also questioned the location of the old image and sought to acquire it (text 31). The legend tells us that the image resisted the pope, confirming the right of the poor nuns of S. Maria in Tempuli to own it and obliging Pope Sergius to atone publicly before it, whereby its fame as embodying the Mother of the Romans was consolidated.

A fourteenth-century guidebook to Rome describes the icon in its new location as an image painted by St. Luke "that was once violently seized by a pope and taken

to the Sancta Sanctorum on the grounds that the Mother should be with her Son, whose icon is kept there. But the next morning the image returned at dawn amid a shining light to the [place where] the nuns venerate it, and this same image changes color during Holy Week, becoming quite pale on Good Friday" (text 35, 6).

Resistance to the greed of the curia, which sought to hoard all the sacred relics of the city in the Lateran, is one of the legend's arguments; the other is the picture's Eastern origin, which prevented any claim of Roman institutions to own it from the very beginning. The legend was first passed down in a manuscript from the archive of S. Maria Maggiore, where there might have been fear, about 1100, that the image of the Virgin held by the church would likewise have to be ceded to the Lateran. It does not explain how the image came to Rome but makes much of the fact that at Christ's behest it was sought by three brothers who had emigrated from Constantinople to Rome and was taken under their protection.

The legend of the icon of S. Sisto develops three arguments, each of which moves the events outside the jurisdiction of the church authorities. There is first, the image that speaks or, in opposing the pope, acts by itself and thus proves to be invested with power from heaven, against which no resistance is possible. There are, second, the three brothers who, though laymen, were invited to take possession of the icon by divine intervention. There are, third, the nuns of the Tempuli monastery who inherited the mysterious brothers from the Orient and, as the present owners of the icon, had probably the weakest possible position in the Roman church at the time. They needed the protection of the image, as they did not enjoy any support from local authorities. Images often opposed the power of institutions, which, in turn, tried to seize the images for themselves. In their capacity of becoming a tool of heavenly intervention, they served to invalidate the established order of society, as miracles usually win over any authority on earth. By performing miracles, images demonstrated a power that allowed no resistance.

The newly acquired fame of the icon of S. Sisto becomes manifest in the numerous replicas that circulated among other Roman monasteries, beginning about 1100. The case of S. Alessio, a monastery with occasionally a group of Eastern monks, is telling, since the church not only appropriated a replica of the icon but also became the burial place of St. Alexis, the "man of God" from the East, a very popular figure who in many ways played a social role similar to that of images. His legend may be interposed at this stage, as it introduces us to the same kind of arguments that characterize the legend of the icon.

The legend of Alexis, with its Eastern ideal of saintliness, was rewritten in Rome after the remains of the saint had been brought by Syrian monks to the monastery of St. Boniface on the Aventine Hill, shortly before the year 1000.[23] According to the Roman version, which was quickly disseminated throughout Europe and even became the theme of old French chansons, Alexis left his Roman family on his wedding night and went to Edessa, "where the cloth with the Lord's face [imago in sindone], not made by human hand, was kept." When he appeared as a beggar in the forecourt of the church of the Virgin, "the image standing there in honor of the Mother of God" drew the sacristan's attention to the "man of God on whom the divine spirit rests."

After escaping veneration as a saint by his flight, Alexis returned at last to Rome and lived unrecognized as a beggar in his parents' house until the hour of his death. Then heaven again gave utterance, when a resounding voice terrified the Romans with the demand: "Go and seek the man of God, that he may pray for Rome." When his identity was finally discovered, he was dead. Even the pope and the emperor honored the humble saint, whose face shone "like the countenance of an angel of God," and announced to the people that the man of God had now been found, after the whole city had searched for him.

The *homo Dei* was a man of the people who lived in the spirit of the Lord. Even the authorities bowed down to him once heaven had singled him out. He stood as much outside the hierarchy as the image in Edessa that spoke of him with the voice of God. Both the image and the man of God in their own way were invested with a grace and sanctity that needed no consecration or validation by the church hierarchy. It is perhaps for these very reasons, so important for the common people, that the legends both of Alexis and of the icon of the Madonna were popular about 1100 and even became the subject of wall paintings, which were not restricted to the original sites of their cults. In the basilica of S. Clemente, Alexis is the only saint other than the patron, St. Clement, to be honored by a picture cycle, which probably had a model in his burial church on the Aventine.[24]

The legend of the icon of S. Sisto became the subject of frescoes in a convent on the Campus Martius that in style are closely related to the murals in S. Clemente.[25] Situated near the entrance of S. Gregorio Nazianzeno, next to the church of the Virgin in the former convent, the paintings show the three brothers twice, with a half-figure of Christ in the sky above their heads. Christ is pointing down at Tempulus to give him the order to seek the Lucan icon of the Virgin (text 31). Although the icon is shown reversed, in order for it to be at the good (i.e., the right) side of Christ, within its painted frame it remains readily identifiable because of Mary's gold cuffs and the clasp on her breast.

The wall painting brings the icon, its owners, and the figurally depicted voice of God, which authorized the icon as an authentic St. Luke image, into a carefully calculated relationship. The picture is less concerned with the brothers, of whose holiness little is said, than with an image of grace sanctioned by divine privilege, which may be guarded by men of the people and by all to whom it is rightfully entrusted. The image represents a kind of authority unique to it that protects and honors its owner.

The argument advanced by the frescoes reveals its true significance by the fact that the two monastic churches on the Campus Martius possessed an old replica of the original,[26] the one in the church of the Virgin still occupying its original site, although today's church is no longer the original one, while the replica in the church of St. Gregory passed into other hands when the monastery was dissolved and ended up in the Cini Collection. It is in good condition and even has the old frame, on which the significant inscription appears: *Sancto Virgo Virginum* "Holy Virgin of the Virgins." The "virgins" can only be the nuns, who placed their trust in the icon no less than the nuns of the convent of Tempulus did in the original icon.

<div style="text-align: right">187</div>

<div style="text-align: right">188</div>

188. *Venice, Cini Collection; icon from S. Gregorio Nazianzeno, Rome, 12th century*

189. *Rome, S. Maria in Via Lata; replica of the Madonna of S. Sisto, 12th century*

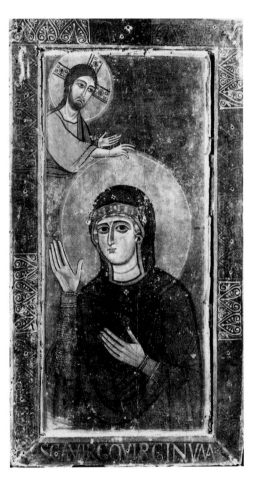

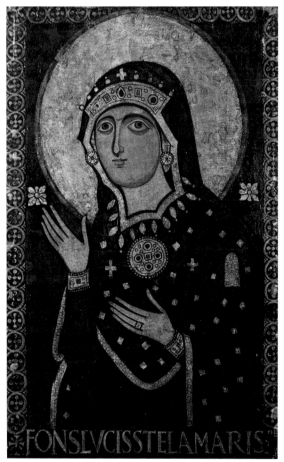

The replica also certifies the authenticity of the original from which it is copied. The small figure of Christ in the upper corner, which is lacking in the original, rather than being the recipient of Mary's plea, provides the divine verification of the genuine icon. The gesture with which Christ reaches past the edge of Mary's halo confirms her image as the Lucan icon he commanded the brothers to seek. It was therefore uniquely capable of the efficacious intercession from which those who commissioned the replicas also wanted to profit.

In both the convent on the Campus Martius and the abbey on the Aventine, the occupants had reason to fear for their precious possessions. The nuns of S. Maria in Campo Martio were able to defend the head of St. Gregory of Nazianzus up to the sixteenth century, before having to relinquish it to St. Peter's. The monks of S. Alessio were less successful but were able to negotiate an agreement in the thirteenth century whereby they kept the head of St. Alexis while ceding the rest of his remains to St. Peter's (text 35). Any careful replica of the icon was expected to acquire the protective powers of the original, which were the privilege of the original.

c. The Competition of the Madonnas

About 1200 only two Madonnas in Rome had undisputed claims to be portraits done
21 by St. Luke: the Madonna of S. Sisto and the temple image in S. Maria Maggiore. Replicas of these two originals therefore were acquired by the surrounding towns of the papal state for their August processions. On these occasions the images were carried to meet a replica of the Lateran panel, which was also attributed to the artist Luke (sec. d below).

V
190 The S. Sisto icon of the Advocate was undoubtedly the most famous image of the Virgin in Rome at that time. The old ornaments on her dress and hands also distinguished her from other icons. But she lacked a crown, which was bound to be thought a deficiency in Rome. A short metal diadem was therefore attached to the veil on her
191
189 forehead, which is shown in a sixteenth-century copy in the Vatican[27] and also, together with the original earrings, in the well-preserved medieval copy in the church of the Virgin in Via Lata (now the Via del Corso), which is inscribed with the words "Fountain of Light and Star of the Sea."[28]

Though unusual, the coronation of an icon was not limited to the Madonna of S. Sisto. Others followed the same course, above all the icon of S. Maria Maggiore,
194 as the replica in Viterbo shows, as well as a panel that, at the behest of a confraternity, was moved from the Sancta Sanctorum to Santissimo Nome di Maria on the Forum Traianum in the fifteenth century.[29] It too dates from about 1200 and reproduces the same type as a panel, signed by two painters, in S. Angelo in Pescheria.[30]

The story of the Madonna of S. Sisto that we are sketching here entered a new phase when the nuns adopted the Dominican rule and moved to the nearby convent of S. Sisto in 1221, St. Dominic accompanying them with the icon.[31] The latter became the pride of the rising mendicant order, but only a few decades later the Franciscans claimed a virtually identical icon to be the true icon painted by St. Luke. In the Aracoeli church on the Capitol, where they had been installed since 1250,[32] they had inherited one of the many medieval copies of the icon. It was the competition

320

190. *Rome, S. Maria del Rosario; Madonna of S. Sisto (prior to restoration)*

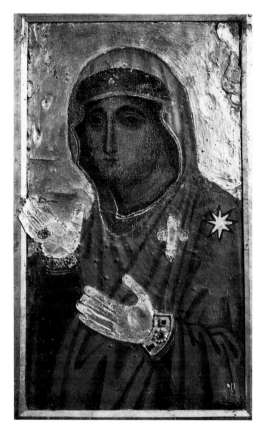

191. *Vatican, Capella Paolina; replica of the Madonna of S. Sisto, 16th century*

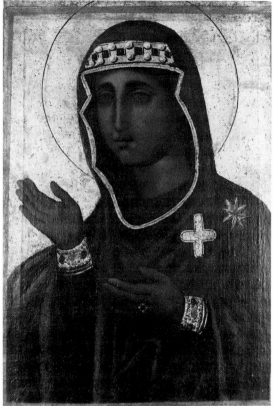

with the Dominicans that gave rise to rivalry as to who owned the genuine icon, a rivalry that persisted with increasing intensity up to the sixteenth century (cf. text 32); the rivals even resorted to falsifying the Golden Legend.

The special reasons for acquiring replicas can be explained only by the history of the churches that acquired them. Together with S. Alessio and the abbey on the Capitol, the convent on the Campus Martius was one of twenty monastic institutions in Rome included in an eleventh-century list.[33] At that time the convent admitted the daughters of the Roman patriciate[34] and, like S. Alessio on the Aventine, could claim to be an Eastern foundation.[35] Both convents owned famous relics and had reason to fear for their property. S. Ambrogio in Massima, which also had a replica,[36] and S. Silvestro in Capite, where there is a record of a replica in a wall painting,[37] also must have had a special interest in the miraculous image that had guarded the nuns of S. Sisto so effectively. However, other churches also acquired replicas whenever possible.[38]

One might wonder how the icon entered the imagination of the common people, who were looking for an efficacious "Mother of the Romans." By the twelfth century the icon was already so popular that it was quoted in the apse mosaic of the Coronation of the Virgin in the church of S. Maria in Trastevere.[39] It is not here, however, but on the Capitol that we must seek the meaning of the people's Madonna, which, in a replica of the icon, arrived at the abbey about 1100.[40] Here and in S. Alessio, where the "man of God" was venerated,[41] the icon was kept in a shrinelike tabernacle near the high altar. It was considered a privilege when Francesca Romana (1384–1440) was allowed to see the Aracoeli image within a ciborium consecrated in 1382, the marble parts of which today are kept in the Palazzo Venezia.

Before the image was placed in the ciborium, it evidently stood on the altar of Augustus consecrated by Anacletus II (1130–37) to commemorate the emperor's Christmas vision. This was not just a religious memory, for on the Capitol the Romans always invoked ancient traditions that gave them a history of their own apart from the papacy. Since the municipal government, later to become the senate, had secured rights of its own in the early twelfth century, the church on the Capitol was a focal point of interest. It was also a convenient place for assemblies of the people. In 1348 the Romans carried the icon to St. Peter's in thanksgiving for being saved from the plague and commissioned the famous staircase that one can still climb today.

The most important clue to the icon's role as Madonna and Advocate of the Romans is provided by the tribune Cola di Rienzo, who in 1347 had himself crowned in S. Maria Maggiore at the culmination of the August procession, the old feast of the people. In the church on the Capitoline Hill he laid down the metal staff and the olive crown as a symbol of humility before the icon of the Advocate to honor the Madonna as the true ruler of the people.[42] It may have been through such actions and not just the energy of the Franciscans that the copy soon began to eclipse the fame of the original.

By the mid-fifteenth century "the icon was venerated by a confraternity to which almost the entire Roman people belonged," as Fra Mariano reports (text 32). The

Romans had always carried the icon in the August procession, before the confraternity was abolished by the Franciscans. Fra Mariano's comments concerning the "weeping" image are supported by a guidebook to Rome that described painted tears on the picture (text 35). This may refer to a kind of oracular function that caused the Madonna to weep in times of emergency. At any rate, we also hear that her rival in S. Sisto went pale during the days of the Passion. At the time it obviously meant a great deal if an image manifested signs of life. But recollections of the Mater Dolorosa at the foot of the cross may also have aided the interpretation of the image.

The fame of the icon of Aracoeli grew to such proportions that in Prague, as a gift to German emperor Charles IV, an archaizing panel was commissioned that used a small parchment copy of this icon.[43] Quite remarkable as well is the Madonna of Leo the Great in Dublin. Antoniazzo Romano painted this panel for S. Maria Maggiore in 1490 as a modernized version of the icon of the Advocate (chap. 19d).[44] *269*

Finally, its Byzantine counterpart in Spoleto,[45] which has already been mentioned *149* (chap. 13f), must be given further consideration. As early as the thirteenth century it is unusual for a Greek import to be venerated as an icon painted by St. Luke. The image represents the Advocate icon type, though basically in a mirror image. Spoleto had belonged to the papal state since 1198, but the former duchy had long been a bone of contention between emperor and pope. For obvious reasons, the icon attributed to St. Luke was later declared in Spoleto to have been a penitential gift from Emperor Barbarossa. The document allegedly supporting this claim, from 1185, was lost before 1600. The image is of the type popular in Rome but, as a Greek original, could not be dismissed as a copy of a Roman model, even if one wished to do so. The metal case with the inscription of a Greek woman with the name of Irine is sufficient proof of its provenance. At that time, therefore, the image seemed to be more authentic than the Roman icons it resembles so closely. Its presence provided the town with a new prestige, as the "Mother of Spoleto" outshone the "Mother of Rome."

d. The Multiplication of an "Original" and the August Procession

A group of panels confined to the province of Latium forms an isolated phenomenon in Italy in the twelfth and thirteenth centuries. While their form has no parallels elsewhere, it replicates a model in Rome. The main type is represented in three triptychs, the oldest of which was acquired by the cathedral of Tivoli in the early twelfth cen- *192* tury.[46] The image of the life-size enthroned Christ closes over two wings, on which the Virgin, dressed entirely in purple, turns to her Son in the pose of the Advocate, while St. John the Evangelist confirms him to be the "Word" that was "in the beginning" (John 1:1). The wings of the triptychs in Trevignano and Viterbo show Peter *193* and Paul as guardians of the Roman church,[47] while a cherub between them guards the entrance to paradise with a fiery sword.

Full-length icons, a rarity in the high Middle Ages, in Latium reproduce the old "unpainted" miraculous image in the Lateran: as in the Tivoli copy, they also match *18* the original's height of about one and one-half meters. The desire to replicate this original is explained by its role in Rome's civic life, particularly in the August proces-

192. *Tivoli, cathedral; central panel of a triptych, 12th century*

193. *Trevignano (Latium), cathedral; triptych, ca. 1200*

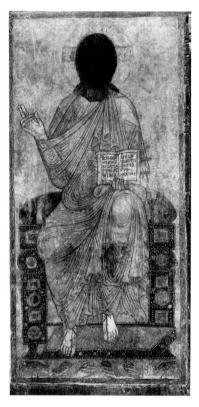

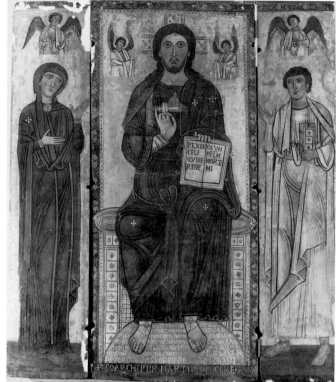

sion, in which the whole populace went with the Christ icon to S. Maria Maggiore on the night before the feast of the Assumption (text 4). For reasons to which we shall return, this institution was adopted by the episcopal towns of Latium.

Our information about this custom, although supported by late texts like that for Tivoli (text 4I), rests on the panels themselves. A relief icon in Castelchiodato even *192* alludes to the anointing of the icon during the procession.[48] At the Redeemer's feet the four rivers of paradise, from which stags drink, refer to the apse in the Lateran. The example in Tivoli was soon venerated as no less a St. Luke icon than the original in Rome.[49] The surviving examples were kept either in the episcopal church of the town or in the church of the Virgin, which was the goal of the procession. In Viterbo the triptych, which had been buried to save it from an invader, was dug up in 1283 and deposited in 1327 in a special chapel in the church of S. Maria Nova.[50] In Tivoli the image was kept in an underground chapel in the cathedral.

The surviving examples are concentrated along the Via Cassia in the direction of Viterbo, in Trevignano, Sutri, Capranica, Vetralla, and Viterbo. Some of them are mutilated or painted over, while others are not the first examples that were kept at the town. To gain a better understanding, we therefore must bring in the counterparts to the images of the Redeemer, which have so far attracted little attention. They are panels of the Madonna that also played a part in the August procession. The icon in Vetralla was given a depiction of Christ on the reverse about 1400, after the respec- *195* tive Christ panel had been lost.[51] Thus the two procession images shared one and the same panel. At Tivoli, where the panel from S. Maria Maggiore was taken to meet the Christ panel in the procession (text 4I), the surviving example is a modern facsimile that faithfully reproduces the thirteenth-century image.[52] But the model in turn cannot have been the original panel on the spot, since the corresponding Christ icon dates from the early twelfth century.

Given such inconsistencies and lacunae in the surviving material, we should reconsider the history of such panels and reconstruct what has been lost. In Vetralla, *195* where the Madonna panel survives alone, and in Viterbo, where it antedates by al- *194* most a century the Christ panel that exists today,[53] we can safely assume the existence of a lost Christ icon that was paired with the Madonna panel and shared its age. Thus, two images of the Virgin that may have been produced in the early twelfth century in the same Roman workshop are part of an important and early group of processional icons in Latium.

But more should be considered in this respect. The surviving panels at Vetralla and at Viterbo, though produced in the same scope, differ in the type of icon they reproduce. The one copied the original of the S. Sisto icon, and the other duplicated *V* the original icon from S. Maria Maggiore.[54] Thus, they give further proof of the par- *21* ticipation of both of the Roman original icons at the August procession. The S. Sisto icon, whose suppliant pose best suited the occasion, accompanied the Christ icon during the procession, and the icon from S. Maria Maggiore awaited the Christ panel at the culmination of the nightly procession. In Latium, however, one or the other Madonna panel was chosen to be paired with the Christ image.

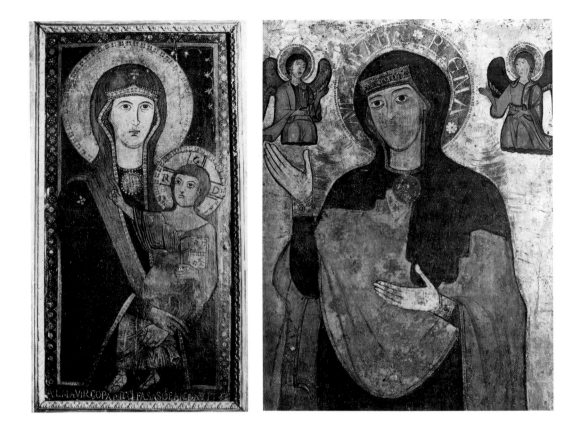

194. *Viterbo, S. Maria Nuova; Marian panel, early 12th century*

195. *Vetralla (Latium), cathedral; Marian panel, early 12th century*

The inscription on the Viterbo panel has an antiheretical thrust, for which there *194*
was occasion enough in the early twelfth century. It states: "The venerable Virgin
gives birth to him whom false Sophia has denied." The inscription on the Christ panel
at Trevignano strikes a new note, making the Redeemer refer to himself in the first *193*
person as "King of Heaven," who has "redeemed the people from death." The phrase
Rex caeli is specific enough to allude to the *Regina caeli*, as the icon in S. Maria
Maggiore then was called (chap. 4d). The wing pictures of St. Peter and St. Paul re-
inforce the Roman features of the group in their own way.[55]

Little thought has been given to the purpose or meaning of the August procession
in which the icons were carried. Images have interested historians less than written
sources, but in this case the images speak a much clearer language than texts, if only
because they have survived. It can hardly be doubted that the ceremonies they served
were part of the reorganization of the papal state in the age of church reform,[56] of
which Latium was the very center and most important province. Its bishops, who
were the strongest faction in the college of cardinals, had been trained in the curia
and were often recalled to it. The monarchical government of the church in Latium
was firmly based on the local cathedral chapters, which had the right to elect bishops.
It is therefore significant that the Christ panel in Trevignano was donated by an arch-
priest called Martinus, who must have been a member of the local cathedral chapter.
In the election of the bishop, the people had only the right of acclamation and thus
had to be contented with the metaphor of a marriage to the church. Another symbolic
act was the popular procession in August. In the inscription in his open book on the
panel at Trevignano, Christ thus speaks of the *populus* that he has redeemed. The
papal presence in Latium was demonstrated more and more frequently by summer
residences of the curia and by synods and judicial sessions attended by the pope. The
August procession exported a Roman institution in order to build up the church of
Rome at the other centers of the papal state. Thus the original that was duplicated in
the images was ultimately the church of Rome itself. The replicas served to demon-
strate the unity of church and people within the framework of a practice originating
in Rome. The church rulers handed over their images to the people in the August
procession to give them an opportunity to play an active part. The people were given
the impression that they were meeting directly with the heavenly persons, to whom
they could express all their communal wishes.

The apse mosaic in S. Maria in Trastevere sums up the role of icons in the civic *196*
life of Rome in a striking way. Its real theme is the feast of the Assumption, the annual
climax of the town's communal life. The two icons that met on this occasion have
given their features to the pair of figures represented in the mosaic. Christ is enthroned
here in the same way as in the Lateran panel, and Mary performs with the gesture of *18*
the S. Sisto icon, which accompanied the Christ image in the procession. The Ma- *190*
donna, understood as the Bride of Christ, symbolized the church of Rome; under-
stood as the Advocate, however, the Madonna symbolized the people of Rome and
their interests. In this role, she once had even opposed the pope when he was ready to
seize her image for his residence. The apse mosaic, to sum up its twofold meaning, as
much represents a couple that meets in heaven as it stages a pair of icons that embod-

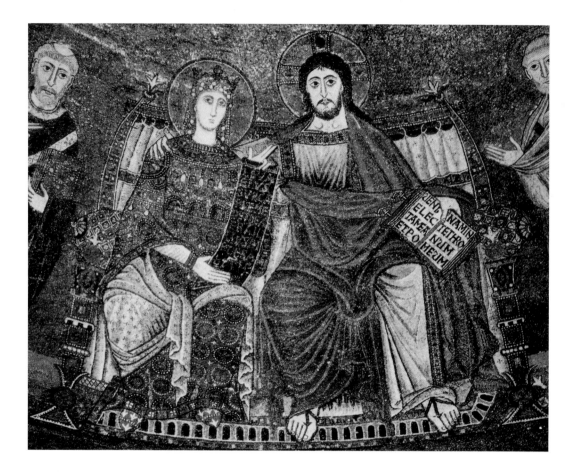

ied the roles of the pope and the people of Rome on the public stage of the August procession.

Even small convents sought to acquire exact replicas of the S. Sisto original, which at the time was in the hands of the nuns of S. Maria in Tempuli. The convent on the Campus Martius at once acquired two replicas, one for each of its churches, *188* and had the legend about the icon prominently perpetuated in wall paintings. But if *187* the legend was to be believed, the original had at first been placed under the protection not of nuns but of three laymen. It may have been for such reasons that the church on the Aventine—where Alexis, the "man of God" and favorite of the people, lay buried—obtained a replica. Finally, on the Capitoline Hill, a further replica found itself caught up in the new communal movement. By putting all these facets together, we gain an outline of the role of icons in the civic life of Rome.

16. "In the Greek Manner": Imported Icons in the West

a. The Eastern Origin: Idea and Reality

Bishop Altman of Passau (d. 1091), his biographer tells us, received as a gift from the dukes of Bohemia "a precious panel with an excellent metal case [*caelatura*], on which the Virgin was depicted in the Greek manner [*graeco opere*]."[1] Such imported icons came to the West at all times, but their influence on panel painting culminated in the thirteenth century, above all in Italy. The importation also persisted afterward, but by then imported icons had long come to be regarded as venerable originals from ancient times, with legends surrounding them. Replicas, whose archaisms distinguish them from other artworks produced at the time, addressed religious desires for the authentic image, not the criteria of contemporary art.

Pre-thirteenth-century imported icons are more commonly to be recognized in their reflections in quite different artistic media. The seal of the convent at Schwarzrheindorf in 1172, for example, shows a Tender Virgin with Child, which, complete with Greek lettering, clearly reveals contact with an Eastern icon, perhaps one seen in Cologne.[2] Such echoes of icons are not uncommon. They are found in manuscript painting[3] as well as in wall painting[4] and stone reliefs.[5]

A twelfth-century pattern book from the Upper Rhine contains a list of seventy-five drawings that mentions full-length *Maiestas* depictions and half-length pictures (*dimidia figura*) of the Virgin and other saints according to the pattern of icons.[6] The laconic reference to a "Theodore on horseback with another saint" does not make clear that it alludes to an icon of two mounted saints that was common at the time of the Crusades. But the drawing, which in this case has survived, leaves no doubt.

If imported icons still exist, they usually have suffered from heavy use and often have had more of an impact through the legends attached to them. The legends, however, seldom tell us the historical truth about the icons' origins, since they generally claim a provenance from the East. A happy exception is the small icon of St. Nicholas in Aachen-Burtscheid, which was given a Gothic metal frame in the thirteenth century. Already at this early time, the legends deal with its origin in the East and celebrate the miracles it had worked in the West.[7] The Gothic inscription on the frame says that "the ycona of Nicholas shines in the glory of the saint's virtues." In his book of miracles written in 1223, the Cistercian Caesarius of Heisterbach tells of the miracles performed by the icon, particularly for women in labor. It had been brought to Aachen by the son of a Greek king, he wrote, and "the miraculous portrait is said to have been painted from life."

The icon itself, "restored" to the point of unrecognizability, was probably valued primarily for its mosaic technique, which was unfamiliar in the West from panel images. The value attached to technical or technological rarities increased further in the Renaissance, when the icon no longer was considered to have anything to teach in the artistic sense. A Greek icon of Christ in Florence is mentioned in the first Medici

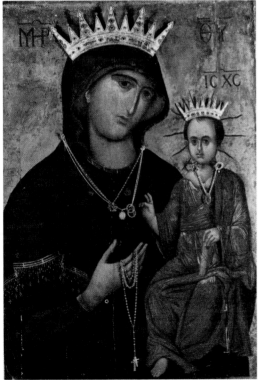

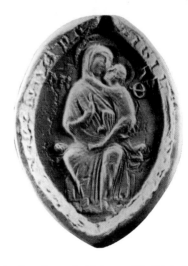

197. *Aachen-Burtscheid; icon of St. Nicholas, 12th and 13th centuries*

198. *Rome, S. Prassede; enamel icon from Constantinople, 12th century*

199. *Venice, SS. Giovanni e Paolo; Madonna della Pace, 14th century*

200. *Düsseldorf, Central State Archives; seal from Schwarzrheindorf for the year 1172*

catalogs as a precious object because of its mosaic technique.[8] In 1475 Pope Sixtus IV presented the mosaic icon preserved in Chimay to Philippe de Croy, the Burgundian envoy.[9] Enameled icons also enjoyed prestige, as can be seen from examples in Maastricht and in S. Prassede in Rome.[10] The Christ panel in Rome, as the inscription in the enamel frame tells us, once depicted Christ as Benefactor (*Euergetēs*), to whom a famous monastery in Constantinople was dedicated.

Imported icons were often prized for their technical extravagance or their costly materials of mosaic, enamel, silver, and steatite. It was not until the thirteenth century that painted icons played an important part in the development of Western panel painting. The icons that inspired this development did not need to be famous ones but often became famous only in the Renaissance, when panel painting was a commonplace affair and the imported icons no longer embodied an artistic ideal but represented a religious tradition that faced the threat of extinction.

The fascination of the icons' origin in the East can no longer be traced back to a given time, but the belief in archetypes that had come from the land of the Bible via Byzantium was universally held by the thirteenth century,[11] as we learn from a sermon by Fra Giordano in Florence (chap. 14e). The body relics were joined by images with an authentic Eastern archetype, whose claim for verisimilitude had to be met by the replica painters. The image painted by St. Luke challenged painters to emulate their apostolic colleague. The Greek icon, thus defined as an ideal attained by only a few originals in the West, took on a multitude of functions, which will be outlined in the following pages.

The imported icon was more important as an *idea* than as a *fact*. The idea could be attached indiscriminately to Western products, whose prestige rose with their alleged provenance. Nevertheless, a considerable number of icons were actually imported. This issue will be discussed first, and we shall try to give a fair account of the miraculous or disreputable circumstances in which icons were acquired. Icons sealed state agreements, were valuable spoils of war, and assigned prestige to the foundation of monasteries. Wherever an Eastern icon—usually reputed to be of great age—made its appearance, it inaugurated a cult in the same way a relic did, bringing fame and wealth to the place or owner. The pattern was always the same. First of all the provenance was important, then the manner of acquisition, which gave credence to the claim of origin. A princely or royal donor could guarantee even the most unbelievable provenance. Legends about the icon's origin and miracles then sprang up, becoming ever more audacious and not hesitating to use forged documents. When entire treatises were devoted to the images, during the Renaissance and the Counter-Reformation, the interweaving of truth and invention often became quite impenetrable.

According to a good tradition, the official icon of Mary, patron of Venice, was seized from the Byzantine general's chariot during the siege of Constantinople (chap. 10d). By its name, *Nicopeia*, the original in S. Marco still recalls the Virgin's Byzantine role as army leader and bringer of victories. At state festivities and pilgrimages in Venice the icon embodied the true sovereign, reigning over and above the republican state. Similarly, the ownership of the original of the *Hodegetria* produced

an open conflict that was fought out in the streets of Constantinople in 1204 be-
tween two Venetian parties representing the state and the church (chap. 4d). Miracle-
working icons were readily used as pledges for the sealing of state agreements, as we
learn from an image of Christ that was given by the Byzantine emperor to the captain *III*
of the Genoese on the Bosporus, Lionardo Montaldo, who in turn donated it to a
church in Genoa in 1384 (chap. 11a). It is, in fact, one of the few old replicas of the
original of the cloth image, and it bears its own history like a seal of authenticity in
the illustrations on its fourteenth-century metal mounting.

Other icons reached their new owners in less spectacular fashion. The so-called
Madonna della Pace in Venice was a recent work when it was acquired by the Vene- 199
tian Paolo Morosini in Constantinople in 1349.[12] In the dignity of the Christ Child
and the treatment of the face, it is close to a Mount Sinai icon that we know to have
been designed by the painter Manuel of Constantinople. Despite the overpainting, it
still clearly has the character of an Eastern product. It achieved high honor in Venice
once it was taken over by the Dominicans of SS. Giovanni e Paolo.

When an icon passed from private to church ownership, it often acquired the
historical legends that would make it suitable as a public cult image. The icon of the *149*
Virgin in the cathedral of Spoleto, a Byzantine masterpiece from about 1100, had
had two private owners before it found public honor in the cathedral at Spoleto
(chap. 15d). On the metal frame a Greek woman from southern Italy redirects toward
herself the original painted petition of the Madonna, concealed by the new mounting.
This person's private inscription, however, did not prevent the bishop of Spoleto from
considering the icon as a penitential gift from Emperor Barbarossa to Spoleto.

A similar panel of the Virgin had already passed through many hands before
Bishop Nicodemus Della Scala donated it to his cathedral in Freising in 1440.[13] Its
first state can be seen only by X-ray, which reveals an unusual work from about 1100. 201
In a second phase in Constantinople shortly before 1235, a prelate named Manuel
gave it a metal mounting on which is inscribed the poetic title "Hope of the Hopeless"
(*Elpis tōn Apelpismenōn*). Within this new metal frame, finally, it was completely
repainted in the early fourteenth century, before coming by a roundabout way into
the possession of the Della Scala family, perhaps as a gift from the Byzantine emperor.
Nicodemus Della Scala, bishop of Freising from 1421, donated the icon to the new
large shrine-altar by Jakob Kaschauer, on which it was displayed on the four feasts
of the Virgin each year. Naturally, in the meantime it had also become an original
painted by St. Luke.

b. The Imperial Court in Prague and Its Icons
New rulers could bolster their authority by donating miraculous icons from the East,
the cult of which included loyalty to the donor. In 1382, with Pauline hermits from
Hungary, a prince from the house of Jagiellon founded the monastery of Jasna Góra
in Poland, where prayers were said for the continuation of the dynasty. The monas-
tery's prestige was enhanced by the gift of the icon of Czestochowa.[14] Whether it is in
fact an Italian or an Eastern work is of secondary importance, for only the official
legend mattered in this context. The Madonna of Brno might, if cleaned, turn out to

201. *Freising, Cathedral Museum; X-ray photograph of a Marian icon in its original state, ca. 1100*

202. *Aachen, cathedral treasury; votive icon of Louis d'Anjou, king of Hungary, 14th and 19th centuries*

203. *Cleveland, Museum of Art; St. Luke Icon from Aachen, Byzantine, 12th and 14th centuries*

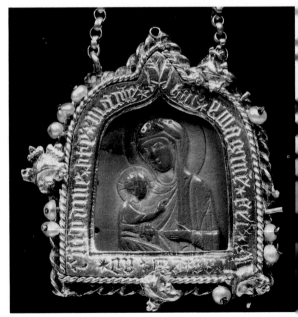

be an Eastern imported image.[15] It was part of the program by which the House of Luxembourg established itself as ruler of Bohemia and Moravia. In 1356 Emperor Charles IV bequeathed it to the order of Augustinian hermits newly founded by his own brother, Margrave John Henry. The founder's son had the image of the "Black Madonna" of Brno mounted in gold and silver.

In Prague, where interests transcended local matters, the emperor introduced a public cult on a grand scale dedicated to the sacred imperial treasures.[16] These were put in place at Burg Karlstein, where relics ranked higher than images. Devotional images were imported from Italy, but local panel painting nevertheless scored a major triumph when the walls of the Chapel of the Holy Cross were covered with an unbroken series of panel images that represented the saints of the local calendar and even included a body relic.[17] The assembly of saints forms a kind of heavenly council, expressed in the metaphor of the shining walls of the heavenly Jerusalem. The individual saints are embodied in icons, joined together as in an iconostasis. In the foundation's charter (1357), the cross of Christ is indeed recognized as the center of worship, but the same text speaks of the longing for Christ's face, "which not only all humankind" but also the angels desire to see.[18]

Imported icons may have received public veneration in Prague. Replicas of the Madonna of S. Sisto (chap. 15c) and of the Roman Veronica in Prague cathedral[19] confirm the high status that the cult of icons enjoyed at the imperial residence. But evidence of a personal cult of icons rests on a small Byzantine steatite icon from the twelfth century in the museum at Cleveland that Emperor Charles IV once donated to Aachen cathedral.[20] Napoleon even played a part in this icon's complex travels, as the small image was handed over, probably not quite voluntarily, to Empress Josephine in 1804.

In the Middle Ages the same icon served in the mise-en-scène of a state cult, embodied at that time in the person of Charlemagne. It is not known how or when the Byzantine icon arrived at Aachen. In the fourteenth century it was believed to have hung around the neck of Charlemagne's corpse when his tomb was opened in 1165. Charles IV had the small image mounted in silver and, in all likelihood, ordered it to hang from the new relic bust of Charlemagne like a talisman. On the mounting we read: "This image was painted by the holy evangelist Luke in the likeness [*similitudinem*] of the Blessed Virgin Mary." St. Luke's bull on the reverse gives further weight to the attribution.

The imperial cult of images seems to have inspired the gift of icons made in 1367 by Louis of Anjou, king of Hungary and Poland, to the Hungarian chapel in Aachen minster, which he had built.[21] The icons are votive panels with mountings, which follow the Eastern pattern of the "embellished icon" by including a painted figure within a costly metal case (chap. 12d). Although they were thoroughly painted over about 1870, they still clearly indicate that, in the type of image, they followed the small icon allegedly made by St. Luke.

Within the milieu of the imperial court in Bohemia, an unusual piece of evidence throws light on the mechanisms by which a famous icon imported from the East was multiplied. This is an icon in Březnice that, according to an inscription on the back,

203

202

203

204

was commissioned by King Wenceslaus in 1396.[22] The royal commission required, the text states, "a replica [*similitudinem*] of the image in Rudnycz [Roudnice]," which, it also says, "St. Luke painted by his own hand." So far this is a familiar situation. The king has a Lucan icon copied, with the intention of transferring the power of the original to a new place by means of an exact copy. The surviving panel, itself a copy of the copy of 1396, served a purpose that was commonplace in such cases.

But the image has a surprising discovery to offer, as its type proves that the model at Roudnice must indeed have been an imported icon. The Virgin's dark skin, indicating an Eastern workshop, by an inscription alluding to the Song of Songs is explained as a biblical metaphor for Mary's beauty: "I am black, but comely, O daughters of Jerusalem" (Song of Sol. 1:5). A cloth with a strikingly bright pattern, which overlaps the veil of the Virgin, and the richly embroidered garment of the reclining child both point to an icon from Crusader circles in Cyprus, which reached the Mount Sinai monastery in a contemporary replica.[23] Apart from a small variation of gesture, the Mount Sinai icon is virtually a mirror image of the Bohemian panel, which, therefore, must have been produced via mechanical copying or tracing.

205

The discovery that King Wenceslaus had a copy made of an icon from the crusader milieu is interesting enough. But it is possible to go one step further and to trace the genealogy of this particular icon even beyond the time of the Crusades. In icon painting, changes from one image to the succeeding one take place gradually, step by step, so that the features of an ancestor image are never lost altogether in the following one. The erstwhile Bohemian imported image and the Mount Sinai panel were both replicas of a common model, which was painted for a Crusader site in Cyprus in the thirteenth century. The almost modish dress and the decorative taste reveal the common model to be the work of a Western artist who had assimilated the syntax of Eastern icon painting in his own way. The Child alludes to Christ's sleep in death

176 (*anapesōn*), a well-known motif of Cypriot icon painting in the twelfth century.[24] The Mother reproduces the most famous icon that was to be found in Cyprus, as the

174 strangely displaced headcloth distinguishes the icon of Kykkos, which came from Constantinople and was reputed to have been painted by St. Luke (chap. 13f).[25]

In this way the fantastic claim of a genealogy of the Bohemian panel from a work by St. Luke actually goes back to an archetype from Constantinople that was taken to Cyprus in the twelfth century and that generated a number of local variants in the thirteenth. Among the latter, a version by a Western painter attained fame for reasons unknown today. The surviving replicas at Mount Sinai and in Bohemia faithfully reproduce this third stage of the image's development. The many cult sites in Cyprus had previously favored a number of subtle changes, which invested each variant with a kind of local identity. Thereafter, this development was suspended and the formulation reached by the icon ready to be exported was protected by a kind of copyright. This account well illustrates the various effects of the external history of an image on its formal development, either encouraging or discouraging changes. With its royal patronage, the Bohemian replica now exerted only the fascination of an authentic archetype in which nothing was to be changed.

336

The resistance to change that canonized a given icon at first was a Western atti-
tude that reflected the distance of imported icons from their place of origin. Where
the original meaning of icon types was unfamiliar, any arbitrary variant could take
on the authority of a binding original. Thus a different variant of the Virgin of Kykkos
generated a faithful Apulian replica that is now in the Palazzo Venezia in Rome.[26] It
represents an early stage in the evolution of the individual Cypriot variants.

The relation of East and West in our case is thus more complex than it might
appear at first. In the West, only icons with an awe-inspiring origin were respected as
canonical, while icons produced in the West were not subject to such restrictions.
Different approaches were adopted, therefore, depending on whether the painter was
reproducing a particular "original" from the East or was free of such obligations.
Only in the former case were the gestures and postures schematically prescribed. This
procedure seems primarily to have been designed to transfer the aura of Eastern mod-
els to exact replicas. It expresses the distanced perspective the painters had of the
works of a different culture. In the East, by contrast, painters delighted in playing
with the spectrum of thematic associations accessible to everyone, which shifted from
work to work (chap. 13f), and they enjoyed a limited freedom of formulation that
was all the more effective within these limits, at least in a time prior to the Turkish
conquest. Though this statement contradicts received notions, it is hardly possible to
draw a different conclusion from the historical material.

c. The Migration of Images to Italy

Most of the imported icons we know are linked to Italy. The *Sainte Face* in Laon, an
Eastern panel from the thirteenth century, was in Rome when the papal treasurer *131*
sent it to his sister in France "instead of the Veronica" (chap. 11c). Imported icons
piled up in Venice from the thirteenth century on, and they were still coming in from
the East in the seventeenth century when Crete fell into the hands of the Turks.[27] In
Apulia too a wide repertory of imported icons was used, but few of these Eastern
originals have survived. The same is true of Pisa, where painters successfully repro-
duced Eastern icons.[28] A small icon of St. Michael, however, the only surviving East-
ern work, has a Western motif in the weighing of souls.[29]

Eastern icons sometimes were commissioned for an Italian destination, as is the
case with an icon in St. Peter's in Rome.[30] Like an image within an image, it quotes 206
the two "original" portraits of the Princes of the Apostles and, in the lower zone,
introduces the Serbian patron, the queen mother Helen (d. 1314), from the house of
Anjou, a Roman Catholic. Helen's sons Dragutin and Milutin, without compromis-
ing her as regent, were given a secondary role, while Helen bows before St. Nicholas
of Bari, the namesake of the reigning pope. As a type of image, the panel is not really
an Eastern icon, but merely a product of Eastern painting that, as votive gift, took on
a Roman profile.

Sometimes there were reasons to disguise an Eastern provenance and to substi-
tute a Western legend that was to conceal it. The owner, in the end, decided which
origin was the right one. In Rome a small mosaic icon from the East was purported 207
to be the "Image of Gregory," which Gregory the Great in Rome had commissioned

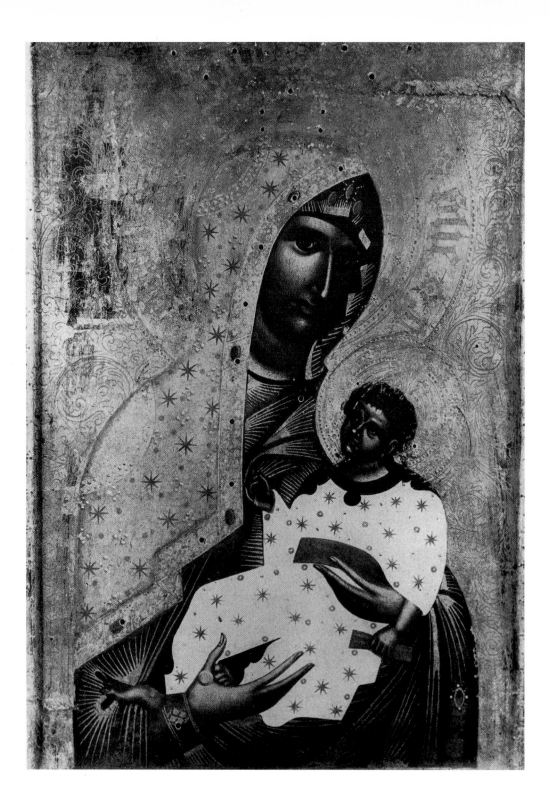

204. *Prague, National Gallery; icon from*
Březnice, 1396

205. *Mount Sinai, monastery of St.*
Catherine; Crusader icon from Cyprus,
13th century

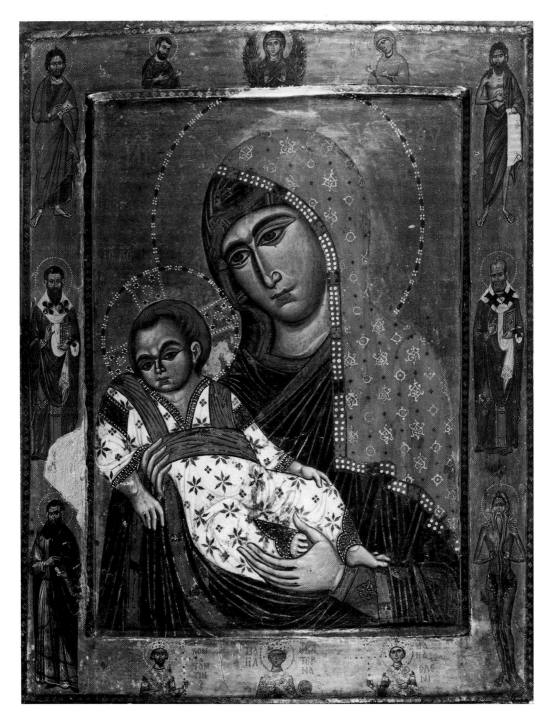

206. *Rome, St. Peter's; votive icon of the Serbian Queen Mother Helen, 13th century*

207. *Rome, S. Croce; mosaic icon from Mount Sinai, ca. 1300*

around the year 600 to commemorate the true appearance of Christ during the Passion, which was revealed to him in a vision.[31] The image in question, which in fact arrived only in 1380, was kept, appropriately, in S. Croce in Gerusalemme, where the pope celebrated Good Friday services. The military leader Raimondello Orsini del Balzo, whose coat of arms it bears, had discovered it in the Mount Sinai monastery, where the icon had been sent from Constantinople, the site of its production in about 1300. Raimondello, who claimed to have stolen the ring finger from the remains of St. Catherine, founded a hospital in Galatina on the south coast of Apulia, which he dedicated to St. Catherine. We do not know what induced him to part with the icon so soon. The legend of the Carthusians of S. Croce promptly annulled the prehistory of the image, which can be reconstructed only from archaeological and historical evidence.

The type of the image was well established in the West when the Eastern icon suddenly was introduced as the archetype. Lost images from the East that came to the notice of Italian painters at an early date had a far greater influence on the history of the types they dealt with. A rare exception is the small image of the Virgin in the VI Chiesa del Carmine in Siena, which has proved to be a Byzantine masterpiece from the mid-thirteenth century.[32] The fresh modeling, together with the transparent glazes, creates a lively play of light and shade on the dark flesh color. The Mother's intense feelings revealed by her features and the movement of her body are contrasted with the aloofness of the child, who, also by the colors of his clothes, keeps a unique aura of his own.

We seldom come across an imported image in such good condition, which makes us understand the impact it had on the people at the time. The fame of the image, however, rested more on its provenance, which was guaranteed by the hermits of the order of the Blessed Virgin of Mount Carmel. The Carmelites, who spread rapidly throughout Europe from the mid-thirteenth century on, earned their reputation from their origin in the Holy Land, where they had lived on the mountain of the prophet Elijah. Their prestige was transferred to the images they owned, which in turn had to be old enough to be able to confirm the age of the order.[33]

The full-length enthroned figure of the Madonna del Popolo in the Carmelite mother church in Florence is, however, a local work commissioned by the confraternity of the town and should not be confused with the imported icons that may also have existed there.[34] Nor was the icon at Siena the only image owned by the Carmelites. The Madonna dei Mantellini, a Pisan work about 1280, as the votive image of the local confraternity, held the second rank beside the Eastern icon, which may perhaps also have once been called a Madonna del Popolo and even inspired copies in Rome, where the church of S. Maria del Popolo acquired a replica.[35] 208

The close resemblance of the Roman panel to the imported icon in Siena is surprising enough to require an explanation, which still is wanting (chap. 15c). The resemblance is present in details like the deep blue garment of the Virgin, with its double braiding on the sleeve; the light blue, striped hairband; or the fringe on the hem of the veil at the shoulder. Even the curious seated posture of the Child with the gold-highlighted garment is repeated. In view of the exactitude of the copy, the de-

viations are all the more important. On one hand they concern artistic qualities, the flesh color being flatter, the Child's body more solid; on the other hand, the copyist has changed the Child's gesture. He now gently touches the ring-adorned hand of his Mother, which introduces affective qualities that the artist failed to convey by the faces.

d. Icons by St. Luke in the Historical Legends of the Renaissance

208 Surprisingly, the replica in Rome attained greater prestige than its model in Siena when it was considered to be an image painted by St. Luke. This identification may well be explained by the interest of the Della Rovere family in rebuilding the titular church of the cardinal. In 1478, as pope, Sixtus IV confirmed the Virgin's image in S. Maria del Popolo as an authentic image by St. Luke and encouraged gifts for the rebuilding by offering indulgences. Alexander Sforza, ruler of Pesaro and papal general, had already had the icon copied by Melozzo da Forli about 1470, with the following inscription added: "This was painted by the *divus Lucas* from life [*vivo*]. The panel is the authentic portrait [*propria effigies*]. Alexander Sforza commissioned it, Melozzo painted it. St. Luke would say it was his own work [*diceret esse suam*]." The copy in the monastery of Montefalco, then owned by the Augustinians of S. Maria del Popolo, adheres to an archaic ideal even in its technique, an almost transparent, fluid tempera painting. Among the further replicas, those by Pinturicchio hold the first rank.[36]

21 Alexander Sforza was also interested in a second image by St. Luke in Rome, for he commissioned Antoniazzo Romano to copy the old icon in S. Maria Maggiore and to add this inscription: "In Rome there is the very holy image of the Virgin, once painted by St. Luke. Who would dare to question the authenticity of St. Luke's own work? I, the Roman painter Antoniazzo, have followed it in [my picture] [*ab illa duxi*], and Alexander Sforza has paid for the work."[37] The fame of the painter, which was now becoming an important factor, complements the continuing fame of the original, which guaranteed that the painting was no mere invention. From now on, a double justification credits the painter with a kind of modern interpretation of the ancient, faded original, while crediting the latter with the truth contained in the copy, just as the living model guarantees the truth of a portrait.

Along with replicas that changed in appearance in the hands of the Renaissance painters, the legends about the originals also changed in their argument. At a time when people were beginning to think in historical terms and no longer blindly accepted the old traditions, they expected the old images to offer credible evidence of their age and provenance that would withstand the doubts of the educated.

In Rome the Greek émigré Bessarion, who had become a Roman cardinal, commissioned Antoniazzo to make reproductions of icons by St. Luke, or images that were purported to be so.[38] Constantinople, which had fallen into the hands of the Turks (1453), offered a convincing provenance of images that also could be mobilized for a crusade. This probably explains why in 1482 Clemente of Toscanella declared an icon he gave to S. Agostino in Rome to have come from Hagia Sophia in Constantinople.[39] The surviving panel, however, dignified with the Roman iconic titles of a

Virgo virginum and a *Mater omnium,* is so heavily overpainted that the legend can no longer be tested for authenticity. In the Greek abbey of Grottaferrata near Rome, Bessarion supported a new cult for a thirteenth-century image of the Virgin by declaring it to be the work of St. Luke.[40]

In Padua two miraculous images by St. Luke challenged each other's status in the fifteenth century, although neither icon came from the East. The fourteenth-century image in the Cathedral has the Child as a crib figure in swaddling clothes. When it fell from the altar and was broken to pieces in 1641, it was reconstructed according to Giusto de' Menabuoi's copies. After Antonio Zabarella (d. 1441) had made rich endowments for its cult, its importance grew steadily. In a rich silver mounting of 1498 it appeared at processions of the cathedral chapter. The type of image, however, is clearly designed for a local nativity play and in this respect is in open contrast to Eastern images of the Virgin.[41]

This deficiency caused historians of the fifteenth century to comment on the unusual features, particularly as the Benedictines of the abbey of S. Giustina owned an accredited image by St. Luke in the old panel of the Madonna di Costantinopoli, which looked totally different.[42] Housed in the Prosdocimo chapel, it was directly connected to the cult of St. Luke at the abbey, where, it was claimed, the remains of the evangelist had been found in 1177. Greek monks were said to have rescued them from the church of the Apostles in Constantinople in the eighth century during the iconoclast controversy. It is difficult to decide whether the panel, today a ruin, was painted in Venice in the thirteenth century, or whether it had been imported and was touched up by a Venetian painter. In the era of the new cult of St. Luke that was flowering in the Renaissance, and at the site of his tomb, it was considered to be an original by his hand, which demonstrated his skill as a painter. Bishop Barozzi of Padua (1487–1507) thus reassured the monks of S. Giustina that they really had an icon by St. Luke in their possession. 209

But what, then, was to be said of the image in the cathedral, which in the fifteenth century was believed to be the work of the painter Giusto? The dissimilarity with the monks' icon was so obvious, and the attribution to a local painter so widespread, that the traditional association with St. Luke faced two serious problems. The solution offered by Michele Savanarola in his travel guide from the mid-fifteenth century is as simple as it is brilliant. Giusto, he said, wanted to paint a replica of the other image by St. Luke. "In so doing, it is said, he avoided similarity to a work painted by such sacred hands by using new motifs [*configurationibus*]."[43] The very deviation from the model offers the desired proof, being a sign of the artist's modesty before the apostolic painter. All the same, Michele continues, "I have seen both of them, and I cannot say that they are so dissimilar. The image by Giusto is likewise held in honor in our cathedral."

A famous icon in Bologna well illustrates the reasoning inherent in the fabrication of legends, since the respective legends developed over the centuries and, since, in this case, we can discern fact and fiction. The Madonna di S. Luca is the treasure of an enormous church complex on the Monte della Guardia, connected to the town by endless columned porticoes, through which the patron saint came to visit her town in 210

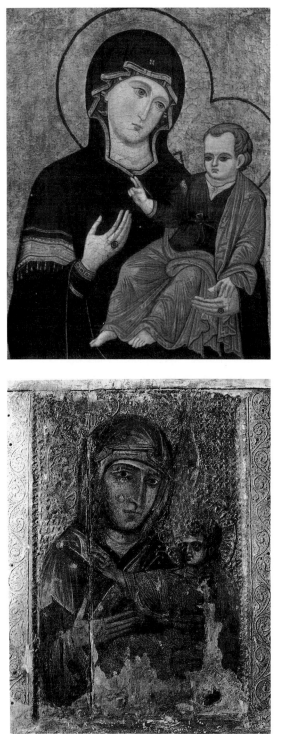

208. *Rome, S. Maria del Popolo; Madonna and Child, 13th century*

209. *Padua, S. Giustina; Madonna di Costantinopoli, Venetian, 13th century*

210. *Bologna, Monte della Guardi; St. Luke icon, 13th century*

feast-day processions.[44] The site was originally the abode of a community of women hermits, who had fought for recognition of their legal status since 1249. In 1253 they received gifts from the town "for the veneration of their Virgin." This clearly refers to the surviving icon, which cannot be significantly older. It has the character of an Eastern icon and is framed by a plaster relief that imitates a metal mounting. The vivid chiaroscuro and the gold hatching also seek to resemble Greek icon painting, but the style points to the painters of the baptistery at Parma, and the shape of the eyes has its closest parallels there. The panel was therefore probably commissioned by a patron of the hermits from a painter in the Emilia.

As events in Rome so clearly proved (chap. 15b), the independence of the powerless was an important stimulus for the local cult of an image that secured protection and prestige for its owner. On the hill near Bologna the dispute over the legal status of the small convent actually had gone on since 1192. At that time a woman named Angelica had placed it under the government of the canons of S. Maria de Reno but had also claimed a personal lay patronage. Even the pope was brought in to resolve the dispute. When a new community was formed in 1249, it responded to the continuing legal dispute by introducing the miraculous icon, which from now on was to represent the case of the women hermits.

The legends took a new turn and argued that the icon had come from Constantinople when, in the fifteenth century, the icon had become the official image of the community at Bologna. In 1433, after a period of persistent rain, the bishop and council decided to carry the icon into the town in procession and beg Mary's intercession. Bologna wanted to emulate Florence, which in such circumstances called on the icon of Impruneta either to make rain or to protect itself from rain.[45] When the efforts to change the weather in Bologna proved successful, the procession was made an annual institution in 1476. The attribution of the icon to St. Luke, already mentioned by Grazioso Accarisi in 1459, went hand in hand with the rebuilding of the church. The legend now has a pilgrim at Hagia Sophia in Constantinople discovering an icon of the Virgin whose inscription stated that she wished one day to go to the hill at Bologna. Even documents were now forged and deposited in the relevant archives. The most important of them, with the faked date of 8 May 1160, records the alleged donation of an icon by the hand of Luke to the women hermits Azolina and Beatrice. The icon, says the text, was "brought from Constantinople by a Greek hermit named Theoclys Kmnia, to be kept at the hermitage on the Monte della Guardia."[46] The age of the icon and its Eastern origin had become important only with the new role as city icon in the Renaissance.

It was a different situation again, when the town of Fermo in the Marche, near the coast of the Adriatic, inaugurated a local cult of an icon by St. Luke. About 1470 a citizen named Petrus, who was of Albanian origin, set up a public cult of an icon that attracted people from far and wide but benefited only the icon's owner. Thereupon Giacomo delle Marche (1391–1476) in 1473 offered "an icon [conam] with the figure of the Virgin painted by St. Luke and being worthy of cult," on the condition that the town should substitute it for the other icon and should establish a solemn procession.[47] The town, whose interests had suffered from the illegal promotion of a

private icon, took the new icon, which was believed to be a true original, into posses-
sion all the more readily, as the donor Giacomo, a pupil of St. Bernardino, had earned
fame as a preacher in the Crusades and had often traveled to the East. When he left
the icon at Fermo, he was on his way to the court of Naples, where he died soon
thereafter.

VII The icon in the cathedral of Fermo, which was the object of the transaction, poses
one of the greatest riddles in the history of icon painting. The metal frame with Greek
feast images and inscriptions persuaded a scholar of the standing of André Grabar to
consider it an import from the East.[48] Scholars of Italian painting, not taking the
frame into consideration, believe the panel to be a regional work.[49] Its style, particu-
larly the linear stylization of the features, suggests that it was produced in the late
thirteenth century on the Italian Adriatic coast. Like the gold hatching on the purple
garment, however, the opaque layer of paint over green underpainting points to East-
ern icons, which also provided the concept of the image. But how did the Italian
image come by its Eastern metal frame? The problem is further complicated by a
Greek inscription running around the frame. Either it was distorted during restora-
tion in 1818 or it was a Renaissance forgery from the start, for unlike other Greek
titles on image frames, it is meaningless.

But the greatest mystery surrounds the image type itself, which represents the
Virgin without the Child in a shoulder-length portrait with her hands crossed on her
breast. It was interpreted early on as a Virgin of the Annunciation, as indicated by a
Gothic reliquary attached at the lower edge of the picture and inscribed *Annuntiatio*.
St. Giacomo therefore handed over the icon in the convent of Maria Annunziata. The
cult of the Virgin who conceived had started in Florence with the miraculous image
in the Servites' church, which was said to have been completed by an angel.[50] An
iconic figure representing Mary's conception without narrating the Annunciation
seems to have been evolved on the basis of an Eastern type that had actually been
created for a different purpose[51] and had shown the Mother lamenting her dead
Son.[52] The panel at Fermo repeats such a model but already shifts its meaning and
indicates the new subject by means of the peaceful expression of the young Mother.

There is every reason to believe that Antonello da Messina was aware of this icon
when he painted his famous pictures of the *Annunziata*.[53] He may have seen it in
Naples, where St. Giacomo often stayed, or on the way to Venice soon after it had
211 attained public honor in Fermo. In the version in Munich the young woman is di-
rected inward, where she has received God's Word, protecting the fetus under her
closed mantle with crossed hands. The open prayer book makes symbolically visible
the Word of God, which at this moment is growing secretly toward visibility in Mary's
womb. The artist thus links the problem of visibility with a new conception of the
image, which he defines in a radically new way. Against the dark background the
image looks like one of the portraits at which Antonello excelled. The psychological
depths of Mary's expression and gestures are close to the qualities of a portrait. Yet
Antonello transcends the ordinary portrait by the implied narrative of the Virgin's
pregnancy. When the divine epiphany is being prepared in the mortal woman, the
prototype, which alone demands veneration, is invisibly present in the visible image.

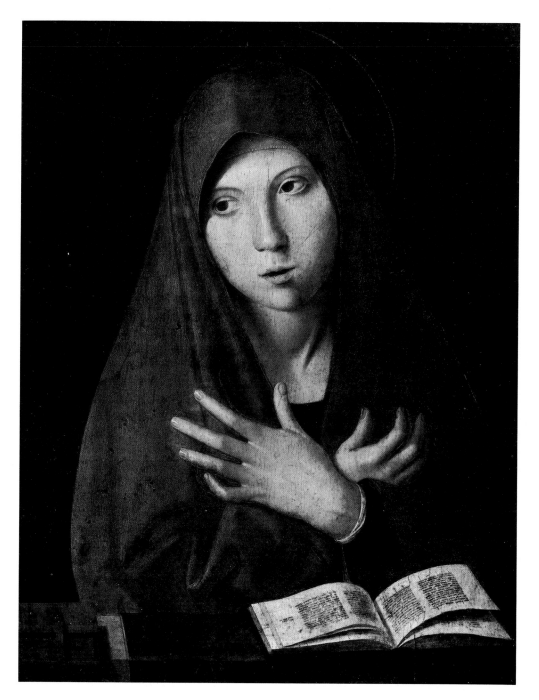

211. *Munich, Alte Pinakothek; Antonello
da Messina,* Maria Annunziata, *ca. 1475*

Antonello understood well the meaning of the old icon and in his modern icon reinforced the antithesis of the visible and the invisible, of the image and its prototype, as a visual paradox.

The long history of imported icons in the West, which reaches from the twelfth century to the Renaissance, cannot be summed up in a simple formula. Nevertheless, certain patterns stand out that continued to play a role in the public use of icons from the East, whose fame rested on their age and on their capacity to perform miracles or on their miraculous origin. Their role usually is linked to a given institution that introduced or appropriated them in order to gain prestige or to renew legal claims. Replicas were commissioned, which in turn drew attention to the fame of the original icon. Special occasions were devised when the icons could "appear" in public. The respective owners took care to link the icons closely to their own needs of self-representation.

The impact of such icons on panel painting in the West differed according to the various stages of development reached by Western panel painting. Three examples *204* will illustrate this point. The Bohemian panel in Roudnice reproduced its model, which came from a Crusader milieu in the East, in a mechanical way. Strangely enough, the interest in a true facsimile then was stronger in the West, where the sub-*208* tleties of Eastern types and their variants were unfamiliar. The image in S. Maria del *VI* Popolo in Rome "translates," as it were, its Eastern model from Siena, bringing it into *211, VII* the idiom of local Roman style. Finally, Antonello's panel of the pregnant Virgin recreates the model from Fermo in a radically modern conception of the image.

Looking back on the examples we have studied, we realize that the idea of an icon from the East was more important than the fact of having an authentic panel in each case, and even encouraged the use of local replacements when originals were not available. The high value placed on imported icons continued up to and beyond the Renaissance. Most of the legends about icons that are known to us today actually date only from the Renaissance period. With the growing distance of their age and their aesthetic difference, the archetypes generated a new interest, which, in the end, conferred a kind of divine sanction on the making of all images, whatever their aesthetic creed was to be.

17. Norm and Freedom: Italian Icons in the Age of the Tuscan Cities

a. East and West in Comparison: What Is an Image?

The facts have been described many times, but their meaning still remains open to question. The painting of panel crosses, altarpieces, and devotional images emerged in Italy in the thirteenth century with the violence of an explosion, expanding in wider and wider circles. Latium, with its center Rome, to be sure had been an old enclave of the icon (chap. 15), and Venice also looked back at a long tradition in this respect (chap. 10d). Now Tuscany with its expanding towns was at the forefront of the movement. There, all the new types of altarpiece that were to be influential from now on had their origin, from the multifigured polyptych to the retable with a saint and the *pala* with the Virgin,[1] while in Venice, in contrast, went its own way with its ancona.[2]

If we want to analyze and to quantify this movement, we are still dependent on the valuable but insufficient list of works compiled by Edward B. Garrison, who published an "illustrated index" with seven hundred examples in 1949.[3] He called the material "Romanesque panel painting" to distinguish it from the "Gothic painting" of the age of Giotto. Garrison's list of surviving panels, though no longer up to date in every case, bears impressive witness to the flood of panel painting that seemed to come from nowhere. We must bear in mind, however, that the surviving works are only a small fraction of what actually was produced at the time.[4]

In his survey of the material collected, two genres stand out that had existed previously as single images in other media. The Madonna Enthroned, now a painted panel, occasionally with shutters, superseded the wooden or metal statue that had been housed in opening shrines behind the altars.[5] The panel cross, the *croce dipinta*, placed over the chancel entrance or on the altar,[6] again inherited metal or wooden crosses with a sculpture of the Crucified but was the first to adopt the fully painted version.[7]

229

216, 241

We may remember that the two basic types of Western cult image—the statue of the Madonna and of the crucified—are carried over into the medium of panel painting (cf. chap. 14). A third genre, the half-length icon of the Virgin,[8] by contrast had no tradition in the West from which it might have developed, but it was no doubt the legitimate heir to the icon. It soon grew to such prominence that even large-sized images of full figures came under its sway, and the multiwinged altarpiece, a genre that remained unknown in the East, from here took its inspiration.

212

It is tempting to trace the stages of such a development, which displays a compelling logic. But what set the development in motion? Where did the commissions and where did the painters workshops suddenly come from? Anyone who initially sees only the "goals" of the development will eventually look back from them, as Vasari did, to the "beginnings." But anyone who seeks explanations will be interested in the milieu in which, for example, urban society and the new mendicant orders of Fran-

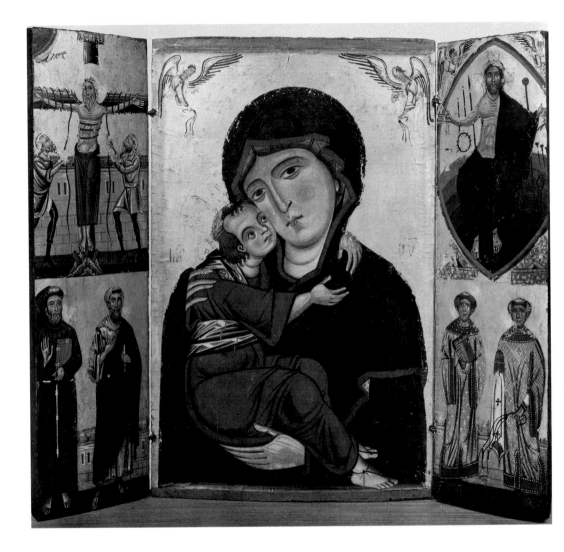

ciscans and Dominicans played a major part and reinforced new demands that were placed on paintings.[9] But how did this milieu affect the medium of panel painting, which was also the medium of the icon?

Whoever has investigated the role of icon painting in this respect has been inclined to contrast the Eastern parent with its Western progeny, a contrast seen in terms of norm versus freedom. The Western panel painting, so it appeared, soon freed itself from the rigid adherence to timeless types, which never lost their hold in the East. However, there are two objections against this easy explanation. First, the tension between norm and freedom, though with a greater concession to freedom, also applies to the West—there too types of images exerted an authority that could not be manipulated at will. Second, Western artists initially were impressed, not by rigid archetypes, but by what we have called "living painting," which, with its rhetorical structure, was a recent phenomenon in the East (chap. 13). Many centuries later, when development in the East came to a standstill, modern minds tended to think that development had never occurred there (chap. 19). It might be noted, moreover, that the East had a temporal lead as much in icon painting as in religious poetry.[10]

In Italy, Eastern painting had two advantages with which local Western production was unable to compete. In technical and artistic terms, it had a mature form of panel painting, and it had developed an attractive concept of what we might call the speaking image. It therefore involved not only a different technique of painting but a different conception of the figure. As prior to the Renaissance no Western theory of the image had been evolved, we only can consult individual works in order to draw conclusions as to the new ideas involved in the making of images.

In relation to sculpture, panel painting implied not only a different technique but also a different approach to the possibilities of the image. The painted figures came alive when they revealed emotions such as grief or love and when they performed the gestures of speech. Their behavior, however individual and spontaneous it might appear, nevertheless was couched in terms of a limited number of characters, or rhetorical types, that were recognized as such and guided the faithful to open a dialogue with the speaking images. The Virgin either performs a lament over the dead Christ *219* or acts as the Lady of Mercy who gathers her clients under her mantle. In either case, *214* the panel is not just a likeness of a person (the Virgin) but a type of image with a given meaning of its own, differing from any other type of image.

Images imbued with a rhetorical activity of their own no longer kept the distance typical of narrative painting but, without recording a given event, became narrative themselves either by engaging in an internal dialogue among the figures represented or by opening an external dialogue with the beholder, for whom the figures were posing or whom they were addressing. As soon as they included the beholder, the images began to enjoy a new freedom of behavior that directed the further development of the genre. The new activity of speech, however, diminished the authority that the old archetypes, with their hieratic aloofness, had enjoyed. It therefore was important to refer to Eastern models, which, despite their activity of speech or their emotional behavior, had an authority of their own because of their origin or their age.

They did not represent random inventions but were types of images with a protected form and an authorized meaning.

We must distinguish images from pictures or painted panels that are their material support in order to gain a better insight into the ideas implied in the creation and the experience of images themselves. Imported icons encouraged a new conception of images, seen now as visual and semantic entities independent of their ever-changing context. The image, as a visual idea, sometimes contrasted with the artifact of the painted panel, or at least its difference from the physical picture was emphasized. A small domestic altarpiece from Lucca makes a distinction between the main figures in the center, which are quoted from a preexisting type of icon, and the small figures on the wings, which act like a figural frame or comment on the image in question.[11] A diptych in the Uffizi in Florence takes us one step further in that it sets off the Madonna, in the upper part of the left wing, as a unity of its own that remains unrelated to, or at least distinct from, the shape of the supporting panel and the size of the surrounding figures.[12] The double panel, with its many figures and narrations, singles out the Virgin and the Crucified as images of an order superior to that of its pictorial context.

The figure of the Virgin stands out by the close-up view and by the concentration on the psychological expression in the features and the gestures (chap. 14b). It performs the rhetorical role or character of the Tender Mother, whose meaning we have analyzed in Greek painting (chap. 13f). This role includes a model of behavior that the beholder is to follow by addressing a personal prayer to the Christ Child, couched in the same mood the Mother displays. The beholder is implied in the dialogue of Mother and Child, as the Mother acts on the viewer's behalf.

We must always remember that painters were not free to invent the details of images but dealt with archetypes that, more often than not, were models locally available that had become famous, for reasons obvious at the time but unknown today. Painters may have ignored the Eastern icons, which we today know to have been the true archetypes, and intermediary models may have gained more importance for the commission of a picture. In its inquiring about the authorship of surviving pictures, art history has neglected this type of research and has therefore tended to overestimate the personal contribution of individual painters and to underestimate the role of given types, which artists reproduced rather than invented. The medieval beholder, by contrast, must have been able to distinguish the norm inherent in an image from the freedom displayed in a painter's interpretation of a given type. Curt H. Weigelt once inaugurated a different approach to early Italian panel painting, one, however, that had no effect on his followers.[13] He wanted "to demonstrate that the study of types of images must be given the attention it deserves alongside the study of styles, and that within the study of types much finer distinctions can be reached." Since scholars had "hardly considered the mentality of the time and the organization of the painter's craft," they had misunderstood "what was the impact of a generally accepted model" as a personal style.

It certainly is difficult to reconstruct the medieval experience of surviving images, which may have depended on factors external to the actual appearance of the images

themselves. If they were owned by a town or a religious confraternity, they offered a public experience different from that to be gained in front of private images. If they had become famous by participating at an important event or if they had once performed a miracle, their official "biography" created expectations as to their continuing power or credited them with an authority that, as a rule, we can no longer ascertain.

It was, in short, a cult legend that caused a given type, or variant, of image to be important and successful and not so much reasons inherent in the visible features of an image as such. This situation lasted to the end of the thirteenth century or even beyond, when, because of competition among public images in the Tuscan cities, an image's exceptional size or exceptional "beauty" (due to the "art" of a renowned artist) became the criteria for judging an image, replacing that of the fame of its archetype. It is for such reasons that the Laudesi confraternity in Florence commissioned the Sienese painter Duccio to produce a panel of exceptional size that would represent their patron saint.[14] 240

There are, to be sure, basic differences between East and West, but they exist on a different plane and have effects different from those of the accepted opinion. Here we must look back once more at the iconostasis and the Eastern church interior 146
(chap. 12, c and d). Eastern churches owned a large range of movable panels that, as a rule, followed the half-length pattern and usually were not related in pairs. An exception was the full-length icons beside the iconostasis, which, being painted on the chancel pillars, were also part of the wall decoration. The situation is well illustrated by the icons of the monastery of Lagoudera in Cyprus, from the year 1192.[15] The 139, 140
altar itself, invisible in the bema behind the iconostasis, did not need an altarpiece. The icons usually became standardized in terms of their size and of their half-length figures, excluding the internal features of the figures and their expression. Since many icons were available for many functions in ever-changing groupings, a single standard for all images was sufficient. Several saints meant several icons, and each icon repeated the same formula, which equated the figure with the image, the image with the panel.

All this was different in the West, where icons had neither a liturgical use nor a fixed position within the churches. Early exceptions were a panel cross over the chan- 241
cel entrance and a shrine of the Madonna behind the altar. It was the altar that first 233
attracted the temporary and then the permanent display of images, which were origi- 243
nally nothing but icons.[16] But there is, again, an important difference from the situation in the East. Because the altarpiece in the West had to accommodate the various local saints, it continuously increased in size as well as changed its shape and overall decoration. This use of one panel for an ever-changing pictorial program was first applied in the twelfth century, when the panel crosses, with their expanding size and flexible shape, supported a vast number of figures and narratives arranged in a hierarchical order.[17]

Soon thereafter other supports for images were invented that were to serve the needs of new types of commissions and that varied according to the function of the single panel and the wishes of the patrons. Again the diptych in the Uffizi, which 213

accommodated secondary figures and subsidiary figures in a lower zone, is a graphic example, as it represents an ad hoc arrangement that remained an exception. Every free space is filled with figures, as the small altarpiece, which belonged to the mendicant order of St. Clare, had to cover the entire liturgical program of the nuns. Later, this panorama of images was given a more convincing structure when the multizoned altarpiece was designed as a type of image with an architectural order resembling the facades of churches. Simone Martini found the classic solution for this task when, in 244 a commission of the Dominicans from Pisa completed in 1319, he assembled a whole program of church decoration within the limited surface of an altarpiece.[18]

229 The cult images of the confraternities of the Virgin, which were not destined for the high altar, attracted attention by their competitive use of an ever-increasing size. They were placed in side chapels, where they were often too big for the site.[19] At the other end of the scale were private votive images and domestic icons of miniature format. Duccio's Franciscan Madonna, 23.5 × 16 cm, sharply contrasts with the 240 immense Rucellai Madonna (450 × 290 cm), which confronted the painter with a major artistic problem in filling the vast surface.[20] The Rucellai Madonna would not have fit into any church in the East.

East and West, it seems, are divided less by themes and types of images than by the sites where the images were displayed. When they abandoned the single schema of the half-length icon, which coincided with the shape of the panel, Western artists lost a firm standard within which to carry on the production of images. Each patron chose the pictorial form that suited it best, subordinating it to a specific task. This freedom gave rise to the infinite variety of panel shapes and pictorial supports, despite the relatively small stock of themes, in which the Madonna in all her variants was in any case predominant. The abandonment of uniform dimensions, which had given a firm framework to icon production in the East, brought about the danger of extravagance and chaos. After a century of unrestrained evolution, general conventions of panel painting reemerged around 1300, providing a new sense of measure. Only then did the unity of the overall structure become an important consideration, which happily coincided with the unity required for the single icon. Only now was the true function of the frame understood, the structure of which had been borrowed from the frames of portals and windows in Gothic architecture.[21]

b. The Introduction of New Types of Images

Two new types of images that now became known in the West are Our Lady of Mercy, 214 who takes her clients under her protecting mantle, and the Pietà, in which 207 Christ is shown at the stage of his burial.[22] The first type was developed in the West, but on the basis of an Eastern "parent," while the second type, though taken over from Eastern icons, in the West adopted a different function and meaning. The latter presents the iconic portrait in the scenic situation of the Passion and in the stillness of the grave. Both types therefore take on a narrative aspect and guide contemplation toward a particular content, a particular idea, instead of toward a person.

They were often treated as a pair, despite the different appearance as full- and 214 half-length figures.[23] On a Venetian ancona of the fourteenth century, Mary was in-

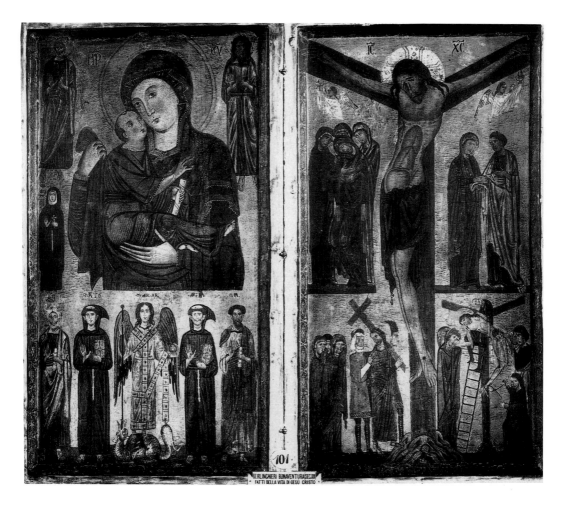

voked as the Mother of Mercy, while Christ was invoked as the Mercy of the Lord on a Bohemian diptych.[24] One could expect compassion from Mary because of her role as Mother, and from Christ because of his suffering, which had brought the forgiveness of sins. Both roles were so vividly portrayed in the images that they became stereotypes for such appeals.

The types of Our Lady of Mercy and of Christ of the Passion were not associated from the outset with panel pictures but began to circulate without being attached to a particular medium or archetype. They successfully embody the compassion of the Mother or the pity of the suffering Lord in a graphic formula that took on an emblematic character when it was chosen by an order or corporation for self-representation. The Western image of the Virgin put the main emphasis on the leitmotif of the protecting cloak, which enabled it to become an emblem. In the case of the Pietà it was the context that transformed the image to an emblem. In the East the icon performed a dialogue with an icon of the Virgin, for which liturgy provided the occasion. In the West the same type received the prayer for the dead when it was mounted on tombs, or signified the Eucharist when it was placed on altars.[25]

We must insist on the fact that the two Eastern types were not introduced in the West by famous examples that predetermined their reception, nor could they be identified with a particular icon. The image of Christ soon underwent a process of expansion and transformation that made it functional for Psalter manuscripts, holy vessels, altars, pulpits, and tomb reliefs, sometimes accompanied by the instruments of the Passion (*arma*). In such a context, the image signified an emblem, a so-called *forma pietatis*.[26] The lack of an archetype was the reason for promoting a small mosaic icon in S. Croce in Rome to the rank of an original from the time of Gregory the Great—in other words, to the *imago pietatis* (chap. 16c). Endowed with this new authority, the image remained popular up to the time of Giovanni Bellini's paraphrases in the Renaissance.[27]

The assimilation of the Our Lady of Mercy took a different course, which well illustrates the expansion of the Western repertory of images at the time. In 1267 a newly founded confraternity placed the figure of Mary "who takes the members [*sodales*] under her mantle [*pallium*]" on its flag (*gonfalone*) in S. Maria Maggiore in Rome.[28] Convents and confraternities—particularly those connected with the mendicant orders, and especially during times of distress—from now on favored the image, which included a first group or social portrait under the patron's mantle. The Laudesi brothers in Bologna chose the "universal Mother" (*Mater omnium*) as the titular image of their statutes, thereby making her the patron of their society.[29] The relevant text states that the corporation bears the name of the Virgin Mary, "under whose flag or mantle" they have come together. The mantle figure on the flag and the flag with the image of the mantle are here conflated. Just as the members of a corporation saw themselves under the mantle in the image, they gathered likewise beneath the flag with the image in their processions. The type was disseminated through as many media and functions as was the Christ of the Pietà—as a figure with which groups could identify, as an image carried in processions, and as an altarpiece.[30]

From the very beginning, the image embodied the idea of the protecting mantle, which finds an early literary expression in visions of the Cistercians,[31] and thus was linked to the mantle relic kept in the Blachernae church in Constantinople. There Andrew the Fool had had a vision in which Mary had appeared and spread out her mantle (text 13A), and the various icons at this site (text 14) favored the Orant Virgin, whose mantle opened as she lifted her arms in prayer. The main icon, directly over the shrine with the relic, performed a miracle each Friday, when the curtain that normally concealed it lifted of its own accord (text 15). During the Latin occupation of the East (from 1204), the Cistercians and the young mendicant orders propagated the idea of the protecting mantle together with the frame of the mantle relic and thus prepared the ground for the transformation of the Eastern icon in the West and its following success.

108

This process of transformation that the image underwent can best be followed in Venice (where else?), as S. Marco, from 1200 on, owned a large collection of the orant-type icons, some of which came from Byzantium (chap. 10d). In Ravenna an Eastern marble icon of this type propagated by the confraternity of the "sons of the Virgin" was reproduced as early as 1112 in the new apse mosaic in the cathedral.[32] In the mosaics of Torcello the same image dominates the cathedral entrance below the Last Judgment, where it is accompanied by an inscription that begs the Virgin "to cover the sinner [with her cloak]."[33] In the harbor town of Ancona and in Pisa, the marble image of the Virgin Orans was seen everywhere on the facades of churches.[34] In S. Marco a famous example to be seen to the left of the main entrance, which was gilded at an early stage, bears the old title of Madonna of Mercy. Like all the other examples of the image, it was the recipient of invocations asking for the heavenly Mother's protection in public and private affairs. Through its provenance and through its association with the cloak relic, even the Eastern orant icon already implied the idea of the protecting cloak.

120

120

This idea was soon made explicit by expanding the motifs of the old icon and by making visual the protection from the cloak, which became part of the image itself. The previous icon was adapted to the new meaning in a way that drastically altered its appearance and now included the recipients of the protection, who usually figure as members of a religious or social group. This shift of emphasis toward the votive image reinforced the emblematic character of the type, or perhaps even created it.

The Orant icon and the image of Our Lady of Mercy succeeded each other in Venice, where they both performed the same function in the same place. The Scuola della Misericordia owned an old stone icon of the Orant Virgin that in the fifteenth century was replaced by a relief from the Buon workshop.[35] The Gothic relief of Our Lady of Mercy repeats the motif of the Child, who floats before the breast of his Mother and thus emphasizes the identity of meaning. We have already discussed the origins of this variant in the Blachernae church (chap. 10a). Here it helps us to reconstruct the succession of the two images in the same function.

An Orant icon in marble that, in S. Maria Mater Domini in Venice,[36] follows the same variant with the motif of the Child again offers a good comparison with a subsequent Venetian example, an altarpiece from the workshop of Paolo Veneziano.

215

214 Here the Madonna, now wearing a crown and a richly patterned garment, is identi-
fied in an inscription as Our Lady of Mercy.[37] In this role she protects a number of
laymen and laywomen kneeling beneath her mantle. The motif of the full-length Child
must not be mistaken as a Venetian invention but has a different model in Eastern art
(chap. 9e). The rectangular frame, including an internal arch that repeats the frame
of the old marble icon, now served to distinguish the center part of a large Venetian
altarpiece whose remaining parts, in this case, have not survived. The Venetian altar-
piece, as a whole, was called "icon" (*ancona*), as it was centered in a large icon panel.

 In the thirteenth century the panel cross was changed in appearance. As a vehicle
of painting long established in the West, it had favored the upright Crucified with
open eyes, who triumphs over death. Now this Romanesque type was replaced by the
depiction of Christ hanging lifeless and with closed eyes from the cross, a type today

216 called *Christus patiens,* as it stresses the human suffering at the cross and elicits the
empathy of the beholder.[38] The choice of the new type, which was borrowed from
Eastern art, was caused by a recent development of religious topics in the West. The
new type attracted viewers' attention when the time was ready for it. St. Francis of
Assisi had developed a model for the cult of the Crucified, whom he wanted to re-
semble even in his sufferings. In 1236 the Franciscans took the lead in propagating
the new type when they commissioned a panel cross (now lost) from the painter
Giunta, a work to become the archetype of the further development because of its
site, the church of S. Francesco at Assisi.[39]

 The Eastern crucifixion once had offended people from the West, who were un-
willing to deal with the paradox inherent in the subject or who disagreed with the
visual emphasis on the living corpse (chap. 13d). Now, the same image filled "every
beholder with deep compassion," as a Western pilgrim tells us who visited Jerusalem
in the twelfth century.[40] The new devotion centered on the passion and the death of
Christ needed a new image of the Crucified, which was available in the Eastern Good

164 Friday icon, although it depicted the biblical scene and not a single figure.

 The choice of the new type by the Franciscans is all the more striking because it

218 contradicted a famous image of the old type, which they especially venerated, as ac-
cording to legend, it once had spoken to St. Francis in S. Damiano.[41] The Roman-
esque cramming of the panel with figures and subsidiary scenes deprives it of visual

216 unity. Giunta's panel cross, which we know best from examples in S. Maria degli
Angeli in Assisi and in the museum in Pisa,[42] by contrast, is restricted to the three
figures of the Eastern icon of the Crucifixion. The figures of Mary and John, mounted
at the ends of the cross, by their half-length size, resemble independent icons and at
the same time compensate for the loss of the narrative unity by being closer in size to
the main figure.

 This invention, proudly signed by Giunta, deserves closer attention, as it became
the norm for subsequent painters. The secondary icons lack frames of their own
where they join the dark cross beam, so that the unity of the three figures is not inter-

217 rupted. The sunken head of the main figure, which is backed by a three-dimensional
halo, forms the expressive center of the dramatized likeness of a corpse. The two
living witnesses invite the beholder to emulate their mourning as they point to the

214. *Venice, private collection; Madonna of Mercy, 14th century*

215. *Venice, S. Maria Mater Domini; stone icon, ca. 1200*

360

216. *Pisa, Museo Nazionale (formerly
Pisa, S. Raniero); Giunta Pisano, painted
crucifix, ca. 1250*

217. *Pisa, Museo Nazionale; painted
crucifix from S. Raniero (detail), ca. 1250*

219 dead hero and as the Mother touches her cheeks in grief with the same cloth with which she was said to have dried her tears. Some examples of this kind of "cruciform icon" were reduced to the format of devotional images or were turned into procession crosses to be looked at from both sides.[43]

While the cross in S. Damiano was given a speaking voice only once, by a miracle, Giunta's crosses seem to speak permanently through their forceful expression of suffering. Whenever sermons were preached or vigils held before such crosses, the interaction between word and image was intensified in such a way as to offer the mutual agreement, or symmetry, of the visual description and the eloquent painting.[44] This image, which was well suited for being staged, as it were, in public rituals, also implied suffering as a collective role in which the Crucified had been the model and St. Francis had become the embodiment of perfect imitation.

Meditation in front of religious images was an activity that enabled lay people to play the role of saints and to live temporarily like a saint. The practice of image devotion involved the same images that had been used by the saints and had inspired their visions. By training their own imagination, urban people sporadically entered the saints' community, at least in the prescribed exercises of daily devotion in which images offered the first stimulus. Images helped to overcome the limits of religious experience, which were imposed on the laity because of their secular life with its many practical needs.[45]

c. Icon and Devotional Image: The Language of Gestures

"The half-length panel of the Virgin is explained by its function as a devotional image"—thus Hellmut Hager characterized the most important branch of early Italian panel painting, meaning by "devotional image" the private image, or the image produced for the use in private religion.[46] But he had to admit that the public cult of the same images started quite early and may even have prepared the way for their private use. Often it is only the format and not the figure itself that indicates the original use of an image. After all, devotion, meaning the exercise of a religious role, was only a private variant of prayer that had been rehearsed publicly. The difference between public and private prayer has been idealistically exaggerated from the modern viewpoint.[47] Even in the public practice of religion, personal piety was the primary model of behavior at that time.

In a sense the icon and the devotional image are synonymous. Apart from a few privileged exceptions, an icon could not be anything other than a devotional image once it came within the sphere of Western piety. Its rhetorical structure (chap. 13) was well suited for a painted dialogue, which challenged Western artists to develop the possibilities inherent in the speaking image. As the evocative depiction of a person, usually in the form of a half-length portrait, the Western devotional image often borrowed the prestige of an Eastern icon as a model that was reported to have acted like a living being and performed a miracle.

Unlike the unspecific term *imago,* which was also used for statues and book miniatures, *icona* best designates the kind of image we have in mind. In his 1252 book on the miracles of St. Francis, Thomas of Celano reports that Roman wives owned in

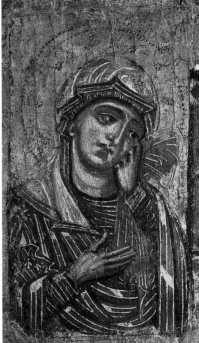

their houses "a painted icon on which they venerated the image of their favorite saint."[48] These were usually half-length images, which were distinguished from the large *tabula,* and had wings that allowed them to be conveniently closed. A small triptych from the school of Lucca represents a major variant,[49] which, as we see it in two other examples, groups several saints around a half-length portrait of the Virgin, including the saint in favor by the private owner.[50] In this case the choice of saints indicates a link with the mendicant orders, which also allowed laypersons to become members.

212

The diptych, too, was used as a portable private image, as a Sienese example, now divided up between museums in London and Budapest,[51] may illustrate. It as yet does not bring together the two companion images of the half-length Virgin and the full-length Crucified into a convincing formula of a pair of images. A holy bishop in Nocera Umbra whose figure turns to a now-missing companion wing,[52] could not be distinguished from a Byzantine icon of St. Nicholas unless he was wearing the Latin miter. Moreover, the gold hatching on his robe (the *chrysography*), though an Eastern technique, was not used for bishops' robes in Eastern painting. The private character of such images became manifest when they included the figure of a donor as a small addition.[53] A special pictorial formula for this inclusion, however, was not produced until much later, when the private portrait was invented as a subject of its own.

5

A brief survey of the use of the half-length image will invalidate the current belief that this genre consisted only of private images. In 1225, as booty from a fortress in Lucca, the citizens of Pisa won a surviving half-length image of the Virgin from Berlinghiero's circle, which they henceforth venerated as a palladium in their cathedral and later placed on an altar *sotto gli organi.*[54] On the Monte della Guardia before the gates of Bologna the cult image of the women hermits received public honors from the town as early as 1253 (chap. 16d). In Siena, the Carmelites imported an Eastern original that soon generated copies even in Rome (chap. 16c). In the cathedral of Pistoia, a wall icon of the Virgin in the manner of Salerno di Coppo, whose site at the north entrance to the chancel corresponds to those of the fixed icons beside Eastern iconostases (chap. 12d), had long been famous as an "old image in the Greek style."[55] In Florence the half-length image of St. Agatha was carried in processions, as is shown by the fact that it is painted on both sides.[56] In 1255 the church of St. Clare in Lucca, which had already owned an old icon of the Virgin, obtained a large diptych, one half of which included an icon of the Virgin as an image within an image, as the altarpiece of the nuns.[57] The most certain proofs of the public cult of half-length icons, however, are the icon friezes that soon became commonplace for altarpieces on high altars. In this permanent display they represented the full catalog of the different icons that hitherto had been distributed to side altars or to side chapels of a big church and embodied the various local cults (chap. 18c).

210

VI, 208

220

213

242

Among the various icons of the Virgin, the one in which the Mother intercedes with the Child by raising one hand was the most popular. This type was not always intended to reproduce the famous icon of the *Hodegetria,* allegedly painted by St. Luke (chap. 4e), as it had been circulating in variants that referred to archetypes closer at hand. Even Byzantine inventories often distinguish variants in which the

Mother carries the child on the right or the left arm (texts 25A and 25D). In the West, such nuances were identified with different models in nearby places of worship, which the faithful were supposed to be familiar with.

The surviving examples begin in the West with a truly monumental panel (165 × 126 cm) that the Sicilian king, probably about 1180, commissioned for the consecration of the cathedral of the Virgin in Monreale.[58] It does not have the marks of an Eastern icon painter but repeats the Eastern image faithfully, down to the angels in the spandrels. The small gold star on the veil, the meaning of which we do not know for sure, keeps the center of the brow. A mosaic above the main entrance of the same cathedral, which repeats this very icon, invokes her "to pray for all, but to work especially for the king, as the inscription says.[59]

About 1230 the Berlinghiero workshop in Lucca produced the so-called Straus Madonna (named after a previous owner),[60] in which the tonal harmony is based on the same triad of reddish ocher, gold, and velvety blue that was favored in Eastern icons. The Mother holds out the light-colored Child toward us, his gold-lit garment glowing warmly against her dark mantle. All linear harshness is banished from smooth surfaces enlivened by soft tonal shades, while outlines that seem as if engraved circumscribe these surfaces, above all in the delicate hands, whose light skin reveals an elegant internal pattern. In order to respond to the high expectations it had to fulfill, the painting was to produce the most vivid possible effect on the beholder.

Compared with earlier images, the Lucca icon combines traits common to all of them, with features unique to particular images. As the given limits of image types were tightly set, each detail takes on a special importance, of which we as yet know little. In a subtle articulation of gesture and mimic, Mary's free hand draws in the Child, to whom she is speaking, while her gaze draws in the beholder, in whose name she is speaking. Her gesture differs from that of her Son, as it conveys a plea (enhanced by the bent head) and as his lifted hand indicates an affirmative answer. The gazes are either undirected or, as in Pistoia, interconnect Mary and the Child both with each other and with us.

Berlinghiero's work operates with nuances that we would discover only through a comparative study. These nuances include the proportions of the figures, the interplay of their bodies and halos, and the language of gestures, with their gentle flow and their subtle meaning on both human and theological levels. There is, finally, the extraordinary and rather unexpected expression of grief in the Mother's face, which starts in the contracted brows and continues in the pinching of the lips and nostrils. Thereby the Passion is brought into play, at least by the same implication that we have studied in Eastern icons (chap. 13f), the gaze into the distance signifying the prolepsis, the anticipation of the future. A magnificent icon from Kastoria proves that Berlinghiero's variant was inspired by contemporary works from the East.[61] A mosaic icon from Constantinople at Mount Sinai that uses the same scheme in mirrorlike form may represent the kind of model that inspired Berlinghiero.[62]

Berlinghiero also acquaints us with a second major prototype from which Eastern icons derived their description of the Virgin: that of the Tender Mother, which Weigelt calls the "motherly" type.[63] Best known from the icon at Vladimir

221

220

163

175

220. *Pistoia, cathedral; pillar icon of the Madonna and Child at the chancel entrance, 13th century*

221. *New York, Metropolitan Museum of Art; Straus Madonna, Lucca, 13th century*

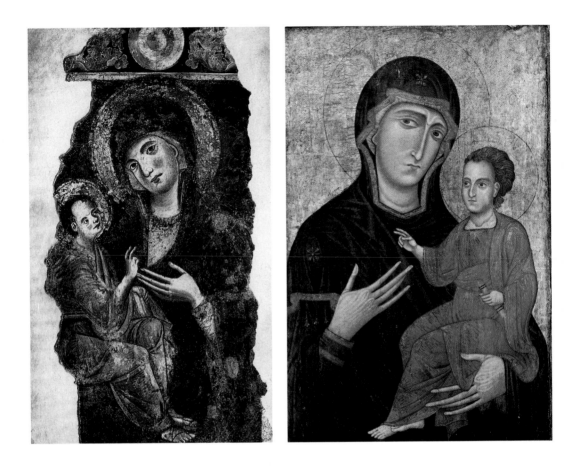

(chap. 13f), the type nevertheless has not come down to us with its old name, nor with the original icon that made it famous. The rhetorical synopsis of two feelings and two levels of time imbues the tender intimacy of Mother and Child with a melancholy presentiment of the Passion. The Child looks with questioning eyes at his Mother, who already knows his fate, and thereby emphasizes the paradox of the mystery, as the Creator behaves like an ignorant child.

In the small domestic altar in Cleveland already mentioned (sec. a above), Berlinghiero translates the features of his model into a coarser idiom that lacks the subtle play of light once contrasting the faces of Mother and Child and does not convey the introduction of melancholy about the eyes of the Mother. He is still struggling with the problem of creating both bodily volume and bodily movement at the same time. To compensate for the lack of the painted poetry he studied in Eastern models, he introduced new motifs of an almost vernacular simplicity.

The Child no longer embraces his Mother with the delicate gesture of the model but reaches energetically around her veil. The Mother presses him to her body with both hands, responding to his high-pitched emotions. His unusual garment in light brown color may allude to the Franciscan habit, as St. Francis is represented among the saints on the wings, and as he was thought of as a living image of Christ in contemporary history. The shorthand version of the Last Judgment finally indicates what Mary's intercession is most needed for.

A small domestic altar from Pisa again focuses on the image of the Mother of Tenderness[64] but at the same time introduces a number of variants that reminded the faithful of yet another archetype. Thus the Mother looks in terror past her Child at the scourging depicted on the left wing. The white cloth she holds in her hand, a motif first introduced into the painted crucifix by Giunta Pisano, is explained as the cloth that Mary presses to her face to dry her tears in the Crucifixion.[65]

The same motif reappears as an extension of the well-known type of image, of which the Lucca altarpiece in the Uffizi is the best example[66] and an icon in the Acton Collection in Florence is a further variant.[67] It adopts an ideographic function, as the Virgin plucks at her garment like a cloth that she is about to lift to her eyes. The gestures of the Child are taken from the *Hodegetria* type, while his half-recumbent pose, with the allusion to the sleep of his Passion, is quoted from yet another source.

It may seem strange to the reader that an icon was actually composed of borrowings that refer to different archetypes, for such an analysis tends to dissolve the unity that we today expect from such an image. But for medieval beholders, who probably could identify the origin of the various motifs, such an accumulation of gestures and signs must have guaranteed an increased power of the image. A frontispiece that introduces the statutes of a confraternity in Bologna teaches us how medieval beholders were "reading" the symbolic implications of the image of the Tender Mother, as it links her figure with the sign of the cross.[68]

The language of gestures, which still needs further investigation, profited from Eastern icons, of which the Italian painters had a comprehensive knowledge. Three examples may be sufficient to prove this transfer of motifs to the West. The famous Cypriot icon of Kykkos, which had the Child move away from his Mother in a violent

212

222

219

213

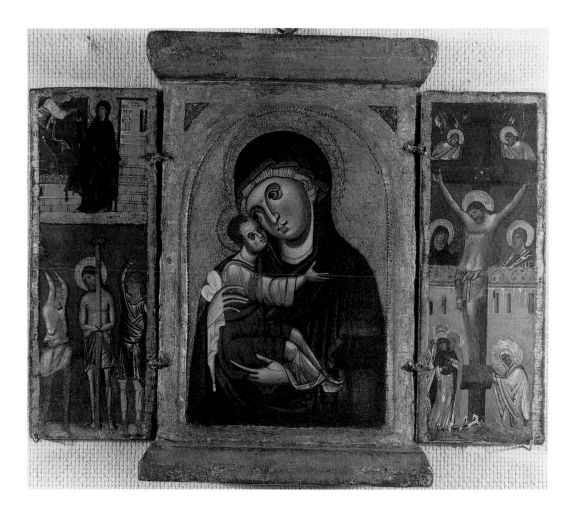

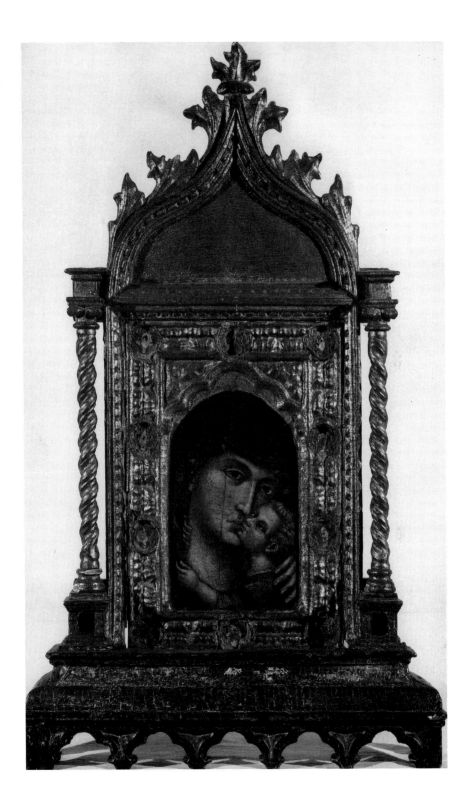

369

gesture (chap. 16b), is faithfully reproduced by an Apulian panel.[69] The equally famous icon of Pelagonia (chap. 13f) is the source of a Sienese panel,[70] and the lost Eastern archetype of the Tender Mother has inspired a Pisan painter for the so-called Madonna dei Mantellini, which ended up in Siena.[71]

The lyrical content that the icon of the Tender Mother implied from the very beginning was fully exploited when, in the fourteenth century, the painter Jacopino di Francesco created a new version that soon became popular even beyond Bologna.

223 A good example is the domestic altar in the Casa Horne in Florence, whose close-up of Mother and Child takes us right into the expressive center.[72] The large, shadowed face of the Mother, whose dark veil receives golden beams from above, effectively contrasts with the fair-skinned, blond child. The erotic motif of the kiss that the Child offers the Mother, a bold reinterpretation of the archetype, is anticipated by a recently discovered panel that has tentatively been attributed to the Sienese painter Duccio.[73] The motif seems to be derived from the secular iconography of courtly love, as the Child in this icon not only touches his Mother's lips with his own but also reaches with his hand under her chin, a gesture we recognize from French depictions of courtly love.

Whether the source of this unusual picture or not, Duccio was highly influential in the invention of new images of the Virgin that at Siena competed with the old ones and struck a very different tone with their lyricism. Duccio's own Madonna of Cre-

224 vole, a work from his youth, surprises us with the playful behavior of the Child, who grasps his Mother's veil as if he wanted to distract her from her melancholy.[74] Like the realism of the Child's costume, the tender touch suggests a private idyll of the nursery, which already in Gothic ivories of the Virgin and Child has been transferred from the iconography of love to that of religious motifs.[75]

The theme of *amore*, which dominated the Tuscan lyric at the time and was the guiding theme of Dante's interpretation of the world, may have suggested this radical reinterpretation of an old iconic subject. Even in the emotional temper of the vernacular *laude* sung by the confraternities, it is found in the dramatic lament of the *mamma* for her *figlio bianco e vermiglio*.[76] In the *lauda* of Jacopone da Todi, the love lyric is used for a panegyric to the Virgin, as when he sings of the "loving gestures" by which Mother and Child take notice of each other.[77] The medium level adopted by Duccio reminds us of the measured lyrical language of the *dolce stil nuovo,* as Dante, in the *Purgatorio* (24.49), terms the love poetry of his predecessors.[78] Here beauty, as the sign of nobility of soul, is a manifestation of suprapersonal *amore.*

d. *"Maniera greca" and "Dolce stil nuovo": Duccio and the Icon*
Duccio, the founder of Sienese art, undoubtedly was the greatest panel painter of his time, as he loved the intimate form and favored lyrical concentration. Though he retained Byzantine motifs (or what were taken for them), he knew better than anybody else how to fill them with a new life and to modernize their emotional content. Like any reformer of style, he creates a need for explanations—which, however, to be honest, have all remained inadequate.

As a painter of icons, Duccio appears to be the classical representative of the so-

called Greek Manner, or *maniera greca,* which Renaissance writers discovered to be the forerunner of the "good" Tuscan art of Giotto. This was, however, a derogatory concept, which attributed to foreigners everything thought to be irredeemably old-fashioned. Architecture of this kind was consigned to the Goths or "Germans," and painting to contemporary Greeks or Byzantines. There was as yet no mention of Romanesque art, nor of the fact that it was precisely Gothic sculpture, in conjunction with the most recent Byzantine painting, that had inspired the reforms that changed the native tradition.

The term *dolce stil nuovo,* by contrast, is a term used at the time but one that pertains only to literature.[79] Referring to the love poetry of Duccio's generation, the "sweet new style" was discussed within a theory of well-defined artistic styles of writing. Nothing would justify the supposition that the term also applies to painting, although we should like to use it in order to go beyond arbitrary descriptions of our own choice. The theme of love, in both its human and its religious aspects, for the lyrics of the time became an ethical and social concept in the Platonic sense, by which the human being was thought to transcend its natural limits through a purification of feeling. The refined style of the love song was discussed by the literary criticism of the time according to the pitch of lyrical speech, of the moderate tone and apt phrase.

The analogies in Duccio's painting seem obvious, yet are difficult to prove. Style in painting and style in literature may have had a similar effect on the same people, yet today they are difficult to compare just because they could not directly influence each other. Painting never became defined by firmly established rules as literature did, and it would be foolish to suppose that love poetry created a desire for Duccio's painting. One might be bold enough to say that both fulfilled a similar need. One might even conjecture that the painters, like the writers, took models of refinement from a superior French culture—which had also inspired the architecture as well as the sculpture of the time. Duccio must have known the great Gothic sculptor Giovanni Pisano during the period when the latter contributed to the cathedral facade of Siena. His pulpit in Siena's cathedral was an inexhaustible pattern book of Gothic and classical motifs that made French forms and motifs, though truly transformed by Giovanni's art, available at Siena.

For Duccio, icon painters from the East, however, had still more to offer. Like his fellow artists of his own generation, he now was ready to learn and to apply what he had learned from the craftsmanship and art of the best Greek icons, and not merely to repeat the skeleton of their iconography. Though it contradicts the still-prevailing opinion and its contempt of Eastern art, our thesis rests on a firm material evidence and can provide critical criteria for analyzing what actually happened in the age of Duccio. Duccio's encounter with itinerant Greek artists can be readily summarized, as the facts have been examined in detail elsewhere.[80]

Two images of the Virgin Enthroned, now in Washington, have caused a never-ending debate ever since Bernard Berenson, with a connoisseur's instinct for their singular features, pronounced them products of Constantinople. And indeed, one of them—known by the name of a former owner, Kahn—has now been generally acknowledged as a product of Greek craftsmanship in terms of technique, with the ex-

225, *VIII*

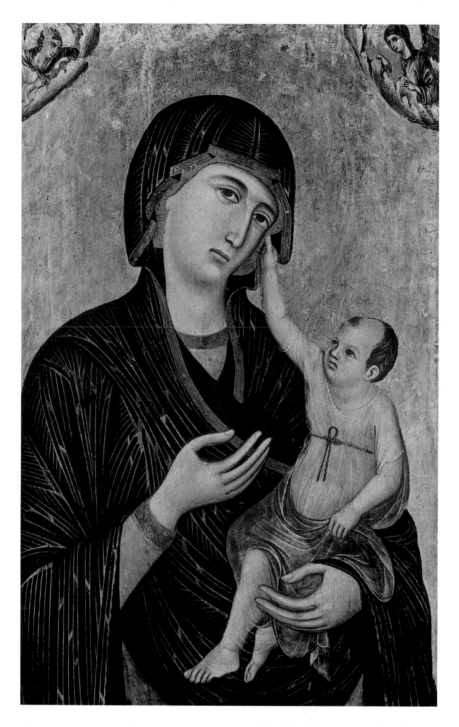

224. *Siena, Opera del Duomo;*
Madonna di Crevole, ca. 1280

225. *Washington, D.C., National*
Gallery of Art; Kahn Madonna,
13th century

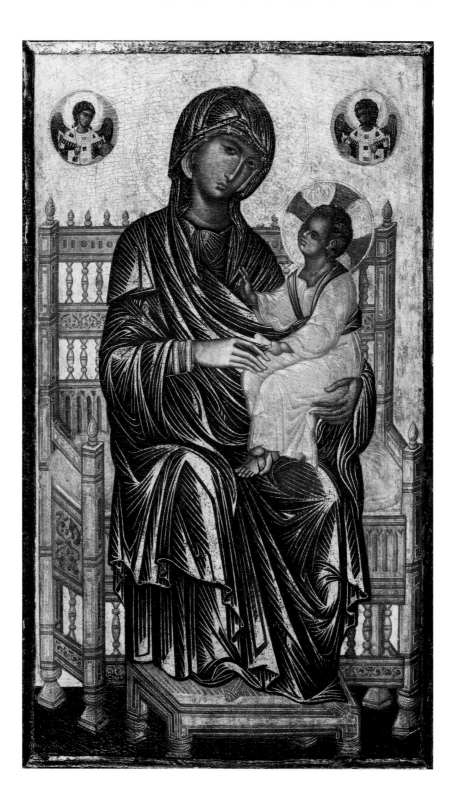

373

ception of the slit-leaf ornaments within the halos, which are found only in Tuscan painting. The size of the vertical rectangular panel and the motif of the enthroned, full-length Madonna, however, were virtually unknown in Eastern painting, popular as they were with the confraternities in Tuscany (chap. 18b).

The conclusions to be drawn from this evidence are obvious, yet scholars have been slow to draw them, Italianists and Byzantinists each claiming the work for themselves. The painter of the Kahn Madonna was an itinerant artist who had been trained in an Eastern icon workshop and was now working on a Tuscan commission. The work was to please the Italian patron, while the painter kept to his Greek technique. He was unfamiliar with the task of linking throne and figure, and the coordination of the motifs with the available picture space is laborious. But the figures themselves display a mastery of *peinture* that outshadows anything in Tuscan art. The gold hatching of the garments has an unusually fluid rhythm that emphasizes the flowing movement of the fabric—without, to be sure, paying much attention to the anatomy of the bodies beneath. The chromatic shades of the transparent ocher, red, purple, and light blue bear witness to a long painterly practice that culminates in the skin of VIII the Madonna, modeled entirely of color and light, and tolerating line only in the outlines of the face. The individual forms lack stability but convey a depth of spiritual expression. A dreamy melancholy is evoked with but a few sure touches of brushwork.

This art could be easily criticized for a certain overrefinement, which may have been the result of concentration on a few recurrent iconic themes (as a similar icon of the Virgin in the monastery of Chilandar on Mount Athos may confirm).[81] But with artists like Duccio, this very technical perfection, combined with the rich poetic expression, left a lasting impression. "Icons of the new kind" had been produced in the Byzantine context of a philosophical debate about art and rhetoric (chap. 13) that was to begin in the West only with the Renaissance.

Further traces left by itinerant Greek artists can be detected if one carefully examines Italian panel painting of the last quarter of the thirteenth century. We no longer have primary witnesses of the kind of the Kahn Madonna, but there are Italian works that vividly reflect a firsthand knowledge of Greek artists and their style. A large panel of the Virgin that in modern times found its way into the Pushkin Museum in Moscow certainly is of Tuscan origin.[82] It faithfully repeats the peculiar combination of Greek style and Western motif that we discovered in the Kahn Madonna.

In Siena, however, the encounter with contemporary Greek painting was not restricted to special cases but had a far-reaching impact on the development of Sienese art not just in matters of technique and style but also in its conception of the religious image, which we do not find anywhere else in Italian art. As this is not the place to trace this development in full, we only mention here two examples in which painters of a different age, each in their own way, made use of the experience with the same kind of Eastern art.

238, IX There is, first, an artist older than Duccio who once was confused with the painter Guido and today is best characterized by the former triptych from S. Bernardino, which, despite mention of the date 1262, must have been produced in the

1270s (chap. 18b).[83] The Child follows its Greek model in that the figure performs a rich interplay of bodily motifs that in a way contradict the painter's adherence to a flat picture plane. The artist, who reveals little practice in the color modeling of Eastern art, makes every effort to transform the style of the model into one of his own. The isolated areas of shadow and the linear treatment of the facial motives of the Virgin cannot conceal the almost desperate attempt at reproducing the model in every detail. "Nature" is replaced by a rigid face mask, so that the affective qualities of the original are totally absent from this Italian imitation.

Duccio no longer aims at imitation for its own sake but instead ventures in a thoroughly personal interpretation that reveals his true empathy with the intentions expressed in the Greek original he saw. When he overcomes the rigid schema of the mask and re-creates the organic unity of the Virgin's face, he achieves nothing less than a basic change of painting style in his native Siena. The smooth, unbroken contours of the body and the free modeling by light and shade bring about this new result, which nevertheless strikes a note different from that of a Greek icon. A firm surface of ivory smoothness, which now characterizes the face, totally resists the Greek device of dissolving the body's solidity in a free play of light. The gold hatching of the garment, which in Duccio's early work still follows the Greek model, will soon be replaced by the elegant rhythm of borderlines and hems that are inspired from Gothic art. 224

The improved painting style clearly serves to enhance the effect of aliveness, which was so much expected from icons of this kind. Duccio favors a middle level of expression where shadow and light, mourning and joy, coolness and warmth are held in balance. He therefore keeps the figures he paints in an ambivalent appearance of distance and aloofness, on the one hand, and of intimacy with the beholder, on the other. In the single face he is able to paint, he brings together so many feelings that his work opens up for many interpretations. The bent head of the Mother moves toward the Child, while the eyes turn toward the beholder. Duccio chooses his forms deliberately as a poet chooses rhythm.

It does not affect our argument whether Duccio actually saw the Kahn Madonna, as he could have known other icons from the East, such as the Carmelites' Madonna (chap. 16c). But the meeting with a Greek painter, which we consider a strong possibility, must have affected his intention not to overcome the icon as a form but to perfect it as a devotional image. This new conception of the icon was adopted by the following generations, such as to cause the overpainting of Coppo's and Guido's Madonnas. They were brought into line with the modern character of Duccio's image in the cathedral (chap. 18b). VI 246

A generation that had become familiar with poetry in the private sphere was able to recognize in Duccio's paintings the same intensity of feeling and elegance of form that were admired in the *dolce stil nuovo*. In vernacular poetry, identification with the emotions of the holy person was one of the means whereby the laity took part in religious life. The account of human nature given by the icon was widened by the elaboration of feeling; in the images of Mother and Child and of Christ on the cross there was inexhaustible scope for a modeling of feelings. Paintings attained a new

elegance in their refinement of color, as in the accents of red and pink on the red mantle, which take on a timbre of their own.

It may seem surprising that this chapter ends with an argument on artistic influence that seems to fall outside the framework of a study not primarily concerned with artistic questions. The veneration of images in fact did not take place within the categories of art proper. All the same, the artistic interchange with Greek icon painting characterized a brief phase of Italian painting and is thus a historical factor we must consider.

To put it in a nutshell, the exchange was not possible before Duccio, and not necessary after him. It not only benefited the style and technique of Sienese painters but changed the general expectations surrounding the religious image. It is not our aim to raise the Italian icon to the level of "high art," where one is more likely to miss its true nature. And yet the pictorial rhetoric that painters were ready to adopt was not accessible without their new artistic approach to the subject. Moreover, in the case of Duccio's public commissions, the work has a social as well as an artistic dimension, in that it is a votive image commissioned by the community (chap. 18).

It is characteristic of the thirteenth century in Italy that the history of the image practically coincides with the general history of art. Painting conquers new terrain in increasing the repertory of its tasks. The cult and the social functions of images, which we so far have been careful to distinguish from their formal history, were in this case factors that, in a sense, actually generated the shape of the pictures and the style they used. Never was the physical appearance of panel paintings more diverse than in this first century of their history in the West, but never was the inner unity of their symbolic language of forms more convincing.

18. The Madonnas of Siena: The Image in Urban Life

Soon after their introduction into Italy, the former icons underwent a process of transformation that affected not only their external shape and their vastly differing size but also their internal composition and the figural language as such. This development manifests a thorough change of functions, which means that images adopted ever-new roles without as yet achieving a generally accepted role. The longer an obligatory practice of dealing with public images was lacking, the more the desire to create a set of firm rules for their use increased. To avoid an arbitrary use of images, the church chose the altar as the place where one would encounter the images of local importance. Unknown in the East, the newly created altarpiece first underwent an experimental phase before reaching its definite shape as a multipart icon frieze.

During this experimental phase, images were not installed permanently on the high altar and were not always adapted to fit the altar table. The altarpiece properly speaking therefore was not established from the very beginning. It was in fact preceded by two kinds of images that, on certain feasts of the church, were temporarily exposed at the altar of a church. The first one was a so-called antependium, which was to cover the front of the altar below the actual table and as yet had no place on top of the altar table.[1] It usually showed Christ, the Virgin, or a locally important saint in the midst of his or her picture biography. The second predecessor of 227 the altarpiece was a shrine, usually for a sculpture of the Virgin or the figure of a saint, that stood behind or above the altar and usually was locked behind painted doors that would be opened for a ritual appearance at the great moments of the church year. 233

a. Feast Images of the Mendicant Orders in Pisa

Unlike the old shrine images, the earliest altarpieces of the mendicant orders did not have a permanent link with the altar but were displayed only on the feast day of the patron saint of the order or a local church.[2] For this reason I shall not include them among the stationary altarpieces but distinguish them as portable feast images. As they were exclusively dedicated to one saint, they also were not suited to appear on the high altar on the feasts of the Lord or the Virgin.

Both the early feast image and the subsequent altarpiece survive from the Dominicans' church in Pisa, where the former, showing St. Catherine, to whom the 226 church was consecrated in 1255, was replaced in 1319 by the latter, a work by Simone Martini. St. Catherine no longer fills the center of the altarpiece but enters the chorus of saints who represent the cult program throughout the year, for which the multizone icon frieze was chosen.[3]

The early image of St. Catherine may serve as an introduction to the new genre because its use of an Eastern icon is obvious. A surviving icon in the Mount Sinai 227 monastery, the center of the veneration of St. Catherine, gives us a good idea of the

226. *Pisa, Museo Nazionale; feast-day
image of St. Catherine from the Dominican
church, 13th century*

227. *Mount Sinai, monastery of
St. Catherine; icon of St. Catherine,
13th century*

379

kind of model that the Pisan painter must have exploited for his own work.[4] It belongs to the rare variety of biographical icons that frame the full-length figure of a saint—also rare—with scenes from his or her life (chap. 12e). The Pisan painter must actually have worked from an icon of St. Catherine, as the gestures are borrowed from the model, as is the grecianized form of the name "ECATERINA" in the inscription. The greenish-blue cloak with the eagle motif and the crown, however, have replaced the Eastern finery of the Alexandrian princess. At that time the Mount Sinai monastery was also a popular destination of Western pilgrims (chap. 16c). Hence the biographical scenes conclude in the Pisan work, though not in the Eastern icons, with the miraculous translation of the saint's body to Mount Sinai.

In linking the portrait with a saint's legend, the Eastern icon too met a feast-day need, for it was only on feast days that the legends telling of the saint's virtues and miracles were read. In the icon there was the same link between image and reading or preaching (chap. 12e). Its shorthand scenes could be understood only if they had been memorized from texts. Their sequence followed the liturgical plan by which the vita was read, being sometimes divided into sections of appropriate length. The figure at the center, not always a full-length standing figure, offered itself for veneration, as it was displaying the saint's visual appearance. The scenes supplemented the physical portrait with the ethical portrait of an exemplary life and with divine approbation in the form of miracles.

This type of image was introduced into Western cult practice with some necessary changes. In 1221 the Dominicans in Pisa took over the small church of the monastic father Antonius, the second patron of which, Catherine, was the Dominicans' model in theological studies and eloquence. From about 1230 they engaged in a building campaign, and the new church was consecrated to St. Catherine alone in 1252, whose image formed the focus of readings and bishops' sermons. In this way the townspeople were drawn into the new order's arms, especially on feast days, when, encouraged by copious indulgences, they also made donations.[5] The scenes on the painted panel thus also serve the self-representation of the order. Complementing the four episodes depicting the martyrdom and the miracles are four others in which the saint is seen disputing over the faith and being illuminated by the Holy Spirit during her imprisonment. Later, after it lost its purpose, the panel gained new honors in the community of Dominican nuns at S. Silvestro. As an early dossal from this church proves,[6] St. Catherine had already been patroness for them since the thirteenth century.

Like its Eastern antecedents, the Western cult image also functioned within the liturgical commemoration of saints. It differed from the Eastern icon in a number of important respects, however, which indicates the influence of other models. The Pisan panel is larger by half (115 × 107 cm) than the Mount Sinai icon and shows by its greater width that it was not hung but placed on an altar table. Thus the saint stood not only on the painted strip at the bottom but, on her feast day, on the high altar. The scenes no longer encircle the saint but occupy two compartments, which resemble the two wings of a triptych. The broad base is matched by a short pediment

that closes the scenes horizontally. The figure of St. Catherine has glass inlays in the form of cabochons, like the carved Madonna statues of the time.

The shape of the pediment and the base, and the tripartite division of the picture area with flanking scenes, both point to a second model, which fortunately has also survived in Pisa: the feast image of St. Francis for the church of the other mendicant order (163 × 129 cm). The latter may even have occasioned an immediate response by a Dominican image, for it precedes the other by only a few years at the most. Two of the six miracle scenes are taken from the book of miracles by Thomas of Celano, which was not completed until 1252.[7] The panel in Pisa remains faithful to the earliest conception of the Franciscan feast image. It survives in the 1230s in two examples at Pescia and S. Miniato, whose common format and minimal variations with each other reveal a kind of series production of this panel.[8]

228

The official icon of the Franciscans, the first standard of a cult image produced in Italy, was fully developed surprisingly soon after the canonization of St. Francis in 1228. Unlike Catherine of Alexandria, who had long figured as a saint in Eastern icons, St. Francis was not only a contemporary but a saint of a new type, and he could no longer be represented by the established iconography. This difficulty necessitated the invention of a new kind of saint's image, which also would provide a welcome opportunity for adapting the likeness of St. Francis to the wishes of his order.

The saint is seen wearing the rough cowl with the rope around the waist, which made plain the order's poverty. As the founder of an order, the saint not only represented himself but embodied an ideal of the Franciscan friar. That is why he holds the book of the Gospels, which the order claimed to know best and to live by. The controversial right of lay monks to preach was no less alluded to than was the equally disputed life of evangelical poverty.

The Pisan image was meant to witness the very sainthood of St. Francis, which at the time was hotly debated. The revolutionary who had challenged the official church was in fact canonized only two years after his death, after the "novelty of the miracle" (*novitas miraculi*)—the wounds of the nails and lance of Christ that were visible on his body—had caused a sensation.[9] As this privilege had been bestowed on no saint before him and as it had turned Francis into a living effigy of the crucified Christ, it met with disbelief on the part of the church and even of the order itself. It is therefore this very miracle that the image propagated, in that it identified the saint through the stigmata and thus demanded loyalty and even a confession of faith from the beholder. As it challenged the contemporary beholder, the image even suffered from violent acts against the stigmata, whereupon the latter would occasionally start to bleed.[10]

The image takes care to be as authentic as possible in terms of the appearance of the saint and thus not to avoid the controversial features of the holy monk but to insist on them on behalf of the order. The partisans were given an opportunity to demonstrate their loyalty before the image. There was a need for such manifestations at a time when the order was enlarging its churches and sought to extend its influence. As it possessed no body relics of the saint apart from the tomb at Assisi, the archetype of his "portrait" came under pressure from two sides. It depicted a contemporary

whom many people had seen with their own eyes, and it was committed to the ideal of the "new man," who had become an imitation of Christ in an unexpectedly concrete way.

The similitude that each icon claimed to offer thus was based on two different ideals, even if it concerned one and the same person. The ascetic monk with the tonsure and the emaciated face conforms to clichés then current in saints' legends, as Gerhard B. Ladner has shown from the vitae of St. Francis.[11] The beard, much discussed at the time, may also have been part of this characterization, which finally aimed at the *type* of a saint, or made St. Francis a type. The other ideal that gave the image of St. Francis its true dimension was the saint's striking resemblance to Christ, which was so heavily debated and raised difficult problems as to how he should be aptly portrayed. The obvious proof of this likeness was the wounds of Christ, which had turned the saint into the living image of the Crucified, an image of suffering. The wounds were also miraculous signs, the cult of which was promoted with the touch relics of the blood-soaked bandages.[12]

The image not only characterized the saint but offered the material proof that in fact he was a saint. Miracles, in this case, were needed as certification of holiness, and after his death St. Francis had performed such miracles as always testify to divine approbation. The texts that described the miracles were appended to the vitae, and the narrative scenes appended to the saint's image served the same purpose. The Pisan panel of St. Francis, which devotes all six accompanying scenes to the miracles, thus presents the saint as miracle worker and not as one who lived an angelic life, so that it subscribes entirely to propaganda proving his sanctity.

The image, seen as a whole, invited the contemporary beholder to compare it with other images of saints and to distinguish its common features from those that were peculiar to it alone. Just as St. Francis had received his special place within the life of the church of Rome, so his image was given a place of its own among the familiar images in churches. The saints who figured at the altars of the old monastic orders usually appeared in the same position on the antependium, which covered the entire width of the altar below the altar table.[13] There they were enthroned amid scenes from their lives. This familiar situation was twice chosen for St. Francis as well but remained an exception in Franciscan practice. On a panel commissioned for the lower church at Assisi, he is shown as a standing figure in the same position.[14]

The main type of Franciscan icon, however, is distinguished by two features that are unique among related images of the time. The frontal figure of the saint, with or without flanking scenes, projects into a pediment that surmounts the image above. From the very beginning the panels were placed on top of the altar table and not below. The origin of both of these distinguishing traits is, as Klaus Krüger suggests,[15] to be seen in the old shrines of the Virgin that also ended with a pediment and occupied the same position on top of or behind the altar. They enclosed a sculpture that opened behind wings with painted scenes from the Virgin's life and occasionally lent their structure to images of saints.[16] Painted images of the Virgin, which later came in use with the Franciscans, inherited the type of a shrine with closing shutters and thus

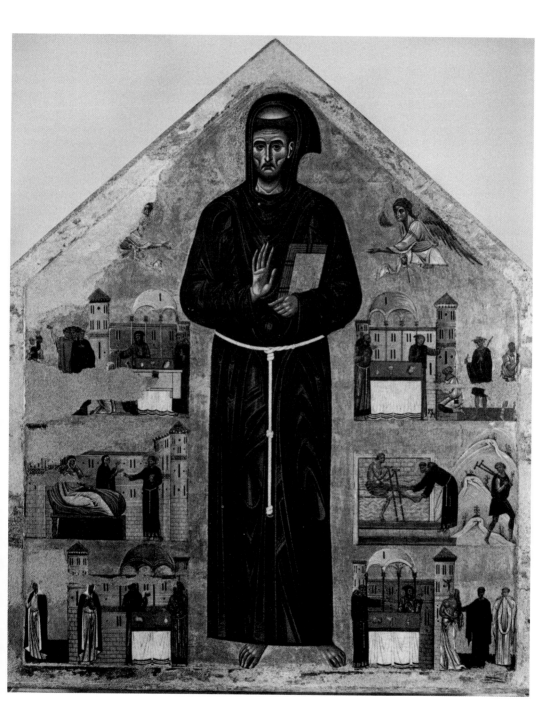

can be seen as an intermediary link connecting the old shrines with the new Franciscan icons.[17]

The Franciscans rejected three-dimensional sculptures, which rigorist orders had placed under taboo by the twelfth century,[18] and instead chose the medium of the icon with a gold ground, while abandoning the movable wings. As only the stationary altarpiece needed a firm installation on the altar table, the Franciscan image, which was meant initially for a temporary exhibition, could do without shutters. Instead of being closed or opened at the same site, it was moved around and shown only during special feasts. In contrast, the painted triptychs of the Virgin that the mendicant or-

229 ders owned instead of shrines continued to be fitted with folding wings, as they were set up permanently but were not always to be visible (sec. b below).

The Franciscan icon well illustrates the genesis of a Western icon that did not hang from an iconostasis but stood on top of an altar. Its invention proved to be of such success that the Franciscans also used it in occupied Constantinople. In the church they owned there, they filled the apse of a small chapel with the tripartite schema of the Western panel, which did not suit the site at all.[19] When the city was reconquered in 1261, the Greeks bricked up the chapel and painted Greek saints onto the new wall.

At the Franciscan feast days, the painted likeness of St. Francis appeared on the

241 altar as did a further likeness of the Crucified, who was seen on the panel cross over the entrance to the chancel. A dialogue was opened between two images that were highly important for the Franciscan order. The Dominicans, by contrast, had little to offer in reply to the stigmatized Francis. They did not set out general rules for the cult of their founder until after the middle of the century, and then simultaneously with inaugurating his feast day.[20] Earlier, in Pisa, they had selected the church patroness St. Catherine for an attractive icon meant to impress the city population.

The Franciscans invented a type of image that represented their founder, but they changed the pattern whenever the interpretation of St. Francis required it. In S. Croce

231 at Florence, although they preserved the general layout,[21] they shifted the emphasis to scenes from the biography, which now surrounded the saint on all three sides. The sequence follows the order of readings on the saint's feast, when the panel was set up as a festival image.[22] The saint's resemblance to Christ is boldly extended, as St. Francis, like Christ, makes a gesture of benediction, and from the top compart-

232 ment the hand of God lowers a text that introduces St. Francis with words similar to those with which the voice of God, on Mount Tabor, introduced his transfigured Son: "Listen to him, who proclaims the *dogmata* of life."

b. The Panels of the Confraternities in Siena and Florence

It remains a legend of art history that the large Tuscan panels of the Virgin were created for a high altar, simply because their size increased almost fourfold within twenty years. It is true that Vasari saw a few of them in this position, but that was three centuries later.[23] There is absolutely no evidence from the thirteenth century to

240 support such a view. The largest panel of all was commissioned from Duccio for the chapel of a confraternity.[24] The obsession with an ever-increasing size instead served

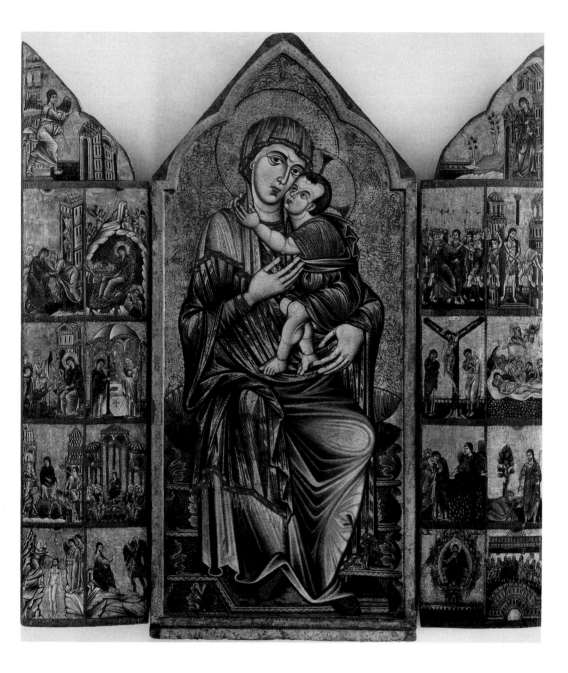

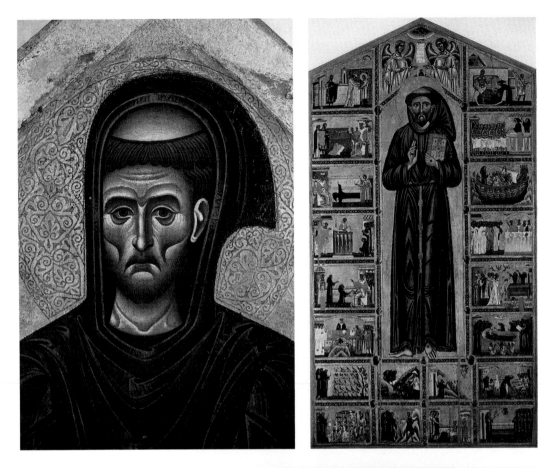

230. Pisa, S. Francesco; feast-
day image of St. Francis (detail
of fig. 228)

231. Florence, S. Croce; feast-
day image of St. Francis,
13th century

232. Florence, S. Croce; feast-
day image of St. Francis (detail
of fig. 231)

the rivalry between religious lay societies; these were often hosted by the mendicant orders and as a rule commissioned the larger panels. Many of these societies sprang up in 1261, a crisis year when religious unrest sought an outlet in the flagellants' movement. Others, like the Franciscan confraternities or the Laudesi, were of earlier date. They dedicated themselves to the cult of the Madonna as much as did the lay order of the Servites, or "Servants of Mary," founded in Florence in 1233, and engaged in a special use of images from early on.[25]

In 1261 "Coppo of Florence" painted for the Servites in Siena a work with which the known history of the large Marian panels begins.[26] The order may have owned an earlier image at its main center, SS. Annunziata in Florence. Soon afterward, Coppo, commissioned by a Florentine priest named Ristoro, painted another Virgin panel for the Servites' church in Orvieto, completed about 1268.[27] Coppo's Madonna Enthroned (225 × 125 cm) became so popular in Siena that it served for decades as a model for other paintings. Nevertheless this Madonna cannot be considered the archetype of the entire genre. 235

Panels of the Madonna Enthroned, which were then no longer a rarity, are usually much smaller, however, and differ from Coppo's work in an important feature that immediately made them appear archaic. In a strictly frontal arrangement, both Mother and Child are placed rigidly on the central axis. The nimbus extends with the head beyond the top of the frame, as in some panel crosses, and permits the figure to project from the framing device of the picture surface. Compared with the rigid frontality, which eliminates any interaction between Mother and Child, Coppo's panel proves to be truly innovative. The earlier type had been introduced in Siena and Florence long before the middle of the century. A panel in the Chigi-Saracini Collection (93.5 × 51.5 cm) seems to represent a very old version from Siena.[28] About the middle of the century a number of similar panels apparently were produced at Florence, and one of them was placed on the altar of the Virgin in the crypt of the cathedral of Fiesole.[29] 236

These works are based in their turn on others still older, which represented the tradition of Romanesque Mary-*Maiestas* sculptures, a tradition that was widespread in Tuscany as well (chap. 14b). An outstanding example of the Throne of Wisdom, now in Berlin, was carved and richly gilded in 1199 by a priest named Martin for the Camaldulians in Borgo S. Sepolcro.[30] It was intended to be hung over the altar and slanted from the wall toward the beholder. The Mother wears a short, light veil, and beneath her mantle she has a short overgarment of liturgical cut. It is a type of Western cult figure that stands in total contrast to the Eastern icon. 233

Its translation into painting is nowhere more evident than in a masterpiece attributed to Coppo, which is a hybrid of sculpture and painting. The Madonna of Mount Carmel in S. Maria Maggiore in Florence has the main figure projecting as a relief from the picture surface, reminding us that it was once a sculpture.[31] The throne and the angels guarding the figure, in contrast, are painted. The broad frame with all twelve apostles is copied from icon painting, so that two different traditions enter into synthesis with one another. The image is adapted to a position over the altar by an increase in size (250 × 123 cm), but even more in the newly introduced socle area, 234

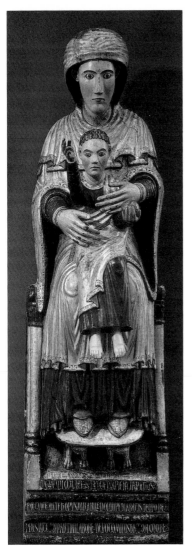

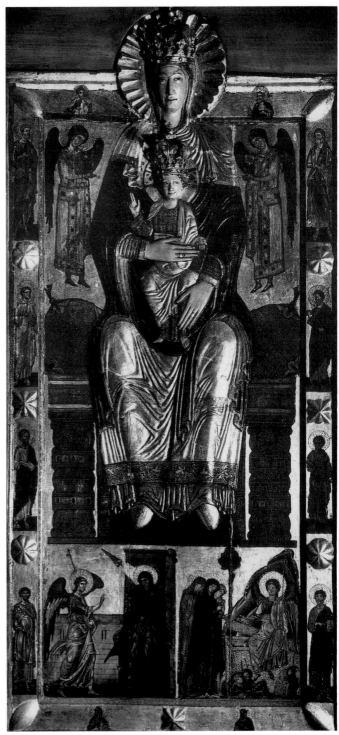

233. *Berlin, Staatliche Museen Preussischer Kulturbesitz; Madonna and Child from Borgo S. Sepolcro, 1199*

234. *Florence, S. Maria Maggiore; Coppo di Marcovaldo, Madonna panel, 13th century*

which raises the figure of the Virgin above the altar table. Its two scenes of the Annunciation and the visit of the holy women to the empty tomb narrate the Incarnation and the revelation of divinity in the Son of Man. In the image at Greve the corresponding zone is totally devoted to the Annunciation.

The genealogy of the sculptured and the painted images of the Virgin Enthroned has not escaped scholars, but it has not yet received a convincing explanation. Henk van Os already has pointed out that the statues of the Virgin enclosed in pediment-shaped shrines, when they were open, presented the Child in the manner of the priest offering the host.[32] In 1215 the Real Presence of Christ's body in the Eucharist had been promulgated as a dogma. From then on, van Os believes, the Eucharistic act at the altar needed some emphasis, which permitted the painted shrines and their decorated doors to function much like a stage set.

The use of shrine images with closing doors was more widespread and existed longer than we believed earlier.[33] In the province of Latium the door wings were normally carved, while in Tuscany they were painted to show scenes from the life of Christ. The shrine figure was functional in that it could be permanently installed but be shown only on feast days. This practice had long been an indispensable staging in order to have the venerated image appear in a ritual context.[34]

While the shrine sculpture continued to find favor with the old orders and the ordinary clergy, the mendicant orders clearly soon preferred the painted version, which could also be closed. A large triptych (215 × 190 cm) commissioned by the Franciscans at Perugia about 1270 was painted but could also be closed like the earlier image shrines.[35] The gabled shape recalls its predecessors, as do the wings with their double rows of images, but they can no longer be folded on themselves. The icon of the Tender Mother (chap. 17c) is here for the first time used for an altarpiece. Coppo prepared this revolution of the image in 1261, and for the cathedral at Pistoia he later produced a triptych with scenic wings, which according to old reports showed the Tender Mother "with the Child clinging about her neck."[36]

When Coppo was working for the Servites in Siena, he was familiar with the Romanesque figures of the Virgin, both in the painted panels already discussed and, in an earlier version, as a wooden figure, of which examples from the Siena area survive.[37] In the cathedral itself the same type of image is reflected by the derivative form of the "Madonna with the *occhi grossi*," which adorned the high altar as an antependium in 1215.[38] In its hybrid form, combining sculpture and painting, and in its rigid frontality with projecting nimbus, it reproduces a *Maiestas* sculpture lost today that was eclipsed by later cults. Once the memory of this sculpture was gone, the commemoration of the victory over Florence in 1260 was associated with the antependium, in front of which Buonaguida is said to have performed the consecration of the town to the Virgin, recorded in Ventura's chronicle.

Seen against this background, the audacious break with tradition that Coppo achieved in 1261 with the Servites' Madonna can be properly appreciated. The enthroned figure is retained, while the format of the panel is increased beyond all prior dimensions. At the same time Coppo introduced the iconic motif of the *Hodegetria* that imparted movement to the image. As this formula had been developed only for

half-length icons it offered no solution to the problem of how to extend its sideward turn to the seated figure. For this reason the Child does not sit on his Mother's lap, as one would expect, but on her left arm, as in the prototype. The old enthroned figure for the first time adopts the features of the "speaking" icon, in which the two figures interact as if in a conversation.

Coppo takes care to mask the problems of rendering an icon as an enthroned full figure by a heavily agitated drapery in the lower parts of the figure. The white cloth on which the Child is sitting fills the gap between the arm holding the Child and the knee, where the Child should have been placed. Here artistic and practical interests go hand in hand. This unusual cloth makes sense only if it is related metaphorically to the altar cloth, or *corporale,* on which the consecrated host (*corpus meum*) was placed. Consistent with this signification is the blood-red scroll in the Child's hand, which refers to the divine Word in the guise of human flesh and blood (chap. 13f). Finally, in a very personal manner, Mary is touching the Child's foot, instead of pointing to him. Perhaps the gesture suggests a petition through prostration at his feet, but that must remain conjecture until we know more about the language of such gestures. The light-colored veil, finally, is borrowed from the Romanesque *Maiestas.* The overpainting of the faces in the fourteenth century will be considered in conjunction with Guido's Madonna.

Coppo's image combines the indigenous *Maiestas* with the Eastern *Hodegetria* to give, as it were, a concentrated effect. Perhaps it was necessary to quote an icon in order to renew the rhetorical impact of the familiar cult image. Perhaps there was an allusion to a particular example, which Coppo combined with an equally well-known enthroned figure. For images were not freely invented but derived their authority from allusions and partial quotations. After all, they existed not merely to be admired but to provide comfort and help. It thus was desirable always to maintain links to previous icons through which the Madonna had already demonstrated her power.

If we are to believe a later legend, the *Hodegetria* icon became popular in Siena by way of the official image of the city's patron saint, which had been placed on the high altar of the cathedral since the 1260s in fulfillment of an oath sworn by the city.[39] In fact, it seems to have been the first altarpiece of the cathedral. The Madonna del Voto reproduces an Eastern icon, without borrowing from the tradition of the *Maiestas* statues. From now on its gesture of the right hand enters the re-creations of Coppo's image of the Virgin Enthroned, so that the two famous archetypes are henceforth linked, in the replicas, in a kind of double identity.

In the next twenty years the development of Siena's Madonnas is linked with the name of a single artist, Guido, but we have long known that several significant painters were involved.[40] The two versions that shaped the image of the Madonna in the age of Guido both survive in the originals, on which all the other examples depend. The older image was commissioned in 1262 by the confraternity of S. Maria degli Angeli, which at the time "owned a single altar in their small chapel,"[41] which was later renamed after St. Bernardino. Its cult image, now in the Siena museum, survives only as a torso, but its appearance can be reconstructed. A restoration revealed the old pediment and traces of the former wings.[42] It is worth mentioning that the image,

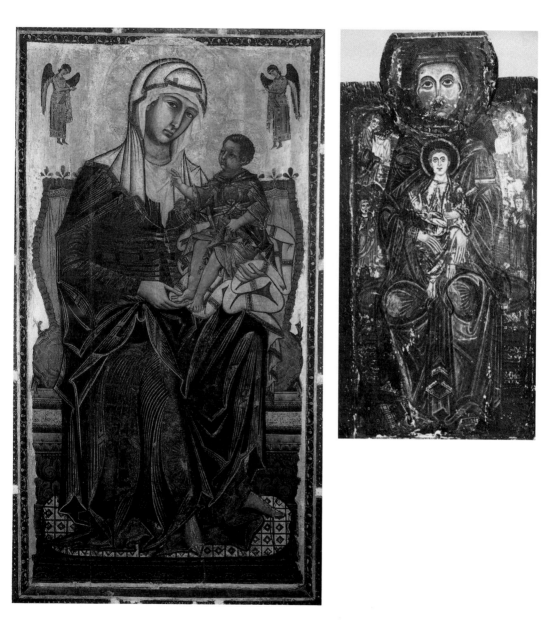

235. *Siena, S. Maria dei Servi; Coppo di Marcovaldo, Madonna panel, 1231*

236. *Chigi-Saracini Collection; Madonna panel from Siena, 13th century*

237. *Siena, cathedral; Madonna del Voto, 1261*

238. *Siena, Pinacoteca Nazionale; Madonna from S. Bernardino, ca. 1280*

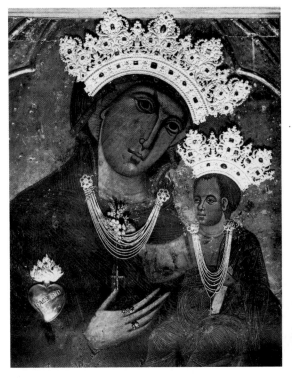

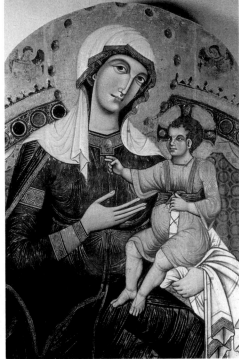

once even larger than Coppo's work, was commissioned by a Franciscan confraternity. The replica in Arezzo, which also had wings, was kept in the local Franciscans' church. There must have been a confraternity there too, which desired a similar cult image for its chapel in the Franciscans' church and therefore had a duplicate produced in Siena.

The former triptych in Siena was more than ten years younger than Coppo's work for the Servites. The date 1262 that once was reported for the image has been 235 unmasked as a later addition. The painter reinterpreted Coppo's panel (chap. 17d) but nevertheless quoted it respectfully in his use of the key motifs. These include the light-colored veil and liturgical cloth, which now falls in soft folds behind the bare legs of the Child. The throne has a vast round back studded with glass ornamentation. The angels are enclosed in medallions, which fit well under the former pediment. Only Mary's gesture has a different model, which can be identified with that of the old cathedral image of the Madonna del Voto. Clearly the new work was shaped not only by the rivalry of the painters but by that of the patrons as well.

But the rivalry went further when a Dominican confraternity took up the challenge and commissioned Guido to outdo all previous cult images once again. The result—the Madonna now in the Palazzo Pubblico, which once stood in S. Dome- 239 nico[43]—was larger in size than anything ever before painted in Siena. Its additional top section brings it to a total height of 362 cm. Now the pediment is a panel in its own right, with the theme of the divine Logos, who, as on the panel crosses, contrasts with the humanity of Christ's earthly life. Other images, too, were given such pediments at this time, as we know from two Sienese pediments, now homeless, showing the Coronation of the Virgin and the Crucifixion.[44]

Guido's Madonna from S. Domenico appears under a tripartite arc, in whose spandrels the earlier pair of angels has been increased to six angels, bending down with vigorous beating of their wings. The former wings cannot be reconstructed with certainty. As the outward data of the work indicate a desire to outdo everything else in town, the conservatism in terms of type and identity of the Madonna is all the more surprising. The only exception is the Child, who lies back in the crook of his Mother's arm to meet her eyes. This may have been, as in Duccio's Madonna of Crevole, an attempt to introduce rhetorical means and also to allude to the sleep of death in the Passion (chap. 13f).[45] Guido's new image was also disseminated in replicas that 176 sometimes are reduced in size. The copy that went to the Augustinian hermits at S. Gimignano represents the order by two supplicant figures kneeling at Mary's feet, which indicate a dating after 1269.[46]

In the early fourteenth century Guido's work from S. Domenico underwent some noteworthy changes that clearly reveal two opposed tendencies of both innovation and conservatism. As also happened with Coppo's picture, a pupil of Duccio's renewed the faces, which are of paramount importance in any icon. This alteration was not meant to modernize the old-fashioned style of the original faces.[47] Rather, it corrected the faces according to the new *Maestà* that Duccio had meanwhile painted for 246 the cathedral, thus conjuring the official identity of the "Holy Virgin of Siena," as the cathedral authorities called the city's patron saint. At the same time, however, a

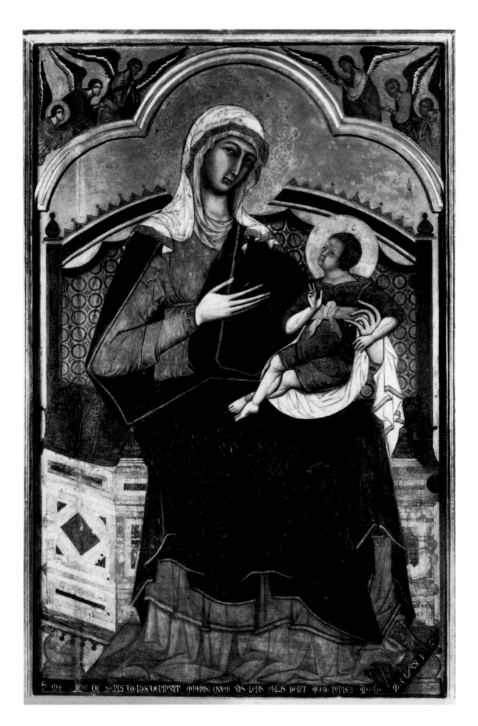

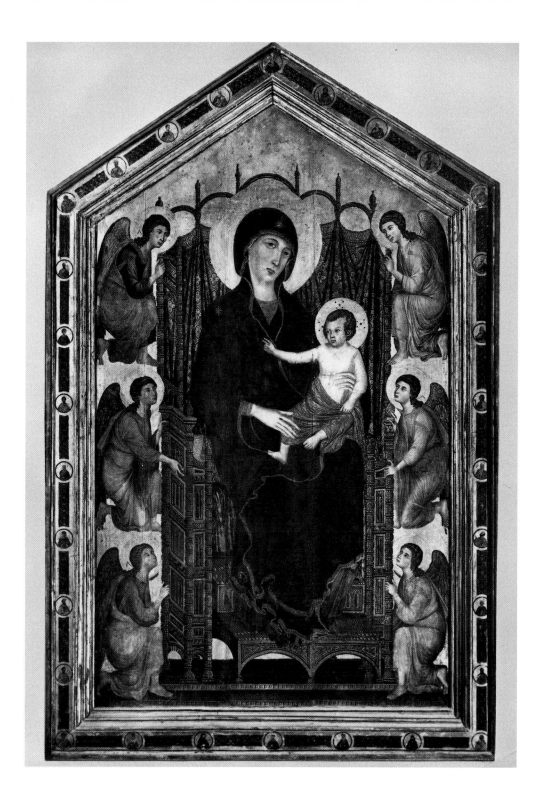

395

forged inscription with a faked date paradoxically dated the picture back to 1221, the year of the death of St. Dominic, the order's founder.[48] This famous forgery, first of all, served the reputation of Guido, who painted the work in "the good old days" (*diebus amoenis*). But it also made the Madonna older than any other famous work in Siena. Duccio's image in the cathedral may have been more splendid, but it was, on this basis, 110 years younger. By this advantage in age, the Dominicans' Madonna laid claim to being the archetype of all other images. The dignity benefited the owner of the panel, as, by implication, it appeared to be the oldest confraternity of the city.

240 It is hardly a coincidence that a few years later an even larger panel was produced, again for the Dominicans, and this time in Florence. According to the surviving contract, the Laudesi, a confraternity located in S. Maria Novella, gave the commission to Duccio in 1285.[49] What could have induced the Laudesi to aim so high and to break all records, if not competition with their peers? Indeed, the painting openly alludes to its model in Siena and, at the same time, beats it by its size and novelty.

The shape of the "large panel," as it was called in the contract, was prescribed to the painter, who received it ready-made from the confraternity. At 450 × 290 cm it was exactly twice as large as Coppo's Madonna of the Servites, a third larger than Guido's Madonna in Siena, and almost four times as big as the Madonnas from the beginning of the century. A heavy frame provides enough room for the whole cult program of the order to be painted. With this format there was no place for wings. The contract required the artist to paint the work "as beautifully as possible [*pulcherrima pictura*]." He was to "adorn it with the figure of the Blessed Virgin Mary, her almighty Son, and others at the will and pleasure" of the patrons. He had to "gild the panel at his own expense and [guarantee] the beauty of the whole as of the details [*et omnia et singula*]."

"Beauty" (*pulchritudo*) here is not merely a word but sums up the artistic merit of the contract from the competitive aspect. In size, as in its novel conception of an old theme, the panel was to win first prize. Thereby it would please the Madonna and enhance the prestige of the Laudesi, who needed the image to represent their authority. From 1312 on, a lamp always burned before the image. In 1335 the image had to leave the chapel, which then was acquired by the Bardi family.

The confraternity chose a Sienese painter because Siena had taken the lead in the genre of the monumental Marian image. They also decided on the unusual form of pediment, as they delivered the panel to the painter, and also on the high-backed throne and the six adoring angels known from Guido's work. The format was forced into almost absurd dimensions, so that the painter had trouble filling the entire area without turning the main figure into a colossus.

Duccio's ingenious solution makes us forget the problems he faced. The former angels of the spandrels are now incorporated into a unified image and carry the heavenly throne down to earth, as if staging the act of a ritual appearance on the actual cult site where the confraternity accommodated the image. The six angels, who form a heavenly ladder like that in Jacob's dream, also have an artistic function, filling up the space that is left free from the throne. The ornately turned elements of the throne, an allusion to the old wooden statues, fill the rest of the picture and help to reduce

the scale of the Madonna in relation to the panel. She is thus enclosed, one might say, in a double passe-partout. The footstool reconciles the spatial perspective, with which all of Duccio's predecessors had their difficulty, and the required frontality of the figure. By lowering her foot to the bottom step of the stool, the Madonna turns her body movement back to the central axis.

But this motif also contributes to the meaning of the picture, which becomes evident from a comparison with a small panel that Duccio painted for three Franciscans.[50] In the private devotional image—a variant, incidentally, of the Madonna of the Protecting Cloak that was common among Eastern Crusaders[51]—the Virgin's foot is kissed by the private owner of the image. In the public cult image she also offers her foot, to the public in general and the corporation in particular, for a symbolic kiss.

The reader may be disappointed to find the author lingering over such motifs without talking about Duccio's art as such. But this is not the place for such discussion, since this book is concerned with images, which were all conceived in relation to each other, rather than with artists. We approach the mentality of the time when we look for the presence of the old in the new and pay attention to the continuity of types and gestures in the "holy images," as Weigelt did earlier.[52]

Seen in this light, Duccio's work confronts us with an anomaly that seems to contradict our argument. The Child no longer sits on the liturgical cloth, which no one in Siena was allowed to forgo, and Mary no longer wears the white veil that always drew attention back to Coppo's archetype in Siena. But what seems to be a *235* contradiction in fact confirms our thesis, if one considers that while Duccio's work arose out of rivalry with Guido's, it was intended for Florence, where Sienese cult images had no authority as types, though they may have commanded attention as rivals.

This conclusion can be further tested by including Mary's gesture in our consideration. It abandons the motif of the raised hand, which in Siena was always associated with the old image of the Madonna del Voto in the cathedral and never with *237* Coppo's panel. Instead, the Madonna touches the Child's knee in a way similar to her touching of Christ's foot in the Florentine Coppo's painting in Siena.[53] This tender *235* touch is not as unambiguous as one might suppose, for the Mother's intercession was still the most important aspect of the picture. But we have, as yet, little insight into the language of gestures. For this reason we cannot explain why the old types disintegrated in Siena after 1300. All the same, the gesture of the old *Maestà* is still so discreetly present in Duccio's new *Maestà* (1311) that one can only wonder at the *246* subtlety of such nuances.

The sequence of large Marian panels, which also was an evolution of the genre in question, should not be misunderstood as a transition from the icon to the altarpiece. Though their format grew to enormous height, these images were not meant to occupy the high altar but were commissioned either by the Servites or by the confraternity of S. Maria degli Angeli (S. Bernardino) and the Laudesi. The confraternities, which assembled in the churches of the mendicant orders, had both the financial means and the motives to show off their status with such pictures. Even the gigantic

panel painted in Cimabue's workshop, now in the Louvre, would have gone to a confraternity, which had its cult image in S. Francesco in Pisa. This may have been different in the other orders. For example, Guido painted a Madonna for the Augustinian hermits of S. Gimignano, and Cimabue painted one for the Vallombrosian monks in SS. Trinità, while Giotto painted an early work for the Humiliati at Ognissanti in Florence.

The Marian panels were ill suited to the regular liturgy, one reason being that they had only a single theme. Furthermore, if they had no wings, they could not be set up permanently in the church body, where they would have become a too-familiar sight. By giving up frontality, they also lost the Eucharistic symbolism of the early statues. Instead, they concentrated on the intercession of the Virgin. In such a picture, a confraternity could advertise itself and take pride in "their" Madonna, who differed from others. The history of the confraternities was also linked to these images, as the forged inscription may prove.

The competition between confraternities also led to strife, sparked off by the cult practices associated with the images. The wall painting of the Virgin that attracted much attention in the civic loggia at Or San Michele in Florence became famous in 1292 by healing the sick.[54] In the same year a special confraternity began organizing its cult. Statutes determined how and when the curtain was drawn before the image, and the disgruntled Laudesi complained of unfair competition. But things went further. After a fire in 1307, Ugolino of Siena painted a new miraculous image, but it was not spectacular enough for the new hall built in 1337. In 1347 Bernardo Daddi thus was finally commissioned to produce the present image. The ample income during the plague year was used to pay for Orcagna's magnificent marble tabernacle, which looks like a small temple for the image. It is, of course, not a high altar.

In the meantime the town itself, in competition with the confraternity, was taking advantage of the opportunity to demonstrate civic piety. The festivities culminated in the consecration of the town in 1365. The performance of the *laudi* was organized by the state, which in a decree of 1388 ordered "all the flute and violin players under the jurisdiction of the priors to appear on Saturdays at the Corn Exchange."[55] Things had reached this point much earlier in Siena. As early as 1302 Duccio painted a large Marian panel (*Maestà*) for the chapel of the town hall, which evidently far outdid all the cult images of the confraternities.[56] Soon afterward, in 1308, the *opera* of the cathedral, a civic authority, commissioned Duccio to paint a high-altarpiece that was to be the most original panel painting of its time, and probably the most expensive as well. It was the first successful application of the full-length Marian panel to a high altar. However, the figure of Mary here appears much like a picture within a picture, since the very different structure of the altarpiece did not allow an easy integration of her image (sec. d below).

245

c. The Altarpiece

After consecrating their city to the Virgin, to whom they attributed their victory over Florence in 1260, the Sienese commissioned a permanent altarpiece (the first of its kind) in the chancel of the new cathedral to be venerated by the commune as the

official cathedral image. The cathedral may have possessed a sculptured shrine Madonna; it certainly had the old antependium, which was promptly reconsecrated as an altarpiece.[57] It became an altarpiece simply by being moved on top of the altar, without changing its appearance.[58] As this could not be a permanent solution in Siena, however, soon after the consecration of the cathedral in 1267 an altarpiece was designed to fill the position on the high altar.

Within forty years it already had to make way for Duccio's *Maestà*, when it was dismantled, leaving only the central icon, which kept the memory of the town's consecration (*voto*) during Siena's heroic period.[59] The half-length *Hodegetria* still shows traces of the arch that once separated it from the rest of the icons, and in turn was surmounted by a gable. A recently discovered altarpiece in Colle di Val d'Elsa gives an idea of the original layout of the whole.[60] A shallow pediment connects five icons that are separated by false arcades with small columns. The same structure recurs in the altarpiece painted by Deodato Orlandi for the Dominicans in Pisa in 1301.[61] In Siena, a number of replicas, in simplified form and without columns, already in the 1270s repeated the recent model from the cathedral high altar.

One of them is regarded as the work of Guido, although the artist's name and the date were lost when the two ends were sawed from the panel.[62] The Madonna is flanked by the two Johns and by Mary Magdalene and St. Francis, all the figures bending toward her. Only the frontality of St. Francis alludes to the order's icons (sec. a above), from which the low, many-figured altarpiece so clearly is distinguished. The Madonna at the center is a half-length figure, like the one in the cathedral, and also raises her hand as she does in the *Hodegetria*. Yet in her white veil, introduced once by Coppo, and in further details of her clothes, she resembles the former triptych of the Franciscan confraternity (S. Bernardino) such as to reveal her true model.[63]

The cathedral icon of the Virgin once was surrounded by the four male patron saints of the city, who join the city's patroness, Mary, as advocates of Siena also in the chancel window and in Duccio's *Maestà*.[64] All three works have been commissioned by the city. One can even speculate that the group of these five patron saints provided the inspiration for the structure of the altarpieces that followed this archetype. The male saints that at first occupied four side altars joined the main patron in a group portrait of the city's saints on the high altar. Given the varieties of the liturgical year in an episcopal church, the decision to include the civic saints in the cathedral image comes as a surprise.

In subsequent images the town's saints were sometimes exchanged for others, but the Madonna continued to keep the central position, this structure becoming a Sienese form of altarpiece that deviates in content from the respective icon friezes on altars in Pisa and Florence. An example in Pisa painted for S. Silvestro frames the icon of Christ with the deesis,[65] which used to form the center of the Byzantine iconostasis (chap. 12d). A parallel from the Mount Sinai monastery[66] was a painted entablature mounted above the altar screen.[67] The Western image that occupied the altar table alludes both to the shrines of the Madonna and to the earlier icons of the mendicant orders. The end positions are reserved for the church's patron saint, St. Silvester, and

237

3

242

228

238

245

3

4

226 the order's patroness, St. Catherine; the Dominican nuns received the early panel of St. Catherine from the Dominican church in 1331.[68] A retable in the Uffizi, according to the inscription painted by a certain Meliore in 1271, repeats the three figures of the deesis, this time with St. John the Evangelist.[69] The whole panel is made to look like a work of precious metal.

To sum up what has been said so far, we must keep in mind that the genuine altarpiece comes into being rather late and reveals itself as a result of several borrowings, ranging from the Byzantine iconostasis to the Romanesque casket shrine. But the final shape is explained solely by the place where it is displayed and by the function it served. Its function was to summarize, in a single work, the various cults of saints in a large church, the icon frieze being the form that fulfilled this function best. It placed in a row the icons of the saints, whose feasts were celebrated at the high altar according to the local plan.

This altarpiece, however, was still far from being the rule in Italy. The beam (or trabes) above the chancel entrance accepted not only the panel cross but other images that satisfied local demands. In 1274, for example, the cathedral authority of Pistoia commissioned from Coppo "a fine crucifix and two equally beautiful and venerable [honorabiles] panels in and above the choir."[70] The Virgin and St. John were to be depicted on the panels. Above the altar of St. Michael "a crucifix on a beam" of pine was to be painted. The figure of St. Michael was to have sculptured form. A fresco

241 from the Legend of St. Francis in Assisi[71] depicts the so-called tramezzo beam with a panel cross between a Madonna panel and a figure of St. Michael with cut out edges, a hybrid of sculpture and panel. The diversity of the images in a large church of the thirteenth century must have reached considerable proportions.

People soon became dissatisfied with the altarpiece as it had developed so far. The "dossal," as Garrison has provisionally called it,[72] looked far too modest beside the paintings of the confraternities. The competition between images, which represented different patrons, was renewed significantly in Siena. About 1280 a painter named Vigoroso exported the new type of Perugia.[73] It is characterized by a new zone of images placed above the icon frieze. Each icon has its own pediment, the Marian icon having a larger one. The upper row of figures, the Pantocrator between angels, also appears in the pediment of Guido's Madonna from S. Domenico, which was then a recent work.[74] The grouping of pediments draws our attention to facade architecture, which provided the vocabulary for the further elaboration of the altarpiece.

The weakness of the structure now became evident, as it could not be taken very

243 far within a single unit. The solution, best exemplified by a work in the museum at Siena,[75] was found soon after 1300 in Duccio's workshop as well as in Giotto's atelier.[76] The individual icons now occupy separate panels, joined in the back by transverse beams and distinguished by dividing frames at the front. This shape, which at first differed only in its carpentry, opened the way for the further development of the genre to what has the misleading name "polyptych," a structure that actually opens with folding wings.

243 An altarpiece by Duccio surprises us by the lyrical mood of the Madonna icon. The child is drawing his Mother's cloak to him in a playful gesture, which loosens up

her ceremonial posture. The motifs have been given a double meaning, both in a human and a theological sense. The colors with their pink tonality gain a strong emotive value. In the new generation the adherence to types is relaxed, giving scope for individual solutions of high poetic value. But the Marian icon's neighbors on the altar are not drawn into the emotive mood, presenting instead the Dominican order's most solemn front, as if the poetry of the main icon had to be balanced by their intensified authority. Peter and Paul at once guarantee the Roman church and confirm the order's authority, since they were said to have inspired St. Dominic to found the order. The altarpiece was clearly intended for the main chapel of S. Domenico, which raises the question of the role of the mendicant orders in the development of the new altarpiece.

If we look back once more at the beginnings, it was the Franciscans who first made the genre their own. Guido's dossal from the 1270s no longer served a confraternity but was placed on the high altar of S. Francesco in Siena or Colle di Val d'Elsa. At that time exceptions from the rule were still possible, such as the bilateral altarpiece in S. Francesco al Prato in Perugia, which was produced by the "St. Francis Master" of 1272.[77] It resembles a columniated sarcophagus with apostles, among whom St. Francis has been accepted, and on the reverse side intermingles Passion scenes with the saints and prophets. A sarcophagus from late antiquity, on whose style the altarpiece was modeled, contained the remains of St. Aegidius, a companion of St. Francis.

In 1302 Cimabue concluded an agreement with the hospital of S. Chiara in Pisa, represented by a Franciscan monk and "magister" named Enrico, for a retable on the high altar consecrated to the Holy Spirit.[78] They agreed on a "panel with columns, tabernacles, and a predella [predula]," on which the "divine Maiestà" of the Virgin, surrounded by apostles and other saints, was to be shown. In commissioning this altarpiece, the Franciscans were ahead of their time.

But in the same years the Dominicans took the lead. In Perugia they commissioned Duccio to produce an altarpiece, of which only the Marian panel survives.[79] The six angels who bend over the arched frame are a modernized variant of Guido's picture for the confraternity in Siena. The order's chapter of 1306 at Siena probably initiated the commission of the Perugia altarpiece, where the Dominicans could speak on their own behalf and no longer leave the initiative to the lay societies that they controlled.

About a decade later, and surely with a reference to Cimabue's retable in S. Chiara, the Dominican chapter in Pisa ordered the largest altarpiece ever acquired by a monastery church. As Duccio had recently died, the commission was awarded in 1319 to his pupil, Simone Martini.[80] S. Caterina, the order's church in Pisa, owned the early icon of St. Catherine, which we have already discussed.[81] In 1301 it was replaced by the altarpiece from the local master Deodato Orlandi (71 × 206 cm), which was probably the first regular altarpiece in the town, resembling, in its choice of saints, Duccio's Dominican altar in Siena.[82]

Simone's altarpiece, which followed in 1319, set a record in its dimensions (229 × 343 cm). It presents the new concept of a theological program in four zones of figures, which show a formal resemblance to a church facade. The Gothic cathedral

242

239

226

244

241. *Assisi, S. Francesco; fresco depicting the obsequies of St. Francis*

242. *Siena, Pinacoteca Nazionale; Guido da Siena, altarpiece, 1270s*

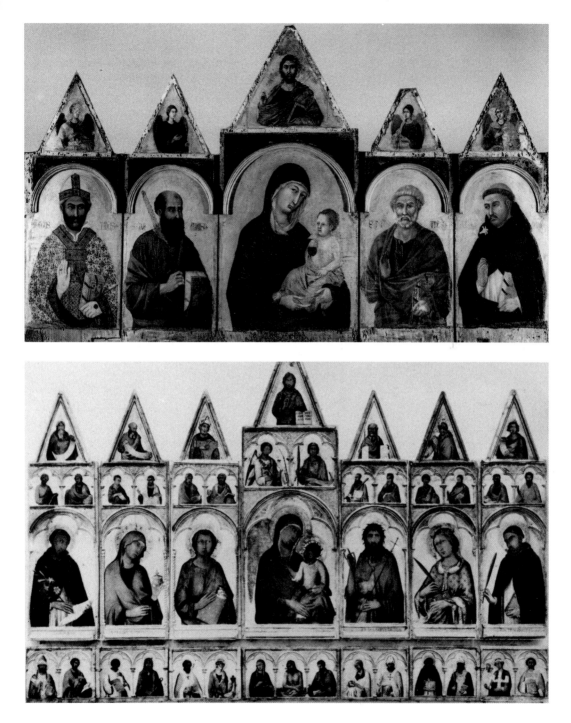

243. *Siena, Pinacoteca Nazionale; Duccio, altarpiece, soon after 1300*

244. *Pisa, Pinacoteca Nazionale; Simone Martini, altarpiece, 1319*

workshop had already provided Duccio's atelier with models for the frame motifs, which help to organize the content of the Pisan retable. The icons in the main zone illustrate the local cult program, which is based on the liturgical plan of the Dominican order. The three other zones enlarge this core into an overview of the order, within the context of the story of salvation and the church. They include the prophets in the pediment fields, the apostles in the gallery zone, and the saints (including the doctors of the church as well as Thomas Aquinas, not yet canonized) in the predella.

This is not the place to analyze this highly sophisticated program.[83] But we may notice the change in the use of the altarpiece that, compared with Duccio's retable, *243* displays the church's role in the plan of salvation by way of a picture wall like a pictorial sermon, as it had been in use on Gothic church facades. Within a well-balanced structure of ideas, the individual image loses its status as an icon and instead plays its part in the didactic promulgation of the faith, which the order subscribed to. This is the reason for the emphasis given to books, which all the saints are reading or writing. Vertical links connect the individual picture zones, in which the saints are characterized by their place in the plan of salvation rather than by personal qualities. Despite the brilliance of this contribution to the genre, one must also note the loss of the altarpiece's old function as an icon frieze. In the service of the theologians, the image here has become a means to an end.

In considering the early history of the altarpiece, one cannot fail to be surprised by the part that, after initial hesitation, the mendicant orders have played. First they displayed the images only at special feasts. Then they left the cult of images to the lay confraternities. Finally, they decided to use this medium for propaganda on their own behalf, as they had done earlier with the panel cross. In this effort they were dependent on donors, but more and more bishops emerged from their own ranks who used the income of their office to make contributions to their old monasteries. This relationship can be proved in detail in the case of Simone Martini's altarpiece for S. Domenico in Orvieto.[84] Gradually, the clergy at large responded to the competition, and in 1320 the bishop of Arezzo ordered a similarly expensive altarpiece from Pietro Lorenzetti. In the life of the towns, however, the advocates of the image up to then were the lay confraternities, in competition with the mendicant orders.

d. Duccio's Synthesis in the Altarpiece for Siena Cathedral

It has long been known that Duccio conflated two important traditions of the image for the high altar of Siena cathedral: the Marian panel and the altarpiece as polyptych.[85] But he worked on public commission and thus must have put into practice a program devised by the civic authorities. Such an image for the cathedral, sponsored by the town, was still unknown in Florence. At the time, cathedrals were under construction in other cities as well. In Florence, however, work on the facade did not advance very far. In Siena, too, the building of the facade gradually came to a halt. Soon the gigantic plan of using the central nave as the transept of a cathedral of unprecedented size had to be abandoned. In Lucca the cathedral was enlarged behind the new facade. In Pisa, where the existing cathedral could not be surpassed, the baptistery was completed and the Camposanto built. Giovanni Pisano created the chancel

and a new portal for the cathedral; above the portal an angel introduces a personifi-
cation of Pisa and the emperor to the Madonna.[86] For the facade in Siena, the same
Giovanni Pisano had produced the large cycle of prophets who had predicted the
miracle of the Virgin Mother, depicting above the main portal the Patroness standing
between the personified town and Buonaguida Lucari, who was credited with having
consecrated the town to the Mother of God in the cathedral.[87]

Duccio's cathedral altarpiece enters this larger context but as a panel painting 245
remains a singular exception. Its format (498 × 468 cm) again far transcended the
limits that had previously been set for panel painting. Also the synthesis of two genres
was unprecedented among altarpieces. The city authorities of Massa Marittima
attempted to have the work repeated, but the necessary expenses proved prohibi-
tive.[88] Duccio's masterpiece caught the general attention in all of Italy, and Cardinal
Stefaneschi commissioned an altarpiece that Giotto was to paint for St. Peter's in
Rome, in order to deprive Siena of the renown of having the finest altarpiece in the
world.[89]

The high altar in the Siena cathedral was the site of historical events that we know
only through the elaboration of later chronicles, which turned them into a city myth.
If we believe them, it was the main altar where, in 1260, Buonaguida had deposited
the town keys, entrusting them to the protection of the Virgin. The five-part altarpiece
with the Madonna del Voto and the town's four patrons, which had stood here ever 237
since, by now looked rather antiquated.[90] This was an excuse for the town to replace
it with a new altarpiece, which was to keep the five patrons of the old cathedral image
but rephrased them with a full-figure Madonna enthroned between the kneeling male
patrons of the town, thus differing from the chancel window of 1287, which also
represents the same group.[91] Duccio's altarpiece also includes the theme of the Virgin
as *Assunta,* as it concludes the front side with an eight-scene cycle on the death of
Mary at the top. The predella at the bottom was adorned with a childhood cycle
alternating with prophets, while the reverse showed an extended cycle from the life
of Christ. As only the main image on the front enters our context, we can leave aside
problems of reconstruction.

As is immediately apparent, the main image integrates two separate genres into
one. At the center the former panel of the single figure of the Virgin has even kept its
old pediment, which has the new function of staging the main figure as a borrowing 245
from other panels (chap. 18b). The broad format with its alignment of saints refers
back to the "polyptych," though the latter, as a rule, was confined to half-length icons
(sec. c above). The polyptych is quoted again in the frieze of apostles but now has
been transformed into a subsidiary motif. The full-length figure of the Madonna re-
quired a choir of saints, also shown full-length, for which there was no model in panel
painting, and inspired Duccio to risk an impromptu invention of his own. The saints
are the same size as the angels who gather around the marble throne. In the fore-
ground, the four male patron saints of the town shift the iconography from the uni-
versal church to the commune. The unique features of the cathedral altarpiece stand
out when compared with a normal altarpiece, which the patrons of the *Maestà,* the
Opera del duomo, also ordered from Duccio for the cathedral hospital.[92] The allusion

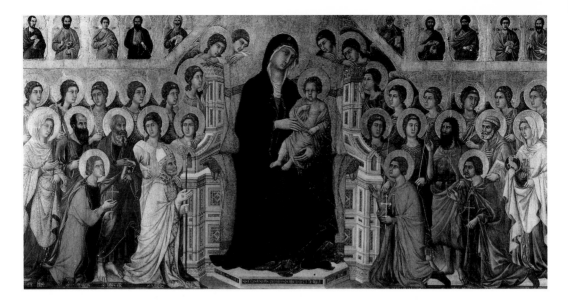

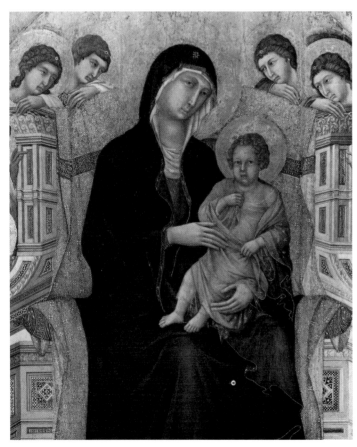

245. *Siena, Opera del duomo;*
Duccio, altarpiece for the high
altar, 1311

246. *Siena, Opera del duomo;*
Duccio, altarpiece (detail of
fig. 245)

to a norm that was at the same time transcended makes the new *Maestà* a complex phenomenon.

The old cathedral image provided the theme for the main figures but did not offer a model for the *Maestà* itself, which up to then had been a single image of the enthroned Madonna. One might wonder, therefore, whether Duccio was alluding to a *240* second model, a *Maestà* now lost, which the city's "council of nine" had commissioned from Duccio in 1302 for "the altar of the palace where they hold office."[93] The cathedral *opera* operated as a civic office, and in 1310 the city government intervened directly to speed up the completion of the new painting for the cathedral.[94] As the cathedral image was repeated by Simone Martini's fresco in the town hall, it is indeed also possible to discern a civic note in the model. It was precisely the Marian panel that had been a means of competition between the confraternities, before it had been usurped in 1302 by the city government itself. The large marble throne so characteristic of many works from Duccio's immediate circle, from Città di Castello to Badia a Isola, clearly derives from Duccio's image in the town hall. The frontal pose of the Child in this model was meant to remind the signori of their civic duties. In the same sense the Child in Simone Martini's town-hall image holds a banderole with an inscription admonishing the beholder to respect justice. The official tone that the Child adopts in the cathedral image is self-explanatory in this context.

Duccio's *Maestà*, which is neither an altarpiece nor a cult image of common type *245* but replaces such images, raises questions that we must consider further. When the city decided to have a new cathedral image, the altarpiece was ill suited to emphasize the Virgin as city patron but provided an opportunity for the city saints to appear in a panoramic image of the heavenly church. The Madonna was addressed as the main patroness of the city in the dedicatory inscription on the steps of the throne. The view of the altarpiece offered the impression that the heavenly court had assembled for the sole purpose of securing Siena's salvation.

Duccio had to swear "with his hand on the Gospel book" to comply with the contract he had concluded with the cathedral *opera* on 9 October 1308 to "paint certain panels intended for the high altar of the main church of S. Maria in Siena."[95] He promised to "paint it and make it as well as he [could] with the help of God." He committed himself not to take on any other commissions during its production, to work on it without interruption, and he was to receive sixteen soldi for each day "on which he [painted] it with his own hands." Two years later the government itself intervened to keep the cost in check and to speed up the completion of the "new and large panel."[96] In June 1311 the time had at last come to order the musicians who were to accompany the finished panel to the cathedral. This happened at midday on 9 July, in a festive procession in which the whole town joined, as Agnolo de Tura's chronicle reported some decades later.[97] It was unusual for an altarpiece, usually a part of the liturgical inventory, to be paraded at the center of a procession like a cult image, on the pattern of the celebrations of the confraternities. When it was finally installed, the *Maestà*, according to the written sources and views of the town from the fifteenth century, was usually concealed by curtains, as was the custom for a cult image.[98]

However, this poses the problem of how a cult image, as discussed in this book, is to be defined in this particular case. For an old "original" had been replaced by a new one whose very newness was emphasized, as well as the beauty created by the citizen Duccio. This new focus shifted the emphasis away from miraculous origins toward the cost of a gift, which the town offered in order to ask the Madonna for protection. A votive character distinguishes all Marian panels commissioned by the confraternities. The *Maestà* had an additional quality as an official gift from the city government, which reaffirmed the city's consecration to the Virgin by a votive image of a size and beauty unprecedented at the time. Thereby the twofold purpose of the early confraternity panels—both to enhance prestige and to affirm identity—was repeated on the level of the city and the state.

The inscription on the panel, one of the first of its kind, sums up its votive character with the inimitable succinctness of dedicatory inscriptions. It is not an artist's inscription but a prayer addressed by the town government to the Madonna, using the terms of the *laudi* and acclamations: "Holy Mother of God, be thou the upholder of peace in Siena and grant [long] life to Duccio, who has painted thee so [extraordinarily beautifully]."[99] Thus the city itself points to the value of the gift it made to the Madonna.

19. The Dialogue with the Image: The Era of the Private Image at the End of the Middle Ages

Most of the subjects discussed in what follows have been studied in depth elsewhere, for example, the devotional image, on which this author has written a book.[1] The stream of image production broadened and split into a number of channels that are hardly recognizable as branches of the same river. This invites us to draw together the different developments in order to discover their links, which tend to be lost sight of in individual studies. The purpose here is not to deal exhaustively with, say, mysticism or the winged altar, but to carry on our argument and to pursue further the long history of images and their use.

Once the era of the private image is viewed as a sequence to the period of the public image, the quantitative increase and the qualitative change that take place become evident, provided that we avoid seeing events as taking place in a late period, in the spirit of Huizinga. Only in retrospect does the rise of panel painting and the statue corroborate the common view that the Middle Ages were ending. In the history of genres these two art forms often mark the beginning of a path that, to be sure, soon reaches a threshold (to be discussed in the last chapter) when the image was to undergo a crisis at the same time as it was to adopt the status of art.

Our narrative now will become more difficult. Where there is no unity, we cannot strive for a unified argument. Contradictions are inherent in the picture that the new era offers us. The privatization of the image was part of what was happening: everywhere it came to the fore, even when the new images were still performing their old functions. In court circles, even the use of jewels in sacred art felt the pull of privatization. The old reliquaries are hardly recognizable in the playful forms of the new arts de luxe.

On its part, the public image fought a rearguard action by resisting the urge for almost unlimited change or, in another variant, by assuming a larger and larger scale. Whereas the private images served up one modernism after another, the old became a preserve of traditions in need of protection. Whereas the former tended more and more toward a pocket format, the latter, particularly the winged altars, grew larger as they were used by public sponsors for competition—much like the giant panels of the confraternities of the Virgin in Italy, which we have discussed (chap. 18b). As soon as the portable image spread to all the property-owning classes of society, whether lay or clerical, the church authorities were driven to keep things under control. The old now took on the appearance of a deliberate archaism, which was meant to counterbalance the continuous disintegration of what previously had been the norm of images.

The pluralism of society at the end of the Middle Ages is reflected in the confusing spectrum of religious images that were used. They either were to represent new religious needs, or else they were to serve new social groups that wished to stand out from others. As a result, the images passed from hand to hand, changing as they did

so. What distinguished the new images was their widespread availability. They side-stepped the old cleavage that had previously separated the sacred image from the common people, when institutions had complete control over images and relics. In the new era the institutions lost these privileges. They offset the loss, however, by making their own pictures more attractive and compelling, commending themselves either through such images as private citizens could not afford or through rare images with an aura conferred by age or authenticity. In this way they kept their hold on images as tools of grace and favor (indulgences) and clung to a power that the Re-formers would attack more than they did the images themselves.

In turning toward the new era, one is tempted to continue the narrative in the form of social history. One can also ask, however, what directions the visual media took in expressing the new functions. In some cases new techniques, such as the woodcut and the engraving, which allowed the production of cheap devotional ob-jects, were used to satisfy the increased demand for private images. A third direction in dealing with the new era may lead us to trace the pattern of an "inner develop-ment" of each genre and, as has been done often enough, to uncover the increasing realism and the psychological meaning of every kind of traditional content as the first steps toward understanding the art of the next age. I prefer to describe what happened as a conflict between the old practice of the image and the new character of art, and to carry our history to the crisis of the image at the end of the Middle Ages. Our first concern in what follows is to pursue further the overall argument and to locate the new images within the framework of the discussion up to this point.

In this framework, the private image now takes the leading position and thus challenges the authority of the old cult image. Although it did not always produce new themes, the private image did privatize the official themes in both form and con-tent (cf. chap. 17c). Individual citizens did not want an image different from the pub-lic one so much as they needed one that would belong to them personally. They expected the image to speak to them in person, just as the saints had experienced miraculous speaking images. Rather than wait for a miracle, however, citizens now wanted to carry on the dialogue in their imagination, with the help of the image. They thus demanded of the image a kind of painted act of speech, which henceforth would determine the aesthetic system.

The image's speech either was delivered to the beholder, or it occurred *within* the image *between* the figures, which were talking about the beholder. In this way the image forsook its traditional aloofness and was ready to address the beholder in a way that produced a private dialogue as it happens between living persons. In this way the image offered itself to the beholder's gaze and thus admitted a subjective moment that could lead to an anecdotal narrative for the benefit of the beholder. The old cult image, in contrast, steadfastly refused to allow its content to be manipulated by the wishes of the beholder.

a. Mysticism and the Image in the Practice of Devotion

Devotion as stimulated by images now became a general practice, in which mysticism was merely the ideal but not the rule. Mystical exercises would open with preliminary

devotion before an image. The next stage of mystical perfection lay in the production of inner images, and the final stage in the exclusion of everything visual and the imageless contemplation of God by the soul. The "mystical union" attained in the ecstatic overthrow of one's own person was considered the summit of the contemplative life. Only "meditation" was possible for those who stayed on in "active life."[2] Mysticism was to bring about a private form of religion, though it aimed at a level ultimately attained only by the saints. The ordinary Christian reached only the lower rungs, or at most the middle. But with the devotional images that had provided the saints with their visions, ordinary believers assured themselves of their participation in the ideal community of the church.

By now the ideal of the saint had shifted, as the hagiographic legends show, to the point where contemplation was ranked higher than one's deeds of charity.[3] The former became the real purpose of the religious life, particularly that of hermits. Catherine of Alexandria, an early Christian martyr, evolves in the legends of the time into a mystic who learns of her vocation before an icon of the Virgin and is finally honored by betrothal to the Child Jesus.[4] Members of the laity who earned their living in urban society practiced devotion in order to compensate for the holiness otherwise denied them, thus also partaking in the life dedicated to God.[5] The same images were available to the mystic as to the ordinary suppliant; they served mystical experience no less than practical piety and the domestic education of children.

In this temporal piety the acquisition of a devotional image was an act of duty. In what we might describe as a domestic icon, owners acquired not only a tool for devotion but a certification of the pious disposition they were to attain. Images became visible proofs of an inner life. Where possible, the daily prayer times were practiced with the help of the "book of hours."[6] They also were the standard occasion for an image devotion. Besides these prayers, laity devoted themselves to the reading of edifying texts that retold the Bible stories and the legends of the saints with a new vividness and psychological depth. The Bible no longer satisfied the laity's desire to share personally in the everyday details that brought the holy protagonists close to them as human beings.[7] For similar reasons they were no longer satisfied with the old images, which were not articulate enough and made the people seem too remote. Thus the new texts and the new images, which emerged at the same time and dealt with the same themes, performed a similar function in making the content of religion a private experience. Both engaged the imagination; the texts supported the response to the images, as the images in turn reinforced the message of the texts. In the "threefold justification" of images, church authors maintained that the eye tends to be impressed easier than the forgetful ear; hence the image seemed better suited than texts to stir up lazy feelings.[8]

For the devotion shown to images, mysticism was always the ultimate ideal in the background. The visions of the saints, a matter of continuing fascination, seemed to be the supernatural answers they received in their sacred dialogue, thus confirming the legitimate use of images in two ways: the saints received their visions sometimes before actual images, and they recognized the images as representing what they had seen in their visions.[9] To their surprise, the heavenly personages had the very appear-

411

ance familiar from the images. The visions had the same character of a private meeting that the images offered. It is no accident that visions increased at the same rate as meditation became the universal standard of piety. Visions had two topics, which were also themes of the images. They either opened a private dialogue or made visible past events from the story of salvation. The Marian images and the scenes from the Passion were the corresponding themes of the devotional images.

The vision, so to speak, carried the natural experience of the image to the miraculous level. The miracle overthrew the earthly state, which the mystic desperately longed to leave behind at last. The visions were beheld, as they used to say, with the eyes of the soul, whereas painted images were restricted to the eyes of the body. Such differences, however, were a matter of degree, and the analogies allowed for a mutual reinforcement. In depicting a person who seemed to come alive and to speak to the beholder, the painted image provided a substitute for the vision. The vision in its turn served to prove that the holy persons represented by the images actually did become visible and their words audible. The vision filled the gap that existed in the imagination of the common beholder and gave a sense of nearness, despite the remoteness of God himself. In the case of the saints, the inner dialogue that was required from the pious beholder was rewarded by the vision granted to them by heaven.

A French manuscript from about 1300 contains instructions for nuns, telling them how they can attain the "three states of the pious soul" (*tres etaz de bones ames*). Alluding to the theological virtues, these states are referred to by the terms "fear," "hope," and "love" but are in reality the three stages of the mystical way. The first stage involves penitence, the second meditation or devotion, while the third alone leads to the union with the Godhead in contemplation. The frontispiece of this French manuscript qualifies a nun's purifying confession as the preparatory penitence, while the ecstatic contemplation of "the three [Persons] who are one [God]," as an inscription puts it, corresponds to the stage of contemplation.[10]

The middle stage, called devotion or meditation, is represented by two pictures in which the experience of the image is distinguished from the experience of the vision. In the first the nun kneels before a sculpture representing the Coronation of the Virgin, and in the second she throws herself to the ground before a vision of the Passion. Christ appears in a cloud, saying to her, "Behold what I took on myself to save the people." The sculpture stands firmly on the altar, while the visionary image floats above it. The connection with the altar is represented by the blood that drops from Christ's wounds into the chalice. In this way the sacrament at the altar is dramatized as it commonly appeared in the visions of the time. Like the visions, it transcends the laws of nature, through transubstantiation and the real presence of God.

The analogy between image experience and mystical experience is confirmed by the fact that the Man of Sorrows and the throne of grace, among the most modern topics of devotional images, appear in the visions.[11] The similarity between image and epiphany is all the more striking, since both address the beholder in person. The relation of image to truth is sought in the formula that truth reveals itself first in images that people could understand. While the French miniature itself is, strictly speaking,

247

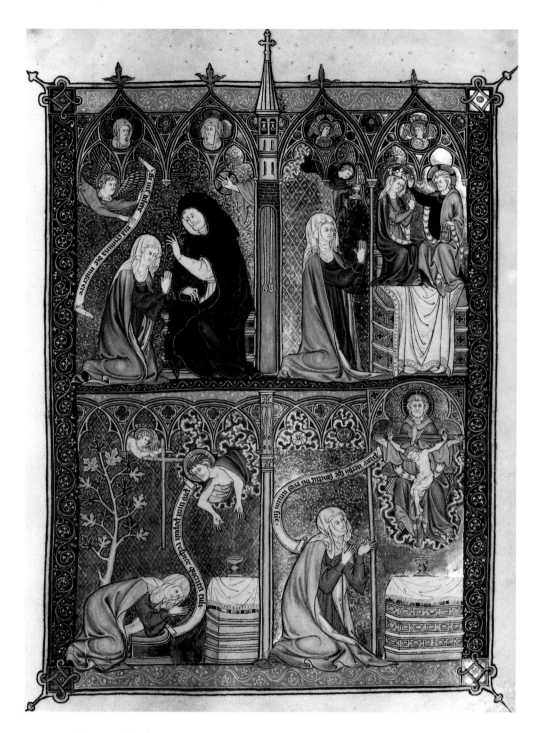

247. *London, British Library; MS Add. 39843, fol. 28; French tract for nuns* Tres etaz de bones ames, *ca. 1300*

not a devotional image, as a book illustration, it took the liberty of explaining how a devotional image was to be used and, finally, transcended.

There are some famous studies on the image in the age of mysticism, but most of them are concerned with sculpture north of the Alps, deriving a law of general development from this limited material. They are neither specific enough, because they immediately generalize from their observations, nor general enough, because their field of observation is too narrow. Dagobert Frey, who made the "reality-character" of the image his theme, brought this research to a kind of conclusion.[12] He sees the mystical image as a symbolic form representing the "process of individuation," which by then had become generally established. In literature, from Suso to Ludolf of Saxony and Thomas à Kempis, there was, Frey argues, a corresponding tendency to reduce the subject matter of biblical stories to images for meditation—that is, to convert it into a "medium of mystical contemplation."

Frey admits, however, that the mystical aspect is apparent only in certain images, which he calls the "new image motifs." The works representing the new type of devotional image are all sculptures—the pietà, the Man of Sorrows, and the like. They all emerged at the same time and had a closer relation to the practice of mysticism than images normally had. It is worth giving some thought to their historical context, but it is just as necessary to understand the real meaning of the subjective moment, which everyone sees in these works without being able to define it adequately.

It has long been known that the South German convents about 1300 were a center of the mystical movement. When the founding of new orders was prohibited, religious women had sought refuge with the Dominicans. This prompted the need for spiritual guidance (cura monialium), by which the church attempted to keep such things under control. The German mystics of the time were mostly preachers dedicated to guiding the spiritual lives of the nuns by means of new kinds of texts that took account of their emotional needs. Some of them, like Meister Eckehart, went so far as to be suspected of heresy.[13] This branch of mysticism, which produced a literature of its own, also favored sculptures, which would lend themselves to mystical practice.

The convent of Katharinental near Diessenhofen in Thurgau is the location that best reveals the new situation. In 1305 four new altars were consecrated in the chancel, including one named after John the Evangelist. On it an image of St. John was set up that, according to the chronicle of Master Heinrich from Constance, was "made so beautifully of walnut that everyone marveled at it, even the master himself." The work was most probably a small sculpture now in Antwerp that came from the convent along with two others of the same theme, one being of silver. A number of Madonnas, two crucifixes, and a small-sized group of the Visitation (now in New York), the last item retaining its original paint, can be traced to the same origin.[14] The convent seems to have owned an abundance of such devotional images—to be sure, devotional images rather than altarpieces, since they served for private meditation outside the hours of prayer, on side altars and in other locations of the convent, as we know from biographies of local nuns.[15]

The St. John image does not incorporate the apostle alone, as one might expect.

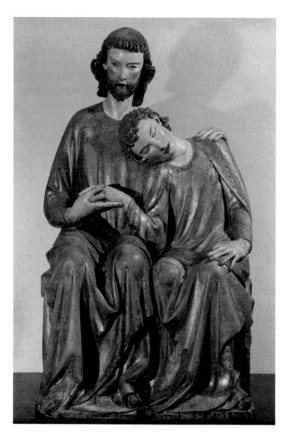

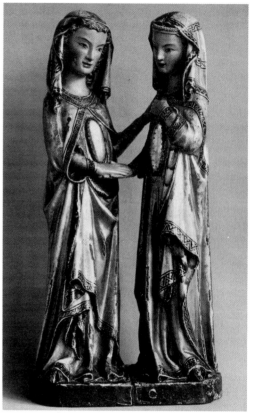

415

He is seen "resting on the heart of our Lord," as a contemporary text from the convent describes it. One nun was overcome by such passion in front of it that, according to the testimony of another person, she was lifted some feet above the ground.[16] The ideal of *Minne,* or courtly love, was inspired by the description of the Last Supper, where we read that "there was leaning on Jesus' bosom one of his disciples, whom Jesus loved," and, two verses later, that he was "lying on Jesus' breast" (John 13:23, 25). One would misread the sculpture and mistake Christ for the main person if one did not realize that it primarily depicts John in the mystical state of love, or even this love itself. The female beholder, whose ideal was to be the mystical bride of Christ, could identify with John when being drawn into a passive self-abandonment by the mise-en-scène of the group, which so subtly expresses the love motif.

The emotional activity shown in the sculpture perfectly matches the mystical performance as required from the nuns. As a single piece, the sculpture seems to continue the tradition of the cult image, but it bears so little resemblance to its predecessors that it cannot be derived from this root. Rather, it implies a new conception of the holy image, according to which the subjective moment exists within the image itself.

The narrative expression of the new image actually contradicts the idea of the static image, since it dispels the familiar experience of its self-contained calm and opens a dialogue with the beholder. The narrative, however, does not depict an event but animates the figures, so that their emotions become apparent. In the pietà it is the Mother of the dead Christ who presents her suffering as a model. In the Visitation group from Katharinental, it is Mary's tender welcome by Elizabeth that the work attempts to convey. The pregnant Mary, who has come to visit her cousin, is almost identical to the woman who venerates her. (Each woman once had on her breast an image of the child she was carrying.) The mysticism dedicated to the Virgin is a way of imitating Mary with the aim of resembling her. The sculpture does not tell an anecdote but seeks to convey the abstract theme of love of the Virgin. Abandoning the previous aloofness of the icons, it suggests the very dialogue that the beholder was supposed to imitate. It admits of two modes of contemplation. Empathy with a person, whether Mary or Elizabeth, is supplemented by the reenactment of a biblical situation: the meeting of the two mothers. The image of St. John also allows the beholders to participate in the conversation at the Last Supper. Devotional images therefore combine the opportunity to speak to persons in a vision with the opportunity to share retrospectively in the life of Christ or a saint.

The subjective aspect, which has not received enough consideration, not only lies in the narrative character of the work but presupposes a certain freedom in the expression or the situation represented. It assists the viewers' imagination by removing any resistance or restriction. The mood is more important than the theme, the nature of which beholders can decide for themselves. This freedom is a subjective moment, just as the mystical transformation that the devotional practice required was a subjective moment. Community normally demands fixed norms, which an individual can typically discard.

Dagobert Frey has described the scope allowed to the beholder's imagination in relation to images, using the example of the nun Margarethe Ebner.

What is important is that here, as in children's play, the reality represented by the object is not located in that object but in subjective experience. And indeed, we are reminded of the games of a child with her doll when Margarethe Ebner tells us how she takes the figure of the Child Jesus out of his cradle because he has been "naughty" in the night and kept her awake, how she places him on her lap and speaks to him, holds him to her bare breast to suckle him and is shocked to feel "a human touch of his mouth." The game passes over into the erotic, even the pathological, when she tells us that she takes a life-size wooden model of the crucified Christ into her bed at night and lays it on top of her.[17]

Such accounts can be interpreted in many ways. Rather than comment here on any specifically female aspects, I see such behavior generally as an extreme form of the mysticism that is our subject. Undoubtedly, innovations like the pietà and the Christ-John group were created for a particular milieu, in this case the Dominican convents. But they were not the only sculptures of their day to be produced in connection with mysticism. In Italy there are similar innovations in panel painting, as when Barna da Siena does not paint the carrying of the cross as a narrative scene, but Christ carrying the cross as a single image.[18] In Italy the lay element seems to have become involved earlier than in the North, where private piety was long under the influence of the orders. Sculptures that, however small, could be placed on side altars were more practical for use in monasteries than panel paintings, which suited house walls. And sculpture was in any case the dominant form in the North. In some monasteries even there, however, every cell had its own panel painting. In the case of the Carthusians of Champmol, it always depicted the Crucifixion but also included a portrait of the cell's occupant.[19]

At this point we should remind ourselves that mysticism was only the radical form of the devotion expected from everybody. This is why the private image was disseminated far beyond the confines of the mystical realm. It passed through many hands and served many purposes, including quite worldly ones. The broad area of inquiry that this development opens will be illustrated by just one example, in which different variants of the private image play a part. It is a donor portrait of an unknown married couple, painted by Pietro Lorenzetti in the lower church at Assisi in about 1320.[20] Strictly speaking, it can no more be called a private image than the French miniature could be considered a devotional image. It is, to be sure, a wall painting in a public place, but it was indeed conceived as a private devotional image and served a private donor. 250

The saints appear above a marble parapet, which allows them to keep the half-length type of the icon. On the parapet itself—that is, in a realm seemingly outside the image—there were once two portraits, a married couple facing each other in the usual profile view. The wife's portrait has now been destroyed. The donors are praying to a small devotional crucifix, which reproduces, so it seems, an actual panel owned by the couple. The remaining fields are filled with the coats of arms of the couple, which portray their existence as citizens and thus supplement the portraits.

Above and behind a kind of window, the heavenly figures seem to be living

people, while the portraits on the parapet possess the character of artifacts. The Virgin, as the main figure, is flanked by the apostle John and St. Francis, patron of the church. She is wholly absorbed in her conversation with the Child, a conversation that is actually about the female donor. St. Francis is drawn in, as he maintains that he is the one who is interceding for the wife, pointing down to her with his right hand. We not only see that he is speaking but learn what he is speaking about. Mary has passed his plea on to the Child, who inquires in turn who has asked her to mediate. She replies with the popular thumb gesture, as if to say: "Behold the one on whose behalf I come to you." Thus a whole chain of speech relationships, linking the four persons, is generated.

The conversation centered on the wife becomes a visual narrative that displays a very human tone. The picture thus not only deals with a private topic but does so in a private manner, as if all this were taking place at this very moment before our eyes. The image has changed to the point where a private salvation becomes its real subject matter. An anecdote has found its way into the timeless icon, and through it private individuals are admitted to the main image. The image fulfills the donors' expectations. It makes their private concern its own.

We are reminded of the old miracles of the Virgin, when the images performed real acts. In the fourteenth century such legends became popular enough to be included in collections of sermons and in texts, such as a penitential treatise whose author, Jacopo Passavanti, describes at length such a miracle, taken from the legends of Caesarius of Heisterbach.[21] To win back his former possessions, a knight had formed a pact with the Devil and denied Christ. But when he was to deny the Virgin as well, he broke the pact and remorsefully entered a church "in which there was a painted statue of the Virgin Mary with the Child on her arm. Kneeling before her, he humbly and tearfully begged her forgiveness. . . . Whereupon the Virgin spoke through the mouth of the image [*per la bocca della imagine*], so that she could be distinctly heard, saying to her young Son: 'Sweetest Son, I beg you to forgive this knight.' But the Child gave no answer and turned his face from her." When he continued to be unyielding, "the image got to its feet, put the Child on the altar, and fell at his feet with the entreaty: 'My sweet Son, I beg you for the sake of my love [*amore*] to forgive the penitent knight.' At this the Child took his mother by the hand, raised her up, and said: 'Dearest mother, I can refuse you nothing that you ask. I forgive the knight his sin for your sake.' And the mother took her Son on her arm and returned to her seat."

The legend, which so graphically represents the private point of view, makes us realize that mediation was needed in addressing oneself to God, and indeed that one's affairs were more likely to prosper, the more advocates one could enlist. This belief explains the unique importance of the Virgin, who had become the universal agent for all private pleas. One addressed the Mother of the Lord as one's own mother and gained her favor by honoring her through an image. As there were images of her everywhere, one made one's own image stand out by some personal feature. The image mediated the owner's concern to the Madonna, and she mediated it to her Son—that is, to God. One would like to define the relation between the mediation of

the *image* and that of the *Madonna* more precisely, but this would soon take us be-
yond the limits of what we are told by the texts of the time.

b. Devotional Images and Jewelry at the Courts
The private devotional image was usually produced for the local market, where the
size of the panel or the cost of the paint determined its value. A humanist like Pe-
trarch, however, valued a Marian icon he owned because it was by Giotto, and be-
cause he was a true connoisseur.[22] But usually people wanted to own a pious subject
rather than a work of art, for which they had as yet no criteria. At the courts the
situation was at first different, because images were constantly moving about, being
acquired by agents or exchanged by princes. In the inventories of the French courts
they are distinguished according to technique, as an *ouvrage* from Rome, Greece, and
so forth, the provenance sometimes indicating whether it was a panel painting, a tex-
tile work, or a piece of metalwork. A lively trade in images between Florence and
Avignon was in progress at the end of the fourteenth century, as we know from the
correspondence of the merchant Datini from Prato.[23]

There existed in the Sainte Chapelle up to the time of the French Revolution a
fourteenth-century wall painting recording the presentation of a panel painting as a
gift in court circles. In the watercolor copy we see a costly diptych being presented to
the pope at his court in Avignon by the French king, John the Good (d. 1364).[24]
Unfortunately, we know neither the occasion nor the significance of the work, on
which there has been much speculation. It cannot have been a typical piece but must
have had a special prestige usually resulting from a legendary origin or from wonder-
working powers. The shape of the panels with their narrow pediments points to its
being an Italian work.

At that time a dual scale separated a work's material and spiritual values, as is
attested by the altarpiece that the Bolognese painter Simone prepared in supporting
the canonization of Pope Urban V, who died in 1370. In 1374 the citizens of Siena
decided to have painted a funerary altar "with the image and figure" of the pope, who
had returned to Rome from Avignon.[25] The image of Urban was intended to establish
his cult and expedite his canonization. Simone's panel shows the pope on the throne
of St. Peter, while angels place the tiara on his head. In his hand he holds a diptych
that, as an image within the image, has a double purpose. It quotes the two apostles'
icons from the Lateran, by which, according to legend, Constantine had been con-
verted to Christianity (chap. 15a). They are thus a symbol for the Roman church, of
which Urban had regained possession. Although, like the diptych of John the Good,
they have a modern form familiar in Italy at the time, in the quotation they are un-
derstood as archetypes of the icon and therefore rank higher than any other panel
painting.

A century later Botticelli painted a portrait of Giovanni de' Medici (1467–98),
which again includes an image within the image. The situation this time, however,
has been reversed.[26] The portrait as a private image of its own had long since been
established. Giovanni de' Medici presents himself to us as an art collector by showing
a fragment of an old painting, recognizable as such by its historic style and, by its

251

252

73

253

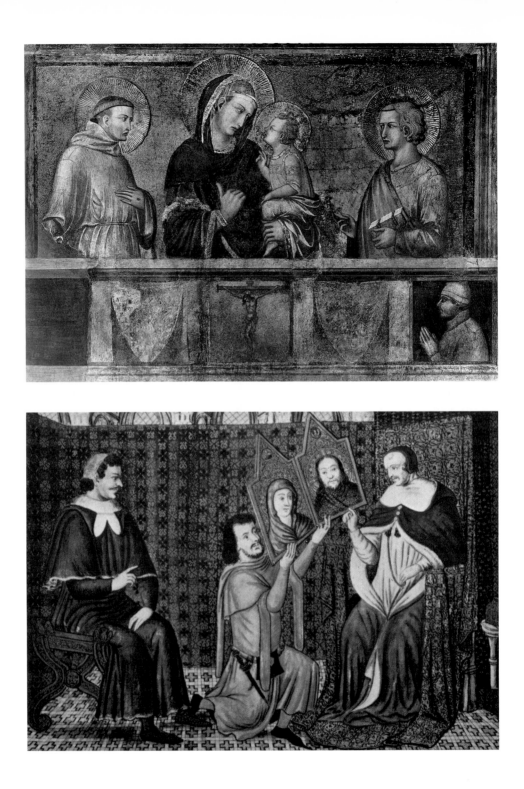

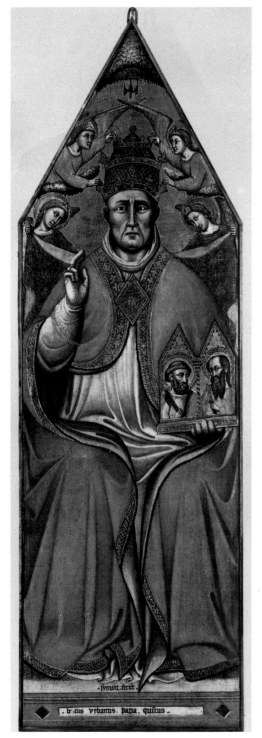

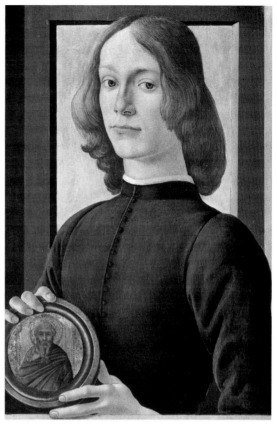

250. Assisi, S. Francesco, lower church; Pietro
Lorenzetti, Madonna and Child with saints and
patrons, ca. 1320

251. Formerly Paris, Ste. Chapelle; fresco with King
John the Good (d. 1364), after the watercolor copy
in the Gaignière Collection; Paris, Bibliothèque
Nationale

252. Bologna, Pinacoteca Nazionale; altar painting
depicting Pope Urban V, 1374

253. New York, Metropolitan Museum of Art;
Botticelli, portrait of Giovanni de' Medici

new frame, as a collector's item. It is significant that the owner has had the trecento image mounted in a tondo frame, as this had become the fashion for private devotional images at the courts about 1400. This brings us to the question of what happened in the period between the papal altar in Bologna and the portrait in Florence. To find out, we must turn our attention to the French courts.

254 A prime example of the private image at court is the large tondo in the Louvre, painted by Jean Malouel for the duke of Burgundy.[27] The reverse has the duke's coat of arms, and the fact that the roundel is painted on both sides reveals its use as a portable image in the court's travels. At such times it was protected by a leather case, from which the duke drew it to use as a devotional image. The owner would look into the expensively painted mirror to see, not himself, but the image of the suffering Christ. The panel, used in such a personal way, suited the educated owner by its original iconography with its many layers of meaning. The Trinity group on the throne of grace is amalgamated with the mourning of Christ by Mary and John, so that the scene takes place neither in heaven nor on earth. The duke could admire the invention of his court painter, without needing to justify its religious truth before church iconographers. The scope for such innovations was much greater than it had been earlier. The private taste coincided with the court taste for complexity in terms of subject matter and for an original treatment in terms of style.

The personal taste was well served with all the object's hallmarks of a precious product of court art. These include the rich colors, in which a deep ultramarine together with the gold ground creates a chord recalling the Parisian goldsmiths' "gold enamels," which were popular at the time. The form of the picture is itself characteristic of the earlier art of producing precious objects, which by then had also been privatized at the courts. Mirrors and vessels, few of which have survived, have the 255 same round shape. A small amulet of "gold enamel" recently acquired by the Metropolitan Museum in New York has the same topic from the Passion on its round surface.[28] In this way Malouel's tondo resembles an item of jewelry, based on criteria different from those suggested by its pious subject.

The close relation of panel painting to the art of the goldsmith is revealed by a 256 tondo owned by the Walters Art Gallery in Baltimore, which also dates from about 1400.[29] This devotional image, about 22 cm in diameter, so closely matches the appearance of a piece of jewelry that it looks like a painted substitute. The richly carved frame, which has a convex molding, has the engraved motto of its owner (*je suis bien*) in one groove and the sculptured rosettes common in jewelry in the other. By overlapping the painted area, the gold of the frame emphasizes the unity of this precious implement more than it insists on the division of picture and frame. Thus, no motif of the image overlaps the frame, and even the Madonna on the crescent moon, veiled in enamel-like blue, is fitted into the round picture area. The Ave Maria is engraved in her nimbus. Two deacon-angels hold the curtain with the courtly emblem of Christ as the Lamb. The owner could enjoy numerous personal allusions, the most important being the pose of the Child Jesus. With his pen he is stretching toward a tiny inkwell held by the Madonna, to write his answer in a dialogue that by implication involves the beholder.

254. *Paris, Musée National du Louvre; Jean Malouel,* Pitié
de Jesus-Christ, *ca. 1400*

255. *New York, Metropolitan
Museum of Art; amulet, Parisian
gold-enamel work, ca. 1400*

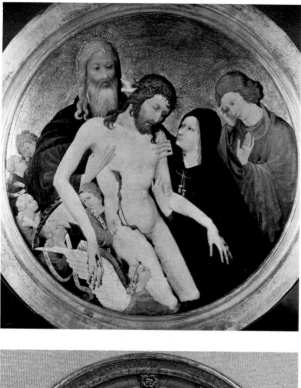

256. *Baltimore, Walters Gallery;
tondo of the Madonna and Child,
ca. 1400*

A piece of jewelry of the kind alluded to by the roundel has been preserved in a minuscule triptych in Amsterdam.[30] It is a pietà with angels, in which the main image is formed in circular embossed enamel (*émail en ronde bosse*) that uses a different enamel technique on the images of Mary and Joseph on the wings and adds a Coronation of the Virgin in cast metal in the pediment. A fourth technique is used on the reverse for the Veronica, which is engraved in polished metal. In other works the image was supplemented by pearls and precious stones, which were often larger than the heads of the tiny figures. At the time, such an object was called a *joyau*, regardless of whether it was a devotional image or a piece of jewelry. In 1380 Louis of Orléans drew up in his own hand an inventory of the *joyaux* in his possession. The duke of Berry employed a special *garde de joyaux* who kept the inventories and recorded the donations to the Sainte Chapelle. Most of these objects were intended as New Year's gifts, the duke receiving hundreds of them himself. They included 177 *joyaux* and eighty manuscripts, most of them illuminated. The so-called *Goldenes Rössl* ("Golden Horse") of Altötting had been given as a New Year's present by the queen of France to her husband in 1404, after which it was mortgaged to her brother, the duke of Bavaria, and from there was sent to the center of pilgrimage. *Joyaux* were also investments, which were sometimes melted down by the recipients so that they could have the value of the gold and reuse the stones.[31]

Here we touch on the process that I have called the privatization of the *arts de luxe*. In church treasures the art of the goldsmith was used for mounting relics, the material value augmenting their religious aura. Church property had always retained the character of an inviolable treasure and was used for public displays. As far as the private art of the courts was concerned, reliquaries were now the exception, and showpieces exhibiting costly materials and technical virtuosity were the rule. The distance separating the new *joyaux* from the old reliquaries was repeated in book painting. Princes commissioned magnificent manuscripts that often lacked any public function (and sometimes were not even real books for reading), since ostentation was their prime purpose and was satisfied by lavish ornamentation. In these two media—the *joyaux* and the illuminated books of hours—the owners had themselves portrayed, though in the posture of prayer before a devotional image.[32]

The inventories of the dukes of Berry and Burgundy, to mention only two, introduce us to art as it was owned by the courts and for which there was already a market.[33] Nobles collected and exchanged pieces of jewelry, which were justified as devotional images but whose true function was in their commodity and display value. Although they may have been taken seriously as instruments of piety, their aesthetic qualities and their iconographic eccentricities were of even more interest. A private taste addicted to innovation became the target for a production that profited from the competition between collectors. In this private art, panel painting and sculpture were at first pushed into the background. Painted panels, as we learn from the inventories, imitated books and reliquaries and were sometimes half made up of metalwork. The old icon was surpassed by the splendor of works commissioned by the princes. However, panel painting, now performing new functions, soon began its triumphal march. At the courts it was prized as the work of the court painter, whose personal style

began to be valued. The forthcoming character of a work of art is already latent in this court production.[34]

c. Visual Media in Competition: Panel Paintings and Prints

Seen from the viewpoint of the court, the printed image seems like the exact opposite of the works just discussed. It was printed on cheap paper and could be disseminated on a large scale; it was thus available to the middle class, which wanted images of its own. Sometimes the prints even seem to have taken over some of the former functions of court art. From about 1440 they were used to express New Year's greetings, as jewelry had done earlier, but now with images and texts from Dominican devotions.[35] Court art and the graphic arts were also connected by the producers, as when such goldsmiths as the Master E.S. on the Upper Rhine switched to engraving copper plates and opened up a new market. However, to gain a true understanding, one should avoid contrasting court art with cheap mass production. The interrelation between graphic art and panel painting is more complex than one might suppose. We are here concerned with only one aspect—the sacred image in its private variety. A number of problems need to be discussed if we are to understand the metamorphoses of the religious image in the new era. The links between the visual media will be given more emphasis than their technical differences.

The prehistory of the woodcut and the engraving remains shrouded in obscurity.[36] The printing of textiles with wooden blocks helped to prepare the way technically. Playing cards are among the earliest products of image printing. The "small devotional picture," as Adolf Spamer has called it, had long been used in monasteries before it was more quickly replicated, with a few changes of form, by the woodcut technique. The mass-produced painted images found in the monastery of Wienhausen throw light on this prehistory.[37] The private religious image either reproduced famous originals in small size or developed its own variants, which aroused interest by vivid details and the increase in sentiment. It was no longer tied to a place where it was visited but made its way into everybody's hands.

These conditions also apply to the printed devotional image,[38] but the latter has two other characteristics that further changed the experience of the image. It was produced mechanically from blocks and thus was restricted, as it were, to the abstract scheme of an image, both by its fragile paper base and by its reduction to the mere outlines. An untrained eye, to be sure, may hardly have noticed the physical absence of the painted image. This was particularly true when a single printed sheet preserved the memory of a painted or sculptured model. It was then a substitute or derivative that spoke not with its own voice but with the voice of its model. The woodcut first appears like a utilitarian medium adapted for popular taste and thus seems diametrically opposed to the aesthetic demands of the upper class. It is tempting to attribute both the simplified canon and the printed duplication to the social milieu of the burgher clients.[39]

But that is only one side of the story. The replicas of existing images were far less numerous than the sheets that explored new compositions. Engraving soon became an opportunity to demonstrate technical virtuosity and thematic inventiveness, which

made it attractive to the upper class as well. The new medium freed the producers from conventions or guild constraints, since it was not tied to the decorum of panel painting, with which it began to compete. In this way the engraving developed an aesthetic charm of its own and was seen not as a derivative of other visual media but as a sophisticated alternative to them. An informed eye may have seen its technical excellence as the very issue that freed artistic style as an autonomous value. But engravers also may have been fascinated by the enlarged repertory of subject matter with which the new printing techniques dazzled their clients.

Topics of secular art that had been restricted to illuminated manuscripts or to wall paintings now became available on separate sheets, even including flowers and ornaments, which derived their effect solely from form. The religious image was only one of several kinds of images sold on printed sheets. It was not exempt from the competition of technique and motif and did not function merely in terms of its subject matter, since aesthetic qualities had now also become important. This development is clearly seen in the fact that the engravings often have famous paintings (e.g., by Campin) rather than miraculous images as their subjects.[40] They are more often used to duplicate artistic inventions than to repeat cult prototypes. The functions of the devotional image and the collector's piece are often inseparable. In the era of the private image, the market changed the conditions to which religious images were subject.

In the production of woodcuts, monasteries clearly competed with "picture makers," who were organized into trades and represented at the markets. The prints were often pasted into books, where they replaced the miniatures, and were sometimes mounted on wooden panels, where they replaced panel paintings. They were bought on pilgrimages, where an indulgence could be earned by acquiring one, or they were ordered for one's own four walls, preferably with the text of a prayer to be said before them. They are seen, for example, in early Dutch interiors, nailed to a wall.[41] In this case they were usually derived from holy images, with benefits being expected from their veneration. They also used the old themes, such as St. Christopher or Christ in the Passion, which performed their old function in the new variants.

257 In the cathedral of Forli, one of the few woodcuts surviving from the early days of the genre in Italy commemorates the local miraculous image of the Madonna del Fuoco, which was destroyed in a fire.[42] The Madonna and Child are surrounded by saints and scenes, a schema exactly reproducing one of the countless devotional images produced at the time, which had been venerated publicly as a wonder-working image. The coloring links the printed derivative directly to its painted model.

Master E.S., who worked primarily in the 1460s, gives us the best idea of the broad range of ideas and functions that were available to engravers at that time. He signed and dated the later sheets, in which motifs from all genres play a part. In 1466 he produced three sheets intended to commemorate the pilgrimage to Einsiedeln, but which do not reproduce the image of the Virgin at that site with any accuracy. The three different sizes are clearly intended for different kinds of clients. The smallest sheet undoubtedly served as a pious token, while the largest is signed and, with its extensive and original composition, is meant to be a collector's item.[43]

A sheet with the stigmatization of St. Francis competes with panel paintings in its

257. *Forli, cathedral; woodcut of the Madonna del Fuoco, ca. 1450 (after Körner 1979, pl. 7)*

258. *Berlin, Staatliche Museen Preussischer Kulturbesitz, Kupferstichkabinett; Master E.S., Madonna and Child, engraving (Lehrs 73)*

259. *Berlin, Staatliche Museen Preussischer Kulturbesitz, Kupferstichkabinett; Master E.S., St. Veronica, engraving (Lehrs 174)*

258 narrative aspect and in its treatment of landscape; the absence of color is made up for by the precise notation of flora.[44] A sheet with a Marian icon attempts a synthesis between the most modern ideas of panel painting and the sculptures on altar shrines. The Madonna is shown half-length behind a windowsill, as was common in Dutch paintings. But the sculptured frame gives a view of the interior, which recalls the three-sided niches of carved altar figures. The hatching plays freely with the light-and-shade effects of paintings and sculpture. The idea of the picture, with all its allusions, does not imitate any of the other media. The printed icon (icon in the sense of the original archetype, not in contradistinction to the devotional image) has become a medium in its own right.[45]

259 On several occasions Master E.S. interpreted the theme of the holiest image of Christendom, the Veronica (chap. 11c). On a sheet of 1467 the theme includes the authority of the papal owner, as the Roman apostles, accompanied by the papal coat of arms, show the sudarium to pilgrims. In other cases, particularly on a sheet in Berlin, the image is in the hands of St. Veronica, who is attended by two angels.[46] The cloth forms rich folds, but the face, printed on the cloth according to the legend, floats undisguised in front of it. The suspension of natural laws clearly expresses the difference between the image and its substratum, between form and matter. The sheet presents us with two kinds of images, or a twofold truth: the truth of the venerated prototype and the truth of sensuous reality, which holds good for the rest of the picture. The female saint stands on the ground, but the angels indicate that the image is of divine origin. The frozen features of the image, contrasting with the movement in the other faces, also define the head of Christ as an image within an image, and as an image of a fundamentally different kind. Here the engraver's control over his subject matter comes to an end. All the rest conforms to his artistic will, but the chief motif is tied to the sacred pattern of the original in Rome.

260 This theme had been common in panel painting since about 1400, as the Veronica in Cologne demonstrates.[47] Hans Memling dramatized the relationship between image and life, and between cloth and image, in a diptych, one-half of which is now in Washington.[48] The reddish hair of Christ seems as lifelike as the flesh of the face and the lively eyes, which reflect the light. Nevertheless, this is an image and not a living head like that of Veronica, though the latter is painted alike—or has the difference been abolished here? Once again, the face is detached from the folds of the cloth, the painter thereby giving it a reality of its own. He knows Christ only from the image, not in person, and so can only copy an image. But the image claims the effect of an authentic impression, and therefore of life. This very ambivalence of the treatment relates what we see to a miracle that happens in front of our eyes.

Memling's diptych is a private image by which the painter satisfies other than pious wishes. The female saint, like John the Baptist on the other wing, sits in an idyllic landscape that is really quite out of keeping with the theme of the Passion and creates a mood that could be called pre-Romantic. While the window opens onto the depths of a poetic landscape, the outside of the panel, also painted, presents a dark wall with niches, from which a shining gold chalice with a snake—the attribute of John the Baptist—seems to stand out in front of the painting in a masterly trompe

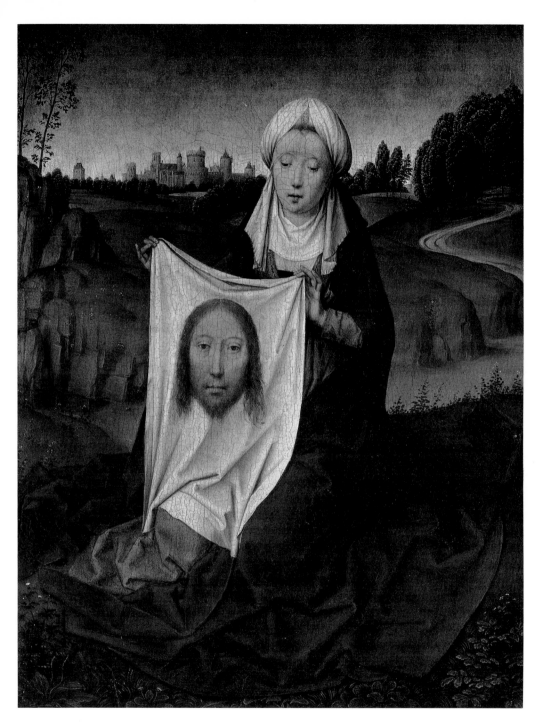

260. *Washington, D.C., National Gallery of Art; Hans Memling, St. Veronica*

l'oeil. Memling displayed all his virtuosity in order to appeal to the connoisseur, although art in the North as yet lacked any verbal theory for its appreciation. The functions of devotion against that of true aesthetics were far apart from each other, but the painter makes this problem the real issue of his picture. The old icon is ensconced in the new painting like a precious memory.

261
An artist of his standing cannot simply repeat the old icon but must interpret it. This path had been opened by Jan van Eyck, who translated the icon into a portrait of a new kind. He took literally the legend that the true likeness of Christ was kept in Rome. It could therefore be reproduced much like a portrait reproduces a sitter. The Roman icon took the place of the model who sat for van Eyck's other portraits. He also took literally the appearance of the Roman icon, which he developed into a vivid idea of the person it represented. Like the secular portraits, Jesus is shown half-length within the square of the frame and against a dark background. The spreading of his hair still recalls the former cloth image, but the cloth has disappeared, and with it the old guarantee of authenticity. The new guarantee lies in the painter's infallible eye, which assures a perfect match between model and likeness.

For this reason the painter signed the panel as he was accustomed to do on portraits of burghers, with the day, month, and year of the work's completion. On the earlier version we read that the artist "painted and completed me on 31 January 1438." On the later version, of 30 January 1440, van Eyck refers to himself, also in Latin, as the "inventor," adding his own motto, "As well as I can" (als ich chan). In a contemporary book of hours the copy of van Eyck's portrait is accompanied by the hymn of the Veronica.[49]

Van Eyck's view, in which portrait and icon were one and the same, is a surprising conclusion that he drew from the private image. With the recent scheme of the individual portrait, the "holy portrait" offers Christ for a private viewpoint. The immobile frontality preserves the aura of the icon, but the close-up simulates the physical appearance of a living person sitting in an interior whose windows are reflected in Jesus' eyes. In the competition between the genres, two separate functions of the picture have been reconciled. Contemporaries fully accepted van Eyck's "modern icon" as a devotional image, to which the many replicas attest.

262
Hans Memling related the functions of icon and portrait in a different way. Like Rogier van der Weyden, who favored this scheme, he brings together an icon and a burgher's portrait as a pair of panels in the diptych of Martin van Nieuwenhove.[50] The figure in the portrait turns toward the Virgin's icon in an attitude of prayer. Memling's idea was to move both to a single place that he identified with Nieuwenhove's private house in Bruges. The two panels are linked by the view of the same room, the back wall being seen in the left panel and a side wall in the right. This seems to take the logic of the private image to the extreme. It locates the figures in the same room in which the picture was hung. Owning a house was a prerequisite for obtaining civic rights. All the same, Memling is fond of ambiguities. A mirror in the back wall, in front of the closed shutter, reinterprets the front picture frame as a double window opening to the outside. By this device the painter cancels out the picture's banality,

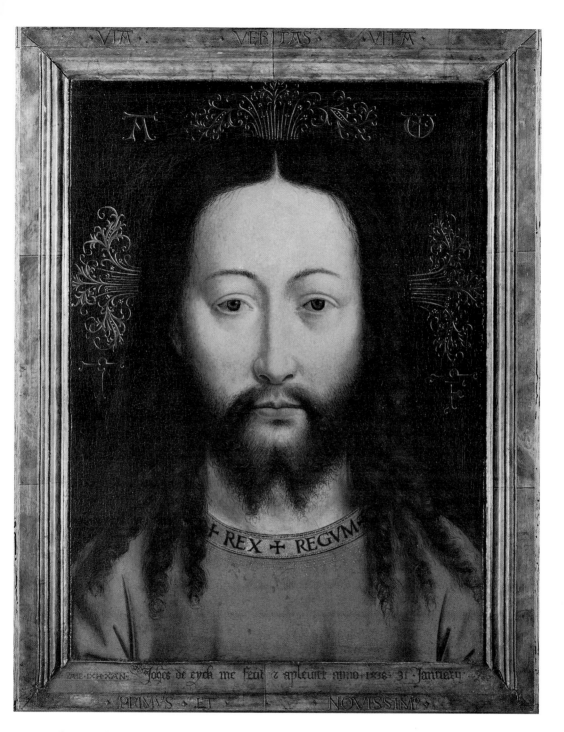

261. *Berlin, Staatliche Museen Preussischer Kulturbesitz; Jan van Eyck, Vera icon, 1438*

431

warning us against taking the burgher milieu too literally. The aloofness of the old icon, which first seemed abolished, is restored on a symbolic plane. Nieuwenhove's dialogue with the divinely beautiful Madonna, who is turned frontally to accept our veneration, takes place in an interior at once real and symbolic, which only the soul can enter.[51] The double view of the secular room and of the "other" reality of religion corroborates the double theme, made up of a portrait and an icon that together represent Nieuwenhove's devotion.

The era of the private image produced, on the one hand, such new pictorial media as engraving and, on the other, such new image functions as the portrait, the donor's image, the altarpiece, and the devotional image.[52] In the resulting competition of different media and also of different functions of images that appeared on the market, the former icon survived in modern disguise. It was effectively transformed to satisfy both a new piety and a new private taste.

d. Archaism and Quotation in the Aesthetics of the Holy Image

The new currents in the era of the private image soon generated countercurrents, namely in the public sphere, where pictorial forms that seemed legitimated by age were to guarantee the weakened authority of the holy image. This retreat from the fashions of the day will now be illustrated by a few examples. The preference for a historic idiom implies a new perception of form as such. It went along with the discovery that not all forms were of equal value, so that now a particular form was needed to pit the authority of the old against the onrush of the new. In the spate of new images, an old style was designated to uphold the claims of timeless values. Thus several idioms entered into competition with each other, each being given a different meaning. Old pictorial forms could be quoted to represent an old concept of the image and to defend it against advancing disintegration.

For the medieval mind, the old was the mark of tradition, which in turn guaranteed authenticity, the rampart against the flood of time. This idea was also applied to images. Relevant sources are rare, but a trial of 1410 introduces us into the current attitude toward old images. The trial was held in Paris, between the chapter of Notre Dame and the monks of St. Denis. Both parties claimed they owned the genuine skull relic of St. Dionysius: the Paris chapter the crown, and the monks the whole skull. To prove their cases, they referred to images in which the traditional appearance of the saint was as each of the relics required, either with the crown cut off or with his head in his hands.[53] Relic and image legitimated each other reciprocally.

For an image to be accepted as proof, it was necessary to formulate rules by which to judge it. A basic principle adopted was that old images had just as much authority as old texts. They were "of greater credence and authority" (*de plus grant foy et auctorité*) than the new. They had a special rank when situated "in exposed and public places" (*en lieux patens et publiques*), where no one could overlook them. When the opposing party used their images as evidence, they were accused of having forged them "to serve their purposes" (*pour servir à leur entencion*). When one's own images proved less convincing, one blamed the willfulness of the artists (*ouvriers*). The only point on which the parties agreed was that images ranked higher the older

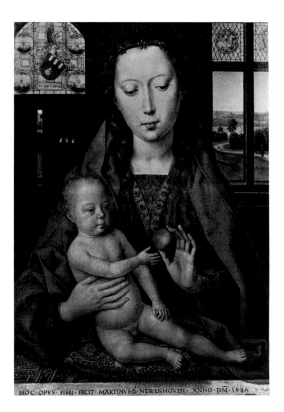 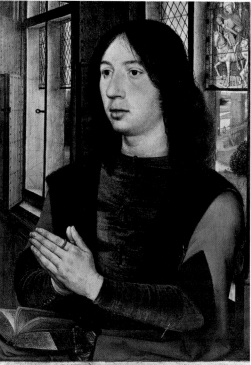

they were. Apart from that, the only rule was that they should display "beauty and piety" (*beauté et devocion*).

In following this debate, one comes to understand that age could be prized for different reasons: not only to legitimate a particular relic but also to justify the sacred claims of the holy image itself. The old and famous model was to have binding authority. In this case there were two possibilities: either to reuse an old image in a new context or to quote it in a replica in such a way that the new image was merely a stand-in for the old. Bernhard Decker has analyzed both procedures when studying late Gothic carved altarpieces.[54] In the generation of Michael Pacher, sculptures from about 1400 were reused in new altars, although—or because—their form was already historic. In Hans Leinberger's generation the procedure was extended to include quotations of old works or styles in new images, which could then serve the claims of the holy image. In this sense, Leinberger's style in carving garments, as well as his conception of the figure, are interpreted as a historicization of form.

It is one thing to make such observations, and another to explain them. Decker looks for the explanation in a crisis over the legitimacy of the cult image, which he sees in progress as early as the fifteenth century. To make "holy sculpture," he argues, one had to go back to a historical form that was believed to hold the truth of authenticity. The retrospective "denotes a method of quotation that revives earlier iconic meanings, not only in subject matter but in form." It "contrasts present and past, by means of retrospection, quotation, or imitation" and constructs a tradition that is made available as a present reality.[55] Art can continue to progress, but at the center of cult practices are old images or old forms that have been invested with the claims of the sacred. In this sense the historic form is a sign for such a timeless value as the mystery of the Christian religion itself. Decker's argument, which we shall take up again in connection with the altar shrine, reaches its conclusion in the idea that the retrospective manner can be regarded as the "period signature" of the time about 1500.

If we look back at the period about 1400, we note that the "international Gothic" was in turn propagating old forms. The Fair Virgin is not simply a new image type but the receptacle of an ideal remote from empirical forms of nature. In a figure formerly at Thorn in West Prussia, the tendency toward a "re-Gothicization" of drapery is clearly expressed,[56] the body playing a very subsidiary part. This tendency shaped the whole style of the time. But its deepest significance is found in venerated images, which produce their effect by their form, as relics had done earlier by the presence of the authentic. Material and form convey a sense of beauty that symbolizes a higher beauty of the Madonna (and the church). Form has a retrospective quality; the type of the figure stands for a timeless ideal. By its form the work seems to transcend the stone or wood of which it is made.

Sadly, we know little about the function of the Fair Virgin, but it is clear that it not only propagated an ideal of aesthetics but advocated an ideal of the church. The same is true of its counterpart, the pietà. In 1383, in the Liebfrauenkirche in Frankfurt, the "new image consecrated to the Blessed Mother" was for the first time empowered to grant indulgences. It stood on a stone column in the middle of the church

263

263. *Formerly Thorn, Fair Virgin,*
ca. 1390

264. *Prague, National Gallery, Madonna and Child from*
Raudnitz (Roudnice), ca. 1390

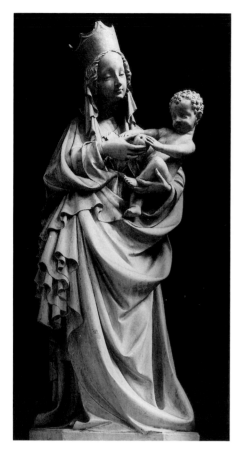

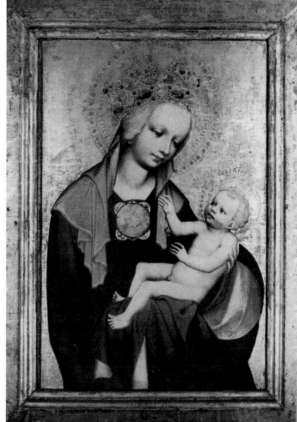

and was equipped with relics in 1419.[57] Its popularity was clearly being promoted by all possible means.

The enormous importance of the Fair Virgin can be seen in the fact that the type was translated into panel paintings, although it is intrinsically sculptural. This occurred in Bohemia, where the Fair Virgin had an early success. One example is a
264 Marian icon from the Capuchin monastery of Raudnitz (Roudnice), which about 1390 took on all the features of the new sculptured Marian images.[58] The comparison
263 with the Madonna of Thorn, which was not the direct model, speaks for itself. The extent of the process can be judged only if we realize that the painted Marian panel had long been firmly established in Bohemia and followed quite different conventions. The half-length figure in the picture frame, as the mantle motif and the turn of the body show, is really part of a full-length figure, adapted with difficulty to the panel format. A new canon was replacing an old icon formula, and yet we find repeated here a process we already know from Eastern icon painting: new speech roles replace old ones in the image (chap. 13f). In this case it should be stressed that the Fair Virgin, regardless of genre and artistic technique, in Bohemia was ranked second only to replicas of authentic icons by St. Luke (chap. 16b).

It may seem confusing that we have interrupted our argument to digress on the Fair Virgins. No matter how many historic ideals from the Gothic of 1300 they may have embodied, they were innovations in their own time and only later became old archetypes. However, it is useful to draw attention to cases in which a new image physically replaces another that has served the same cult in the same place. One such
265 case is the half-length panel of the Virgin from the monastery of Fröndenberg in Westphalia, also from the period about 1400.[59] It was a new version of the local wonder-working image, which, according to legend, was made of the wood of the cross and had been donated by the father of the monastery's founder. Two fragments of this earlier image were worked into the reverse of the new image, to guarantee through material identity its rights as successor. The type of the new image also preserves that of its model, though the treatment of figures and background clearly shows an attempt to synthesize them with the modern aesthetic of the time.

In other cases such a synthesis was avoided. The aesthetic of the holy image, if we can speak of one, lies rather in archaism and the quotation of a historical type. It was best for an image to prove its age by its form. If it was not really old, its form was forged to look old. The prime examples of this tendency are the St. Luke icons in the Netherlands in the fifteenth century, which present the strongest possible contrast to the flourishing art of the region. They were the main focus of a public cult that addressed them as image relics from biblical times, and as such they stood apart from the style of the time.

266 In Liège in 1489 the St. Luke icon from the monastery of St. James was carried in procession along with the remains of St. Lambert and held first place among the relics in the cathedral.[60] It is clearly an old Byzantine icon of the Virgin, whose original metal frame bears the inscription of the *Hodegetria*. About 1400, however, and for unknown reasons, the figures were repainted within the Eastern metal mount. The old type of the model was retained, but the painting follows the style of the time,

265. *Dortmund, Museum für Kunst und Kulturgeschichte; Madonna and Child from Fröndenberg, ca. 1400*

266. *Liège, cathedral; St. Luke Madonna, 1200 and ca. 1400*

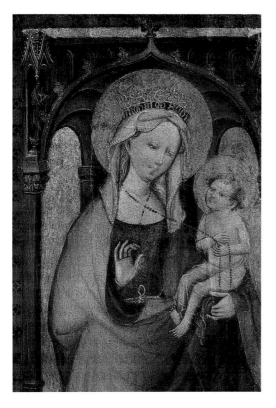

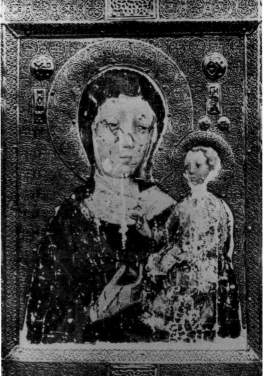

which, in our eyes, presents a striking contrast between picture and frame. For the beholder at the time, the old panel and the metal casing, which so visibly proved the Eastern origin, together guaranteed the image's claim to be an authentic icon by St. Luke.

X The miraculous image in the cathedral of Cambrai, still in the southern Netherlands, gives us a better insight into the circumstances that gave rise to a public cult of an image by St. Luke, including the distinction between historic form and modern style.[61] In 1440 Canon Fursy de Bruille brought an image of the Virgin to Cambrai when he returned from a long absence as secretary to a French cardinal in Rome. He claimed that the image was a genuine icon by St. Luke. In reality it is a Sienese work from the circle of Ambrogio Lorenzetti, which, despite its origin in the second quarter of the fourteenth century, shows noteworthy archaisms pointing to a Byzantine archetype. The colors and gold hatching are quoted from such a distant model, but the faces follow the style of the time. The panel, which was about a hundred years old when it arrived in Cambrai, thus had a double face, the Italian replica being distinct in style from the Byzantine original. The original was also the source of the kicking movement of the Child Jesus, a characteristic trait of the so-called Virgin of Pelagonia, a familiar iconic type in the twelfth century (chap. 13f). We do not know which picture served as a model for this type. It must have been especially famous at just this time in Tuscany, where de Bruille had attended the Council of Ferrara-Florence; this is proved by the many replicas from the circle of Ghiberti.[62]

153 Canon de Bruille soon propagated the work in his hometown as an original by the hand of St. Luke. The cathedral was then under construction, and the imported icon was clearly intended to attract visitors and capital. A public cult was established when the canon presented the image to the cathedral in 1450. In 1451, on the eve of the feast of the Assumption, on which it was henceforth carried in procession, the icon was installed in its place in the chapel of the Holy Trinity, where the foundation stone was kept. In 1453 a confraternity assumed responsibility for its veneration. The town chose the icon to represent its patron saint, had a relief copy mounted in the town hall, and called on its help in times of need. The civic importance of *Notre Dame de Grâce* was an extension of the role the image had adopted in the cathedral. There it superseded an older cult image that had been called *Notre Dame la Grande*, or *La Flamenghe*. The transfer of cults was quite common at the time. The cult of one image would be switched to another of higher rank, which raised new hopes. In this case the new image was older than the previous one, for no icon could be older than one painted by St. Luke.

The transfer had to be accepted, however, particularly by the adherents of the old image. This was effected by a propaganda campaign that included not only the activities of the cathedral chapter and the town, already mentioned, but the production of copies as well. The copies that were circulated helped to disseminate the cult. By venerating a copy, one explicitly acknowledged the rank of the original and conceded a privilege to the cathedral and the town, which may also have been of political and judicial importance. Happily, in this case we are well informed about the propaganda

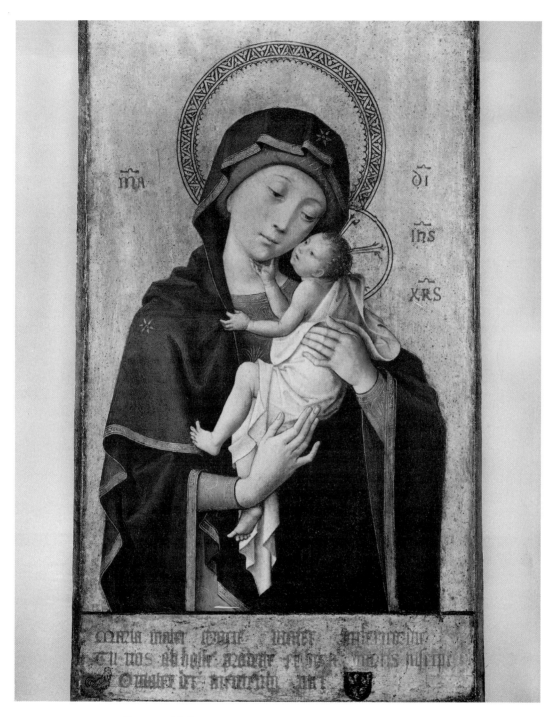

*267. Kansas City, William Rockhill
Nelson Gallery of Art—Mary Atkins
Museum of Fine Arts; Hayne of Brussels,
Madonna and Child*

conducted with copies. In 1454 the Bruges master Petrus Christus, a famous painter, made three copies at the request of the count of Estampes, for which he was paid twenty pounds. The commission mentioned "three pictures in the likeness [*ad simili- tudinem*]" of the icon painted by St. Luke. The following year the cathedral chapter itself had "twelve images of Our Dear Lady in oil paint" executed by the "painter Hayne of Brussels, resident in Valenciennes," for which only twelve pounds were paid. Of all these copies, only one work can be identified with certainty today; it is in the Atkins Museum of Fine Arts in Kansas City and is usually attributed to Hayne, but occasionally to Petrus Christus. It is larger than the original and has an inscription at the bottom with a Latin prayer to the "Mother of Mercy," which also serves to certify its relationship to the original. The prayer represents those responsible for the cult (i.e., the authorities in Cambrai) and amounts to an official attestation of the copy by the owners of the original.[63]

 We have as yet little knowledge of the production of copies at that time, but some of the basic principles are clear. The copy is recognized as a painting in its own right, whose value is expressed by the payment, which varies with the rank of the respective painter. Painters were expected to show their own artistic idiom and demonstrate their skill. In this sense the panel in Kansas City is wholly a work of its time, despite the fact that it scrupulously follows the type of the original in all its details. It is not an invention but repeats the very type on which its cult value depended. At the same time, however, it is a product by the hand of an eminent painter, whose technique and style determined its artistic value. Its relation to the original is best summed up by the term "interpretation." Painters interpreted, in the language of their time, the original they were copying. This implied delicate sentiments, as in the lowered eyes of the Virgin, which reflected a contemporary ideal of womanhood. The bodies look fragile, almost doll-like, and the surfaces of the garments have a new sensuous fasci- nation. Characteristic of the new style is the delicate touching of Mary's chin by the Child's hand, which is in stark contrast to the vigorous gesture we find in the original. We can end the description here, since the point is clear. The copy represents a con- temporary view of the original; it has the same relation to the art of its time as the portraits van Eyck produced as interpretations of the Veronica (sec. c above).

 It is more difficult to define the function of the copy in contemporary cult prac- tices. As we said, it helped with the propaganda for the original by introducing its cult in other places. The owners of the original may also have claimed that the copy dispensed the same divine favor as the original to those who visited it. All the same, the copy was not the original, even though it resembled it in form. Indeed, its modern appearance showed that it was not identical to the original. The concept of originality was founded on there being one unique example. There was only one miraculous image of Cambrai, and only this original had a history of its own that justified the cult. But the authorized type could be multiplied and disseminated. It is therefore useful to recall the wonder-working images of Fröndenberg and Liège discussed ear- lier. They are both modern versions of an original that is present beneath their sur- face—in a sense, they are simultaneously copy and original.

Only material identity guaranteed the notion of originality and the history that went with it. But the replica was a witness of the original and aroused the same hopes as the latter. It was known from cult legends that images had multiplied miraculously and had worked miracles through their copies. The copy was therefore expected to share in the privileges enjoyed by the authentic original, in this case through the will of the Virgin. The copy is thus defined by an inner contradiction whereby it is not an original, yet presupposes one. By the duplicate one honored the unique original. This is why the duplicate makes sure that the original is being easily recognized as type. It is in this sense that the copy in Kansas City differs from Rogier van der Weyden's Madonna in Houston, which was inspired by motifs of the Cambrai image, without repeating its exact type.[64]

We can take the argument further by moving from the Netherlands to Rome, where we can study the aesthetics of the holy image from a different aspect in the work of Antoniazzo Romano. In 1464, while still a young man, Antoniazzo received his first important commission from Cardinal Bessarion, who had his funerary chapel in SS. Apostoli decorated by the artist. The program included a panel of the Virgin that was fitted into a niche in the apse, with an inscription referring to Mary's immaculate conception. Antoniazzo gave the image, which was to remind the Greek emigrant Bessarion of the icons of his homeland, a strangely modern treatment, which nevertheless, in its hieratic severity (if one can employ that much-used term), differed sharply from the Renaissance art of the time.[65] In the same year he prepared decorations for the coronation of Paul II, who as a cardinal had assembled an imposing collection of "Greek icons" in the Palazzo Venezia.[66]

In 1470 Antoniazzo became a *camerlengo,* or agent, for six religious confraternities, whose statues he drew up. The foremost among them was the confraternity of the *Gonfalone,* dedicated to the Virgin, by which he was given responsibility over the famous images by St. Luke in S. Maria Maggiore and S. Maria di Aracoeli (chap. 15c). In the same year he copied the icon from S. Maria Maggiore for the ruler of Pesaro; a few years later he copied the icon in S. Maria del Popolo for Cardinal Levy, and again for S. Lucia, commissioned by the *Gonfalone* (chap. 16d). The copy for S. Lucia, which has survived, is distinguished by an extraordinary degree of fidelity to historical style, by which it differs clearly from the work commissioned by Bessarion. Its role as a copy is also seen in the brushwork: even the gold hatching is retained in the replica.[67]

In the 1480s Antoniazzo worked for members of the Spanish colony in Rome. The colony was based in the former church of S. Giacomo by the Colosseum, where the confraternity dedicated to the image of the Salvator in the Sancta Sanctorum was also stationed (chap. 4d and text 4G). This constellation of circumstances explains a work that accompanied its owner to Spain but has the emblem of the confraternity as its main theme. It is a triptych in the Prado, at the center of which a larger bust of Christ emerges behind an altar, against an irregular gold ground.[68] John the Baptist, the titular saint of the Lateran, and Peter, the hero of the papal church, bear witness in their scrolls to Christ's divine nature and his act of redemption. An inscription on

267

268

the altar refers in words from the Bible to Christ's archetypal beauty, which is reflected in the icon. The latter, in its oversize and its strictly frontal features, is treated as an image within an image, which turns out to be a quotation of an original in the papal chapel. The original, which was looked after by the confraternity and used the church of S. Giacomo as a station in the August procession, is, as we know, a full-length figure, though only the face was to be seen in the window opening. This is why the confraternity chose to show the veneration of the face as an emblem on an altar. Antoniazzo used the emblem but makes the icon itself visible, which appears with an almost visionary power. The subsidiary figures do not have to conform to this archaism.

Antoniazzo seems to have been the official copyist of old Roman icons at the time. His copies preserved the touch of the authentic, thereby guaranteeing a continuous power of the holy image that seemed endangered by the concurrent development of Renaissance art. His retrospective commissions needed a special style, which he developed for the purpose of copying, and which could be called an iconic style. This does not mean that Antoniazzo surrendered to each original and negated his own style. The uniform style he adopted for these commissions, however, gave the original he was replicating enough room to speak with its own voice.

The strangest commission he ever executed is the Leo Madonna from S. Maria Maggiore, now in Dublin.[69] It is a sensitive interpretation of the interceding Madonna of the type found in the churches of Aracoeli or S. Sisto, though with the addition of a small figure of Christ, which we know only from a replica from S. Gregorio on the Campus Martius (chap. 15b). This copy has a kind of painted commentary that is distinguished from the image proper. From a painted parapet an angel joins the severed hand of Pope Leo the Great (440–61) back to his arm. The action relates to a miracle reported in the *Golden Legend,* which, however, does not mention that an image was involved. The pope had amputated his own hand to free himself from sensual contact with a woman. But the Virgin gave him back the hand through an angel. The inscription on the parapet claims that this was the image "before which the pope, while praying, felt that his hand had been restored to him." In S. Maria Maggiore guides used to point out the place where the miracle supposedly happened.

This text cannot be understood to mean that Antoniazzo wanted to forge an original from late antiquity. Either there was another, older icon there that has now disappeared, or in the absence of an original, Antoniazzo suggests that the miracle once had happened before one of the two famous icons by St. Luke (which, he implies, would have been kept in S. Maria Maggiore). At any rate, the hagiographic commentary that Antoniazzo adds refers to the existence of an original. In the replica, the pope is praying before the original. The legend became part of the replica, attesting to the image's history and its power to work miracles. In this sense Antoniazzo's work is not just a replica but a certificate of the original. This function, too, was often performed by replicas. They could "discuss" what the original merely "stated." When they repeat a historical type, even with stylistic precision, they confirm in their way the aesthetics of the holy image, which followed its own criteria.

e. The Winged Altarpiece as the Stage of the Public Image

In the late Middle Ages the cult image was the counterpart of the private image. The former was at the center of public attention and sometimes achieved the status of an emblem of a church or state community. The recognition of its uniqueness—its miraculous history and its link to the public authorities who owned it—placed it outside the reach of private individuals; only copies were allowed a private use. But the cult image remained a rare exception. By contrast, every self-respecting church owned a painted or sculptured altarpiece.[70]

Altarpieces may contain cult images of the kind just mentioned, but they cannot be equated with them. They incorporate a number of different traditions that the church used for self-representation. There is first the liturgy, by which the clergy everywhere celebrated the same sacrificial act in a yearly cycle. But the liturgy also contained the local saints' feasts, which differed from place to place. These feasts had a dual purpose: on the one hand they honored a saint, and on the other they represented a local institution in the name of its patron saint, whether monastery, foundation of the nobility, or town community, to name only three institutions that became conspicuous through their lavish donations of altarpieces. As a rule, the cult of saints was a cult of shrines rather than of images. Shrines were placed behind the altar, and reliquaries on it. Images might be used to give these receptacles a distinct form and to distinguish one altar from the other, in which case they did not have a separate importance as images.[71] The situation must therefore be examined individually from case to case. In Italy the polyptych developed as an icon frieze on the high altar (chap. 18c). In the North the winged altarpiece was the dominant form. To clarify the respective problems, we should not treat it in isolation but first look at its early history.

In the twelfth and thirteenth centuries there was still violent disagreement over whether there should be images on the altar and, if so, which images. Unlike images on the walls or the exterior of the church, images on the altar impinged on the relics venerated there. It was not a big step from the cult of a relic to the cult of an image. For this reason the controversy over altarpieces was always a controversy about the veneration of images, which many wanted to keep in check. In a ritual at Magdeburg, only crucifixes were allowed on the altar, since they referred to the content of the sacrifice: "for images are shadows and have no part in the truth they portray." But in England at the same time, an image of the saint to whom the church or altar was consecrated was approved on the high altar or the chancel screen. Finally, a synod at Trier in 1310 demanded that every altar should bear an inscription or an image of the titular saint.[72]

A panel placed on the altar, no matter what image it carried or of what material it was made, was related to the cult vessels, and was thus probably confined, in the early stages, to occasions of special feasts. It might have included reliquaries hardly distinguished from its own appearance. In such cases images were mere supplements of something else, unable to speak with a voice of their own. This changed when a crucifix or the figure of a saint was admitted to the altar, thus responding to a specific liturgical framework. One should bear in mind this double root (cult vessels and movable image) in order to understand the development that followed.

268. *Madrid, Museo del Prado;*
Antoniazzo Romano, triptych with Vera
icon *and saints*

269. *Dublin, museum; Antoniazzo*
Romano, Leo Madonna from S. Maria
Maggiore

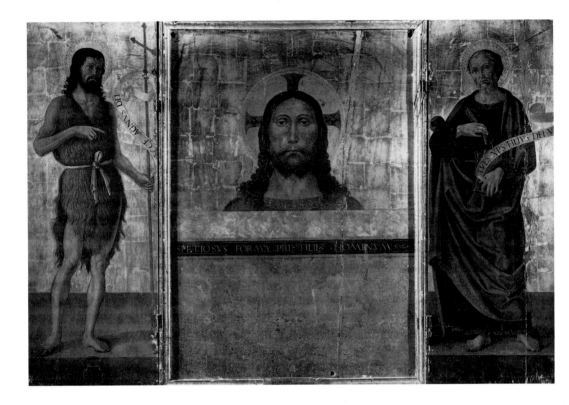

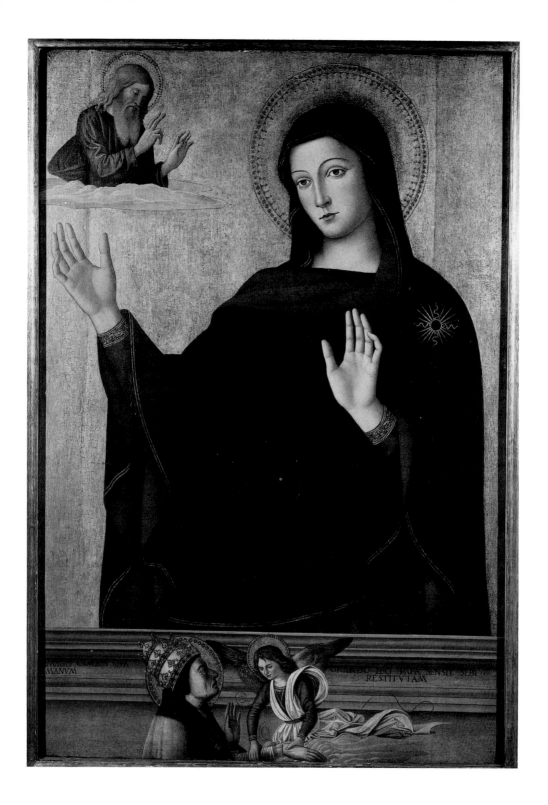

As we have only a patchy knowledge of events up to the fourteenth century, it is
best to start with concrete examples. In the choir chapel of St. Denis in the thirteenth
century, altars were fitted with stone retables, behind which baldachins with figures
were erected. This arrangement is recorded only in drawings from the time of the
French Revolution.[73] The retables had no fixed pattern but were devoted to images of
the Passion or the legend of the saint of the altar. The statues of saints, probably
usually concealed behind curtains, stand where shrines would otherwise have been
at the same height, and are comparable to the folding-image tabernacles in Italy
(chap. 18b). A fresco from about 1300 in Westminster Abbey, London, describes this
altar arrangement through the substitute medium of the mural.[74] A low retable with
the Crucifixion at the center, originally of stone, fills the whole width of the altar.
Above it St. Faith appears in an elegant baldachin, shown unmistakably as a statue
by the socle with a capital that supports her. Such a statue represented the titular saint
of the altar and acted as a focus for veneration. But it did not necessarily have the
qualities that would justify an image cult as such, being merely an accessory to the
saint's cult.

A different solution was to be found, again in the early fourteenth century, in the
pilgrims' church of St. Thibaut-en-Auxois.[75] The shrine with the saint's remains was
now displayed in a special chapel; but the images relating to the saint had been sepa-
rated from the casket and placed on the high altar, in which a relic was enclosed. As
the local saint's legend was a particularly attractive one, it was narrated in a large
number of scenes not only on the retable but also on the antependium below the altar.
Nevertheless, there is a difference between the two stone panels. The center of the
retable is kept by the Crucifixion, while the enthroned figure of the local saint appears
as a *Maiestas* at the center of the antependium (chap. 14a). The cult of sacrifice pe-
culiar to the mass and the cult of the saint pertaining to the locality are thus kept
apart. The relief below that decorates the altar represents the independent image of
the saint at the cult site.

About that time the painted and carved winged altarpiece appeared for the first
time on German soil in monasteries of the reformed orders. An early example, the
altarpiece in the Premonstratensian monastery at Altenberg, was assembled from its
now-dispersed parts for an exhibition in Frankfurt.[76] The place of the actual shrine
casket, between relics visible through scenes of Gothic tracery, is given over to a ven-
erated statue of the Virgin, which was given a permanent place in the altarpiece of
1334. The painted wings, which could be opened in two different ways, show the life
of the Virgin, while the figures in the Adoration of the Magi directly address the image
of the Virgin. The wings serve both to close the relic container and to promote the
cult of the Virgin figure, which, as was the privilege of every cult image, could in this
way be made either visible or invisible. But which of the two functions gave rise to
the construction of a folding altarpiece?

Different questions are raised by the winged retable of the Cistercian monastery
of Marienstatt, for here the cult image that might have benefited from the usual ritual
of showing and concealing was absent.[77] The upper zone of the three wings is devoted

270

271

272

273

274

270. Paris, St. Denis; chapel of St. Romain (after a drawing by Charles Percier), 13th century

271. London, Westminster Abbey; chapel of St. Faith, ca. 1300

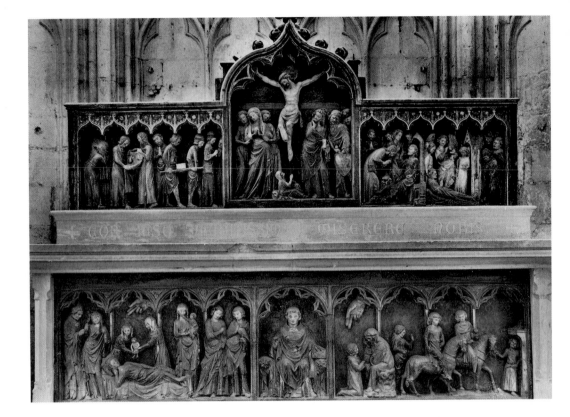

to carved figures, and the lower to the same number of relic busts. The ensemble gives the effect of a program representing the idea of the church. This is aided by the architectural structure of the retable, which resembles a church facade, and by the heavenly council (Coronation of the Virgin and apostles), which includes the choir of the Holy Virgins of Cologne at the bottom. The arrangement of the reliquaries expresses the ecclesiastical status of the virgins rather than the presence of any particular relic.

Images and relics fulfill a similar function in the overall program, which embodies a specific order conveying a conceptual rather than a literal or visual meaning. It has been rightly pointed out that this altar was shaped by a reformist desire to do away with the materialism of the cult of saints.[78] This does not mean, however, that the image had now taken over the function of the relic. Still less can we talk of an image cult. A similar development can be observed at the same time in Italy (chap. 18c). Simone Martini's retable for the Dominicans at Pisa had for the first time a pictorial program form that devalues the individual image and presents instead a theological concept. In Marienstatt the retable brought the church's treasures together in one place, so that viewing of them could be controlled. At the same time it represents the divine liturgy in such a way that it makes plain the order's intention to present itself as the representative of the heavenly church on earth. In this sense the altar symbolizes the institution that owns it. *244*

It does not follow from this principle, however, that the wings have to fold, which they never do in Italy. The presence of relics makes it legitimate to suppose that the winged altarpiece was the successor to the earlier relic casket, which holds true also for the example in Marienstatt.[79] There can be no question of such an explanation for the winged altarpiece of the collegiate foundation at Oberwesel, to mention another early example. In this case, there must have been different reasons for opening and closing the wings. It is therefore worth noting that a number of retables show the Passion in the closed position, which can only mean that they offered this view during Lent. This leaves us with a liturgical explanation. The altar changed its appearance with the rhythm of the church year, distinguishing the feasts by the sight of its open wings.[80]

This is also likely to have been the intention of Marienstatt. The theological program of the retable was supplemented by an appearance that changed in step with the liturgy. One should not conclude from this that the altarpiece was now assuming functions abandoned by the cult image or the relics.[81] It folded like the old cult image, but for different reasons. It was always a special event when the cult image was shown. Only then could one appeal for its help. The mise-en-scène of the cult image affected only the visibility of the image itself, by revealing and concealing it, which was important only for the fixed image (movable ones could simply be removed when necessary).

The changing of the altar (not the image) from its normal to its festival aspect was quite different. This change followed the liturgy and had a primarily liturgical meaning. One had a privileged view of the altar for the sake of the feast, not of the image. That may sound like splitting hairs, yet the double perception of the altarpiece (as a pictorial program and as a sight restricted to special occasions) indicates that

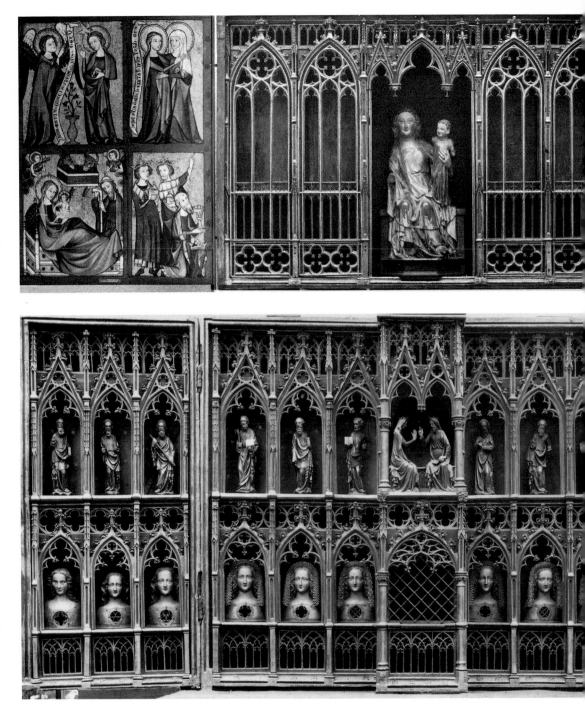

273. *Frankfurt, Liebieghaus; altar from*
Altenberg, 1334; reconstruction with
substitute Madonna figure, 1976

274. *Marienstatt, Cistercian monastery;*
high altar, before 1350

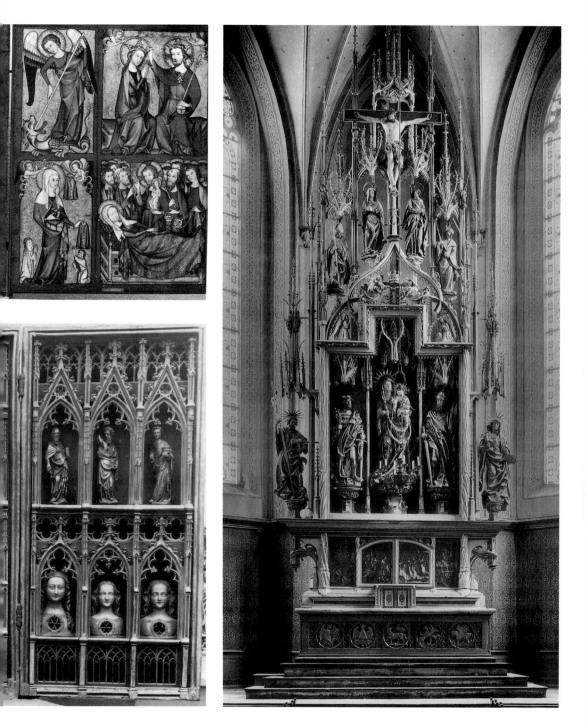

275. Moosburg, former church of St. Castulus; Hans Leinberger,
high altar, 1511–14

the church was imposing its discipline on the cults of both relics and images. It is also true of Marienstatt that the appearance of the altarpiece was controlled and its visibility periodically restricted.

This makes it clear that we need to employ a more exact definition of the term "cult" if confusion is to be avoided. When the altar is referred to as the scene of a cult, it is always the sacrificial cult of the church that is meant. This is fundamentally different in kind from an image cult, which came into being outside the liturgy (though it could be combined with the liturgical cult of saints). An image was not a cult image simply because it stood on an altar. The performance on the altar was not directed at the image, though the status of the image was enhanced by liturgy. We come closer to the truth if we see the altarpiece as serving the self-representation of the church.

The altarpiece represents the church on a number of levels.[82] It symbolizes the mystery of the sacrificial cult, and on another level, the church as an institution that administered the mystery. Finally, it represents a local community—a parish, a monastery, or a foundation—that supported its church. The cult of a saint was always a symbol of a social body, and the altarpiece was the stage of a saint's cult. In this sense the carved altars of the late Gothic period, with their extravagant increase in size and decoration, can be seen as a means of competition. They stand both for ideas of the church in general and for the social claims of a local institution. In this tendency the monasteries and foundations took the lead in the fourteenth century, followed by the towns and parishes in the fifteenth.

Michael Baxandall has summed up the situation in late Gothic Germany, and we can follow his description here.[83] "The greatest retables . . . were on the high altars and were usually the offering of a community," the sculptures visibly embodying the identity of a collective donor, as in the case of public fountains. "Quite a number of the most magnificent high altarpieces were subscribed for by communities in some need of emblems of identity and unity." Noteworthy examples are the southern German free cities and, in the case of the Cracow altar by Veit Stoss, the German colony in the Polish metropolis. A parish would also invest in altarpieces that enhanced its prestige. The winged altar, as the stage on which the public image appeared, was a means both of display and of competition between institutions, as the Marian retables of the Italian confraternities had been in the thirteenth century (chap. 18b). When the painted wings were opened and the three-dimensional gilt figures inside were exposed, the demonstration of the local donation went beyond the overt liturgical meaning of the event and resembled the festival decorations that were used to emphasize the prestige of a city or guild on great occasions. The material cost and the original invention, as well as the skill of the commissioned master, brought honor to the collective donor. As with Duccio's *Maestà,* the meaning of the altarpiece shifts from that of a sacred image to that of a precious votive gift (chap. 18d). When the reformers criticized not only the unbridled extravagance but the vain and worldly gestures of the altar figures, they touched on a sensitive nerve.

In 1511–14, Hans Leinberger created for the foundation of St. Castulus in Moosburg one of the last and, at a height of 14.40 meters, one of the largest Gothic

carved altars, which can be used to illustrate the genre.[84] In the casket-shrine of the *275*
corpus the figures of the patron saint Castulus and the sainted emperor Henry II stand
beside the Virgin. The shrine once had two wings showing the life of St. Castulus in
low reliefs. The three-tiered structure begins with the predella at the bottom and ends
with the steep upper structure, with the Crucifixion reaching almost to the vaulting.
In the new building just begun, the remains of Castulus, an early Christian martyr,
were moved in 1469 to a position "below the new altar in the chancel." In 1514,
when Leinberger's high altar was finished, they were integrated into the unusually tall
predella, where they could be displayed on days of pilgrimage. On the painted wings
of the predella a Wittelsbach duke is to be seen with members of the foundation as
the donor of Leinberger's costly retable.

This unusual winged altarpiece was intended to assert the importance of an insti-
tution threatened with removal to Munich. This is why the local traditions, as sym-
bols of traditional rights, are carefully spelled out in the program (Castulus and
Henry II). The "Mother of God," as the inscription on the veil calls her, had an old
patron right in the locality and now becomes the principal figure. This gives her a
rank higher than the pilgrims' cult, allowing the Christian mystery to be made the
central concept. The Virgin appears in the floating pose of a heavenly apparition (epi-
phany) characteristic of Leinberger, and in the historical style of "international
Gothic," as if to recall the Fair Virgin as an archetype. Her veil reveals an attempted
synthesis with the icon of St. Luke. The myth of the image's origin (St. Luke) and the
"cult of form" as a symbol of the "theological ideal of sacred forms" have once again
been forced into a single focus.[85] In this way Leinberger's altar can be seen as a reflec-
tion on the purpose and the crises of the genre.

f. The Pilgrimage to the Fair Virgin of Regensburg

The crisis of the holy image began to emerge in the emphatic, visionary style of Lein-
berger's figures. The crisis was brought on above all by the excesses of the pilgrimages,
which drew the holy image into the controversies of the Reformation period. The
form of the old cult image had become as uncertain as its use. The institutions, the
theologians, and the art connoisseurs spoke with different tongues, and it is some-
times quite impossible to disentangle their motives and arguments. The situation is
best exemplified by a famous occurrence in which these conflicts broke out openly. In
the pilgrimage to Regensburg in the spring of 1519, old and new convictions came
into irreconcilable opposition and were violently articulated.[86]

It was for political reasons that the town's magistrates had established a cult of
the Virgin with the image of the Fair Virgin at its center. This is a telling name, as it
recalls historical models that bore this title. "Fairness" here is not a quality of the
image, still less of its artistic merit, but a property of the Virgin that can be estab-
lished only theologically. The source in the Bible is the Song of Songs (4:7), the
verses of which had already been used to characterize the St. Luke icon in Březnice *204*
in Bohemia.[87] All the same, this bridal mysticism, which was to emphasize the ideal
of the Virgin, was thought to be better embodied in historical images than in the
art of the time.

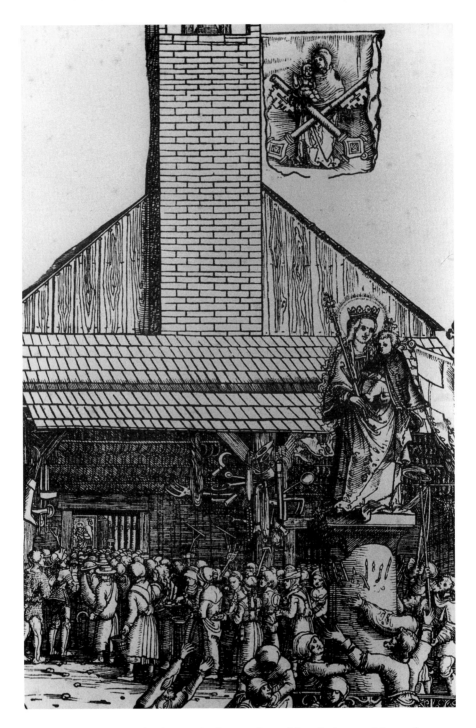

276. *Veste Coburg; Michael Ostendorfer, woodcut of the pilgrimage of Regensburg, 1519 (detail)*

A gigantic woodcut by Michael Ostendorfer shows the climax of the pilgrimage.[88] 276
On 18 March an image had been displayed in a hastily erected wooden chapel that
the cathedral preacher, Dr. Balthasar Hubmaier, described as the "panel of the Fair
Virgin." The woodcut shows the country people crowding into the chapel to see the
icon inside. Outside the chapel stands a stone statue of the Virgin that the cathedral
sculptor Ehrhard Heydenreich had made in 1516 for a different purpose, the first
triumphal column of the Virgin known to us that stands in open space outside a
church. In 1543, a year after the introduction of the Reformation, it was smashed to
pieces. In the woodcut the pilgrims and the sick are seen embracing it and begging its
help before going on to the original image. Votive offerings in the form of agricultural
implements and boots hang everywhere. From the right another procession of pil-
grims is approaching with a flag and an oversize wax candle. The ruins of the ghetto,
on the site of which the new chapel stands, rise toward the sky.

Within a week of Maximilian I's death in January 1519, the town council set
about driving out the Jews, who now had lost their imperial protection. To justify the
act, the Jews were denounced in well-tried fashion as enemies of religion, and their
crimes were "expiated" by building a church of the Virgin on the site of the syna-
gogue. The cult of the Virgin was to efface the blot left by the violence done to the
Jews. Heaven itself, so it appeared, had approved the pogrom when the Virgin per-
formed the desired miracle. A workman who had been almost fatally injured when
the synagogue was demolished appeared fully recovered at the site the next day. This
was taken as a heavenly sign signifying the Virgin's sympathy. The propaganda for
the new cult was in the hands of the cathedral preacher, but he joined the Reforma-
tion side soon after and was finally executed as an Anabaptist. On 1 June 1519 an
indulgence of one hundred days was granted by the bishop. Clothes that had touched
the statue in front of the church cured sick cattle. By the next year, 109,189 pilgrims'
badges of lead and 9,763 of silver had been sold.[89] Criticism of excesses soon began
to be voiced, by artists among others. On his copy of Ostendorfer's woodcut, Dürer
noted: "This specter [the pilgrimage] has arisen in Regensburg against the Holy Scrip-
ture; it has been allowed by the bishop and, because of temporal advantage, has not
been stopped. God help us not to do such dishonor to his worthy Mother, but to
honor her in Jesus Christ. Amen. AD."

The part played by the image cult in these events can be ascertained only from
scanty evidence. When the wooden chapel was erected, a holy image was hastily
moved into it; this can only have been the thirteenth-century icon from the "Old 277
Chapel."[90] This original, which is mentioned only in later sources, was probably at-
tributed to St. Luke at that time. It was perhaps lent for only a short time before being
replaced by a work by Albrecht Altdorfer. The latter offers a synthesis of copy and 278
new creation. The old type has been retained, right down to the posture of the Child
and the fringes on the head veil. But its conception is just as modern as that of Hayne's
replica of the Madonna of Cambrai.[91] An aureole of light in the midst of dark clouds 267
transforms the figure into a visionary apparition. A costly wooden aedicula frame
carries the official coat of arms of the town and the verses of the Song of Songs that
explain the name of the Fair Virgin and link the work to the pilgrims' cult.

277. *Regensburg, Old Chapel; St. Luke Madonna, ca. 1220*

278. *Regensburg, Episcopal Museum; Albrecht Altdorfer, Madonna and Child, 1519*

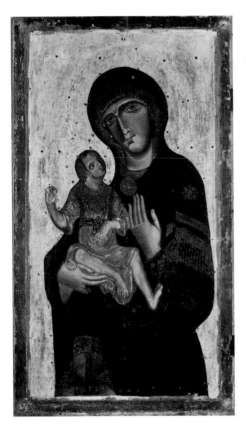

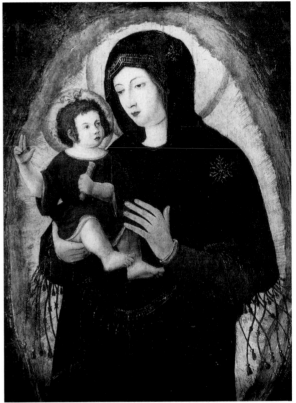

Altdorfer clearly had the images used for cult propaganda in the town. He not only painted the town's flag for the chapel, as shown in Ostendorfer's woodcut, but also printed a colored woodcut in which the Fair Virgin is reproduced, even including an exact rendering of the surviving frame. This is a curious procedure, since the artist is presenting his own work as the official cult image. Yet the circumstances allow no other interpretation. The cult had arisen all of a sudden through the miracle in the Jewish quarter. The miracle had not been caused by an image, but the image was needed to commemorate it. It therefore needed no old original, only a new creation interpreting the miracle worked by the Virgin as an epiphany.

The cult image's identity resides in its official role at the cult site, a role legitimated by the town authorities (as in their coat of arms). The original by St. Luke in the Old Chapel could not be the Fair Virgin because it resided in a different place. All the same, there was a reason for alluding to the St. Luke panel, which Altdorfer used as his model and archetype (as van Eyck did with the Veronica), for it was believed that St. Luke had seen the Madonna. One was therefore on solid ground in keeping to her attested appearance. It was expected of Altdorfer, however, that he would give the image a new face at a new place, to permit a distinction between the two. It is Altdorfer's vivid treatment, particularly his interpretation of the figure as a heavenly apparition, that distinguishes the Fair Virgin from other images. The cathedral preacher described the situation surprisingly well when he said of the panel of the Fair Virgin that it was created "according to the portrait painted by St. Luke the Evangelist."

This approach was not without its problems, however, and people soon began to be dissatisfied with Altdorfer's solution, wanting an even fairer Madonna for the rebuilt chapel. In 1519, therefore, Hans Leinberger was commissioned to produce a statue intended to be used in a stone retable. In 1520 Altdorfer designed such an altar, as a woodcut by his own hand shows. The new altar, a kind of tabernacle for the new cult image, was actually produced, as it was covered in cloth by supporters of the Reformation in 1554. They were offended by the Virgin's coronation by the Holy Trinity, which they regarded as an idolatrous theme, and the work was soon removed. Only Leinberger's small statue in St. Kassian in Regensburg may possibly have survived.[92] When the Reformation had passed Regensburg, the emperor mounted an unsuccessful search for the Fair Virgin in 1630. No one knew what had become of it, particularly as two images by this name had existed. Thus, like many old cult images, the original by St. Luke in the Old Chapel received new honors during the Counter-Reformation and the Baroque era.

20. Religion and Art: The Crisis of the Image at the Beginning of the Modern Age

Arguing over the Old Testament's ban on images, Luther resisted the iconoclasts by saying, "There are two kinds of images." God was not speaking of all images, but only of those that were "set in God's place." In the Old Testament God therefore prohibited only the cult images. They should continue to be forbidden, Luther argued—or, better, they should be stripped of their function. It is, after all, the beholder who is free to use the image (text 39B). Luther urged his contemporaries to free themselves from the alleged power of images (chap. 1c).

There were indeed "two kinds of images" in Luther's own age. The empty walls of the Reformed churches were visible proof of the absence of the "idolatrous" images of the papists. They symbolized a purified, desensualized religion that now put its trust in the word. But the crowded walls of the picture cabinets in private houses, which did not interest Luther, testified to the presence of painting, of which key works (of genres and artists) were then being collected. The resulting collections were unaffected by the verdict against images in churches. Images, which had lost their function in the church, took on a new role in representing art.

The coexistence of two kinds of images was, it seems, not confined to the realm of religious practice, which Luther had in mind. The theologians and the connoisseurs of art were not talking about the same images. One side wanted to strip the old kind of image of its sacred aura; the other strove for a definition of art that accorded with the new kind of image. But each in its way contributed to the crisis that the old image faced in those days. Except in the Reformed churches, the dividing line was not between the religious and the secular image. It separated, rather, an old concept of image from a new one. In Italy, where the churches kept their images, an effort was made not to choose between them but to synthesize them. People did not experience two kinds of images but images with a double face, depending on whether they were seen as receptacles of the holy or as expressions of art. This double view of the image persisted, even when applied to a single work. Although in the Catholic world no verdict was pronounced against the veneration of images, yet even there the holy image could not escape its metamorphosis into the work of art.

Luther, who merely defended religion's shrinking hold on life, certainly is more a witness than the cause of what has been called the "birth of the modern age from the spirit of religion."[1] Religion, however belligerently it asserted itself, was no longer the same. It fought for the place that it had held before, but it ultimately was assigned the segregated area in society with which we are now familiar. Art was either admitted to this area or remained excluded from it, but it ceased to be a religious phenomenon in itself. Within the realm of art, images symbolize the new, secularized demands of culture and aesthetic experience. In this way a unified concept of the image was given up, but the loss was obscured by the label "art," which now was generally applied. A general validity of an image independent of the idea of art be-

came inadequate to the modern mind. Its abolition opened the way to an aesthetic redefinition in terms of the "rules of art." Artistic and nonartistic images now appeared side by side, addressed to people of different levels of culture.

The process I am describing has nothing to do with the "loss of the center," which Hans Sedlmayr proposes in a book dealing with the shortcomings of the modern age.[2] He looks back to a humanist definition of art that was just being formed in the age of Luther and Dürer. The comparison between the media of poetry and painting is sufficient evidence of another type of discussion at that time (text 42). The painter now became a poet and as such had the claim of poetic freedom, including that of interpreting religious truths. The religious subject, in the end, could be invented only by the artist, since it could not actually be seen, like the objects in a still life or landscape. The new presence *of* the work succeeds the former presence of the sacred *in* the work. But what could this presence mean? It is the presence of an idea that is made visible in the work: the idea of art, as the artist had it in mind.

It is here that the history described in this book comes to an end. In what follows I shall confine myself to highlighting a contrast. As we look back, the image, with which this book has dealt, stands out more distinctly. With the new distance, our perception of the old situation has sharpened. The sources that inform us of the theory and practice of images are themselves a witness to the new state of things. The meaning of *art* now had to be explained, since there were (apart from the texts of antiquity) no ready-made justifications, nor could there be. The new painting called for a hermeneutics of art of the sort that had been applied previously to literature. It now is no longer enough to tell the stories of images, as was done in this book as well. Images find their place in the temple of art and their true time in the history of art. A picture is no longer to be understood in terms of its theme, but as a contribution to the development of art.

a. Criticism and Destruction of Images during the Reformation
Criticism of images was not a new phenomenon in the Reformation, even though the Reformers were at pains to claim they were the first to castigate the abuse of images. In late medieval Catholicism, voices of moderation and warning frequently were raised against the excesses of the image cult and its misuse as a means of accumulating capital.[3] New, however, was the context in which the old criticism now found itself. With the general reform of the church, the image question became a pivotal issue. Abuses in the matter of images and indulgences by the Papal church were a welcome means of drawing a visible dividing line where everyone would recognize it.

The Reformers, therefore, could not stop simply at criticizing images. Because the situation demanded a new practice, the new faith had to present itself as a church without images. The cleansing of the temple of traders and images was to restore the church to its original state, before it had gone astray. In this sense iconoclasm was the applied criticism of images. However, iconoclasm is a phenomenon with many facets and, indeed, many contradictions.[4] Not even the Reformers agreed on how it was to be handled. Karlstadt saw it as an opportunity for activism; Luther opposed it as threatening general upheaval; and Zwingli advocated, in the orderly removal of im-

ages, a middle position between iconoclasts and image protectors. The debate between the theologians is reflected in the respective writings (text 39).

But iconoclasm was not only an affair of theologians. It included an uprising against capital and authority, whether the enemy was the hated landlords, rich monasteries exempt from taxes, or the Spanish army of occupation. Iconoclasm was initiated sometimes by the masses, sometimes by the officials of a town in conflict with church ownership, but seldom by the theologians themselves. It was the symbolic cleansing of the temple that made this action a potent weapon for many. It could be used equally well against the church, the local magistrates, or the rich landlords who had erected monuments to themselves (*simulacra,* in the language of Erasmus of Rotterdam) in the churches (text 39D). Here we touch on controversies in political and social history that we cannot pursue properly.

In Wittenberg in the spring of 1522, theologians fighting for church reform needed the support of the Saxon rulers. Luther therefore wanted to avoid any disturbance that could jeopardize his cause and was prepared even to permit the old use of images in the case of the elector. "There are people who have not yet attained this [correct] opinion [on images]," he said, who could be convinced of their error only by preaching.[5]

In Münster, by contrast, the Anabaptists brought about the overthrow of the regime in 1534. As a movement, they had long been politicized, an imperial edict having branded them as rebels. They expelled the bishop as the ruler of Münster and launched a general attack on money (which they regarded as an idol), withdrawing capital from circulation and hoarding all jewelry in the town hall. Their millenarian expectation of salvation was to be fulfilled in a new incarnation of the "Word," which, as their memorial coins suggest, the Anabaptists identified with their own realm of peace. From now on God was to be honored "only in the living temple and in the hearts of men," rather than in the image of the sacrament, as one of their leaders put it. The new movement in Münster dispelled every symbol and memory that images perpetuated, such visible custodians of tradition being an obstacle to a new beginning.[6]

The revolution in Münster was a short-lived episode on the fringe of the main course of the Reformation, which was carried forward by the Lutheran and Calvinist wings and in 1566 first reached the Netherlands. In other places, too, religious self-determination was closely coupled to political self-determination; one form of emancipation seldom stopped short of the other. With the removal of images, a crisis developed in the way the old order—dominated by the church and the landowners—presented itself. New forms of public display were sought. The more problematic the public sphere became, the more quickly the private sphere, which then was only a recent phenomenon, developed.

In Geneva, image breaking on 8 August 1535 was the central event in the consolidation of the Reformation. The new preachers dominated the scene once the bishop had been deposed as ruler of the city. Calvin joined them in 1536 but was able to found a theocratic regime in the city only in 1541, after the old boundaries between secular and church life had been abolished. The new era, reckoned as beginning with

the cleansing of the churches, was celebrated in a square bronze plaque (99 cm²) that
remained affixed to the wall of the town hall until 1798:[7]

> In the year 1535 the tyranny of the Roman Antichrist was overthrown. We have
> abjured superstition and restored the sacrosanct religion of Christ to its original
> state, his church to a better order. The city, whose enemies we have put to flight,
> was not given back its freedom without a miracle from heaven. The Senate and
> the people of Geneva have erected this monument in this place for eternal
> memory. May it bear witness before their descendants to the thanks they have
> rendered to God.

This monument, an inscription in classical Latin and in the style of antiquity, is a
kind of "icon of the word" which opposes a verbal memory to the memory invested
in images. At the same time it is a manifesto of humanist culture in which mind,
represented by the word, was to triumph over matter and the "outward image." This
inscription expressed the victory of "enlightenment" and the desire for religious self-
determination, doing so in the form of a proclamation and in the tone of a law that
bound all—preachers, parish, and city alike—to the word of God. In both public and
private life, religion was present and visible through the words of the Bible. All rep-
resentation by images was forbidden in the "Calvinist religion," as it is called in a
Netherlandish engraving. The civic inscription fixes the inauguration of a new era in
the collective memory. The destruction of the images (not the introduction of the
Reformation three years earlier) marked the official date.

The forms taken by iconoclasm sometimes reveal the motives underlying these
actions. The chronicler Fizion of Reutlingen describes how the main church of the
town was "entirely cleansed of superstitious substance and papist idolatry" in 1531.
The altars, too, were destroyed, and "the images torn down with derision."[8] Two
motives are prominent. The first was to demonstrate the impotence of the images,
which had been credited with much power. The second was to expose the old insti-
tutions, particularly the Roman church, which had sought to exert power over the
people by such ineffectual images.

Beyond simply removing the images, a further step was to leave them where they
were but to break off their faces and hands, thus depriving them of the features with
which they had most impressed the people. If the images left this sacrilege unpun-
ished, their powerlessness was all the more clearly proved. The mocking of images
was sometimes more important than their removal. The exposure of the institutions
that had administered the images sometimes took the form of punishment by proxy,
in effigie. If the guilty parties could not be reached, resentment was vented on the
images they had left behind. It was now in the cult images that the old church was
punished. Sometimes ritual acts were performed, using familiar methods of punish-
ment. If an image was left standing, mutilated and derided, like a caricature of itself,
beholders who had grown up to respect it could vividly remind themselves of their
newly gained freedom.

The Roman church, at which the iconoclasm was aimed, was further attacked
with satirical pamphlets. The "error" of Rome could best be unmasked by denounc-

279. *Geneva, St. Pierre;
bronze plaque from the
City Hall, after 1535*

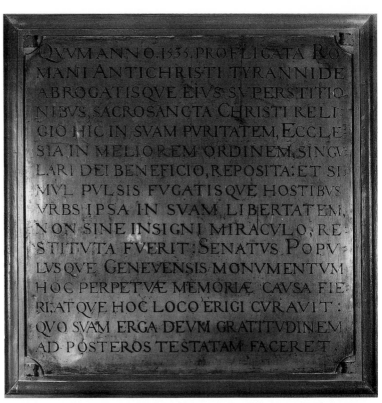

QVVM ANNO 1535, PROFLIGATA RO
MANI ANTICHRISTI TYRANNIDE
ABROGATISQVE EIVS SVPERSTITIO
NIBVS, SACROSANCTA CHRISTI RELI
GIÒ HÌC IN SVAM PVRITATEM, ECCLE
SIA IN MELIOREM ORDINEM SINGV
LARI DEI BENEFICIO, REPOSITA: ET SI
MVL PVLSIS FVGATISQVE HOSTIBVS
VRBS IPSA IN SVAM LIBERTATEM,
NON SINE INSIGNI MIRACVLO, RE
STITVTA FVERIT: SENATVS POPV
LVSQVE GENEVENSIS MONVMENTVM
HOC PERPETVÆ MEMORIÆ CAVSA FIE
RI, ATQVE HOC LOCO ERIGI CVRAVIT:
QVO SVAM ERGA DEVM GRATITVDINEM
AD POSTEROS TESTATAM FACERET.

280. *Dinkelsbühl,
Evangelical-Lutheran
Congregation; altar, 1537*

ing the cult of images and relics as a relapse into paganism. This charge was especially effective when the supposed parallels were taken from Judaism, for which all image worship had been an aberration from the true faith that was immediately punished by Yahweh. The idolatry to which Solomon was seduced by the foreign women was a telling example.[9] Seen in this light, the Reformation was a return to the true faith like that which had followed every chastisement of the Jews by Yahweh in the Old Testament. What was happening to the church of Rome at the hands of the iconoclasts, if one followed the logic of the pamphlets, was just one more lesson of history.

Luther had other reservations about images, seeing them as symbols of the false doctrine of justification through works. It was a "misuse" to place an image in a church and claim to have "done God a good service and a good work, which is veritable idolatry."[10] But Luther had equal reservations about the violent removal of images. This, in his eyes, amounted to a similar justification by works, as if the destruction of images were in itself a good deed. Would it not be more enlightened to leave the images where they were, but no longer pray before them? "We must persuade the people by the word to trust them no more. For the heart must know that nothing can help it . . . but God's grace and goodness alone." It was above all the moralist that now stirred in Luther, who was suspicious of iconoclasm as a diversion from the task of moral renewal. "By following such laws, they do away with outward images while filling their hearts with idols" (text 39B). The real idols are the vices of men and women.

A pamphlet illustrated with a woodcut by Erhard Schoen and published about 1530, a few years after Luther's sermons, takes this moralist's argument further. *Lament of the Poor Persecuted Idols and Temple Images* is a long text of 383 verses in six columns, in which the images reject the punishment meted out to them because the same human beings who now punish them previously erected and venerated them.[11] The woodcut highlights a contrast, as was popular in the polemical images of the day, by setting the removal of images from the churches against the arrogance of the iconoclasts, who surround themselves with wine, women, and money and who do not see the beam in their own eyes (Matt. 7:3). After the alleged idols were burned, the real idols became worshiped with an even better conscience.

In the accompanying text, the images make a confession that also lays bare the human beings who arraign them. As images, they had put on "such fine appearance" that they might have been taken for "God himself," heeding the cries and entreaties of all. But then follows the accusation of the accused: "You who now laugh at us have made us into idols. We can never be cured while you perform such antics." The "so many and unnumbered" real idols that rule people are the well-known deadly sins, which continue to exist under the new doctrine.

This critique of iconoclasm is more radical than the iconoclasm itself. The disempowering of images, which could no longer offer salvation, threw people back on themselves. The images were their work, and the cult of images, their mistake. People remained the same whether or not they did away with the images, which provided only the outward appearance of their inner images. The moral is obvious, as the virtuous person now becomes the only real image of God that can exist on earth. The

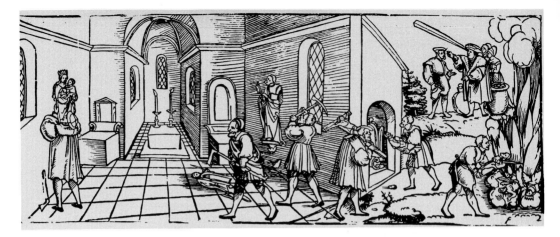

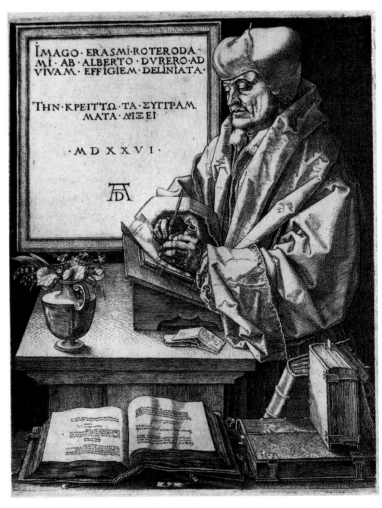

281. Nuremberg,
*Germanisches
Nationalmuseum; Erhard
Schoen, woodcut,
ca. 1530*

282. Nuremberg,
*Germanisches
Nationalmuseum;
Albrecht Dürer,* Erasmus,
engraving, 1526

theological argument, however, points ultimately beyond the religious and ethical spheres. In the modern age, subjects remain alone with themselves. They can invent an image, but it has no other truth than the one they themselves invest it with.

b. Image and Word in the New Doctrine

In 1525 the artists of Strasbourg addressed a petition to the city government, asking its help in changing their profession, as they had been without work since "the respect for images had noticeably fallen away through the word of God." [12] The Reformation taught the dominion of the word, which suppressed all the other religious signs. Christianity had always been a revelation through the word but now the word took on an unprecedented monopoly and aura. After all, the new preachers had only the word of Holy Scripture and no other authority in practicing a religion without the institution of the church. They wanted, as it were, to rediscover the primal sound of the word, free of all the dross and errors of papism, and to teach it to the congregations. "For on words rests all our ground, protection, and defense against all errors and temptation," as Luther says in his Large Catechism. "The kingdom of God is a kingdom of hearing, not of seeing," he announces in another place. "God's word, properly understood," as Luther says in his *Table Talk,* "is the ground of faith. . . . He who has it pure and unfalsified, can . . . triumph over all the gates of hell."[13]

In the era of Gutenberg, the word was present everywhere. The new humanist culture profited from this, for it claimed the reign of the spirit through the mirror of the word. The new philology directed its efforts at deciphering the true texts of the authors of antiquity. Humanists wanted to understand their truth, just as the theologians sought the truth of the Bible. As the tool of rational argument, the word was the refuge of the thinking subject, who no longer trusted the surface appearance of the visual world but wanted to grasp truth only in abstract concepts. These intellectuals emphasized that a painter can represent only their body, but "the better image [of such persons] is expressed in the books" they have written.

Thus wrote Erasmus to the elector of Brandenburg when sending him his portrait medal made by Quentin Massys.[14] The inscription on Cranach's first engraving of Luther, from the same year, contrasts the "mortal features" Cranach has engraved with the "eternal image of his mind" that only Luther himself could express.[15] In 1526 Dürer found a classical formula for the dualism of word-body (writings) and image-body (portrait) in his famous engraving of Erasmus,[16] which in fact contains two different portraits of the same scholar. The inscription panel transcends the "bodily likeness from life," using the "better [image] in the writings." It is this panel that Dürer signed, as it was his idea to represent the spiritual or intellectual personality of the scholar through a suitable pictorial metaphor. Painters too now had to practice a kind of "indirect speech" when making the human subject the theme of a picture or when addressing the subject (the beholder). The written word ranked higher than any painted or sculptured image.

In theology, the word has the highest status, as the word of God. Any discussion of this raises the question of its role in revelation—the question of whether God has established other means of encountering him besides the word. One's answer to this

282

465

would include or exclude the painted image as well as the "image" of the sacraments. The controversy over the Last Supper brought this fundamental question to the fore. Luther remained faithful to St. Augustine in believing the word powerful enough to "transform the element into the sacrament," the bread into the Body of Christ. For Calvin, in contrast, the bread is only a sign, which, like all signs, can never actually become what it merely signifies. The Body of Christ is thus only a "figure of speech" (texts 40, II, and 41, II). This divergence is of fundamental importance. Calvin allowed no symbol an authority equal to that of the word. Luther recognized only "bodily signs" in which God manifested himself, as well as the "word of mouth of the gospel." Among the bodily signs Luther included "baptism and sacrament" (ibid.). The word was one means among many for the experience of faith, and this brings one back once again to the painted image.

Calvin, by contrast, would allow no infringement on the monopoly of the word. Only the word allows us to see "God in the manner of a mirror." The only problem was the manner in which spirit and word were joined. For Calvin, God's promise was all that was needed to believe that the spirit was present in God's word. He all the more radically rejected bodily images of God as crimes, since they willfully and senselessly usurped the word's right to embody the spirit. For him the separation between God and the world, between spirit and matter, was irreversible, and the spirit was impervious to all sensuous or personal experience. Images could be used outside religion, either for instruction, when they adopted a didactic, narrative mode, or for enjoyment, when they depicted visible nature (text 41, I and V).

Luther, however, saw no philosophical problem in images. For him an image was a means to an end that enlightened beholders could choose for themselves. Images were "unnecessary but free" (text 40, I). In his epilogue to the *Decameron*, Boccaccio had reflected that his stories might "be hurtful or profitable according to the quality of the reader" but were not good or bad in themselves. Luther applied this pragmatic approach to religious images, though he was then forced to give examples of their beneficial effects.

When they depict events from the Bible, images narrate and instruct in much the same way a biblical text does. The narrative image is thus a permissible alternative to the prohibited cult image. "I even consider images from the Scriptures or depicting good histories to be almost useful," he said, since they remind us, like the biblical text, of divine salvation. Yet crucifixes and images of saints were also among the permitted images, which Luther called images of "memory or witness." He allowed images in which one "sees only past history and objects as in a mirror," as well as the "signs on coins," while Calvin permitted only one mirror of God: the word.

The biblical painting that Luther allowed was no recent phenomenon; it had been used even in the Roman church without abuse. Luther, however, introduced fine distinctions that had to be carefully observed. To begin with, he did not allow this genre of images to be seen in churches, but only in private "rooms and chambers." He also desired that "mottoes" be added to pictures—that is, biblical quotations, so that, through their authentic words, "one can have God's work and word always and everywhere before one's eyes" (text 40, I and III). The painted image, he claimed, then

acted as an illustration of the word, or of the deeds of God recorded by the word. In practice, as in paintings from Cranach's workshop, it was primarily the parables of Christ and incidents from his life that were to be represented in paintings. The story of the woman taken in adultery, for example, illustrated the mercy that God shows to the believer.

Faith in the word long continued to hold priority. The word did not leave any doubts, and it was possible to have control over whether something was true or false. Images, by contrast, were uncertain ground until a Protestant church art had been explored. At the Saxon court, which continued to commission the old Catholic devotional images, the elector at an early stage used an affirmation of God's word as the motto of his coins. It was visible support of the Reformation when he made the monogram VDMIE (*Verbum Domini manet in eternum*) from the Latin text of the First Epistle of St. Peter: "The word of the Lord endures forever." In 1522 the "rhyme" (i.e., acronym) was introduced for the first time into the embroidery of winter clothing. "Five years before this time," the chronicler writes, "the venerable Doctor Martinus Luther of Wittenberg began to write and preach, and he restored the holy word of God to the light of day."[17] The device VDMIE, which later adorned the portal of Dresden castle, was a formula invoking the word as the last refuge in a time of uncertainty.

In the Spitalskirche at Dinkelsbühl a plain written panel, one of the first altarpieces serving the new doctrine, was commissioned in 1537.[18] An altarpiece without painting, without images? The triptych form comes from the tradition of the painted image, the absence of which is polemically underlined by the written text replacing it. Texts previously read in books are now displayed in the place formerly occupied by the image—the altar—and demand the same kind of veneration. The triptych is closed at the top by a semicircular pediment with shell ornamentation. Such text-bearing altars must have been quite common. Karel van Mander reported from the Netherlands that a triptych by Hugo van der Goes depicting the Crucifixion was painted over with the Ten Commandments.[19] Such an act demonstrates graphically the antithesis between text and image.

The divine word, as Luther taught, was handed down in the "law" of the Old Testament and the "grace" of the New, hence the text with the words of the Last Supper is flanked on the Dinkelsbühl altar by the text of the Decalogue of Moses. Luther's doctrine of law and gospel was intended to distinguish the twofold nature of the word and to relate the two aspects to one another: one threatens, while the other comforts. We cannot fulfill the demands of the law, and thus are unable to justify ourselves before God by our own resources; thus we are driven to the point of death. Only when we realize that our own resources are not sufficient, do we understand through faith that we are already justified in Christ. Grace takes over from the law. Luther's doctrine of justification initiated a new way of representing God's word in Dinkelsbühl,[20] one echoed in the two panels of the Decalogue.

Since 1529 Cranach's workshop had been treating the same theme of law and grace in paintings, though these were not made for churches. Seen in this light, the Dinkelsbühl altar is a corrective administered by the pure word to the unreliable im-

age. In Wittenberg, Luther and the painter, who were friends, set about developing a didactic image of law and grace. The many versions of the theme, in which the "visual text" is rewritten again and again, reveal a continuing dialogue of the two friends that persistently sought the best solution. The image panel is treated like a text—amended, edited, and glossed. The undertaking is clearly an attempt to elaborate a model for the new genre of the Protestant didactic image.

283 I shall confine myself here to the Gotha version, which exists in a woodcut and various paintings,[21] though the paintings have significant variations of detail. The very form of the image invites an approach by reading. It is divided at the center, like the pages of an open book, by a tree that has foliage only on the side of grace. The bipartite structure of the image is used for an antithesis between law and grace. It is actually made up of two conflicting images that the beholder is supposed to compare and contrast. The viewer is required to cast his or her eye back and forth between the two images as if they were texts presenting different propositions, relating the two aspects of the word of God to each other. On the left, sinful Adam, under a threatening cloud of the Last Judgment, is driven toward death and hell. On the right, guided by John the Baptist, Adam turns in faith to the Redeemer on the cross, who has already vanquished sin and death for him.

Luther saw John the Baptist as a "mediator between Moses and Christ" who, in his preaching, "infused the letter with the spirit and brought together law and gospel." Thus "in the law is death, in Christ life. The law thrusts down to hell and kills. Christ lifts up to heaven and makes alive."[22] This theology is set out in the painting. The beholder faces, not a lifelike picture that appeals to his or her empathy, but a pictorial thesis that appeals to the reason. There is no rendering of space to create an illusion of reality; the dual composition is made up synthetically of the "picture concepts" usual in allegories. The mottoes at the bottom extend the argument of the picture.

On the large altars produced in Saxony after 1539, the didactic allegory was adopted only hesitantly, in a subsidiary role. Here the sacraments catch the eye by their robust simplicity. In Schneeberg (1539) and Weimar (1555), the Crucifixion points to the Eucharist, which in Wittenberg (1547) forms the centerpiece with the theme of the Last Supper and is framed on the wings by baptism and confession.[23] Cranach thus depicted precisely the sacraments that Luther, as we saw, regarded as the "bodily signs" of God's presence in the church. The presence of the images on the altar is justified by the fact that all they do is depict what God himself has established as the visible transactions of faith. Melanchthon and Bugenhagen, who administer the baptism and confession in the picture, were active at the time in the same parish that had commissioned the altar. The altarpiece should therefore be understood as a demonstration of doctrine. The people of the time would have found no use for a cult image.

284 On the predella, which in Wittenberg is joined to the altar, Luther appears in person before the congregation. Where, in the Catholic tradition, donors' portraits laid claim to justification by works, we now find types or examples illustrating the office of the preacher. This also applies to the crucifix at the center, before which

283. *Nuremberg, Germanisches Nationalmuseum; Lucas Cranach the Elder,* Law and Grace, *1529(?)*

284. *Wittenberg, municipal church; Lucas Cranach the Elder, high altar, predella, 1547*

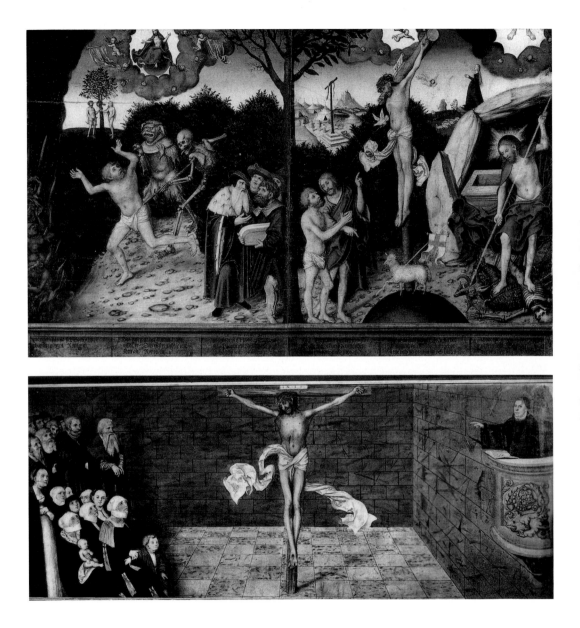

Luther preaches. The cross is the content of the message proclaimed by the word, the means by which one can attain genuine faith. Only belief in the Redeemer on the cross can justify the Christian. The crucifix is thus a kind of pictorial sign or visible content of the word of the sermon. The subordination of image to text and word could not be more graphically expressed. The image is an entity to be read like a text, invested with a secondhand authority conferred on it by the word.

Three years earlier, on 5 October 1544, Luther personally consecrated the chapel of Schloss Hartenfels in Torgau, the first genuinely Protestant church interior; Luther himself had decided on all the images and the whole liturgical arrangement. He preached from a pulpit strikingly similar to the one on the altar at Wittenberg, except that it bore three reliefs showing the twelve-year-old Jesus in the temple, the adulteress before Christ, and the casting out of the money changers from the temple—standing for the themes of doctrine, grace, and justice, which were the themes of his sermons. And the preacher expressed the wish that in the new chapel "nothing would happen except that our dear Lord would speak to us himself through his holy word."[24]

c. Image and Art in Renaissance Painting

The house of Lucas Cranach was in mourning after receiving the news of his son Hans's death in Italy. The painter had sent his son to the South to learn the new art of painting and now reproached himself for bringing down God's punishment on him (Italy was the home of the papists). At this point Luther entered the house and put his old friend right. If Cranach bore the guilt for his son's death, "I should be as much to blame as you, for I too earnestly advised him to go."[25] The great Reformer was thus well able to distinguish between matters of religion and matters of art.

The arts of antiquity "were again brought to light by the Italians," as Dürer says in his *Painter's Manual* (or *Treatise on Measurement*). The Nuremberg artist had been to Italy twice; there he had learned that painting could be taught according to rules, like a science. On 7 February 1506 he wrote from Venice to Willibald Pirckheimer, saying that he was surrounded by "connoisseurs of painting." He also had envious colleagues who criticized his work on the grounds that "it was not in the antique style and hence was no good."[26] Jacopo de' Barbari, a Venetian painter who was then in Nuremberg, applied for a post at the court of the elector of Saxony with a treatise setting out a theory of the art of painting (text 42A).

As images fell from favor, they began to be justified as works of art. Being unable to use them in the old, straightforward manner, people now wanted to admire them with the eye of a painter to prove their own taste. The professionalization of painting and its new market changed the situation. In his *Manual*, Dürer argued that "straightforward painting gives pleasure rather than vexation"—if it is painted according to the rules of art (text 42C). He was by now dealing in his own works, as individuals were collecting not only devotional images but pictures by his hand. The themes of the old icons were still in demand, provided they were painted professionally, as can be inferred from a note in Dürer's Netherlands diary: "I have done a good Veronica

in oil, worth twelve guilders. I gave it to Francisco, the agent in Portugal. I then painted another Veronica in oil, better than the first, and gave it to the agent Brandan in Portugal."[27]

The theory of painting was first developed in Italy. Leon Battista Alberti, the cosmopolitan encyclopedist, wrote on every conceivable subject, but on nothing with greater success than on painting, since nothing of importance had been written on it since antiquity. The difference between his textbook on painting (1435) and the workshop books of Cennino Cennini (about 1390) is obvious. Though Alberti may not have initiated the theory of painting, he provided artists and connoisseurs with a text to refer to. What the book contained was of less importance than the fact that such a book existed at all, for it raised painting to the status of a science among the "liberal arts."[28]

The image formerly had been assigned a special reality and taken literally as a visible manifestation of the sacred person. Now the image was, in the first place, made subject to the general laws of nature, including optics, and so was assigned wholly to the realm of sense perception. Now the same laws were to apply to the image as to the natural perception of the outside world. It became a simulated window in which either a saint or a family member would appear in a portrait. In addition, the new image was handed over to artists, who were expected to create it from their "fantasy."[29] Seen in this light, a work was an artist's idea or invention, which also provided the standard for evaluation. With its double reference to imitation (of nature) and imagination (of the artist), the new image required an understanding of art. Like poets, artists had the license of controlling their subject matter; in their representation, however, they were bound by the rules of nature. Savonarola, who knew more about art than is generally accepted, put this in a nutshell when he said in a sermon, "Every painter, one might say, really paints himself. Insofar as he is a painter, he paints according to his own idea."[30] When Raphael died, we read in Vasari that "painting too might as well have died. When he closed his eyes, it was left blind." Raphael's last work, the great Transfiguration of Christ, was set up behind the bier, "and the image seemed alive, although its creator was now dead."[31] Nothing could express more clearly how much the image was now the work of the artist and a manifestation of art.

In the treatise on painting that he left behind when he died, Leonardo complained of how little painters wrote about painting and that writers knew nothing about it. His first object hence was to have painting accepted as a *scientia* among the "arts that can be learned."[32] No argument was too abstruse, provided it served that end. The old cult image was used as evidence that God had chosen painting to represent him before humankind (text 42E). In his *Lives* of the artists, Vasari eagerly made use of a legend about Raphael's painting of the Carrying of the Cross, the *Spasimo* in Madrid, to explain the fame and the cult of the old miraculous images in terms of art. The painting, which does not enjoy great prestige today, sank with the ship in the crossing to Palermo but was washed ashore unharmed in its crate, the only piece of cargo to survive. "It was fished from the water [on the coast at Genoa] and discovered to be a

divine work, for which reason it was undamaged. Even the raging winds and the wild sea showed respect for the beauty of such a work." From then on it became so famous that in Palermo it "overshadowed even the volcano."[33]

Savonarola, who saw art as a symbol of superfluity in contradiction to the Christian call for simplicity, deplored the new interest in art as a deviation from the true path. "I shall give you a piece of good advice. Shun the works of art, which are counted among the riches of the world. Today they are invented for churches with such art and at such expense that they eclipse the light of God," tempting us "to contemplate in them not God but art." One was to admire God, who created the beauties of the world, and not the artist, who merely copies them. It was an error, he contended, to seek the image of the artist in a work, instead of seeing an image of God in it.[34]

Occasionally a great work of art, provided its subject was pious enough, had the same public success as the old cult image, often doing so with considerable economic profit. Vasari remarks, not without a veiled irony, that Titian's iconlike half-length painting in S. Rocco of Christ bearing the cross was "the most venerated image in Venice today. It has taken more money in gifts from the faithful than Titian and Giorgione have earned in their entire lives."[35]

All these examples illuminate aspects of a process of very wide scope that is difficult to reduce to an easy formula. To make a different use of Luther's phrase, there are now "two kinds of images," or images with two different faces. There are also two kinds of subject matter—the old themes of the devotional images and the new ones of mythology and allegory, which laid claim to being works of art from the outset. If Venus and Cupid were shown on the kind of panel that had previously been the monopoly of saints, it could be justified only by granting art the same freedom as poetry to create fictions, beautiful illusions. An image of Venus that was not a work of art would have been outright nonsense.

The new themes, which had no reality of their own in a literal sense, now affected the way images in general were seen. If what they depicted was based on fiction, the older themes (images of saints and portraits), which were taken literally, could not remain free of ambiguity. Artist and beholder found themselves in twofold agreement when the painting represented both the laws of perception and an original idea—that is, when it was both beautiful and profound.

Art historians usually suffer from professional blindness with regard to this process. Either they ignore the crisis of the image that has been delineated here, or they see the emergence of the new image as the beginning of the real history of art. In what follows we shall pursue an as-yet-uncharted path in studying, with the help of telling examples, the change in the concept of the image. Artists found themselves driven by new arguments when they tried to present their works as results of an aesthetic concept. The image became an object of reflection as soon as it invited the beholder not to take its subject matter literally but to look for the artistic idea behind the work.

The first example dates from roughly the time of Dürer's second stay in Venice. There he met Giovanni Bellini, who, as Dürer wrote in a letter, "is very old yet still the best painter." Bellini's panel of the Virgin sitting on a lawn or meadow (Italian

285. *London, National Gallery; Giovanni Bellini, Madonna del Prato, ca. 1505*

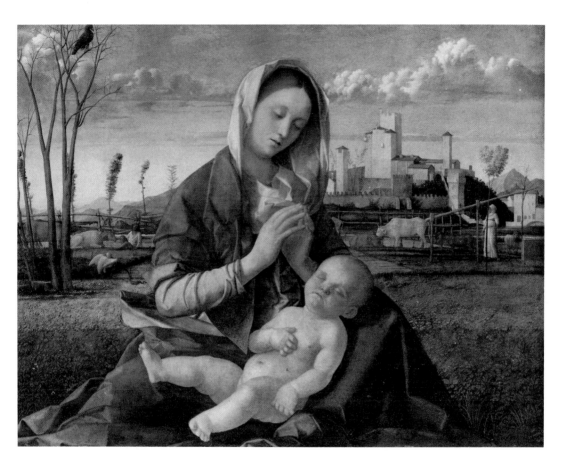

prato) represents the kind of work that has shaped this judgment of Dürer's. In contradiction to an art scene dominated by Giorgione and the "young" generation, it attempts a synthesis between the old icon and the new kind of painted poetry.[36]

The Madonna, though shown full-length, is seen in the close-up view characteristic of the half-length icon. The sleeping Child is something of an exception in the tradition of the Marian icon, as he does not speak to the beholder and cannot be addressed. The sleep is a metaphor for the Passion and for the sleep of death, from which the Son of God will reawaken. The sleep of the Child relates to the cycle of nature, which wakes to new life in spring. Early spring, which dominates the landscape, is the ecclesiastical time of the Passion and the Resurrection. Thus the landscape in the painting is more than mere background. It contains the argument that the Christian mystery is in harmony with the cycle of nature. The interrelation between figures and landscape provokes the kind of response that is fundamental to an understanding of the picture, the double theme of which proves to be a single idea when seen at a metaphoric level.

The educated beholder would quickly recognize that the motifs of landscape and agriculture were all taken from Virgil's celebration of rural life in the *Georgics* and thus were features of the art of poetry. Bellini did not actually need to quote poetry, as he was well able to depict a landscape by himself. But Virgil's experience of nature on the Venetian mainland, which had been his homeland as well, was still valid and available to the present. The motifs from Virgil enter the rivalry between painting and poetry, as nature is the common theme of both. The rivalry involved the retrospect on antiquity, which also set the standard for poetry. The painting therefore advances an argument, thereby revealing its character as a work of art. What was, to a superficial observer, a pious and unambiguous subject, for an informed beholder proved to be a painted definition of painting.

The Dutch and Flemish painters who were returning from Italy about that time followed a similar course but could, in addition, present the art of painting as an import from the South. There is a revealing example in the Metropolitan Museum in New York by Joos van Cleve, who worked in Antwerp from 1511.[37] The still life that catches the eye at the very edge of the painting is not only a novel motif for an icon, but also a symbol of a radically different kind of painting that seeks to deceive the eye by duplicating real objects. The individual motifs are still related to the Passion, but the artistic meaning of the arrangement as a whole lies in the correspondence of natural object to painted image. Many of these motifs already existed in old Netherlandish painting, but there they occurred in isolation, scattered about an interior. Only now do they become a still life, which has moved into the foreground as a theme in its own right.

Where this mimetic equation held good, the traditional image—in this case the figure of the Virgin—could no longer sustain the familiar impression of simple visibility. The still life is the mirror image of natural objects in the sense of the Augustinian *aequalitas,* whereas the figure of the Virgin, as an *imago,* is a likeness in a different, symbolic sense: it is a preexisting image, not the copy of something from

286

nature.[38] Joos van Cleve distinguished the "image" of the Madonna from the painted still life by setting it at a distance and by quoting the figure from an old painting that symbolically represents the true prototype: in this case it is Jan van Eyck's Lucca Madonna in Frankfurt. The painter was not alone at the time in reproducing the themes 287 of old Netherlandish models. The Madonna, we now notice, in fact is an *image* of a Madonna, repeated in the new work as if the painting were quoting its own history.

The old man who appears in the background before an open window takes up a pictorial idea of Dürer's that incorporates a Venetian experience.[39] But he is no longer, as in the earlier work, Joseph from a "Holy Family" but the client who commissioned the painting, who is holding a prayer roll showing the end of the Ave Maria and the beginning of the Magnificat. The figure of the Virgin in the painting is the one that appears before his inner eye, which is why he has taken off his reading glasses. This finally helps to exclude any literal meaning of the image. The double framing of the main figure in the front and in the back does not respond to the laws of space, as the unpracticed viewer might suppose, but invites us to distinguish between two different levels of perception and of reality juxtaposed in the painting. The crisis of the old image is met by the picture's multilayered structure. The former icon appears as a quotation within the modern invention of the artist; this appearance from the past both presents lost qualities of the "pious icon" and evokes the brilliant history of Netherlandish art. In van Eyck's time, archaism was the distinguishing mark of the cult image (chap. 19d). In van Cleve's, the quotation was part of the justification of the religious image as such.

The "Romanists" in the Netherlands inherited a double tradition of painting, as the native models from the legacy of van Eyck and Rogier were set against new models from the ancient art of the South. This also finds expression in Dürer's diary, when he describes his visit to Bruges on 7 April 1521: "Afterward they took me to St. Jacob and showed me the delightful paintings by Roger and Hugo, two great masters. I then saw the alabaster image of the Virgin in the church of Our Lady, made by Michelangelo in Rome."[40] The painters often had their own difficulty in reconciling the Italian style with their native models. The dual aspect that permeates every image at the time therefore emerges in a particularly dramatic form in the Netherlands.

An icon of Christ in Madrid by Jan van Scorel bears vivid witness to the kind of 288 conflict that artists faced in the light of the dual tradition.[41] The figure itself repeats the "holy portrait" by van Eyck (chap. 19c) but enlarges it to a half-length figure. The immobile, frontal face now adopts an archaic look, for van Eyck had preserved the sacred quality of an icon, or rather of an image relic, from Rome. The new setting is a hybrid of a niche and a temple. At the bottom a rectangular niche holds the figure as if it were a statue, but it is too shallow to enclose it. At the top the niche is extended into a structure of cornices and pillars, with several tiers and open on all sides, exhibiting the "grotesque" fashionable in Italian art. A double ring of putti surrounds the incarnate Word with the gestures of wonderment familiar from the marble sacramental tabernacles of the Italian early Renaissance. The architecture therefore seems to imply the idea of a house of the sacrament that accommodates but cannot confine the

286. *New York, Metropolitan Museum of Art; Joos van Cleve, Madonna and Child, after 1511*

287. *Frankfurt am Main, Städelsches Kunstinstitut; Jan van Eyck, Lucca Madonna, ca. 1435 (detail)*

288. *Madrid, Museo del Prado; Jan van Scorel,* Salvator Mundi, *ca. 1520/1530*

Corpus Domini. This idea, while working to counteract the breach between the old icon, now an image within an image, and the new invention in the spirit of "foreign" (Italian) art, at the same time confirms the double aspect of such images.

289 A generation later, at the end of his life Maarten van Heemskerck painted an image by which he confidently proclaimed the victory of the Italian theory of art in the Mannerist painting as a fait accompli. No theme was better suited to this purpose than St. Luke painting the Madonna, for the legend of St. Luke had always been used to demonstrate divine approval for the use of images (chap. 4b). In the Netherlands, since Rogier van der Weyden, this theme had been the trademark of the guild of painters. It was therefore an obvious choice for Heemskerck to promote it to a program that explains the art of painting based on a theoretical foundation. In his large panel in the museum at Rennes, which hung in the town hall of Nuremberg up to Napoleonic times, the artist argues that St. Luke was a painter of antiquity who had mastered all the rules of art.[42] The contemporary painter identified with the prototypical painter of Christianity, St. Luke being stylized into a universal Apelles. The many books spread around in his library, the telling attributes of a man of letters, complete the self-portrait of the educated artist.

The image, in fact a painted treatise on the theory and practice of painting, places the holy painter in the midst of the ancient statues in the courtyard of the Sassi Collection in Rome, which Heemskerck himself had drawn twenty years before but now repeats from an engraving. In the background directly behind the painter's palette, Michelangelo is seen carving a statue on his own while standing near an ancient statue that was believed at the time to be a Roma. In the foreground Roma's ideal figure is repeated in the Madonna, whose portrait St. Luke is painting from life. The comparison between the sister arts, which Leonardo had demonstrated to end with the victory of painting over sculpture, could not be carried through without reference to ancient art, which supplied the ideal of the *disegno*.[43] But the argument suffered from the fact that ancient art was known only through sculpture. Nevertheless, painting triumphed not only over sculpture but over antiquity as well. In the Madonna, who does not pose for St. Luke but poses for us, the primal image of the icon is boldly equated with the ideal image of art.

d. The Controversy over Raphael's Sistine Madonna

The debate about religion and art, which had taken a different course in the various creeds during the time of Reformation, was revived in the years about 1800, when Classicism was being overthrown by Romanticism. This time the debate centered on the true meaning of Renaissance painting, which had a different meaning for the Classicists and the Romantics, since each had their own idea of artistic excellence. Was Renaissance painting nothing but classical, indeed pagan, or was it also devout? The issue was confused by church paintings that seemed to uphold only the ideals of ancient art, as if the old gods had been dressed up in Christian clothes.

290 The controversy was focused on the oeuvre of Raphael, and nowhere took on greater vehemence than with respect to his Sistine Madonna. The painting had had a very obscure existence until King August III of Saxony acquired it for the col-

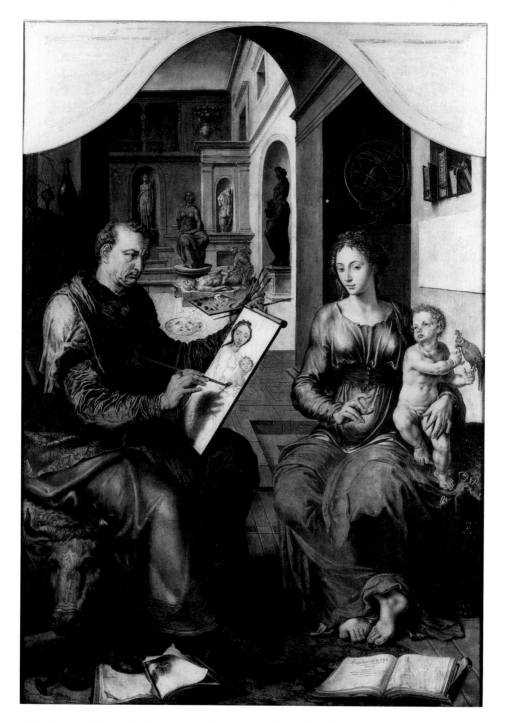

289. *Rennes, Musée des Beaux-Arts; Maarten van Heemskerck, St. Luke Madonna, ca. 1550*

lections in Dresden in 1745. When Winckelmann reported that "art lovers and connoisseurs" had made pilgrimages to Piacenza to see the work, he probably exaggerated. The most important statement had been Vasari's terse observation that Raphael "painted the panel for the high altar of S. Sisto in Piacenza, and it is truly an unparalleled work."[44]

For educated Germans who had grown up without Catholic church art, the painting soon became the ultimate masterpiece. Winckelmann had his share in this reputation when he recommended it, along with the works of antiquity, as a model for imitation. In Dresden it was absent from the collection for long periods because it was "always downstairs on the easel for the students," as Friedrich Schlegel noted in the second volume of the *Athenäum* in 1799. In a long study of the painting, Schlegel described the confusion that so devout a work caused among Protestants. "They are in danger of becoming Catholics," some said reproachfully. "There's no danger if Raphael is the priest," others retorted. Soon afterward Schlegel himself became a Catholic. In the text referred to, he summed up the current state of the debate about art when he wrote, "Only republicans will never imagine anything superhuman. If the artist does not wish to forgo this idea altogether, he is reduced to the choice of either repeating the ideals of a world of extinct gods, or of upholding and developing further the divine and sacred persons of a faith still alive and active."[45]

Two years previously Wilhelm Heinrich Wackenroder and Ludwig Tieck, in *Outpourings of an Art-Loving Friar,* had set out to convert the Classical Raphael into a Romantic one. He was to represent the cult of genius in a new religion of art, in which divine inspiration transcended the subliminal discord between art and religion. The old "idea" of the artist, of which Raphael wrote in the letter to Castiglione, now became the "apparition" of the Madonna in Raphael's dream. The Riepenhausen brothers were among the first to apply this legend to the very painting of the Sistine Madonna. An engraving of about 1816 shows Raphael sitting asleep before the painting, from which the figure of the Virgin is still absent. The Virgin appears to him on a cloud just as she was to be represented in the painting.[46] The idea of a vision, which subsequent interpretations attributed to the painting, was thus traced back to an actual vision of the artist's.

The Riepenhausen brothers were, at the same time, referring to the St. Luke Madonna in the Roman Academy of Painters, a painting in which Raphael himself witnesses the appearance of the divine Virgin, also on a cloud, before the painter St. Luke. While Luke looks at the Madonna, Raphael looks at the picture, in which the apparition is taking shape. There is disagreement today whether the painting is the work of Raphael's pupil Gianfrancesco Penni or a much later production, a pastiche by Federico Zuccari.[47] But the Romantics saw it as an authentic picture of the Renaissance that introduces Raphael as a new St. Luke. In this way, the vision of the Madonna, which provides an ideal of art, lent itself to become a retrospective confession of the inspired genius. In Riepenhausen's engraving it is not the St. Luke Madonna but the Sistine Madonna that inspires the act of painting. The sense of a vision that one actually felt in front of Raphael's work was thus expressed in a legend of its miraculous origin.

<div style="text-align: margin-left">291</div>

<div style="text-align: margin-left">292</div>

The debate on the correct interpretation of the painting never reached a conclusion. Could the work be a paradigm of art if it was painted for the altar of a church? Although the Sistine Madonna was well known to be an altarpiece, Rumohr saw it, in view of the nonspatial, cloudy apparition, as a processional flag, which would explain the peculiarity of the image's conception. It is still a matter of debate whether the famous curtain, and with it the whole image, has a theological rather than a purely artistic meaning.[48] But we know for certain that the patron saint Sixtus, who looks up to the Virgin, was meant to honor Julius II (whose features he bears) and his uncle Sixtus IV, and that the work was commissioned about 1513 for a town that had become part of the papal state only in 1512.

If we disregard the history of its interpretation and, as far as this is possible, try to see the image in the context of its own time, we soon realize that it is a crucial piece of evidence for our theme of "religion and art." I should therefore like to develop a view of my own that may help to clarify Raphael's definition of the image, and while taking the theological meaning of the work for granted, concentrate on its aesthetic concept—which, to be sure, cannot be entirely divorced from theology. The argument is both very simple and very important for an understanding of the work. The curtain is best understood as a picture curtain, which is not a new idea. But what was a picture curtain at that time, if not the curtain before a cult image, which can conceal or reveal it as a ritual apparition? Leonardo justified the nobility of painting with the status of the cult image, which achieved its greatest effectiveness at the moment of revelation. When the costly curtains were drawn back, he said in a subtle word play, the divine conception of the painting (the *Iddea*) appeared as if alive, being the divine person (*Iddio*) in the ideal of beauty (*idea*), thus uniting religion and art in one (text 42E).

Raphael's curtain exists only in the painting. But where is the image that the curtain could conceal or reveal? We see neither a picture plane that coincides with the panel nor a picture space that opens behind the frame and the curtain. Surface and space recede in a cloud of light—a cloud bank that, unusually, also bears the two saints of the *sacra conversazione*. The curtain is the only remaining residue of the material image. Its physical presence is shared only by what previously was the threshold of the picture at the bottom, where two angel children are leaning in the pose of spectators. The sainted pope has put his tiara there, as it will be worn henceforth by his successors on earth (Sixtus IV and Julius II).

The curtain and the parapet at the bottom, which are in a dramatic contrast to the sight that opens in their back, remain close to the eye, as if one could touch them, while beyond them opens an immeasurable distance, a nonspace without boundaries. The cloud bank, which dissolves in the distance into cloudy angels, reinforces the impression of a celestial vision, much as the one that characterizes Raphael's Madonna of Foligno. There, however, it is a motif in the background; indeed, it rises above the horizon of a landscape that includes the donor and the saints. The earlier painting *contains* a heavenly apparition; the Sistine Madonna, in contrast, *is* one. The work appeals to the inner vision, rather than creating the window illusion that has to be taken at face value. In the absence of a natural space, the figures, without spatial

290

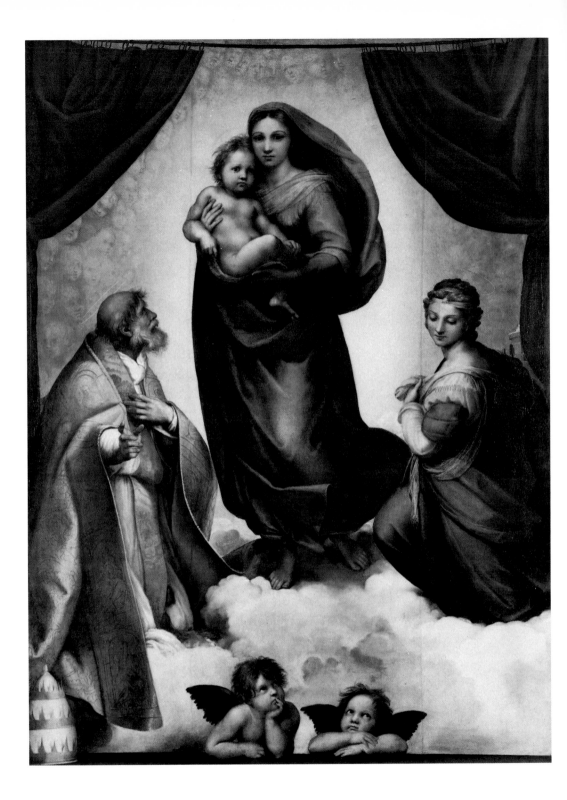

482

290. *Dresden, Staatliche Kunstsammlungen; Raphael, Sistine Madonna*

291. *Johannes Riepenhaus, Raphael's Dream, 1816*

292. *Rome, Academia S. Lucca; School of Raphael, St. Luke Madonna*

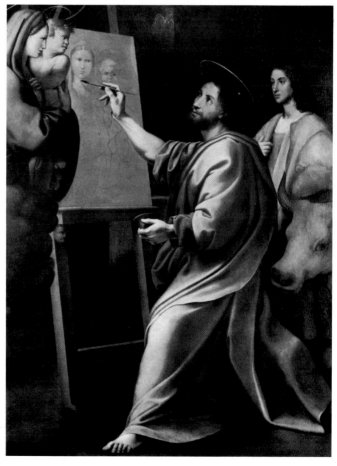

coordinates, appear as if directly before our eyes; only the two putti have a measurable place in the picture. The presence of the main figures is set free, as if they had become "absolute" images in the literal sense. When the figures are themselves images, the panel can no longer be an image in the traditional sense. The curtain is drawn aside from an image that is in reality the *idea* of an image, and thus it partakes of a different order of reality. The visible work is a symbol of an invisible beauty.

We here discover Raphael elaborating a pictorial philosophy that draws a surprising conclusion from the crisis of the old cult image. The material image dissolves into a fantasy image that is justified by the artist's imagination and is addressed to that of the beholder. *Fantasia,* in the thinking of the time, was a promise of a freedom that causes the subject to experience himself or herself.[49] Fantasy is also the source of the artistic idea, whether it was called *disegno, concetto,* or *idea.*[50] In Raphael's time this idea was either "the notion of a beauty transcending nature" or that of "a pictorial form independent of nature," both of which are prefigured in Raphael's letter, when he refers to a "certain idea" of absolute feminine beauty "that came into my mind."[51]

291 The vision of the idea, which the pious Romantics later trivialized, had for Raphael a double meaning derived both from the work and from the person of the artist. It is the new art of painting that changes the nature of images against which the Reformation was directing its polemics. The work loses its aura as an "original" in the religious sense—an image exercising power over believers by its actual presence. Instead, it becomes an "original" in the artistic sense, in that it authentically reflects the artist's idea. This idea ultimately is tied to a philosophical or even a metaphysical experience, which was formulated by the Mannerist theory of art.

e. Art as the Mise-en-scène of the Image at the Time of the Counter-Reformation
Subsequently, the relation between image and art seems to become polarized. The "two kinds of images" move dramatically apart when old images are inserted into picture tabernacles on altars or when they appear within the framework of a picture that provides a commentary on them.[52] The old image was divested both of its objective character and of its historicity, exchanging the old aura of the sacred for the new aura of art. In opposing the Protestants, Catholic theologians had two possible ways of justifying the continuing cult of images. They could adopt the Reformed kind of image, stripped of its offensive features—an image that stimulated theological reflection by a speculative content presented in artistic guise. Or they could push the matter to the extreme by using wonder-working images in the manner of relics, commanding acceptance because of their age. In the first case, art was allowed to mediate a sublimated notion of the image that the theologians also made their own. In the second, an appeal was made to the alien nature of old images, which cut across the new criteria of taste by their mere appearance. This old-style cult did not apply to all images, only to those from a different age.

Some have suggested that the renewed cult of old images may have been a concession to popular piety, to which tribute had to be paid. There was even talk of a "failure" of the Council of Trent, but its decisions regarding images allowed for many

different interpretations (text 43).[53] In any event, there were various schools of thought within the church that took a different view of the same matter. The new orders, in particular, adopted a militant policy toward images, using cult images deliberately as a means of propaganda. Selection was inherent in the process. The cult had always focused on a few privileged images. Now it was addressed to examples dating from before the age of art. The task of art was to present them with due dignity in sumptuous surroundings, whether in special chapels already existing or in frames and mountings on altars, which both displayed and interpreted a venerated image for the public.

A process, it seems, was repeated here that had taken place in a somewhat different form in antiquity. The object of the old cult then fell outside the new sphere of art, through its age and appearance. Now, too, famous artists created sumptuous receptacles for sculptures and panels quite devoid of artistic pretensions but bearing visible features of myth. The procedure was corroborated by a vigorous production of treatises, which provide the only information on the history of old icons and statues we now possess. In many places the sources on the old images started only during the Counter-Reformation. The favorite subjects are legends about the origins of images and the miracles they performed.

The ceremonial, staged with art and liturgy and backed by printed propaganda, was strictly controlled by the church institutions, which upheld the cause of images as a means of imposing discipline on the church's members. This policy and the actual presentation of the images have a defensive, even belligerent tone quite absent in the Middle Ages. Skepticism and reformist ideas within the church's own ranks placed further pressure on the argument about images. Not only the dualism between image and art, which emerged more and more clearly in Mannerism, but also the anachronistic nature of the image cult, which theologians would not admit, prepared the ground for the Baroque intoxication with lavish presentation. The less favorable the general climate became for the old use of images, the more this cult was imposed on believers as a duty, and the more intense grew the efforts to create a new kind of aura. But there is another difference as well. In the Middle Ages the cult of images was managed locally. Now it became the affair of the church as a whole, whose identity depended on it, which explains the militancy and the missionary zeal of the orders that upheld the images.

In the seventeenth century the Jesuits started to collect all information on wonder-working images. In the *Marian Atlas* of 1657, there is a list of 1,200 examples of such icons, strictly classified in terms of place and status.[54] In the preface, the author, Gumpenberg, states that the Virgin Mary hates "exquisite and superfluous painting"—that is, art. Anyone who had doubts about the early history of the cult of images was to consult the church annals of Cardinal Baronius, where the early Christian use of images was demonstrated. To find out the reasons that guided the church in its cult of images, one was advised to read Cardinal Robert Bellarmine.

In Gumpenberg's atlas, the icon of the Virgin in S. Maria Maggiore (chap. 4d) holds second place after the miraculous image of Loreto. In 1569 the general of the

21

order, Francis Borgia (1565–72), obtained permission from the pope to have this image copied for the use of the Jesuits. He at once sent copies to all the crowned heads of Europe, instructing them to set up cult places for them and to organize a general veneration of the image. At the order's monastery of San Andrea al Quirinale in Rome, the novices had to pray twice daily before the copy, which is still in its place today. The order's college at Ingolstadt also received a copy, which later induced a trance in Father Jakob Rem and was then made the official emblem of the order's schools in Bavaria.[55]

II

21

293

In Rome, another icon, the title image of the church of the Virgin in Trastevere (chap. 7c), was given one of the first chapels (1584–89) specially set aside for an image cult. The donor, Cardinal Altemps, ordered wall decoration devoted entirely to glorifying the Council of Trent.[56] In S. Maria Maggiore the cult of the famous icon now became so important and so urgent that it could no longer be left to the confraternity of the *Gonfalone* and was increasingly taken over by the papal curia, though it was not until 1613 that the icon could be moved into the sumptuous Cappella Paolina that Paul V had had built for it. The frescoes, painted by the leading masters of the time, are a true compendium of the theology and the historical cult of the image. The early Baroque tabernacle on the altar, a resplendent shrine, removed the image from the squabbles of the various rival cult factions and displayed it permanently for veneration. A circle of angels in gilt bronze seems to carry the image down from heaven. The dove of the Holy Spirit at the apex recalls not only the Incarnation of Christ in the Virgin but also the divine grace invested in the image.[57] Art has lent the old image a new aura, creating a stage on which, reinforced by its extraterrestrial original, the old image could hardly have produced a more intense effect.

294

A few years previously, a public controversy had broken out among the Roman Oratorians over the relation of image and art. It happened in the Chiesa Nuova, where an unnamed cardinal had donated an altarpiece to be painted by Rubens. Baronius, the rector of the Roman congregation, died in June 1607, after the artist delivered the altarpiece but before the work could be unveiled in the church. Now the painting was no longer met with approval, and six months later Rubens was engaged to paint a new version, different in the upper part. Both versions have survived. The real difference between them lies in the function they assign to the wonder-working image owned by the congregation of Philip Neri.[58]

XI

This work was a bleeding fresco of the Virgin that had been venerated since 1537 in the church that the Oratorians had taken over when they were recognized by the pope in 1575. During rebuilding in 1593 all the images were covered, "with the exception of the painting [*quadro*] of the Madonna, which is to remain visible in order to be venerated by the people, although only the face of the Madonna and not the whole painting shall be exposed." When the new building was ready in 1607, the fresco was not to remain in its chapel but had to be moved to the high altar, for which Rubens had painted the first version of the altarpiece. Before the latter could be unveiled—on 8 September, the feast of the Virgin's birth—the plan was dropped; evidently the combination of image relic (*icona*) and altarpiece (*quadro*) was no longer found convincing.

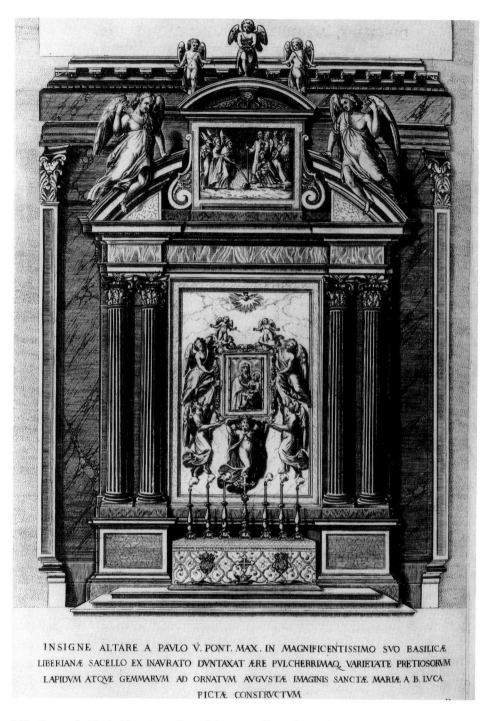

INSIGNE ALTARE A PAVLO V. PONT. MAX. IN MAGNIFICENTISSIMO SVO BASILICÆ
LIBERIANÆ SACELLO EX INAVRATO DVNTAXAT ÆRE PVLCHERRIMAQ VARIETATE PRETIOSORVM
LAPIDVM ATQVE GEMMARVM AD ORNATVM AVGVSTÆ IMAGINIS SANCTÆ MARIÆ A B. LVCA
PICTÆ CONSTRVCTVM

293. *Rome, S. Maria Maggiore; altar of the Cappella Paolina (after P. de Angelis, 1621)*

294 In the new version, over which Baronius no longer had any influence, the old image is physically incorporated into the altarpiece. The miraculous image is now at the center of the cult, while Rubens has supplied only the artistic frame in the form of an image tabernacle. The painting shows heaven opening and the miraculous image in an oval frame being carried down to earth and into the church by a throng of putti. The heavenly host surveys the event with gestures of wonder and veneration. The theme alludes subtly to the Incarnation, which had its origin in heaven. But now it is an image that comes down from heaven, and in it the Virgin, who has yet to conceive the Son of God on earth, is depicted. This message is consciously couched in ambivalent terms, suggesting the most audacious ideas, which could not be described verbally. It points both to the idea and aura of an icon, and to the concrete original owned by the Oratorians. Here too a theological and a very material concept of the image converge, as the local image is intended to set an example of how the icon of the Virgin in general is to be understood and why it is to be venerated.

But the description is not yet complete, for the altarpiece is not an image tabernacle of the usual kind, in which the inlaid image is always visible in a uniform picture surface. Here the original, placed behind the painting on the wall of the apse, is normally concealed by a copper panel, which replaces it and repeats its shape within the painting. Aesthetic reasons were given for this unusual procedure; indeed, without the copper panel the artistic unity of Rubens's composition would not be assured. It completes the impression that the icon is being carried down toward the beholder and

XI tones down the contrast with the artless old icon. The cover could be removed, by a mechanism specially invented for the purpose, whenever the original was shown. The new role of art in presenting an old cult image is here revealed in a surprising elegance. The painting takes over the function of the curtain formerly used for the ritual exposing of the holy image. The roles of art and of the mythical original are neatly distinguished. Art sets the scene for the old, ungainly image, which is loved by the public but is now revealed through the painted poetry of Rubens's picture in both its metaphysical idea and its cultic significance.

290 A retrospective glance at Raphael's Sistine Madonna will complete our view of the new situation of the image in the age of Counter-Reformation. Raphael negates the physical existence of the image as an object that can command a cult and possess a history. The curtain is drawn aside to show a vision that makes visible both the idea of the divine and the idea of beauty, symbolized in the perfection of art. The curtain emphasizes the absence of the familiar kind of image, which it used to reveal as well as conceal, and remains the only physical trace of the reified image cult—and then only as a painted substitute. The idea of the immaterial archetype, which was always embodied in images, is now, if only in the artist's imagination, made visible before us. Art now transcends the traditional image. The old image looks in retrospect like something auxiliary and extraneous.

This development, however, cancels the claim of the particular concrete image. Ideas are not the same as icons, no matter how closely they might be linked. Ideas cannot be the recipient of a cult, which is always tied to an object and localized in a certain place. The cult of the work of art, to which Raphael's creation invites us,

294. Rome, Chiesa Nuova; Peter Paul Rubens, Madonna of Mercy, 1608

XI replaces the cult of the holy image, which at the time of the Counter-Reformation is being forcefully—and ineffectively—revised. The icon is present in Rubens's painting as a relic is present in a reliquary. But this should not be dismissed as a special case. In the first version, too, an image is venerated by the saints, so that the icon is indirectly present. The Madonna appears as a framed image within the painting, no matter how Rubens may have conceived of this image. Only the saints can contemplate the image's heavenly prototype. The believer who is beholding its embodiment is therefore compelled to venerate the material image. This is an idea from the age of mysticism (chap. 19a); now, however, the dualism inherent in the image becomes a general feature of the era of art. This stage completes the transformation of the holy image into a memory from olden times.

Appendix: Texts on the History and Use of Images and Relics

The texts in this Appendix, which span the millennium of the sixth to the sixteenth century, are organized generally chronologically. Some of the sections comprise more than one work (by one author or by several), each of which is indicated by a capital letter. Within a single work, roman numerals refer to distinct topics or sections.

The Appendix includes the following topics and texts:

1. On Dissimilar Images
Pseudo-Dionysius, *The Celestial Hierarchy* (6th century)

> Pseudo-Dionysius, or Dionysius the Areopagite, was a sixth-century author from the Syrian region who was much read in the Middle Ages and who was identified with St. Denis of Paris. Page references below are to *Pseudo-Dionysius: The Complete Works*, trans. C. Luibheid (New York, 1987).

[The author praises "dissimilar icons," referring to symbols in the Bible that are mere signs of an imageless truth that they do not try to depict.] For it is quite impossible that we humans should, in any immaterial way, rise up to imitate and to contemplate the heavenly hierarchies without the aid of those material means capable of guiding us [*cheiragōgia*] as our nature requires. Hence, any thinking person realizes that the appearances of beauty are signs [*apeikonismata*] of an invisible loveliness. . . . Material lights are images [*eikona*] of the outpouring of an immaterial gift of light. . . . And so it goes for all the gifts transcendently received by the beings of heaven, gifts which are granted to us in a symbolic mode (1.2–3, p. 146).

The Word of God makes use of poetic imagery when discussing these formless intelligences (2.1, p. 148).

As for the incongruity of scriptural imagery [*eikonographias*] or the impropriety of using humble forms to represent the divine and holy ranks, this is a criticism to which one must say in reply that sacred revelation works in a double way.

It does so, firstly, by proceeding naturally through sacred images [*hierotypōn eikonōn*] in which like represents like, while also using formations which are dissimilar [*morphōpoiion*] and even entirely inadequate and ridiculous. Sometimes the mysterious tradition of the scriptures represents the sacred blessedness of the transcendent Deity . . . as light and [sometimes it

is] hailed as life. . . . [However,] the Deity is far beyond every manifestation of being and life; no reference to light can characterize it; every reason or intelligence falls short of similarity to it.

Then there is the scriptural device of praising the Deity by presenting it in utterly dissimilar revelations [*ekphantoriais*]. He is described as invisible, infinite, ungraspable, and other things which show not what he is but what in fact he is not. . . .

Since the way of negation [*apophaseis*] appears to be more suitable to the realm of the divine and since positive affirmations are always unfitting to the hiddenness of the inexpressible, a manifestation through dissimilar shapes [*anaplaseis*] is more correctly to be applied to the invisible. So it is that scriptural writings, far from demeaning the ranks of heaven, actually pay them honor by describing them with dissimilar shapes [*morphōpoiiai*] so completely at variance with what they really are that we come to discover how those ranks, so far removed from us, transcend all materiality. Furthermore, I doubt that anyone would refuse to acknowledge that incongruities are more suitable for lifting our minds up into the domain of the spiritual than similarities are. High-flown shapes [*hieroplastias*] could well mislead someone into thinking that the heavenly beings are golden or gleaming men, glamorous, wearing lustrous clothing. . . . It was to avoid this kind of misunderstanding among those incapable of rising above visible beauty that the pious theologians so wisely and upliftingly stooped to incongruous dissimilarities. . . . Even the materially inclined cannot accept that it could be permitted or true that the celestial and divine sights could be conveyed by such shameful things (2.2–3, pp. 149–50).

2. Images of the Virgin Save Constantinople from Its Enemies
Theodore Synkellos, sermon on the siege of the city (626)

> This sermon on a contemporary event was published in extract form by Angelo Mai, in *Nova Patrum Bibliotheca* 6.2 (Rome, 1853), 423–37, and in its complete form by Leo Sternbach, *Analecta Avarica* (Cracow, 1900), 297–342. It has also appeared in Ferenc Makk, *Traduction et commentaire de l'homélie écrite probablement par Théodore le Syncelle sur le siège de Constantinople en 626,* Acta Universitatis de Attila Jozsef nominatae, Acta antiqua et archeologica 19, Opuscula byz. 3 (Szeged, 1975), 9–47 (French translation) and 74–96 (Greek text). In the following selections, chapter divisions and page numbers follow the Greek text in Sternback and Makk.

On the senseless siege of this heaven-protected city by the godless barbarians and Persians, and on their ignominious retreat, brought about by the Mother of God through divine philanthropy.

It would be for you [Isaiah] to depict . . . the signs and miracles performed by the Mother of God . . . for this city [which the prophet once foretold, in Jerusalem, where he was not understood] (298; 74).

[The siege of the city began when Emperor Heraclius was far off waging war against the Persians. He had] left the imperial throne to his son . . . entrusting it, his brothers, and the city to the protection of God and the Virgin (300; 76).

[While the emperor on his campaign was calling down divine help for them, his children prayed to the Mother of God in her chapel (*euktērion*) in the palace (*kata basileia*)]: "O almighty Mistress [*despoina pantodynamē*], to you our father has entrusted your city and us, your servants, who, as you see, omnipotent one [*panagia*], are still children. . . . Save us, the city, and its inhabitants from the serpent that threatens us." In processions and Masses by

which it sought help, the city had as its teacher the venerable patriarch [*hierarchēn*], who knew how to arm it . . . and who appealed to the Virgin as helper and general [*hypermachon*] (303; 79). [The emperor had appointed him administrator (*epimelētēs*) and protector (*phylax*) of the city.]

On all the gates to the west of the city, whence the monstrous brood of darkness came, the venerable patriarch [*hierarch*] had painted, like a sun that drives away the darkness with its rays, images [*eikosin*] of the holy figures [*typous*] of the Virgin with the Lord her Son on her arm, and cried with a terrible voice to the masses of the barbarians and their demons: "You wage war against these very images. . . . But a woman, the Mother of God, will at one stroke crush your temerity and assume command, for she is truly the mother of him who drowned Pharaoh and his whole army in the Red Sea. . . ." Thus did the hierarch act and speak, begging God and the Virgin to help the city that is the eye of the Christian faith (304; 80).

[As Moses had once helped his people win the battle against the Amalekites by raising his arms], so our new Moses [the patriarch] lifted up in his pure hands the figure [*typos*] of God the Son, whom the demons fear: it is said to be "not made by human hand" [*acheiropoiēton*], for it needed no material support [*hypereidontos*] after Christ had let himself be crucified for the world alone. Like an invincible arm, he bore this [figure] on all the city walls; that was on Tuesday (305; 81).

[On the third day of the siege, when the enemy scaled the walls, the Virgin gave the khan of the Avars a foretaste of his defeat.] She lured a great number of his soldiers into an ambush in one of the churches in front of the city walls, in which a sacred spring flows . . . and destroyed them at the hands of the Christian soldiers (306; 82).

[The battle raged on until the eighth day, and the Golden Horn was covered with the canoes (*monoxyloi*) of the Slavs. The khan wanted to attack the city from there] but did not know that in the sacred house [*oikos*] of the Mother of God in the Blachernae quarter above the Golden Horn, the city possesses its invincible protector [*phylax*], and that the whole army of this new Pharaoh would be sunk beneath the waves, so that the bay was afterward called the Red Sea (308; 84). [This was on the tenth day, which was the fifth day of the week and the seventh of August (310; 86).]

We were all witnesses [*autoptai*] of how the Virgin and Mother of God broke with one assault the power of both enemies [the Avars and the Persians] . . . through her word [*logos*] and her will alone (314; 90). Which other place could one rightly call the navel [*omphalos*] of the world, apart from the city in which the God of the Christians has set up his dominion? . . . The kings and peoples have risen up against it . . . but the Lord broke their strength . . . and the Virgin shattered their arrows (317; 93).

[While the emperor in the field responded to the good news of the deliverance of the city with a prayer of thanksgiving, the patriarch celebrated the redemptress in her sacred temple in the Blachernae with public processions (320; 96).]

For a later account of this event, written after 717, cf. the text in Dobschütz 1899, 131*. It tells of the holy icons of the Mother of God, with her Child, that were carried by the patriarch on the walls, and also of the *acheiropotēton* of Christ and the relic of the cross, which he also carried.

3. Icons on Campaigns and on the City Walls
A. George the Pisidian, *The Persian Campaign* (622)

This seventh-century Byzantine poet addressed his *Expeditio Persica* to Emperor Heraclius (610–41), whom he accompanied on part of the emperor's campaign against the Persians. Line numbers refer to the text in Pertusi 1960, 84ff.

[The emperor, who fights against the barbarians like a new Moses and does so in the name of Christ (ll. 19–20 and 135), sets off to the war on the day after Easter with the miraculous icon of Christ, the *acheiropoiēton*.]

You took the divine and venerable figure of the unpainted image [*morphēn tēs graphēs tēs agraphou*], not painted by [human] hands. The Logos, which forms and creates all, appears in the image [*eikoni*] as a form without painting [*morphōsis aneu graphēs*]. He once took form [*typousthai*] without seed and now without painting, so that by both these forms of the Logos the faith in the Incarnation might be confirmed and the error of dreamers might be confounded. You offered this figure painted [or willed] by God [*theographos typos*], whom you trusted, as a first divine sacrifice [*aparchē*] for the battle (ll. 139–54).

[When the army acclaimed you during the campaign, lowered their standards and demanded to hear your address (*adlocutio*) before the battle,] you took the awesome image [*phrikton apeikonisma*] of the figure painted by God [*theographou typou*] in your hand and spoke briefly (ll. 86–87). This one [not I] is the universal emperor and lord and general of our armies. . . . We, his creatures [*plasmata*], must enter the field of battle against enemies who worship created [idols, *ktismata*] (ll. 105–6). [The enemies are the unbelievers (*tēs planēs*, l. 240), who worship fire as we worship the cross (ll. 252–53). The emperors who wage war as subordinate commanders (*hypostratēgen*) according to the will of God (l. 401), are images of God the Father (*patros eikonismata*, l. 433).]

B. George the Pisidian, *The Avar War* (626)

This poem (*Bellum Avaricum*), on the successful deliverance of the capital from the siege of the Avars and Persians in 626, the poet dedicates not to the emperor, who is far away on a campaign, but to the Mother of God, who he believes is the true victor, and to Patriarch Sergios, 610–38, who acted as the emperor's representative. Both are addressed in direct speech. Cf. Pertusi 1960, 176ff.

If a painter wished to show the victorious outcome of the struggle, he would place in the foreground [as the conquering hero] the one who gave birth without seed [*tēn tekousan asporōs*] and paint her image [*eikona*]. For she alone has conquered nature, in bearing her child as in fighting. She brought redemption first without seed and now without weapons, showing herself in both, in battle as in giving birth, the invincible Virgin (ll. 1–9).

You, to whom no soul is lost, and who daily bring forth children for our God, while you remain a virgin and are a mother . . . hail, general of our busy night-watch. With a ready heart you stood and spoke, without words, so that your steadfastness brought the enemy low. Hail, leader of our army, you who fight with tears [as your weapons]. . . . The more streams of tears you shed, the more rivers of blood you cause [among the enemy] (ll. 130–144).

[Then the poet sings the praise of the patriarch, who had the Virgin on his side and had the outcome of the events foretold to him by her (*proistorei*, ll. 226–27).] When the struggle reached the outcome desired by God [*krisin theographon*], you again grew active. For not in vain did you become the spokesman of the people. You demanded to speak, hastened to the city wall, and steadfastly held up to them [the Avars] the awe-inspiring image of the unpainted painting [*to phrikton eidos tēs graphēs tēs agraphou*] (ll. 366–73).

One might say that in this you had outwitted the judge [*kritēs*, meaning God], showing the enemy its paralyzing gaze [*antiprosōpon*]. Since, as you know, a child naturally feels more compassion for its mother than for anyone else, you sought the favor of the judge's mother by lamentations, entreaties, tears, fasts, and generous donations. . . . Thus you first convinced her before she quickly convinced her child and announced the victorious outcome [*nikōsan krisin*] almost before the verdict [*dikēs*] was uttered (ll. 376–89).

[But the struggle dragged on], and the barbarians occupied the cult sites of the [divine] judge and of the commander [Mary], the invincible Virgin, as a bastion (ll. 403–6). For the barbarians attacked the house of the commander and Virgin [in the Blachernae quarter] . . . but then the visible fight became an invisible one, and she who bore without seed was the one, I believe, who drew the bows . . . a sword again entered her soul (ll. 448–60).

C. George the Pisidian, *Heraclius* (610)

In his poem on Emperor Heraclius, the poet also mentions an icon of the Virgin with which the emperor had won the throne in 610, overthrowing his predecessor Phocas when he returned to Constantinople from Africa. Cf. Pertusi 1960, 240ff.

You did not defeat him by cunning, as Perseus once did [against Medusa], but opposed to this despoiler of virgins the awe-inspiring figure [*phrikton eidos*] of the immaculate Virgin [*achrantou Parthenou*]. You had the image as your aid [*autēs . . . tēn boēthon eikona*], when you laid low the wild beast [the tyrant] (ll. 12–16).

4. **The Roman Procession with the Lateran Icon**

In the night before the feast of the Assumption of the Virgin, on 15 August, the procession went to the station church where the service was held, S. Maria Maggiore, or *ad praesepe* (the church "by the crib"). As always, the papal retinue came from the pope's residence in the Lateran, but on this occasion it brought with it the unpainted icon of Christ from the Sancta Sanctorum chapel, to represent the visit of Christ, who was fetching his mother up to heaven. The procession became a main event of Roman public life and underwent a historical development that is reflected in the texts below. In addition, cf. Volbach 1940–41, 97–126, and Caraffa 1976, 127–51. Under Pius V (1566–72) the procession was banned.

A. Under Sergius I (687–701)

LP 1:376.

Sergius decreed that on the feasts of the Annunciation, the Assumption, and the Birth of the Virgin, and of St. Symeon, which the Greeks call Hypapanti [Candlemas, on 2 Feb.], the procession [*letania*] should start from the church of St. Hadrian [formerly the curia of the senate on the Forum Romanum] and that the populace should hasten to meet it after Sancta Maria [Maggiore on the Esquiline].

B. Under Stephen II (752–57) against the Langobard threat

The pope appeals to the whole population to attend services to ask for divine help to save Rome (*LP* 1:443).

On one of these days he led the procession in deep humility, as was his custom, carrying the most holy image [*imagine*] of the Lord, our Savior Jesus Christ, which is called the Acheiropiite [*acheropsita*], and displaying various other sacred mysteries, which he . . . carried with the other clerics, while he and the whole people went barefoot. On their shoulders they bore the holy image into the church of the Holy Mother of God, which is called the Church by the Crib (*ad praesepe*). Everyone scattered ashes on their hair and called on the help of the most merciful

Lord with the loudest lamentations. In this way the pope renewed the pact with the venerable cross, which the Langobard king had wickedly torn up.

C. Under Leo IV (847–55); the miracle against the dragon

Pestilence was rife in Rome, and people imagined it was caused by a dragon that lived in subterranean caves near S. Lucia in Orfeo on the Esquiline. Once again the icon on its annual journey to S. Maria Maggiore was pitted against this evil, or at least, the procession was used for a supplication by the whole people (*LP* 2:110).

On the glorious and famous day when the Assumption of the Virgin is celebrated . . . the pope set off on foot from his palace, as is the custom [*sicut mos est*], singing hymns and spiritual songs on his way to the church of St. Hadrian, walking with his clergy ahead of the *ycona*. When he left [St. Hadrian's] amid a great concourse of the people, he hastened, singing songs of praise [*laudes*] to God, to the [church of] the Mother of God, called the Crib. [On the way he stopped the procession and entered the caves, to summon God's help against the monster, in which he succeeded.] Then he hurried . . to the basilica just mentioned [S. Maria Maggiore] to say Mass.

As G. Wolf has pointed out to me, a Lateran canon expanded this account in the twelfth century, saying that the pope crossed himself with the icon three times before the entrance of the cave (cf. text 4F).

D. Under Otto III (983–1002); the song to the Virgin

M. Andrieu, *Les Ordines Romani du haut Moyen Age* (Louvain, 1961), 5:358–62; ordo 50, cap. 49.

In the night of the feast of the Assumption the Song of Songs and the sermons [*omelie*] relating to this day are read. The evening before, a carrying frame [*portatorium*] is prepared in the chapel of S. Lorenzo [Sancta Sanctorum] in the Lateran, and the most famous panel, the image [*tabula imagine insignita*] of our Lord is . . . placed on it. Joined by the people, the procession proceeds in the middle of the night past festively lit houses to the small [*minorem*] church of the Virgin. The icon [*ycona*] is set down for a while on its steps, and the whole choir of men and women kneel before it, praying together one hundred kyrie eleisons and shedding tears. . . . Then they continue by way of St. Hadrian's [on the Forum Romanum] to the great [*maiorem*] church of the Virgin, celebrating Mass there and finally returning to the [Lateran] palace.

[The text then quotes the Marian hymn that was sung "in the night when the panel was carried about." It expresses the Roman tradition and the hope for the divine support that the people were seeking on this night. For the reason given, it seeks to win the people over to Otto III, including him in the prayers. In a dialogue with old Roma, the latter is comforted by the assurance that she will be delivered by the Princes of the Apostles.] Holy Virgin, what is happening today? When you reach the heavenly regions, be merciful to your own people. . . . The Creator is no longer far away [says Roma]. For behold the face [*vultus*] that the mother's oracle seeks for the firstborn among men [the Romans]. . . . The face of the Lord is there, to whom the earth is subject under the law. . . . The splendid sign [*spectabile*] of the Lord on his throne-like plinth [*solium*] pauses [*sistitur*], as does the *Theotokos* on hers. . . . They bring thyme, incense, and myrrh. . . . The Greek school of song intones its song, while the Roman people hum, using various melodies. . . . Virgin Mary, look down in mercy on your children and hear

your servants. . . . The herd of the city weeps tears of supplication before you. . . . Holy Mother of God, look down on the Roman people and be gracious to Otto.

E. Canon Benedict, liturgical regulation (ca. 1143)

P. Fabre and L. Duchesne, *Liber Censum* (Paris, 1910), 2:158–59.

[The cardinals and deacons set off with the image of Christ from S. Lorenzo in the Lateran (i.e., the Sancta Sanctorum), carrying it across the Campus Lateranus to St. Gregory's (on the Celio?).] They also take the station cross; the prefect is accompanied by twelve men [representatives of the districts of the city], and the doorkeepers [*ostarii*] of the Lateran also carry twelve torches. . . . While the image crosses the campus, servants [*cubicularii*] stand on the hill [*culmine*] of St. Gregory's with two burning torches, which they put out when the image has passed. When the image has reached S. Maria Nova [now S. Francesca Romana on the Forum Romanum], it is set down in front of the church, and its feet are washed. Returning the way it came, the image then passes through the arch of the Latrona [*Latronis*, a passage through the Maxentius basilica], as there was here a great visitation of the devil long ago. Then the procession passes the house of Orpheus [cf. text 4C] on account of the basilisk that once lived in a cave there. . . . Pope Sergius [cf. text 4A] established the procession on this high feast day so that the Roman people might be freed from danger and persecution by the prayers [*laudes*] of so many people and the intercession of the Blessed Virgin Mary. It then climbs to the [church of] the Holy Virgin. The pope, who is ready there [*preparatus*], says the Mass. Then he blesses the people, who have gone without sleep, and everyone goes home.

F. Nicholas Maniacutius, treatise on the Lateran image (12th century)

This treatise was copied at the end of the twelfth century for a liturgical book of S. Maria Maggiore (Bibl. Vaticana, Fondo SMM 2, fols. 237–44): *De s. imagine SS. Salvatoris in palatio Lateranensi* (Rome, 1709). Cf. V. Peri, in *Aevum* 41 (1967): 67ff.

[St Luke, "who as a Greek was a good painter," painted the picture so that Christ would stay behind with the disciples, at least in his image, after the Ascension. Heaven intervened and completed the picture "without the work of man." It came to Rome in A.D. 70 with the booty of Titus and] was placed on the altar of the most holy chapel of S. Lorenzo, where only the pope is allowed to say Mass. [Thus Christ fulfilled his promise to be always with his followers in the place where his earthly representative resides,] in the presence of his person in the image. [In visions one sees the Virgin with all the heavenly household visiting her son in the chapel in the octave of the Assumption (chap. 9, p. 19).] Why does the procession go to S. Maria Maior on the feast of the Assumption? As many other images are carried in processions on other feasts of the Virgin [*multae aliae imagines in aliis beatae Mariae solemniis procederent*], some say that this feast ought to be celebrated more solemnly and should be reserved for this [image of Christ] alone. . . . [Others see the meaning of the procession] in the remembrance of the Virgin's Assumption, when the Redeemer appeared on earth and placed her beside him on the throne (chap. 11, pp. 22–23) . . . and others again point to the deliverance of Rome from the dragon under Leo IV (p. 25).

G. A confraternity document (1462)

This document is in the archive of the confraternity Compagnia de Raccomandati del SS. Salvatore; cf. Marangoni 1747, 120–24, and Caraffa 1976, 135–43.

[The people assemble in the senate church on the Capitol, S. Maria in Aracoeli, whose bells summon them, and pray before the specially "unveiled image of the Virgin owned by this church." Then they set off by way of S. Maria Nova for the hospital S. Giacomo near the Colosseum, where they meet the papal clergy and where the roles of the members of the confraternity in the procession are decided. Together the parties proceed along the Via Sacra to the Sancta Sanctorum in the Lateran, where the image, adorned in a new garment of gold (*pallio d'oro*), awaits them on a festive stand (*talamo*). The image is then borne "down the marble staircase to the Lateran square" while the people, the confraternity, and the clergy take their places in the procession. Then it is carried under a baldachin to the hospital just named, where priests wash its feet and then sprinkle the people with the water that has been used. The consuls of the guilds (*arti*) now present wax votive offerings to the image; these are placed on wooden stands (*thalami*) with the guild escutcheons and carried before the image by twelve bearers in a carefully defined order.]

[Further along the way the nocturnal footwashing takes place in S. Clemente, where the people] converge in front of the image to see and venerate it. [The confraternity of the Virgin, Raccomandati di Maria, with their torches and musical instruments, give the procession a festive air,] following the ancient rite of the imperial triumphs, when images of gods and portraits of the emperor were also carried. [Now the triumph is celebrated] in honor of our Redeemer, the Blessed Virgin, and the holy Princes of the Apostles of Rome; and among the images of these the coats of arms of the pope, the church, the senate, and the Roman church are also carried.

[There are further washings of feet on the steps of S. Maria Nova, on the altar of St. Hadrian on the Forum, where the senate pays its respects, in the vestibule of SS. Cosma e Damiano, where the women have access to the image, and in S. Prassede. Finally, amid the rejoicing of the people, the image is placed on the altar of S. Maria Maggiore, where it is under the protection of the Compagnia and the authorities of Rome. There, at the third hour on the morning of 15 August, Mass is celebrated. Then the image is lifted up again and carried, after it has taken leave of the Virgin (*salutatasi*) back to its home. To protect it from the hands of the people, ten armed men from Rione de Monti, called *stizzi*, always go with the image. When all the festivities are over, the image is locked up in its place in the papal chapel until Christmas, when it is opened for the first time in the church year.]

[On frescoes in S. Giacomo del Colosseo depicting the veneration of the image, cf. S. Waetzoldt, *Die Kopien des 17 Jahrhunderts nach Mosaiken und Wandmalereien in Rom* (1964), 34 and fig. 70.]

H. Inscription in the Palace of the Conservators (16th century)

This inscription probably dates only from the early sixteenth century but reproduces the wording of an earlier decree that the magistrate had had inscribed permanently in his stone seat. The occasion for the decree was a conflict between the different professions over the order of precedence in the procession, since this had come to reflect the social order and its hierarchy. Nothing is said about the clergy and the principate, nor about the confraternity, since the magistrate had authority only over the people. The reference to old Roman traditions, as in text 4G, had clearly become a preoccupation of the otherwise powerless magistrate, who invokes old rights and even older rituals. Cf. Marangoni 1747, 125–26.

[The celebration of the triumph of the pagan emperor (*triumphalis gentilium pompa*) has been renewed on the day of the Virgin's Assumption in a form appropriate to Christian worship, when the miraculous image (*mirabile simulacrum*) of Christ is taken in procession to S. Maria

Maggiore in honor of the senate, the magistracy and the whole knightly estate, closely followed by the people.] So that no further conflict arises between the professional associations of the people [*plebeia collegia*], this statute decrees the order in which everyone shall accompany the holy image when it sets off on its way, with their torches [*thalami*, see text 4G] and lamps, for those who are closer to the image have higher rank. [More than twenty-five professions are then listed, with the threat of a fine if the regulation is not respected.]

I. The procession in Tivoli (18th century)

In many places in Latium the procession with images of Christ that were in principle copies of the original in Rome and had folding wings was repeated. Surviving examples from the twelfth and thirteenth centuries in Tivoli, Casape, Velletri, Capranica, Sutri, Tarquinia, Trevignano, and Viterbo are in Garrison 1955–62, 2.1:5ff.; Hager 1962, 36–37; and Matthiae 1966, 58–59. In Tivoli, as late as the eighteenth century, the procession took the Christ icon from the cathedral to S. Maria Maggiore, where it greeted the titular icon of Maria Advocata before the church by bowing down to it (the *inchinata*). On the twelfth-century Christ image, cf. Garrison 1955–62, vol. 2, fig. 4, and Matthiae 1966, plate facing p. 60. On the thirteenth-century Virgin's image, which survives in a replica from about 1800, cf. I. Toesca, in *Mostra dei restauri 1969* (Rome: Pal. Venezia, 1970), 9–10 and pls. 1–3. It has an inscription of the angel's greeting at the Annunciation. Cf. Volbach 1940–41, passim; Marangoni 1747, 143–44; and V. Pacifici, *L'inchinata. Il significato della cerimonia* (Tivoli, 1937).

5. Icons on Early Chancel Screens
Miracle of St. Artemios (Constantinople, before 668)

A. Papadopoulos-Kerameus, *Varia graeca sacra* (St. Petersburg, 1909), 51–52.

A woman named Anna placed, as usual, a candle before the image of the holy prophet . . . John [the Baptist], which is housed in a lunette above the portal as one enters from the forecourt, where there are stairs [in the church of John the Baptist and St. Artemios in Oxeia]. In the same place . . . there was also an image of the martyrdom of St. . . . Artemios. She [Anna] asked the twelve-year-old daughter of a neighbor to do the same, but the girl fell ill and seemed to be dead. She saw two angels coming to fetch her [soul]. But Artemios prevented them. He then led [the girl] to his grave [*soros*] at the church, where she was healed. Asked what the angels looked like, she pointed to the angels depicted in the church with the Lord in their midst. Asked to describe the appearance of Artemios, she replied: "He appears as he does in the image in the left part of the church, on the *templon* [chancel screen] with the pediment at the center, on which the Lord is painted, with the image of the Forerunner [John the Baptist, the other patron of the church] at his right hand [i.e., opposite Artemios]."

6. The Defense of Images by the Patriarch of Constantinople
Patriarch Germanus, speech on icons (ca. 730)

D. Stein, *Der Beginn des byzantinischen Bilderstreits* (Munich, 1980), 274–75, with translation into German.

Preserving the good tradition of the most celebrated apostles and the six revered synods, we bow down before the Trinity, which is of one being—Father, Son, and Holy Spirit—a deity,

power, and force on which we are baptized and in which we believe. But after it we acknowledge the *oikonomia* of our Lord Jesus Christ, the true God made incarnate on earth. . . .

But about the icons of the saints we say the following: when, to come straight to the point, we contemplate the figure of the true God made man for our redemption, we are cast down, for we remember with awe his presence in the flesh on earth, which happened because of his great compassion. But when we make a likeness of her who gave him birth, our pure and ever virginal mistress, the *Theotokos*, a likeness beyond all our imagining, we think of her as the all-holy house of God, who, as the only entirely pure being on earth, was deemed worthy to become the Mother of God, and who surpasses the spiritual natures in heaven. When we depict the figures of those who by good works and pious deeds have proved themselves the servants of God, we remember their unconquered resistance to the invisible foe. For although they acted through a perishable body, they vanquished the enemy and brought shame on the Devil by destroying the passions of the flesh and stifled [the Devil's deceit by the dispassionate blood they shed] in the battle for truth, in which they did not spare themselves. When we look on an icon of a saint—and this is true for every icon of a saint—we venerate not the panel or the paint but the pious and visible figure.

7. The First Theology of the Image

John of Damascus (ca. 675–749), a great theologian whose writings became known in the West only in the sixteenth century, came from a noble family of Arabian Christians. After serving as financial officer under the caliph of Damascus, about the year 700 he entered the Saba monastery near Jerusalem, where he spent the rest of his life studying, writing, and preaching.

A. John of Damascus, "Exposition of the Orthodox Faith" (rev. ca. 743)

Chapter 89 of John's "Exposition" succinctly summarizes his doctrine of images. The translation here is from *Saint John of Damascus: Writings,* vol. 37 of *The Fathers of the Church,* trans. F. H. Chase (New York, 1958), 371–73. See also the references in chap. 8 n. 28.

The original is the thing imaged from which the copy is made. For what reason did the people of Moses adore from round about the tabernacle which bore an image and pattern of heavenly things? . . . And what was the celebrated temple in Jerusalem? Was it not built and furnished by human hands and skill?

Now, sacred Scripture condemns those who adore graven things, and also those who sacrifice to the demons. The Greeks used to sacrifice and the Jews also used to sacrifice; but the Greeks sacrifice to the demons, whereas the Jews sacrificed to God. . . . And thus the statues of the Greeks happen to be rejected and condemned, because they were representations of demons.

But, furthermore, who can make a copy of the invisible, incorporeal, uncircumscribed, and unportrayable God? . . . For this reason it was not the practice in the Old Testament to use images. However, . . . God for our salvation was made man in truth. . . . He abode on earth [which is recorded in the Scriptures and in images for us who were born later, who believe without seeing]. It certainly happens frequently that at times when we do not have the Lord's Passion in mind we may see the image of His crucifixion and, being thus reminded of His saving Passion, fall down and adore. But it is not the material [of the image] which we adore, but that which is represented. . . . For what is the difference between a cross which does not typify the Lord and one which does? It is the same way with the Mother of God, too, for the honor paid

her is referred to Him who was incarnate of her. This is the written tradition, just as is worshiping toward the east, adoring the cross, and so many other similar things.

Furthermore, there is a story told about how, when Abgar was lord of the city of Edessenes, he sent an artist to make a portrait of the Lord, and how, when the artist was unable to do this because of the radiance of His face, the Lord Himself pressed a bit of cloth to His own sacred and life-giving face and left His own image on the cloth and so sent this to Abgar who had so earnestly desired it.

B. John of Damascus, *Three Discourses on Sacred Images* (ca. 730)

From the safe distance of his post in Syria, John wrote these three discourses against the views of Byzantine emperor Leo III and the iconoclasts. Supporting his arguments with numerous quotations from the church fathers, he dedicated the first to the patriarch of Jerusalem and then composed the second in order to make the subject matter of the first more understandable. We follow here the summary of John's doctrine of images presented in P. Bonifatius Kotter, *Die Schriften des Johannes von Damaskos,* vol. 3 (Berlin, 1975), 8ff.

John defines the image both as similarity, which unites it with the archetype in form, and as difference, which divides it from the archetype in substance. He distinguishes five kinds of images, beginning with the "natural image," as the son is the natural image of the father, who must exist in nature in order to be able to be imitated. Thus Christ is an image of the invisible God. In the natural image, image and archetype coincide in their being, in nature, but not in the person, or hypostasis. In understanding, word, and spirit, man is an image of God (3.16–23). What can be depicted is what is visible as body, figure, outline, and color. Therefore Christ as a human can also be depicted, as can angels, who have shown themselves to people. God, however, has not shown himself in his essence, but only in the form in which he was to be born as a man (3.24–26).

For John, veneration is a sign of submission. In the form of adoration (*latreia*), it is due only to God. In the form of reverence (*proskynēsis*), it is due also to saints and images, which deserve worship (*timē*) because they refer to God (3.27–41). The person depicted in an image is present in it, if his or her name is given to it. Like saints themselves, images acquire a share of divine grace and therefore can perform miracles like saints (2.14; 1.36; 3.55, 90–91). An image is just as deserving of reverence as are the cross and relics. Its effect, however, does not lie in its material form but in the faith of the beholder (1.22; 3.41). An image receives its honor from the prototype it depicts (1.16, 21; 3.41), which explains why many images of the same person can be in circulation simultaneously.

The three writings on images are now in the edition by P. Bonifatius Kotter, *Die Schriften des Johannes von Damaskos,* vol. 3 (Berlin, 1975). The English translation below is from *On the Divine Images,* trans. David Anderson (Crestwood, N.Y.: St. Vladimir's Seminary Press, 1980). See also chap. 8 n. 28.

[The third discourse in defense of images ends with the assurance that the writer has now fully explained] the difference between idols and icons (3.42). [The icon must be legitimized to the Jews, who until the incarnation of Christ had no right to make human images of the invisible God, and to the ancient Greeks (the *Hellēnes*), who made stones or images into gods (*theopoiountes;* 1.24).] Pagans make images [*eikones*] of demons which they address as gods, but we make images of God incarnate, and of his servants and friends, and with them we drive away the demonic hosts (1.24).

[John repeatedly expresses his concern to purify the church from the terrible suspicion of idolatry. If the church] declines one iota from perfection, it will be a blot on her unblemished face, destroying by its ugliness the beauty of the whole. A small thing is not small when it leads to something great; and it is no small matter to forsake the ancient tradition of the church

which was upheld by all those who were called before us, whose conduct we should observe, and whose faith we should imitate (1.2).

[Everything thus depends on interpreting correctly the true tradition in the writings of the church fathers. To defend images is therefore to defend tradition. When the iconoclasts attack the present church as an aberration from the tradition, they are in error because they misunderstand the tradition. The core issue in the dispute about images is thus one of the correct reading of the sources.]

[Among the many writings, only a few, late passages mention an actual veneration of images. One such is the "Acts of Maximos the Confessor," from the seventh century.] Then all arose with tears of joy, did penance and prayed. And each of them kissed the holy Gospels and the venerable cross and the icon of our God and Redeemer Jesus Christ and that of our Lady, the most holy Mother of God, who gave him birth, and they clasped hands to affirm what had been said (2.65; Kotter, *Schriften*, p. 164).

8. Resolutions of the Second Council of Nicaea (787)

Translation of the dogmatic definition of this seventh ecumenical council is from Norman P. Tanner, ed., *Decrees of the Ecumenical Councils*, 2 vols. (London: Sheed & Ward; Washington, D.C.: Georgetown University Press, 1990), 1:133–37. The acclamations are from *A Select Library of Nicene and Post-Nicene Fathers of the Christian Church*, 2d ser., vol. 14: *The Seven Ecumenical Councils*, ed. Henry R. Percival (New York: Scribner's, 1905), 550–51.

[Dogmatic definition:] The holy, great and universal synod, by the grace of God and by order of our pious and Christ-loving emperor and empress, Constantine and his mother Irene, assembled for the second time in the famous metropolis of the Nicaeans in the province of the Bithynians, in the holy church of God named after Wisdom, following the tradition of the catholic church, has decreed what is here laid down.

The one who granted us the light of recognizing him, the one who redeemed us from the darkness of idolatrous insanity. . . . To this gracious offer some people paid no attention; being hoodwinked by the treacherous foe they abandoned the true line of reasoning, and setting themselves against the tradition of the catholic church they faltered in their grasp of the truth. . . . For they followed unholy men and trusting to their own frenzies they calumniated the holy church, which Christ our God has espoused to himself, and they failed to distinguish the holy from the profane [Ezek. 22:26], asserting that the icons of our Lord and of his saints were no different from the wooden images of satanic idols.

Therefore the Lord God, not bearing that what was subject to him should be destroyed by such a corruption, has by his good pleasure summoned us together through the divine diligence and decision of Constantine and Irene, our faithful emperor and empress, we who are those responsible for the priesthood everywhere, in order that the divinely inspired tradition of the catholic church should receive confirmation by a public decree. So having made investigation with all accuracy and having taken counsel, setting for our aim the truth, we neither diminish nor augment, but simply guard intact all that pertains to the catholic church. Thus, following the six holy universal synods, in the first place that assembled in the famous metropolis of the Nicaeans, and then that held after it in the imperial, God-guarded city;

We believe in one God the Father all-powerful, maker of heaven and earth [the creed follows].

We abominate and anathematize Arius and those who think like him and share in his mad error; also Macedonius and those with him, properly called the Pneumatomachi ["adversaries

of the Spirit"]; we also confess our Lady, the holy Mary, to be really and truly the God-bearer, because she gave birth in the flesh to Christ, one of the Trinity, our God, just as the first synod at Ephesus decreed; it also expelled from the church Nestorius and those with him, because they were introducing a duality of persons. Along with these synods, we also confess the two natures of the one who became incarnate for our sake from the God-bearer without blemish, Mary the ever-virgin, recognizing that he is perfect God and perfect man, as the synod at Chalcedon also proclaimed, when it drove from the divine precinct the foul-mouthed Eutyches and Dioscorus. We reject along with them Severus, Peter and their interconnected band with their many blasphemies, in whose company we anathematize the mythical speculations of Origen, Evagrius and Didymus, as did the fifth synod, that assembled at Constantinople. Further we declare that there are two wills and principles of action, in accordance with what is proper to each of the natures in Christ, in the way that the sixth synod, that at Constantinople, proclaimed, when it also publicly rejected Sergius, Honorius, Cyrus, Pyrrhus, Macarius, those uninterested in true holiness, and their like-minded followers. To summarize, we declare that we defend free from any innovations all the written and unwritten ecclesiastical traditions that have been entrusted to us. One of these is the production of representational art; this is quite in harmony with the history of the spread of the gospel, as it provides confirmation that the becoming man of the Word of God was real and not just imaginary, and as it brings us a similar benefit. For, things that mutually illustrate one another undoubtedly possess one another's message.

Given this state of affairs and stepping out as though on the royal highway, following as we are the God-spoken teaching of our holy fathers and the tradition of the catholic church—for we recognize that this tradition comes from the holy Spirit who dwells in her—we decree with full precision and care that, like the figure of the honoured and life-giving cross, the revered and holy images, whether painted or made of mosaic or of other suitable material, are to be exposed in the holy churches of God, on sacred instruments and vestments, on walls and panels, in houses and by public ways; these are the images of our Lord, God and saviour, Jesus Christ, and of our Lady without blemish, the holy God-bearer, and of the revered angels and of any of the saintly holy men. The more frequently they are seen in representational art, the more are those who see them drawn to remember and long for those who serve as models, and to pay these images the tribute of salutation and respectful veneration. Certainly this is not the full adoration in accordance with our faith, which is properly paid only to the divine nature, but it resembles that given to the figure of the honoured and life-giving cross, and also to the holy books of the gospels and to other sacred cult objects. Further, people are drawn to honour these images with the offering of incense and lights, as was piously established by ancient custom. Indeed, the honour paid to an image traverses it, reaching the model; and he who venerates the image, venerates the person represented in that image.

So it is that the teaching of our holy fathers is strengthened, namely, the tradition of the catholic church which has received the gospel from one end of the earth to the other. . . .

Therefore all those who dare to think or teach anything different, or who follow the accursed heretics in rejecting ecclesiastical traditions, or who devise innovations, or who spurn anything entrusted to the church (whether it be the gospel or the figure of the cross or any example of representational art or any martyr's holy relic), or who fabricate perverted and evil prejudices against cherishing any of the lawful traditions of the catholic church, or who secularize the sacred objects and saintly monasteries, we order that they be suspended if they are bishops or clerics, and excommunicated if they are monks or lay people.

[Acclamations:] The holy Synod cried out: So we all believe, we all are so minded, we all give our consent and have signed. . . . Believing in one God, to be celebrated in Trinity, we salute the honourable images! Those who do not so hold, let them be anathema. Those who do not

thus think, let them be driven far away from the Church. For we follow the most ancient leg-islation of the Catholic Church. We keep the laws of the Fathers. We anathematize those who add anything to or take anything away from the Catholic Church. We anathematize the intro-duced novelty of the revilers of Christians. We salute the venerable images. We place under anathema those who do not do this. Anathema to them who presume to apply to the venerable images the things said in Holy Scripture against idols. Anathema to those who do not salute the holy and venerable images. Anathema to those who call the sacred images idols. Anathema to those who say that Christians resort to the sacred images as to gods. Anathema to those who say that any other delivered us from idols except Christ our God. Anathema to those who dare to say that at any time the Catholic Church received idols.

Many years to the Emperors, etc., etc.

9. The Contradiction of the Emperor by the Pope
A letter allegedly from Pope Gregory II to Emperor Leo III (8th century)

Mansi 1901, 12:959ff. (to which page numbers below refer); J. Gouillard, "Aux origines de l'iconoclasme: Le témoignage de Grégoire II?" *Travaux et mémoires* 3 (1968): 253ff. An early version of this letter was cited in the Second Council of Nicaea in 787. To give an authentic effect, the text refers to Gregory's colleague Germanus as well as to Pope Martin, who was the victim of a conflict with the emperor in the seventh century. According to Gouil-lard, the letter was rewritten about 800.

[The text justifies the veneration of images with many arguments and proofs. They include a reference to the *Mandylion,* or cloth image, which Christ sent to Abgar on his request.] Now send [messengers] to this image not made by human hands [*non manufactam imaginem*] and you will find out that throngs of people from the Orient gather and pray before it. And there are many other images of this kind, to which crowds of pilgrims show pious Christian love when they come before such a spectacle, which you can see and revere every day.

Why do we not set God the Father . . . before our eyes and paint him? Because we do not know who he is and because one can neither see nor paint the nature of God. If we had been able to see or know him, like his son, we should have been able to place him too before our eyes and paint him, and you would have been able to call his image an idol. Christ's love [for us] knew that when we enter the church of the Prince of the Apostles, Peter, and contemplate the holy painted image [*pictam imaginem*], we are seized by a reverent feeling [*compunctione percellimur*]. . . . Christ restored sight to the blind. But you have blinded those who saw well (964).

You say that we worship stones, walls, and panels [*tabellas adorare*]. That is not so. . . . [The images are there] to reinforce our memory and . . . to elevate our minds. This is brought about by those whose names and petitions [*appellationes*] and whose images we possess. We do not venerate them as gods, as you assert, for we have no trust in gods.

When we see an image of the Lord, we say: "Lord Jesus Christ, Son of God, stand by us and save us." If it is an image of his holy Mother, we say: "Holy Mother of God, intercede with your Son, our true God, that he may save our souls." Finally, before the image of a martyr, we say: "Holy Stephen, who have shed your blood for Christ and who, as an archmartyr [*proto-martyr*], have the right to speak [*loqui confidentiam*], intercede for us" (965).

When we enter a church and contemplate the miracles of Christ, our Lord, and those of his holy Mother, who holds our Lord whom she nourished, on her lap, while angels surround them, singing the hymn of the thrice-holy [*ter sanctum hymnum*], we do not leave without our emotions being touched (967).

[Finally, the letter deals with the reaction of the "kings of the West" to the destruction of images in Byzantium, which they can scarcely believe.] But they became certain when they heard that you had sent the adjutant Jovinus to the [church of the Virgin in the] Chalcoprateia with instructions to cast down and smash the [image of] the Redeemer that is called the *Antiphonites* [he who gives answer], an image before which many miracles have occurred (969). [There follows the story of the resistance of the pious women and the start of the persecution of the supporters of images.]

10. Poems on Images by Abbot Theodore of Studion (759–826)

Page references are to Speck 1968.

[No. 30:] The image you see is Christ; but do not call it Christ, only of that same name, for naming lies in resemblance and not in nature. But for both there is undivided reverence. He who venerates this image therefore venerates Christ; he who does not venerate it is wholly his foe, for he is filled with hate for him and does not wish his depicted, incarnate appearance to be venerated (175).

[No. 31:] If we eat the body of Christ and drink his life-giving blood, why should we not show him in paint, whose body can be represented? Insofar as he simply is, there is no way of representing him, for he is God outside any place. But insofar as he has taken on a being corresponding to ours, he is a man and can be represened by virtue of this constitution, since by nature he has both unmixed. He who fully honors the Word in this way proves himself a faithful member of the church (177).

[No. 37:] You who have given birth to God surpass the angels, for the one that they cannot even look upon you hold as your Son in your immaculate hands (186).

[No. 38:] As is fitting for a mother, I carry my son in the picture, so that he may appear as the real child of a mother, he who is beyond all depiction in his resemblance to the Father; for he is inseparably double by his nature (187).

11. The Inscription in the Restored Throne Room (856)

When images were restored to the Chrysotriklinos ("golden [dining] room"), or principal throne room of the Great Palace, a Greek text inscribed around the ceiling celebrated their return. The English version below appears in Mango 1972, 184, based on the text in *Anthologia Graeca* 1.106, ed. H. Beckby (Munich, 1957), 1:152–53.

The ray of Truth has shone forth again and has dimmed the eyes of the imposters [the iconoclasts]. Piety has grown, error has fallen, faith blooms and Grace spreads out. For behold, once again the image of Christ shines above the imperial throne and confounds the murky heresies; while above the entrance is represented the Virgin as divine gate and guardian. The Emperor [Michael III] and the Bishop [Photius] are depicted close by along with their collaborators inasmuch as they have driven away error, and all round the building, like guards, [stand] angels, apostles, martyrs, priests. Hence we call "the new Christotriklinos" that which aforetime had been given a golden name [*Chrysotriklinos*], since it contains the throne of Christ, our Lord, the forms of Christ's Mother and Christ's heralds, and the image of [Emperor] Michael whose deeds are filled with wisdom.

12. Imperial Speeches on the Consecration of Churches
A. Address of Leo VI (886–912) at the consecration of the church of Stylianus

> Stylianus Zaoutzas, Leo's father-in-law, built this church after 886 and before ca. 893. English translation is in Mango 1972, 203–5. See also the references in chap. 9 n. 18.

In the center [of the church], i.e., in the segment of a sphere [i.e., dome] that rises at the summit, is an image [of Christ] that lacks the lower part of the body. I think that the artist wished, by means of this treatment of the picture, to offer a mystical suggestion of the eternal greatness inherent in the One represented, i.e., that His incarnation on earth did not detract from His sublimity. . . . At the springing of the hemisphere [hēmikuklion] are represented, all round, His servitors whose being is higher than that of matter. They are the messengers [angeloi] of God's communications to men, and are named accordingly. Some of them . . . are called polyommata [cherubim] because of the multitude of their eyes. . . . And others are named after the number of wings [seraphim], namely six, which they have. The disposition of their wings is indicative of the mysterious hiddenness and folding in upon itself of the Godhead . . . while the veiling of their faces and feet teaches us that the Godhead is altogether incomprehensible and invisible. . . . Next to these [the artist] has placed another category of servitors who are agreeable to God; these, although beings of a material composition, have nevertheless surpassed the bounds of matter and attained to the immaterial life. Some of them [the prophets] foresaw from afar the events which at a later time would be enacted for the salvation of the world; while others took part in these very events—here you may see kings and priests—so that the universal King receives universal homage. With these images is the summit of the church decorated, while the remainder contains the events of the Incarnation.

Here [describing the Annunciation] a winged being who has just descended from heaven converses with a virgin. You might say that this picture was not devoid of speech, for the artist has infused such natural color and feeling [ēthos] into the faces, that the spectator is forced to assume that they are so colored because of their awareness of what is being said. [Then follows mention of scenes depicting the events of Christ's life: nativity, epiphany, presentation in the temple, baptism and transfiguration, the raising of Lazarus, crucifixion, entombment, resurrection, and ascension.]

B. Address of Leo VI at the consecration of the church in the monastery of Kauleas

> This church was founded or restored by Patriarch Antony II Kauleas (893–901). English translation is in Mango 1972, 202–3. See also chap. 9 n. 18.

The [structure] which is above the beautiful pavement and forms the roof is raised in the shape of a half-sphere. In the midst of it is represented an image of Him [Christ Pantocrator] to whom the craftsman has dedicated the church. You might think you were beholding not a work of art, but the Overseer and Governor of the universe Himself who appeared in human form, as if He had just ceased preaching and stilled His lips. The rest of the church's hollow and the arches on which the roof is supported have images of [God's] own servants, all of them made of mosaic smeared with gold. The craftsman has made abundant use of gold whose utility he perceived: for, by its admixture, he intended to endow the pictures with such beauty as appears in the apparel of the emperor's entourage. Furthermore, he realized that the pallor of gold was an appropriate color to express the virtue of [Christ's] members. Along with them is represented in a certain place [doubtless in the apse] the Virgin Mother holding the infant in her arms and gazing upon Him with a mixture of maidenly composure and motherly love: you can almost see her opening her lips and addressing motherly words to the child, for to such an extent are the images endowed with life.

13. Images of Saints in Visions
The biography of Andrew, the Holy Fool (10th century)

> The holy fool, Salos, named Andrew, is the hero of a fictitious biography written by Nice-phorus, a priest at St. Sophia in Constantinople in the tenth century. The visions of Andrew, which resemble those of a seer, take a prominent place in it. An edition is in *PG* 111; a critical edition with translation is to be published by L. Ryden (Uppsala). Cf. Beck 1959, 567–68, and G. da Costa-Louillet, in *Byzantion* 24.1 (1954): 179ff.

I. [In a vision during the week of festivities in the Blachernae church (cf. text 15) Andrew sees before his inner eye the Mother of God, attended by the two Johns and other saints, appear in the chancel of the church and spread out her mantle over the people (*PG* 111.848–49 and Belting-Ihm 1976, 44 and 60–61).]

II. [Andrew himself is the subject of a vision experienced by a certain Epiphanios during early Mass. An old man (*presbytēs*) shows him Andrew in a heavenly state, after he was asked] to show him the lifelike image [of the blessed Andrew] in the rows of saints. . . . The other led him into a chamber that shone like lightning. From it stepped the blessed Andrew, appearing as if in an icon [*hōs en eikoni*] and with a resemblance [*symmorphos*] to the appearance of an emperor. His face shone like the sun. On his head he wore a crown, on his brow a cross from the crown of the emperor, in his right hand a cross, and in his left a scepter (*PG* 111.737C).

14. Ceremonial Visit of the Emperor to the Blachernae Church
Constantine Porphyrogenitus, Book of Ceremonies of the Byzantine Court (10th century)

> This selection from book 2, chapter 12 of the Book of Ceremonies is entitled: "What it is necessary to observe when the rulers leave to bathe at Blachernae." The text appears in Reiske, 1829, 551–56.

[The dignitaries] receive the rulers outside the gate . . . and they fall down making obeisance before the rulers. . . . In the porch . . . the clergy of the church receive them. When the rulers go into the narthex they put on gold-bordered cloaks and light candles and go in through the middle of the church and . . . into the holy sanctuary and kiss the holy altar-cloth [*endyte*]. While the rulers are praying at the holy bema, [their retinue] go through and stand in the narthex [of the reliquary chapel] of the Holy Soros. Then [the rulers] go through the right-hand side of the bema to the east and [through] the sacristy [*skeuophylakion*]. The imperial guard stand on the left-hand . . . and [the retinue] stand on the right as one faces the doors. The rulers light candles . . . at the imperial doors of the Holy Soros and go in . . . [to] the bema and . . . kiss the holy altar-cloth, and the senior emperor . . . censes around the holy altar. Then . . . they go away from the right-hand side to the *episkepsis* and light candles there and make obeisance.

And from there they go away to outside the Metatorikion when the icon of the Mother of God and the silver cross are located and they light candles there and go into the Metatorion and, if they wish, their heads are covered. And when they leave they go through the narthex . . . and ascend through the spiral staircase [*kochlias*] and go away . . . to the dressing-rooms [*apodyta*] and, undressing, put on their golden towels [*lentia*] and go in to the holy bath [*lousma*]. . . .

They take candles . . . and light them and make obeisance before the holy silver icons which are at the *kolymbos* [bath, basin]. . . . Then the rulers light candles in the conch to the

east where indeed the silver icon of the Mother of God stands at the Phiale [bowl, fountain]. And from there they go away to the left where the relief of the hand of the Mother of God is carved in marble and enclosed in a silver mount, and they light candles there, too, and . . . the senior emperor places unguent [*aleipton*] in the incense-burner [*kapnisterion*] there [as previously in front of the silver icons at the bath].

And from there the rulers turn back and go into [the Church of] St. Photeinos to the inner chamber [*tholos*], and as they leave they light candles in front of the marble icon of the Mother of God which pours out holy water from her holy hands. . . . The *praepositus* takes the holy *stakte* [oil of myrrh?] . . . and gives it to the rulers . . . and they go out and bathe. After the bathing they go out into the small outer chamber [*tholos*] and taking off their towels they put on others woven with gold. . . . The senior emperor gives each of the assistants [*bastakta*] one nomisma. . . . The *protembatarios* sanctifies the bath [*kolymbos*] with the cross, giving the rulers holy water [*hagiasma*] from the bath with the said cross. After receiving the holy water they go into the bath and while the ritual prayer of supplication is taking place, they immerse themselves three times. (Trans. A. Moffatt and M. Tall)

15. The Miracle of the Curtain at Blachernae
Michael Psellus, address (1075)

X. A. Siderides, in *Orthodoxia* 2.23 (1928): 508ff., and V. Grumel in *Échos d'Orient* 30 (1931): 136ff. The text is from a notarial report on a dispute between General Leon Mandalos and the monks of Kallias, which was decided by the oracle of the icon in 1075. Grumel 1931, 130ff. also gives the Latin text of the *Liber Virginalis,* in which the whole course of the miracle, up to the evening of the following day, is described.

On the right side of the church when one enters facing east [probably in the relic chapel, or the Holy Soros] hangs an icon that is also firmly fixed to the wall. In its form [*idea*] it is inimitable, in grace [*charis*] incomparable, and in miraculous power [*dynamis*] unique. A curtain [*katapetasma*] woven of costly material and with a border of images, hangs before it. In the same part of the room there is an altar, from which the icon is addressed in all the ways customary among the clergy and the people: with hymns of every kind, prayers of propitiation, and offerings befitting holiness. An extraordinary thing happens to the icon on the sixth day of the week after sunset. At this time everyone leaves the church, not just the crowds of lay people, but even the celebrants and the priests, both the ones who move about in the holy building and whoever happens to be within the veil [*katapetasma*; i.e., in the sanctuary] celebrating holy Mass. What happens then? All the doors of the sanctuary are closed, and the crowd stays in the vestibules near the doors. As soon as the clergy have finished their regular rites, it is the custom to open the church. The doors are opened and those waiting outside are allowed to enter. As they enter in a mixture of joy and fear, the curtain [*peplos*] before the icon suddenly is buoyed up as if a breath of wind [*pneuma*] moved it. Those who have not seen it cannot believe that the event takes place. All who have witnessed it see a miracle [*paradoxon*] in it, manifestly a visitation of the Holy Spirit [*pneuma*]. While the event is happening, the appearance of the heavenly image (or heavenly creature, *theopais*) changes, and it receives, I believe, her [the Virgin's] living visit [*empsychos epidēmia*], making what otherwise remained invisible, visible. [As the veil of the temple was rent at Christ's death, so] in a mysterious way [*aporrētos*] the holy curtain [*peplos*] is lifted for the Mother of God, so that within it the multitudes might enter and be embraced as if in a new sanctuary [*aduton*] and an inviolate refuge. [Sometimes the miracle

does not happen, which for the icon is like an eclipse of the sun and is perhaps intended to discourage suspicions that the miracle has natural causes.]

In a prayer on the consecration of the water in the basin (*kolymbos*), God is besought, in the name of his Mother, whose outstretched arms once carried him, and who is the merciful (*philoiktirmon*) mistress and fountain of compassion (*Eusplanchnias*), to consecrate the water (Jean B. Papadopoulos, *Les palais et les églises des Blachernes* [Athens 1928], 101–2).

16. The Oracular Icon of Empress Zoe
Michael Psellus, *Chronographia* (11th century)

In his history, Michael Psellus tells how Empress Zoe used an icon of Christ during her marriage with Emperor Constantine IX (1042–55). The translation below appears in Sewter (see chap. 10 n. 4), 188–89.

[Empress Zoe] had made for herself an image [*eikonisma*] of Jesus, fashioning it with as much accuracy as she could (if such a thing were possible). The little figure, embellished with bright metal, appeared to be almost living. By changes of colour it answered questions put to it, and by its various tints foretold coming events. Anyway, Zoe made several prophecies with regard to the future from a study of this image [*eikona*]. So, when she had met with some good fortune, or when some trouble had befallen her, she would at once consult her image, in the one case to acknowledge her gratitude, in the other to beg its favour. I myself have often seen her, in moments of great distress, clasp the sacred object in her hands, contemplate it, talk to it as though it were indeed alive, and address it with one sweet term of endearment after another. Then at other times I have seen her lying on the ground, her tears bathing the earth, while she beat her breasts over and over again, tearing at them with her hands. If she saw the image turn pale, she would go away crestfallen, but if it took on a fiery red colour, its halo lustrous with a beautiful radiant light, she would lose no time in telling the emperor and prophesying what the future was to bring forth.

[After referring to ancient Greek theories that one could invoke a deity by the use of precious stones and certain herbs and ceremonies, the chronicler expresses the opinion that] Zoe's religious ceremonies . . . were not conducted after the Greek or any other style. She worshipped God in her own way, making no secret of her heart's deep longing and consecrating to Him the things which we regard as most precious and most sacred.

17. A Miracle in a Painter's Studio
Athanasius the Athonite, *Vita A* [of St. Athanasius], on the painter Pantoleon (ca. 1000)

Vita A of St. Athanasius (ca. 293–373), written by Athanasius the Athonite (ca. 920–ca. 1000), reports on the icon painter Pantoleon and on the miraculous origin of the icon of the saint at Mount Athos. This English translation appears in Mango 1972, 213–14.

The time has come to mention also a miracle which I witnessed with my own eyes. I am sure that all of you, brethren, have known Cosmas the former *ecclesiarch* of the monastery [the Lavra] either by hearsay or by sight. This man used to put in at my father's whenever he had need to come to the capital. Arriving on one occasion and seeing at our house an icon of the Saint [Athanasius] which my father [abbot of the Panagiou monastery?] had recently had made, he acknowledged it to be an exact likeness [*homoiotatos*]—the very man himself [*au-*

tochrēma]—and he demanded to have it as something indispensable to him. My father would not consent on the grounds that he did not have another one that was equally well made. Cosmas replied that a man who as as much of a connoisseur [*gnōmōn*] as my father would be able to obtain one that was just as good; by way of supplication he invoked the Saint himself as intercessor [*mesitēs*], and finally prevailed upon my father. The latter, in part willingly (because of the man's great faith) and in part against his will, agreed to the request, adding, "If you wish to attain your goal, stay here another three days during which I shall have this icon copied [by using it as an *archetypos*] and then give it to you without regret." The old man consented to await the appointed time; as for my father, he arose at the hour of matins and went to see the painter of the icon [*eikonos ergatēs*], named Pantoleon, to whom he explained the matter and pressed the work upon him, for Pantoleon was a friend of ours and would do anything for us. "If you wish to do me a favor," said my father (Pantoleon happened at the time to be engaged on an imperial commission), "make me with all speed an icon just like [*empherēs*] this one." . . . Pantoleon complained of the untimely vexation, saying, "What need was there to remind me once again when I have already been reminded?" Whereupon he showed his paints which were in readiness along with all the other materials necessary for the work. "For late yesterday evening," he added, "I was notified of this through your servant so-and-so, and requested to present myself in the morning [equipped] with these materials." . . . [But the servant had not left his cell, and up to now had not wanted to] watch the painter paint. So, we all concluded that this had been a clear manifestation on the part of the Saint.

18. The Icon of the Victorious Virgin in the Imperial Victory Procession
Niketas Choniatēs, *Annals* (12th century)

Niketas Choniates recorded two occasions on which the Byzantine emperor openly credited the Virgin for military victory. Page numbers in the following selections refer to *O City of Byzantium: Annals of Niketas Choniatēs,* trans. H. J. Magoulias (Detroit: Wayne State University Press, 1984).

John [II] proclaimed a triumph in celebration of the enemy's defeat [1133] and gave instructions that a silverplated chariot be constructed; and the chariot, adorned with semi-precious jewels, was a wonder to behold. When the day designated for the procession had arrived, all manner of gold-embroidered purple cloths decorated the streets. Nor were there missing the framed images [*eikasmata*] of Christ and the saints, fashioned by the weaver's hand, and which one would have said were not woven figures but living beings. Worthy too of admiration were the wooden platforms and scaffoldings set up along both sides of the parade route to hold the spectators. The part of the city that was thus bedecked was that which extended from the eastern gates to the Great Palace. The splendid quadriga was pulled by four horses, whiter than snow, with magnificent manes. The emperor did not himself mount the chariot but instead mounted upon it the icon of the Mother of God, in whom he exulted and entrusted his soul. To her as the unconquerable fellow general [*amachō systratēgetidi*] he attributed his victories, and ordering his chief ministers to take hold of the reins and his closest relations to attend to the chariot, he led the way on foot with the cross held in his hand. In the Church of the Wisdom of God [Hagia Sophia], he ascribed his accomplishments to the Lord God and gave thanks before all the people before he entered the palace (12).

The emperor [Manuel I], informed of this most glorious victory [in 1167, over the Hungarians], offered thanks to God. . . . A few days later, he prepared a triumph and entered the megalopolis through the Eastern Gate, which opens out in the direction of the acropolis. To celebrate a magnificent triumph on the occasion of this stupendous and genuine victory, he

issued instructions that the most lavish preparations be made for the procession [*pompeia*]. Every purple-bordered and gold-speckled cloth was hung. . . . Nor was the triumph lacking in troops of captives, and many of these entertained the spectators and magnified the solemn procession as they marched along. . . . When the time came for the emperor to join the triumphal procession, he was preceded by a gilded silver chariot drawn by four horses as white as snowflakes, and ensconced on it was the icon of the Mother of God [*eikon Theomētoros*], the invincible ally [*aprosmachou symmachou*] and unconquerable fellow general of the emperor [*akatagonistou systratēgou tō basilei*]. The axle did not creak loudly, for it did not carry the dreadful goddess, the pseudo-Virgin [*thean deinēn pseudoparthenon*] Athena, but the true Virgin, who, beyond understanding, bore the Word through the word. . . . [Following his relatives and top state officials came] the most glorious and most great emperor mounted on a stately horse and arrayed in the imperial regalia. Close behind came Kontostephanos, the man responsible for the triumph, receiving praise for his victory and congratulations for his generalship. [The emperor] entered the Great Church [Hagia Sophia] and offered up praise to the Lord before all the people (89–90).

19. The Emperors as Living Icons
Anna Comnena, *Alexiad* (12th century)

Anna here describes the physical appearance of her parents, Emperor Alexius (1081–1118) and Empress Irene. The translation is by E. R. A. Sewter (Penguin Books, 1969), 109–11. On Anna, cf. K. Varzos, *Genealogia tōn Komnenōn* (Salonika, 1984), 1:176ff. no. 32, and G. Buckler, *Anna Comnena: A Study* (Oxford, 1929).

The physical appearance [*morphai*] of the two rulers, Alexius and Irene, was remarkable, indeed quite incomparable [*amimētoi*]. A painter could never reproduce the beauty of such an archetype [*pros archetypian tou kallous*], nor a sculptor mould his lifeless stone into such harmony [*rhythmiseien*]. Even the celebrated canon of Polyclitus would have seemed utterly inadequate [*eis atechnian*], if one looked first at these living statues [*physeōs agalmata*] (the newly crowned rulers, I mean) and then at Polyclitus' masterpieces. Alexius was not a very tall man, but broad-shouldered and yet well proportioned [*symmetros*]. When standing he did not seem particularly striking to onlookers, but when one saw the grim flash of his eyes [*gorgōpon selas;* cf. Aeschylus] as he sat on the imperial throne, he reminded one of a fiery whirlwind, so overwhelming was the radiance that emanated from his countenance and his whole presence. His dark eyebrows were curved, and beneath them the gaze of his eyes was both terrible and kind. A quick glance, the brightness of his face, the noble cheeks suffused with red combined to inspire in the beholder both dread and confidence. [With such a heroic appearance,] the man's person indeed radiated beauty and grace and dignity and an unapproachable majesty. When he came into a gathering and began to speak, at once you were conscious of the fiery eloquence [*rhētorikē*] of his tongue. . . . [His] tongue and hand alike were unsurpassed and invincible, the one in hurling the spear, the other in devising fresh enchantments.

The Empress Irene, my mother, was at that time only a young girl, not yet fifteen years old. . . . She stood upright like some young sapling [*ernos*], erect and evergreen, all her limbs and the other parts of her body absolutely symmetrical and in harmony one with another. With her lovely appearance and charming voice she never ceased to fascinate all who saw and heard her. Her face shone with the soft light of the moon; it was not the completely round face of an Assyrian woman, nor long, like the face of a Scyth, but just slightly oval in shape. There were rose blossoms on her cheeks, visible a long way off. Her light-blue [*charopon*] eyes were both

gay and stern: their charm and beauty attracted, but the fear they caused so dazzled the by-stander that he could neither look nor turn away. Whether there really was an Athena in olden times, the Athena celebrated by poets and writers, I do not know, but I often hear the myth repeated and satirized. However, if someone in those times had said of this empress that she was Athena made manifest to the human race, . . . his description would not have been so very inappropriate. . . . For the most part her lips were closed and when thus silent she resembled a veritable statue of Beauty [*empnoun agalma kallonēs*], a breathing monument of Harmony. Generally she accompanied her words with graceful gestures, her hands bare to the wrists, and you would say it (her hand) was ivory turned by some craftsman into the form of fingers and hand. The pupils of her eyes, with the brilliant blue of deep waves, recalled a calm, still sea, while the white surrounding them shone by contrast, so that the whole eye acquired a peculiar lustre and a charm which was inexpressible. So much for the physical characteristics of Irene and Alexius.

20. The Topography of the Icons in an Imperial Monastery
Emperor John II Comnenus, rule for the monastery of the Pantocrator at Constantinople (1136–37)

> P. Gautier, "Le typikono du Christ Sauveur Pantocrator," *Revue des études byzantines* 32 (1974): 1ff. On the monastery, with its three churches—Pantocrator, St. Michael, and Ele-ousa, Mother of God—cf. Janin 1953, 529ff.; Cormack 1985, 200ff.; and A. S. Megaw, in *Dumbarton Oaks Papers* 17 (1963): 335ff. Page numbers below refer to Gautier's edition.

[The main church of the Pantocrator and its illumination:] We [the emperors] wish the Mass [*akolouthia*] in this venerable monastery to be conducted in the holy hymns according to the church rule that we have formulated (31). [After the assembly for prayer the priest who cele-brates the liturgy on these days enters the church for the ceremony of incensing, which begins before the sanctuary at the chancel screen.] Then he stands still before the icon of the Pantocra-tor, makes the sign of the cross with the censer before it, and then does the same at all the holy places [*hierous topous*] inside the church and the most venerable icons [*panseptous eikonas*] in them, and the monks who are standing there (33).

The illumination [*phōtagogia*] shall be as follows. Perpetual lamps [*kandēlai akoimētoi*] must burn: two in the sanctuary [*bēma*], one in the triple lamp in the sanctuary, two before the Pantocrator, one each before the Anastasis [the Easter image with Jesus's Descent into Hell] and the Crucifixion, one on the triple lamp of the main cupola, one before the right apse of the sanctuary, where the Last Supper is depicted, and one before the left apse, where the Washing of Feet is shown, and another before the Beautiful Doors [the inner main portal], where there is an image of the Dormition of the Virgin. . . . During the morning service, the main liturgy and vespers, all the lamp-bowls [*krateres*] around the large chandelier [*choros*] shall be lit, sixteen in number, and all the lamps of the *templon* [the entablature or icon-frieze above the chancel screen]. . . . During the Divine Office three [candles] shall burn on the *templon*, one on the small *templon* [of the side apse], . . . two more before the Pantocrator, and one each before the two titular [or day] icons [*proskynēseis*] (37–38). [On high feast days chandeliers (*poly-kandela*) should be used, and on the feast of the Transfiguration (*Metamorphōsis*), a candle of a pound of wax should be placed] on the candelabra with twelve candle holders before the icon of the Redeemer, which is set up [for veneration, *prokeimenes* (39)]. [For feast days of the church fathers the usual illumination applies.] But a candelabra with twelve candle holders should be placed before the holy icon that is then celebrated [*heortazomenes*] (40).

[The church of the Virgin:] The donor also supplies the rule for the service at the church of the Eleousa, Mother of Mercy, which he built, and for the church of the archangel Michael, a chapel of the type of a mausoleum [*hērōon*], which is at the center and is intended to receive the tombs of the imperial family (73).] [Candles are to be provided as perpetual lights] before the two *proskynēseis* and on the *signom* [the cult site or image stand] with the holy icon of the *Eleousa*. [Their number increases during the service and also includes] a candle before the icon of the *Eleousa* in the mosaic in the vestibule.

On Friday evening every week we have ordained a procession of supplication [here abbreviated as procession icon, or *signon*] during the vespers of the Virgin of the *Presbeia*, at which the other holy icons [apart from that of the *Eleuosa*] shall take part. It shall also pass by our graves and pause there for a great supplication [*ektene*]. For the lighting on this evening we ordain the following: At the meeting [*hypantē*] of the holy procession icons [*signa*], four lamps shall burn in the porticoes [*embolous*] beside the public portico and shall be used during the entry and exit of the holy icons. . . . On the outside of the church, at the main entrance, six lamps, and at the entrance to the vestibule [*narthex*], one lamp and one candle. At the image of Christ before the portal of the vestibule a standing lamp . . . at the [image of] the Forerunner [John] above the portal of the vestibule likewise, and a candle on the mosaic of the Mother of God that is opposite. . . . Inside the church four large candles, and a further seven candles, that is, one before each image [*eikona*] placed over the various doors inside the church. . . . In the mausoleum two candles before the icon of Christ situated at the entrance to our tombs. . . . Before the two arches [*apsides*] of the mausoleum, that is, before the Crucifixion and the Anastasis, one candle, one before the other arch at the Holy Sepulcher, and one before the meeting of Christ with the two Marys (75).

[The visit of the *Hodegetria* icon: In the mausoleum, the chapel of St. Michael, the lighting is first prescribed. It applies to the usual places, including] the *proskynēsis* or titular icon of the incorporeal [archangel] opposite the Redeemer (81). On the anniversaries of the deaths of the family members buried here, the divine icon of my most holy mistress and Mother of God, the *Hodegetria,* shall be brought into the monastery. . . . At the reception of this holy icon a great supplication shall be enacted [the *ektenēs deēsis*] for us . . . and the holy icons shall be left standing near our graves. Then the monks and clerics shall spend a night watch in prayer. The next morning the divine liturgy shall be performed in the presence of the holy icon, followed by a great supplication for us with the assembled people. Before the icon returns home, at every visit [*eleusis*] of the Mother of God, 50 coins in the form of hyperpyres shall be distributed as follows: 6 coins in the name of the holy icon, 24 coins for the 12 *koudai* [corners of the procession], 2 coins for the bearers [of the icon] and the other servants of the holy icon [the confraternity], and the rest, in coins of St. George, to the [bearers of the] procession icons [*signa*] (83).

21. A Monastic Rule without Instructions on Icons
Timotheos, rule for the monastery of Evergetis in Constantinople (1054)

P. Gautier, "Le typikon de la Théotokos Évergétis," *Revue des études byzantines* 40 (1982): 5ff. (to which the simple page numbers below refer), and Dmitrievskii 1895, 1:256ff. (to which the page numbers prefixed by D refer).

O Lord and Master of the Universe, and most famous Mother of the Lord . . . may this [rule] stay in force until the end of the world for us and ours at the entreaty of your servant and our father and founder (19).

Now we must speak about the divine mystagogy [the main liturgy], which is to be celebrated without fail each day in the church and, brothers, deserves all your attention, because divine events . . . take place in it, and more than anywhere else the terrifying and incomprehensible mystery of our orthodox faith, the divine . . . sacrifice of the body and blood of our Lord (23).

[The morning service begins with the priest responsible on that day] blessing the *typos* of the venerable cross before the altar with the censer. . . . He then walks all round the church spreading incense smoke on all. Then he stands before the holy chancel screen [*kinklidēs*] and again holds the censer before the *typos* of the venerable cross while singing the praise of the holy, consubstantial, and life-giving Trinity (27).

The divine feasts of the Lord [*despotikai heortai*] and those of our most holy mistress, our benefactress and Mother of God, shall be celebrated by you in a quite different way than the others, both in their psalmody and in the illumination of the church, and even in the food eaten. The feast of the [Virgin's] decease [*Metastasis*], which we also call her Dormition [*Koimēsis*], shall be celebrated in splendor [on 15 August], for it is the feast of feasts and the ceremony [*pannegyris*] of all ceremonies (45).

The liturgical implements and divine icons and books may not be disposed of—not to speak of the immovable inventory. Not only may they not be sold, they must never be removed by anyone, for no matter what reason, because we have acquired them with such toil and cost and because they have been dedicated as votive offerings [*anathemata*] to our Lady . . . the most holy Mother of God and benefactress [the patron of the monastery]; and he who violates this commandment shall be arraigned for sacrilege [*hierosylia*] (63).

[On the feast of the Annunciation everyone assembles in the church at the fifth hour. After the singing of the Troparion] the procession starts with the cross, the Gospel book, and the censer, and with a lamp, and we walk in procession around the whole monastery; when we arrive at the vestibule of the church, we say [to the Virgin]: "Hail, thou gate [*pylē*] of the Lord," . . . and then we go in (D431).

[On the feast of the consecration of the church on 28 December the liturgy begins at the fourth hour in the chapel of the Holy Apostles, while the main church is blessed with incense. After the glorification] we take the cross and the Gospel book with the candles for the entry . . . singing as we pass round the church. When the procession [*litē*] has arrived at the outer vestibule [*exo-narthex*] . . . we all stand before the royal doors [*basilikai pylai*] and sing, after finishing the song to the Virgin [*Theotokion*], the hymn "Open Your Gates. . . ." Others stand within, singing: "Who is this, the King of Glory" [*Basileus tēs Doxēs*] . . . and the priests make their entry (D366–67).

22. The Cult of Icons in the Monastery of an Imperial Prince
Isaac Comnenus, rule for the monastery of Kosmosoteira in Pherrai/Bera (northern Greece) (1152)

Isaac, son of Emperor Alexius I Comnenus, first planned his tomb at the Chora monastery in Constantinople, where his image still exists in a fourteenth-century replica (cf. Underwood 1967, 1:10ff. and 45ff., and Belting 1970, 78 and 81). Later, however, he moved it to the new monastery of the Redeeming Virgin (*Kosmosoteira*), in Bera (cf. N. P. Ševčenko, "The Tomb of Isaak Komnenus at Pherrai," *Greek Orthodox Theological Review* 29.2 [1980]: 135ff.). On the church and its frescoes, cf. Stefan Sinos, *Die Klosterkirche des Kosmosoteira in Bera (Vira)* (Munich, 1985).

Page numbers below refer to the edition by L. Petit, "Le typikon du monastère de la

Kosmosotira près d'Aenos," *Izvestia Russk. Arkheol. Instituta* (Constantinople) 13 (1908): 17ff. I have been able to refer also to an English edition (under preparation by Nancy Patterson Ševčenko), part of a collected edition of all typica, under preparation by Dumbarton Oaks.

[No. 1:] The typicon [or rule] was composed by me . . . for the new monastery that was consecrated in 1152 and in which the mosaic icon of my Redemptress [*kosmosōteiras eikonisma*] . . . and great benefactress [*euergetis*] takes her seat [*kathidrytai*] (17).

[No. 3:] First, to sing the praise of the Virgin . . . I wish fifty psalm-singing monks [*hymnodous*] to form the convent and to pray for my poor soul. In addition twenty-four further monks shall take care of the needs of daily life. None shall be younger than thirty, and none shall be a eunuch (21).

[No. 7:] After the end of vespers they shall all assemble before the icon of the Mother of God and beseech her each evening to have mercy [*eleos*] on my poor soul, by singing the Trisagion . . . and saying the Kyrie Eleison forty times from their hearts. Then they shall address the following invocation to her: "Oh Mother of God and our Lady, save from his impending damnation your servant who approaches you, the monastery's founder Isaac, by interceding [*mesiteia*] with your Son, whom you shelter in your immaculate arms" (22–23).

[The *proskynēseis* icons; no. 8 begins the liturgical regulations. As the rule of the monastery of the Theotokos Euergetis proved useful in reforming monastic life, it shall be used here as a model (23).

[No. 9:] On each feast of the Mother of God throughout the year . . . the monks should enter the church in a dignified manner and enact the whole hymnody [the liturgical songs] pertaining to the feast in a very ceremonial way. Four large lamps shall burn at the center of the church, and two eight-light candelabras shall stand before the two *proskynēseis* [the titular icons on the chancel pillars] on each side of the church [actually the chancel], where Christ the Supremely Good [*Hyperagathos*] and the Mother of God and World Redemptress [*Kosmosoteira*] are depicted with great art. The icons [*eikonismata*] appear to our eyes as living beings [*empnoa*] and seem to speak graciously with their mouths to all who look on them. It is truly a miracle to see these figures as a kind of living painting, which is yet fixed in place and space. One can only praise the artist [*technourgos*] who received from the first creator of the world [*demiurg*] the wisdom of painting it in new splendor. Who would not praise him, since the figures [*typoi*] seem as if living to the eye and imprint themselves on the heart? (23–24).

[No. 12:] Two perpetual lights shall burn throughout the year before the Supremely Good Christ and the Mother of God . . . the *Proskyneseis* (26).

[No. 35:] We must now come to the appointment of the other officials [in the monastery]. . . . Their keys are deposited with [the icons] of Christ and the Mother of God. The steward shall take the keys in his hands after the three prescribed genuflections . . . and receive the blessing of the abbot. For those offices which do not require keys, the kissing of the holy icons and the blessing of the abbot suffice. [In another place the rule refers to three low genuflections made before the holy chancel screen (*kinklidēs*), of the divine bema, before the venerable icons (*eikonismata*) of our Savior and his most pure Mother are kissed (39).]

[Nos. 10 and 50, the first feast of the Virgin in the year:] I should like the holy vespers on the eve of the divine *koimēsis* [Dormition] and the whole following day to be celebrated more splendidly than all [the Virgin's] other feasts, with full illumination and a larger number of priests and deacons at the altar [*adyton*]. For this is the feast of feasts and the celebration [*panēgyris*] of all celebrations (24). [The feeding of 110 poor people is to be more generous than usual and so correct that God can look on it from heaven. The poor are to sit on the floor in a row or a circle, so that their feeding provides a dignified ceremony, and then, while standing up, they are to pray the Kyrie Eleison forty times for the benefit of the founder (25).]

[No. 50:] Let me come back once more to the above-mentioned feast of the divine *koimēsis* of the Mother of God . . . my benefactress . . . and ordain the following for the morning service of the feast. A sufficient number of priests and deacons shall put on liturgical robes, the abbot shall carry the Gospel book, another the icon of the Mother of God [the portable mosaic image, cf. No. 1, as distinct from the fixed pillar-icons of the *proskynēseis*], and another the great cross situated at the sanctuary. When the appropriate prayer of supplication has been said, the priests leave the church with all the necessary lights and walk in procession out of the gate of the monastery walls, to the monks' cemetery and to the other entrance in the west. The procession shall pass around the entire monastery walls to consecrate [*eis hagiasmon*] and preserve the monastery and its land. When they reenter the church, they should return the sacred objects [*hiera*] they have taken with them to the holy places [*hagiois topois*] where they belong. The *Koimesis* [icon] of the Mother of God executed in mosaic above the entrance to the church is to be illuminted on this feast in an . . . appropriate way. Before this icon [*eikonisma*] of the divine *Koimesis* an everlasting lamp with oil from the mastic tree shall burn throughout this time, for the grace of divine inspiration [*epipnoias*] lies, I believe, on this icon (50).

[No. 67. A stone icon of the Mother of God is mentioned as a cult object on the stone bridge leading to the monastery. Passersby are to honor it and pray for the poor soul of the founder.]

[Nos. 89–90, the tomb of the founder and the icon of the patron of the monastery:] It was once my intention that my mortal remains should be buried in the monastery of Chora [in Constantinople], and I have already laid out the tomb . . . but now I wish to be laid to rest in the new monastery. . . . The marble slabs for my tomb shall be brought here from my tomb in the monastery of Chora and used for the tomb that is planned on the left side of the vestibule through an enlargement of the building. . . . In the middle of the lid of the tomb I want my encolpion of the Theotokos to be fastened in a prone position in [a setting] of silver work. . . . Apart from the marble slabs, my previous tomb in Chora includes the following: a lattice of cast bronze, the portraits [*stelen*] of my venerable parents, . . . and the stand [*stasideion*] for my [icon of the] Mother of God in mosaic. My own portrait [*stēlē*], which I had made in the unripe vanity of my youth, shall [unlike the others] not be removed from the Chora, so that my wretched body . . . after its dissolution, shall not be given the honor of an image [*eikonismatos*] (63). Instead of other adornments of fanciful splendor, I should like to have on my tomb the icon of the Mother of God from Rhaidestos [a nearby town on the River Hebros], which was sent to me from heaven. This is the *Kosmosoteira* [the monastery's patron, entitled the World's Redemptress], and I have adorned it with as much gold and silver as I could. It should be set up at one end of my planned tomb, so that it may stay unchangeably in that place for all time to intercede for my poor soul. Furthermore, one should also place there the equal-sized [icon] of Christ, in the beautiful position and illumination that befits these icons. And if the abbot and the other monks act against my instructions, let them be judged with me on the Day of Judgment (64).

23. Rule and Inventory of the Convent of an Empress
A. Empress Irene, rule for the convent of Kecharitomene in Constantinople (before 1118)

The convent bordered on the monastery of Christus Philanthropos. It used a system of communal living and accommodated twenty-four, or at most forty, nuns with six lay sisters as servants. The steward was a eunuch, as were the two priests who lived in the convent. The spiritual father heard confession. The preface resembles a long treatise on the theological figure and the womanly ideal embodied by the Virgin. The Virgin's title (and the convent's)

comes from the greeting of the angel at the Annunciation, according to St. Luke. Page numbers below refer to P. Gautier, "Le typikon de la Théotokos Kécharitôméne," *Revue des études byzantines* 43 (1985): 5ff. and (text) 19ff.

O Mother of the living God, who after giving birth were again a holy treasure [*keimēlion*] of virginity . . . what a blessing the giver of all good bestowed on us when he made you the heavenly ladder and the bridge for the human race to attain to heaven (19). The pillar of faith and bulwark against unbelief. . . . Who could fittingly praise the greatness of your miraculous deeds or the signs you have given, all those deeds by which you have preserved the imperial rule, suppressed uprisings, and strengthened the most Christian people in their hope of future bliss? . . . You Mother of God throughout the entire world and beyond the heavens [*hyperkosmion hapantōn Theogennētria*] . . . You radiant empress [*basilissa*] standing at the right hand of the Pantocrator [clearly referring to the two main icons, or *proskynēseis,* on the chancel pillars, despite a formulation taken from Psalm 44] (21). Deign to be the invincible ally of the emperor against the barbarians, so that your inheritance and the great city [*megalopolis*] entrusted to you may be preserved forever as the source and root of piety (23). You who are "full of grace" in God's eyes [*kecharitomenē*], you who transcend all seeing and understanding and overcome the limits of nature, you who are the mediator [*mesitis*] between God and men, . . . keep forever your invincible rights over the flock of nuns [*adelphotes*] dedicated to you, and turn their female nature into the virtue [*aretē*] proper to the male sex (25). As a small sign of thanksgiving for the benefits bestowed on us by the Virgin Full of Grace, we have placed this convent under the authority and ownership of this same Virgin Full of Grace (31).

[Nos. 59–75:] Liturgy and illumination. On the highest feast day of the Virgin Full of Grace and our mistress, the feast of the Dormition [*koimēsis*], silver chandeliers with many lamps shall be hung in place of the usual crater lamps. . . . Candles with cotton wicks will also be placed on the candelabras of the *templon* [entablature of the chancel screen] and the *proskynēseis* [titular icons], each weighing six ounces. In addition, candles of one pound . . . shall be lit in the candelabras with twelve candle holders that stand before the holy icon of the Mother of God that is displayed for veneration [*pro tēs prokeimenēs eis proskynēsin hagias eikonos tēs Theotokou*]. . . . On the tombs . . . candles of four ounces shall be placed . . . and rose oil, essence of aloe wood, and incense shall be added [further instructions follow for the feasts of the Virgin's Birth, the Raising of the Cross, St. Demetrius, and the Presentation of the Virgin in the Temple] (109). Everlasting lamps shall burn day and night [on other days as well]: one in the bema and one before the Virgin Full of Grace. Candelabras with twelve candle holders shall stand permanently in front of the *proskynēseis;* on them one candle shall be lighted every day during the psalmody [the liturgical singing at the seven prayer times during the day] (113). As regards the processions [*litai*] that the nuns must perform according to church custom, they shall not be long, leading from the church through the vestibule up to the [icon of the] *Koimesis* . . . that is situated outside the communal dormitory, and during the procession the priests of the convent shall carry the holy Gospel book and the venerable cross (131).

B. Inventory of relics, icons, books, and liturgical implements

[Besides the cross relics or reliquaries in the form of triptychs, the following were mentioned:]

> [diastylic icons for the spaces in the openings of the chancel screen, in metal and with the four Evangelists;]
> an [icon of the] Mother of God that, like Christ [who was probably depicted above it], is seated on the throne; [surrounding it are depictions of the feasts of] the birth and death of the Virgin, the Annunciation, the Presentation in the Temple, the Nativity;

the Baptism of Christ . . . ;

a large painted icon of the most holy Mother of God with the Child [at the entrance?] of
the bema;

an equally large icon of John the Theologian and a similar icon of Basil;

an icon of the prophet Daniel with side-wings [doors], and other saints . . . ;

an icon . . . of St. Eupraxia, of Christ *Antiphonetes* [cf. text 9], and of the most holy
Mother of God;

[further icons of a martyr, of the forty martyrs, of the Mother of God, of Chrysostom, etc.;]
and old icon [*palaia*] and a similar [old] icon (152–53).

[The icons with costly mountings are listed below:]

an icon of the Mother of God with her Child, with silver gilt mounting with various figures
and paste [*hyelion*];

another icon painted on wood in the new style [*kainourgos eikōn hylographia*] with Christ
Enthroned and below him [at the center] the Mother of God, also enthroned, and Peter
and Paul on each side;

the two saints Theodore with gilt silver mounting [*peripherion*];

a small silver icon of the Crucifixion and another of the Nativity (153).

[Also described is the chancel screen, which was richly adorned with silver and had depictions
of saints and six-winged seraphim. It also had the figures of the Anunciation, *Chairetismos*,
also of silver, on its "holy doors" (*hagiai thyrai*). The doorposts (*harmosphinia*) bore images
of Christ and the Virgin (154).]

24. The Ostentation of a General's Monastery

Gregory Pakourianos, rule for the monastery of Petritsa, or Bačkovo (1083).

The founder, who held the high imperial office of Grand Domestikos for the west of the
empire, received the parish of Petritsa (Basilikis) from the emperor. The monastery lay in the
province (*thema*) of Philippoupolis in present-day Bulgaria and based its rule on the model
of the Ta Panagiou monastery in Constantinople. The monastery includes three churches.
The patrons of the monastery, apart from the Virgin, are John the Baptist and St. George the
martyr. Tombs for the founder and his brother are planned in the monastery. Not counting
the head, the community is to be formed of fifty monks of Georgian descent. Six priests and
two deacons are to celebrate the liturgy three times a week apart from Sundays and
feast days.

Page numbers below refer to P. Gautier, "Le typikon du Sébaste Grégoire Pakourianos,"
Revue des études byzantines 42 (1984): 5ff. and (text) 19ff. On the person of the founder,
cf. P. Lemerle, *Cinq études sur le XIᵉ siècle byzantin* (Paris, 1977), 158ff.

The preface describes the origins and biography of Gregory the founder, and his inten-
tion to make the monastery his last resting place, exchanging the beauty of the church for
his reward in the afterlife. The liturgy and the other regulations were to follow the model of
the Ta Panagiou monastery (21).

[During a crisis in his life and career, the founder decided] to turn to my sure hope [*vevaia
elpis*] and the hope of all sinners . . . the celebrated Mother of Christ our God, and to the
famous Forerunner [*Prodromos*] . . . John, and the glorious martyr and athlete of Christ,
George. I took these as my guides and advocates with Christ our Lord on the dreadful Day of

Judgment, with all the other saints and friends of Christ. I therefore built the . . . precincts of the church . . . to the praise and fame of these three [saints] . . . as beautifully and sumptuously as was within my power and as the times allowed (33).

Liturgy and illumination. We have decided to celebrate the feast of the most holy Mother of God, her holy and solemn Dormition (*koimēsis*), in our church on 15 August in this manner. We wish this universal feast of the Mother of God to be celebrated in fear and splendor . . . as in the most famous and largest churches (71). [General information is given on the illumination of various churches, no. 12.] Day and night three everlasting lamps shall burn before the icon of the most holy Mother of God: one in the large bema, one lamp before the holy bema by the chancel screen [*kankelois*] in front of the Crucifixion, and one before the holy icon of the Forerunner and Baptist and before the icon of St. George. . . . Furthermore, twelve lamps shall be lighted each day at the time of the Hymnodia before the [icons of the] twelve feasts of the Lord [*Despotkōn dōdeka heortōn*]. [They are probably on the chancel screen; see under Inventory] (73).

The commemoration of the founder. [Apart from the offerings on behalf of the founder, which are to be made daily both in the liturgy and in the form of a distribution of alms, the following is ordained.] On the feast of the anniversary of our holy church, all the priests must celebrate the liturgy for us; for me, for my brother, and for our deceased parents, as they shall also do on the day of the famous Anastasis of Christ our Lord, which we usually call Easter, on the day of the Lord's Ascension, and on the holy feast of Whitsun. . . . The same applies to the Annunciation, the Nativity and the Baptism of Christ, . . . and to all the other feasts of the Lord [*Despotikais heortais*] (101). The commemoration of the deceased [monks] is the responsibility of a priest, who is to perform this duty constantly in the chapel [*euktērion*] of the holy Baptist (109).

[*The inventory*] of the holy implements and holy icons and all the other sacred offerings . . . which have been donated and bequeathed to our monastery (119). [Apart from very costly crosses and cross relics, large and small icons of gold, enamel, and carved stones are mentioned, in the same style as in Georgia, e.g., in the style of the Virgin's triptych of Kachuli; cf. chap. 10 n. 18. Deserving special mention are:]

> a large icon of the Transfiguration in enamel [*cheimeutē hē Metamorphōsis*];
> a small icon of the Mother of God, with wings [*thyrides*] in enamel . . . ;
> an icon of the Crucifixion, with wings in carved stone [*lithinos*];
> an icon of St. George, painted on wood [*hylographia*] with silver mounting;
> a total of twenty-seven icons painted on wood with metal leaf decoration [*petala*];
> a *templon* that has [icons of the] twelve feasts [*dōdeka heortai*] (119, 121).

[Also there are] twelve large candelabras [*manoualia*] in bronze and two small ones. A complete candelabra [*manoualion holoklēron*] is on the *templon* with its candle holders [*kēropēgia*], and two other small ones with handles [*meta tōn dia cheirōn kratēmatōn autōn*] (123).

25. Descriptions of Icons in Monastery Inventories and Wills

A. Michael Attaleiates, instructions for the monastery of Christ the All-Merciful in Constantinople (1077)

W. Nissen, *Die Diataxis des Michael Attaleiates von 1077* (Jena, 1894), esp. 78ff. and, P. Gautier, "La diataxis de Michel Attaliate," *Revue des études byzantines* 39 (1981): esp. 16ff. and 890–91.

1. A large painted icon of Christ the All-Merciful [*Panoiktirmon*] in standing pose or full length [*stasidia*]. . . .
2. A triptych silver icon of Christ shown in bust form [*laimen;* lit. head and shoulders] on a gilt support; on its wings [lit. doors] are shown the Mother of God and the Forerunner [John], the apostles Peter and Paul, saints Artemios and Loukilian, with the martyrs George, Akindynos, Nicholas, Methodios, Cosmas, and Damian on the outside.
3. A further gilt silver icon of Christ shown half-length with six figures and the Hetoimasia [the empty throne kept ready for Christ's return] around it.
4. A silver gilt icon of the most holy Mother of God with the Child on her left arm [*Aristerokratousa*] with nine figures around her and above—as indicated by the inscription—the church of the holy Mother of God. . . .
5. A painted icon of St. Catherine with gilt silver mounting, on which [are] six half-length figures and two full-length figures.
6. A painted icon of the venerable Forerunner without mounting.
7. Further painted icons with the deesis.
8. The *templon* and at the center [of the icon frieze] the deesis and [on each side] the story [biography, *diēgēsis*] of the venerable and holy Forerunner.
9. A painted icon of the holy Panteleimon with gilt silver mounting and twenty-five paste jewels [*hyelion*], the mounting having sixteen figures around it. . . .
10. The capitals [*kephalokionia*] of the holy doors [of the altar space, or the chancel screen] with the images of Christ and the Mother of God, weighing one pound [silver].

B. The will of Eustathius Boilas (1059)

S. Vryonis, "The Will of a Provincial Magnate, Eustathius Boilas," *Dumbarton Oaks Papers* 11 (1957): 264ff. (the quotation below is from p. 268); P. Lemerle, *Cinq études sur le XI^e siècle byzantin* (Paris, 1977), 15ff. and esp. 24–25.

[In his will, Eustathius leaves many liturgical implements to the church that he has built long before. These include a gilded cross with enamel images and a processional cross, as well as the following:]

Eight gilt icons; that is, one of the Crucifixion on a diptych [*dithyron*], St. George *scoutarēn* [in the shape of a shield], one of St. Theodore with St. George, a small one of the Theotocos, one of St. Basil, two large ones of the Theotocos [icons of the Virgin with liturgical extensions and hymns], and one of the Crucifixion *scoutarēn;* altogether eight.
Twelve other icons of copper.
Thirty assorted icons painted on wood in gold, with the Lord's [twelve] feast days [*despotikai heortai*] and those of the various saints.

C. Inventory of the monastery of Eleousa in Veljusa (1085)

The monastery of Eleousa Mother of God, in Veljusa near Strumica, was founded in 1085 by a certain Manuel, later bishop of Strumica (in present-day Bulgaria). In the early twelfth century it received generous imperial gifts. The surviving inventory was made in its present form in ca. 1449 under Abbot Meletios and thus contains more recent donations. What is important is the distinction between decorated icons—those with costly mountings and frames—and undecorated [*akosmētoi*] icons. The existence of an icon of three saints from Chalcedon shows that the founder brought the cult of these saints from his native Bithynia to the monastery. A strikingly large number of icons bore his image as founder. On the *templon* entablature there was a second row of icons with half-length figures. The text is

based on L. Petit, "Le monastère de Notre Dame de Pitié," *Izvestija Russk. Archeol. Instituta* (Constantinople) 6 (1900): 1ff. and esp. 118ff.

1. A copper [*sarout*] icon of the Mother of God with Child, seated, with a narrow gilt silver frame.
2. A silver icon [*monopetalos*] with full-length relief figures [*stasidia*] of the three holy generals [George, Theodore, Demetrios] with various saints in bust form on the frame.
3. A painted icon of the Mother of God with a narrow nimbus [*phengos*] and a narrow frame of gilt silver without figures.
4. Another icon of the Mother of God seated, made of steatite [*amiantos*] with a narrow frame of silver without figures.
5. A large icon of the most holy Mother of God with Child in a standing pose, the Child nestling against her breast [*enkardion*] and babbling sweetly [*eulalaton*] with her, the two nimbi [of Mother and Child] being of enamel and gilt silver.
6. A large wood painted icon of the Mother of God with Child, shown half-length as a procession icon [*laimion signon*], the two nimbi being of silver without gilding.
7. An icon of the Mother of God standing with Child, one cubit high [*pēchyaion*: probably taller, a standardized unit of length], the two nimbi being of silver. These are the holy icons. . . .
8. The undecorated [*akosmētoi*] icons are the following: An undecorated icon of the most holy Mother of God in supplicant pose [*presbeia*], one cubit high, standing close to the *Eleousa* Mother of God [the titular icon], the *proskynēsis* or cult image [*proskynēma*].
9. Another icon, one cubit high, with the feast of the Entrance of the Virgin into the Holy of Holies [*heortē ta hagia tōn hagiōn*].
10. An icon, the same size, of the Dormition of the Virgin [*koimēsis*].
11. An icon, the same size, of the *Theotokos*, seated, which also shows the founder.
12. An icon, the same size, of the three martyrs Manouel, Sabel, and Ismael.
13. An icon of St. Nicholas, in standing pose, also with the founder.
14. A large icon, four spans long [*tetra spithamon*], with Christ, Peter, and Paul shown full-length with various busts around them.
15. Above the *templon* are bust icons, Christ and John the Baptist, both one cubit high, St. Peter three spans high, and a standing John Chrysostom, one cubit high.
16. An icon of St. Auxentios with Stephen the Younger [*Neos*].
17. A triptych icon with the Crucifixion at the center and the Koimesis, the Anastasis, the Ascension, and the Nativity at the sides.
18. An icon of the Deesis on a panel [*sanidi*].
19. An icon of the forty martyrs, with wings.
20. A large icon of the Second Parousia, or Second Coming, with wings.
21. A bust icon of the holy Anargyroi, on a panel.
22. A St. Demetrius icon, about a cubit high [*pseudo pēchyaion*].
23. A [St. John] Chrysostom icon.
24. Two new icons of Christ and the Mother of God, one span long.
25. A small icon of St. Menas in gilt bronze.
26. Three icons of Ss. Eleutherios, Chrysostom, and Blasios, one cubit high, on a board.
27. A copper icon of the Redeemer in shield form [*skoutarion*].

D. Inventory of the monastery of Xylourgos (1143)

 The following inventory (*apographē*) from the monastery of the Mother of God of Xylourgos appears in a notarial record of 1143 that was contained in a document of the Pantelei-

mon monastery on Mount Athos. The costliness and the very large number of icons are remarkable for this relatively unimportant monastery. How great must have been the losses in the large centers! The inventory mentions several groups of icons allocated to various churches, including no less than ninety painted icons in one place. An icon of the deesis of the Virgin was no doubt linked by her praying posture to the corresponding icon of Christ, which is also mentioned.

The text is based on *Akty Ruskogo na sv. Afone monastyria sv. Pantelejmona*, Acta praesertin graeca Rossiki in Monte Athoni monasterii (Kiev, 1873), 50ff., no. 6.

In the altar space [*bēma*] there are ten icons. In addition there is an icon of St. Symeon on the column, with figures of St. Martha and St. Konon (50).

Now to turn to the holy icons [in detail]:

An icon of the most holy Mother of God with the name Deesis [i.e., in a sideways praying posture] and above it a history [*historia*] of the Lord; it also had an inscription and a gilt silver nimbus [*phengos*] with cuffs [*epimanika*] of the same material.

Christ [as icon] in the same style, with costly nimbus and cuffs; all round the gilt silver frame are various painted figures. . . .

The [three-figured icon of the] Deesis [Christ with the Virgin and John], with nimbi and cuffs of gilded silver.

An icon of a large standing figure [*stasidion*] of our Lord, with *chrysopetalon* [gold leaf?] and a silver cross on his head and sleeves of the same material and fifteen stones.

The *templon* of the holy church with the Lord's feasts [*despotikai heortai*] in one piece [as a frieze], with *chrysopetalon*.

Further, ninety large and small icons painted on wood [*hylographiai*] (54).

[A number of icons of particularly costly execution may have been among those already mentioned.] They include:

A Christ with gilded silver casing, a nimbus of enamel with a border of pearls.

Similarly executed is an icon of the most holy Mother of God, a Deesis.

Another icon of the Mother of God with the Child on her left arm [*Aristerokratousa*], with silver mounting [*peripherion*]. . . .

Another icon [of the three-figured Deesis], with Christ, the Mother of God, and the Forerunner [John]. . . .

The twelve feasts [feast icons] with the twelve months [ιβ *heortes tous* ιβ *mēnas*; i.e., calendar icons] (60).

E. Inventory of a church in the palace of Botaneiates (1202)

A document describes the appearance and movable inventory of a Constantinopolitan church that was ceded to the Genoese in 1202. Cf. F. Miklosich and J. Müller, *Acta et diplomata graeca medii aevi* (Vienna, 1865), 3:49ff., esp. 55; Epstein 1981, 7; and, the source of the translation below, Mango 1972, 239–40.

The holy church is domed, has a single conch and four columns, one of them being of white Bithynian marble. . . . [Above] are images in gold and colored mosaic [*eikonismata dia mouseiou chrysou*]. . . . The partition of the *bēma* [the chancel screen] consists of four posts [*stēmonorōn*] of green [marble] with bronze collars, two perforated closure slabs [*stētha*], a marble entablature [*kosmetes*] and a gilded wooden *templon*.

F. Inventory of the monastery of Koteina near Philadelphia in Anatolia (1247)

S. Eustratiades, in *Hellenika* 3 (1930): 332; cf. Epstein 1981, 22.

[It contains:]

Large icons [*eikonismata*] of the *proskynēsis.*
Five further icons on the *templon.*
Also on the *templon,* the twelve small [feast-day] icons of the chief feasts of the Lord [*ei-konismata tōn basilikōn heortōn*].
Two icons adorned [*kekosmēmena*] [with precious metal], of Christ and of St. George.

26. The Relics of the Palace Chapel in Constantinople
A list by Nicholas Mesarites (ca. 1200)

Nicholas (d. ca. 1220) prepared the following list of relics to be found at the palace chapel in Constantinople. The text is based on F. Grabler, *Byzantinische Geschichtsschreiber* (1958), 9:287–88, which describes the palace revolt of John Comnenus.

1. The crown of thorns is displayed for veneration, still fresh and green and unwithered, since it had a share in immortality through its contact with the head of Christ the Lord, refuting the still-unbelieving Jews, who do not bow down to worship the cross of Christ. . . . If one could touch it, it would feel smooth and lovely.
2. The sacred nail, which to this day has formed not the slightest rust, because of the pure flesh of Christ, free of all baseness, which it pierced with three others in the hour of suffering. . . . Through the entrails of the arch-foe, the evildoer, this nail plunged to kill him who as a spirit is immortal by nature, in a foul manner. . . .
3. The linen shrouds of Christ. . . . They still have the scent of myrrh and have conquered decay because they . . . have embraced the anointed, untouchable, naked corpse.
4. . . . that "linen cloth" . . . which to this day has remained wondrously damp and wet from the moisture that it wiped from the "beautiful feet of those that preach the gospel of peace, and bring glad tidings of good things" [Rom. 10:15].
5. The lance that pierced the side of the Lord. It looks like a double-handed weapon and is shaped like a cross. He who . . . has sharp eyes will discover traces of blood on it. . . .
6. The purple cloak that iniquitous men placed on the Lord of Glory, to mock him as king of the Jews.
7. The cane placed in the right hand of the Savior to smash the head of the arch-foe, Satan, who had taken on the form of a snake. . . .
8. The soles beneath the feet of the Lord—also called sandals. Their length and width is less than the span of a large man's hand, and they are harmoniously formed. . . .
9. This number nine is completed by a stone hewn from the tombstone [of Christ]. It is a second stone of Jacob (cf. Gen. 28:18), a witness to Christ's resurrection from the dead, a cornerstone of the cornerstone of Christ. . . .

Now, people, you have these ten commandments, but I will also show you the legislator himself, faithfully copied on a towel and engraved in fragile clay with such art that one sees it is not done by human hand. . . . This church, this place is a second Sinai, a new Bethlehem . . . Jerusalem, here a second time is the washing of feet, the Last Supper, Mount Tabor, the praetorian guard of Pilate and Calvary, which in Hebrew is called Golgotha. Here he is born, is baptized. . . . Here he is nailed to the cross, and they that have eyes, let them see the footstool

[of the cross]! In this church he is buried, and the stone rolled away from the tomb is in this church a witness to the Word. Here, here he rises from the dead, as the sudarium and the winding sheets visibly attest.

27. A Western Catalog of the Relics in Constantinople
A Latin catalog (early 12th century)

> This Latin catalog describes the relics and icons to be found in twelfth-century Constantinople—in the palace chapel, in Hagia Sophia, and in three churches of the Virgin. Cf. K. N. Ciggaar, "Une description de Constantinople traduit par un pèlerin anglais," *Revue des études byzantines* 34 (1976): 211ff. and esp. 245ff. An earlier, more complete form of the text is in Mercati (see chap. 10 n. 1), probably a translation from a Greek original.

I. First, in the *Temple of the Mother of God* in the *Great Palace,* there are the following sacred objects and relics: the holy handcloth [*manutergium*] on which the face of Christ is painted [*vultus . . . impictus*], which Christ sent to King Abgar of Edessa . . . the holy cloth also has the face of the Savior without painting [*sine . . . pictura*]. The holy tile [*tegula*] on which the face of Christ also appeared [in an imprint] from the holy cloth. They bear witness to a great miracle, since they bear the face of the Lord without having been painted. And then the letter written by Christ's own hand to the said Abgar. . . . The apostle Thaddaeus baptized Abgar after the Lord's Ascension. The cloth [*pelvis*] with which Christ washed the feet of the disciples. The linen with which the Lord was girded. The crown of thorns, the mantle [*clamis*], the scourge, the cane [*arundo*], the sponge, the wood of the Lord's cross, the nails, the lance, blood, the robe, the girdle, shoes, the linen cloth and sudarium of the entombment [*lintheamen et sudarium*]. . . . The stone that they laid beneath the head of the Lord. The robe of the holy Mother of God . . . her veil [*velamen*], a part of her girdle, her shoes. . . . The head of John the Baptist, his hand with the arm, some of his hairs . . . the staff of Moses . . . the complete head of the apostle Paul and his chains . . . the arm of the apostle Andrew . . . the finger which Thomas placed in the wound in the Lord's side, the head of the evangelist Luke . . . the relics of saints Cosmas and Damian . . . and of Sts. Pantaleon, Theodore, Demetrius [the garment] . . . and of the patriarchs Abraham, Isaac, and Jacob . . . and of many saints and holy virgins without number.

II. In *St. Sophia,* the great church . . . are the swaddling clothes in which Christ . . . was wrapped, the gold of the Magi . . . the wood [of the cross] and parts of other relics that are in the great palace. The blood of Christ. The blood and the milk [*lac*] of St. Pantaleon . . . in a large crystal vase with a gold lid [at his martyrdom milk is said to have flowed from his wounds, which on his feast day separates from the blood and rises to the top] . . . the head of Anastasius the confessor, the writing stool of St. John. The measure of Christ taken by pious men in Jerusalem [*mensura longitudinis corporis*], from which Emperor Justinian took the measure of the gilded cross that he had displayed at the entrance of the treasury [*gazophilacii*] [with the above-mentioned relics]. To the right of the altar of the church, in the wall in front of it, is the lock [*hostium*] of the Lord's tomb. . . . Behind it in the wall are sacred relics of the Passion of Christ. . . . In front of the tomb relic is a silver panel of the same size as the lock, entirely gilded, showing the Crucifixion with the Virgin and John. In front of it a marble slab with windows has been placed, indicating the holy place [*locum sanctum*]. In this place they keep the wood of the cross for four days in the middle of Lent, and the blood of the Lord is honored. . . . On the wall beside this place is to be found a miraculous icon of Christ [*imago . . . fecit Deus magnum miraculum per illam*]. [There follows a long account of the miracle that the icon

performed for a notary.] Next to it is the stone from Jacob's well, on which the Lord sat when he talked with the Samaritans. . . . Above it in the wall is the gilt silver cross that St. Constantine had made after the model [*figura*] he saw in the sky. . . . He therefore placed in it emerald-green stones like stars. In the corner is the icon of the Mother of God . . . who carries Jesus . . . on her arm, Jesus whose neck a Jew wounded with a knife, so that blood flowed. [There follows an account of the blood-flecked Jew who had to free himself of the suspicion of being a murderer.] There are also three doors . . . made of the wood of Noah's Ark, which daily perform miracles. In the outer vestibule at the right of the church is the icon of St. Mary, which was in Jerusalem and which St. Mary begged of the Egyptians at that time, hearing a voice from the mouth of the Mother of God. [The table of Abraham at which he gave his hospitality to the three angels was, according to this text, in the chapel of St. Michael in the palace and not yet in St. Sophia, as it was later.]

III. Near the palace, at the side of St. Sophia, is the monastery of the holy Mother of God, in which is kept the icon that they call the *Hodegetria*. This is interpreted as guide [*deducatrix*], since the Virgin appeared at that time to three blind people, led them to her church, and restored their sight [there was a home for the blind there]. This icon . . . was painted by the evangelist Luke and is carried every Tuesday in procession through the city, with songs and hymns. Many people accompany it, the men at the front and the women behind.

IV. Next to St. Sophia is the church of the Virgin called the *Chalcoprateia* [*Chalcopracia*], in which three churches are united: one of Christ, one of the Virgin, and one of Jacob, the brother of the Lord. In the large church of the Virgin are the relics of the holy martyr Niketas, and in the church of Christ, high up near the altar, is an icon of Christ that performed a great miracle at the time of Emperor Heraclius [there follows the legend of Theodore and the Jew Abramios] . . . and on the altar of the church of the Virgin stands a silver shrine with the garment [girdle] of Mary.

V. In the church of the Virgin in the *Blachernae,* in the second church, . . . where the curtain [*pallium*] lifts not by human hand but by divine grace [*divina gratia*]. On the altar of this chapel stands a silver shrine with the girdle of the Virgin [confusion with Chalcopraetia].

28. A Literary Description of an Icon
Michael Psellus, treatise on an icon of the Crucifixion (11th century)

> P. Gautier, "Un sermon inédit de M. Psellos sur la crucifixion," *Byzantina* 14 (1987). I thank Kenneth Snipes, Washington, for pointing out the text and Gianfranco Fiaccadori for advice in translating it. On the text, cf. *Bibliotheca hagiographia graeca*, supp. vol. 3, no. 447c. Pagination follows the edition of Gautier.

[At the end of a long treatise, Psellus describes an icon of the Crucifixion in the style of the ancient *ekphrasis* (1413ff.). Not only beings endowed with reason but inanimate images (*indalmata*) can be means of grace.] They seem to be by human hand, but secretly God is their artist, using the painting by the artist as his instrument [*organon*] (1420). [The painter has told all the details of the event, keeping to the truth even in the choice of the wood of the cross.] If Christ had not yet died and given his soul back to the Father, you would see him suffering and calling for his Father's help (1440). As he has already given up the ghost, consider him as of the living dead [*empsychos nekros*]. It is enough to make this visible in the body, not in the soul (1447). His attitude is in keeping with the [irregular] human anatomy (1460). One might

rather have attributed the work to nature [*physei*] than to art [*technē*] (1465). [The head has not suffered (1495).] Such is the body of our Lord . . . animated and yet dead, so that his depiction cannot be taken from a model [*paradeigma*], but one would like it to be the model for all other icons (1509). Does not the Virgin, the Mother of the Lord, appear here as the living ideal image [lit. statue, *agalma*] of the virtues? In her grief she has not given up her dignity. Rather, she seems to be musing within. Her eyes are fixed on inexpressible ideas [*aporrhētous ennoias*], and within her soul everything that preceded this [death] is passing once more (1520). Jesus died there in suffering. But as the [divine] force [*dynamis*] moved the painter's hand . . . he showed Christ living, at his last breath . . . at once living and lifeless [*empsychos* and *apsychos*]. That he now shows him with exact empathy [*mimēsis*] is possible because both [life and death] were united in that moment. As Christ was then living against the laws of nature and despite his pain was dead, so he now allows himself to be painted against the rules of art, because grace [*charis*] makes it possible for art (1539–47).

[Finally Psellus speaks of the value of the painted representation (1584).] That painting proceeds exactly according to the law of art is clear from its use of color, as a wise man has observed. But what is admirable here lies rather in the fact that the icon is full of life and nowhere lacks movement. If one lets one's eyes rest successively on different parts, one can see them change, grow larger, and move. . . . Thus the dead man seems to be alive, yet one sees precisely what is dead—the body [*kai to dokoun houtos apsychon akrivos*] (1591). To be sure, the elements [*schēmata*] of such painting can also be found in artless [*atechnois*] icons, namely . . . the impression of life in the color of the blood and the impression of death in the pallor. But there they are imitated from models [*typōn mimēmata*] and copies of copies [*eikasmatōn eikasmata*] (1595). Here, however, the impression does not arise from the composition of colors, but from the nearness to living nature, which is not moved by art. One can hardly imagine how the icon could come into being in such a form. As its beauty [*kallos*] resides no less in the contrast [*antilogias*] than in the harmony [*euarmostias*] of the parts and limbs, so the painting shines [*hyperphyōs apolampei*] with such beauty, although it is not a phenomenon [of nature] (1600).

Although this living painting [*empsychos graphē*] is built up from the skillful composition of such parts, the appearance of life [*empsychōn eidos*] goes beyond such means. The icon lives on the one hand from the fact taht it imitates [life] from art, and on the other in that it does not merely copy it but reproduces it in spirit through the influence of grace [*charis*]. What use now is Plato's comparison of images with shadows? I would not compare this icon with any other painting, even if one were to discover images in the ancient manner [*tēs archaias cheiros*] or even its archetype. I should no more wish to do so if [painters] of our time or of the recent past depicted such apparitions [*eidē*] anew [*ekainotomēsan*]. This icon, I say, resembles exactly the appearance of Christ when he stood facing Pilate and was condemned by him at the desire of the clamouring people [with the words: *Ecce homo* (1610)]. Thus he is shown in a very similar manner in the icon. I shall not, therefore, call into doubt that a higher power [*epistasia*] guided the hand of the icon painter [*exeikonisantos*] and the understanding of the one who executed it, to the true prototype.

29. Image and Virtue: Man as the Likeness of God
Michael Psellus, treatise on Genesis 1:26

Michael Psellus, *Scripta minora*, ed. E. Kurtz and F. Drexl (Milan, 1936), 1:411–14. This text, which was probably intended for the emperor's son (who was a pupil of the author's), explains the ideas in a well-known biblical passage. Here only a résumé is given.

The concept of the *eikōn,* or image, is compared to that of *homoiōsis,* or resemblance. Man, created in the image of God, *is* his likeness—that is, "in the image" and "image" mean the same thing. "Image," philosophically understood, is the capacity of imperfect human beings to perfect themselves, in contrast to the beast, or to attain the true likeness of God. "Likeness" is understood quite arbitrarily as a process of perfection through virtue, in which the body participates through progressing to true beauty. Beauty is thus an ethical category. We can either advance on the way to the good or, equally, can lose our way through "incapacity for beauty."

The essential meaning of the text lies in its polemic against Origen and the old Neoplatonists. The hierarchy in the worldview of late antiquity, with its personal idea of the image as an angel or as Christus Logos, who is a copy of the invisible Father, is rejected. Between man and the invisible God there is neither a creator, other than God the Father himself, nor a model that could be distinguished from that of God himself. Psellus thinks more simply, without the abstractions of ancient philosophy, interpreting the nature of the image dynamically as the goal of the inner progression toward God. If we draw near to God the Son, we also draw near to the invisible God the Father. Only Gregory of Nazianzus, says Psellus, could interpret the Bible correctly.

What seems important to me is a possible connection between this ethical understanding of the old concept of the image and a new, freer interpretation of the icon, in which it was precisely the ethical dimension in the expression of suffering and the nobility of the God-like persons of the Virgin and the saints that were emphasized. While the depiction loosens its link to its canonical prototype, it takes on movement and, like poetry, tells of the life and suffering of the people depicted, who are understood as models of spiritual perfection. In this way the loosening of the static concept of the image, which had so long applied to the icon, permits a new way of viewing ethical models of conduct or theological ideas.

30. The Liturgy at St. Sophia in Thessalonica
Symeon of Thessalonica, description of the liturgy (ca. 1400)

J. Darrouzès, in *Revue des études byzantines* 34 (1976): 45ff. The description is an introduction to an account of the liturgical order in the church of St. Sophia in Thessalonica. Cf. the order of the Constantinople church, as handed down in a manuscript from the fifteenth century in the monastery of Andreaskiti at Mount Athos (Dmitrievskii 1895, 1:164ff.). The latter refers to the archbishop at vespers kissing the "holy icon that stands in the middle of the church [*tēn eis to meson tou naou histamenēn*]" (164). When the small procession enters the church, the holy doors before the bema are closed, and the archbishop kisses the holy icons that are situated there (169).

[The order described, which is extolled as a model, begins with the preparations for evening vespers. The procession with the patriarch starts from the galleries, the *katechoumeneiois,* and descends to the vestibule.] Before the main portal [the *horaias pylas*] the patriarch venerates [*proskynei*] the holy icon of the Mother of God, near whom the icon of the Blessed Mary [of Egypt] is also situated; Mary was said to have taken her vows before this icon of the Mother of God. . . . After passing through the portal he turns . . . to the west and venerates the holy icon [of the Redeemer] above the portal and intones the song: "We honour your most pure icon [*achranton eikona*]" (47). After the clergy have taken their seats, the patriarch climbs to his seat [*stasidion*] and venerates the holy icon situated there. The singers intone the verses a third time in a still louder voice: "Our Lord and High Priest" . . . and when the deacon climbs to the

pulpit [*ambon*], Vespers begin. . . . The spreading of incense [with frankincense, *thymiama*] takes place in the following way. After the deacon has received a blessing for this act, he first incenses the holy altar from all sides. Then he passes out through the holy doors [of the chancel screen], moves the censer in a cross, and then incenses the holy diastylic icons [in the openings of the chancel screen], particularly the icon at the center, which is set out for veneration [*proskynēma*]. Then he goes up to the seat [*stasidion*, of the patriarchs in the choir stalls], incenses the holy icon there and the patriarch, and is blessed by him. [Then the text describes in detail how he incenses the various representatives of the clergy and the people, but not the heretics, for] incensing means participation in divine grace [*metadosis tēs theias charitos*]. Then he turns back to the chancel, where he incenses the holy icons at the center a second time, the *proskynēma*, and the . . . patriarch (49). Then the deacon takes part in the procession of entry [*eisodos*] and, when the prayer has been said and the song of the Virgin [*theotokion*] sung, makes a sign of the cross toward the East and calls out in a loud voice at the center of the church: wisdom [*sophia, orthoi*]. . . . And when all come to the bema, they venerate [*proskynēsanton*] first the deacons and priests, the holy icons in pairs, and the patriarch. As they enter [the chancel], they kiss the holy doors [*hagia thyria*] [of the chancel screen] (52).

[Then begins the description of the rite in the church of St. Sophia at Thessalonica, where everything happens in the same way, the diastylic icons being venerated and even a replica of the *Hodegetria* playing a special role.]

31. The Legend of the Virgin's Icon of S. Sisto, Rome
A homiliary from S. Maria Maggiore (ca. 1100)

The oldest version is in a homiliary from the period about 1100 in the Bibl. Vaticana, Fondo S. Maria Maggiore, No. 122, fol. 141–142; I am indebted to G. Wolf, Heidelberg, for this information. Regarding thirteenth-century manuscripts of a different version of the legend, cf. V. J. Koudelka, in *Archivum Fratrum Praedicatorum* 31 (1961): 13ff. On the probable depiction of the legend in frescoes of the period about 1100 in S. Gregoria Nazianzeno on the Campus Martius in Rome, cf. O. Montenovesi in *Capitolium* 25 (1950): 219, and E. T. Prehn, in *Rivista d'arte* 36 (1961): 19 (without identification of the theme).

 The encaustic icon of the pleading Mother of God, published in Bertelli 1961a, 82–111, was to be found in the Monasterium Tempuli near the Caracalla bath, a convent that was consecrated to St. Agatha about 800 and to the Virgin about 900, when it received rich endowments from Pope Sergius III. In 1221 the rights and property of the convent were transferred to the nearby new Dominican foundation of S. Sisto (later SS. Sisto e Domenico). In 1931 the nuns moved to the Monte Mario, where they now keep the icon in the convent of S. Maria del Rosario. On the diploma issued by Sergius III in 905 in favor of the Tempuli convent and its abbess, Euphemia, cf. Koudelka's article cited above, 11–12.

[The legend begins with the origin of the panel as a work of St. Luke, which later came to Rome. There three brothers from Constantinople—Tempulus, Servulus, and Cervulus—were living in exile, in the place called S. Agatha in Turri.] And the Lord spoke to Tempulus, saying: Rise up and seek the venerable image [*venerabilem imaginem*] that a just man has brought to this city . . . and set it up [*colloca*] in the church that is situated in your house . . . and which later, on account of the venerable image, bore the title of the Blessed Virgin. . . . And there [the brothers] lived, on account of the wonderful face [*ammirabilem vultum*] and the vision [*revelationem*] that the said Tempulus had seen. After their deaths the clergy assembled in the time of Lord Sergius, bishop of the city of Rome, and said that such an image [*talis imago*] ought to

belong to the Lateran palace. The bishop agreed, saying: Go thither and move the image with fitting honors. . . . When a large number of clergy had gathered there, they entered the church and took away the miraculous image, to take it to the Lateran palace. But God . . . wanted to glorify his Mother [and performed a miracle]. The clergy carried off the sacred image on their shoulders with the maids of God [*ancillis Dei,* i.e., nuns of the convent] . . . and a great crowd of people and took it to a place called Spleni. But they could not move it further.

When the pope heard of this, he hurried to the place where the image stood immovably and uttered prayers of supplication [*deprecationem*]. Then they moved [the image] and . . . took it to the Lateran palace, where it was set up, and where the image of our Lord the Savior is also found [the acheiropoietic images in the Sancta Sanctorum]. The following night [the image] returned by God's will to the place where it had been kept [*constituta*] earlier, without anyone knowing. . . . The abbess of that place, who was grieving in the church [*tempuli*], saw it come in through the window and, greatly moved, sang a song of praise to God, since he had vouchsafed to bring back the said Lady. [In the Lateran there was much concern at the disappearance of the image.] . . . When it was discovered that the image had returned to its old place . . . the pope asked the abbess there to explain what had happened. . . . All were seized with wonder. . . . And the pope celebrated Mass there and set up the miraculous image in a suitable place [*apto loco*] after blaming himself for agreeing to its removal. And the pope made many gifts to the convent at that hour, donating everlasting lamps to burn henceforth [before the image]. . . . Amen.

32. The Rivalry of the Roman Icons
Fra Mariano da Firenze, *Itinerarium Urbis Romae* (1517)

> Cf. *Itinerarium Urbis Romae* 2.16 and 15.11, ed. E. Bulletti, in *Studi di antichità Cristiana* (Rome, 1931), 2:42–43 and 189–90

[In the chancel of S. Maria in Aracaoeli, the church of the senate on the Capitol, there was, "below the image of the Weeping Virgin painted by St. Luke," a stone inscription claiming that this was the image that had been carried to St. Peter's under Gregory I and had put an end to the plague. The canons of S. Maria Maggiore made the same claim for their St. Luke image, and the Dominicans likewise for the St. Luke image of S. Sisto. "But God alone knows which is the true icon" (*sed qualis sit, Deus scit*). Before the icon of S. Maria Maggiore the author recalls the legend and the tradition of S. Maria in Aracoeli, where] up to the time of Nicholas V, 1447–55, the icon was venerated by a confraternity to which almost the entire Roman people belonged [until it was dissolved at the instigation of the Franciscans.] The celebrations that were held with the images of the Lord and the Virgin in the night before the Assumption included the said image of Aracoeli, which was carried to meet them on the Capitol. Incensed by the supression of the confraternity, the Romans moved everything to S. Maria Maggiore. [Whether the historical icon of the plague] is there, or in S. Sisto, or in Aracoeli is of little account. All three are worthy of veneration. The opinion of the people seems to carry more weight than that of the authorities who have been called in. [Neither William Durandus nor Jacobus de Voragine, author of the *Golden Legend,* comments on the subject. When Antonin, the archbishop of Florence, asserts in contradiction to them that the original is to be found in S. Sisto,] he makes this and the other icon suspect, since all three authors belong to the Dominican order and do not agree on the matter. [He has dealt with the matter at length because it is referred to by inscriptions in several churches.]

33. The Attitude of the Carolingians to the Veneration of Images
A. The report in the *Libri Carolini* (ca. 790)

When the Latin translation of the decisions of the Council of Nicaea (cf. text no. 8) arrived at the Carolingian court about 790, Charlemagne commissioned his theologians to write a report that was to refute the ideas of the Greek clerics. His annoyance at being excluded from a general council of the church played no small part in this. In the argumentation of the report, Spanish traditions are evident, and the hand of Theodulph of Orléans has been detected in its drafting. The so-called *Libri Carolini* did not achieve the dissemination planned for them, as the pope seemed to make common cause with the Greeks and was not to be provoked. A new edition by Ann Freeman is under preparation: Until then, the edition followed here, by H. Bastgen, in *Monumenta Germaniae Historia Legum* 3, Concilia 2, supp. (Hanover, 1924) is valid. Cf. H. Schade, "De Libri Carolini und ihre Stellung zum Bild," *Zeitschrift für katholische Theologie* 79 (1957): 69ff.; G. Haendler, *Epochen karolingischer Theologie* (Berlin, 1958), 27ff.; A. Freeman, "Theodulph of Orleans and the Libri Carolini," *Speculum* 32 (1957): 663ff.; idem, "Carolingian Orthodoxy and the Fate of the Libri Carolini," *Viator* 16 (1985): 65–108.

The *Libri Carolini* deal with many arguments, only a few of which will be mentioned but not quoted here. With St. Augustine, it refutes the equation of image and likeness (cf. 1.8). It argues against linking the face of the Lord in the Bible with a painted image, and it propounds a theological doctrine on the face of the Lord in the church (cf. 1.24). It argues that the legend of St. Sylvester (which was not, in any case, accepted by everyone) should not be used to support the veneration of images, since the portraits of the Princes of the Apostles were not shown to the emperor for veneration but for identification (1.12). Nor did the views of the Council of 692 justify any conclusions (2.18). The cross, which is referred to in military contexts as the banner in the field of mortal combat, has precedence over any painted image both as a relic and as a sign of the majesty of Christ, and as a symbol (1.28).

I. [The Introduction supports the charge of the Council of Nicaea that by destroying images, the iconoclasts had treated them like idols.] They do not know that the image is a general [*genus*], whereas the idol is a special [*species*], so that one cannot be related to the other. Although almost every idol is an image, not every image is an idol. An idol is defined quite differently than is an image [*imago*]. Images are there to ornament [churches] and to demonstrate the story of salvation, whereas idols serve only to mislead wretched people into sacrilegious rites and hollow superstition. The image refers to something else; the idol, as it is called, only to itself (p. 3). [The distinction between genus and species is to be found in the ancient grammarians (e.g., Priscian 17.42 and Boethius, *PL* 64, 139) and less clearly in Isidorus 2.8.]

II. We are content with the writings of the prophets, the evangelists and the apostles, and we also follow the direction of the holy, orthodox church fathers . . . accepting the authority of the six universal synods, but we reject all the new definitions and foolish inventions . . . like the synod held in Bithynia regarding the shameless worship of images, and its writings, which are bereft . . . of all reason (pp. 4–5). [The distinction between *latreia* and *proskynēsis* had been lost in their common translation as *adoratio*.]

III. Images are not to be equated with the relics of the martyrs or confessors to the faith . . . for the latter come from a body or have been in contact with a body . . . and will rise again in glory with the saints at the end of the world. . . . But images sometimes turn out beautiful and sometimes ugly, according to the understanding [*ingenium*] and skill [*artificium*] of the artist. They have neither lived, nor will they rise again but, as we know, will be burned or will decay, and they merely obstruct us in the adoration that is due to God alone (3.24, pp. 153–54).

IV. Images are not to be worshiped because they have allegedly performed signs or miracles. . . . Nor is there a single word [in the Bible] to say that images have done such things. [Either these miracles are based on lies and the deception of the Devil, or they are performed by God himself through the things, but not by the things themselves] (3.25, pp. 155–56).

V. Since images, depending on the *ingenium* of the artist, are either beautiful or ugly, alike or unlike what they depict, radiantly new or worn by age, one must ask whether the more or less costly [*pretiosores an viliores*] deserve more honor. In the first case the form of the work or the material chosen [*operis causa vel materiarum qualitas*] receives the veneration, but not the power of devotion [*devotio*] itself. [In the last case, even if the likeness with the person has not been achieved, this reason ceases to apply.] For we reject nothing except the adoration [*adorationem*] of images . . . and permit images in churches as reminders [*memoria*] of the deeds of salvation and as decoration [*venustas*] for the walls. . . . The Greeks worship walls and painted panels [*tabulas*] and so are at the mercy of painters. To be sure, some more learned people [*docti*] can avoid worshiping the images themselves and can venerate that to which they refer [*innuant*]. But for the ignorant they constitute a scandal, for they worship only what they see (3.16, pp. 137–38).

VI. [Even the name of a saint on an image does not confer on it the right to be venerated. A supporter of images should be shown images of two beautiful women and told that one represents the Virgin and the other Venus.] Both are similar to the point of confusion in figure, colors, and panel and differ only in the title [which the painter can add at will], which can make them neither holy nor censurable. Holiness is conferred on people endowed with reason on account of merit and good works; on inanimate things it is conferred, not by an inscription, but by consecration by a priest and the invocation of the name of God (4.16, p. 204).

B. The Synod of Paris on the imperial letter from Byzantium (825)

> In Byzantium the pendulum again swung to the side of iconoclasm, and in 824 the letter of the emperors, Michael and Theophilus, to Louis the Pious gave rise to another theological report. In the autumn of 825 a synod held in Paris was instructed to produce it, after Louis had obtained authority from Pope Eugenius. The bishops and abbots think it important to use written testimonies on the question of iconoclasm, not only against the parties in Byzantium, but against the vacillating pope, in order to place the true authority of tradition above all hierarchies, and Louis instructs his envoys to adopt a hard line in Rome. On the Byzantine letter, cf. P. Speck, in R. J. Lilie and P. Speck, *Varia 1*, in *Poikila Byzantina* 4 (Bonn, 1984), 175ff. Page numbers below refer to the edition of the letter in A. Verminghoff, *Monumenta Germaniae Historica Legum* 3, Concilio 2.2 (Hanover, 1908), 475ff., which also contains the text of the Libellus of the Paris synod (480ff.) and the Epitome (535ff.). See also Freeman, "Carolingian Orthodoxy," 100ff., cited above under A.

I. [The imperial letter accuses the supporters of images in Byzantium of deviating from tradition.] They threw the . . . crosses out of the churches and replaced them with images, before which they lit lamps and burned incense. They held images in the same honor as the [wood of the] cross . . . hoping to receive help from them. They often surrounded them with hangings and made them the godparents of their children. . . . Some priests rubbed paint from them and mixed it with the bread and wine [before Communion]. . . . Some even used the panels in private houses as altars, celebrated Mass at them. [All this was banned by a local synod], and the images were removed from the lower [*humilioribus*] places, though they were left in the higher [*sublimioribus*] places [in the churches], where painting instead of writing tells a story. . . . Thereupon the supporters of images went to ancient Rome to slander the new direc-

tion and cast doubt on our faith, while we invoke the *symbolum* of the six general councils, venerating the Trinity in three persons and confessing to a deity of one nature . . . we invoke the intercession of our Lady, the Mother of God and pay tribute to the relics of the saints (478–79).

II. [In the Epitome the Paris assembly discusses the cult of the cross, which represented their own line, because] there can be no reason to equate images with Christ's cross; humankind was redeemed through the cross, and Christ hung from the cross, not from an image. . . . This cross is prefigured [*figurata*] in many ways in the Old Testament, but nowhere does one read that, in the revelation of truth in the New Testament, images were to be equated with or even preferred to Christ's cross. Now that the earlier symbols [*typicis figuris*], which were fulfilled by truth, have become obsolete, it is as clear as day that we and the world are designated by the wood of the cross, not by images. . . . In the sign [*signum*] of this holy cross, we read, countless saints have awakened the dead, driven out demons from possessed people, healed the blind, and performed similar miracles (549–50). [The Epitome is a collection of writings, as is the report itself. They include the Acts of Sylvester and Eusebius's report on the vision of Constantine, who saw the *signum* of the cross in the eastern sky.]

III. [In the Introduction, the Frankish theologians take a critical view of Pope Hadrian's letter to the Byzantine emperors (Mansi 1901, 12:1055). Though he rightly condemned the iconoclasts, he did so thoughtlessly] in that he ordered that images be superstitiously venerated. To this end he summoned a synod . . . and pronounced that images should be painted, venerated, and called holy, whereas, although it is permissible to own images, it is wrong to venerate them. He attached written testimonies to the letter, which in our view are misleading and irrelevant (481). [Thereupon the reprehensible Council of Nicaea, which Charlemagne rightly refused to attend, was convoked. But Hadrian rejected the *Capitula* sent to him by Charlemagne, in which he was so wrong that, had he not been pope, his opinion would have been in contradiction to truth as well as *auctoritas*. Fortunately, he did finally adopt the position of Gregory the Great, the only correct one.]

IV. [The emperor is now advised to follow his own line and a straight path, since abysses of error threaten on both sides.] Although we owe due respect to those who sit on the seat of Peter, we know their superstitious veneration of images from reports, some of us even from our own experience. Therefore, we wish first to submit written evidence against them [the iconoclasts], since they have destroyed images with presumptuous heedlessness. May those [i.e., the popes] who are animated by them therefore all the more earnestly seek with you [Louis and Lothar] to correct the errors of others [the image worshipers], and the more readily accept and be swayed by the testimonies of truth [submitted here], which teach them their own superstition. In this way, it seems to us, the correction in your reply can absolutely oppose those who . . . have sent you the letter [the Byzantine emperors], since their text shows that both parties [of the Greeks] deserve censure: both that which venerated images with an unseemly and superstitious cult [*indebito ac superstitioso cultu*] and that which removes them from the lower [*inferioribus*] places and destroys them. We thus believe that the [Byzantine] emperor, though he may have acted in accordance with the truth in other matters, has in this matter caused vexation to thoughtless people [*infirmos*] there [in Byzantium] and even confused some of our [theologians] in Rome [the old Rome of the popes] (484).

V. [At the end of 825 Louis the Pious gives the report containing this advice to Bishops Jeremias of Sens and Jonas of Orléans, to be presented by them to the pope. In an accompanying letter he urges them to be diplomatic in manner but firm as regards substance, and under no circumstances to allow the pope to send his own envoys to Byzantium (533).]

34. The Statue and Saint's Cult in the Abbey of Conques
Bernard of Angers, book of the miracles of St. Faith (11th century)

Bernard, a pupil of Fulbert at the cathedral school of Chartres, was put in charge of the cathedral school at Angers about 1010. Not until 1013 was he able to fulfill his wish to travel to the Auvergne, to convince himself of the miracles of St. Faith, or Foy, in the abbey of Conques. The fruit of this and two later journeys is the book of miracles that he dedicated to Fulbert. It has been edited by Auguste Bouillet, *Liber miraculorum S. Fidis* (Paris, 1897), and later was translated by the same author in a joint publication with L. Servières, *Sainte Foy, Vierge et Martyre* (Rodez, 1900), 441ff. On this and the surviving relic statue of the saint, which in a miracle of 985 received ornamental borders to its hem and cuffs and a new crown, cf. J. Taralon, in *Les Trésors des églises de France* (Paris, 1965), pp. 289ff. and no. 534, and, above all, Forsyth 1972, 68ff., 78–79, and 85–86; also cf. E. de Solms, *Ste-Foy de Conques* (Paris, 1965).

I. According to an old tradition, every church here [in the Auvergne] has a statue of its saint made of gold, silver, or other metal . . . to enclose the head or another part of the saint. This practice was . . . considered a superstition by enlightened people and seems at first sight to continue the cult of gods or demons. I too was thoughtless enough to see it as an abuse of the Christian faith. I first saw the statue of St. Gerald, made entirely of pure gold and precious stones, on the altar in Aurillac. His face was animated by such a living expression that his eyes seemed fixed upon us and the people could read from the luster of these eyes whether their plea had been heard.

I turned, as I now remorsefully confess, to my companion Bernier and asked him in Latin: "Brother, what do you make of this idol? Would Jupiter and Mars think the statue worthy of them?" Bernier, who shared my feelings, agreed emphatically. . . . As true veneration is only fittingly directed at God, it seems absurd to make statues of stone, wood, and bronze, unless of our Lord on the cross. For it is customary throughout Christendom to venerate the divine crucifix in sculpture and bronze, to guide our piety to his Passion. But to remember the saints . . . one should be content with the truthful writings of a book or with paintings that show them on frescoed walls. Statues have only been justified . . . on grounds of the long-established traditions that cannot be eradicated from the common people. The error was so popular here that I should have been treated like a criminal if I had . . . openly insulted the statue (1.13).

II. Three days later we entered the monastery of St. Faith [in Conques] at the very moment when the closed cult room of the statue was being opened to the public. At once the room was so full of people, and the crowd of people casting themselves on the ground were so overwhelming, that we could not even kneel. Thus to my regret I remained standing, lifted my eyes to the statue, and prayed: "Holy Faith, whose relic is kept in this statue, be merciful to me on the Day of Judgment." Then I looked with a mocking smile at Bernier, since so many people were thoughtlessly directing their prayers at an object without language or soul, . . . and their senseless talk did not come from an enlightened mind. I contemptuously called the statue Venus and Diana, although it is not an oracle to be questioned or an idol to receive sacrifices.

Rather, the statue is honored in memory of the holy martyr in order to glorify the highest God. Today I regret my foolishness toward this friend of God. . . . Her image is not an impure idol but a holy memento that invites pious devotion and strengthens our wish for the powerful intercession of the saint. To be more precise, it is nothing but a casket that holds the venerable relics of the virgin. The goldsmith has given it a human form in his own way. The statue is as famous as once was the ark of the covenant but has a still more precious content in the form of the complete skull of the martyr. This is one of the finest pearls in the heavenly Jerusalem,

and like no other person in our century it brings about the most astonishing miracles through its intercession with God. . . . One should not therefore destroy or spit on the statue, for its cult . . . is nurtured by no prejudice against religion.

III. The monastery of Conques was consecrated to the Redeemer. But when the body [of St. Faith] was secretly brought here from Agen by two monks long ago . . . the abbey was reconsecrated to her in view of the miracles performed here. In our day the miracle of the healing of the blindness of Guibert had such an effect throughout Europe that many gave their goods to the saint, or made them over by will. So the poor monastery began to grow rich and famous [and the shrines and crosses multiplied]. But the most famous among the church's treasures is the ornament of the image [*decus imaginis*], which was made in olden times [*ab antiquo fabricata*] and would now be something quite ordinary had it not been entirely renovated and turned into a beautiful figure [*de integro reformata in meliorem renovaretur figuram*]. A very large crucifix of silver, gilded on the crown and loincloth, is also admired here [as is an altarpiece more than seven feet high for the high altar, which is made with just as much art and is inlaid with stones like the two larger altarpieces at Tours; the new altarpiece, which is still being completed, constantly brings in donations, which St. Faith requests from the faithful by demands and dream apparitions] (1.17).

IV. I cannot conceal that the shrine of St. Faith, shining in the glory of its miracles, holds first place among the many shrines that are carried to the church synods according to the custom of this land. Thus, Bishop Arnaldus of Rodez called a synod for his own bishopric, to which the monks and canons carried the shrines and gold statues with the bodies of the saints. The display of these shrines took place in tents and under canopies on the meadow of St. Felix about a mile outside the town. There the golden "majesties" of the holy bishops Marius and Amans gathered, with the shrine of the martyr Saturninus, the golden statue of the Mother of God, and finally the golden "majesty" of St. Faith. I do not need to list the many other shrines of saints that were also present. [There follows a miracle involving the healing of a child who] sat at the foot of the raised throne on which the statue of the saint had been placed (1.28).

V. On other occasions the statue of the saint, accompanied by a gold shrine allegedly donated by Charlemagne, without which she never went abroad, was carried into her estates. . . . The procession was intended to curb any encroachment on the property of the monastery. According to a fixed custom, the monks carry the statue of their patron to any point where lands have been unlawfully occupied by someone else, to proclaim her rights. They arrange a solemn procession of the clergy and the people, carrying candles and candelabras. Before the venerable shrines they carry the golden processional cross with its relics and jewels. Some of the young novices carry Gospel books and holy water, while the others play cymbals or oliphants, that is, ivory horns donated by noble pilgrims to adorn the monastery. On these processions the saint performed an unbelievable number of miracles (2.4).

35. A Pilgrim's Guidebook to Rome (1375)

The *Mirabilia Urbis Romae,* which praises the ancient monuments, has been handed down in many editions and reprints from the Middle Ages; cf. Valentini and Zucchetti 1942–46, 3:196ff., which also includes the *Graphia Aureae Urbis* and the text of Magister Gregorius. In addition, pilgrims' guidebooks concerned with the Christian shrines begin to be produced at an early stage but appear in greater abundance after the introduction of the Holy Year in 1300. We quote below from a text dating from 1375, the wording of which is incomplete

and corrupt. In the *Codex lat.* 4265 of the Vatican Library, fols. 209–16, which was published in Latin by Gustav Parthey, *Mirabilia Romae* (Berlin, 1869), 47–62.

1. [The text begins with the miracle of the snow during the building of S. Maria Maggiore, which it places in May, and then tells of the healing of Constantine's leprosy, faithfully following the legend of St. Sylvester, according to which, on the painted panel (*tabulam depictam*) showing the two apostles, Constantine recognized the one who had appeared to him in his dream.] This panel stands to this day on the high altar of the Lateran (48).

2. [There follows a description of St. Peter's, where the author mentions the chapel of Peter and Paul near the altar of St. Gregory.] Here are images of wood, made in the likeness of the apostles . . . and near the side entrance stands the altar of St. Alexios, where, it is said, his body lies beneath a hanging lamp, the saint's own church having only his head. On the altar stands an image of the Blessed Virgin in the manner and with the dimensions of those painted by St. Luke. Behind it, under a *sacristia*, is the head or the *cathedra* of St. Peter. Further back in the nave rises the papal altar of St. Peter. . . . At the entrance to the church one sees on the right the altar of the Veronica, above which the Veronica is concealed, and high in the wall on the left the cross of St. Peter, with which rest the bodies of the apostles [one also saw the image of St. Maiestas, which King Charles demanded as a gift] (49ff.).

3. [The description of the Lateran begins with the *sedia stercatoria*, on which the test was carried out to see if the newly elected pope was really a man. An image of the *Maiestas* in stone is also mentioned. After a brief glimpse of the Sancta Sanctorum, at the entrance of which was the Virgin's image of Theophilus, the author returns to the basilica, mentioning the heads of Peter and Paul kept there.] High up in the apse one sees the image of the *Maiestas*, produced at God's will [*divinitus*], painted by the blessed Luke . . . and on the high altar the panel already mentioned with the images of Peter and Paul. In a chapel stands the image of Our Lady, who herself put on the ring that a woman once donated to her (52–53).

4. In S. Maria Maggiore one sees, above the high altar, an image of the face [*facies*] of Christ, with another painting that was not done by human hand but *divinitus*. There we also find the image of the Blessed Virgin, which was also produced *divinitus*, but was left to St. Luke to paint (54). [This explanation, relating to the old icon of the Madonna now called Salus Populi Romani, repeats the one customary for the Lateran panel of acheiropoietic images; cf. text 4F.]

5. In the church of S. Maria Nova [now S. Francesca Romana] is to be found a panel on which, it is said, St. Luke painted an image of the Virgin with her Child. After a fire in the church the panel was quite blackened, only the faces of the Mother and Child remaining unscathed, as one can still see today (54).

6. In S. Maria mamma celi [Aracoeli on the Capitol] one sees an image of the Blessed Virgin that was painted *divinitus*, with tears in her eyes, as [or as if] she stood beneath the cross. In S. Sisto, the church of the monks and nuns of the Dominican Order, . . . is the image of the Blessed Virgin painted by St. Luke that was once violently seized by a pope and taken to the Sancta Sanctorum on the grounds that the Mother should be with her Son, whose icon is kept there. But the next morning the image returned at dawn amid a shining light to the [place where] the nuns venerate it, and this same image changes color during Holy Week, becoming quite pale on Good Friday (56–57).

7. In S. Maria in Trastevere, where oil flowed for three days at Christmas, the image of the Virgin still sits above the entrance—the image that gave the Romans the reply that they could be secure . . . on account of the penance they had done . . . and in a chapel above S. Spirito on the hill is the image of the Virgin painted by St. Luke. . . . In S. Prisca [on the Aventine] stands

the altar on which the image of the Crucified appeared to Pope Gregory, on which account Pope Urban inaugurated a feast; on the altar stands the image of St. Luke [?], painted by his own hand (60–61).

36. Resistance to the Veneration of Images in Prague
Matthew of Janov, *Rules of the Old and New Testaments* (ca. 1390)

At the Prague Synod of 1389, Matthew withdrew under pressure his criticism of the excessive cult of images and relics that Emperor Charles IV had introduced in Prague. Images, he was forced to state, gave no cause for idolatry and could be venerated and receive genuflections as representatives of the saints. They were also capable of miracles. It was sensible to honor relics, since the saints had more power in heaven than they had had on earth. In this way the institution of the mediation of grace by the means held by the official church was verbally acknowledged. Cf. C. Höfler, *Concilia Pragensia, 1353–1413* (1862), 37 no. 17.

At the same time, Matthew refined his criticism in the Latin treatise, never published, *Rules of the Old and New Testaments*. I thank H. Bredekamp in Hamburg for arranging the transcription by Mrs. J. Nechutovà, Brno, from two manuscripts in Prague, III A.10 in the National Library, and in Olmütz, C 211 of the State Archive. On Matthew, cf. Bredekamp 1975, 251ff.

I. [In Distinction VI, Prague fols. 126ff., the author opposes the view that mere cult acts could make up for a lack of faith or virtue. The misuse of the image cult, he argues, encouraged the credulity of the common people, led the clergy into covetousness, and finally impaired the purity of religion. It was therefore as evil as the poison that remains unnoticed in honey.] Anyone who attributes any divine power to a wooden or stone image, so that fear, respect, and love are felt for it, forgets that it is a thing of wood without perception or life, nor is it consecrated or blessed by God's word. [No objection is made to images in a church, as long as they are properly explained to the ignorant, and as long as Satan, who uses them to seduce the people to a cult of Baal, is resisted.] If all images are equal yet one is venerated more than others and attracts the people on grounds of fanciful, unproven events, . . . it should be removed as a vexation (Olmütz fol. 387v). [Today the saints no longer performed miracles, and the subtle danger of Satan now lay in the very secrecy of the Christian cult.]

II. Those priests who misuse images and encourage their veneration mislead the common people and cause them to bend their knees before images. With the stories they trump up about the images . . . they hand over the flock entrusted to them to the Antichrist (Prague fol. 128). [If one wished to honor living images of Jesus, one should turn to one's fellow human beings, who are precisely that. Why kneel before dead images, when one does not do so before the Holy Scripture, which is no less holy? Inside the church the images distracted attention from the sacrament at the altar, which conferred eternal life and was worthy of adoration] (Prague fol. 128). Instead, one allows oneself to be awed by any famous or beautiful piece of sculpture or relic [*sanctuaria*] . . . merely because a few tradesmen in God's temple promise many indulgences in their sermons (Prague fol. 129). [All this he was submitting for the information of his magisters at Prague University, whom he wished, all the same, to obey. The church had permitted images and statues not for veneration] but only as signs [*signa*] of the holy events, not as especially equivalent or appropriate signs nor as ones that could be installed and consecrated like the sacraments of Christ . . . which thereby gain authority and effect.

III. As Thomas of Aquinas said, . . . on close reflection this or that statue comes into being from nothing other than the taste [*beneplacito*] of the painter, who shapes the wood or the

stone according to his fancy as it pleases him; his fancy draws from himself a likeness [*simili-tudinem*] that serves his own advantage and meets the desire of the client [*ementis*]. Within the church it serves only for ornamentation and to aid the piety of simple-minded people, without having anything to do with the sacraments or being animated by the word of God. But that such a statue represents only a remote or unfitting image [*ymago*] or likeness [*similitudo*] can be seen from the fact that nothing can be called an image or likeness that is more unlike than like. Precisely this is true of such a statue. . . . Statues are of a corporeal nature, but the saints of a spiritual nature [*spirituales*] (Olmütz fol. 390), . . . so that statues cannot resemble the saints in heaven, as they are not taken from their persons or their *effigies*. No observer has ever seen the latter, least of all the painters [*pictores*], . . . since they have invented their images according to their *phantasmata* from everything they see and hear today. Thus statues are unlikenesses rather than likenesses of Christ and the saints . . . particularly in their sub-stance. . . . And each growing plant or wild animal [*brutum*] is closer to Christ and his saints in its resemblance to life than the finest statue in a church. . . . All such images and statues are likenesses in the "figure" of the artist's fantasies . . . not according to the *effigies* and form [which the saints possessed in life, not to speak of their present existence in heaven] (Olmütz fol. 391). If the image has an effect [he concludes from Gregory the Great], it is not because of the hand of the painter but because of the pious disposition of the beholder (Olmütz fol. 393).

IV. On the image of the Blessed Virgin Mary said to have been painted by St. Luke, and on the face of Jesus Christ and its cult, I believe I should say that such things deserve honor, but within the limits and according to the truth of their substance, since they are things without soul or life that have no immanent power [*virtus*]. Rather, they are images or copies of what they represent, from the model [*effigies*] of which they are painted. The countenance of Christ, which he imprinted on it with wonderful, divine power, and which has been kept till today in Rome; the image of the Virgin drawn directly from the living model [*effigies*]; and finally the *Volto Santo* in Lucca, in which Nicodemus, through his love of Christ, copied his limbs and molded the head. . . . Even though it was brought miraculously across the sea to Lucca and proved its authenticity there by great signs and miracles, it is nevertheless nothing other than a piece of wood without spirit or effective power. . . . Such miraculous images, which enjoy extraordinary privileges, do not excuse the many fictions that are rampant in the church of God (Olmütz fol. 395).

[The examples mentioned must, Matthew argues, be allowed a special justification, as Christ left them behind to comfort his followers before his Ascension into heaven. His transfig-ured body could be seen only in terms of its resemblance to a copy of its earthly appearance.] Nor is it without a special reason that only two portraits of Christ are famous in the church, one in Rome by the name of the Veronica, which has a gentle and friendly appearance [and shows Jesus to human beings], and one in Lucca . . . the *Volto Santo*, the face of which is terrible to behold, a commanding, majestic image (Olmütz fol. 395). From this I conclude that the Lord Jesus, who will come a second time into the world and show himself to all, has left behind an image of his two manifestations [one of his human form and one of his divine majesty as judge].

I can bear witness to this myself. Whenever I have seen this image, a kind of copy of the image [*ymaginem ymaginis*], on a great flag [*vexillo*] in Lucca that was repeatedly raised in the air, I have always been terrified, my hair stood on end, because I thought of the coming of Christ to sit in judgment. [Thus the names of the images were apt, for the *facies* in Rome reminds us of the face that is mild and full of mercy, while the *vultus* in Lucca hints at the *furor* that is delineated terribly in the face. Thus the images match Christian doctrine, in that one recalls the gracious mercy and the other the rigorous justice of God.]

Why the image of the Blessed Virgin was painted by Luke the evangelist can be proved as

follows. Whether the Mother of Christ rose into heaven with or without her body, we know for certain that we own no relics of her sacred body, which has prevented the temptation of the weak in keeping with divine Providence. All the same, the Redeemer in his goodness wanted to leave behind a lifelike and appropriate image in his church, and it was to be taken from her sweetest *effigies*. She therefore authorized a person who commanded belief [to paint such an image], to the honor of the Mother and for the devotion and comfort of the elect. That image therefore is worthy of honor, but only such honor as befits a painting, with its lack of life and spirit [*spiritu et virtute*] (Olmütz fol. 395v).

37. Stories and Legends about the Veronica in Rome

As early as the eleventh century the chapel of the Virgin of John VII (705–7), in front of the inner entrance wall of St. Peter's, was called Veronica, after the cloth relic, as in the chronicle of Benedict of Monte Soracte, *Ubi dicitur Veronica,* Monumenta Germaniae Historica Scriptores 3, 700. Cf. Anton De Waal, "Die antiken Reliquiare der Peterskirche," *Römische Quartalschrift* 7 (1893): 257, where a "Johannes clericus et mansionarius S. Mariae de Beronica" from this time is also mentioned. Also according to De Waal, in 1191 Pope Celestine III showed the relic to the French king.

A. Petrus Mallus, history of St. Peter's (ca. 1160)

The earliest known description of St. Peter's and the cult site is Petrus's *Historia basilicae Vaticanae antiquae,* chaps. 25 and 37; see De Waal, "Die antiken Reliquiare der Peterskirche," 255 and 257; and Dobschütz 1899, 285*.

The oratorium of the holy Mother of God, called the Veronica, in which are kept [apart from the crib relic] . . . the indubitably genuine sudarium of Christ [*ubi sine dubio est sudarium*], the cloth into which he pressed his most holy face before his Passion, when his sweat ran in drops of blood to the earth. . . . Before the Veronica ten lamps burn day and night.

B. Gervase of Tilbury, *Otia imperialia* (ca. 1210)

Gervase, in his early thirteenth-century work *Otia imperialia* (3.25), is the first to mention an image appearing on the Veronica (G. G. Leibnitz, ed. *Scriptores rerum Brunsvicensium* [Hanover, 1707], 1:968; Dobschütz 1899, 292–93*; Lewis 1985, 103). In the context of miracles of worldwide significance, he mentions images of Christ in Rome, Lucca, and Edessa. Cf. H. G. Richardson, "Gervase of Tilbury," *History* 46 (1961): 102ff.

And there are images of the countenance [*vultus*] of the Lord, like the Veronica, which is said to have come to Rome with a certain Veronica, an unknown woman. But we have proved from very ancient texts that in truth she was Martha . . . who was cured of a twelve-year issue of blood by touching the hem of the Lord's robe. We know from old tradition [the legends of Pilate, chap. 11 n. 32] that she possessed a likeness of the Lord's face painted on a panel [*in tabula pictam habuisse Dominici vultus effigiem*]. Emperor Tiberius sent his friend Volusian to Jerusalem to find out about the miracles of Christ, by whom he wanted his illness cured [whereupon Volusian seized the image from Martha]. . . . Tiberius is said to have been cured at his first sight of the Veronica painting. . . . It is therefore the Veronica, the authentic painting, which shows the likeness of the head and shoulders of the Lord in the flesh [*pictura Domini vera secundum carnem representans efficiem a pectore superius*] and is kept in St. Peter's, on

the right of the entrance. There is also another copy [*effigies*] of the Lord's face, also painted on a panel [*in tabulae aeque depicta*] in the chapel of S. Lorenzo in the Lateran palace [on the image in the Sancta Sanctorum, see chap. 4d]. Pope Alexander III (1159–81) had it covered with several layers of silk cloth [*multiplici panno serico operuit*] because it caused mortal fear in the onlooker. And an eyewitness reports the following: if one looks closely at the Lord's face [*vultum Dominicum*], which was so badly damaged by a Jew in the Lateran palace, near the chapel of S. Lorenzo, that blood flowed from the wound and covered the right side, one notices that it resembles the Veronica in St. Peter's as well as the painting that is found in the chapel itself, and the *Volto Santo* in Lucca [cf. chap. 14e and text 36, IV].

C. Gerald of Wales, *Speculum ecclesiae* (ca. 1215)

About the same time as Gervase of Tilbury, Gerald of Wales discussed the same images of Christ in chapter 6 of his *Speculum ecclesiae*. Cf. J. S. Brewer ed., *Giraldi Cambrensis Opera* 4, Rerum Brittanicarum medii aevi scriptores 21 (London, 1873), 278–79.

[Gerald reports on the five basilicas of the patriarchate in Rome and] the two icons [*iconiis*] of the Redeemer, the *Uronica* [*sic*] and the *Veronica,* one of which is to be found in the Lateran and the other in St. Peter's. [After Christ's Ascension, St. Luke was asked by Mary to paint an image of her son, which with her help was authenticated and approved in its physical details.] Thus he produced two or three, one of which is kept in Rome . . . in the Sancta Sanctorum. It is said that when the pope once dared to look at it, he lost his sight at that very instant. From then on, the image was covered entirely in gold and silver, except for the right knee, from which healing oil issues. This image is called *Uronica,* that is, the genuine [*essentialis*].

Another image in Rome is called the Veronica after a matron of that name. [Once, when the Lord was coming out of the temple, this woman lifted] her robe [*peplum*] and pressed it to his face. On it he left his image as an imprint. This image is likewise held in honor [*reverentia*], and no one can see it, except through the veils hanging in front of it [*nisi per velorum quae ante dependent, interpositionem*]. . . . And some say that Veronica is a play on words [*vocabula alludentes*], meaning the true icon [*veram iconiam*] or the true image [*imaginem veram*].

Now I shall deal with the *vultus Lucanus* [the *Volto Santo in Lucca*] that was not painted but carved in wood with pious skill by Nicodemus. Four bishops . . . who were sent to Constantinople for relics . . . brought back this image together with an ampoule and the blood that flowed from the icon crucified by a Jew [*de iconia a Judaeo crucifixa*].

D. Acts of Pope Innocent III (1208)

The *Gesta Innocentii Papae* (PL 214, 201, and Dobschütz 1899, 291*) mention a procession in 1208 to the hospital of S. Spirito near S. Maria in Saxia. Under Honorius it changed as a result of the miracle (cf. Dobschütz 1899, 295*).

At the said hospital, Innocent III [1198–1216] inaugurated a solemn station Mass [*stationem*] on the first Sunday after the octave of the Epiphany. The Christian populace gathered there to see and venerate the sudarium of the Lord, which was carried by a procession from St. Peter's to that place, singing hymns and psalms by torchlight. They also want to hear the sermon [*sermonem exhortatorium*] preached there by the Roman pontiff on the works of compassion [*de operibus pietatis*] and the remission [*indulgentiam*] of sins.

We, Honorius III [1216–27], decree that the likeness [*effigies*] of Christ at St. Peter's . . . shall be carried to the said hospital . . . in reverence, in a specially made reliquary [*capsam*] of gold, silver, and jewels. There, in the presence of the pope, it shall be shown to the faithful according to their expectation.

E. Matthew Paris, *Chronica majora* (after 1245)

For the year 1216 in his *Chronica majora,* the monk Matthew Paris from St. Albans near London reports on the miracle of the Veronica in Rome. In Codex 16 at Corpus Christi College, Cambridge, the text of fol. 49v is accompanied by an image (Suzanne Lewis, *The Art of Matthew Paris in the Chronica Majora* [Berkeley, 1986], 126ff. and pls. 4–5). The text was written soon after 1245 and was taken over into the author's *Historia Anglorum* (Richard Vaughan, *Matthew Paris* [Cambridge, 1958], 49ff. and 59ff.). On the use of the Veronica as a titular and devotional image, cf. Karen Gould, *The Psalter and Hours of Yolande of Soissons* (Cambridge, Mass., 1978), 81ff., and Lewis 1985, 100ff.

On the Veronica and its authentication [*autenticatione*]. As was customary, Pope Innocent . . . led the image [*effigiem*] in procession from St. Peter's to the hospital of Sto. Spirito. When the procession was over and people wanted to put the image back in its place, it turned round of its own accord [*se per se girabat*], so that it stood on its head with the forehead below and the beard at the top. The pope was shocked, taking it as a bad omen [*triste presagium*] and on the brothers' advice wanted to make amends to God. He therefore composed an elegant prayer in honor of the image, to which he added a psalm with a number of verses [probably Ps. 4:7], and granted a ten days' indulgence to all who said the prayer. . . . Many have commended the prayer and everything connected to it [*cum pertinenciis*] for memorization [*memorie commendarunt*] and, to arouse more devotion in themselves, have illustrated it as follows [*picturis effigiarunt hoc modo,* followed by a framed miniature with a bust of Christ on a gold ground]. The name "Veronica" is derived from a woman of that name, at whose request Christ printed his face on the cloth [in red]. One should make the sign of the cross and say [*signans se igitur homo dicat*]: The light of your countenance, O Lord, has appeared to us [*signatum*]; [after Ps. 4:7. There follow Ps. 85:16; 26:18; 104:4, and 79:20 and the prayer said to have been composed by Innocent]. Lord, you have left behind for us, who are marked [*signatis*] by the light of your face, the image imprinted on the cloth of Veronica [*sudario impressam imaginem*] as your memento [*memoriale*]. Grant, for the sake of your Passion and the cross, that we, as we now adore and venerate this on earth in a mirror and parable [*per speculum et in enigmate*], shall one day see you face to face [*facie ad faciem*] as judge on the good side [*securi*].

F. Two Latin hymns on the Holy Face (13th and 14th centuries)

In its original version, the hymn "Ave facies praeclara" (Ulysse Chevalier, *Repertorium hymnologicum,* no. 17914; Dobschütz 1899, 298* no. 40) is linked with Innocent IV (1243–54). A similar hymn, "Salva sancta facies" (*Repertorium hymnologicum,* no. 18189; Dobschütz 1899, 306* no. 60), is dated in the period of John XXII (1316–34). On the tradition, cf. Solange Corbin de Mangoux, "Les offices de la Sainte Face," *Bulletin des études portugaises,* n.s., 11 (1947): 1–65.

Here we quote the original text of only the main passages of the two hymns. The first hymn praises the face grown pale on the cross but darkened by fear and stained with blood, which has kept its form in the linen cloth and has become the standard of compassion. The second hymn ventures a reference to the divine light in the face that was imprinted in the snow-white cloth. It attributes the unpainted face to the supreme Artist.

> Ave facies praeclara
> quae in sancta crucis ara
> facta es sic pallida.
> Anxietate denigrata
> sacro sanguine rigata

te texit linteola
in qua mansit tua forma,
quae compassionis norma
cunctis est prelucida. . . .

Salve sancta facies nostri redemptoris,
in qua nitet species divini splendoris,
impressa panniculo nivei candoris
dataque Veronicae signum ob amoris. . . .
Non depicta manibus, sculpta vel polita:
Hoc scit summus artifex qui te fecit ita. . . .

38. The "Icon of God" in the Mystical Theology of Nicholas of Cusa
Nicholas of Cusa, *The Vision of God* (1453)

Nicholas of Cusa's treatise *De visione Dei*, dedicated to the monks of Tegernsee, is accompanied by a panel painting of the All-seeing Christ, whose eyes follow the viewer everywhere. This example is intended to illuminate for the reader the relation between the Creator and the creation, which the text discusses. Cf. the Latin edition: *Nicolai de Cusa Opera Omnia*, vol. 4, ed. M. Bodewig and R. Haubst; the German translation: Nikolaus von Kues, *Des Sehen Gottes*, trans. H. Pfeiffer (Trier: Institut für Cusanus-Forschung, 1985); and the English, on which the following selections are based: *Nicholas of Cusa's Dialectical Mysticism*, trans. J. Hopkins (Minneapolis: Arthur J. Banning Press, 1988).

If I strive to convey you by human means unto divine things, then I must do this through a likeness [*similitudine*]. Now, among human works I have not found an image more suitable to our purpose than the image of someone omnivoyant, so that his face, through subtle pictorial artistry, is such that it seems to behold everything around it. . . . I am sending to Your Love [such] a painting [*tabellam*] that I was able to acquire. It contains the figure of an omnivoyant [individual]; and I call it the "icon of God" [*eiconam Dei*].

Hang this icon somewhere, e.g., on the north wall; and you brothers stand around it, at a short distance from it, and observe it. Regardless of the place from which each of you looks at it, each will have the impression that he alone is being looked at by it. . . .

Moreover, if while fixing his sight [*visum*] upon the icon [a brother] walks from west to east, he will find that the icon's gaze proceeds continually with him; and if he returns from east to west, the gaze will likewise not desert him. . . .

On the basis of such a sensible appearance [*apparentia*] as this, I propose to elevate you very beloved brothers, through a devotional exercise, unto mystical theology (Preface).

Whatever is *apparent* with regard to the icon-of-God's sight is *truer* with regard to God's true sight. . . . Therefore, if in the image the depicted gaze can appear to be beholding each and every thing at once, then since this [capability] belongs to sight's perfection, it cannot truly befit the Truth *less* than it apparently befits the icon, or appearance. . . . Absolute Sight, from which comes the entire sight of those who have sight, excels all the acuity, swiftness, and power both of all those who actually have sight and of all those who can be given it. For suppose I view abstract sight [*abstractum bisum*], which mentally I have freed from all eyes and organs [and from all conditions of time and place]. . . .

. . . [It belongs to God alone.] Hence, the appearance of the icon's gaze is less able to

approximate the supreme excellence of Absolute Sight than is conception. Therefore, that which is apparent in the case of that image must undoubtedly be present in an excellent way in Absolute Sight (chap. 1).

Absolute Sight encompasses all modes of seeing—encompasses all modes in such way that it encompasses each mode. And it remains altogether free from all variation. For in Absolute Sight every contracted mode of seeing is present uncontractedly [*incontracte*] (chap. 2).

Now, O brother contemplative, draw near to the icon of God and . . . a speculative consideration [*speculatio*] will be occasioned in you [by the gaze that follows you]. . . .
 [A prayer should express the icon's gaze as the experience of God's providence and love. The guarantee of partaking in the being of God is provided by similarity.] Therefore, if by every possible means I make myself like unto Your goodness, then according to my degree of likeness thereto I will be capable of receiving truth. . . .
 . . . I presently contemplate eternal life in a mirror, an icon, a symbolism, because eternal life is only Your blessed gaze (chap. 4).

The invisible Truth of Your Face I see not with the bodily eyes which look at this icon of You but with mental and intellectual eyes. This Truth is signified by this contracted shadow-like image. But Your true Face is free of all contraction. For it is neither quantitative nor qualitative nor temporal nor spatial. For it is Absolute Form. . . . It is, therefore, Truth, or Equality [*aequalitas*], that is free from all quantity [and identical with itself without limit or disproportion]. . . . Therefore, every face that can look at Your Face sees nothing that is *other* than itself or *different* from itself, because it sees its own Truth. But Exemplar-Truth cannot be other or different; instead, these characteristics befall the image, by virtue of the fact that it is not the Exemplar. [Thus the face of God looks as different to each beholder as that beholder is different from others—young or old, joyful or sad—and in this changing agreement remains always present as the archetype. It corresponds to the understanding the beholder has of it, not to absolute being, which cannot be understood] (chap. 6).

The one who looks unto You does not bestow form upon You; rather, he beholds himself in You, because he receives from You that which he is. And so, that which You seem to receive from the one who looks upon You—this You bestow, as if You were a living Mirror-of-eternity, which is the Form of forms. When someone looks into this Mirror, he sees hiw own form in the Form of forms, which the Mirror is. And he judges the form seen in the Mirror to be the image of his own form, because such would be the case with regard to a polished material mirror. However, the contrary thereof is true, because in the Mirror of eternity that which he sees is not an image but is the Truth, of which the beholder is the image. Therefore, in You, my God, the image is the Truth and Exemplar of each and every thing that exists or can exist [and so is also our own archetype, of which we are copies] (chap. 15).

39. The Breaking of Images, as Seen by the Reformation

The destruction of images broke out in 1522 in Wittenberg, where it found its first advocate in Karlstadt and its first opponent in Luther. In 1524, on the advice of Zwingli, images were removed in Zurich without violence. In Basel, Erasmus of Rotterdam criticized the breaking of images in 1529. The four contemporary documents below illuminate various positions in this controversy.

A. Karlstadt, justifying the breaking of images (1522)

In 1522 the Wittenberg theologian Andreas Karlstadt published his treatise *Von Abtuhung der Bilder und das keyn bedtler unther den Christen seyn sollen*. Page numbers below refer to the edition by Hans Lietzmann, which is volume 74 in the series *Kleine Texte für theologische und philosophische Ubungen* (Bonn, 1911).

On the extirpation of dummies. The fact that we have images in our churches is . . . against the First Commandment: "Thou shalt not have strange gods." That carved and painted idols should stand on altars is still more damaging and devilish. . . . Churches are houses in which God alone should . . . be worshiped (4). Why have we had images painted with satin and damask . . . and adorned them with gold crowns? . . . Statues are hideous, and it follows that we become hideous if we love them. They strangle their worshipers, . . . so that our temples can be called murderers' graves, for our spirit is killed in them (5). [God reproaches us:] You offer them wax ex votos in the form of your sick arms and legs . . . as if such images would have healed you (5).

 Artists, as the perpetrators of the images, are good for nothing and understand nothing [cf. the *plastae idoli* in Isa. 44:9]. . . . Who then can say that their images are useful? [This can be proved from Isaiah 44], who is a Protestant prophet (9). The image-maker makes an image and bends double before it . . . praying that it might redeem him. . . . They have forgotten that the images' eyes do not see, nor do their hearts understand (12).

B. Luther's reply (1522, 1525)

Luther begins his reply in the *Invocabit* sermons of March 1522 (Weimar edition [*WA*], 10.3) and extends it in 1525 into two long texts, the treatise *Wider die himmlischen Propheten* (Against heavenly prophets) and a sermon on Exodus (*WA* 18:62ff. and 16:437ff.).

[Misunderstanding of images] is no reason to remove all images. . . . We must permit them. . . . But you are to preach that images are nothing: God does not ask about them. . . . [It is] better to give a poor man a guilder than to give God a gilded image [as a donor; the abuse lies not in the object but in the user] (*WA* 10.3:31–32).

I have attacked the breaking of images because I seek first to tear [images] from the heart by God's word, by making them despicable. . . . For when they are cast out of the heart, they no longer harm the eye (*WA* 18:67). [The breakers of images base themselves on the force of law and the error of believing that by destroying images they gain the approval of God.] Thus, by following such laws, they do away with outward images while filling their hearts with idols . . . false justice and fame through works. . . . The Jews shun outward idols . . . yet in their hearts they are for God full of idols (68, 78). I, who as a Christian command no power on earth, as a preacher guide the people and see to it that images are removed in an orderly manner without fanaticism and violence (75).

 Up to now we have made images while believing . . . that we were doing a great service to God by honoring them. We had confidence in them. But they not only cost us our money but our souls. . . . Now we do not need to break the arms and legs of such images . . . for our hearts would still be impure; we must persuade the people by the word to trust them no more. . . . For the heart must know that nothing can help it . . . but God's grace and goodness alone (*WA* 16: 440). Although the Jews have a commandment that they should have no graven images, they have interpreted it too narrowly. For God prohibits the images that are erected, prayed to, and set in God's place. There are two kinds of images, and God therefore makes a distinction. . . . So that here no image is forbidden except God's image that is worshiped (441). [On Luther's

view that God's commandments do not apply for all time but only to a single historical moment, cf. Stirm 1977, 41ff. and 59ff.]

C. Zwingli, on the removal of images in Zurich (1524)

On 21 May 1524 H. Zwingli proposed to the council of Zürich how images should be dealt with and later achieved their nonviolent removal while preserving the citizens' rights of property (*Sämtliche Werke*, 2:115–16, and commentary in Garside 1966, 156–57).

Private citizens who have made images or had them made . . . may remove them from the churches within a week and keep them. If they do not do so, the sacristans will do it. . . . If the images have been donated by the parish . . . the parish should decide by a majority whether to leave them or not. . . . But no one shall henceforth have an image made in order to donate it to a church, and no sculptor should offer his services for such purpose on pain of punishment. But if a parish wishes to leave its images in the church, it should no longer burn candles before them or light incense before them . . . but should turn all its thoughts to honoring God and our Redeemer. [Only the crucifix shall be preserved] because it does not signify any deity but only the humanity and suffering of Christ, and because it is a sign to Christians.

D. Erasmus's position (1529, 1533)

Erasmus was uncomfortable about the way in which images were destroyed, as these two selections indicate. The first is from a letter he wrote on 9 May 1529 to Willibald Pirckheimer in Nuremberg, in which he described the destruction of images, as he witnessed it in Basel (P. S. Allen, *Opus Des. Erasmi Roterodami* 8:161–62). The second is a passage from his *Modus orandi* (1533), in which he discusses the misuse of images but nevertheless opposes their destruction (*Opera* 5:112ff., and Panofsky 1969, 208–9).

When it was decided to take violent action against the sacred images [*in divos*], a crowd armed with crowbars came together on the square before the minister and carried on its mischief for nights, building a mighty fire that frightened everyone. The city council put an end to the tumult and decided that people were allowed to have craftsmen and artists remove whatever they liked from churches. The images of donors [*simulacra*] and tombs and even the crucifixes were much derided [*ludibriis*] because, curiously, no miracles now happened, whereas earlier they had occurred when much lesser indignities were inflicted on the holy objects. But of the sculptures nothing is left either in the churches or in the vestibules. Paintings have been covered in whitewash. . . . Neither costliness nor skill [*nec pretium nec ars*] caused anything to be spared.

[Erasmus considers pilgrimages and church processions] a legacy of ancient paganism. It was easier for the Christians to change a belief than a public custom. Above all, saints, their rank determined by their miracles, enjoyed the favor of cults. . . . This was tolerated by the church fathers. But since then, many abuses have arisen, and one sees the saints portrayed in senseless and even indecent images. There are images that invite lasciviousness rather than piety. All the same, we should tolerate them, for I see greater evil in destruction than in tolerance.

40. Image and Word in the Teaching of Luther (1522–44)

Martin Luther's teaching on images gradually became more complex and tolerant. Nevertheless, he continued to assert the neutrality of images and their loss of function for the

enlightened beholder, and also to champion the absolute priority of the word. Even in the biblical text the word is differentiated, with the word of God or the clarifying concept distinguished from metaphoric speech and disorganized visions. Luther also made practical suggestions for introducing a new image in Protestant church art.

The following statements of Luther (all based on the Weimar edition [*WA*]) consider the nature of images, the significance of the word, and the character of the new church art. On Luther's doctrine of images, cf. Hans Preuss, *Martin Luther der Künstler* (Gütersloh, 1931); Campenhausen, 1957b, 150ff.; F. W. Kantzenbach, "Bild und Wort bei Luther," *Zeitschrift für systematische Theologie und Religionsphilosophie* 16 (1974): 57ff.; J. S. Preus, *Carlstadt's Ordinaciones and Luther's Liberty* (Cambridge, Mass., 1974); Stirm 1977, 23ff. and passim.

I. [The freedom from justification by works makes images themselves neutral, on the use of which the beholder alone decides. This doctrine is advanced for the first time in the "Invocabit" sermons of 1522.] As for images, the situation is that they are unnecessary but free. We may want to have them or not to have them (*WA* 10.3:26). The worshiping is forbidden, not the making (27). For in my opinion there is no person who would not have sufficient understanding to be able to say: The crucifix standing there is not my God, for my God is in heaven. It is only a sign (31). Therefore I must admit: images are neither one thing nor the other, neither good nor wicked. One may have them or not. . . . It is possible that there may be people who can make good use of images (35).

Where hearts are instructed that one pleases God by faith alone and that images cause him no pleasure . . . they give them up of their own accord (*Wider die himmlischen Propheten* [1525], *WA* 18:67). But when images or columns are made without idolatry, such making is not forbidden, for the main teaching [of Moses' commandment against other gods] is not violated (69). Thus the breakers of images will have to leave me too a crucifix or image of the Virgin . . . provided I do not worship them but use them for remembrance (70). [One has to confront images with the gospel and thereby] instruct and illuminate the conscience. [Idols may be destroyed or left intact.] The images that remind and bear witness, like crucifixes and saints' images . . . should probably be tolerated . . . and, since memory or witness adheres to them, are even praiseworthy as well (74). We desire no more than to be left a crucifix or saint's image to look at, to bear witness, to remind, and as a sign, like the image of the emperor (80).

Images, bells, vestments, church adornments, altar lamps, and such I hold free. Those who want them may keep them. I even consider images from the Scriptures or depicting good histories to be almost useful, but I leave this open to everyone to decide (*Vom Abendmahl Christi* [1528], *WA* 26:509).

II. [In our context the word of God plays an important part in several ways. It is the medium of God's self-revelation and thus of absolute importance for salvation. But its use for the prohibition of images in the Old Testament is of limited validity and applies only to the Jews of that time. It sanctifies all things and even transforms bread into the sacrament. It is the subject of the sermon and the instrument of faith, a means of creating order that, in its conceptuality, ranks higher than inner visions, permitting the control of the community.]

The word of God is the most sacred of all objects, the only sacred object that we Christians know and possess. Even if we had all the bones of all the saints . . . they would not help us. For all that is dead matter that can sanctify no one. But the word of God is the treasure that makes all things holy. . . . In the hour one hears . . . God's word, . . . the person, the day, and the work are made holy, not for the sake of the outward work, but for the sake of the word, which makes us all saints (German Catechism [1529], *WA* 30.1:145). [The sacrament of the altar is not usual bread and usual wine] but bread and wine clasped in God's word and bound to it. The word, I say, is what makes this sacrament. . . . [Invoking St. Augustine, Luther continues:] The

word has to transform the element into the sacrament. When it does not do so, it remains mere element. . . . It is not founded on human holiness but on God's word [so that the consecrator is unimportant]. . . . The word through which it became a sacrament is not falsified by persons or disbelief. . . . Words are our sole foundation, our protection and defense against every error and seduction (223–24).

Now that God has sent forth his holy gospel, he deals with us in two ways. First he deals outwardly . . . through the oral word of the gospel and by physical signs such as baptism and the sacraments. He deals inwardly with us through the Holy Spirit and by faith, together with other gifts. But all this . . . in such a way that outward things must go first . . . and the inner ones after them. . . . For he will give no one spirit or faith without the outer word and the signs that he has used in addition (*Wider die himmlischen Propheten*, WA 18:136).

[In connection with the revelation according to St. John, Luther defines where the true word of God is to be found in the holy Scriptures. He mistrusts fantastic visions and images, since the apostles always express themselves] in a clear and understandable way, without images or visions . . . in clear, dry words. [He therefore distinguishes between three kinds of prophecy. The first] makes use of expositional words, without images and metaphors [among these he includes Moses, David, and Christ. The second] uses images, but adds an interpretation in explicit words. [He relegates the Apocalypse to the third and lowest kind of] prophecies that speak only in images (*Vorreden zur Offenbarung des Johannes* [1530], WA 7:404 and 406).

III. [The role of images as signs and memory aids increases if one includes biblical quotations, which guide us back through images to the word of God. Like texts, images can point to God's works. They are outward signs that the beholder does not worship but interprets.]

[Even the destroyers of images use Luther's German Bible with its illustrations. They should therefore allow us] to paint such images on the wall for the sake of memory and better understanding, since they can do no more harm on walls than in books. It is better to paint on the wall how God created the world, Noah built the ark, and all the other good histories, than to paint some shameless worldly thing. I wish to God that I could persuade the powerful and rich to paint the whole Bible word for word on houses for everyone's eyes. I know for certain that it is God's wish for his works to be heard and seen, especially the sufferings of Christ. But if I am to hear or think about it, it is impossible for me not to form images of it in my heart. When I hear Christ, an image of a man hanging from a cross appears in my heart, just as . . . my face naturally casts an image in water when I look into it. If it is not sin, but good that I carry Christ's image in my heart, why should it be a sin if I have it in my eyes? The heart is surely worth more than the eyes . . . being the true seat of God (*Wider die himmlischen Propheten*, WA 18:82–83).

A small image of the Virgin on paper [became an idolatrous image because people expected it to help them]. But the other images, in which one . . . sees only past history and objects as in a mirror, they are reflections. Them we do not condemn. The only idolatrous images are those in which one puts one's trust, but not the signs on coins. . . . An image on a wall that I look at without superstition is not forbidden. Otherwise mirrors would be forbidden (WA 28:677–78).

I do not think it a bad thing for such histories [from the Bible] to be painted in rooms and chambers, with mottoes, so that one can have God's work and word always and everywhere before one's eyes (WA 10.2:458).

[On the altar one should] paint the Last Supper and these two verses . . . [Ps. 114:4, with the invocation of the name of God and the plea for redemption] around it, so that they are there for the eyes and the heart can think upon them (*Psalmenauslegung* [1530], WA 31.1:415).

Nothing other should happen in [the chapel] than that our dear Lord himself should speak to us through his sacred word, and that we should speak to him through prayer and song (in Luther's sermon at the consecration of the Schlosskapelle at Torgau, 1544).

41. Image and Truth in Calvin's Doctrine
John Calvin, *Institutes of the Christian Religion* (1536–59)

In his dogma on Christian faith, John Calvin follows a different path from Luther's. Philosophically and ethically Calvin is a rigorist who tolerates no blurring of the dualism between spirit and matter. For this reason he opposes not only the veneration but even the production of images representing God. The Scripture is the only mirror in which one can see the invisible God. The Scripture is the image of the spirit, and the sacrament is only an agreed sign that does not partake in the nature of God. Finally, Calvin develops an aesthetic of the image that, as a product of art, is limited to visible models and has a solely didactic purpose.

The *Institutes* appeared in Latin in 1536, in French in 1541, and in a heavily revised final Latin version in 1559. The early version is quoted in the edition by P. Barth and W. Niesel, *Opera Selecta* (*OS*) (Munich, 1928), and the French version is cited from the edition by J. D. Benoit (Paris, 1962). Otherwise I have used as a basis the German translation of the final version by O. Weber, *Unterricht in der christlichen Religion* (Neukirchen, 1955). Section numbers below refer to the standard division of the *Institutes*. Cf. E. Doumergue, *L'art et le sentiment religieux dans l'œuvre de Calvin* (Geneva, 1902); L. Vencelius, *L'esthétique de Calvin* (Paris, 1937); L. Beddinger Dubose, *The Transcendent Vision: Christianity and the Visual Arts in the Thought of J. Calvin* (Louisville, 1965); Stirm 1977, 161ff.

I. [For humankind after the Fall, God is no longer recognizable in his creation but only in his word, which alone in this world has divine authority.] The word allows us to see God in the manner of a mirror. [In the human life of Jesus only God's actions are manifested, not his incarnate image. Only the abstract word with its power to describe actions is the bridge to God.] Hence the word is like a mirror in which faith contemplates God (*OS* 3:153 and 4:14). The divine spirit . . . wishes to be recognized in the image conveyed by the Scripture. It is the writer of the Scripture—so it cannot change or be unlike itself. . . . The Holy Spirit is so bound to its truth that it only expresses its power . . . when its word is perceived. . . . The Lord had linked together the certainty of his word and his Spirit. . . . We receive the Spirit . . . when we recognize it in its image, the word (1.9.2, Weber, 36).

II. [The sacrament is a sign that is separate in principle from the body of Christ, which it symbolizes, and can be confused with this body only by a Satanic fantasy.] The bread is only a sacrament for the eyes of those people to whom the word is addressed. [The laws of nature cannot be transcended.] The Last Supper offers no reason for us to believe the body of Christ to be the true flesh, unless by agreement in an external sign. . . . The authors of the Old Testament express the fact that Christ's body hung from the cross by an allegory. Others see that one cannot change the relation [*proportion*] that exists between the sign and the thing signified. . . . Nevertheless, they believe Christ's body to be contained within it. I can only agree with them to the extent that truth is inseparable from their sign (4.16; Benoit 4:393). As regards the affinity between the beings referred to and their images [*figures*], we profess that the name "body" was attributed to the bread . . . through a resemblance [*similitude*]. . . . This is a figure of speech that is always used by the Scripture when it refers to the sacraments (Benoit 4:401).

III. [An image of God can never be anything other than an anthropomorphic idol and so constitutes an insult to God, which furthermore violates his express commandment.] The Second Commandment signifies that all cults and all worship should be directed toward God alone. As God is unimaginable, incorporeal, and invisible . . . we may not represent him by any *figura* or *simulacrum,* nor by any idol, as if it had some resemblance to God. Let us rather adore God, who is pure spirit, in spirit and in truth [*in spiritu et in veritate*]. Thus the [Mosaic] commandment teaches us what God is like and . . . forbids us to invent a fleshly form for him or to subject him to our senses. . . . All idolaters were convinced that God was as their vain minds imagined. . . . The mind brought forth the idol, the hand merely executed it (1.1, *OS* 1:42–43). To be sure, some passages in the Bible offer descriptions in which his true face appears pictorially [*eikonikos*] imaginable. . . . But they do not describe how he is in himself, but as he presents himself to us. . . . We therefore experience God . . . as he manifests himself in words [*verbo declarat*] (1.10, *OS* 1:86).

The world has been seized by a crude absurdity in wishing to possess a visible form of God. . . . [Isaiah warned against] debasing God's majesty . . . by representing the incorporeal in physical stuff, the invisible in a piece of petty wood. . . . [The symbols of the dove and the ark of the covenant signify only] that images are unsuited to representing the secrets of God (1.11, Weber, 40–41). The origin of the idol lies . . . in the belief that God will come to a person's aid if he is depicted as physically present (Weber, 45). . . . Why have such differences been made between the images of the same God that one is ignored . . . and another worshiped to excess? . . . Why do people not grow tired of gazing in solemn processions at images that everyone already has at home? (Weber, 47).

IV. [With this argument Calvin passes from the problem of the representation of God to that of the cult of images and criticizes the hair-splitting distinction between worship and veneration, *douleia* and *latreia,* which he seeks to refute in terms both of substance and of philology, since both amount to the same thing: the cult of God in the cult of images (1.11; Weber 47–48 and *OS* 1:99–100).]

V. [Finally, Calvin raises the question whether other images are entitled to exist, and so touches on the function of art.] Despite this superstition, I do not rule out the possibility that images should exist at all. But as sculpture and painting are gifts of God, I require them to have a pure and legitimate use [*purum et legitimum usum*], so that what God has given us . . . should not be abused. We believe it a crime [*nefas*] to depict God in a visible form, for he has forbidden it, and it cannot be done without deforming his glory. . . . It therefore remains to paint and sculpt only that of which our eyes are capable [*capaces*]. God's majesty, which far surpasses our sight, should not be corrupted in unseemly forms. The permissible images include histories and events [*res gestae*], as well as images and forms of bodies, without historical significance. The former serve to instruct and admonish [*docendo vel admonendo*], while the latter can offer nothing beyond enjoyment [*oblectationem*]. Yet it is precisely images of this last kind that have always been displayed in churches. We may say that they did not serve judgment or enjoyment, but foolish . . . covetousness (1.12, *OS* 1:100–101).

42. The Artistic Character of the Image

About 1500, even outside the direct sphere of the Renaissance, some voices reevaluated the image as a work by an artist—that is, as a product of art. Concurrent with its loss of religious authority and its becoming no more than an agreed-upon symbol, the image began to be

evaluated aesthetically, and judgments on it passed to the art connoisseur. The five documents in this section reveal new approaches to the image by contemporary artists. They evaluated the image in terms of artistic merit, which they believed ultimately determined its beauty and rank. At this point there still was no clear distinction between the old and the new aesthetics of the image.

A. Jacopo de' Barbari, letter to the elector of Saxony (ca. 1502)

> About 1502, as a way of offering his services, the Venetian painter Jacopo de' Barbari wrote a letter in Italian to Elector Frederick the Wise of Saxony on the *eccelentia de[lla] pittura*. Jacopo, then staying at Nuremberg, wished to raise the status of painting (and the artist), arguing that it belonged to the *artes liberales*. The ideas expressed here had been in circulation since Albert's book on painting. Cf. P. Kirn, "Friedrich der Weise und Jacopo de' Barbari," *Jahrbuch der preussischen Kunstsammlungen* 46 (1925): 130ff., and J. A. Levenson, *Jacopo de' Barbari and Northern Art of the Early Sixteenth Century* (New York, 1978), 8ff. and 342ff.

[Jacopo writes about the former status of painting as an art cultivated in antiquity by the nobility, and about its subsequent decline.] And without these arts [the *artes liberales*], artists cannot produce any appropriate painting. They have to be experts in the arts mentioned, particularly geometry and arithmetic, the two conditions for the measurement of proportion [*commensuracione de proportione*]. There is no proportion without numbers, and no form without geometry. If painters are to depict the forms of nature with understanding, they must above all study the proportions of human beings, whose forms and measurements are perfect. . . . They also need poetry, which arises . . . from grammar and rhetoric, in inventing their works [*la inventione de le hopere*] and also a wealth of histories. . . . Finally, astronomy deserves special attention [*diligencia*] in painting, for it gives rise to physiognomy and chiromancy through the influence of the stars. Humans receive this influence . . . particularly in their faces and hands, and artists must pay attention to this when they attribute signs [*segni*] to people in accordance with the history or poetry concerned. [Finally, optics too are brought into the ambit of art in keeping with the text *De anima* by Aristotle.]

If artists lack this knowledge [*intelligenzie*], their works become unbelievable and false, as one sees today. Art has fallen into the hands of uneducated [*innobeli*] painters, so that it does not attain the quality possessed by Apelles and others in Alexander's day. It is not talent that is lacking, but practice and education [*commoditade e nobilitade*]. . . . Painting is . . . an inanimate nature [*natura exanimata*] that brings forth visibly what nature produces tangibly and visibly. [It contains all the other arts and can be regarded as the eighth and highest of the liberal arts.]

B. Franz von Sickingen, circular (1522)

> In his *Sendschreiben,* von Sickingen discusses the religious and artistic aspects of images. The following translation is based on Warnke 1973b, 73.

One can be improved by such works as well as annoyed by them. If they are worshiped from a false faith, that is idolatry. . . . But if in contemplating them, one considers the steadfast lives [of the saints] and their firm faith in Christ, and takes their lives and work as a model . . . such images would be fertile. My concern is that that seldom happens but, rather, art and beauty are seen in them. This leads our minds . . . astray from the true path in God, for which reason they would almost be more useful as ornaments for fine rooms than in churches, so that the cost and . . . trouble would not be wasted.

C. Albrecht Dürer, *The Painter's Manual* (1525)

Dürer dedicated his *Painter's Manual* to his friend Willibald Pirckheimer. He took the occasion to affirm the artistic quality of the image, rejecting the charge that images foster idolatry. For the original German text, cf. H. Rupprich, *Dürer: Schriftlicher Nachlass,* vol. 1 (Berlin, 1956), 114–15. The following translation is by Walter L. Strauss (New York: Abaris Books, 1977), 37.

It has until now been the custom in our Germany to put a great number of talented lads to the task of artistic painting without real foundation other than what they learned by daily usage. They have therefore grown up in ignorance like an unpruned tree. Although some of them have achieved a skillful hand through continual practice, their works are made intuitively and solely according to their tastes. Whenever knowledgable painters and true artists had occasion to see such unplanned works, they smiled—not without reason—about the ignorance of these people. Nothing is more annoying to men of understanding than a blunder in a painting [*falscheyt im gemel*]. . . . Because such painters have derived pleasure from their errors has been the sole reason that they never learned the art of measurement. . . .

It is this skill which is the foundation of all painting. For this reason, I have decided to provide to all those who are eager to become artists a starting point and a source of learning about measurement with ruler and compass. From this they will recognize truth as it meets their eyes. . . . At the present time the art of painting is viewed with disdain in certain quarters, and is said to serve idolatry. A Christian will no more be led to superstition by a painting or a portrait than a devout man to commit murder because he carries a weapon by his side. It must be an ignorant man who would worship a painting, a piece of wood, or a block of stone. Therefore, a well-made artistic, and straightforward painting gives pleasure rather than vexation. The books of the ancients show the degree of honor and respect in which the Greeks and Romans held the arts, in spite of the fact that they were later lost or lay in hiding for a thousand years. Only during the last two hundred years they were again brought to light by the Italians.

D. Johannes Butzbach, *On Famous Painters* (1505)

In this treatise, the Laach Benedictine Johannes Butzbach gives a painter-nun a moral history of Christian art by emphasizing its superiority over the art of antiquity. The ancient artists are seen both as models and as a challenge to be surpassed. Cf. O. Pelka, ed., *J. Butzbach, Von den berühmten Malern* (Heidelberg, 1925), and Decker 1985, 269–70. Decker compares this view with the one that is manifested in the inscriptions on a Madonna figure by Daniel Mauch, produced about 1535 for the Liège humanist Berselius. They claim that the ancient times have handed over the palm to the new and that the illustrious statues of antiquity were nothing beside Daniel's own work, which is thus presented as the invention of the artist.

[For Butzbach, Christian doctrine and Christian themes enable virtuous painters to surpass even the art of Phidias or Apelles. As the addressee of Butzbach's treatise was not depicting] the image or the deeds of false gods . . . but the true God and his Mother, the most beautiful of all women, and the saints who already reign with them in the heavenly realm, she will be able to present them more artistically and delicately . . . than [do the heathens. In the second part the divine origin of art is stressed, for Christ, says Butzbach, was the only painter and sculptor. But art was lost through the decline in morals and was restored only by Giotto, in a kind of reform of the virtues.]

E. Leonardo da Vinci, *Treatise on Painting*

Among the writers left behind by Leonardo were some notes for a textbook on painting, which was intended to present painting as a science (*scientia*) and to enhance its status by comparing it with poetry and sculpture. The author adopts a sophistic approach whereby he deduces the favor of the painted image in the eyes of God from its cult uses. In a play on words, God (*Iddio*), the subject of the cult image, is associated with the artist's conception (*idea*), the idea of the work. The following translation appears in Martin Kemp, ed., *Leonardo on Painting* (New Haven: Yale University Press, 1989), 20.

Do we not see pictures representing the divine beings constantly kept under coverlets of the greatest price? And whenever they are unveiled there is first great ecclesiastical solemnity with much hymn singing, and then at the moment of unveiling the great multitude of people who have gathered there immediately throw themselves to the ground, worshipping and praying to the deity, who is represented in the picture, for the repairing of their lost health and for their eternal salvation, exactly as if this goddess [*Iddea*] were there as a living presence. This does not happen with any other science or other works of man, and if you claim that this is not due to the power of the painter but to the inherent [supernatural] power of the thing represented, it may be replied that in this case the minds of the men would be satisfied were they to remain in their beds rather than going to wearisome and dangerous places on pilgrimages, as may be continually witnessed. But since such pilgrimages continue to take place, what causes their inessential travels? Certainly you will concede that it is the visual image [*simulacro*]. All the writings could not do this, by representing so potently the form and spirit of this deity [*Iddea*]. Accordingly it would seem that the deity [*Iddea*] loves this painting and loves those who love and revere it, and takes delight in being adored in this way rather than in any other form of imitation, and thus bestows grace and gifts of salvation in accordance with the faith of those who gather in that location.

43. The Council of Trent on the Veneration of Saints and the Honoring of Images (1563)

At its twenty-fifth session, the Council of Trent (1545–63) promulgated resolutions that reaffirmed equally the intercession of saints, the veneration of relics, and the honoring of images. The translation below is from Norman P. Tanner, ed., *Decrees of the Ecumenical Councils,* 2 vols. (London: Sheed & Ward; Washington, D.C.: Georgetown University Press, 1990), 2:774–76.

The holy council charges all bishops and others with the office and responsibility of teaching, according to the practice of the catholic and apostolic church received from the earliest times of the christian religion, to the consensus of the holy fathers and to the decrees of the sacred councils, as follows: they are first of all to instruct the faithful carefully about the intercession of the saints, invocation of them, reverence for their relics and legitimate use of images of them. . . . And they must also teach that images of Christ, the virgin mother of God, and the other saints should be set up and kept, particularly in churches, and that due honour and reverence [*honorem et venerationem*] is owed to them, not because some divinity or power [*divinitas vel virtus*] is believed to lie in them as reason for the cult, or because anything is to be expected from them, or because confidence should be placed in images as was done by the pagans of old; but because the honour showed to them is referred to the original which they represent: thus, through the images which we kiss and before which we uncover our heads and go down on our knees, we give adoration to [*adoremus*] Christ and veneration to [*veneremur*]

the saints, whose likeness [*similitudinem*] they bear. And this has been approved by the decrees of councils, especially the second council of Nicaea, against the iconoclasts.

Bishops should teach with care that the faithful are instructed and strengthened by commemorating and frequently recalling the articles of our faith through the expression in pictures or other likenesses of the stories of the mysteries of our redemption; and that great benefits flow from all sacred images, not only because people are reminded of the gifts and blessings conferred on us by Christ, but because the miracles of God through the saints and their salutary example is put before the eyes of the faithful, who can thank God for them, shape their own lives and conduct in imitation of the saints, and be aroused to adore and love God and to practise devotion. If anyone teaches or holds what is contrary to these decrees: let him be anathema.

The holy council earnestly desires to root out utterly any abuses that may have crept into these holy and saving practices [*observationes*], so that no representations of false doctrine should be set up which give occasion of dangerous error to the unlettered. . . . All superstition must be removed [*tollatur*] from invocation of the saints, veneration of relics and use of sacred images [*imaginum sacro usu*]; all aiming at base profit must be eliminated; all sensual appeal [*lascivia*] must be avoided, so that images are not painted or adorned with seductive charm [*procaci venustate*]. . . . And lastly, bishops should give very great care and attention to ensure that in this matter nothing occurs that is disorderly, . . . nothing profane and nothing unseemly [*inhonestum*], since holiness befits the house of God.

44. The Justification of the Image by Cardinal Paleotti
Gabriele Paleotti, *Discourse on the Sacred and Profane Images* (1582)

> Gabriele Paleotti, archbishop of Bologna, planned a five-volume work on images, the first two volumes of which were published in 1582. He offers a proof based on tradition, using much exegetical and historical subtlety, on the basis of the doctrines of Trent. Taking issue with contemporary theories of art, he defends the position of the church. The sacred or cult image is distinguished from the profane on the grounds that it represents the old state of affairs in a new time and that it alone justifies the cult of images. The arguments take account of the new era of art, but their thrust is familiar and their tenor defensive. Above all, they seek polemically to isolate from the art produced at the time those images that were still suited to serve church functions. Cf. G. Paleotti, "Discorso intorno alle imagini sacre e profane," ed. P. Barocchi, in *Trattati d'arte del cinquecento*, 2 vols. (Berlin, 1961).

[The image the book is concerned with is defined as follows: It is material in nature and is produced by the art of *disegno*, instead of being a reflection of nature; it is modeled on a previous image through similarity. It is thus distinct, following St. Augustine, both from an identity (*aequalitas*) and from a similitude (*similitudo*). A difference from its subject is inherent in the image and is bridged by resemblance (132–33). Paleotti then rewrites the Christian history of art in the mode of a hagiography or apology. Art and virtue, he affirms, are united with God's will in the form of images proclaiming the Christian faith, which are superior to pagan images in that the objects and functions of Christian art are themselves superior to pagan ones (163ff.).]

We divide our subject matter . . . into sacred and profane images [*imagini sacre e profane*]. . . . The differences between the two kinds lie on the one hand in the works themselves, and on the other in the beholder [*la persona che le riguarda*]. It is possible for an image to be included in the sacred kind while falling for the beholder into a different category [*in*

altro ordine] . . . and even to be counted by some fools as profane art, which serves only as entertainment [*passatempo*]. . . . Thus, one and the same image presents itself in quite different ways, depending on the ideas [*concetti*] that the beholders have of it (171–72). [He discusses the possibility that artistic quality may be an end in itself for profane images but argues that they can also serve purposes of instruction and education. Finally, idols as such are discussed and distinguished from cult images, so that Paleotti can more easily approach his main theme, the *imagini sacre.*]

Images . . . are here called sacred [*sacre*] because this concept separates them from the ordinary realm of lay people [*popolo*] and assigns them to the religious cult [*culto di religione*]. [Paleotti then names eight reasons for calling an image sacred. It has this status if ordained by God, if it has been in contact with the body of Christ or the saints, if it has been painted by St. Luke, or if it had a miraculous origin like the acheiropoietic images. Other reasons are if it has performed miracles, has been consecrated like a church, or has been sanctified by its theme or its church location (197–200). In the controversy with the Protestant critics of images, the age of the Christian cult image is invariably cited. Following St. Bonaventure, its function is seen as aiding the intellect, will, and memory of the pious. Even in the sacred image] the style of depiction serves a purpose. In studying this, one must distinguish the artist as such [*puro artefice*] from the Christian artist. . . . The objective of the painter as artist is to earn money by means of his art . . . and to earn praise. . . . The chief purpose of the Christian artist . . . is to attain divine grace by means of his industry and skill. . . . In the case of the work . . . its purpose is not exhausted by the usual resemblance to its object . . . but serves the higher purpose of contemplating the eternal splendors in an act of virtue, to lead people away from vice and to the true cult [*vero culto*] of God (210–11) . . . in which function, images as the subject of the outward cult [*culto esteriore*] must be distinguished from the inward cult (213).

[Paleotti's objective is to use Neoscholastic arguments to integrate the new art-image with the old concept of the image. This means keeping his distance from pagan antiquity, while countering Protestant criticisms of the excesses of the image cult. Even invisible beings could be depicted, he argues, if they are shown as they appeared to people in the Bible, adopting forms appropriate to the human senses. As far as the cult of images is concerned, Paleotti follows the old distinction between adoration, veneration, and honoring (*latria, hyperdulia,* and *dulia*), to which Calvin took such vehement exception (246–47). While the beholder's conduct before images of God and those of the saints looks similar, it has a different meaning that cannot be expressed in the form in which images are honored; what looks similar outwardly is quite different within the soul (250). The image is not divine in itself but merely represents the divine according to the prototype to which it refers (251–52).]

Three aspects of images deserve attention: they are made of material substance, . . . in the substance chosen they bear a particular form given to them, and finally, in the combination of the two, they possess the image itself, the representation of something else by means of resemblance. . . . It is to the latter that we direct our thoughts. . . . Thus, while our corporeal eyes gaze at the image, our mind rests upon the object of the depiction . . . that is contained in it through the manner of representation [*modo di rappresentazione*]. It is therefore possible mysteriously [*misteriosamente*] to address to the image the honor due to the prototype, in keeping with the three stages of *latria* [for God], *hyperdulia* [for the Virgin], and *dulia* [for the saints] (255).

Notes

Chapter 1

1. This chapter was first published in the journal *Orthodoxes Forum* (St. Ottilien) 1.2 (1987): 253ff.
2. V. Laurent, ed., *Concilium Florentinum 9* (Rome, 1971): 250–51.

Chapter 2

1. M. Didron, *Manuel d'iconographie chrétienne grecque et latine, traduit du manuscrit byzantin, le guide de la peinture par P. Durand* (Paris, 1945), Introduction, iii–xlviii, and Dedication to Victor Hugo, i–ii.
2. Godehard Schäfer, *Das Handbuch der Malerei vom Berge Athos, aus dem handschriftlichen neugriechischen Urtext übersetzt,* with notes by Didron the Elder (Trier, 1853), including a translation of Didron's Introduction (pp. 1–32). On Victor Hugo's message, cf. p. 20.
3. Quoted from Didron (see n. 1 above), ix, and Schäfer (see n. 2 above), 5.
4. On the consecration of painters, cf. Schäfer (see n. 2 above), 43–44.
5. A. Papadopoulos, *Kerameus, Dionysiu tu ek Phurna Hermeneia tēs zographikēs technēs* (St. Petersburg, 1909).
6. Cf. H. Belting, "Vasari und die Folgen," in idem, *Das Ende der Kunstgeschichte?* (Munich, 1983).
7. The icon painters' handbook, named after the Stroganov family (ca. 1600), was published in 1869 under the title *Stroganovskii Ikonopisnyi Licevoi Podlinnik;* like the other examples of these *Podlinniki,* it consists of schematic drawings and name inscriptions that can be converted directly into panels. On this genre, cf. Rothemund 1966, 56ff., and Onasch 1968, 29ff. The new edition is *Ikonenmalerhandbuch der Familie Stroganow* (Munich, 1965; 2d ed., 1983).
8. Brockhaus 1891, 87ff. and 151ff. (on the *Painters' Manual*).
9. P. Uspenski, *First Journey to the Sinai Monastery in 1845* (Russian) (St. Petersburg, 1856). Cf. N. Petrov in *Iskusstvo,* nos. 5–6 (Kiev, 1912): 191ff.
10. J. Strzygowski, *Byzantinische Denkmäler* (Vienna, 1891), 1:113ff., and idem, *Orient oder Rom* (Leipzig, 1901), 123–24. Cf. D. V. Ainalov in *Vizantiiskii Vremennik* 9 (1902): 343ff.; Wulff and Alpatoff 1925, 8ff.; and, more recently, Weitzmann 1976.
11. The main works of Nikodimos Pavlovich Kondakov (1844–1925), who emigrated to Prague after the Revolution, appeared posthumously; cf. *The Russian Icon* (Oxford, 1927, and in several volumes, Prague, 1928–33). But his travel reports (to Athos and Sinai) and iconographic studies, as on the Mother of God (1914), attracted early notice.
12. *Vystavka drevne russkogo iskusstva* (catalog; Moscow, 1913), with 147 icons.
13. On N. Leskov's work, cf. M. L. Roessler, "Leskov und seine Darstellung des religiösen Menschen" (diss. Marburg, 1939), and W. Benjamin, *Illuminationen* (Frankfurt, 1961), 409ff.
14. On Tatlin, cf. J. Milner, *U. Tatlin and the Russian Avant-Garde,* 2d ed. (Yale University Press, 1984), 8 and 24. On Goncharowa, cf. M. Chamot, "Goncharova's Work in the West," in *Russian Women-Artists of the Avant-Garde* (Cologne, 1979), 150. On Malevich's reaction to the icon, cf. J. C. Marcade and S. Siger, *K. Malevitch. La lumière et la couleur. Textes inédits de 1918 à 1926* (Lausanne, 1981), 23 and 51ff. I am indebted to Jens T. Wollesen for some of this information. Cf. K. Bering, "Suprematismus und Orthodoxie. Einflüsse der Ikonen auf das Werk K. Malevičs," *Ostkirchliche Kunst* 2.3 (1986): 143ff.
15. The Berlin Museum director also made a major contribution; cf. O. Wulff, *Lebenswege und Forschungsziele* (Baden-Baden, 1936).
16. Wulff and Alpatov 1925, passim.
17. Cf. Rothemund 1966, passim, and Skrobucha 1975, passim.
18. Carli 1958, figs. 56–58; Hager 1962, 109–10; and Weitzmann 1984, 143ff. with figs. 13–14.
19. See chap. 12.
20. Carli 1958, figs. 77–78; Hager 1962, 95ff.; and Weitzmann 1984, figs. 22–23.
21. On the domestic altar from Lucca (the Stoclet Tabernacle), now in Cleveland, cf. H. S. Francis, "The Stoclet Tabernacle," *Bulletin of the Cleveland Museum of Art,* 1967, 92ff.

22. On the Kahn Madonna, cf. Belting 1982a.

23. On the panel in Nocera Umbra, cf. Garrison 1949, no. 274.

24. On the manuscript in Donaueschingen, cf. the exhibition *Ornamenta ecclesiae* (catalog; Cologne, 1985), vol. 3, no. H 64, which also refers to the pattern sheet in Freiburg.

25. Soteriou and Soteriou 1956–58.

26. Felicetti-Liebenfels 1956.

27. On the Mount Sinai monastery, cf. H. Skrobucha, *Sinai* (Olten and Lausanne, 1959); G. H. Forsyth and K. Weitzmann, *The Monastery of Saint Catherine at Mount Sinai: The Church and the Fortress* (Ann Arbor, Mich., 1973); J. Galey, *Sinai und das Katherinenkloster* (Stuttgart, 1979). On the Sinai icons, cf. Weitzmann 1976, 1982.

28. On the Roman icons, see chaps. 4 and 6, and nn. 25–27 above.

29. Cf. the references in chap. 6.

30. See chap. 5.

31. See chap. 8.

32. Cf. Belting 1982c, 35ff., which has further references.

33. Cf. Belting 1971, passim, for further references.

34. Cf. Lasareff 1967; Kitzinger 1977; Weitzmann 1978; Demus 1947; Demus 1970.

35. See chap. 13.

36. Demus 1965, 139ff., esp. 144 and 147.

Chapter 3

1. See chap. 12.

2. Cf. Anna Kartsonis, "The Identity of the Image of the Virgin and the Iconoclastic Controversy: Before and After," *Jahrbuch für österreichische Byzantinistik*, 1987.

3. Cf. Weis 1985, though he puts forward some problematic suggestions. The first use known to me of the metaphor that the Virgin has "confined the limitless . . . within the Mother's womb" appeared in A.D. 431 in Cyril of Alexandria (*PG* 77, 922–23, and Delius 1963, 110).

4. Cf. Tatić-Djurić 1976, 259ff. Cf. chap. 13 on iconic types and names, and nn. 75–78 in chap. 13.

5. Letter to a theologian against the Nestorians (*PG* 78, 216–17, no. 54).

6. M. J. Vermaseren, *Cybele and Attis: The Myth and the Cult* (London, 1977); R. Salzmann, in Olson 1985, 60ff. On the influence on Christianity, cf. Franz Josef Dölger, in *Antike und*

Christentum 1 (1929): 118ff., and M. Gordillo, *Mariologia orientalis* (1954), 159–60.

7. G. Rochefort, *L'empereur Julien. Œuvres complètes* 2.1 (Paris, 1963), 103ff., with French translation, and G. Mau, *Die Religionsphilosophie Julians . . .* (Leipzig and Berlin, 1907), 152ff., with German translation. On the temple in Constantinople, cf. Mango 1963.

8. P. T. Camelot, *Ephesus und Chalkedon*, 3 vols.; vol. 1: *Geschichte der ökumenischen Konzilien* (Munich, 1963); on this theme in the context of Mariology in general, cf. Lucius 1904, 435ff.; Delius 1963, 104ff.; Wellen 1961, passim; still unsurpassed is M. Jugie, *La mort et l'assomption de la Sainte Vierge* (Rome, 1944); also useful is Turner 1978, 148ff.; problematic is H. Graef, *Mary: A History of Doctrine and Devotion*, vol. 1 (London, 1963). Cf. in addition E. Ann Matter, in Olson 1985, 80ff.; H. Koch, *Virgo Eva—Virgo Maria* (Berlin and Leipzig, 1937); T. Livius, *Die allerseligste Jungfrau bei den Vätern der ersten sechs Jahrhunderte* (1901); and Christa Mulate, *Maria—die geheime Göttin im Christentum* (1985).

9. "Homily II on the Death of the Virgin," in *Homélies sur la nativité et la dormition*, Sources chrétiennes 80, ed. P. Voulet (Paris, 1961), 160ff.

10. E.g., Epiphanius of Salamis (Delius 1963, 98).

11. C. Picard, *Ephèse et Claros*, Bibliothèque des écoles françaises d'Athènes et de Rome 123 (1922), 376ff.; Kötting 1950, 32ff.; R. Fleischer, *Artemis von Ephesos und verwandte Kultstatuen aus Anatolien und Syrien* (Leiden, 1973).

12. J. Gwyn Griffiths, *Plutarch's De Iside et Osiride* (University of Wales Press, 1970); R. E. Witt, *Isis in the Graeco-Roman World* (London, 1971); v. Tran Tam Tinh, *Isis lactans* (Leiden, 1973), an iconographic work that contains evidence of the influence of the Virgin image (40ff.); S. Kelly Heyob, *The Cult of Isis among Women in the Graeco-Roman World* (Leiden, 1975), on the nature of Isis (37ff.) and on her cult (111ff.); C. J. Bleeker, in Olson 1985, 29ff. Cf. Frankfurt 1983, 509ff., with nos. 117–21 on a statuette of *Isis invicta* and another with the name *Myrionymus* in Cologne.

13. Cf. Lucius 1904, 466–67, and Delius 1963, 100. The sects were called Kollyridians or Philomarians. They were women who had emigrated from Thrace to Arabia.

14. Delius 1963, 107ff. and references in n. 16 below. On Rome (and containing references), cf. Klauser 1972.

15. See n. 11 above. On Romanus, cf. the edition referred to in chap. 13 n. 67, and C. A. Trypanis, *Fourteen Early Byzantine Cantica* (Vienna, 1968). On the *Akathistos* hymn, see chap. 13 n. 58.

16. Delius 1963, 113–20. Later, John of Damascus (ed. Voulet [see n. 9 above], 100), looking back over the previous two centuries, asks, "[What is] the mystery that surrounds you, Virgin and Mother?" She is, as Isis once was, the "imperial throne around which angels stand" (102). He makes her tomb say: "I am the inexhaustible source of healing, the warder-off of demons, the medicine that drives away evil from the sick, the refuge of all who seek protection" (166). On the stereotypes of mother deities in Romanus's Hymn of the Virgin, cf. Delius 1963, 115.

17. At this time the protogospel of James, a Greek religious tract from about A.D. 200 with the Virgin at its center and containing the earliest legend relating to her, became popular. Cf. E. Hennecke, *Neutestamentliche Apokryphen in deutscher Übersetzung,* vol. 1 (Berlin, 1916), and W. Michaelis, *Die Apokryphen Schriften zum Neuen Testament* (Bremen, 1956), 62ff.

18. Cf. the prayer to the Virgin in the Byzantine liturgy referred to in Delius 1963, 113–14. For other aspects, cf. the references in nn. 16 and 24 and Der Nersessian (see chap. 12 n. 37), 72–73, and Turner and Turner 1978, 155–56.

19. Ostrogorsky 1940, 46 and 49, and E. Schwartz, "Die Kaiserin Pulcheria auf der Synode von Chalkedon," in *Festgabe für A. Jülicher* (1927), 203ff.

20. See, in particular, the history of the church compiled in the sixth century by Theodorus Lector from earlier sources (*PG* 86, 168–69). The churches in question are those of the Blachernae, the Chalcoprateia, and the Hodegon; cf. Janin 1953, 169ff., 208ff., and 246ff.

21. Cf. P. Wenger, in *Revue des études byzantines* 11 (1953): 293ff.; Wenger 1955, 111ff.; Baynes 1955b; and Jugie (see n. 8 above), 688ff. The legend in the *Historia Euthymiana,* as well as Cosmas Vestitor and John of Damascus (ed. Voulet [see n. 9 above], 168ff.), moved the time of the translation of the cloak to that of Pulcheria. The legend of the two Arians Galbios and Kandidos, which can be traced back as far as the early seventh century, places the event in the era of Leo I and Verina. Cf. also Belting-Ihm 1976, 38ff. A novella by Justinian attributes the building of the Virgin's church in the Chalco-

prateia quarter, in which the Virgin's girdle was kept, to Verina, Leo's wife (cf. M. Jugie, "L'église de Chalcopratia et le culte de la ceinture de la Sainte Vierge à Constantinople," *Échos d'Orient* 16 [1913]: 308). Cf. Mango 1972, 35, on the inscription with Leo and Verina in the Blachernae church.

22. Cf. Belting-Ihm 1976, 38ff.

23. Cf. the *Historia Euthymiana* (see n. 21 above).

24. Turner and Turner 1978, 159–60.

25. Janin 1953, 232ff. Cf. esp. the testimony of Procopius (*De Aedificiis* 1.3.5ff.).

26. Cf. esp. Cameron 1981, passim, with the collected essays.

27. Cameron 1978, 79ff., esp. 82ff. Here the Virgin is called the *gloria matrum* and *servatrix* of the imperial house.

28. Ibid., 96 n. 2.

29. A. Cameron, "Images of Authority: Elites and Icons in Late Sixth Century Byzantium," in Cameron 1981, chap. 13, p. 5. On the statue of Athena Promachos, cf. R. H. Jenkins, in *Journal of Hellenic Studies* 67 (1947): 31ff.

30. Cameron (see n. 29 above), 5–6, which also contains an interpretation of the Virgin as a city deity. Cf. A. Frolow, "La dédicace de Constantinople," *Revue de l'histoire des religions* 127 (1944): 61ff.

31. See chap. 13 n. 58.

32. See text 3A. Cf. Cameron (see n. 29 above), 22–23.

33. Cameron 1979, 42ff., with English translation of the so-called Combefis text, a homily from A.D. 620 on the first robe miracles during a siege by the Avars in 619 (48ff. and esp. 51 sec. 5 on the triple reliquary and sec. 7 on the traces of milk). Cf. Baynes 1955b, 240ff. Gregory of Tours also mentions the robe. On the relic as a palladium, a "source of life and treasure of salvation," cf. Cameron (see n. 29 above), 19–20. Also see n. 21.

34. Cameron 1978, 87.

35. *Anthologia Palatina* 1.120–21, ed. H. Beckby (Munich, 1957), 104 and 160–61.

36. A. Kartsonis (see n. 2 above).

37. Book of Ceremonies 1.8 (Reiske 1829–30), 55.

38. Dobschütz 1899 and Bevan 1940, passim.

39. Tertullian, *Apologeticum,* ed. C. Becker (Darmstadt, 1984), 108 and 142.

40. Artemidorus of Daldis (ca. A.D. 96–180, *Das Traumbuch,* ed. K. Brackertz (Munich, 1979), 163–64.

41. O. Weinrich, *Antike Heilungswunder,* Reli-

gionsgeschichtliche Versuche und Vorarbeiten 8.2 (Giessen, 1910), 144–45 and 155. Cf. E. Schmidt, *Kultübertragungen,* ibid. 8.1 (Giessen, 1909), 88ff. and 97ff., and Dawson 1935, passim.

42. Ovid, *Metamorphoses* 15.622ff. On dream visions of images of gods and the sleep in the temple, cf. Weinreich (see n. 41 above), 156ff.

43. Libanios's letter to Theodore (*Letters* 2.1534F).

44. Cf. the references in chap. 4 n. 42. Cf. esp. the miracle legends I.1, I.2, and I.3. The author of the legends refers beholders to the icons on the facade of the church, asking them to look at the images so that they will believe his story. On the mosaic of Demetrius with the golden hands, cf. Cormack 1985, fig. 23, and on the one of Stephen in Durazzo, cf. fig. 24.

45. Weinreich (see n. 41 above), 1ff. (on God's hand). On the votive gifts on the Tiber island, p. 30; on Julian's treatise (*Contra Christianos*), pp. 31–32; on Hera Hypercheira, p. 13.

46. Cf. Weinreich (see n. 41 above), 137 and 151–52.

47. P. Lemerle, *Essais sur le monde byzantin* (London, 1980), 4:96ff.

48. Cf. Nordhagen 1987, passim.

49. Theodorus Lector, *Historia ecclesiastica* 50.15 (*PG* 86, 173); cf. chap. 7 n. 44 and Dobschütz 1899, examples 107 no. 9.

50. Dobschütz 1899, 197ff., and P. L. Feis, "Del monumento di Paneas . . . ," *Bessarione* 4 (1898): 177ff. The passages from Eusebius are in *Historia ecclesiastica* 1.13 and 7.18.

51. Cf. esp. the image used during the siege by the Avars and described by the Pisidian (text 3B) and the images of the Virgin with Christ on a portrait shield described in chap. 6.

52. Pertusi 1960, 142–43. Cf. the examples given by George the Pisidian (text 3C), in the *Chronography* of Theophanes (1.459, Bonn), and in the *Chronicon paschale* (298, Bonn; ed. C. de Boor).

53. Cf. text 2 (304; 80). On the *propylaioi* (esp. Apollo, who, like Athena, was sometimes set up on the city gate with bow and arrow to repel the plague), cf. Weinreich (see n. 41 above), 149.

54. John Moschus, *Pratum spirituale*, ca. 180 (*PG* 87.3, 3052). Also cf. Kitzinger 1954, 97. On other texts (e.g., one that tells of a monk trampling on an image of the Virgin that has aroused him sexually), cf. Mansi 1901, 13:193; Brown 1982, 279.

55. Kitzinger 1954, 108.

56. Ibid. The Isis images are discussed in detail by Karanis; see chap. 4 n. 34.

57. On the iconoclasts' view of this question, cf. Brown 1982, 261–62.

58. Cf. esp. Grabar 1943–46, 2:343ff. and 357; Kitzinger 1954, 115ff.; Grabar 1957, passim; Brown 1982, 251ff.; Cameron 1978, 101; Cameron (see n. 29 above), 24.

59. See chap. 4c.

60. See chap. 5.

61. Cf. Brown 1982, passim, esp. 266ff.

62. See chap. 6 and the following studies: Cameron 1981; Grabar 1957; Kitzinger 1954, 125–26.

63. Brown 1982, 275.

64. Ibid., 287. See chap. 8.

65. L. Buñuel, *My Last Sigh* (New York, 1983), 151 and 153–54.

66. Cf. the publication in *Time* magazine on 10 Sept. 1973 (photo by Francisco Vera). The prayer was "Ampáranos desde el cielo."

67. Cf. the studies by Turner and Turner 1978, and individual contributions in Olson 1985.

68. E.g., Brown 1982, 266, against Kitzinger 1954, 115ff.

69. See chap. 6.

70. Cf. Brown 1982, 272–73, 280–81, and 259. On the comment below on *Koinos* and *Lagion,* cf. Hennephof 1969, 68 no. 227, and Mansi 1901 13:268–69.

Chapter 4

1. On the ontological relationship, cf. Demus 1965, 144.

2. Cf. esp. Kollwitz 1954, 318ff.; on the concept in Platonism, cf. Willms 1935; on the relation to liturgy, cf. Düring 1952; and on the theology of the church fathers, cf. Ladner 1953 and 1965. References on the use of the concept and its transfer to Western languages are in Henry Kahane and Renée Kahane, *Graeca et Romanica Scripta Selecta* (Amsterdam, 1981), vol. 2, sec. 368, p. 12.

3. I obtained this early photo from the photographer Lykides in Thessaloniki.

4. The quotation is from P. Huber, "Athos. Wundertätige Ikonen," *Orbis Pictus* 45 (1966), on pl. 6.

5. On depictions of funeral processions with icons or processions in the context of the *Akathistos* hymn cycles, cf. Hamann-MacLean 1976,

178ff. and 192–93. Also cf. V. Djurić, *Sopocani* (Belgrade, 1963), 137; G. Millet and T. Velmans, *La peinture du moyen Age en Yougoslavie* (Paris, 1969), vol. 4, figs. 153–54. This example comes from the monastery church of Markov Manastir, 1366–71.

6. Cf. text 20 in the Appendix.

7. Soteriou and Soteriou 1956–58, vol. 1, fig. 146; Wellen 1961, 147–48; and Weitzmann 1966, 1ff. and 14 with fig. 36.

8. A fundamental contribution appears in Dobschütz 1899, 37–38 and 40ff., with examples 127*ff. and 118*ff.; also cf. Kitzinger 1954, 112ff. and 143; Grabar 1957, passim; and Brown 1982, 261–62.

9. Dobschütz 1899, appendixes pp. 267–80; H. Martin, *St-Luc* (Paris, 1927); D. Klein, "St. Lukas als Maler der Madonna" (diss. Bonn, 1933); C. Henze, *Lukas der Muttergottesmaler* (Louvain, 1948); Wellen 1961; Brown 1982, 262.

10. Dobschütz 1899, 143 n. 2; E. Bratke, *Das sogenannte Religionsgespräch am Hof der Sasaniden* (1899), 87ff.; Beck 1959, 501–2. On the illustration in the Codex Taphou 14 in the Greek patriarchate in Jerusalem (fol. 92) in the context of Gregory Nazianzus's homilies, cf. K. Weitzmann, in *Mélanges M. Mansel* (Ankara, 1974), 397ff.; G. Galavaris, *The Illustrations of the Liturgical Homilies of Gregory Nazianzenus* (Princeton, 1969), 222ff.

11. Dobschütz 1899ff., 40ff. and examples.

12. Baynes 1955d, 248ff. Cf. Brown 1982, 275ff. (on civic patriotism).

13. Cf. text 3B.

14. The miniature in the *Codex Rossanensis graecus* 251, fol. 12v, in the Vatican is illustrated in Grabar 1957, fig. 67.

15. Hennephof 1969, 55 no. 168. Cf. Brown 1982, 259–60.

16. Dobschütz 1899, 1–25 and esp. 263–94. Cf. examples nos. 1–120, pp. 3*–96*.

17. Ibid., example no. 118, p. 84* (*Chronicon paschale*).

18. Ibid., example no. 37c, p. 19*.

19. See chap. 3 n. 15.

20. Dobschütz 1899, 37–38. Cf. n. 8 above.

21. Acts 19:23–36. Cf. the exegesis of this passage in Dobschütz 1899, examples chap. 1, no. 105, p. 77*.

22. Kötting 1950, 32ff. On the curtain, cf. Pausanias 5.12.4. See chap. 3, n. 19.

23. Examples from Hypatios of Ephesus, Leontios of Cyprus, and the *Quaestiones ad Antiochum*

ducem are in Baynes 1955c, 228ff. and 237; Gero 1975, 208ff.; Kitzinger 1954, 83ff.

24. See chap. 11 n. 10. Examples in Dobschütz 1899, on chap. 5 and appendixes II, esp. p. 70**; Kitzinger 1954, 113.

25. Dobschütz 1899, 265–66.

26. Ibid., 79 and examples p. 146*; Kitzinger 1954, 104 and 112ff.

27. See n. 9 above.

28. Dobschütz 1899, appendixes pp. 269** and 271**.

29. Esp. Andrew of Crete and Patriarch Germanus (Dobschütz 1899, examples pp. 186* and 188* and appendixes p. 269**).

30. L. Duchesne, "L'iconographie byzantine dans un document grec du IXᵉ siècle," *Roma e l'Oriente* 5 (1912–13): 222, 273, and 246; Cormack 1985, 122ff. and 261–62. The document is now regarded as a fabrication from 843.

31. Dobschütz 1899, 79–85 and examples pp. 146–47* on the acheiropoietic images of the Virgin.

32. Ibid., examples pp. 127* and 128* (Theophylakt Simokatta).

33. Cf. the sermon on a siege of Constantinople, apparently in 717; Dobschütz 1899, examples p. 131* (Combefis 807, *PG* 106, 1337): "tas hieras eikonas tēs theomētoros, hais malista brephos ho sotēr exeikonistheis en ankalais tēs mētros enephereto."

34. See chap. 3 n. 20. Tinh (see chap. 3 n. 12), fig. 48 (no. A-24), with an example of the private Isis image in Karanis.

35. See chap. 6 nn. 35–37 with examples; Weis 1985, 20–50 with figs. 9–22.

36. See n. 30 above; Cormack 1988, 55ff.

37. Weitzmann 1976, no. B9, and Grabar 1957, 36ff.

38. Deichmann 1983, 54ff., and Lucius 1904, passim. Also cf. Kitzinger 1954, passim and 92 on Augustine's pronouncement (*De moribus ecclesiae catholicae* 1.34). Cf. esp. Brown 1982, passim, and esp. 103ff. and 222ff.

39. Baynes 1955c, 235.

40. Theodoretus, *Historia religiosa* 26.11 (*PG* 82, 1431). Cf. Kitzinger 1954, 100ff.; Grabar 1958; Metzger 1981; and esp. Vikan 1982, 32.

41. Kitzinger 1954, 100–101, also on Virgin's images from which oil issues; Brown 1982, 251ff. and 283 (on Germanus, cf. Mansi 1901, 13:125).

42. Recently P. Lemerle, *Les plus anciens recueils des miracles de St. Demetrius*, 2 vols. (Paris, 1979–81). Cf. the detailed description in Cor-

mack 1985, 50ff., and Brown 1982, 276ff., 282.

43. Brown 1982, 251ff., esp. 266–74 and 275–84.
44. See chap. 3 nn. 29 and 41, with references, and the sermon cited in n. 33 above.
45. Cf. New York 1978, no. 569.
46. Cf. the homily from 620 mentioned in chap. 3 n. 33, and esp. Cameron 1979, 50–51, with English translation.
47. See text 3C; cf. Pertusi 1960, 143.
48. See text 3A.
49. See text 3B.
50. Cf. the homily by Theodore Synkellos on the Avars' siege of 626 (Cameron [see chap. 3 n. 29], 20, and text 2).
51. Moscow, Tretyakov Gallery (Lazarev 1969, fig. 60).
52. Kitzinger 1954, 101. Cf. esp. *De gloria martyrum,* chap. 23 (a crucifix in Narbonne asks to be concealed), and chap. 29 (a Christ image bleeds after being stabbed by a Jew) (*PL* 71, 724–25).
53. The documentation on the Roman image cult and its legends is still best in Dobschütz 1899, passim. Cf. Dejonghe 1969. On the surviving panels, cf. Kitzinger 1955, 132ff., Bertelli 1967, 100ff.; Wright 1963, 24ff.
54. On *Maria Rhomaia,* cf. Dobschütz 1899, 233ff., and idem, "Maria Rhomaia," *Byzantinische Zeitschrift* 12 (1903): 173ff.
55. Klauser 1972, 122.
56. On the introduction to the Virgin's feasts in Rome, cf. ibid., 126, after *LP* 1:376. Cf. text 4A.
57. On the Pantheon icon, cf. Bertelli 1961b, 24ff.; on the Pantheon in the Christian era, cf. R. Krautheimer, "Sancta Maria Rotunda," in *Arte del primo millennio. Atti II Convergno per lo studio dell'arte dell'alto medio . . .* (Pavia, 1950; Viglongo, 1953), 21ff.
58. *LP* 1:472.
59. On the Savior icon in the Lateran, cf. Dobschütz 1899, 61ff.; Wilpert 1907, 161ff.; H. Grisar, *Il Sancta Sanctorum e il suo tesoro sacro* (Rome, 1907); esp. Volbach 1940–41, 97ff., which is exhaustive; Hager 1962, 35–36; Wilpert 1914–17, vol. 3, pl. 139. On the replicas, cf. esp. Garrison 1955–62, 2:5ff. On the legend of the completion of the image by an angel, cf. Hager 1962, 37 with n. 63.
60. On the Ordo 12 from the time of Honorius III (1216–27), issued by Censius Camerarius, cf. Dobschütz 1899, example on chap. 4, 2d; also Hager 1962, 37.
61. Cf. J. Wilpert and W. N. Schumacher, *Die römischen Mosaiken der kirchlichen Bauten . . .* (Freiburg im Bresgau, 1976), 24; G. J. Hoogewerff, "Il mosaico absidale di S. Giovanni in Laterano," *Atti delli Pontificia della Accademia Romana di Archeologia: Rendiconti* 27 (1954): 297–326; and Warland 1986, 31ff. The mosaic was removed in 1876 and replaced by a facsimile.
62. Wilpert 1903, pl. 257, and Bertelli 1967, 100.
63. A. Vittorelli Bassanese, *Gloriose memorie della B. Vergine . . .* (Rome, 1616); F. de' Conti Fabi Montani, *Dell'antica immagine . . . nella Basilica Liberiana* (Rome, 1861); Dobschütz 1899, 279**; Cellini 1943, passim; Hager 1962, 44ff.; Dejonghe 1969, 201ff.; Wolf 1990. On the church, cf. R. Krautheimer, *Corpus basilicarum Christianarum Romae* (Rome, 1967), 3:1ff.
64. Illustration in Angelis 1621, 249–50. Cf. J. Gardner, in *Papers of the British School at Rome* 38 (1970): 220ff.
65. G. Barone, "Il movimento francescano e la nascità delle confraternite Romane," *Ricerche par la storia religiosa di Roma* 5 (1984): 71ff.
66. First by Bartholomaeus Tridentinus (ca. 1240) in *Codex Vat. Barberinus latinus 2300,* fol. 23v, where the image on the *limen Baptisterii* is mentioned. (I am indebted to G. Wolf for this information.) See chap. 15d.
67. *Imago Marie moveri cepit.* Cf. A. Wilmart, in *Revue Benedictine* 45 (1933): 62ff. and 75. In a fifteenth-century tomb inscription the St. Luke image is also linked to the annual *triumphalis pompa* (C. Huelsen, "Eine Sammlung römischer Renaissance-Inschriften . . . ," in *Bayerische Akademie der Wissenschaften. Sitzungsberichte* [Munich, 1920], no. 15, pp. 38ff. no. 125).
68. *LP* 1:418.
69. Bertelli 1961c, 98 n. 22.
70. See chap. 15d and n. 56. As early as the eighth century a fresco in S. Maria Antiqua seems to have reproduced this icon.
71. In June 1987, at the beginning of the Marian Year, the icon spent a week in the Vatican's restoration workshops, where it was hastily examined and photographed. I owe this information to G. Mancinelli and V. Pace. See Amato 1988, 52ff. with color plate.
72. Weitzmann 1976, no. B2 and pl. 3. The gesture is explained by P. J. Nordhagen 1987, 459, as expressing the offering of a votive gift, as in a fresco in S. Maria Antiqua.
73. See chaps. 3d and 10a.
74. See chap. 15 n. 42.

75. Cellini 1950, 1ff.; Kitzinger 1955, 132ff. and 147ff. (with the sources); Bertelli 1967, 100ff.; also Amato 1988, 18ff.

76. Cf. Tronzo 1990. E. Kitzinger first drew attention to the connection with the *Assunta* procession in his "Virgin's Face: Antiquarianism in Twelfth Century Art," *Art Bulletin* 62 (1980): 6ff.

77. Cf. Amato 1988, passim.

78. Dobschütz 1899, 275**.

79. Kondakov 1915, 152ff.; V. Lasareff, in *Art Bulletin* 20 (1938): 46ff.; Wolff 1948, passim; Janin 1953, 212ff.; H. Hallensleben, in *Reallexikon christlicher Ikonographie* (1971), 3:168; Kalokyris 1972, 60.

80. Berlin, Staatliche Museen, Kupferstichkabinett, MS 78 A 9, fol. 139v. The illustration is in Grabar 1957, fig. 1.

81. M. Achimastou-Potamianou, in *Actes XV. Congrès International d'Études Byzantines* (Athens, 1981), 2:1ff. with figs. 14–17.

82. Wolff 1948, 319ff. On Anthony of Novgorod's account of the miracle, cf. Dobschütz 1899, 273**. On Lámbeck and the debate about the icon in the Michaelskirche, Vienna, cf. the detailed report on the famous miraculous image of the Virgin from Candia (Vienna, 1773), 18; W. Sas-Zaloziecky, in *Jahrbuch österreichischen-byzantinischen Gesellschaft* 1 (1951): 135ff.

83. L. A. Muratori, *Von der wahren Andacht des Christen* (Vienna, 1762), 249.

Chapter 5

1. On the Mount Sinai icon of Philip, cf. Weitzmann 1976, no. B 59 and pl. 116; on the mummy portrait in the Louvre, cf. Zaloscer 1961, no. 19.

2. On this subject, cf. Egger 1963, 212ff.

3. On the icon of Irene, cf. Weitzmann 1976, no. B 59 and pl. 116.

4. On the fresco of Theodotus, cf. W. de Grüneisen, *Sainte Marie Antique* (Rome, 1911), pl. 35, and Wilpert 1914–17, vol. 3, pl. 184. Cf. H. Belting, "Eine Privatkapelle im Frühmittelalterlichen Rom," *Dumbarton Oaks Papers* 41 (1987): 55ff. The frescoes were produced under Pope Zacharias (741–52). Also cf. P. Romanelli and P. J. Nordhagen, *Santa Maria Antiqua* (Rome, 1964), a general monograph on the church.

5. On the fresco in SS. Giovanni e Paolo, cf. Wilpert 1914–17, vol. 3, pl. 131, and idem, "Le pitture della 'Confessio' del SS. Giovanni e Paolo," in *Scritti in onore di B. Nogara* (Rome, 1937), 517ff. On the church, cf. A. Prandi, *Il complesso monumentale della basilica celimontana dei SS. Giovanni e Paolo* (Rome, 1953). On the question of the saints venerated there, cf. P. Franchi de Cavallieri, "Dove furono sepolti i SS. Cipriano, Giustina, e Teoctisto?" Note Agiografiche 8, *Studi e Testi* 65 (Rome, 1935), 335ff.; N. M. Denis-Boulet, *Rome souterraine* (Paris, 1965), 278–79. It is difficult to determine the exact relationship of the cult chamber (*confessio*) to the basilica of Pammachius. Pammachius (unlike Ruffina?) venerated SS. Paul and John, who were both beheaded. Only a later legend made two other saints of the same names out of them, whose bodies had been hidden in their own house during their persecution under Emperor Julian—clearly an attempt to justify the cult in the city retrospectively.

6. Cf. Wessel 1963, 181 with fig. 10.

7. On the catacomb of Callistus, cf. Wilpert 1903, pls. 84, 88, and 110.

8. On the saint's image, cf. Belting-Ihm 1986, passim.

9. On the curtain motif, cf. Eberlein 1982, passim. In the case of the transition from the cult of the images of the emperor and the dead to that of the saints, cf. A. Grabar, in *Cahiers archéologiques* 1 (1947), 124–25; Treitinger 1938, 55–56; Bertelli 1961b, 87–88.

10. On the death image of the lady in the Thrason catacomb, cf. Wilpert 1903, pl. 163.2; on that in the Vigna Massimo, ibid., pl. 175.

11. On the martyrs' cult, cf. most recently Deichmann 1983, 54ff., and Denis-Boulet (see n. 5 above), 141ff. In connection with the image cult, cf. esp. Kollwitz 1957, 57ff., and Lucius 1904, 271ff. and 306ff.

12. Achelis 1936, 48, 62–63, and pl. 27, referring to the main gallery in the second catacomb. The arcosolium of Proculus (160 × 85 cm) dates from the fifth century (Fasola 1975, 73 and pl. 5b). Also cf. Kollwitz 1957 and Weis 1958.

13. In another grave in the second catacomb of S. Gennaro in Naples (Achelis 1936, 48, 68, and pl. 38; and Fasola 1975, pl. 7, p. 93, and fig. 70), St. Januarius himself is depicted between the women Nicatiola and Cominia who are buried here; he even has a Christogram on his nimbus and is shown in the same prayerful attitude. Only the burning candles and the size of the figures distinguish him.

14. On the church of Demetrius in Thessaloniki and its mosaics, cf. Grabar 1943–46, 1:450ff.; esp. G. A. Soteriou and M. G. Soteriou, *Hē basilikē tou hagiou Demetriou Thessalonikēs* (Athens, 1952); Krautheimer 1965, 95ff.; Kitzinger 1958, passim; and Cormack 1985, 50ff. See nn. 15 and 16 below. This is not a genuine tomb but a cult site that indicates the presence of a tomb.

15. On the mosaic on the west wall of the church of Demetrius, see Soteriou and Soteriou (see n. 14 above), pl. 62 (pls. 63–69 show the other votive images), and Cormack 1985, 80–81 and fig. 23.

16. Cf. Pallas 1979, 44ff., and Cormack 1985, 76. Soteriou and Soteriou (see n. 14 above), pl. 65 shows the ideal type of the praying figure, without other figures, before a shell niche.

17. Cf. Papageorgiu 1908, 342ff. (before the fire), and Cormack 1969, 17ff. (with analysis of the watercolor by W. S. George illustrating the burnt mosaics). Cf. Grabar 1957; Kitzinger 1958; and Cormack 1985, 87–88 with figs. 27–28.

18. Cf. Pallas 1979, fig. on p. 56.

19. K. M. Kaufmann, *Die Mensastadt* (Leipzig, 1910). The relief in Vienna (inv. I 1144; 67.5 × 46.2 cm) is in Wessel 1963, fig. 13, and Frankfurt 1983, no. 177. Also cf. ibid., pp. 223ff., article by J. Christern, "Die Pilgerheiligtümer von Abu Mina and Qual'at Siman." A different relief (from Alexandria Museum) appears in Zaloscer 1974, fig. 105.

20. Cf. Grabar 1958; C. Metzger, *Les ampoules à eulogie du Musée du Louvre* (Paris, 1981); Vikan 1982, with further references; Frankfurt 1983, no. 175; and New York 1978, no. 517. On Menas, cf. P. Porta, "Le ampolle inedite . . . di Bologna," in *Il Carrobbio* 6 (1980): 301ff.

21. These are frescoes in Karm al-Ahbariya; cf. W. Müller-Wiener, in *Archäologischer Anzeiger*, 1967, 473ff.

22. On the tomb fresco in Antinöe, cf. M. Salmi, "I dipinti paleocristiani di Antinoe," in *Scritti dedicati alla memoria di Ippolito Rosselini* (Florence, 1945), 159ff. Also cf. A. Grabar, "Deux monuments chrétiens d'Egypte," in *Synthronon*, Bibliothèque des Cahiers Archéologiques 2 (Paris, 1968), 4ff.

23. On the tondo of the brothers in Cairo (Egyptian Museum G.33267) from Antinoopolis, cf. Parlasca 1966, 67 no. 7, 131, and pl. 19.1, and Parlasca 1969, no. 166 and pl. 40 (with dating in the period of Hadrian).

24. On the portrait of Eutyches (New York, Met-ropolitan Museum inv. 18.9.2), cf. Parlasca 1966, 80 no. 8, 228 no. 113, and pl. 29.3; Zaloscer 1961, pl. 5; and Parlasca 1969, no. 167 and pl. 40.

25. The bust of St. Peter, with a bust of Paul, was once on an arcosolium in the second catacomb (Achelis 1936, 48 and 70 with pl. 42, and Weis 1958, 23 fig. 4).

26. On the Pantocrator in the Commodilla catacomb in Rome, cf. A. Nestori, *Repertorio topografico delle pitture delle catacombe romane* (Rome, 1975), p. 138 no. 5, and A. Ferrua, in *Rivista archeologica cristiana* 34 (1958): 18. Good color illustrations are in A. Grabar, *Le premier art chrétien (200–295)* (Paris, 1967), fig. 237.

27. On paintings of gods and heroes, cf. Weis 1958, 51–52; Parlasca 1966, 72 and pl. 21; G. K. Boyce, *Corpus of the Lavaria of Pompei* (Rome, 1937; W. Ehrlich, *Bild und Rahmen im Altertum* (Leipzig, 1954), fig. 77 and passim.

28. On the portrait in the Oceanus chamber of the catacomb of Callistus in Rome, cf. Wilpert 1914–17, vol. 3, pl. 182.1; Kollwitz 1957, 70–71 and pl. 8.2. Also cf. Nestori (see n. 26 above), 101 no. 15.

29. On the gold-glass collection, cf. Charles R. Morey, *The Gold-Glass Collection of the Vatican Library* (Vatican City, 1959), esp. the early private portraits (no. 5), those showing a couple (nos. 1, 7) and a couple with child (no. 5), and the portrayals of Peter and Paul crowned by Christ (nos. 50, 66, 67) or flanking St. Agnes (no. 75). Here we illustrate a gold-glass in Arezzo.

30. On the Abraham panel in former East Berlin, cf. Wessel 1963b, frontispiece; Zaloscer 1974, fig. 75; Kollwitz 1957, 66. On Abbacyrus in St. Maria Antiqua, cf. Wilpert 1916, pl. 196.4.

31. New York 1978, no. 498 with further literature.

32. On the portraits of the patriarchs, cf. Theophanes' *Chronographia*, ed. C. de Boor (Leipzig, 1883), 155, and John of Ephesus, *Historia ecclesiastica* 3, ed. E. W. Brooks (Louvain, 1952), 7.13–15; 32.13–14; 66.25–67.17, and 73.3–6. On the diptych in Brescia, cf. Delbrueck 1929, 103ff. with no. 7, and H. Belting, "Probleme der Kunstgeschichte Italiens im Frühmittelalter," *Frühmittelalterliche Studien* 1 (1967): 94ff. and esp. 119 with fig. 95.

33. On letter 32.2, cf. G. de Hartel, ed., "S. Paulini Nolani Epistulae," in *Corpus Scriptorum Ecclesiasticarum Latinorum* 29 (Vienna, 1894), 276.9ff. Also cf. R. C. Goldschmidt, *Paulinus'*

Churches at Nola (Amsterdam, 1940), 35ff. Cf. Kollwitz 1957, 70.

34. On the angel icon in the Cabinet des Médailles, Paris, cf. *Koptische Kunst* (catalog; Essen, 1962), no. 235, and New York 1978, no. 483.

35. Cf. Baynes 1955c, 226ff.

36. On the Paris icon, cf. Felicetti-Liebenfels 1956, 25 and pl. 29; Wessel 1963b, 186 and pl. 14.

37. See n. 36 above.

38. Bawit, Chapel 42, Photo École des Hautes Études, Paris, no. C 2213. On the monastery of Apollon in Bawit, cf. J. Clédat, *La monastère et la nécropole de Baouit,* Mémoires Institut Français d'Archeologie du Caire (Cairo, 1916); G. Maspero, *Fouilles exécutées à Bavit* (Cairo, 1923); and Badawy 1978, 247ff. with a summary on the frescoes. The apses and niche frescoes are discussed in Ihm 1960, 198ff.

39. See n. 17 above.

40. Papageorgiu 1908, 342.

41. On the conception of the portrait, cf. Zaloscer 1961, 31ff. and 41ff.; Parlasca 1966, 59ff. and 73ff.

42. Zaloscer 1961, 7.

43. Parlasca 1966, 107 and pl. 5.3 on the cardboard mask from Havara in Berlin (Ägyptisches Museum inv. 14211).

44. Ibid., 114 and pl. 4.2–3 on the Claudian funerary bust of Aurunceius in Brussels, contrasted with the so-called spouse of Aline in Berlin (Ägyptisches Museum inv. 11414).

45. Ibid., pl. 5.3–4.

46. Washington, D.C. 1967, no. 355 (height = 36.9 cm). Dating is to the third century; cf. Parlasca 1966.

47. W. Benjamin, *Das Kunstwerk im Zeitalter seiner technischen Reproduzierbarkeit,* Edition Suhrkamp 28 (Frankfurt 1972), 53 n. 7.

48. See n. 27 above.

Chapter 6

1. On the Psalter of Theodore in the British Library, London, Codex Add. 19352, produced in 1066 in the Studios monastery in Constantinople, cf. Der Nersessian, *L'illustration des psautiers grecs du Moyen Age* (Paris, 1970), 2: 104–105 and fig. 318, with reference to our description in chap. 9e. Also cf. Spatharakis 1981, no. 80.

2. Treitinger 1938, 49ff. Still the most important publication on imperial iconography in Byzantium is Grabar 1936. Also cf. the volume of illustrations by S. Lampros, *Leukōma byzantinon autokratorōn* (Athens, 1930). A main source on the ceremonies in the throne room is the report by Luitprand of Cremona from the tenth century.

3. On this manuscript, Codex gr. 17 in the Marciana, Venice, cf. Rice 1959, pl. 11, and A. Cutler, "A Psalter of Basil II," *Arte Veneta* 30 (1976): 9ff., 31 (1978): 9ff. Cf. Grabar 1936, 86–87 and pl. 23.1; Cutler 1984, no. 58 fig. 412; and Spatharakis 1981, no. 43.

4. On the mosaic of Emperor Alexander, cf. Mango 1962, 32, 46–47, and fig. 50, and P. A. Underwood and E. Hawkins, in *Dumbarton Oaks Papers* 15 (1961): 187ff. On the stone tondi, cf. Washington, D.C. 1967, no. 49 (diameter 89.5 cm, inv. 37.23 Dumbarton Oaks), and Grabar (see chap. 10 n. 10).

5. The source, the *Parastaseis Syntomai Chronikai,* appeared first in T. Preger, *Scriptores originum Constantinopolitanarum* (Leipzig, 1901), 1:71 no. 82. Cf. Belting 1970, 80, and A. Cameron and J. Herrin, *Constantinople in the Early Eighth Century: The Parastaseis Syntomai Chronikai* (Leiden, 1984), 161 no. 82. Also cf. the description of the mosaics of Basil I (after 867) in the part of the great palace called Kainourgion, by Theophanes Continuatus (Constantinus Porphyrogenetus, *De Basilio Macedone,* no. 89 [ed. Bonn], 3.332ff.). In the eleventh century John Mauropus wrote an epigram on an image depicting the coronation of Constantine IX Monomachus and the empress, according to a formula known from an ivory (Mango 1972, 221).

6. Kruse 1934, 33ff. (after Mansi 1901, 12:1013: Theodosius of Amorium in the first session, including parallels). Cf. n. 8 on the *clipeus.*

7. On the image and cult of the emperor, cf. esp. Kruse 1934, 23ff. and 79ff.; Grabar 1936; Treitinger 1938; Wlosok 1978; Pekary 1985, 143ff. On Diocletian's reforms, cf. Alföldi 1970. On the functions of the imperial image, cf. J. P. Rollin, *Untersuchungen zu Rechtsfragen römischer Bildnisse* (Bonn, 1979), 117ff.

8. On the colossus of Barletta, cf. R. Delbrueck, *Spätantike Kaiserporträts* (Berlin, 1933), 219ff. with pl. 116; Volbach 1958, fig. 69; Grabar 1966, fig. 247; New York 1978, no. 23; and Theodore Kraus, ed., *Das römische Weltreich,* Propyläen Kunstgeschichte 2 (Berlin, 1967), no. 331. On Philostorgius (ed. J. Bidez [Leipzig, 1913], 28 no. 17), cf. Kitzinger 1954, 92.

9. On the Probus diptych, cf. Delbrueck 1929, no. 1, and Volbach 1952, no. 1.

10. On the *Notitia dignitatum* preserved in medieval copies, cf. H. Omont, *Notitia dignitataum Imperii Romani* (Paris, 1911); R. Grigg, "Portrait-Bearing Codicils in the Illustrations of the N.D.," in *Journal of Roman Studies* 69 (1979): 107ff.; I. Maier, "The Barberinus and Munich Codices of the N.D.," *Latomus* 27 (1968): 96ff.; P. C. Berger, *The Insignia of the N.D.* (New York, 1981), 25ff. Figure 53 is reproduced here from the example in the Bayerische Staatsbibliothek, Munich, Clm. 10291, fol. 178.

11. Kruse 1934, 79ff. and 100ff.; Rollin (see n. 7 above), 141ff. On the Probianus diptych in Berlin, cf. Delbrueck 1929, no. 65, and Volbach 1952, no. 62.

12. On the purple gospel book in Rossano, cf. New York 1978, no. 443. Cf. Volbach 1958, fig. 239; Grabar 1966, fig. 232. Cf. the recent facsimile edition: *Codex Purpureus Rossanensis*, Codices Selectis 81 (Graz, 1985).

13. On the family portrait of Septimus Severus in Berlin (inv. 31329), cf. K. A. Neugebauer, in *Die Antike* 12 (1936): 156. On the *damnatio*, cf. Pekary 1985, 134ff.

14. See n. 7 above. On the portrait and the rights associated with it, cf. Pekary 1985, 116ff. and 143ff.

15. Quoted in the Book of Ceremonies 1.87 (Reiske 1829–30, 395–96). Cf. Kruse 1934, 29; MacCormack 1981, 67ff.; and Pekary 1985.

16. Kruse 1934, 31–32, 46. Gregory the Great (590–604) described the reception of the icons of the imperial couple (Phokas and Leontia) in Rome, first in the Lateran, then on the Palatine Hill.

17. Ibid., 103ff., referring to codicil images of Constance II.

18. Ibid., 47–48. On the type of the portrait shield in general, the *imago clipeata*, cf. esp. Bolten 1937, 9ff. and 14ff.; Blanck 1968, 1ff.; also cf. *Reallexicon der byzantinischen Kunst*, "Imago Clipeata"; Grabar 1968, 1:208ff. ("Un médaillon en or provenant de Mersine en Cilicie" [1951]) and 607ff. ("Imago clipeata" [1957]); R. Winkes, *Clipeata imago. Studien zu einer römischen Bildnisform* (Bonn, 1969).

19. Kruse 1934, 16–17 and 51ff.; Rollin (see n. 7 above), 123ff. On the triumphal arch of Septimus Severus in Leptis Magna and the relief with this motif, cf. Grabar 1968, vol. 3, pl. 29a; J. B. Ward Perkins, "The Arch of Septimus Severus at Leptis Magna," *Archaeology* 4 (1951): 226ff.; and A. Birley, *Septimus Severus: The African Emperor* (1972), 88–89 with fig. 6.

20. On the ampoules, or *enkolpia*, from the Holy Land, with illustrations, cf. Grabar 1958 and Metzger 1981. An important piece illustrated here is the small lead ampoule in Dumbarton Oaks (New York 1978, no. 524; Ross 1962, no. 87 pl. 48). Also cf. a large gem with this motif in the Kunsthistorisches Museum, Vienna (New York 1978, no. 525, and Frankfurt 1983, no. 174), and a stone relief found in the church of Demetrius in Salonika (published in *Ergon hetaireias archaiologikēs* [Athens, 1959], 34 fig. 33). Especially important in reconstructing the situation in Jerusalem is the mosaic-covered side apse from the seventh century in the Roman church S. Stefano Rotondo on the Celio (Ihm 1960, 143–44 no. 9 and pl. 221.2). The mosaic was produced under Theodore I (642–49). On this theme in general, cf. R. Grigg, "The Cross and Bust Image," *Byzantinische Zeitschrift*, 1979, 16ff.

21. On the hung *clipeus* in Mainz, acquired in Cairo in 1927 (dia. 8.5 cm); cf. J. G. von Sachsen, *Neue Streifzüge durch die Kirchen und Klöster Ägyptens* (Leipzig and Berlin, 1930), 50–51 fig. 149. A similar tondo, but at the center of a cross from the treasure of Antioch, appears in M. Mundell Mango, *Silver from Early Byzantium* (catalog; Baltimore, 1986), no. 42.

22. On the labarum, cf. Kruse 1934, 68ff.; R. Egger, *Das Labarum. Die Kaiserstandarte der Spätantike*, Osterreichische Akademie der Wissenschaften, Phil.-hist. Klasse 234, Abhandlung 1 (Vienna, 1960).

23. On the vision of the cross, cf. Barnes 1981, 42–43 and 48ff., with further references.

24. This usage is studied in depth in Kruse 1934, 64ff.

25. Ščepkina 1977, frontispiece, and Lichačeva 1977, pl. 1.

26. This miniature in the menologion of Emperor Basil II (976–1025) appears in Codex Vat. gr. 1613, p. 392; cf. the edition *Il Menologo de Basilio II (Codex Vat. gr. 1613)*, Codices e Vaticanis selecti 8 (Turin, 1907), fig. 392, and Grabar 1957, fig. 53. On the codex, cf. Spatharakis 1981, no. 35.

27. On Castelseprio, cf. K. Weitzmann, *The Fresco Cycle of S. Maria di Castelseprio* (Princeton, 1951). On the *clipeus* motif, cf. G. P. Bognetti et al., *S. Maria di Castelseprio* (Milan, 1948), pl. 42, and idem, *Castelseprio, Guida* (Vicenza, 1974), fig. 26. On the dating, cf. Belting (see chap. 5 n. 32 above), 121–22.

28. On this information supplied by Trebellius Pollo in the *Historia Augusta*, cf. Bolten 1937,

15ff. On the apotheosis, cf. H. P. L'Orange, *Likeness and Icon* (Odense, 1973), 325ff. On the small arch of Galerius, cf. R. Calza, *Iconografia romana imperiale da Carousio a Galerio,* Quaderni e guide di archeologia 3 (1972), 141–42 no. 53 and pl. 36; R. Bianchi, *Bandinelli, Roma. Le fine dell'arte antica* (1970), 306 fig. 283.

29. Cf. detailed discussion in Delbrueck 1929, passim.

30. Ibid., no. 21; Volbach 1952, no. 21; New York 1978, no. 88; Volbach 1958, fig. 220.

31. Delbrueck 1929, no. 16; Volbach 1952, no. 15; New York 1978, no. 48.

32. Berlin, Staatliche Museen Preußischer Kulturbesitz, Frühchristlich-Byzantinische Abteilung (Delbrueck 1929, no. 34; Volbach 1952, no. 33; New York 1978, no. 51).

33. Weitzmann 1976, no. B 11 and pl. 57 on this icon of the fifth or sixth century from the Sinai; also cf. H. Belting and G. Cavallo, *Die Bibel des Niketas* (Wiesbaden, 1979), fig. 53; New York 1978, no. 479.

34. On the icon of St. Peter, cf. Weitzmann 1976, no. B 5 and pl. 48; New York 1978, no. 488.

35. Weitzmann 1976, no. B 28 and pl. 76.

36. Delbrueck 1929, no. 6; Volbach 1952, no. 5; Volbach 1958, fig. 97.

37. Ihm 1960, 203 no. 52; and pl. 18.1. Also cf. Grabar 1966, fig. 193. The location concerned is Chapel 28 of the Apollo monastery.

Chapter 7

1. W. de Grüneisen, *Sainte Marie Antique* (Rome, 1911); Wilpert 1916, pls. 155–87; E. Kitzinger, *Römische Malerei vom Beginn des 7. bis zur Mitte des 8. Jahrhunderts* (Munich, 1936); E. Tea, *La Basilica di S. Maria Antiqua* (Milan, 1937); G. B. Ladner, *Die Papstbildnisse des Altertums und des Mittelalters,* vol. 1 (Rome, 1941), on Popes Martin I, John VII, Zacharias, and Hadrian; P. Romanelli and P. J. Nordhagen, *Santa Maria Antiqua* (Rome, 1964); P. J. Nordhagen, *The Frescoes of John VII (A.D. 705–707) in S. Maria Antiqua in Rome,* Acta ad archaeologiam et artium historiam pertintia 3 (Rome, 1968); esp. Nordhagen 1987, 453ff.

2. Wilpert 1916, pl. 159; Romanelli and Nordhagen (see n. 1 above), pl. 18; Kitzinger 1977, 116ff. and fig. 207.

3. Wilpert 1916, pl. 144.2; Kitzinger 1955, 137 and fig. 5; and Nordhagen 1987, 454.

4. Wilpert 1916, pl. 163; Romanelli and Nord-

hagen (see n. 1 above), pl. 2; Kitzinger 1936 (see n. 1 above), 8ff.; Kitzinger 1958, 2 and fig. 2 (1976, 158); Kitzinger 1977, 114 and pl. 7.

5. Cf. the references in chap. 5 n. 4.

6. Wilpert 1916, pl. 180; Romanelli and Nordhagen (see n. 1 above), pls. 7 and 32.

7. Romanelli and Nordhagen (see n. 1 above); pls. 6 and 13; Nordhagen 1968 (see n. 1 above), 75ff. and pls. 92, 93; cf. esp. Weis 1958, 19ff.

8. Cf. the proof demonstrated in Weis 1958, passim.

9. Ibid., 39ff. and fig. 15; W. de Grüneisen, *Caractéristiques de l'art copte* (Florence, 1922), pl. 26.

10. Kitzinger 1955, 134ff.; Kitzinger 1958, 5ff. and passim; Kitzinger 1977, 116ff. The discussion was first taken up by Myrtilla Avery, who detected an "Alexandrian style" in the paintings (in *Art Bulletin* 7 [1925]: 131ff.), and then by Leonid Matsulevich, who discovered influence from the seventh century on "Hellenistic" silver plates (cf. his *Byzantinische Antike* [Berlin and Leipzig, 1929]).

11. Weitzmann 1976, nos. B 32, B 36, and B 50 (pls. 84, 89, and 105). Cf. Belting and Belting-Ihm 1966 for detailed discussion, and now Kartsonis 1986, 40ff. and figs. 9–13.

12. C. R. Morey, "The Painted Panel from the Sancta Sanctorum," in *Festschrift Paul Clemen* (Düsseldorf, 1926), 151ff.; K. Weitzmann, "Loca Sancta and the Representational Arts of Palestine," *Dumbarton Oaks Papers* 28 (1974): 31ff., 36, and fig. 32; Weitzmann 1976, 32 and fig. 14; cf. *Ornamenta Ecclesiae* (catalog; Cologne, 1985), 3:80ff. no. H 8.

13. Hartmann Grisar, *Die römische Kapelle Sancta Sanctorum und ihr Schatz* (Freiburg im Breisgau, 1908), 118–19 and pl. V.5-6; C. Cecchelli, "Il tesoro del Laterano," *Dedalo,* 1926–27, 428. The small panels (8.5 × 5.8 cm) have a frame that is recessed and raised so that they fit into each other.

14. B. Mombritius, *Sanctuarium seu vitae sanctorum* (Paris, 1910), 508ff.; W. Levison, *Konstantinische Schenkung und Silvesterlegende. Miscellanea für F. Ehrle* (Rome, 1924), 2: 159ff.; E. Ewig, "Das Bild Konstantins des Großen in den ersten Jahrhunderten des abendländischen Mittelalters," *Historisches Jahrbuch* 75 (1956): 1ff.; H. Belting, "Die beiden Palastaulen Leos III. im Lateran," *Frühmittelalterliche Studien* 12 (1978): 55ff. and esp. 76–77. In the well-known letter of Pope Hadrian (787) to the Byzantine emperors (Mansi 1901, 1060), the veneration of images is justi-

fied expressly by appeal to Sylvester's testimony when he showed the emperor the *imago apostolorum.*

15. See chap. 4 nn. 32-39.

16. See chap. 4 n. 28.

17. See chap. 4 n. 25.

18. The Madonna Avvocata in S. Sisto also had a golden hand, one appliquéd with gold foil (Bertelli 1961a, 82ff.). On the hand of Demetrius of Salonika, see chap. 5 n. 15.

19. References on this icon are in chap. 4 n. 38.

20. R. Krautheimer, *Corpus basilicarum christianarum Romae* (Rome, 1961), 2:254-55, 264.

21. Kitzinger 1955, 133ff.

22. Wilpert 1916, pl. 133; Romanelli and Nordhagen (see n. 1 above), pl. 14; Nordhagen 1968 (see n. 1 above), pl. 44. Cf. esp. Kitzinger 1936 (see n. 1 above); Kitzinger 1955, 134; Kitzinger 1977, 114 and figs. 201-2.

23. A. Grabar, "La représentation de l'intelligible dans l'art byzantin du moyen Age," in Grabar 1968, 1:51ff. Also cf. the collected essays of H. P. L'Orange (see chap. 6 n. 28) and L'Orange 1965, 25ff.

24. Cf. the detailed discussion in Bertelli 1961c and, more recently, with divergent dating, Russo 1979, 35ff. On the church, cf. D. Kinney, "S. Maria di Trastevere from Its Founding to ca. 1215" (diss. New York University, 1975).

25. An icon curtain in Cleveland (178 × 110 cm) and an ivory in the Berlin museums are the main evidence (New York 1978, nos. 474 and 477, and D. G. Shepherd, in *Bulletin of the Cleveland Museum of Art* 56 [1969]: 90ff.). Further evidence are the mosaics in the aisle of the church of Demetrius in Thessaloniki (see chap. 5 nn. 14 and 17).

26. Grabar 1966, fig. 310; Bertelli 1961c, 49-50.

27. P. J. Nordhagen, "The Mosaics of John VII (705-707 A.D.)," in *Acta ad archaeologiam et artium historiam pertinentia* 2 (Rome, 1965), 121ff.; Wilpert 1914, pls. 113-14; J. Wilpert and W. N. Schumacher, *Die römischen Mosaiken der kirchlichen Bauten vom IV.-VIII. Jahrhundert* (Freiburg, 1976), 67ff. and pls. 111-12.

28. L'Orange 1965, 25ff. and 105ff.

29. Kitzinger 1958, 40ff.

30. Weitzmann 1976, 18ff. no. B 3 and pls. 4-6; Kitzinger 1958, 30ff. and 47-48; Kitzinger 1977, 117-18 and fig. 210; Weitzmann with Chatzidakis et al. 1965, pls. 1-3.

31. Kitzinger 1958, 30.

32. Ibid., 47.

33. Weitzmann, with Chatzidakis et al. 1965, ix.

34. G. H. Forsyth and K. Weitzmann (see chap. 1 n. 27), with illustrations, and K. Weitzmann, "The Classical in Byzantine Art," in *Byzantine Art and European Art: Lectures* (Athens, 1966), 171-72 and figs. 132-33.

35. L'Orange 1965, 26.

36. See chap. 6 n. 34 and, further, Kitzinger 1977, 120 and pl. 8, and a forthcoming work by H. Hallensleben that suggests a Roman origin.

37. Wilpert and Schumacher (see n. 27 above), 328ff. and pls. 101-6. Also cf. Kitzinger 1977.

38. Volbach 1958, pls. 56-57.

39. M. Chatzidakis, "An Encaustic Icon of Christ at Sinai," *Art Bulletin* 49 (1967): 197ff. Cf. Kitzinger 1976, 13ff. no. B 1 and pls. 1-2, 39-41, and Kitzinger 1977, 120ff. with fig. 221.

40. Inv. 40.386; Parlasca 1966, frontispiece.

41. Parlasca 1966, pl. 15.2.

42. See chap. 5 n. 24.

43. Breckenridge 1959, passim. On the coin image, cf. M. Restle, *Kunst und byzantinische Münzprägung von Justinian I. bis zum Bilderstreit* (Athens, 1964), 118ff.; P. Crierson, *Catalogue of the Byzantine coins in the Dumbarton Oaks Collection* (Washington, D.C., 1968-73), vol. 2.1, 65ff.; vol. 2.2, 568ff., 578-79, 614-15, and 649-50 (second reign, with Semitic type); vol. 3, 146ff. (the portrayal of Christ and its subsequent history after iconoclasm).

44. Breckenridge 1959, 58; the source is in *PG* 86, 173 and 221. Cf. comments in Kitzinger 1977, 20-21.

45. Apart from Breckenridge 1959, references are in n. 43 above.

46. See references in n. 43 above.

47. Grabar 1936, passim.

48. Restle (see n. 43 above), 12-13.

49. Breckenridge 1959, 91-92.

50. Grabar 1957, 124.

51. Kitzinger 1963, 185ff.

52. Breckenridge 1959, 96. Cf. Rösch 1978, passim.

53. Grabar 1957, 68, 71ff.

54. Ibid., 68 and fig. 63.

55. Cf. E. Fehrenbach, in *Historische Zeitschrift* 213 (1971): 296ff.

56. Cf. A. A. Vasiliev, "The Iconoclastic Edict of the Caliph Yazid II, A.D. 721," *Dumbarton Oaks Papers* 9-10 (1955): 23ff.; O. Grabar, "Islam and Iconoclasm," in Bryer and Herrin 1977, 45ff.

57. R. Paret, "Textbelege zum islamischen Bilderverbot," in *Das Werk des Künstlers. Festschrift Hubert Schrade* (Stuttgart, 1960), 36ff.; idem,

"Das islamische Bilderverbot und die Schia," in *Festschrift W. Caskel* (Leiden, 1968), 224ff.; idem, "Das islamische Bilderverbot," in J. Iten-Maritz, *Das Orientteppich-Seminar* 8 (1975), 4 pp.; cf. A. Grabar 1957, 47ff. ("La guerre par les images") and 103ff. ("Hostilité aux images: Musulmans"), and O. Grabar (see n. 53 above), passim.

58. All examples are assembled in Breckenridge 1959.

59. Weitzmann 1976, no. B 6 and pl. 11 (35 × 21.2 cm), which contains further examples for comparison.

60. Ibid., no. B 3 and pl. 4.

61. Ibid., no. B 9 and pl. 12.

62. Cf. the examples in n. 11 above.

63. Weitzmann 1976, no. B 51 and pl. 107.

64. Cf. Speck 1968, passim.

65. Weitzmann 1976, no. B 11 and pl. 57. I am indebted to the stimulating study by Kathleen Corrigan, "The Witness of John the Baptist on an Early Byzantine Icon in Kiev," *Dumbarton Oaks Papers* 42 (1988): 1ff.

66. Weitzmann 1976, no. B 5 and pl. 8.

67. G. B. de Rossi, *Inscriptiones Christianae Urbis Romae Septimo Saeculo Antiquiores* (Rome, 1888), vol. 2.1, p. 33, no. 82: "In igona sancti Petri . . . ton Theon Logon. The[asth]ē chrysō tēn theo[gl]ypton petran en hē vevēkōs ou klonou[mai]." It is mentioned in the collection of inscriptions in the *Codex Einsiedlensis* compiled in the eighth century (cf. Valentini and Zucchetti 1942, 155ff., and G. Walser, *Die Einsiedler Inschriftensammlung und der Pilgerführer durch Rom,* Historia Einzelschriften 53 [Wiesbaden, 1987]). I am grateful to Richard Krautheimer for this information.

68. Cf. F. W. Deichmann, "Die Entstehungszeit von Salvatorkirche und Clitumnustempel bei Spoleto," *Römische Mitteilungen des Deutschen Archälogischen Instituts* 58 (1943): 106ff. and esp. 143–44 with figs. 34 and 35 (after 760), and M. Andaloro, "I dipinti murali del Tempietto sul Clitunno doppo il restauro," in *I dipinti murali e l'aedicola marmorea del Tempietto sul Clitunno,* ed. G. Benazzi (Spoleto, 1985), 47ff. (after 700).

Chapter 8

1. Cf. the important studies Koch 1917 and Elliger 1930, as well as Kollwitz 1954, 318ff.; Kollwitz 1957, 57ff.; and Murray 1977, 326ff.

2. On the practice of images in the period before the formulation of the doctrine of images, cf. Kitzinger 1954, 83ff.; Cameron 1981, passim; Baynes 1955c, 226ff. For a critique of the doctrine of images, cf. esp. Beck 1975.

3. Among more recent works, cf. esp. Gero 1981, 460ff., and Gero 1977, 37ff. and 85ff. (on the reuse of the letter at the iconoclastic council of 754 and its later refutation by Nicephoros). Cf. also Koch 1917, 41; Elliger 1930, 47; Mango 1972, 16; and Schönborn 1976, 55. What is noteworthy in Eusebius is the description of the Christ statue of Paneas in Palestine (*Historia ecclesiastica* 7.18). On the letter, cf. Hennephof 1969, 42–43.

4. Cf. esp. Holl 1928, 351ff.; Ostrogorsky 1929, 68ff., with edition of letters and testaments. Also cf. Koch 1917, 58ff.; Elliger 1930, 53ff.; Mango 1972, 41ff.; and Hennephof 1969, 44ff. On Epiphanius (*Panarion haereticon* 27.6, 10, ed. K. Holl [Leipzig, 1915], 311), cf. Kitzinger 1954, 93.

5. Koch 1917, 31ff., and Elliger 1930, 34ff.

6. *De imaginibus oratio* 3.16 (*PG* 94, 1337, and B. Kotter, ed., *Die Schriften des Johannes von Damaskus* [Berlin and New York, 1975], 3: 125ff.). See also n. 28 below.

7. Cf. Mango 1972, 34–34, and the literature on the *Hodegetria* icon (see chap. 4 n. 7).

8. Cf. esp. Gero 1975, 208ff. Cf. Kitzinger 1954, 94–95; Lange 1969, 44ff.; Mango 1972, 116–17. This "classification" of Christians was later criticized by Theodore of Studion.

9. Letters 11.13 and 9.6 of Gregory the Great in particular influenced this canonical view. Cf. Koch 1917, 77ff., and Kollwitz 1957, 57ff.

10. Edited by A. N. Vaselovskii, in *Sbornik Otdeleniia Russkogo Jazyka i Slovenosti Imperialni Akademii Nauk* 40.2 (1886), 65ff., esp. 73ff. Cf. Mango 1972, 137. In Jerusalem Peter was said to have had a much-reproduced icon of Christ painted by a painter named Joseph. A Peter icon was also found in the luggage of Pancras, whose biography was written by his successor Evagrius.

11. Only a selection of the vast literature can be mentioned. The following works seem to me particularly important in the history of the subject, with reference to art history. Grabar 1957; Bredekamp 1975, 114ff.; Bryer and Herrin 1977; Speck 1978; and Cormack 1985. A number of sources are conveniently assembled in Mango 1972, 149ff. Especially important on theological positions are Ostrogorsky 1929; Beck 1959, 296ff.; Ladner 1953, 1ff.; Kollwitz 1954, 318ff.; Wessel 1966, 635ff.; Schönborn

1976, 149ff. and 179ff.; Barnard 1974. A different aspect, the question of how to characterize the sacred, is dealt with by Brown 1973,1ff., and Brown 1982, 284–301. Also cf. the following notes as well as K. Schwarzlose, *Der Bilderstreit* (Gotha, 1890; 2d ed., Amsterdam, 1970); Ostrogorsky 1940, 97ff.; B. Brock, in Warnke 1973a, 30ff.; P. Schreiner, "Legende und Wirklichkeit in der Darstellung des byzantinischen Bilderstreits," *Saeculum* 27 (1976): 165ff.; J. Irmscher, ed., *Der byzantinische Bilderstreit* (Leipzig, 1980).

12. On the start of the controversy, cf. esp. Gero 1973a, 94ff. (official iconoclasm and the role of Germanus); L. Lamza, *Patriarch Germanos I. von Konstantinopel* (Würzburg, 1975); D. Stein, *Der Beginn des byzantinischen Bilderstreits und seine Entwicklung bis in die vierziger Jahre des 8. Jahrhunderts*, Miscellanea Byzantine Monacensia 25, (Munich, 1980).

13. On the letter to Gregory II, cf. E. Caspar, in *Zeitschrift für Kirchengeschichte* 52 (1933): 85. In the letter Leo calls himself emperor and high priest (*archiereus*).

14. Cf. esp. Barnard 1974, 108ff., and Gero 1977, 143ff. Sources also are in Hennephof 1969, 52ff.

15. Mansi 1901, 13:205ff.; Mango 1972, 165ff.; Hennephof 1969, 58ff. nos. 188–99 and 61ff. (the *horos*) nos. 200–264. Also cf. Gero 1977, 53ff.

16. Mansi 1901, 12:951ff. and vol. 13, passim (the *horos*, 373ff.; the *kanones*, 417ff.); Lange 1969, 158ff.; Mango 1972, 172–173; Schönborn 1976, 142ff.; Thon 1979, 207ff.

17. *PG* 108, 1025 (vita of Leo V).

18. Cf. esp. the polemical Life of Leo V (as in ibid.) and Alexander 1958, passim.

19. Cf. *PG* 108, 1024–24 (vita of Leo V). On the connection between iconoclasm and success in war, cf. Ostrogorsky 1940, 168.

20. Alexander 1953, 35ff., and Alexander 1958, 137ff. Texts are in Hennephof 1969, 79ff. nos. 265–81, and Mango 1972, 168–69.

21. J. Gouillard, *Le synodikon de l'orthodoxie. Édition et commentaire*, Centre de recherches d'histoire et de civilisation byzantines, travaux et mémoires 2 (Paris, 1967), passim, and Mango 1972, 181ff.

22. Cf. I Ševčenko, "The Anti-Iconoclastic Poem in the Pantocrator-Psalter," *Cahiers archéologiques* 15 (1965): 39ff., esp. 55ff. On the biography and subsequent influence of Nicephorus, cf. Alexander 1958, passim.

23. Cf. the Life of Niketas Paphlagon, which describes the life of Ignatius (847–58 and 867–77) (*PG* 105, 540–41). Cf. Grabar 1957, 185–86, and Mango 1972, 191–92.

24. Cf. Ševčenko (see n. 22 above), passim. Dating under the patriarchate of Photios appears in A. Grabar, "Quelques notes sur les psautiers illustrés byzantins du IX^e siècle," *Cahiers archéologiques* 15 (1965): 61ff. The early dating (cf. A. Frolow, "La fin de la querelle iconoclaste et la date des plus anciens psautiers grecs à illustrations marginales," *Revue de l'histoire des religions* 163 [1963]: 219ff.) is now rejected. On this group, in which Codex 61 of the Pantocrator monastery and the Chludov Codex (see n. 25 below) are predominant, cf. R. Cormack, in Bryer and Herrin 1977, 149, and Cormack 1985.

25. Moscow, Historical Museum, Codex 129, fol. 51v (Ščepkina 1977, pl. fol. 51v), and Cormack 1985.

26. Moscow, Historical Museum, Codex 129, fol. 23v (plate in Ščepkina 1977). A parallel illustration is in the Pantocrator Psalter Codex 61, fol. 16 (cf. Ševčenko, see n. 22 above, fig. 1), with a circumscribed poem on Nicephorus, the "tower of Orthodoxy," who treads on his dead successor Theodotus and Emperor Leo V, the "enemy of God" (*theomachos*) and "savage lion."

27. Gero 1973a, 94ff., and Stein (see n. 12 above), 269ff., being a text on the icons.

28. Cf. the references in n. 6 above and in H. Menges, *Die Bilderlehre des hl. Johannes von Damaskus* (Münster, 1938); Beck 1959, 476ff.; Lange 1969, 106ff.; Hennephof 1969, 85ff.; Mango 1972, 169ff.; Schönborn 1976, 191ff.

29. Alexander 1958, 189–90.

30. See n. 14 above.

31. See sources in nn. 14 and 15 above. Also cf. Maria-José Baudinet, "La relation iconique à Byzance au IX^e siècle d'après le Nicéphore le patriarche: Un destin de l'aristotélisme," *Les études philosophiques* 1 (1978): 85ff., esp. 88.

32. Cf. esp. Alexander 1958, passim. Cf. J. A. Visser, *Nikephoros und der Bilderstreit* (The Hague, 1952); Beck 1959, 489ff.; Lange 1969, 201ff.; Schönborn 1976, 203ff.; and Baudinet (see n. 31 above), 85ff. The three books of the *Antirhētikoi* are in *PG* 100, 201–534; the *Apologeticus* in ibid., 533–850.

33. A. Gardner, *Theodore of Studium: His Life and Times* (London, 1905); B. Hermann, *Des hl. Abtes Theodor von Studion Märtyrerbriefe aus der Ostkirche* (Mainz, 1931); Alexander

1958, 83ff. and 142ff.; Beck 1959, 491ff.; Speck 1968, passim; Henry 1968, passim and 177ff.; Lange 1969, 217ff.; Schönborn 1976, 217ff.

34. *PG* 100, 384. Cf. Lange 1969, 215.

35. Mansi 1901, 16:400 (canon 3 of the anti-Photionic synod).

36. Homily 24 against the Sabellians and Arians (*PG* 31, 608). Cf. Theodore of Studion (*PG* 99, 344). On this and the patristic arguments on images, cf. the important work by Ladner 1953, 1ff. Cf. also Kollwitz 1954, 334ff.; Campenhausen 1957a, 77ff.; Lange 1969, 13ff.; Beck 1975, passim; Schönborn 1976, 21ff. The passages from the church fathers relevant to John of Damascus and the Second Council of Nicaea are also discussed in Menges (see n. 28 above), 151ff., and in Kruse 1934, in relation to the emperor image.

37. Basil, *De spiritu sancto* 17.44 (*PG* 32, 149); Ladner 1953, 1; and Mango 1972, 47. Cf. Basil, *De spiritu sancto* 18.45.

38. *Oratio III contra arianos* 3.5 and 5 (*PG* 26, 322 and 332). Cf. Ladner 1953, 11–12.

39. John of Damascus, *De imaginibus* 3.18. The argument is found in Basil (see n. 36 above). Cf. Ladner 1953, 2–3, 25ff.

40. Theodore of Studion (*PG* 99, 432–33; 95, 163). Cf. Lange 1969, 222–23.

41. This idea is found in John of Damascus, *Oratio de imaginibus* 1.19–20 (*PG* 94, 1252) and 2.14. Cf. Kollwitz 1954, 339, and Menges (see n. 28 above), 76ff.

42. Cf., most recently, Gero 1973b, 7ff.; in addition, the studies of G. Ostrogorsky, E. Caspar, and G. B. Ladner deserve particular attention.

43. On the general theme, cf. Willms 1935; also Dürig 1952, for application to the liturgy, and G. Sörbom, *Mimesis and Art* (Gothenburg, 1966), for application to art.

44. See n. 40 above.

45. Canon 82 of the council *in trullo* (i.e. in the palace chamber); the canon was also known as *quinisextum* because of its treatment of the fifth and sixth ecumenical councils with regard to disciplinary resolutions (Beck 1959, 47); cf. Mansi 1901, 11:977, and Mango 1972, 139–40.

46. Grabar 1966, fig. 359, and C. Belting-Ihm, "Das Justinuskreuz in der Schatzkammer der Peterskirche zu Rom," *Jahrbuch des Römisch-Germanischen Zentralmuseums* 12 (1965): 142ff.

47. See chap. 7 n. 11.

48. Nordhagen 1968 (see chap. 7 n. 1), 50ff.

and 95ff. Cf. corrections in B. Brenk, in *Byzantinische Zeitschrift* 64 (1971): 394–95. Comparable examples and discussion of this iconography are in Ihm 1960, 146–47 and (on the parallel in SS. Cosma e Damiano) 137–38.

49. *Apologeticus* (*PG* 100, 549). On the author and this work, see n. 32 above.

50. See n. 52 below.

51. Cf. G. Mercati, "Sanctuari e reliquie constantinopolitane . . . , *Rendiconti. Atti della Pontificia Accademia Romana di Archeologia* 12 (1937): 133ff., esp. 143.

52. Moscow, Historical Museum, Codex 129, fol. 67. Illustration with folio number is in Ščepkina 1977; see nn. 24–26 above; Grabar 1957, 149 and fig. 146; and Cormack 1985.

53. See n. 42 above and G. Haendler, *Epochen karolingischer Theologie. Eine Untersuchung über die karolingischen Gutachten zum byzantinischen Bilderstreit* (Berlin, 1958).

54. Wulff 1903, 194ff., and P. A. Underwood, "The Evidence of Restorations in the Sanctuary Mosaics of the Church of the Dormition at Nicaea," *Dumbarton Oaks Papers* 13 (1959): 235ff. Cf. Cormack 1977b, 147–48, and Cormack 1985.

55. Cf. Grabar 1957, 154ff. and fig. 88; Cormack 1977a, 35.

56. *PG* 100, 428. Cf. Lange 1969, 213. On the theme of similarity, cf. the literature in n. 36 above, esp. Ladner 1953, 15ff., and P. Schwanz, *Imago Dei als anthropologisches Problem in der Geschichte der alten Kirche* (Halle, 1970).

57. Cf. R. Cormack and E. J. Hawkins, "The Mosaics of St. Sophia at Istanbul: The Patriarchal Apartments," *Dumbarton Oaks Papers* 31 (1977): 177ff., and Cormack 1985.

58. Sources in Mango 1959, 108ff. Cf. Grabar 1957, 130–31; Anthology E, 24–25, in Bryer and Herrin 1977, 185, and Speck 1978, 606ff.

59. Mango 1959, 121.

60. Reproduced in Theodore of Studion (*PG* 99, 437); cf. Mango 1959, 122–23.

61. Mango 1959, 126ff.; Mango 1972.

62. Mango 1972, 141. Cf. Walter 1970, 14ff., 20ff., and Grabar 1957, 55ff.

63. Walter 1970, 22–23, and Grabar 1957, 55–56.

64. Mango 1972, 153, and Brown 1982, 293–94. On the life of Stephen the Younger, cf. J. Gill, "A Note on the Life of Stephen the Younger by Simeon Metaphrastes," *Byzantinische Zeitschrift* 39 (1939): 382ff.; G. Huxley, "On the Vita of Stephen the Younger," *Greek, Roman,*

and Byzantine Studies 18 (1977): 97ff.; and esp. Cormack 1985.

65. *PG* 108, 1028 and 1032.

66. A refutation of the charge is in Nicephorus (*PG* 100, 436; cf. Lange 1969, 211), to the effect that people know whom they must venerate and whom they must not.

67. *LP* 2:32. On the subject matter, cf. L. D. Longman, in *Art Bulletin* 12.2 (1930): 115ff.; W. F. Volbach, *I tessuti del Museo Sacro Vaticano* (Rome, 1942), no. T 104–5.

Chapter 9

1. P. Grierson, *Catalogue of the Byzantine Coins in the Dumbarton Oaks Collection*, (Washington, D.C., 1973), vol. 3.3, 46, 146–47, and 463. On the whole context, cf. Cormack 1985, 141ff., which also deals at length with the problem of the true tradition.

2. Grierson (see n. 1 above), vol. 3.1, 154, and vol. 3.2, 487. On conditions under Justinian II, see chap. 7 n. 43.

3. *Anthologia graeca* 1:106; Mango 1972, 184.

4. R. J. H. Jenkins and C. Mango, "The Date and Significance of the Tenth Homily of Photios," *Dumbarton Oaks Papers* 9–10 (1956): 123ff.; Ebersolt 1951, 26–27; Janin 1953, 232ff. no. 121.

5. Mango 1958, 184ff. (Homily 10), and Mango 1972, 185–86.

6. Mango 1962, 80ff.; C. Mango and E. J. W. Hawkins, "The Apse Mosaics of St. Sophia at Istanbul," *Dumbarton Oaks Papers* 19 (1965): 113ff.; Cormack 1985, 146ff.

7. Mango 1958, 286ff. (Homily 17); Mango 1972, 187ff. Cf. S. Aristarches, *Photiou logoi kai homilai* B.II (Constantinople, 1900), 294ff. no. 73; B. Laourdas, *Photiou homilai* (Salonika, 1959), 164ff. no. 17. On Photios, cf. Beck 1959, 520ff. with further references to the homily.

8. E.g. the thesis of Nikolaos Oikonomides, "Leo VI and the Narthex Mosaics of St. Sophia," *Dumbarton Oaks Papers* 30 (1976): 151ff. He also takes issue with the extensive earlier literature.

9. Cf. Capizzi 1964; Matthews 1976; J. T. Matthews, "The Byzantine Use of the Title Pantocrator," *Orientalia cristiana periodica* 44 (1978): 442ff.; A. Cutler, "The Dumbarton Oaks Psalter and New Testament: The Iconography of the Moscow Leaf," *Dumbarton Oaks Papers* 37 (1983): 35ff.

10. Such a view is expressed by A. Schminck,

"Rota tu volubilis. Kaisermacht und Patriarchengewalt in Mosaiken," in *Cupido Legum,* ed. L. Burgmann et al. (Frankfurt, 1985), 211ff. and esp. 218ff.

11. Cf. the description in Theophanes' *Continuatus* 3 (Konstantin Porphyrogennetos, *De Basilio Macedone*), ed. Bonn, 332ff., no. 89. Cf. Mango 1972, 196–98.

12. Detailed discussion is in Walter 1982, 164ff.

13. Cf. the source mentioned in n. 11 above. English translation is in Mango 1972, 192–93, nos. 79–82 of the *Vita Basilii.*

14. C. Mango, *Architettura bizantina* (1974), 196–97, and idem, *Byzantium: The Empire of New Rome* (London, 1980), 268–69.

15. Cf. the source mentioned in n. 11 above: chaps. 75 and 83–86, ed. Bonn, 319 and 325–29; translation in Mango 1972, 194–95. This church is also mentioned in the Book of Ceremonies. It refers to an image of the emperor before which the emperors dismiss the patriarch (Reiske 1829–30, 121.1). Cf. Janin 1953.

16. Mango 1972, 196. If the description of the mosaics in the church of the Apostles given by Constantine of Rhodes (tenth century) refers to the restoration by Basil (as Mango, 1972, 199–200, suggests), we have here an exact idea of a contemporary program. Also cf. the remarks on the Pantocrator image and the Whitsun mosaic in the Virgin's Church by the Spring (*Pēge*) (Mango 1972, 201–202, and Janin 1953, 223ff.).

17. Akakios edition, *Leontos tou Sophou panegyrikoi logoi* (Athens, 1868), 243ff., and Anatole Frolow, "Deux églises d'après des sermons peu connus de Léo VI le Sage," *Études byzantines* (Bucharest) 3 (1945): 43ff., and French translation, 49–49. An extract in English translation appears in Mango 1972, 203–4.

18. Akakios edition (see n. 17 above), 274ff., and French trans. in Frolow (see n. 17 above), 49ff. Extract in English translation in Mango 1972, 203ff.

19. On this topic, cf. the following selected references: Demus 1947a, passim; E. Giordani, "Das mittelbyzantinische Ausschmückungssystem," *Jahrbuch der österreichischen-byzantinischen Gesellschaft* 1 (1951): 124ff. Cf. Der Nersessian, "Le décor des églises du IX siècle," in *Actes VI Congrès International d'Études byzantines* (Paris, 1951), 2:315ff.; Lasarev 1967, 126ff.; Belting 1978, 79ff.; Walter 1982, 164ff.; Demus 1984, 231ff.

20. F. E. Brightman, *Liturgies Eastern and Western* (Oxford, 1896; 2d ed., 1965); Schulz 1964;

R. Bornert, *Les commentaires byzantins de la divine liturgie* (Paris, 1966); R. Taft, *The Great Entrance* (Rome, 1975); Walter 1982, passim.

21. On the monastery, cf. Janin 1953, 529ff.; P. Gautier, *Le typikon du Christ Sauveur Panto-crator* (Paris, 1974), esp. 30ff.; Cormack 1985, 200ff.

22. The rules (typika) of private monasteries often refer to the "icon that is being celebrated," or the Proskynesis (icon), as in the typikon of the Pantocrator monastery (see n. 21 above), 41 and 73. Cf. Walter 1982, 80.

23. Hamann-MacLean and Hallensleben 1963, fig. 19. Cf. a parallel example from the twelfth century in the burial church at Backovo (fig. 39 in a monograph in Bulgarian [Sofia, 1977] by Elena Bakalova).

24. As when he is said to look down over the edge of heaven. Cf. the twelfth-century description of the Apostles' church at Constantinople by Nicholas Mesarites (Downey 1957, 869).

25. Demus 1947a, passim.

26. Kazhdan 1973, 144.

27. Hamann-MacLean and Hallensleben 1963, 15–16 and figs. 4, 6, and 11; Hamann-MacLean 1976, 224 and pl. 6; A. W. Epstein, "The Political Content of the Paintings of St. Sophia at Ochrid," *Jahrbuch für österreichische Byzantinistik* 29 (1980): 315ff. On the apostles' communion, cf. Walter 1982, 184ff. and 189ff., with special reference to the churches of St. Sophia at Ohrid and Kiev.

28. V. J. Djurić, *Sopoćani* (Leipzig, 1967), pl. 1.

29. On this iconography, cf. Walter 1982, 203ff.

30. See n. 20 above and Kazhdan 1973, 151–52, and Onasch 1968, 29ff.

31. Demus 1947a, passim; Diez and Demus 1931, passim; Lazarev 1967, 150ff. with fig.; E. Stikas, *To oikodomikon chronikon tēs Monēs Hosiou Louka Phokidos* (Athens, 1970); P. Lazarides, *Hosios Loukas* (Athens, 1970) (English, with color plates); T. Papadakis, *Hosios Lukas und seine byzantinischen Mosaiken* (Munich and Zurich, 1969). On the history and ornamentation of the earlier church of the Virgin, cf. L. Bouras, *Ho glyptos diakosmos tou naou tēs Panagias sto Monasteri tou Hosiou Louka* (Athens, 1980), 123–24 and 134.

32. Demus 1947a, passim; Diez and Demus 1931, passim; Lazarev 1967, 194ff.; A. Chatzidakis, *Byzantine Monuments in Attica and Boeotia* (Athens, 1956), pls. 16ff.; H. Belting and G. Cavallo, *Die Bibel des Niketas* (Wiesbaden, 1979), 43–44.

33. Underwood 1967, vol. 2, pls. 30–31.

34. C. Bouras, *Nea Moni on Chios: History and Architecture* (Athens, 1982), 25ff. on its foundation, and passim on its architecture; D. Mouriki, *Nea Moni on Chios: The Mosaics* (Athens, 1985).

35. Rome, Codex Vat. greco 1162, fol. 2v; C. Stornajolo, *Miniature delle omilie di Giacomo Monaco* (Rome, 1910), pl. 1; A. Grabar, *La peinture byzantine* (Geneva, 1953), 181. On the manuscript, cf. an unpublished study by Irmgard Hutter (Vienna).

36. See nn. 20 and 22 above. On the veneration of images in the liturgy, cf. Pallas 1965, 81, 87, and 118ff.; H. Belting, "An Image and Its Function in the Liturgy," *Dumbarton Oaks Papers* 34–35 (1981): 1ff.; Walter 1982, 79–80. Cf. esp. the typika (see chap. 16b), the corresponding rubrics in the liturgy (e.g., Mercenier 1953, 2:12–13), and the illustrations of the *Akathistos* liturgy (T. Velmans, in *Cahiers archéologiques* 22 [1972]: 155ff.). On the kissing of icons, cf. Hofmann 1938, 106ff. and 141.

37. Onasch 1968, 29ff.

38. This must be objected to in Epstein's argument (see n. 27 above). The best compilation of early examples from the sixth to the eighth centuries is in Weis 1985, 27ff. Cf. comments in chap. 6 above with nn. 35 and 36, and Freytag 1985, 473ff.

39. I owe to J. Kalavrezou-Maxeiner this reference to a study by P. Seibt. Cf. Seibt 1983, 284ff. As Cedrenus remarks (ed. Bonn, 2:497), the icon was discovered during the reign of Romanus II. On its place in the iconography of coins, cf. Grierson (see n. 1 above), 171ff.

Chapter 10

1. Cf. Majeska 1984, esp. 200ff., and idem, in *Dumbarton Oaks Papers* 27 (1973): 69ff. On the cults at Constantinople churches, cf. Ebersolt 1951, passim; Janin 1953, passim; S. G. Mercati, "Santuari e reliquie constantinopolitane secondo il codice Ottobon. lat. 169 prima della conquista latina," *Atti Pontificia Accademia Romana di Archeologia Rendiconti* 12 (1937): 133ff.; and text 27. On pilgrimages in late antiquity, cf. Kötting 1959, and in the Middle Ages, Turner and Turner 1978.

2. Reiske 1829–30 (with Latin translation) and (in part) Albert Vogt, ed., *Constantin VII Porphyrogenète: Le livre des cérémonies*, 2 vols. (Paris, 1940), vol. 2 (with French translation).

3. J. Mateos, *La célébration de la parole dans la liturgie byzantine* (Rome, 1971), 34ff.

4. Michael Psellus, *Chronographia* 6.1. Besides the edition in the Bonn corpus, cf. the Byzantine writer and E. Renauld, *M. Psellos Chronographie* (Greek and French translation) (Paris, 1926; 2d ed., 1967), 1:149, and the English translation in E. R. A. Sewter, ed., *Fourteen Byzantine Rulers: The Chronographia of Michael Psellos* (Penguin Books, 1966), 188–89.

5. Psellus (see n. 4 above), 3.10–11. Cf. Sewter (see n. 4 above), 69–70, and Renauld (see n. 4 above), 39. It was the icon the emperors usually took into battle, as the general and protectress of the whole army. Cf. text 18 in the Appendix.

6. Chronicle of John Scylitzes; cf. the illustrations (with an image of the *Eleousa*) in the Madrid Codex, fol. 172v, A. Bozkov, ed., *Miniatjuri at Madridskija Rekopis na Joan Skilica* (Sofia, 1972), fig. 67, and Cutler and Nesbitt 1986, 253. Cf. G. Schlumberger, *L'épopée byzantine à la fin du X^me siècle* (Paris, 1896), 1:87ff.

7. Anna Comnena, *Alexias* (a book about Emperor Alexius) 13.1 (*PG* 131, 936). An English translation is E. R. A. Sewter, ed., *The Alexiad of Anna Comnena* (Penguin Books, 1969), 395. Cf. B. Leib, ed., *Anne Comnène, Alexiade* (Paris, 1945), 3:87.

8. V. Grumel, "Sur l'Episkepsis des Blachernes," *Échos d'Orient* 29 (1930): 334ff., and idem, "Le miracle habituel de Notre Dame des Blachernes à Constantinople," ibid. 30 (1931): 129ff. On the icon and church, cf. J. B. Papadopoulos, *Les palais et les églises de Blachernes* (Salonika, 1928); Ebersolt 1951, 44ff.; Janin 1953, 208ff.; Belting-Ihm 1976, 49ff., with a detailed analysis of the cults and images. Also cf. texts 14 and 15.

9. See n. 7 above.

10. Rice 1959, fig. 142; Lange 1964, figs. on p. 43. Cf. R. Demangel and E. Momboury, *Le quartier des Manganes* (Paris, 1939), 155ff. and pl. 14; A. Grabar, *Sculptures byzantines du moyen Age*, vol. 2 (Paris, 1976), 35 no. 1. The relief measures 200 × 99 cm.

11. Book of Ceremonies, chap. 12 (Reiske 1829–30, 551ff.). On the fountain image of the Virgin, cf. R. Demangel, in *Bulletin de correspondence héllenique* 62 (1938): 433ff. Cf. text 14.

12. Cf. Belting-Ihm 1976, 54–55 and 58–59.

13. Cf. the description by Nicholas Mesarites 38.2 (Downey 1957, 890 and 914).

14. Istanbul, Archaeological Museum, inv. no. 1964.

15. Grabar (see n. 10 above), vol. 1 (Paris, 1963), 100ff. (Fenari İsa Camii) and pl. 61.2; T. Macridy et al., "The Monastery of Lips (Fenari İsa Camii) at Istanbul," *Dumbarton Oaks Papers* 18 (1964): 250ff. and fig. 79; Rice 1959, fig. 149.

16. Cf. generally Grabar 1975, passim.

17. G. N. Čubinašvili, *Gruzinskoe čekanie iskusstvo* (Goldsmith's art in Georgia) (Tiflis, 1957). Cf. G. Alibegašvili and A. Volskaja, in Weitzmann, with Chatzidakis et al. 1982, 85ff.

18. S. J. Amiranašvili, *Les émaux de Géorgie* (Paris, 1962), pl. 51; idem, *Chacul'skij triptich* (The Kachuli triptych) (Tiflis, 1972), passim; Alibegašvili and Volskaja (see n. 17 above), 111.

19. H. R. Hahnloser, *Il tesoro di San Marco* (Florence, 1971), vol. 2, nos. 16–17; Wessel 1963a, nos. 28 and 30; M. E. Frazer, in *Der Schatz von S. Marco in Venedig* (catalog; Cologne, 1984), 149ff. no. 12 and 179ff. no. 18. The panels measure 46 × 35 or 44 × 36 cm. After their arrival they were imitated in the mosaics in the aisles (Demus 1984, 2:45ff. and figs. 60ff.).

20. Dobschütz 1899, 233ff.** and edition of the text of the festival sermon (Source C); idem, in *Byzantinische Zeitschrift* 12 (1903): 193ff. On the type of the interceding Virgin, the titular icon in the church (not necessarily identical with the Roman Virgin), cf. e.g. Hamann-MacLean 1976, 110ff.; C. Bertelli 1961a, 82ff.; Andaloro 1970, 85ff. and esp. 118ff. (with discovery of a homily of Germanus).

21. Cf. the typicon in a manuscript from 1027 in Paris, Coislin 213, fols. 198–209 (R. Devreesse, *Le Fonds Coislin* [Paris, 1945], 194); Dmitrievskii 1901, 2:1050–51.

22. Grabar 1957, fig. 1. See chap. 4 n. 7.

23. See chap. 9 n. 21. On the text (with English translation), cf. Cormack 1985, 200ff., and text 20.

24. D. Winfield, "Four Historical Compositions from the Medieval Kingdom of Serbia," *Byzantinoslavica* 19.2 (1958): 251ff. and 257ff. (with a quotation of the biography of Nemanja written by his son Sava); G. Babić, *Les chapelles annexes des églises byzantines* (Paris, 1969), 142ff. and figs. 109–10.

25. E.g. the pilgrim Anthony of Novgorod about 1000. On the Russian pilgrims, see n. 1 above; on *Hodegetria*, see chap. 4 n. 7.

26. Text in C. A. Garufi, "I capitoli della confraternità di S. Maria di Naupactos," *Bullettino dell'Istituto storico Italiano* 31 (1910): 73ff.,

with illustration of the miniature. Cf. J. Nesbitt and J. Wiitta, "A Confraternity of the Comnenian Era," *Byzantinische Zeitschrift* 86 (1975): 360ff.; Belting 1981a, 34.

27. See the references in n. 1 above.

28. It is part of a report on the palace revolution of John Comnenus; cf. A. Heisenberg, *Die Palast-revolution des Johannes Komnenos* (Würzburg, 1906), 28ff.; F. Grabler, *Die Kreuzfahrer erob-ern Konstantinopel,* Byzantinische Geschichts-schreiber 9 (Graz, 1958), 285ff. (for English translation, cf. text 19). Cf. the Latin report from the twelfth century, in Mercati (see n. 1 above), 140, and the complete version (text 26).

29. Robert de Clari, *La conquête de Constantino-ple,* ed. P. Lauer (Paris, 1924), 82. Cf. Belting 1982c, 35ff. with n. 20.

30. Belting 1982c, 36–37 with n. 17.

31. Majeska 1984, 200ff.; cf. Janin 1953, 481ff., the Latin catalog of relics (text 20), and the legend of the Jew's crime against the image in Mercati (see n. 1 above), 143–44. Also cf. the general references in n. 1 above.

32. Cf. references on Rublev. Late Byzantium icons on this theme are in the Benaki Museum, Athens, and the Hermitage, Leningrad.

33. Cf. Belting 1970, 84ff. with fig. 51, which refers to the theological tract by Emperor Canta-cuzenus (which uses a similar frontispiece in the polemic against Islam).

34. F. Ongania, *La Basilica di S. Marco* (Venice, 1888), with sources and documents; Demus 1960, passim.

35. H. R. Hahnloser, *Il tesoro di S. Marco;* vol. 1: *La Pala d'Oro* (Florence, 1971); S. Bettini, in Cologne 1984 (see n. 19 above), 33ff.

36. Demus 1960, 120ff.; Lange 1964, passim; O. Demus, "Die Reliefikonen der Westfassade von S. Marco," *Jahrbuch der österreichischen-by-zantinischen Gesellschaft* 3 (1954): 87ff.; W. Wolters, ed., *Die Skulpturen von S. Marco in Venedig* (Munich, 1979).

37. Wolters (see n. 36 above), nos. 70, 73 (164.5 and 177 cm high).

38. Ibid., nos. 71–72 (both 166 cm high) On the dating of the Demetrius relief (Constantinople, ca. 1070) with stylistic parallels, cf. H. Belting in *Pantheon* 30.4 (1972): 263ff.

39. Grabar (see n. 10 above), 117.

40. Ongania (see n. 34 above), vol. 4 of plates, pl. 243. Cf. Belting-Ihm 1976, 64, with quotation from G. Meschinello, *La chiesa ducale di S. Marco* (Venice, 1753), 1:28.

41. See n. 38 above.

42. Felicetti-Liebenfels 1972, 19 and fig. 4; Anto-nova and Mneva 1963, vol. 1, no. 10 and pl. 15 (156 × 108 cm).

43. A. Papadopoulos-Kerameus, *Analecta hiero-solymitikēs stachyologias* 4, 238ff.; M. I. Gedeon, *Byzantinon heortologikon* (Constan-tinople, 1899), 182; Janin 1953, 530. On the monastery, see chap. 9 n. 21.

44. On this and the sources, cf. D. Pincus, "Chris-tian Relics and the Body Politic: A Thirteenth-Century Relief Plaque in the Church of S. Marco," in *Interprezioni veneziane. Studi di storia dell'arte in onore di M. Muraro,* ed. D. Rosand (Venice, 1984), 39ff.

45. E.g. G. Meschinello (see n. 40 above), 2: 60–61.

46. Ibid., 21–22; F. Sansovino, *Venezia città nobi-lissima* (1581; 3d ed., 1663), 99. Documents and sources are in Ongania (see n. 34 above), 266–67 (documents) and nos. 87 and 822. On the cross, cf. Garrison 1949, no. 452, and G. Mariacher, "Croci dipinte veneziane del'300," in *Scritti di storia dell'arte in onore di L. Venturi* (Milan, 1956), 1:100–101 and fig. 1. A Ba-roque overpaint was removed from the cross at that time. Cf. Gamulin 1983, 19 and fig. 19.

47. Kretzenbacher 1977, passim.

48. Garrison 1949, no. 453; G. Gamulin, "Un cro-cefisso del millecento e due Madonne duecen-tesche," *Arte Veneta* 21 (1967): 9ff.; Gamulin 1983, fig. 19.

49. On the so-called Trimorphon (177 × 111 cm), cf. Demus 1960, 122, and Lange 1964, no. 7. On the sources, cf. Sansovino (see n. 46 above), 103, and Meschinello (see n. 40 above), 2: 30–31. Cf. Ongania (see n. 34 above), 260–61, with a text by N. Doglioni (1662).

50. Demus 1960, 121 and 187; Lange 1964, no. 39. For sources, cf. Sahsovino (see n. 46 above), 96–97; Meschinello (see n. 40 above), 1:68ff. Also cf. Ongania (see n. 34 above), 11 and 261, 265 on other sources, including the report of the French pilgrim Jehan de Tourney, who spoke in 1487 of the "quatres trous par où l'eaue issit."

51. Lange 1964, no. 40.

52. Ongania (see n. 34 above), pl. 259; H. v.d. Ga-belentz, *Mittelalterliche Plastik in Venedig* (Lepizig, 1903), 134; Demus 1960, 188–89. On the Mascoli confraternity, cf. G. M. Monti, *Le confraternite medioevali dell'alta e media Italia* (Venice, 1927), 1:91ff. Cf. Belting-Ihm 1976, 66.

53. Belting-Ihm 1976, 45.

54. Cf. detailed discussion in Belting-Ihm 1976,

66–67 and pl. 16. Cf. Monti (see n. 52 above), 37ff.; Lange 1964, 51; G. Gerola, "Il mosaico absidale della Basilica Ursiana," *Felix Ravenna* 5 (1912): 177ff. The Virgin mosaic from 1112 is preserved in the archbishop's chapel in Ravenna.

55. Demus 1960, 124, and Lange 1964, no. 2 (80 × 140 cm).

56. *Venezia e Bisanzio* (catalog; Venice, 1974), no. 66.

57. W. Wolters, *La scultura veneziana gotica (1300–1460)* (Venice, 1976), no. 4 fig. 8 (112 × 86.8 cm).

58. Hahnloser (see n. 19 above), no. 15 and pl. 14; R. Gallo, *Il tesoro di S. Marco e la sua storia* (Venice, 1967), 133ff.; Belting 1982c, 42. The enamels were removed and destroyed when the image was stolen about 1980.

59. Giovanni Tiepolo, *Trattato della immagine della Gloriosa Vergine dipinta da S. Luca* (Venice, 1618). On the history of the image in Venice, cf. the detailed account in A. Rizzo, "Un'icona constantinopolitana del XII secolo a Venezia: La Madonna Nicopeia," *Thesaurismata* 17 (1980): 290ff. Even Sanudo mentions the image by St. Luke. In 1559 G. B. Ramusio established the link with the source of 1204. C. Querini called the icon *Nicopeia* for the first time in 1645.

60. Cf. esp. the Virgin of Vladimir in Moscow and the Madonna in Spoleto. There are also stylistic parallels in the Panteleimon icon in the Lavra monastery (M. Chatzidakis, in Weitzmann 1965, 42). There is an important stylistic analogy to the portrait of Empress Maria (1078–81) in a Paris miniature, Codex Coislin 79, fol. 1v (H. Omont, *Miniatures des plus anciens manuscrits grecs de la Bibliothèque Nationale* [Paris, 1929], and Spatharakis 1981, no. 94).

61. Wessel 1963a, 172 no. 53, and Belting 1981a, 185–86.

62. R. de Clari (see n. 29 above), 66–67. Cf. the chronicle of Geoffroy de Villehardouin.

63. Cf. generally Sansovino (see n. 46 above), 492ff. with a list of the *andate*. See n. 66 below.

64. M. S. Theocharis, "On the Dating of the Panagia Mesopanditissa Icon" (Greek), *Praktika tēs Akademias Athēnōn* 36 (1961): 270ff.

65. G. Gerola, *I monumenti veneti dell'isola di Creta* (Venice, 1908), 2:302ff. and fig. 2. On the historical sources, cf. G. Gerola, "Gli oggetti sacri di Candia salvati a Venezia," *Atti R. Accademia degli Agiati in Ronvereto*, 3d ser., 9 (1903): 231ff., esp. 236ff. and 261ff.

66. R. Wittkower, "Santa Maria della Salute," *Saggi e memorie di storia dell'arte* 3 (1963): 31ff.; G. Moschini, *La chiesa e il seminario di S. Maria della Salute* (Venice, 1842). For the photo I am indebted to Prof. Ralph Reith (Heidelberg).

Chapter 11

1. Still authoritative on the history and legends is Dobschütz 1899, and more recently, Cameron 1980. On the image in particular, cf. Grabar 1931; Bertelli 1968; Dufour Bozzo 1974; Thierry 1980; Wilson 1978; also Cameron 1983. On Edessa, cf. J. B. Segal, *Edessa, "the Blessed City"* (Oxford, 1970).

2. Dobschütz 1899, 102ff. and 197ff., and K. Pearson, *Die Fronica. Ein Beitrag zur Geschichte des Christusbildes im Mittelalter* (Strasbourg, 1887); M. Green, "Veronica and Her Veil," *Tablet*, 31 Dec. 1966, 1470ff.; Chastel 1978; Belting 1981a, 200ff.; Belting 1982c, 45–46; Heinrich Pfeiffer, in M. Fagiolo and M. L. Madonna, eds., *L'arte degli Anni Santi* (Rome, 1984), 106ff. and 113ff. Also cf. K. Gould, *The Psalter and Hours of Yolande of Soissons* (Cambridge, Mass., 1978), 81ff., and A. Katzenellenbogen, "Antlitz," in *Reallexikon zur deutschen Kunstgeschichte* (1937), 1:732ff.; Lewis 1985, 100ff.

3. W. Grimm, *Die Sage vom Ursprung der Christusbilder* (Berlin, 1842).

4. Bertelli 1968, 7ff., and Fagiolo and Madonna (see n. 2 above), 122 no. II.9.

5. Dufour Bozzo 1974. On the Vatican's image, cf. G. Baronio, *Annales Ecclesiasti* (Venice, 1740), 10:824; the Abgar image today is in S. Silvestro.

6. K. Weitzmann, "The Mandylion and Constantine Porphyrogenetos," *Cahiers archéologiques* 11 (1960): 163ff. Cf. Soteriou and Soteriou 1956–58, vol. 1, figs. 34–36; Weitzmann, with Chatzidakis et al. 1982, 28.

7. Bertelli (see n. 4 above).

8. Cameron 1980; Wilson 1978; Belting 1981a, 162–63. Sources are in P. Vignon, *Le St-Suaire de Turin . . .* , 2d ed. (Paris, 1939), 100ff. (e.g. Clari, as in nn. 28, 90). The preserved shroud was initially identified as a copy (*imago*) of the original in the fourteenth century.

9. G. Vikan, ed., *Illuminated Greek Manuscripts from American Collections* (Princeton, 1973), no. 56.

10. Dobschütz 1899, 130ff. Cf. the references in n. 1 above.

11. Ibid., 149ff., with document nos. 56–64. Cf. Weitzmann 1960 (see n. 6 above) and Grabar 1931.

12. On the theme of the Koimesis, cf. M. Jugie, *La mort et l'assomption de la Sainte Vierge, étude historico-doctrinale* (Vatican, 1944). On an early icon, illustrated here, cf. Soteriou and Soteriou 1956–58, vol. 1, fig. 42.

13. Dobschütz 1899, 167 and appendix II B 25.32.

14. V. Grumel, in *Analecta Bollandiana* 58 (1950): 135ff. Cf. Pallas 1965, 137–38, and Belting 1981a, 182–83.

15. Thus Anna Comnena, in her *Alexiad* on her parents, Alexios and Irene (*Anne Comnène, Alexiade,* ed. B. Leib [Paris, 1943], 2:110.20, and E. R. A. Sewter, *The Alexiad of Anna Comnena,* Penguin Classics [Baltimore, 1969], 109). Cf. text 19.

16. V. N. Lazarev, *Novgorodian Icon Painting* (Moscow, 1969), pls. 8–9; K. Onasch, *Icons* (London, 1963), 374–75 and pl. 10; Belting 1981a, 182 and fig. 69.

17. Soteriou and Soteriou 1956–58, vol. 1, fig. 68. On the theme of the Pantocrator and its portrayals, cf. the references in chap. 9 n. 9.

18. See n. 15 above.

19. Mango 1962, fig. 17, and Rice 1959, fig. 23.

20. Cf. the icons at Sinai (Soteriou and Soteriou 1956–58, vol. 1, fig. 167), the Great Lavra on Mount Athos (Chatzidakis, in Weitzmann, with Chatzidakis et al. 1965, fig. 42), and the wall icon in the church consecrated to him at Nerezi, from 1164 (see chap. 12 n. 63).

21. V. Lazarev, *Old Russian Murals and Mosaics* (London, 1966), 252 fig. 56, and Grabar 1931, pl. 3.

22. V. Lazarev, *Iskusstvo Novgoroda* (Moscow, 1947), pl. 30b.

23. Moscow, Military Museum; cf. Wilson 1978, fig. A, p. 146.

24. Imperial War Museum, London, ref. no. Q 32210; cf. Wilson 1978, fig. B, p. 146, and Grabar 1931, 33.

25. See the references in n. 16 above.

26. See the references in n. 2 above.

27. Robert de Clari, *La conquête de Constantinople,* ed. P. Lauer (Paris, 1924), 82–83. On the sources on the fourth Crusade, cf. Comte de Riant, *Exuviae sacrae Constantinopolitanae,* 2 vols. (Geneva, 1875–77); J. P. A. van der Vin, *Travellers to Greece and Constantinople* (Istanbul, 1980), 1:65ff. and esp. 73ff. Cf. Belting 1982, 27ff. on the plundering of Byzantium and its repercussions in the West.

28. Dobschütz 1899, 185–86 and document 96. Cf. Riant (see n. 27 above), 2:135.

29. Detailed discussion is in Grabar 1931, passim. Also cf. Belting 1982c, 46, and Gould (see n. 2 above), pl. 7, with a reproduction of the *Ste. Face* from the thirteenth century.

30. Fagiolo and Madonna (see n. 2 above), 108.

31. Dobschütz 1899, 290.

32. Ibid., 197ff., and Pearson (see n. 2 above). Grimm's study of 1842 (see n. 3 above) remains a classic text. Cf. Lewis 1985, 100ff. The legend has its root in one about the statue in Paneas and its owner Berenice (see chap. 3 n. 50). But after the sixth century it elaborates more and more on the story of Pilate. The most important versions are the *Cura Sanitatis Tiberii* (Dobschütz 1899), 157ff.**, the *Vindicta Salvatoris,* and the *Mors Pilatii* (C. von Tischendorf, *Evangelia Apocrypha* [Leipzig, 1876], 456ff. and 471ff.). The version of Roger d'Argenteuil is in Dobschütz 1899, 304* document 56.

33. Dobschütz 1899, 219ff.; Fagiolo and Madonna (see n. 2 above), 106 and 113ff., and Schüller-Piroli, *Zweitausend Jahre St. Peter* (Olten, 1950), 217–18 and 380–81.

34. London, British Library, Codex 157, fol. 2. At issue is a Psalter made for use in Oxford and deriving from the circle of Matthew Paris. The text is "Et ut animus dicentis devotius excitatur, facies Salvatoris per industriam artificis expresse honoratur." On the references, see text 37E.

35. A. Chastel, *The Sack of Rome, 1527* (Princeton, 1983), 104.

36. On Bernini's reliquaries in the dome pillars of St. Peter's and the Veronica statue by Francesco Mocchi, 1635–40, cf. I. Lavin, *Bernini and the Crossing of St. Peter's* (New York, 1968), and Preimesberger, in *Jahrbuch der Görres-Gesellschaft,* 1985.

37. Fagiolo and Madonna (see n. 2 above), 106 and 110. On the container of rock crystal, cf. *Venezia e Bisanzio* (catalog; Venice, 1974), no. 81.

38. On the iconography, cf. Fagiolo and Madonna (see n. 2 above), 113ff., and Pearson (see n. 2 above), passim; J. H. Emminghaus, in *Lexikon für christliche Ikonographie* 8 (1976): 543ff.; M. Meiss, *Painting in Florence and Siena after the Black Death* (Princeton, 1951), 35ff.; and Katzenellenbogen (see n. 2 above). On the change in indulgences, cf. H. Delehaye, in *Analecta Bollandiana* 45 (1927): 323ff., 46 (1928): 149ff.

39. Cf. H. Appuhn, "Der Fund kleiner Andachts-bilder des 13. bis 17. Jahrhunderts in Kloster Wienhausen," *Niederdeutsche Beiträge zur Kunstgeschichte* 4 (1965): 199ff.

40. *Frankfurter Allgemeine Zeitung*, 15 Sept. 1984 (photo Barbara Klemm).

41. Cf. R. Suckale, "Arma Christi," *Städel-Jahr-buch* 6 (1977): 177ff.

42. See the references in n. 38 above.

43. Fagiolo and Madonna (see n. 2 above), 107, fig. IId, and *Raffaello in Vaticano* (catalog; Milan, 1984), 324–25 no. 123. The panel is owned by a Rev. Fabbrica of St. Peter's (previously Sagrestia dei Beneficiati). On the passage in Vasari, cf. G. Milanesi, ed., *Giorgio Vasari. Le vite degli eccellenti pittori . . .* (Florence, 1906), 5:421: "egli dipinse a olio senza adope-rare pennello, ma con le dita, e parte con suoi altri instrumenti capricciosi" (for the image on the altar of the Volto Santo).

44. Pearson (see n. 2 above); pl. 17. On this en-graving by Dürer, cf. H. Tietze and E. Tietze-Conat, *Kritisches Verzeichnis der Albrecht Dürers* (1937), 2:90–91 no. 562 (Bartsch 25), and W. L. Strauss, *The Intaglio Prints of Al-brecht Dürer* (New York, 1977), no. 69.

45. H. Belting and D. Eichberger, *Jan van Eyck als Erzähler* (Worms, 1983).

46. Petrarch's sonnet no. 16. Cf. Dante, *Paradiso* 31.103.

47. Dante, *La vita nuova* (1293), chap. 11.

Chapter 12

1. Cf. J. B. Konstantynowicz, *Ikonostas* (Lemberg, 1939); C. Walter, "The Origin of the Iconosta-sis," *Eastern Church Review* 3 (1971): 251ff.; and Chatzidakis 1978, 326ff.

2. The following works should be chiefly men-tioned from the copious literature: T. F. Ma-thews, *The Early Churches of Constantinople* (1971), 168ff.; M. Chatzidakis and V. Lazarev, in *Deltion tēs Christianikēs Archaiologikēs He-taireias* 4.4 (1964): 326ff. and 377ff.; N. Firatli, "La découverte d'une église byzantine à Sébaste de Phrygie," *Cahiers archéologiques* 19 (1969): 151ff.; Chatzidakis 1978, 326ff.; Babić 1975, 3ff.; Chatzidakis 1976, 157ff.; Epstein 1981, 1ff. See nn. 43, 45, 49ff. below.

3. Chatzidakis 1978, 327.

4. See texts 20 (39) and 23 (109).

5. H. Delehaye, *Deux typika byzantins de l'époque des Paléologues* (Brussels, 1921); R. Janin, "Le monarchisme byzantin du moyen âge," *Revue*

des études byzantines 22 (1964): 29ff.; Kazhdan and Epstein 1985, 80–81 and 86ff.; and P. Gau-tier's introductions to texts 20, 21, 23, and 24.

6. R. F. Taft, *The Great Entrance*, Orientalia Christiana Analecta 200 (Rome, 1975).

7. J. Mateos, *La célébration de la parole dans la liturgie byzantine*, Orientalia Christiana Ana-lecta 191 (Rome, 1971), 38ff., 72ff.

8. Text 22 (63–64).

9. Ibid. (50).

10. Text 20 (33).

11. Ibid. (37–38).

12. Text 22 (50).

13. See texts 21 (45), 22 (24), and 27 (71).

14. Text 20 (39).

15. Text 21 (45).

16. Text 22 (no. 67).

17. Text 23 (131).

18. Mateos (see n. 7 above), 88–89.

19. Ibid., 83.

20. Text 21 (D431).

21. Text 22 (50).

22. Ibid., (39).

23. Text 20 (75).

24. Ibid., (81–82).

25. Text 22 (63), for *stasidion*; text 20 (73), for *signon*; text 25C (8), for *proskynēma*.

26. Text 24 (73 and [Inventory] 121), 25B (21), and 25F (7).

27. Text 24 (101).

28. Text 22 (50).

29. Belting 1981a, 154ff., and Belting 1981b, 1ff., with references to the Man of Sorrows (*Akra Tapeinosis*), *Mandylion*, and *Epitaphios*.

30. Text 25C (8).

31. Text 30.

32. Text 22.

33. Cf. the references in ibid.

34. Text 25C (8).

35. Cf. C. Walter, "Two Notes on the Deesis," *Re-vue des études byzantines* 26 (1968): 311ff. and esp. 318–19.

36. Text 20 (37, 72, 81).

37. Cf. Der Nersessian, "Two Images of the Virgin in the Dumbarton Oaks Collection," *Dumbar-ton Oaks Papers* 14 (1960): 81, and Stylianou 1985, 157ff., with further references on the fres-coes. The panel images (105 × 70.5 cm and 103.5 × 73.5 cm) are in the Athens 1976, 34ff. nos. 6–7.

38. Vatican, Codex graecus 1156, fol. 1r.

39. Text 24.

40. *Kekosmētoi* vs. *akosmētoi*; cf. texts 25C D, and F and text 23B.

41. Cf. the studies by Čubinašvili and Amiranašvili

(see chaps. 10 nn. 17 and 18) and Tiflis 1984.

42. Text 21 (63).

43. Cf. Mathews (see n. 2 above), 96ff.; S. Xydis, "The Chancel Barrier, Solea, and Ambo of H. Sophia," *Art Bulletin* 29 (1947): 1ff.; K. Kreidl-Papadopoulos, "Bemerkungen zum justinianischen Templon der Sophienkirche in Konstantinopel," *Jahrbuch der österreichischen Byzantinistik* 17 (1968): 279ff. See n. 45 below.

44. Text 5. Cf. Mango 1979, 40ff.

45. L. Nees, "The Iconographic Program of Decorated Chancel Barriers in the Pro-Iconoclastic Period," *Zeitschrift für Kunstgeschichte* 46 (1983): 15ff. (with further references).

46. *LP* 1:503. The text concerns six images donated for the rugae of the chancel screen by Pope Hadrian (772–95). They were made of *laminis argenteis,* including painted panels. The three in front showed Christ (*vultus Salvatoris*) between Michael and Gabriel, the three others the Virgin between the apostles Andrew and John. Each group was fixed to a *regularis.*

47. P. Meyvaert, "Bede and the Church Paintings at Wearmouth-Jarrow," *Anglo-Saxon England* 8 (1979): 63ff.

48. See n. 45 above.

49. R. Polacco, *La cattedrale di Torcello* (Venice, 1984), 30–31 figs. 28–31, and idem, *Sculture paleocristiane e altomedievali di Torcello* (Treviso, 1976), nos. 73–77 with further references.

50. G. Mariacher, *Il Museu Correr di Venezia. Dipinti dal XIV al XVI secolo* (Venice, 1957), 1: 156–57, and R. Pallucchini, *La pittura veneziana del trecento* (Venice and Rome, 1964), fig. 677; esp. O. Demus, "Zum Werk eines venezianischen Malers auf dem Sinai," in Hutter 1984, 131ff.

51. Cf. a study by G. Kopp-Schmidt, "Die Dekorationen des Ostportals am Pisaner Baptisterium," *Münchner Jahrbuch der bildenden Kunst* 34 (1983): 25ff.

52. Soteriou and Soteriou 1956–58, 2:112ff.; vol. 1, figs. 117–24 (168.5 × 44 cm); Weitzmann, with Chatzidakis et al. 1982, 228ff. with figures (Venetian artist of the third quarter of the thirteenth century); on the whole context, cf. esp. Weitzmann 1984, 143ff. and esp. 158–59.

53. Cf. text 25E.

54. Chatzidakis 1978, 331–32: The *templon* of the New Church (chap. 9c) was made of silver and jewels, like that in the Virgin's church in the palace. In the ninth century Emperor Basil had enamel icons fixed to the gilt *templon* of the church of the Redeemer at the palace (see chap. 9 n. 5); Epstein 1981, 6.

55. K. Weitzmann, "Die byzantinischen Elfenbeine eines Bamberger Graduale und ihre ursprüngliche Verwendung," in *Festschrift für K. H. Usener* (Marburg, 1967), 11ff.; Epstein 1981, 9.

56. N. Firatli, "Découverte d'une église byzantine à Sebaste de Phrygie," *Cahiers archéologiques* 19 (1969): 151ff.; Epstein 1981, 12.

57. Cf. the chronicle of Leo of Ostia (*PL* 173, 756–58). Cf. O. Lehmann-Brockhaus, *Schriftquellen zur Kunstgeschichte des 11. und 12. Jahrhunderts...,* (Berlin, 1938), no. 2274ff. Cf. H. R. Hahnloser, "Magistra Latinitas und Peritia graeca," in *Festschrift Herbert von Einem* (Berlin, 1965), 77ff.

58. Cf. texts 23B (154) and 25A (10).

59. H. R. Hahnloser, *La Pala d'Oro,* vol. 1 of Il tesoro di S. Marco (Venice, 1965), pl. 42ff., and Epstein 1981, 2ff. The six festival images have a format of 30 × 30 cm. Also cf. Hahnloser, pls. 95–98, for a comparison of the palla with the screen of S. Maria in Valle Porclaneta in Rosciolo, which Hahnloser (see n. 57 above) related to the lost structure at Monte Cassino.

60. Cf. Grabar 1975, passim. On the ornamented and unornamented icons, with an exact description of the parts of their mountings, cf. texts 23B (nos. 1, 17–20), 24 (inventory, items 1–4), 25A (nos. 3–5 and 9), 25C (nos. 1–7 and 27), 25D (nos. 12–15 and 107–9), and 25F (nos. 19–20). On these distinctions, cf. Kalavrezou-Maxeiner 1985.

61. Cf. texts 25C (nos. 3, 5–7) and 25D (nos. 12–14, 107).

62. Dejonghe 1967.

63. N. Okunev, in *Seminarium Kondakovianum* 3 (1929): 5ff.; Babić 1975, 17–18 and 43; Epstein 1981, 14–15.

64. Cf. Čubinašvili (see chap. 10 n. 17).

65. *Bibliotheca Sanctorum* (Rome, 1968), 10: 107ff.

66. Text in Der Nersessian and Walter (see nn. 35 and 37 above). A different version of the text, on a Sinai icon, is in Soteriou and Soteriou 1956–58, 2:160–61.

67. On the Hagiosoritissa, cf. detailed discussion in Bertelli 1961a, 82ff.; Andaloro 1970, 85ff.

68. Cf. text 9. On the *Antiphonites,* cf. Mango 1959, 142ff., which discusses the confusion with the *Christus Chalkites.*

69. T. Schmit, *Die Koimesiskirche von Nikaia* (Berlin and Leipzig, 1927), 44–45 and pls. 25, 27. The Virgin, with the Child on her arm, bears the title *Eleousa.*

70. On the painted *Staurothek* of the Sancta Sanctorum, cf. Grisar (see chap. 7, n. 13), and Co-

logne 1985 (see chap. 7, n. 12), vol. 3, no. H 11.

71. On the icon in the Mount Sinai monastery (65 × 40.5 cm), the basis of which Weitzmann dates in the sixth or seventh century and Soteriou believes to have been overpainted in the thirteenth, cf. Soteriou and Soteriou 1956–58, 2:160–61; and Weitzmann 1976, no. B 4 and pl. 47. The icon in Spoleto (a canvas image of 31 × 24 cm), now newly restored, was earlier linked to Barbarossa and an Italo-Greek donor, which has proved a legend. The first historical evidence of the icon is from ca. 1290; cf. M. Bonfioli and E. Ermini, "Premese ad un riesame critico dell''icona' del duomo di Spoleto," in *Atti del IX Congresso internazionale di studi sull'alto medioevo* (Spoleto, 1983), 1ff.; M. Bonfioli, in *Spoletium* 27 (1982): 37–38.

72. Cf. Athens 1976, 30ff. and nos. 4–5 (both icons in a format of 73 × 46 cm). On the hermitage in Paphos and the iconostasis, cf. C. Mango and E. J. W. Hawkins, in *Dumbarton Oaks Papers* 20 (1966): 122ff.; Epstein 1981, 19; Cormack 1985, 215ff.

73. J. Mateos, *Le typicon de la Grande Église* (Rome, 1962), 372ff. Christ, who through the intercession of his most pure Mother took pity on the whole city (and is hence called *Polyeleos*), is credited with saving Constantinople from Islam in 718. On this feast a procession went to the "Jerusalem" church of the Virgin at the Golden Gate.

74. Babić 1975, 27–28, 46, and text fig. 7. Above the Virgin, Daniel appears with the text Daniel 2:34. Cf. Weitzmann, with Chatzidakis et al., 1982, 174–75.

75. Athens 1976, no. 9.

76. Athens 1985, no. 8. The format of the icon is 168 × 140 cm.

77. Cf. the studies of Chatzidakis and Lazarev 1964 (see both in n. 2 above) and Chatzidakis 1978, 337ff., and Weitzmann 1986, 64ff.

78. Soteriou and Soteriou 1956–58, vol. 1, figs. 57–61; Weitzmann 1966, 16–17 and fig. 42.

79. Cf. Walter (see n. 35 above), 318–19.

80. On this concept, cf. Mateos (see n. 7 above), 148–49. On its use, cf. text 20 (75 and 86).

81. Soteriou and Soteriou 1956–58, 1:100ff. and figs. 87–116; Weitzmann, with Chatzidakis et al. 1965, xv–xvi and figs. on pp. 32–35; Weitzmann 1978, nos. 20 and 24; Epstein 1981, 15–16; Weitzmann 1982, 245ff.

82. Soteriou and Soteriou 1956–58, vol. 1, figs. 87–94; 2:102ff.; Weitzmann, with Chatzidakis et al. 1965, fig. on p. 32; Weitzmann 1982, 245ff. Cf. the comparison with the enamels of

the *Pala d'Oro;* cf. Hahnloser (see n. 57 above), figs. 69–70.

83. Text 20 (37–38).

84. Soteriou and Soteriou 1956–58, vol. 1, figs. 99–102 and 103–111; 2:107ff. and 109ff.; Weitzmann 1978, no. 20; Weitzmann 1982, 245ff.

85. R. Delogu, *La Galleria Nazionale della Sicilia* (Palermo, 1962), 78 and figs. 30–31. The panels (Anastasis, Burial and Raising of Lazarus), which date from the thirteenth century, are inv. 3 and 3bis in the Galleria Nazionale della Sicilia in Palermo.

86. Soteriou and Soteriou 1956–58, vol. 1, figs. 76–79.

87. On Carpaccio's painting in the Accademia in Venice and its theme, the vision of the cross-bearing martyrs of Mount Arafat (1511) in the church of S. Antonio Abate founded in 1346, cf. A. Zorzi, *Venezia scomparsa,* (Milan, 1972), 2: 312ff.

88. See n. 38 above. Cf. esp. Weitzmann 1967, 12–13.

89. Beck 1959, 251–52.

90. A. Erhard, *Überlieferung und Bestand der hagiographischen und homiletischen Literatur der griechischen Kirche* (Leipzig, 1937ff.); P. Mijović, *Menolog* (Belgrade, 1973). See nn. 91 and 92 below.

91. Spatharakis 1981, no. 63 (Oxford, Codex Barocci 230: Sept.), 64 (Vienna, Codex Hist. Gr. 6: Oct.), 65 (Paris, Codex Gr. 580: Nov.), and 67 (Sinai, Codex Gr. 512: Jan.). Our illustration is in Paris, Codex Gr. 580, fol. 2v. On the illustrated menologia, apart from Mijović (see n. 90 above), cf. esp. Nancy Patterson Ševčenko, "An Eleventh Century Illustrated Edition of the Metaphrastian Menologion," *East European Quarterly* 13 (1979): 423ff. Ševčenko has also prepared this with a corpus, published by the University of Chicago Press. Also see n. 92 below.

92. H. Belting, in R. Naumann and H. Belting, *Die Euphemiakirche am Hippodrom zu Istanbul und ihre Fresken* (Berlin, 1966), 147ff., and K. Weitzmann, "Illustrations to the Lives of the Five Martyrs of Sebaste," *Dumbarton Oaks Papers* 33 (1979), 97ff. The chief evidence is a book of the legend of St. Eustratios, one of the five martyrs of Sebaste, now in the National Library in Turin.

93. Beck 1959, 570ff.

94. Soteriou and Soteriou 1956–58, vol. 1, figs. 131–35; 2:119ff.

95. Cf. text 25D.

96. I. Ševčenko, in *Dumbarton Oaks Papers*, 1962, 273 n. 97, and P. Mijović, "Gruzinskie menologii s XI po XIV vek," *Zograph* 8 (1977): 17ff. The poem is a manuscript (Sion) A 648 in the National Library in Tiflis.

97. Soteriou and Soteriou 1956–58, vol. 1, figs. 126–30; 2:117ff. Cf. Weitzmann 1967, 13–14 and figs. 21 and 34; Weitzmann 1986, 107ff.

98. Soteriou and Soteriou 1956–58, vol. 1, figs. 136–43; 2:121ff.; and Weitzmann 1966, 14–15 and figs. 36–37; Weitzmann 1978, no. 17; and Weitzmann, with Chatzidakis et al. 1982, 50.

99. Cf. text 24 (33).

100. See chap. 9 nn. 4 and 5.

101. Cf. esp. Belting (see n. 92 above), 143ff.; Babić (see chap. 10 n. 24), passim; Ševčenko (see n. 91); and Weitzmann 1986, 94ff.

102. Cf. text 25A (8).

103. Soteriou and Soteriou 1956–58, vol. 1, figs. 103–11; 2:109ff.; Weitzmann 1978, no. 20; Weitzmann 1982, 250–51. Also cf. Weitzmann (see n. 92 above).

104. Cf. the references in n. 92 above.

105. Cf. N. P. Ševčenko, *The Life of St. Nicholas in Byzantine Art* (Turin, 1983), 163.

106. Cf. text 25A (9).

107. Ševčenko (see n. 105 above), 162ff.

108. Ibid., 162–63.

109. Soteriou and Soteriou 1956–58, vol. 1, fig. 165; 2:144ff., and Weitzmann, with Chatzidakis et al. 1982, 67.

110. Weitzmann, with Chatzidakis et al. 1982, 56; Bank 1977, 371 and figs. 225–26.

111. C. Jones, *St. Nicholas of Myra, Bari, and Manhattan* (Chicago and London, 1978); Ševčenko (see n. 105 above); P. Belli d'Elia, *Las Basilica di S. Nicola a Bari* (Galatina, 1985).

112. P. Belli d'Elia, *Bari. Pinacoteca provinciale* (Bologna: Musei d'Italia, 1972), 4–5 no. 9 (128.5 × 83.5 cm); idem, in *Rivista "Terra di Bari"* (Molfetta) 6 (1972): 8–13; Pace 1982b. Cf. the biographical icon of St. Margaret in Bari.

113. Soteriou and Soteriou 1956–58, vol. 1, figs. 166 and 168; 2:147–48 and 152–43.

114. Ibid., 2:150.

115. Ibid., vol. 1, figs. 74 and 75; 2:88–89; Weitzmann 1978, no. 29; Weitzmann, "The Classical in Byzantine Art," in *Byzantine Art—A European Art: Lectures* (Athens, 1966), 172–73; Weitzmann, "Byzantium and the West around the Year 1200," in *The Year 1200*, ed. K. Hoffmann (New York, 1975), 53ff.; Weitzmann 1986, 102.

116. K. Weitzmann, "Loca sancta and the Representational Arts of Palestine," *Dumbarton Oaks Papers* 28 (1974): 31ff.

117. Soteriou and Soteriou 1956–58, vol. 1, fig. 161; 2:141.

Chapter 13

1. Cf. text 23B (153).

2. Cf. text 28 (1600–1601).

3. Cf. text 22 (23–24).

4. Maguire 1981, 9.

5. Ibid., 11.

6. Cf. text 16.

7. Belting 1981a, 162.

8. Cf. text 23.

9. P. Lagarde, ed., *Johann von Euchaita*, Abhandlungen Königlichen Gesellschaft der Wissenschaften, Phil.-hist. Klasse 28.1 (Göttingen, 1881); *PG* 120, 1123ff.; and E. Follieri, "Altri testi della pietà bizantina II: Giovanni Mauropode . . . ," *Archivo Italiano per la storia della pietà* 5 (1968): 1–200.

10. Lagarde (see n. 9 above), 10, no. 20, and *PG* 120, 1130–31 no. 7. Cf. Belting 1981a, 173.

11. Lagarde (see n. 9 above), no. 80. Cf. Mango 1972, 221.

12. Cf. Anna Comnena's description of Emperors Alexios and Irene (see text 19). Also cf. the description that Psellos devotes to his daughter Styliane (Kazhdan and Epstein 1985, 211–12, with a comparison to the Zoes mosaic in Hagia Sophia).

13. M. Psellos, *Scripta minora*, ed. E. Kurtz and F. Drexl (Milan, 1941), 2:220–21. Cf. Kazhdan and Epstein 1985, 199.

14. Cf. the vita of Panteleimon in the menologion of Symeon Metaphrastes (*PG* 115, 447ff. and esp. 448–49). On the healer, cf. E. Follieri, *I calendari in metro innografico di Cristoforo Mitileneo* (Brussels, 1980), 1:464.

15. See chap. 12d.

16. Maguire 1981, 91.

17. H. Maguire, "Truth and Convention in Byzantine Descriptions of Works of Art," *Dumbarton Oaks Papers* 28 (1974): 113–14 and 132ff.

18. Maguire 1981, passim. Cf. n. 17 and H. Maguire, "Sorrow in Middle Byzantine Art," *Dumbarton Oaks Papers* 31 (1977): 125ff. and esp. 160ff., and idem, "The Iconography of Symeon with the Christ Child in Byzantine Art," ibid. 34–35 (1981): 261ff.

19. Kazhdan and Epstein 1985, passim.

20. Maguire 1981, 14ff.; H. Hunger, *Die hoch-*

sprachliche profane Literatur der Byzantiner, vol. 1, Handbuch der Altertumswissenschaften 12.5 (Munich, 1978), 65ff.; G. L. Kustas, *Studies in Byzantine Rhetoric* (Thessaloniki, 1973).

21. Kazhdan and Epstein 1985, 83ff.; cf. Hunger (see n. 20 above) and H. G. Beck, *Geschichte der byzantinischen Volksliteratur,* Handbuch der Altertumswissenschaften 12.2–3 (Munich, 1971).

22. Cf. the sermons on the Virgin's visit to the temple (*PG* 100, 1419ff. and 1440ff.), on Mary at the foot of the cross (ibid., 1457ff.), and on the presentation in the temple (*PG* 28, 973ff.). John of Damascus's homilies on the Virgin are in P. Voulet, *Homélies sur la nativité et la dormition,* Sources chrétiennes 80 (Paris, 1961). For bibliography on John of Damascus, cf. chap. 8, nn. 6 and 28; on George of Nicomedia, cf. Maguire, "The Iconography" (see n. 18 above), 264–65, and Belting 1981a, 148.

23. On the typicon of the Euergetis monastery, cf. Dmitrievski 1895, 1:256ff., esp. 320–21 (Visit to the Temple) and 333–34 (Conception).

24. G. Galavaris, *The Illustrations of the Liturgical Homilies of Gregory Nazianzenos* (Princeton, 1969).

25. Maguire 1981, 14ff. and 22ff.

26. Ibid., 42–43, with reference to Gregory of Nazianzus's homily on the Sunday after Easter, still heavily influenced by the rhetoric of Libanios.

27. Ibid., 53ff. and 84ff.

28. Ibid., 91ff.

29. Kazhdan and Epstein 1985, 206ff. and 220ff.

30. Ibid., 133ff. Cf. R. Browning, "Homer in Byzantium," *Viator* 6 (1975), 25–26, and H. Hunger, "Allegor. Mythendeutung in der Antike und bei Johannes Tzetzes," *Jahrbuch der österreichischen-byzantinischen Gesellschaft* 3 (1954): 46.

31. Kazhdan and Epstein 1985, 126ff. and 158ff.

32. L. Oeconomos, *La vie religieuse dans l'empire byzantin au temps des Comnènes et des Anges* (Paris, 1918), 38ff. Cf. Kazhdan and Epstein 1985, 162ff.; D. Gress-Wright, "Bogomilism in Constantinople," *Byzantion* 47 (1977): 163ff.

33. Niketas Choniates, "Historia," ed. F. Grabler, in N. Choniates, *Die Krone der Komnenen* (Graz, 1958), 260–63 (ed. Bonn, 275–77).

34. C. Mango, "The Conciliar Edict of 1166," *Dumbarton Oaks Papers* 17 (1963): 317ff., on the discovery of the inscription panels.

35. Oeconomos (see n. 32 above), 65ff. and 223ff.

36. Cf. text 28.

37. On the early controversy over this issue, see chap. 7 with n. 11.

38. L. H. Grondijs, *L'iconographie byzantine du crucifié mort sur la croix,* 2d ed. (Utrecht, 1947), 121ff., and R. Hausherr, *Der tote Christus am Kreuz. Zur Ikonographie des Gerokreuzes* (Bonn, 1963), 207ff. For Humbert's comments, see *PL* 143, 986–87.

39. Grondijs (see n. 38 above), 188ff., and idem, *Auteur de l'iconographie byzantine du crucifié mort sur la croix* (Leiden, 1960), 72ff.

40. Mansi 1901, 11:956–57. Cf. Kartsonis 1986, 235.

41. Grondijs (see n. 38 above), passim, and idem (see n. 39 above), 51ff.

42. The epigrams begin with a small icon from the ninth century (?) on Mount Sinai; cf. Weitzmann 1976, pl. 107 and no. B 51.

43. *PG* 120, 1148 no. 31.

44. Ibid., 1129 no. 6. Cf. Lagarde (see n. 9 above), no. 7.

45. Istanbul, Ecumenical Patriarchate, Codex no. 3, fol. 4, J. Nielson, "Text and Image in a Byzantine Gospel Book in Istanbul (Ecumenical Patriarchate cod. 3)" (Ph.D., New York University, 1978), 210. Illustrations are in G. A. Soteriou, *Keimelia tou Oikoumenikou Patriarcheiou* (Athens, 1937). Cf. a Psalter formerly in Berlin (G. Stuhlfauth, in *Art Bulletin* 15 [1933]: 311ff.).

46. Cf. text 28.

47. Soteriou and Soteriou 1956–58, vol. 1, fig. 64; 2:78–79; Weitzmann, with Chatzidakis et al. 1965, 21, fig.; Weitzmann 1978, fig. 26. The small panel has a format of 38 × 27 cm (according to Soteriou) or 28.2 × 21.6 cm (Weitzmann 1978). For a similar icon, cf. Weitzmann 1976, B 60 (37.8 × 32.1 cm).

48. *PG* 100, 1461. Cf. Belting 1981a, 156–57.

49. *PG* 100, 1476.

50. W. Völker, *Scala paradisi. Eine Studie zu Johannes Climacus und zugleich eine Vorstudie zu Symeon dem neuen Theologen* (Wiesbaden, 1968).

51. J. R. Martin, *The Illustration of the Heavenly Ladder of John Climacus* (Princeton, 1954), esp. figs. 15, 17, 31, 66, 67, and 133, with frontispieces.

52. 41 × 29.3 cm.; cf. Weitzmann, with Chatzidakis et al. 1965, fig. on p. 20; Weitzmann 1978, no. 25.

53. 37.5 × 30.7 cm.; cf. Soteriou and Soteriou 1956–58, vol. 1, fig. 65; 2:79–80; Weitzmann 1978, no. 22; Weitzmann, with Chatzidakis et al. 1982, 57 with fig.

54. *Analecta hymnica graeca* 3, ed. A. Kominis (Rome, 1972), 220ff., and E. Follieri, *I calen-*

dari in metro innografico di Cristoforo Mitili- neo (Brussels, 1980), 2:71.

55. Kötting 1950, 166ff.

56. Michael Psellos, *Opera minora*, ed. E. Kurtz and F. Drexl (Milan, 1936), 1:120ff.

57. 61 × 42 cm.; cf. Weitzmann 1965, fig. on p. 30; Weitzmann, "Eine spätkomnenische Ver- kündigungsikone des Sinai . . . ," in *Festschrift für H. von Einern* (Berlin, 1965), 299ff., with color plate; Weitzmann 1978, no. 27; Weitz- mann, with Chatzidakis et al. 1982, figure on p. 62. Also see n. 62 below.

58. Beck 1959, 427–28 (Romanus the Melodos, with a new introduction from the early sev- enth century); E. Wellesz, "The Akathistos: A Study in Byzantine Hymnography," *Dumbar- ton Oaks Papers* 9–10 (1956): 141ff.

59. *Opera minora* (see n. 56 above), 1:82ff.

60. C. Stornajolo, *Miniature delle Omilie di Gia- como Monaco* (Rome, 1910), figs. 48–57. The two image manuscripts are Codex Gr. 1208 in Paris and Codex Gr. 1162 (here fols. 111–33v), from which the illustrations in Stornajolo are taken.

61. Weitzmann 1965 (see n. 57 above), 302.

62. Maguire 1981, 42ff. and 50.

63. Galavaris (see n. 24 above), 101ff. and 149ff., with figs. 102–8 and 140–42.

64. Introduction to the *Akathistos* hymn (see n. 58 above).

65. John of Euchaita, epigram on a Christmas icon (*PG* 120, 1123). Cf. John of Damascus, homily on the birth of the Virgin, ed. Voulet (see n. 22 above), 61, on the radiance of the Holy Spirit, and 71, on the inaccessible light.

66. John of Damascus (see n. 65 above), 61.

67. Romanus the Melodos, ed. J. Grosdidier de Matons, Sources chrétiennes 110 (Paris, 1965), 2:90 no. 3; hymn no. 11 (second Christmas hymn), from 88ff.

68. John of Damascus (see n. 65 above), 71.

69. Stylianou 1985.

70. 36.3 × 21.2 cm.; cf. Weitzmann, with Chatzi- dakis et al. 1965, 22–23 with fig.; Maguire 1981, 31.

71. In Venice, S. Marco, Cappella Zen, there is a relief with the Nativity and the Flight into Egypt, and a related piece in S. Giovanni Elemo.

72. See n. 58 above.

73. Ed. Grosdidier de Matons (see n. 67 above), 2: 50ff.: *Hē Parthenos sēmeron.*

74. See n. 65 above.

75. Cf. esp. Rothemund 1966 and Skrobucha 1975, who are right about the later material. On the history of the image types in Byzantine

times, cf. esp. H. Hallensleben, in *Lexikon der christlichen Ikonographie* 3 (1971): 161ff.; K. Kalokyris, *Hē zōgraphikē tēs orthodoxias* (Thessaloniki, 1972), 35ff. and passim; Ha- mann and MacLean 1976, 88ff.; Freytag 1985, passim.

76. Cf. the important study Tatić-Djurić 1976, 259ff.; also Kolb 1968, 94ff.

77. On the corresponding types, cf. Kalokyris (see n. 75 above), 67ff.; Hamann-MacLean 1976, 89ff.; A. Grabar, "Les images de la Vierge de tendresse," *Zograph* (Belgrade) 6 (1975): 25ff.; N. Thierry, "La Vierge de tendresse à l'époque macédonienne," ibid. 10 (1979): 59ff.; Freytag 1985, 332ff.

78. Moscow, Tetyakov Gallery, 78 × 54.6 cm (en- larged to 103.6 × 68.5 cm); cf. A. J. Anisimov, *Our Lady of Vladimir* (Prague, 1928), an essen- tial study; V. I. Antonova, in *Vizantikskij Vre- menik* 18 (1961): 198ff.; K. Berckenhagen, "Die Ikone der Gottesmutter von Vladimir und ihre byzantinischen Parellelen," *Kyros* 3 (1963): 146ff.; Pallas 1965, 167ff.; Weitzmann 1978, no. 21; Weitzmann, with Chatzidakis et al. 1982, 55 with fig.; Belting 1981a, 174–75; Ma- guire 1981, 102–3; cf. M. Alpatoff and V. La- zareff, "Ein byzantinisches Tafelwerk . . . ," *Jahrbuch der preussischen Kunstsammlungen* 67 (1925): 140ff.

79. *Perigraphē tēs hieras . . . monēs tēs hyperagias Theotokou tou kykkou* (Venice, 1851); G. So- teriou, "Hē kykkiotissa," in *Nea Kestia*, 1939, 36 fig. 3; A. Papageorghiou, in Athens 1976, 16. The heavily overpainted image is almost entirely concealed beneath a metal casing. The most important replicas that give us an idea of the original in this catalog are no. 27 (icon in Asi- nou, 88 × 56 cm) and no. 30. Cf. Papageorgiu 1969, fig. 48. On the monastery and the icon, cf. R. Gunnis, *Historic Cyprus* (London, 1936), 302ff.

80. See chap. 12 n. 74. An important early panel from Thessaloniki, from the twelfth century, is in the Byzantine Museum in Athens; cf. Athens 1985, no. 4 (114 × 70 cm), Chatzidakis 1976, fig. 22.

81. See chap. 12 n. 68.

82. M. Chatzidakis, "Anciennes icones de Lavra d'après un texte géorgien," in *Mélanges P. Del- voye* (Brussels, 1986), 425ff.

83. Ohrid, Museum of the church of St. Clement, each half measures 111 × 68 cm; cf. Djurić 1961, nos. 20–21; Hamann-MacLean 1976, 90; Babić 1980, pls. 2–3; K. Balabanov, *Icone della Macedonea* (Rome-Musei Vaticani, 1986),

12–13 and colored title pages. The silver mounting bears the following inscription: "Ta da prosagō soi, Korē Panhagia. Leon sos oiktros oiketēs Theou thytēs" (I offer you what is yours, most holy Virgin. Your faithful servant Leon, God's priest). Perhaps this Leon is the archbishop Leon Mung (1108–20), which would make the icon somewhat older.

84. Janin 1953, no. 96, of the churches of the Theotokos.

85. Cf. text 23.

86. Cf. text 25A (4).

87. See chap. 4 n. 12. On toponymous icons, cf. Hamann-MacLean 1976, 93ff.

88. Janin 1953, 156ff.

89. J. Mateos, *Le typicon de la Grande Église* (Rome, 1962), 1:18–19 (Birth of the Virgin, celebrated on 8 Sept.), 110–11 (Visit to the Temple, 21 Nov.), 126–27 (Anne's conception, 9 Dec.), 220–21 (Presentation in the Temple, 2 Feb.), 254–55 (Annunciation, 15 Mar.), and 368–69 (Dormition, 15 Aug.).

90. Janin 1953, nos. 31, 32, 40, 54, 61, 86, 87, 89, and 96 of the churches of the Theotokos. Mainly concerned are the monasteries of Euergetis, Kecharitomene, Kyros, Pammakaristos, Panachrantos, Pantanassa, and Peribleptos (i.e., the Virgin).

91. See n. 76 above.

92. Janin 1953, nos. 31 and 32 under "Monasteries." On the Eleousa church of the Pantocrator monastery, cf. text 13.

93. Cf. text 25C (5).

94. Kolb 1968, fig. 25 ("Original Eleousa"). This is an ivory relief in the Walters Art Gallery in Baltimore.

95. Stylianou 1985, 367, and Mango and Hawkins 1966 (see chap. 12 n. 72), 156 and fig. 41. The inscription reads, "Ei tis ou proskyni ton k[yrio]n . . . k[ai] tēn achranton autou M[ēte]ra en ikoni perigraptō e[st]o anathema." (Accursed be anyone who does not worship the Lord . . . and his undefiled Mother [as they are] enclosed in an icon.)

96. See chaps. 3 and 4.

97. Maguire 1981, 53ff. (antithesis of Creator and Child) and 96ff. (lament of the Virgin). Cf. the texts on the feast of the Virgin's birth (Mercenier 1953, 78ff.) and a Christmas hymn by Romanus (Grosdidier [see n. 67 above], 2:128, no. 13) that honors the Virgin, who carries on her arm him who is enthroned with his Father above.

98. Pallas 1965, 167ff.

99. Maguire 1981, 14–15 and 96.

100. Pseudo-Symeon Metaphrastes (*PG* 114, 126). Cf. Maguire 1977 (see n. 18 above), 162–63.

101. Maguire 1981, 98.

102. Gregory of Nicomedia, sermon of the Virgin at the foot of the cross (*PG* 100, 1457 and esp. 1488). For references on the author, who wrote in the ninth century, see n. 22 above.

103. Grosdidier (see n. 67 above; 1967), 4:160ff. no. 35.

104. *PG* 100, 1488.

105. Thierry (see n. 77 above), 65ff. and figs. 1–2, 13 (dated 950–64); C. Jolivet-Levy, "Le riche décor peint de Tokali Kilise à Göreme," *Histoire et archéologie* 63 (May 1982): 61ff.; A. W. Epstein, *Monks and Caves in Byzantine Cappadocia* (catalog; Dumbarton Oaks, 1984), fig. 5.

106. Maguire 1981, 60–61.

107. In Tiflis, metal icons were a donation by the Lakladidze family from the early eleventh century; cf. Thierry (see n. 77 above), 69–70, and G. Alibegašvili, in Weitzmann, with Chatzidakis et al. 1982, 103 fig.

108. See n. 78 above, with references.

109. Cf. text 28 (1520).

110. Cf. text 25C (5).

111. In the Byzantine Museum in Athens; cf. M. Chatzidakis, in Weitzmann 1978, fig. on p. 51.

112. E.g. the frescoes of the Descent from the Cross and the Lamentation in Nerezi (1164); cf. Belting 1981a, 173 fig. 64.

113. Chatzidakis 1976, pl. 37; Belting 1981a, 143ff. and figs. 49–50.

114. Hamann-MacLean 1976, 60; Belting 1981a, 176ff. and fig. 66; Stylianou 1985, 158–59 and fig. 85.

115. See n. 79 above, with references; Babić 1988, 61ff.

116. In the Sinai monastery, 50 × 40 cm; Soteriou and Soteriou 1956–58, vol. 1, figs. 54–56; 2:73ff.; Hamann-MacLean 1976, 90; H. Maguire, in *Dumbarton Oaks Papers* 34–35 (1981): 267 and fig. 12; Weitzmann, with Chatzidakis et al. 1982, 48 with color pl.; Babić 1988, 63ff.

117. Maguire 1981 (see n. 116 above), 264–65 and 267ff., with examples esp. from the sermon of Gregory of Nicomedia (*PG* 28, 985–88).

118. Belting 1981a, fig. 67, and Stylianou 1985, with good illustrations.

119. Interpolated in the *Akathistos* hymn; cf. K. Kirchhoff and C. Schollmeyer, *Hymnen der Ostkirche*, 2d ed. (Münster, 1960), 197, as a canon by the hymn composer Joseph.

120. *PG* 100, 1425 (Gregory of Nicomedia on Mary's visit to the temple).
121. Athens, in the Byzantine Museum, 117.5 × 75 cm; Athens 1985, 16 no. 5, with dating in the thirteenth century.
122. See n. 80 above.
123. John of Damascus, homily on the birth of the Virgin, ed. Voult (see n. 22 above), 60. "There [in the Sinai] the word of God was written on stone tablets . . . ; in her [Mary] the Word [*logos*] was made incarnate from the Holy Spirit and her blood.
124. See n. 116 above. In fig. 178 the persons on the frame are, from the left: *top,* Paul and John the Evangelist, John the Baptist and Peter; *second row,* Aaron and Moses with Jacob; *third row,* Hannah and Simeon, Zechariah and Elizabeth; *fourth row,* Ezekiel and David, Isaiah and Daniel; *bottom row,* ?, Daniel, Anne and Joachim, Joseph, Adam and Eve, Solomon and Gideon.
125. 48.5 × 37 cm; Moscow 1977, vol. 3, no. 883.
126. Maguire 1981, passim; see nn. 20 and 21 above.
127. E.g. Gregory of Nicomedia, sermon on Mary's visit to the temple (*PG* 100, 1419–40, esp. 1425). On the author, see n. 22 above.
128. Cf. Romanus's Christmas hymn *Katenplage Joseph* (ed. Grosdidier [see n. 67 above], 2:28 no. 13). In the eleventh century this hymn was sung in the Euergetis monastery on the feast of the Birth of the Virgin (Dmitrievskii 1895, 1: 264). On other texts, cf. Mercenier 1953, 78ff.
129. *PG* 100, 1424 (see n. 127 above). Mary is the spiritual gate (*noetē pylē*), the living curtain (*empsychon katapetasma*), behind which the Logos hides his divinity.
130. See n. 124 above.
131. See n. 128 above. Also cf. a sermon on Mary's conception composed by John of Euchaita (*PG* 96, 1477 and 1489; Mary as *Hagia tōn Hagiōn*). Also important is Romanus's second Christmas hymn (ed. Grosdidier [see n. 67 above] 2:88ff. no. XI), with dialogues between the Virgin and Adam and Eve. Here the refrain is also addressed to the *Kecharitomene.*
132. The five Marian feasts are Birth of the Virgin (8 Sept.), Visit to Temple (21 Nov.), conception by Anne (9 Dec.), Presentation in the Temple (2 Feb.), Annunciation (15 Mar.), and Dormition (15 Aug.).
133. Dmitrievskii 1895, 1:263ff., 320ff., 330ff., 406ff., 429ff., and 487ff., on the Euergetes monastery.
134. Cf. homilies on the monk Jacob from the monastery of Kokkinobaphos, ed. Stornajolo (see n. 60 above), figs. 9–21 and 23–32, esp. fig. 20 (fol. 50v), with our example.
135. See n. 83 above.
136. Cf. text 23B, nos. 2 and 18.

Chapter 14

1. Forsyth 1972, 39 and 79.
2. Cf. esp. H. Keller, "Zur Entstehung der sakralen Vollskulptur in der ottonischen Zeit," in *Festschrift H. Jantzen* (Berlin, 1951), 71–90 (reprinted in H. Keller, *Blick vom Monte Cavo* [Frankfurt, 1984], 19ff.); R. Wesenberg, *Berwardinische Plastik* (Berlin, 1955); R. Haussherr, *Der tote Christus am Kreuz. Zur Ikonographie des Gerokreuzes* (Bonn, 1963); C. Beutler, *Bildwerke zwischen Antike und Mittelalter* (Düsseldorf, 1964); idem, *Statue. Die Entstehung der nachantiken Statue* (Munich, 1982); Forsyth 1972, passim; J. Hubert and M. C. Hubert, "Piété chrétienne ou paganisme? Les statues reliquaires de l'Europe carolingienne," *Settimane di studio del centro Italiano di studi sull'alto medioevo* (Spoleto) 28 (1982): 235–75.
3. Forsyth 1972, 74–75, and W. Braunfels, "Karls des Grossen Bronzewerkstatt," in *Karl der Grosse,* ed. W. Braunfels (Düsseldorf, 1965), 3: 168ff.
4. *Monumenta Germaniae Historica Legum* 3: *Concilia,* 2 suppls., ed. H. Bastgen (Hannover, 1924); *PL* 98, 599–1248; cf. H. Schade, "Die Libri Carolini und ihre Stellung zum Bild," *Zeitschrift für katholische Theologie* 79 (1957): 69ff.; G. Haendler, *Epochen karolingischer Theologie* (Berlin, 1958), 27ff.; A. Freeman, "Carolingian Orthodoxy and the Fate of the Libri Carolini," *Viator* 16 (1985): 65ff.
5. A. Freeman, "Theodulf of Orleans and the Libri Carolini," *Speculum* 32 (1957): 663ff.; Forsyth 1972, 72–73.
6. W. Braunfels, *Die Welt der Karolinger und ihre Kunst* (Munich, 1968), 183ff. and fig. 249 (apse with Ark of the Covenant).
7. P. C. Claussen, "Goldschmiede des Mittelalters," *Zeitschrift des Deutschen Vereins für Kunstwissenschaft* (Berlin) 32 (1978): 45ff. and esp. 79ff. (artistic value and material value). On the goldsmith's art, cf. M. M. Gauthier, *Les routes de foi* (Fribourg, 1983).
8. K. Guth, *Guibert von Nogent und die hochmittelalterliche Kritik an der Reliquienverehrung* (Ottobeuren, 1970), and P. Geary, *Furta Sacra:*

Theft of Relics in the Central Middle Ages (Princeton, 1978).

9. Cf. Forsyth 1972, passim, and esp. 32–33 and 105ff.

10. Cf. the argument between Keller (see n. 2 above) and Forsyth 1972, 76–77 and passim.

11. Forsyth 1972, 73, after *Acta Sanctorum Mali* 1.153–54.

12. Gregory of Tours, *De gloria martyrum* 1.23 (*PL* 71, 724–25).

13. Jonas of Orléans, *De cultu imaginum* (*PL* 106, 307ff. and esp. 340). The three books were written against Claudius of Turin on the instructions of Louis the Pious; they were completed in 840.

14. A. Peroni, "Il crocifisso della badessa Raingardia a Pavia e il problema dell'arte ottoniana in Italia," in *Kolloquium über spätantike un frühmittelalterliche Skulptur,* ed. V. Milojcic (Mainz, 1970), 2:75ff. and pls. 54, 60, 64, and 66.

15. E. Sandberg-Vavalà, *La croce dipinta italiana e l'iconografia della passione* (Verona, 1929); Hager 1962, 75ff.; and Belting 1981a, 218ff.

16. Examples in Forsyth 1972, 1 n. 1. Statues of saints such as the silver Peter in Cluny were also denoted by the name *maiestas.*

17. On the adoration of sorcerers and the throne motif, cf. Forsyth 1972, 53ff. and 86ff. On the throne motif generally and its meaning in the context of resistance to heretical movements, cf. G. Francastel, *Le droit au trône* (Paris, 1973), 83ff. and esp. 299ff.

18. Berlin, Staatliche Museen Preußischer Kulturbesitz (inv. no. 29): Madonna of the presbyter Martinus; P. Metz, ed., *Europäische Bildwerke von der Spätantike bis zum Rokoko* (Munich, n.d.), no. 78; E. Carli, *La scultura lignea italiana* (Milan, 1960), 22–23.

19. Forsyth 1972, 105ff. and 102–3. Both statues were lost during the French Revolution.

20. Ibid., 31, 39, and 49 and fig. 3; the text is edited by L. Bréhier, in *La renaissance de l'art français* 7 (1924): 5ff.

21. Forsyth 1972, 51 and no. 30 and fig. 6. The 73-cm-high statue from the twelfth century in St. Philibert is thought to come from St. Pourçain-sur-Sioule.

22. On an eleventh-century mystery play in Nevers and another in Rouen in the fourteenth century, cf. Forsyth 1972, 55 and 57.

23. Ibid., 77. On the genre, cf. Eva Kovács, *Kopfreliquiare des Mittelalters* (Leipzig, 1964), and the exhibitions *Die Zeit der Staufer* (catalog; Stuttgart, 1977) and *Ornamenta Ecclesiae* (catalog; Cologne, 1985).

24. Cf. the introductory literature to text 34, III.

25. Forsyth 1972, 41–42.

26. Cf. the survey by R. Kroos, "Vom Umgang mit Reliquien: Ornamenta Ecclesiae" (see n. 23 above), 3:25ff. and esp. 38ff.

27. Cologne, Museum für ostasiatische Kunst, inv. B 11.37; cf. *Ornamenta Ecclesiae* (see n. 23 above), 3:50–51.

28. See n. 19 above.

29. Forsyth 1972, 36. Walter Strumme gave the abbey a number of relics, which were deposited in the *nova imago* of the Virgin.

30. Ibid., 32–33, with a report by Hugo of Poitiers (ca. 1165) on the *imago lignea* from the crypt of Vézelay, on which the Child wore a *sericum phylacterium* around his neck. During restoration an *occultissimum ostiolum inter scapulas* of the Virgin figure, full of relics with suitable certificates, was discovered.

31. Cf. Belting 1981a, 129–30, with further references.

32. *Die Zeit der Staufer* (see n. 23 above), no. 542 fig. 333; and *Rhein und Maas* (catalog; Cologne, 1972), no. G 11, with further references.

33. On the relevant aesthetics, cf. F. de Bruyne, *Études d'esthétique médiévale* (Bruges, 1946), and R. Assunto, *Die Theorie des Schönen im Mittelalter* (Cologne, 1963), passim, and 150 with the quotation from Suger. On Suger, cf. E. Panofsky, *Abbot Suger on the Abbey Church of St. Denis and Its Art Treasures* (Princeton, 1946).

34. See n. 7 above. On the "retable" of the Remaclus shrine, cf. *Rhein und Maas* (see n. 32 above), 249 no. G 10.

35. J. R. Gaborit, "L'autel majeur de Grandmont," *Cahiers de civilisation médiévale* 19 (1976): 231ff., and M. M. Gauthier, "Du tabernacle au retable," *Revue de l'Art,* 1978, 23ff. and 35ff.

36. A. Schneider, ed., *Die Cistercienser* (Cologne, 1974), with a reference to J. M. Canivez, *Statuta capitulorum generalium ordinis Cisterciensis* (Louvain, 1933), 1:17 no. 20 (1130); 98 no. 4 (1185) and no. 12; 61 no. 15 (1157 against large metal crosses); and 2:218 no. 12 (against *tabulae pictae*).

37. H. Schwarzmeier, *Lucca und das Reich bis zum Ende des 11. Jahrhunderts* (Tübingen, 1972), chap. 5 (cf. the review by H. Jakobs, in *Quellen und Forschungen aus italienischen Archiven und Bibliotheken* 54 [1974]: 477); R. Hausherr, "Das Imervardkreuz und der Volto-

Santo-Typ," *Zeitschrift für Kunstwissenschaft* 16 (1962): 129ff.; R. Manselli et al., in *Lucca, il Volto Santo e la civiltà medioevale. Atti Convegno Internazionale di studi 1982* (Lucca, 1984); and P. Lazzarini, *Il Volto Santo di Lucca* (Lucca, 1982).

38. This miniature is the Codex Tucci-Tognetti, fol. 2, in the library at Lucca; cf. G. Dalli Regoli, *Miniatura pisana del trecento* (1963), 18 fig. 2, and further illustrations in Lazzarini (see n. 37 above).

39. The icon, from about 1200, measures 277 × 266 cm. Cf. *Die Zeit der Staufer* (see n. 23 above); no. 462, and n. 37 above.

40. Leo Diaconus, *Historia* 10.4 (ed. Bonn, 1828, 166 and 167–68), on the eikōn of the Crucifixion. Cf. Dobschütz 1899, appendix VII B, pp. 280ff.**. On the Luccese legend of Deacon Leboinus, cf. references in n. 37 above.

41. Belting 1981a, 42–43.

42. F. Werner, "Christophorus," in *Lexikon der christlichen Ikonographie* (Freiburg, 1973), 5: 496ff. On our illustration in the Codex Laur. 25.3, fol. 383, in Florence, cf. Belting 1981a, 217 fig. 85.

43. For references, see n. 19 above.

44. Cf. Hager 1962, 94ff., and the dissertation by F. Krüger, "Die frühen Altarbilder des Franziskus in Italien" (Munich, 1987). On the depiction of a saint's miracle before the image, cf. the panel in the cathedral in Orte (C. Brandi, in *Scritti di storia dell'arte in onore di M. Salmi* [Rome, 1961], 1:351ff., with figs. 4 and 9).

45. Gauthier (see n. 7 above), fig. 100; Cleveland Museum of Art, inv. 7826.

46. F. Tomasetti et al., *Statuti della Provincia Romana*, Fonti per la storia d'Italia 48 (Rome, 1910), 1:202–3 no. 144.

47. R. C. Trexler, *Public Life in Renaissance Florence* (New York, 1980), 63ff. and 353ff., with pl. 6.

48. Ibid., 71.

49. Ibid., 71–72.

50. Gautier de Coinci, *Les miracles de la Sainte Vierge*, ed. V. F. Koenig, 4 vols. (Geneva, 1955–66). Cf. U. Ebel, *Das altromanische Marienmirakel. Ursprung und Geschichte einer literarischen Gattung* (Heidelberg, 1965).

51. Biblioteca S. Lorenzo el Real de El Escorial, Codex T.I.1. Cf. J. Snow, *The Poetry of Alfonso X el Sabio* (London, 1977), and the facsimile volume: *Alfonso X el Sabio. Cantigas de S. Maria* (Madrid, 1979), The examples discussed here are songs no. 34 and 10 on fols. 50r and

17r of the Escorial manuscript. The second text has been published in Gauthier's version by Koenig (see n. 50 above, 4:378ff.).

Chapter 15

1. *Descriptio Lateranensis Ecclesiae* (Valentini and Zucchetti 1942–46, 2:319ff., esp. 336 no. 4).

2. Ibid. 356–57 no. 13.

3. Cf. the text by Benedictus Canonicus (ibid., 216–17).

4. As in a tenth-century lectionary and in John Diaconus in the twelfth century, before a bull of Clement V in 1305 repealed the version. For references; see chap. 4 n. 61.

5. Cf. Krautheimer 1980, 56. For references on the icon by St. Luke, see chap. 4, n. 67, and Wolf 1990. Bartholomaeus Tridentinus speaks in 1244 of an "imago ad fontes quae dicitur Regina Coeli." In the thirteenth century Durandus, in his rationale for the *divina officia*, mentions that "super limen baptisterii servatur quam Romani Reginam vocant." The image tabernacle is probably later than that of the crib relic (1256), but still from pre-Gothic times.

6. For references, see chap. 4 n. 67.

7. For references, see n. 40 below.

8. Cf. Belting 1982c, 35ff.

9. Marangoni 1747, 240ff., and Hager 1962, 45 and 47. The image, also called *Regina caeli*, was said to have been brought there under Gregory IX, though this is precluded by its more recent date of origin. Also cf. Garrison 1949, no. 117; Hueck 1970, 140ff. On the earliest cult legend (Clm. 14630, fol. 11), cf. Huelsen (see n. 23 below), 151.

10. On the image in Grottaferrata (cedarwood, 125 × 42 cm), cf. A. Rocchi, *L'immagine di S. Maria di Grottaferrata* (Rome, 1887); *Soprintendenza alle Gallerie e Opere d'Arte . . . del Lazio: Mostra di opere d'arte restaurate* (Rome, 1968), 8 no. 2; Pace 1985, 265–66 (with attribution to a Cypriot painter).

11. Cf. Belting 1981a, 66–67, 308, no. 1.

12. Garrison 1949, no. 280, and Hager 1962, 35–36. The inscription reads, "Rex ego sum coeli populum qui de morte redemi."

13. Cf. Benedictus Canonicus (Valentini and Zucchetti 1946, 213 and 216–17).

14. Forsyth 1972, 42.

15. Nicholas Maniacutius (cf. text 4C), p. 19 no. 9; Jakob Rabus, *Eine Münchner Pilgerfahrt*

i. J. 1575 (Munich, 1925), 54ff.; Bertelli 1988, 52ff.

16. P. Bombelli, *Memorie istoriche delle immagini di Maria Vergine che si venerano in Roma coronate del R.mo Capitolo,* 3 vols. (Rome, 1795), and Dejonghe 1967.

17. Ladner 1941–84, 1:195ff. and pl. 19 on the Camera pro secretis consiliis.

18. Ibid., 202ff. and pl. 20.

19. Anonymous pilgrim of Salzburg (Bertelli 1961c, 17ff.).

20. See chap. 4 n. 59.

21. On the construction, cf. R. Krautheimer, *Corpus basilicarum Christianarum Romae* (Rome, 1967), 3:61ff. On its history, cf. G. Ferrari, *Early Roman Monasteries* (Rome, 1957), 225ff., and V. J. Koudelka, "Le Monasterium Tempuli et la fondation dominicaine de S. Sisto," *Archivum Fratrum Praedicatorum* 31 (1965): 5–81.

22. On the icon, cf. C. Bertelli, "L'immagine del Monasterium Tempuli dopo il restauro," *Archivum Fratrum Praedicatorum* 31 (1965): 82–111; Hager 1962, 47ff., and C. Bertelli, in *Storia dell'arte italiana* 2.1 (Turin, 1983), 31.

23. The Roman legend appears in *Acta Sanctorum July 17* (Paris, 1868), July, 4:251–53. For references, see L. Duchesne, "Notes sur la topographie de Rome au moyen Age," *Mélanges d'archéologie et d'histoire de l'école Française de Rome* 10 (1890): 225–26, on the vitae; M. Rössler, *Die Fassungen der Alexioslegende* (Vienna, 1905), and A. Amiaud, *Le légende syriaque de St. Alexis l'homme de Dieu* (Paris, 1889). On the Greek version, cf. F. M. Pereira, in *Analecta Bollandiana* 19 (1900): 243ff., and on the old French versions, cf. D. K. Uitti, *Story, Myth, and Celebration in Old French Narrative Poetry* (Princeton, 1973), 3ff. On the history of the Roman monastery in the quarter called Blachernae on the Aventine, cf. Ferrari (see n. 21 above), 78ff.; and C. Huelsen, *Le chiese di Roma nel medioevo* (Florence, 1927), 171–72. Alexios's remains were reputedly taken to Rome from Damascus in 977 by Metropolitan Sergios.

24. Wilpert 1914–17, vol. 4, pl. 242, and G. Ladner, "Die italienische Malerei im 11. Jahrhundert," *Jahrbuch der Kunsthistorischen Sammlungen in Wien,* n.s., 5 (1931): 33ff., and esp. 63 and pl. 16; and E. B. Garrison, *Studies in the History of Medieval Italian Painting* 1.1 (Florence, 1953), 1ff.

25. O. Montenovesi, *La chiesa di S. Gregorio Nazianzeno* (Rome, 1959), and idem, in *Cap-*

itolium 25 (1950): 219; E. T. Prehn, in *Rivista d'arte* 36 (1961): 19ff. On the history of the monastery, cf. M. Bosi, *S. Maria in Campo Marzio,* Le chiese di Roma illustrate (Rome, 1961), and Ferrari (see n. 21 above), 207ff. The convent is mentioned for the first time with the double title Gregory and Mary in 937, though it is referred to only as the oratorium of Gregory in 806. It was said to have been originally occupied by members of the Basilian order.

26. Dejonghe 1967, 147–48 and fig. 35; L. Grassi, "La Madonna di Aracoeli," *Rivista di archeologia cristiana* 18 (1941): 83–84; and L. Mortari, "La Madonna di S. Maria in Campo Marzio," *Studi romani* 22 (1974): 291–92. On the panel in the Cini Collection, cf. Garrison 1949, no. 138, and E. B. Garrison, in *Bibliofilia* 70–71 (1972): 121ff., and Eunice D. Howe, "Antoniazzo Romano, the 'Golden Legend,' and a Madonna of S. Maria Maggiore," *Burlington Magazine* 126 (1984): 417–18. When the convent was dissolved, the panel (107 × 57 cm) seems to have passed to the oblates of the Teatro di Marcello, who sold it.

27. The panel is now beside the altar of the Cappella Paolina and gives an exact idea of the appearance of the original in the sixteenth century.

28. The panel, 90 × 58 cm with canvas, bears the inscription "Fons Lucis Stella maris." The signature is probably "Petrus pictor." In the fifteenth century, tomb inscriptions referred to the *miraculosa imago.* On the image, cf. Grassi (see n. 26 above), 89–90; Hager 1962, 48; Matthiae 1966, fig. 237; M. V. Brugnoli, in *Attività della Soprintendenza alle Gallerie del Lazio 10 Settimana dei Musei* (Rome, 1967), 16–17 no. 8 fig. 12.

29. The panel, measuring 101 × 75.5 cm (canvas on chestnut wood), went to S. Vergine Assunta e S. Bernardo, the confraternity's church built in 1418 and, as a St. Luke's image, was only *scoperta in feste solemni.* Cf. Matthiae 1966, fig. 241; L. Mortari, "L'antica Madonna su tavola della chiesa romana del SS. Nome di Maria," *Commentari,* 1972, 3ff., and *Restauri della Soprintendenza alle Gallerie per il Lazio* (catalog; Rome, 1972), no. 2 pl. 3.

30. The panel is signed by "Belizo presbyter" and "Bellus homo pictor." Cf. I. Toesca, "L'antica Madonna di S. Angelo i. P.," *Paragone* 227 (1969): 3ff.

31. See the references in n. 21 above.

32. See n. 40 below.

33. Ferrari (see n. 21 above), 211–12, and Valen-

tini and Zucchetti 1946, 319 and 360. The list states: "S. Alexii, ubi est corpus eius," and "S. Maria in Capitolio, ubi est ara Filii Dei."

34. For references, see n. 25 above.

35. For references, see n. 23 above. On the heavily overpainted canvas image of the Madonna in S. Alessio, cf. Grassi (see n. 26 above), 81–82 fig. 7; C. Brandi, in *Bollettino dell'Istituto Centrale del Restauro*, 1952, 183 and 193; Dejonghe 1967, 95–96 fig. 20.

36. The panel is recorded only in the laterally inverted engraving by Barbazza, where it also shows a bust of Christ in the top corner (cf. Dejonghe 1967, fig. 51). On the history of the monastery, which was in dispute with the Tempuli convent over land in the eleventh century, cf. *Notizie dell'origine . . . del monastero di S. Ambrogio alla Massima* (Rome, 1755). The monastery was situated close to the portico of Octavia.

37. Dejonghe 1969, 109, and J. S. Gaynor and I. Toesca, *S. Silvestro in Capite* (Rome, 1963), 80.

38. E.g., S. Maria in Via Lata (see n. 28 above), S. Lorenzo in Damaso (57 × 81 cm on canvas; cf. I. Toesca, in *Paragone* 231 [1969]: 56), Vetralla and Tivoli (see nn. 51 and 52 below). In the old oratory in the Lateran, below the Scala Santa, there was a fresco with the inscription "Compagna de l'iconi," to which William S. Tronzo has drawn my attention. Cf. S. Waetzoldt, *Kopien des 17. Jahrhunderts nach Mosaiken und Wandmalereien in Rom* (Vienna, 1964), no. 134.

39. Ladner 1941–84, 2:9ff., and Matthiae 1967, 305ff. Cf. esp. E. Kitzinger, "A Virgin's Face: Antiquarianism in Twelfth Century Art," *Art Bulletin* 62 (1980): 6ff., and Tronzo 1990. Cf. also Belting 1987a.

40. On the beech panel, which measures 82 × 52 cm, cf. E. Lavagnino, "La Madonna dell'Aracaeli e il suo restauro," *Bollettino d'arte,* 1938, 529ff.; B. Pesci, "Il problema cronologico della Madonna di Aracoeli," *Rivista dell'archeologica cristiana* 18 (1941): 51ff.; Grassi (see n. 26 above), 65ff.; Bertelli (see n. 22 above), 95ff.; and Hager 1962, 49. On the history of the altar and the image, apart from Pesci, cf. esp. R. E. Malmstrom, *S. Maria in Aracoeli at Rome* (Ann Arbor, Mich.: University Microfilms, 1973), 121ff.

41. For references, see n. 23 above.

42. R. Piur, *Cola di Rienzo* (Vienna, 1931), 111–12; A. M. Ghislaberti, ed., *Vita di Cola di Rienzo* (Florence, 1828), 76–77.

43. A. Matejcek and J. Pesina, *Czech Gothic Paint-*
ing (Prague, 1950), no. 177 and pl. 120 (72 × 48 cm).

44. Cf. the study by Eunice Howe mentioned in n. 26 above and Wolf 1990.

45. See chap. 12 n. 71. For earlier references, cf. esp. S. B. Mercati, in *Spoletium* 3.1 (Apr. 1955): 3 (a detailed study has never been produced), and Hager 1962, 52 and 48, and nn. 201–2, with evidence of veneration in the thirteenth century. The descendants of Petrus de Alipha, who included the donor of the metal frame, were clearly of importance in southern Italy in the twelfth and thirteenth centuries. On the history of Spoleto and Rome, cf. D. Waley, *The Papal State in the Thirteenth Century* (London, 1961), 37 and passim.

46. For references, cf. Volbach 1940–41, 97ff.; Garrison 1949, nos. 278–92; Garrison 1955–62, 2:5ff.; 3:189–90, 210–11; Hager 1962, 36ff.; Matthiae 1966, 58ff. On the Tivoli panel, cf. Garrison 1949, no. 279; Garrison 1955–62, 3:189–90; Hager 1962, fig. 279; Matthiae 1966, color pl. at p. 60; and F. Bologna, *La pittura italiana delle origini* (Rome, 1962), color figs. 17–18.

47. Garrison 1949, nos. 280 and 299; Garrison 1955–62, vol. 2, figs. 11 and 14–15.

48. Hager 1962, 36 with fig. 36.

49. Cf. the examples in Garrison 1955–62, 3:189–90.

50. Hager 1962, 37.

51. Ibid., 49 and figs. 52–53. Also cf. Garrison 1955–62, 3:210 with fig.; Matthiae 1966, fig. 71. The dimensions are 105 × 97 cm.

52. I. Toesca, in *Mostra dei restauri 1969* (Rome: Palazzo Venezia, XIII Settimana dei Musei, 1970), 9–10 and pls. 1–3 (103 × 65 cm). The Madonna delle Grazie bears the inscription with the English greeting at the bottom edge.

53. Garrison 1955–62, 3:210–11 with fig.; Matthiae 1966, fig. 70. The inscription reads "Alma Virgo parit quem falsa sofia negavit" and is followed by the signature "Petrus pictor." The dimensions are 80 × 42 cm.

54. See chap. 15a and chap. 4 n. 63. On a different copy, cf. E. B. Garrison, in *Burlington Magazine* 89 (1947): 147–48 with pl. IC.

55. Cf. the triptychs in Viterbo and Tivoli (Garrison 1955–62, vol. 3, with figs.).

56. P. Toubert, *Les structures du Latium médiéval* (Rome, 1983), 2:806ff. (the bishops), 840ff. (the cathedral chapters), and 1039ff. (the origins of the papal state). On the outward history, cf. P. Partner, *The Lands of St. Peter* (University of California Press, 1972), 127ff. and 159ff.

Chapter 16

1. O. Lehmann-Brockhaus, *Schriftquellen zur Kunstgeschichte des 11. und 12. Jahrhunderts für Deutschland, Lothringen, und Italien* (Berlin, 1938), nos. 905 and 2617.
2. Düsseldorf, Hauptstaatsarchiv Schwarzrheindorf Urkunde 2; cf. W. Bader, *Die Benediktinerabtei Braunweiler bei Köln* (Berlin, 1937), fig. 76; *Rhein und Maas: Kunst und Kultur, 800–1400* (catalog; Cologne, 1972), no. 11.8.
3. Cf. the Psalter in Donaueschingen, cf. Codex 309, with reproduction of a diptych (Kermer 1967, 45, and *Ornamenta Ecclesiae* [catalog; Cologne, 1985], no. H 64).
4. Cf. the triptych with the three-figure deesis reproduced in the frescoes of the church of St. John in Taufers, which appears in N. Rasmo, *Affreschi medievali Atesini* (Milan, n.d.), pl. 9, and Belting 1982c, 45.
5. Cf. the image friezes on the portals of the baptistery in Pisa and at S. Michele in Scalzi (Rasmo [see n. 4 above] and Belting 1982c); see also chap. 12 n. 51.
6. Full publication is only in H. Flamm, "Eine Miniatur aus dem Kreise der Herrad von Landsberg," *Repertorium für Kunstwissenschaft* 37 (1915): 122ff. On the link of the horseman image to Crusader icons, cf. Weitzmann 1966, 78 with fig. 62, and Weitzmann 1982, 352.
7. It measures 22 × 16.5 cm and is published in full in A. A. Krickelberg-Pütz, "Die Mosaikikone des hl. Nikolaus in Aachen Burtscheid," *Aachener Kunstblätter* 50 (1982): 9–141. Also cf. *Ornamenta Ecclesiae* (see n. 3 above), no. H 62.
8. Florence, Accademia, measuring 54 × 41 cm. Cf. I. Marcucci, *Gallerie Nazionali di Firenze: I dipinti toscani . . .* (Rome, 1958), 79–80 no. 25 with examples.
9. Chimay, Collegiale St. Pierre et Paul, measuring 12.2 × 10 cm without frame. The inscription is "Effigiem Christi fieret quam carneus ante / Hanc magni fictam dedit in pignus (sui) amoris / Namque roy Legato Sixtus Papa Philippo." Cf. *Splendeurs de Byzance* (catalog; Brussels, 1982), no. 3, and *Ornamenta Ecclesiae* (see n. 3 above), no. H 65.
10. In Maastricht, there is O. L. Vrouwebasiliek (11.8 × 7.3 cm, eleventh cent.), reproduced in *Ornamenta Ecclesiae* (see n. 3 above), no. H 63; in Rome, S. Prasseda (22 × 19 cm, twelfth cent.), in M. Andaloro, "Gli smalti dell'icona col Cristo Evergetes . . . ," *Prospettiva* 40 (1985): 57ff.

11. Belting 1982c, passim.
12. Rizzi 1972, 270 no. 21, measuring 123 × 95.5 cm.
13. M. Kalligas, "Byzantinē Phorētē Eikon en Freising," *Archaiologikon Ephemeris* 100 (1937b): 501ff.; C. Wolters, "Beobachtungen am Freisinger Lukasbild," *Kunstchronik* 17 (1964): 85ff.; *Ornamenta Ecclesiae* (see n. 3 above), no. H 69. The panel is made of limewood and measures 27.8 × 21.5 cm.
14. The fourteenth-century Sienese image can be traced back as far as the Jasna Gora in 1382. Cf. W. Turczynski, *Conservation de l'image miraculeuse de ND de Czestochowa* (Czestochowa, 1948); Rothemund 1966 (3d ed., 1985, 2:338).
15. K. Stejskal, *Karl IV. und die Kultur und Kunst seiner Zeit* (Prague, 1978), 94, fig. on p. 91; Fröhlich 1967, 14ff. Cf. C. Janetschek, *Das Augustiner-Eremitenstift St. Thomas in Brünn* (Brno, 1898), 1:9 (on the donation), 240 (on the veiling of the image).
16. Chronicle of Benes of Weitmühl, *Fontes rerum Bohemicarum* 4 (Prague, 1884), 519 (on the year 1349); Anna Rozycka Bryzek, "L'immagine d'Odighitria di Czestochowa: Origini, culto, e la profanazione Ussita," *Arte cristiana* 724 (1988): 79ff.
17. J. Neuwirth, *Mittelalterliche Wandgemälde und Tafelbilder der Burg Karlstein in Böhmen* (Prague, 1896); V. Dvorakova and D. Menclova, *Karlstein* (Prague, 1965); K. H. Möseneder, "Lapides vivi," *Wiener Jahrbuch für Kunstgeschichte* 34 (1981): 39ff. The wooden panels (without canvas) measure 114 × 90 cm.
18. Document of 27 Mar. 1357; cf. Neuwirth (see n. 17 above), 105–6.
19. See chap. 15 n. 43.
20. E. G. Grimme, "Die 'Lukasmadonna' und das 'Brustkreuz Karls des Grossen,'" in *Miscellanea pro Arte. Festschrift H. Schnitzler* (Düsseldorf, 1965), 48ff.; Kalavrezou-Maxeiner 1985, 124 no. 32 pl. 9, measuring 5.5 × 4 cm.
21. E. G. Grimme, *Der Aachener Domschatz*, Aachener Kunstblätter 42 (Düsseldorf, 1972), nos. 82–84 and figs. 96–98. Within the casings with the coat of arms of Anjou, the three panels (each 52.5 × 42 cm) show the Virgin and Child (twice) and the Coronation of the Virgin.
22. Matejcek and Myslivec 1946, 6ff., and Matejcek and Pesina (see chap. 15 n. 43 above), fig. 278 with further details. The icon measures 41.5 × 29.5 cm.
23. Soteriou and Soteriou 1956–48, vol. 1, figs. 188–90; 2:171ff.; Weitzmann 1966, 66ff. with figs. 33–40. Also cf. Weitzmann 1982, 340–41.

24. Cf. Belting 1981a, 179–80, and chaps. 13–14 above.

25. See chap. 13 n. 79.

26. Weitzmann 1984, 149–50 with fig. 6; Garrison 1949, no. 113.

27. Cf. esp. Rizzi 1972, 250ff. The most important are the *Mesopanditissa* in S. Maria della Salute (in Venice in 1670) and a metal-encased icon of John Cantacuzenus (1380–83) in S. Samuele (from Nauplia to Venice in 1541). Cf. Grabar 1975, no. 30.

28. E. Carli, *Pittura medievale pisana* (Milan, 1958); idem, *Il museo di Pisa* (Pisa, 1974).

29. From the Orfanotrofio Maschile in Pisa, measuring 32.8 × 24.5 cm; cf. Rice 1959, 86–87 and pl. 189; V. Lasareff, "Duccio and Thirteenth Century Greek Icons," *Burlington Magazine* 59 (1931): 159–60; M. Chatzidakis, in Weitzmann, with Chatzidakis et al. 1965, pl. 35; *Splendeurs de Byzance* (catalog; Brussels, 1982), no. 4.

30. Rome, Tesoro di S. Pietro, measuring 49 × 74 cm, canvas on poplar wood; cf. G. Anicini, in *Rivista Archeologia Cristiana* 18 (1941): 141ff.; W. F. Volbach, in *Orientalia Cristiana Periodica* 7 (1941): 480ff.; A. M. Ammann, in ibid. 8 (1942): 457ff.; M. Tatić-Djurić, in *Zograph* 2 (1967): 11ff.; Weitzmann 1983, 26.

31. Rome, S. Croce di Gerusalemme, measuring 13 × 19 (23 × 28) cm. For referencnes, cf. C. Bertelli, "The Image of Pity in S. Croce in Gerusalemme," in *Essays in the History of Art Presented to R. Wittkower* (New York: Phaidon, 1967), 40ff.; Belting 1981a, 66–67 and 186–87. On the Sinai travelers, cf. M. Labib, *Pélerins et voyageurs au Mont Sinai* (Cairo, 1961).

32. *Mostra di opere d'arte restaurate nelle provincie de Siena e Grosseto* (catalog; Genoa, 1979), 104 no. 38 (Maria Bonfioli, 28 × 22 cm), and 0.H. van Os, *Sienese Altarpieces* (Groningen, 1984), 1:37 fig. 39; cf. V. Lusini, *La chiesa di S. Niccolo di Carmine in Siena* (Siena, 1907), and J. Cannon, "P. Lorenzetti and the History of the Carmelite Order," *Journal of the Warburg and Courtauld Institutes*, 1987, 18ff. and esp. 20.

33. E. Friedman, *The Latin Hermits of Mount Carmel* (Rome, 1979). Cf. references in Cannon (see n. 32 above), 20–21.

34. Cannon (see n. 32 above), 19–20, and *Capolavori e restauri* (catalog; Florence, 1986), no. 2 and pl. 27.

35. It measured 112 × 95 cm; cf. Garrison 1949, no. 117. For references, cf. Hueck 1970, 140ff. Also cf. C. Ricci, "La Madonna del Popolo di

Montefalco," *Bollettino d'arte* 4 (1924–25), 97ff.; P. Strieder, "Hans Holbein d. Ä. und die deutschen Wiederholungen des Gnadenbildes von S. Maria del Popolo," *Zeitschrift für Kunstgeschichte* 22 (1959): 252ff. The old cult legend is discussed in C. Huelsen, *Le chiese di Roma nel medioevo* (Florence, 1927), 151.

36. Ricci (see n. 35 above), 101 with plate.

37. Cf. n. 36.

38. On Antoniazzo and Bessarion, cf. G. Noehles, "Antoniazzo Romano" (diss. Münster, 1974), 20ff. and 25ff.

39. W. Buchowieski, *Handbuch der Kirchen Roms* (Vienna, 1967), 1:302. In 1500 the image was carried ceremonially in procession; cf. M. Armellini and C. Cecchelli, *Le chiese di Roma* (Rome, 1942), 2:1231–32. On the miracles during the plague in 1495, cf. Gaspare Pontani, "Diario romano," in L. M. Muratori, *Rerum Italicarum Scriptores*, n.s., 3.2 (Città di Castello, 1908), 49–50.

40. The image, measuring 125 × 85 cm, is now in a high altar of 1665 donated by F. Barberini the Elder. Bessarion found the icon in the narthex of the church in 1462. Pius II devoted some remarks to it in his *Commentarii*. For references, see A. Rocchi, *L'imagine di S. Maria di Grottaferrata* (Rome, 1887); Weitzmann 1966, 75 and fig. 52 (perhaps a Crusader icon); and Pace 1985, 265–66 (Cypriot).

41. Hueck 1967, 1ff.; H. van Os, "The Madonna and the Mystery Play," *Simiolus* 5 (1971): 5ff.; C. Belinati, *Il duomo di Padova e il suo battistero* (Trieste, 1979), 45 fig. 147. Giusto's replica is in the Sagrestia dei Canonici.

42. It measures 88 × 53 cm; cf. R. Zanocco, "Il vescovo Barozzi e la Madonna Costantinopolitana," *Bollettino diocesano di Padova* 19 (1934): 250ff.; A. Lazzarini, in *Feste cinquantenarie dell'incoronazione della Madonna Costantinopolitana* (Padua, 1960), 6; L. Lorenzoni, in *I Benedettini a Padova* (catalog; Padua, 1980), 361ff., no. 286. On S. Prodocimo and the chapel of St. Luke in the fifteenth century, cf. P. L. Zovatto et al., *La Basilica di S. Giustina* (Padua, 1970), 53ff.

43. Hueck 1967, 6, with quotations from Muratori, *Rerum Italicarum Scriptores* 24, p. xv.

44. C. Bertelli, "Zametki ob ikone Bogometeri . . . , in *Vizantije juznye Slavjane i drevnjaja Rus. Festschrift V. N. Lazarev* (Moscow, 1973), 415ff. (influential in classifying the work within art history), and M. Fanti, "La Madonna di S. Luca nella leggenda, nella storia, e nella tradizione Bolognese," *Carrobbio* 3 (1977): 179ff.

(important historical work). Also cf. Gottarelli 1976.

45. Cf. R. C. Trexler, *Public Life in Renaissance Florence* (New York, 1980), 63ff., 353ff., and pl. 6.

46. Savioli, *Annali Bolognesi* (Bassano, 1784), 1: 262, no. 173.

47. The new icon measured 48 × 36 cm; cf. G. Cicconi, "L'effigie de Marie Vergine detta comunemente Sacra Icona venerata in Fermo," *Voce delle Marche* 15 (1906): 8ff. and 17–18; C. Tomassini, "La città di Fermo e S. Giacomo della Marca," *Picenum seraphicum* 13 (1976): 171ff., esp. 181 and 198 with a reprint of the deed of gift of 1473. On S. Giacomo, cf. G. Caselli, *Studi su S. Giacomo d. M.* (Ascoli Piceno, 1926). See nn. 48–49 below.

48. Grabar 1975, no. 42 pl. 26.

49. Garrison 1949, no. 68; A. Valentini, *La pittura e Fermo . . . (Fermo, 1968)*, 49–50.

50. K. Algermissen et al., *Lexikon der Marienkunde* (Regensburg, 1957), 1:259ff.; G. Prampolini, *L'annunciazione nei pittori primitivi italiani* (Milan, 1939); M. Gössmann, *Die Verkündigung an Maria im dogmatischen Verständnis des Mittelalters* (Munich, 1957).

51. Cf. the retable by Lorenzo Veneziano in the Accademia in Venice (1371); cf. R. Pallucchini, *La pittura veneziana del trecento* (Venice, 1964), fig. 542.

52. Cf. Belting 1981a, 167ff. with figs. 59 and 62.

53. On Antonello's image in Munich, which is earlier than the version in Palermo, cf. *Antonello da Messina* (catalog; Rome, 1981), 148–49 no. 31, and F. Sricchia Santorio, *Antonello e l'Europa* (Milan, 1986), no. 24. The panel, measuring 42.5 × 32.8 cm, is thought to come from Padua.

Chapter 17

1. For references, see Hager 1962, 75ff.; Stubblebine 1966, 85ff.; and van Os 1984, passim. Also cf. Weitzmann 1966, 51ff.; Weitzmann 1984, 143ff.; Demus 1970, 205ff.

2. Pallucchini 1964, with relevant material.

3. Garrison 1949, passim.

4. Cf. E. B. Garrison, "Note on the Survival of the Thirteenth Century Panel Paintings in Italy," *Art Bulletin* 54 (1972): 140.

5. Garrison 1949, nos. 1–42, 175–203 (total 119), and Hager 1962, 118ff.

6. Garrison 1949, nos. 447–605 (total 158), and Hager 1962, 76ff.

7. See chap. 10 n. 15.

8. Garrison 1949, nos. 62–149, 170–74, 311–17, 630–52, etc. (total 135).

9. Cf. Hager 1962, passim; Belting 1981a, 25ff. and 199ff.; van Os 1984, passim.

10. Belting 1981a, 154ff. and 218ff.

11. Cleveland Museum of Art (formerly Brussels, Stoclet Collection); the icon measures 42 × 25.5 cm. Cf. Garrison 1949, no. 284, and Henry S. Francis, "The Stoclet Tabernacle," *Bulletin of the Cleveland Museum of Art* 54 (1967): 92ff. The work is now attributed to Berlinghiero in Lucca and dated ca. 1230. Cf. references on Lucca in n. 60 below.

12. Garrison 1949, no. 243 (each part measures 103 × 61 cm); cf. C. H. Weigelt 1928, 217–18; Hager 1962, 86–87; Belting 1981a, 204ff. and fig. 81; L. Marcucci, ed., *Gallerie Nazionali di Firenze: I dipinti toscani del secolo XIII* (Rome, 1965), 19 no. 4. The work originates from S. Chiara in Lucca and is attributed to Bonaventura Berlinghieri.

13. C. H. Weigelt 1928, 195ff.

14. Florence, Uffizi: Madonna Rucellai from S. Maria Novella of 1285, measuring 450 × 290 cm; cf. Garrison 1949, no. 186; White 1979, 32ff. and 185ff. (contract); Belting 1981a, 47–48; van Os 1984, 30ff.; Deuchler 1984, 32ff.; Cannon (see n. 18 below), 76–77; B. Cole, *Sienese Painting* (New York, 1980), 26.

15. Chap. 12 n. 37.

16. Cf. the corrections to Hager in the dissertation by Klaus Krüger, "Die frühen Altarbilder des Franziskus in Italien" (Munich, 1987), chaps. 2 and 3.

17. See n. 6 above and Carli 1958, figs. 1–31.

18. Pisa, Museo Nazionale: 195 × 340 cm, from S. Caterina; cf. E. Carli, *Il Museo di Pisa* (Pisa, 1974), no. 40; van Os 1984, 65ff.; Hager 1962, 114–15; and J. Cannon, "Simone Martini, the Dominicans, and the Early Sienese Polyptych," *Journal of the Warburg and Courtauld Institutes* 45 (1982): 69ff.

19. See n. 5 above; also cf. van Os 1984, 21ff.

20. See n. 14 above and, on the small Madonna, Belting-Ihm 1976, 68–69 (image type); White 1979, 46ff.; Deuchler 1984, 42ff. and figs. 42–43; and P. Torriti, *La Pinacoteca Nazionale di Siena* (Genoa, 1977), 1:48 no. 20.

21. M. Cämmerer-George, *Die Rahmung der toskanischen Altarbilder im Trecento* (Strasbourg, 1966).

22. On the two image types, cf. the detailed studies by Belting-Ihm 1976, passim, and Belting 1981a, passim. Also cf. P. Perdrizet, *La Vierge de la Miséricorde* (Paris, 1908).

23. Cf. the examples in Belting-Ihm 1976, pl. 1 (statutes of the Laudesi brothers of Bologna from 1329) and pl. 22b (altar of the order of St. Clare from Venice in Trieste, from about the same time); references are in Belting 1981a, 308.

24. Cf. Belting-Ihm 1976, pl. 24b (see n. 37 below), and Belting 1981a, fig. 8 (diptych in Karlsruhe).

25. Cf. Belting 1981a, 160ff.

26. Examples in ibid., 281–82 and 303 no. 4.

27. Belting 1985.

28. Belting-Ihm 1976, 70.

29. Bologna, Archiginnasio, Fondo Ospedale 3, MS N.52 fol. 1 (1329). Cf. Belting-Ihm 1976, 71, and Belting 1981a, 303 no. 4 (with references).

30. Examples are in Belting-Ihm 1976, 62ff.

31. Cf. the vision in the book of miracles of Caesarius of Heisterbach (*PL* 71, 713–14); Belting-Ihm 1976, 9.

32. See chap. 10 n. 54 (with references).

33. Belting-Ihm 1976, pl. 15b: "Virgo Dei, natum prece pulsa, terge reatum."

34. Examples are in ibid., 65 n. 19.

35. Ibid., pl. 23 and p. 66, n. 23, and W. Wolters (see chap. 10 n. 57).

36. Lange 1964, no. 6.

37. Venice, private collection, measuring 103 × 58 cm; cf. Pallucchini 1964, fig. 136, and Belting-Ihm 1976, 73 and pl. 24b.

38. Cf. the references in n. 6 and Hallensleben 1981, 7ff. On the relationship between West and East, cf. Demus 1970, 218, with examples of the influence of Byzantium on the facial types of the Crucified. Material on Giunta also appears in D. Campini, *Giunta Pisano Capitini e le croci dipinte romaniche* (Milan, 1966).

39. Hager 1962, 70 with n. 360. The earliest description is by Wadding (1625). Cf. H. Belting, *Die Oberkirche von S. Francesco in Assisi* (Berlin, 1977), 25, 43.

40. Belting 1981a, 20, with quotation from Theodoricus, *Libellus de locis sanctis.*

41. Garrison 1949, no. 459, and Hager 1962, 79 and 160.

42. Garrison 1949, no. 543, and Hager 1962, 75 and fig. 97. Also cf. references in n. 38 above. On the example in S. Raniero in Pisa (184 × 134 cm), cf. Carli (see n. 18 above), no. 25 pl. 4.

43. As in the cross in S. Paolo a Ripa d'Arno; cf. Carli 1958, figs. 38–39, and Carli (see n. 18 above), no. 26. On the change in function, cf. Hager 1962, 79–80.

44. Cf. the detailed discussion in Belting 1981a, 218ff., and Boskovits 1988, 93ff.

45. See chap. 19 n. 5.

46. Hager 1962, 83.

47. Belting 1981a, 96ff.

48. Thomas of Celano, *Tractatus de miraculis S. Francisci Assisiensis* 2.8, Legendae S.F.A. (1926–41), 275–76: "aliquam depictam habent iconam et illius imaginem quem specialiter venerantur."

49. See n. 11 above; the triptych, measuring 42 × 25.5 cm, is in the Cleveland Museum of Art.

50. One of the images (35 × 26 cm at the center), from the Pisan school, is in the Princeton University Art Museum; cf. Garrison 1949, no. 303, and Hager 1962, 82 fig. 109 (formerly Reder Collection). The other work (27 × 23 cm at the center), whose home is Florence, is now in Yale University, New Haven; cf. Garrison 1949, no. 330. Detailed discussion of the Pisan work appears in E. B. Garrison, in *Burlington Magazine* 89 (1947): 211–12.

51. Garrison 1949, nos. 272–73; Kermer 1967, n. 16; and Belting 1981a, 30ff. and figs. 2a–b (each 36 × 26 cm).

52. See chap. 2 n. 23.

53. This incorporation happens as early as the duecento in the Venetian diptych in Chicago (Kermer 1967, no. 69 fig. 88). On the theme, cf. J. T. Wollesen, in *Kunstchronik* 36 (1983): 28ff.

54. E. B. Garrison, "The Madonna di sotto gli organi," *Burlington Magazine* 89 (1947): 274–75 with pl. 1, and Hager 1962, 83–84 and fig. 101.

55. U. Procacci, "La pittura romanica pistoiese," in *Il romanico pistoiese* (Pistoia, 1966), 366 and fig. 20.

56. Garrison 1949, no. 608A, and *Mostra Giottesca* (catalog; Florence, 1937), no. 76A.

57. See n. 12 above.

58. W. Krönig, "Das Tafelbild der Hodegetria in Monreale," in *Miscellanea pro arte. Festschrift H. Schnitzler* (Düsseldorf, 1965), 179ff., pl. 94.

59. Ibid., pl. 95.3: "Sponsa sue prolis, stella puerpera solis, pro cunctis ora, sed plus pro rege labora."

60. Garrison 1949, no. 96; the Madonna, measuring 76 × 50 cm, is in the Metropolitan Museum, New York. Cf. Garrison (see n. 54 above), with pl., and Hager 1962, 81 and fig. 102; Stubblebine 1966, 89–90. On Lucchese

painting, cf. esp. E. B. Garrison, "A Berlinghier-esque Fresco in S. Stefano, Bologna," *Art Bulletin* 28 (1946): 211ff.

61. Belting 1981a, 143ff. with figs. 49–50 and list of monuments no. 19. On the large-format (115 × 77.5 cm), double-sided icon of the Virgin and the Suffering Christ, cf. *Affreschi e icone dalla Grecia* (catalog; Florence, 1986), nos. 27–28 with color plates.

62. The icon, from ca. 1200 in the Monastery of St. Catherine on Mount Sinai, measures 44.6 × 33 cm. It is frequently reproduced in the publications of K. Weitzmann (e.g. Weitzmann, with Chatzidakis et al. 1965, fig. 36).

63. See n. 13 above.

64. See n. 50 above. On the iconography of the Virgin of Tenderness, with many examples, cf. D. C. Shorr, *The Christ Child in Devotional Images in Italy during the Fourteenth Century* (New York, 1954), type 6.

65. Carli 1958, fig. 36 (Giunta's panel cross in Bologna). The motif is also found in the panel crosses in Assisi and Pisa (from S. Raniero; ibid., pl. 3 and fig. 32.

66. See n. 12 above.

67. Garrison 1949, no. 83, and *Mostra Giottesca* (see n. 56 above), no. 60. Supporting our position is Weigelt 1928, 217ff.

68. Belting 1981, 210–11 and fig. 83 (Archiginnasio, Fondo Ospedale 1, fol. 2). Statutes of the Devoti battuti di S. Maria della Vita (founded 1261) date from 1285.

69. See chap. 16 n. 26. On the type in Byzantium, see chaps. 13–14.

70. Perugia, Galleria Nazionale (32 × 24 cm); cf. F. Santi, ed., *Galleria Nazionale dell'Umbria* (Rome, 1969), no. 21 (Maestro della Maestà della Volte). On the type, cf. Shorr (see n. 64 above), type 7, with six examples. On the type in Byzantium, see chaps. 13–14.

71. Garrison 1949, no. 125 (78 × 49 cm); Carli 1958, fig. 83; van Os 1984, 37–38 and fig. 40. The relationship between this example in S. Maria del Carmine and that in the Fogg Art Museum in Cambridge, Massachusetts, needs further investigation; cf. Weigelt 1928, 195ff. and figs. 2 and 5.

72. On the type, cf. Shorr (see n. 64 above), type 6, Venice 3 (Florence, S. Maria Maggiore) and Verona 1 (Vatican). On the example in the Casa Horne (picture area 42 × 28 cm, frame 86 × 53.5 cm), cf. R. Longhi, in *Paragone* 5 (1950): 13ff.; F. Rossi, *Il Museo Horne di Firenze* (Milan, 1967), 136–37 and pl. 31.

73. A. Smart, "A Duccio Discovery," *Apollo,* Oct. 1984, 227ff. and pl. 1 (70 × 46 cm).

74. Siena, Museo dell'Opera del Duomo (89 × 60 cm). The icon is from S. Cecilia in Crevole but formerly was in the Eremo of Montespecchio; cf. White 1979, 23–24 and fig. 1; Deuchler 1984, 30 with figs. 28 and 29; Belting 1982a, 11 with fig. 7.

75. R. Koechlin, *Les ivoires gothiques français* (Paris, 1968), 2:2 no. 98.

76. Belting 1981a, 238–39.

77. H. Federmann, ed., *Jacopone da Todi. Lauden* (Cologne, 1967), 72ff. ("O Vergine più che femina").

78. H. Friedrich, *Epochen der italienischen Lyrik* (Frankfurt, 1964), 49ff.

79. Ibid.

80. Belting 1982a, 7ff. with color pl. 1.

81. Ibid., 11 with n. 14 and fig. 10.

82. Ibid., 17 with n. 33 and fig. 16.

83. See chap. 18 n. 41.

Chapter 18

1. Hager 1962, 59ff. and figs. 65–75 and 122–27.

2. References are in Krüger (see chap. 17 n. 16). They are found partly in the history of the titles of the large convent churches, which were mixed, in the arrangements for the feasts of the orders, and in the linking of the scenes with readings from the vita in the monks' choir. Stationary high-altarpieces of the Franciscans were of composite character, not limited to the order's founder. Cf. V. Facchinetti, *Iconografia francescana* (Milan, 1924); D. Blume, *Wandmalerei als Ordenspropaganda* (Worms, 1983), 9ff.; L. Bellosi, "La barba di S. Francesco," *Prospettiva* 22 (1980): 11ff. The most important studies so far are B. Bughetti, in *Archivum Franciscanum Historicum* 19 (1926): 636ff., and J. R. H. Moorman, in *Bulletin of the John Rylands Library* 27 (1943): 340ff.

3. On Simone Martini, see chap. 17 n. 18. On the panel of St. Catherine, cf. Garrison 1949, no. 399; Carli 1958, figs. 77–81; Hager 1962, 95ff.; Stubblebine 1966, 92; E. Carli (see chap. 17 n. 18), 41 no. 31 and pl. 6; Weitzmann 1984, 154–55.

4. See chap. 12 n. 113.

5. J. B. Supino, *Arte pisana* (Florence, 1904), 105ff.; A. Bellini-Pietri, *Guida di Pisa* (Pisa, 1913), 229ff.; G. Corallini, *La chiesa di S. Ca-*

terina in Pisa . . . (Pisa, n.d.). On the sermons and studies, cf. C. Fedeli, in *Memorie Domenicane* 39 (1922): 28ff., and J. Taurisani, ibid. 44 (1927): 178ff. I am indebted to K. Krüger for some of this information.

6. The only evidence of the panel is from S. Silvestro, given by A. da Morrona in 1792 (on S. Silvestro, cf. Bellini-Pietri [see n. 5 above], 246–47). However, a remark by Vasari on a work by Margaritone that was kept in S. Caterina may refer to it (*Vite* 1:365).

7. Garrison 1949, no. 408; Hager 1962, fig. 131; Carli 1958, figs. 45–51.

8. Garrison 1949, no. 402, and Hager 1962, 94ff. and figs. 128 and 130. The date 1228 in Boverio's engraving is not credible, for the panel in S. Miniato. Bonaventura Berlinghieri's panel in Pescia is dated 1235.

9. E.g. the formulation in a circular by Elias of Cortona, written in 1226 (*Analecta Franciscana* 10 [1941]: 526).

10. O. von Rieden, in *Collectanea Franciscana* 33 (1963): 210ff. In 1237 Gregory IX condemned the bishop of Olmütz for resisting the depiction of the stigmata. On the bleeding wounds, cf. the quotation in J. Gardner, "The Narrative Altarpiece," *Zeitschrift für Kunstgeschichte*, 1982, 222.

11. G. B. Ladner, "Das älteste Bild des heiligen Franziskus von Assisi," in *Festschrift P. E. Schramm*," (Wiesbaden, 1964), 449ff., esp. n. 35. Cf. J. R. H. Moorman, *The Sources of the Life of St. Francis of Assisi* (London, 1966).

12. M. M. Gauthier, *Les routes de la foi* (Fribourg, 1983), 183ff. no. 82, on the rotating reliquaries in the Louvre and the Musée de Cluny.

13. See n. 1 above.

14. Hager 1962, 93 and fig. 129.

15. See chap. 17 n. 16.

16. E.g., in Verona, S. Zeno; cf. A. Da Lisca, *La Basilica di S. Zenone in Verona* (Verona, 1956), 91–92 (though the attribution of the shrine is not certain).

17. Garrison 1949, nos. 1–8, 10–12, 16–25, 27–35 etc., 175–97, 207–34. The motif was taken over in antependia (ibid., nos. 360, 365–66, 377–78). Also cf. Hager 1962, figs. 144–46, 150, 176–77, 181–86, 195–202.

18. Cf. chap. 14d with fig. 36.

19. L. Striker, "Crusader Paintings in Constantinople," in Belting 1982b, 117ff., and Blume (see n. 2 above), 18ff. and 158–59.

20. *Acta Capitulorum Provincialium Provincia Romanae* (Rome, 1941), 7, with the request to introduce the feast and the image of the order's founder, and *Acta Capitulorum Generalium Ordinis Praedicatorum* (Rome, 1898), 1:70 and 81 (chapters of 1254 and 1256).

21. Garrison 1949, no. 405 (234 × 127 cm); Hager 1962, 94–95 and fig. 133; Blume (see n. 2 above), 13ff.; C. L. Ragghianti, *Pittura del duecento a Firenze* (Florence, 1955), passim; E. T. Prehn, *A Thirteenth Century Crucifix in the Uffizi and the Maestro del S. Francesco Bardi* (Edinburgh, 1958); idem, *Aspetti della pittura medioevale toscana* (Florence, 1976), 39ff., and A. Tartuffi, in *Castelnuovo*, 1985, 228–29.

22. References are in Krüger (see chap. 17 n. 16).

23. For references, cf. Hager 1962, 134ff. and 146ff.; van Os 1984, 21ff. Vasari mentions Cimabue's panels at SS. Trinità in Florence and S. Francesco in Pisa on the high altar.

24. See chap. 17 n. 14.

25. References are in Hager 1962, 118ff.; G. G. Meersseman, *Ordo fraternitatis*, 3 vols. (Rome, 1977); and Belting 1981a, 237–38. The Servites clearly evolved from the Laudesi brothers (ibid., with nn. 70 and 71).

26. G. Coor-Achenbach, "A Visual Basis for the Documents Relating to Coppo . . . ," *Art Bulletin* 28 (1946): 234–35; Hager 1962, 137–38; F. Bologna, *La pittura italiana delle origini* (Rome, 1962), pl. 62; van Os 1984, 22–23; B. Cole, *Sienese Painting* (New York, 1980), 8–9.

27. Hager 1962, 137; Bologna (see n. 26 above), pl. 64; M. Cordaro, in *Arte Medievale* 1 (1983): 273; and J. Polzer, in *Antichità viva* 23 (1984): 5ff.

28. Garrison 1949, no. 210. On the similar Madonna in the parish of Tressa, cf. P. Torriti, ed., *Opere d'arte restaurate nelle provincie die Siena e Grosseto* (catalog; Siena, 1979), 16.

29. Garrison 1949, nos. 215, 220–22; A. Tartuferi, in *Castelnuovo*, 1985, 228–29. Cf. Hager 1962, 126ff. and figs. 177–79. The images concerned are in Rovezzano, Greve in Chianti, the Acton Collection, and the Museo Bandini in Fiesole.

30. Hager 1962, 129–30; E. Carli, *Scultura lignea italiana* (Milan, 1960), 22–23; *Bildwerke der christlichen Epochen . . .* (catalog; Berlin, 1966), 53–54 no. 207; on its provenance from Borgo S. Sepolcro, cf. the study by M. Pericoli, *Frate Jacopone e un'antica statua della Madonna in Todi* (Todi, 1982), 23ff.

31. The relief is modeled in stucco on the wood panel. Cf. W. Paatz and E. Paatz, *Die Kirchen*

von Florenz (Frankfurt, 1952), 3:627 (on a possibility of an early link with the Carmelites, who may have brought it with them, cf. ibid., 2:217 n. 109). Also cf. G. Sinibaldi and G. Brunetti, eds., *Mostra Giottesca di Firenze* (Florence, 1937), no. 59; Hager 1962, 128–29; G. Coor, "Coppo di Marcovaldo," *Marsyas* 5 (1949): 8ff.; Weitzmann 1984, 151–52. Cf. Ragghianti (see n. 21 above). The church was a canons' foundation and was taken over by the Carmelites in 1521.

32. Hager 1962, 151, and van Os 1984, 12 and 14.

33. Krüger (see chap. 17 n. 16) presents a large collection of material in his dissertation and is producing another work on the subject. On the sculpture, cf. in general Carli (see n. 30 above), passim, with figs. 17–28 and pls. 1–3.

34. See n. 58 below on the curtain before the cult image of Or San Michele, Florence.

35. F. Santi (see chap. 17 n. 71), 37ff. no. 14; Hager 1962, 131; F. Todini, in *Castelnuovo*, 1985, 320–21. Also cf. Weitzmann 1966, 82. On an earlier triptych in S. Chiara in Assisi dating from 1265 and attributable to a Master Benvenuto of Foligno, cf. Garrison 1949, n. 325, and Todini, in *Castelnuovo*, 1985, 320. The triptych in Perugia might well originate from the convent of S. Francesco al Prato.

36. Coor-Achenbach (see n. 26 above), 241, with quotation from Fioravanti's *Vacchettone* (ca. 1600).

37. E. Carli, *La scultura lignea senese* (Milan, 1954), 135 and pl. 4, which is of a statue in the Abbazia di S. Antimo (Castelnuovo dell'Abbate). The statue is 152 cm high.

38. In general on the Madonna in the Siena cathedral, cf. Garrison 1955–62, 4:5ff.; Hager 1962, 106–7, 134ff., and 152–43; Stubblebine 1964, 72ff.; and van Os 1984, 11ff. and 17–18. On the Savior antependium, which has a date of 1215 and is regarded by van Os as belonging to the former choir altar, cf. P. Torriti, ed., *La Pinacoteca Nazionale di Siena: I dipinti dal XII al XV secolo* (Genoa, 1977), 20–21.

39. See n. 38 above.

40. Cf. the important study Stubblebine 1964, passim.

41. The present size is 140 × 97 cm; cf. ibid., 61ff. no. 5 and fig. 31 (with correction of the date 1262), and Hager 1962, 137 (with reference to the old position on the chapel altar). Also cf. Torriti (see n. 38 above), 22 no. 16; van Os 1984, 25; Cole (see n. 26 above), 5–6.

42. Stubblebine 1964, 64ff. no. 6 and fig. 32 (198 × 122 cm); E. Carli, *Dipinti senesi del contado*

e della maremma (Milan, 1955), 22–23; and Hager 1962, fig. 191. On the small-format (125 × 73 cm) replica in the Accademia in Florence, with intact pediment, cf. Stubblebine 1964, 76–77 no. 11 and fig. 39.

43. Stubblebine 1964, 30ff. no. 4 and figs. 14–19; Hager 1962, 137–38 and fig. 196; C. Ressort, ed., *Retables italiens du XIII^e au XV^e siècle* (catalog; Louvre, 1978), 7ff., esp. on the problem of the wings. Also cf. Bologna (see n. 26 above), pl. 63; Cole (see n. 26 above), 14; and Cannon (chap. 17 n. 18), 76.

44. London, Courtauld Institute (56 × 164 cm), and New Haven, Yale University Art Gallery (58 × 96.5 cm); cf. Stubblebine 1964, 81–82 and 91–92, figs. 44 and 52.

45. Chap. 17 n. 73.

46. Carli (see n. 42 above), 15ff. no. 2 and fig. 5 (170 × 134 cm); Stubblebine 1964, 104ff. no. 24 and fig. 60; Hager 1962, fig. 195; van Os 1984, 29–30. The newly introduced figures of the order, on whose rules the Dominicans based their constitution, are Augustine and St. Juliana of Imola (d. 1269).

47. B. Cole, "Old and New in the Early Trecento," *Mitteilungen des Kunsthistorischen Instituts in Florenz* 17 (1973): 229ff., and van Os 1984, 22–23.

48. Cf. most recently J. Gardner, *Guido da Siena* (1921), and Tommaso da Modena, in *Burlington Magazine* 21 (1979): 107ff. Cf. references in n. 43 above.

49. Chap. 17 n. 14.

50. Chap. 17 n. 20.

51. Belting-Ihm 1976, 68–69.

52. Weigelt 1928, 195ff.

53. On this motif, cf. Cimabue's frescoed Madonna in the lower church of S. Francesco in Assisi.

54. R. Davidson, *Forschungen zur Geschichte von Florenz* (Berlin, 1908), 4:453ff.; A. Cocchi, *Le chiese di Firenze* (Florence, 1903), 1:229 and 238 (on the curtain); Hager 1962, 144ff. and figs. 214–15.

55. Hager 1962, 146.

56. Deuchler 1984, 26 and 30.

57. For references, see n. 38 above.

58. Garrison 1949, nos. 357–79, and Hager 1962, 101ff.

59. Stubblebine 1964, no. 10 and figs. 37–38 (112 × 82 cm).

60. Van Os 1984, fig. 13.

61. Hager 1962, 109 and 156; van Os 1984, fig. 12. Cf. Carli (see chap. 17 n. 18), no. 36 and fig. 53.

62. Stubblebine 1964, no. 2 and fig. 7; Hager 1962, 111–12; Torriti (see n. 38 above), 26; White 1979, 68. The inscription, however, has the same wording as the inauthentic inscription on Guido's Madonna (see n. 48 above) and thus also refers back to earlier times that differ from the actual date. The panel measures 85 × 186 cm. Cf. dossal no. 6 in the Pinacoteca, Siena; Stubblebine 1964, no. 7 and fig. 33 (102 × 208 cm).

63. For references, see n. 41 above.

64. White 1979, 137ff., with fig. 104 (window), and van Os 1984, 77ff., on the four patrons. On the *Maestà* however, St. Victor replaces St. Bartholomew. The other three saints are Savinus, Ansanus, and Crescentius.

65. Hager 1962, 109–10; Carli 1958, figs. 56–58; Carli (see n. 61 above), no. 36 and fig. 53 (71 × 206 cm).

66. Chap. 2 n. 18 and chap. 12 n. 52, with references.

67. Chap. 12 n. 51.

68. See n. 6 above.

69. Hager 1962, 110, 112, and fig. 157.

70. Coor-Achenbach (see n. 26 above), 237–38.

71. Hager 1962, fig. 87.

72. Garrison 1949, 139 (mentioning a fifteenth-century source) and nos. 417–22 and 430–39; Hager 1962, 108ff.

73. Santi (see chap. 17 n. 71), 41 no. 15; Cämmerer-George (see chap. 17 n. 21), 140–41; J. White, in *Art Bulletin* 55 (1973): 548–49; Hager 1962, fig. 162.

74. See n. 43 above.

75. Cf. the retable of the Badia in the Uffizi (White 1979, 69).

76. Siena, Pinacoteca: Polyptych no. 28 (139 × 241 cm); cf. Torriti (see n. 38 above), 50; White 1979, 70–71; Cannon (see chap. 17 n. 18), 79; Deuchler 1984, 216 no. 11; van Os 1984, 37 and 63–64.

77. Garrison 1949, nos. 424–29 and 440–43; D. Gordon, "A Perugian Provenance for the Franciscan Double-sided Altarpiece by the Maestro di S. Francesco," *Burlington Magazine* 124 (1982): 70ff.

78. L. Tanfani-Centofanti, *Notizie di artisti tratti dei documenti pisani* (Pisa, 1897), 119ff.; Hager 1962, 113–14 with n. 94.

79. White 1979, 62ff. with fig. 31; Cannon (see n. 76 above), 80–81; Deuchler 1984, 209 no. 5; and van Os 1984, 34.

80. For references, see chap. 17 n. 18.

81. See n. 3 above.

82. See n. 61 above.

83. Detailed discussion appears in Cannon (see n. 76 above), passim.

84. Ibid., 82ff.

85. White 1979, 80ff.; E. Carli, *Il duomo di Siena* (Genoa, 1979); J. H. Stubblebine, *Duccio di Buoninsegna and His School* (Princeton, 1979), 31ff.; E. Carli, *La pittura senese del trecento* (Milan, 1981); Deuchler 1984, 26ff.; van Os 1984, 39ff.; H. Belting, "Das Werk im Kontext," in H. Belting et al., *Kunstgeschichte—Eine Einführung* (Berlin, 1986), 186ff.

86. M. Seidel, *Giovanni Pisano a Genova* (catalog; Siena, 1987), 179ff. (the Porta di S. Raniero), with reconstruction shown in fig. 143.

87. M. Seidel, "Ubera Matris," *Städel-Jahrbuch* 6 (1977): 96 n. 243; A. Middeldorf-Kosegarten, *Sienesische Bildhauer am Duomo Vecchio* (Munich, 1984), 77ff.

88. E. Carli, *L'arte a Massa Marittima* (Siena, 1976); van Os 1984, 56–57.

89. J. Gardner, "The Stefaneschi Altarpiece," *Journal of the Warburg and Courtauld Institutes* 37 (1974): 57ff.

90. See n. 38 above.

91. White 1979, 137ff. with fig. 104.

92. Polytychon no. 47 in the Pinacoteca, Siena, measuring 184 × 257 cm; cf. Torriti (see n. 38 above), 52–53; White 1979, 70ff.; Deuchler 1984, 216; van Os 1984, 64–65.

93. J. H. Stubblebine, "Duccio's Maestà of 1302 for the Chapel of the Nove," *Art Quarterly* 35 (1972): 239ff.; Deuchler 1984, 26–27.

94. White 1979, 195 no. 31.

95. Ibid., 192 no. 28.

96. See n. 94 above.

97. L. A. Muratori, *Rerum Italicarum Scriptores* 15.6 (Bologna, 1931), 90. Cf. White 1979, 96–97, and van Os 1984, 39–40.

98. Van Os 1984, 55.

99. "Mater Sancta Dei, sis causa Senis requiei, sis Duccio vita te quia pinxit ita."

Chapter 19

1. Belting 1981a.

2. J. Stelzenberger, *Die Mystik des Joh. Gerson* (Breslau, 1928), 71ff.; H. S. Denifle, *Die deutschen Mystiker des 14. Jahrhunderts* (Fribourg, 1951); H. Grundmann, *Religiöse Bewegungen im Mittelalter,* 2d ed. (Darmstadt, 1961); *Mystik am Oberrhein und in benachbarten Gebieten* (catalog; Freiburg im Breisgau: Augustinermuseum, 1978), with contributions by A. M. Haas, W. Blank, and E. M.

Vetter; Körner 1979, 43–44, with references to J. Gerson and Tauber.

3. A. Vauchez, *La sainteté en Occident aux derniers siècles du Moyen Age* (Rome, 1981), 247ff. and 435ff.

4. J. Sauer, in *Festschrift F. Schneider* (Freiburg im Breisgau, 1951), 339ff., and Meiss 1951, 107ff.

5. For new insight, cf. K. Krüger, in H. Belting and D. Blume, eds., *Die Argumentation der Bilder* (Munich, 1989).

6. Belting 1981a, 93–94, with further references. Cf. Ringbom 1965, 30ff., A. L. Mayer, "Die Liturgie und der Geist der Gotik," *Jahrbuch für Literaturwissenschaft* 6 (1926): 93ff.; and F. X. Haimerl, *Mittelalterliche Frömmigkeit im Spiegel der Gebetbuchliteratur Süddeutschlands* (Munich, 1952).

7. I. Ragusa and R. B. Green, *Meditations on the Life of Christ* (Princeton, 1961). On the later development, cf. Baxandall 1977, 60ff., and Belting 1981a, 77–78 and 82. The genre culminates in Ludolf of Saxony and Thomas à Kempis.

8. The "triplex ratio" of the image begins with Gregory the Great and is extended by the Scholastic movement. It remains unchanged until the Renaissance and the classical argument for images; cf. Baxandall 1977, 55ff., and Belting 1981a, 18–19.

9. E. Benz, *Die Vision. Erfahrungsformen und Bilderwelt* (Stuttgart, 1969).

10. London, British Library, Codex Add. 39842, fol. 28; cf. G. Vitzthum, *Die Pariser Miniaturmalerei* (Leipzig, 1908), 224ff.

11. Further references are in Belting 1981a.

12. Frey 1946, 107ff., and esp. 118ff. The earlier studies are by Georg Dehio, Wilhelm Pinder, and Julius Baum. Cf. the valuable dissertation by K. H. Blei, "Neue Bildkonzeptionen der deutschen Plastik um 1300 und ihr Kontext" (Munich, 1983), with research history.

13. K. Bücher, *Die Frauenfrage im Mittelalter* (Tübingen, 1910); Grundmann (see n. 2 above); H. Wilms, *Geschichte der deutschen Dominikanerinnen* (Dülmen, 1920); O. Decker, *Die Stellung des Predigerordens zu den Dominikanerinnen* (Vechta, 1935); W. Blank, in 1978 Freiburg catalog (see n. 2 above), 25ff.; J. Quint, *Meister Eckehart. Deutsche Predigten und Traktate* (Munich, 1963).

14. A. Birlinger, "Leben heiliger alemannischer Frauen im Mittelalter V: Die Nonnen von S. Katharinental," *Alemannia* 15 (1887): 152ff. On the history of the monastery, cf. Hausherr 1975,

79ff. and esp. 82 and n. 23, which also contains the quotation on Meister Heinrich. On the group in Antwerp, cf. J. de Coo, *Museum Mayer van den Berg* (catalog; Antwerp, 1969) 2:87ff. On the group in New York, cf. I. Futterer, *Gotische Bildwerke der deutschen Schweiz* (Augsburg, 1930), 60ff. and no. 76. On the theme in general, cf. the work by K. H. Blei mentioned in n. 12 above.

15. Cf. the vitae of local nuns edited by Birlinger (see n. 14 above).

16. Cf. the vita of Adelheit Pfefferhartin, ca. 1340 (Birlinger [see n. 14 above], 152). Also on this theme, cf. W. Blank, "Dominikanische Frauenmystik und die Entstehung des Andachtsbildes um 1300," *Alemannisches Jahrbuch,* 1964–65, 61ff.

17. Frey 1946, 124–25, with quotations from P. Strauch, *Margarethe Ebner und Heinrich von Nördlingen* (Freiburg and Tübingen, 1882), 21 and 87ff.

18. Cf. Delogu Ventroni, *Barna da Siena* (Pisa, 1972), pl. 70.

19. Belting 1981a, 96.

20. On Lorenzetti's fresco, cf. Belting 1987b, 104, and J. Poeschke, *Die Kirche S. Francesco in Assisi und ihre Wandmalereien* (Munich, 1985), 111 and pl. 259.

21. Jacopo Passavanti, *Lo specchio della vera penitenza* (Florence, 1725), 54–55. On the Virgin's miracles, see chap. 14 n. 50.

22. Cf. Petrarch's will; H. W. Eppelsheimer, ed., *Petrarca. Dichtungen, Briefe, Schriften* (Frankfurt, 1956), 188.

23. Belting 1981a, 47, 95, and 282 with examples. On the special characteristics of the *ouvrage,* cf. Meiss 1967, 41–42.

24. Pächt 1961, 402ff. and fig. 29.

25. On Siena, cf. Vauchez (see n. 3 above), 106 with n. 23. On the panel by Simone in the Pinacoteca in Bologna, cf. Pächt 1961, fig. 28, and F. Arcangeli, *Pittura bolognese del '300* (Bologna, 1978), 200–201.

26. New York, Metropolitan Museum of Art. The panel, measuring 58.5 × 39.2, is reproduced in color in Christie's sales catalog *Forthcoming Sales, November–December 1982.*

27. Meiss 1967, 280 and fig. 832. On Malouel, cf. also *Europäische Kunst um 1400* (catalog; Vienna, 1962), no. 19, and G. Troescher, *Burgundische Malerei* (Berlin, 1966), 67ff. The tondo has a diameter of 64.5 cm.

28. New York, Metropolitan Museum of Art, inv. 17.190.913.

29. D. Miner, in *Art News* 64.10 (1966): 41ff. Cf. Belting 1987b, 160.
30. Meiss 1967, 132, 142, and fig. 572. Cf. T. Müller and E. Steingräber, "Die französische Goldenmailplastik um 1400," *Münchner Jahrbuch der bildenden Kunst 5* (1954): 48 and 72, and Belting 1981a, 115.
31. On the theme generally, cf. Meiss 1967, 40–41, 48–49, 50–51. On Louis of Orléans's inventory, cf. H. Moranvillé, *Inventaire de l'orfèvrerie et des joyaux de Louis I, duc d'Anjou* (Paris, 1906). See n. 33 below.
32. Cf. the scholarly editions by Millard Meiss.
33. J. Guiffrey, *Inventaire de Jean duc de Berry*, 2 vols. (Paris, 1894–96); B. Prost, *Inventaires . . . des ducs de Bourgogne*, 2 vols. (Paris, 1902–13); and Troescher (see n. 27 above), 91ff.
34. Cf. M. Warnke, *Der Hofkünstler* (Cologne, 1985).
35. P. Heitz, *Neujahrswünsche des 15. Jahrhunderts* (Strasbourg, 1909).
36. Cf. the history of research in Körner 1979, 11ff.
37. On the "small devotional image," cf. Spamer 1930. On the finds in Wienhausen (e.g., pilgrims' emblems of the Veronica on parchment), cf. H. Appuhn, *Der Fund vom Nonnenchor* (Wienhausen, 1973).
38. Cf. Körner 1979, 39ff. with further references, and E. Mitsch, in *Europäischer Kunst* (see n. 27 above), 280ff., and *Fifteenth Century Woodcuts and Metalcuts* (catalog; Washington, D.C., n.d.), with the rich material of the Rosenwald Collection.
39. A more complex view is in Körner 1979, 32ff. Also cf. P. Kristeller, *Kupferstich und Holzschnitt in vier Jahrhunderten*, 2d ed. (Berlin, 1921), and H. Bewers, introduction to *Meister E.S.* (catalog; Munich and Berlin, 1987), 7ff.
40. E.g., the E.S. Master and the Banderol Master; cf. M. Lehrs, *Geschichte und kritischer Katalog des deutschen, niederländischen, und französischen Kupferstichs im 15. Jahrhundert* (1908ff.), no. 186 and no. 83. Numerous references are in Bewers (see n. 39 above).
41. E.g., in Petrus Christus; cf. Belting 1981a, 93 with fig. 26. On the other functions mentioned, cf. G. Gugitz, *Das kleine Andachtsbild in den österreichischen Gnadenstätten* (Vienna, 1950), n. 4C (regarding indulgence in the diocese of Seckan in 1442), and Körner 1979, 34–35.
42. Körner 1979, 85 and fig. 7.
43. On this theme, cf. O. Ringholz, *Wallfahrtsgeschichte Unserer Lieben Frau von Einsiedeln* (Freiburg im Breisgau, 1896). The three sheets (Lehrs nos. 68, 72, 81) are now reproduced in A. H. Mayor, ed., *Late Gothic Engravings of Germany and the Netherlands* (New York, 1969), figs. 218–20, and Bewers (see n. 39 above), nos. 31–33.
44. Lehrs no. 143 and Mayor (see n. 43 above), fig. 208.
45. Lehrs no. 73 and Bewers (see n. 39 above), no. 35.
46. Lehrs no. 174 and Bewers (see n. 39 above), no. 84. On the other sheet, with Peter and Paul, cf. Lehrs no. 190 and Bewers (see n. 39 above), no. 85.
47. On the "Veronica Master," cf. *Vor Stefan Lochner* (catalog; Cologne, 1974), 36ff. (F. G. Zehnder), and no. 17 (London, National Gallery).
48. On Hans Memling's diptych, cf. M. Corti, *L'opera completa di Memling*, Classici dell'Arte (1969), no. 59; A. Zöller, *Hans Menling* (Seligenstadt, 1983), color pls. 24–25; and Kermer 1967, no. 139.
49. H. Belting and D. Eichberger, *Jan van Eyck als Erzähler* (Worms, 1983), 95–96, with further references.
50. On the Nieuwenhove diptych, cf. Corti (see n. 48 above), no. 13; Zöller (see n. 48 above), figs. 18–19. Also cf. Bäumler, "Studien zum Adorationsdiptychon" (diss. Munich, 1983), 171ff. no. 13, and A. Rooch, *Stifterbilder in Flandern und Brabant* (Essen, 1988), 213ff.
51. Cf. Belting 1987b, 168–69, which defines the portrait.
52. A survey of the new functions of panel painting appears in Belting 1987b, 128ff., and Belting 1981a, 69ff.
53. I. Bähr, "Aussagen zur Funktion . . . von Kunstwerken in einem Pariser Reliquienprozeß d. J. 1410," *Wallraf-Richartz-Jahrbuch* 45 (1984): 41ff.
54. Decker 1985, 114ff. and 128ff.
55. Ibid., 134–35.
56. W. Pinder, "Zum Problem der 'Schönen Madonnen' um 1400," *Jahrbuch der preußischen Kunstsammlungen* (1923), 147ff. (on re-Gothicization); *Schöne Madonnen, 1350–1450* (catalog; Salzburg, 1965); K. H. Clasen, *Der Meister der Schönen Madonnen* (Berlin, 1974), with a history of research (1ff.) and information on the Thorner Madonna (34ff.); H. Beck, V. Beeh, and H. Bredekamp, in *Kunst um 1400 am*

Mittelrhein (catalog; Frankfurt, 1976), 4ff.; and J. Homolka, in *Die Parler und der Schöne Stil, 1350–1400* (catalog; Cologne, 1978), 2:515 (also on the Thorner Madonna).

57. W. Beeh, "Das gotische Vesperbild in der Frankfurter Liebfrauenkirche," *Kunst in Hessen und am Mittelrhein* 5 (1965): 11ff.

58. J. Homolka (see n. 56 above), 3:39; G. Schmidt, in *Gotik in Böhmen,* ed. K. M. Swoboda (Munich, 1969), 226, 242, and fig. 157.

59. R. Fritz, "Das Halbfigurenbild in der westdeutschen Tafelmalerei um 1400," *Zeitschrift für Kunstgeschichte* 5 (1951): 161ff. and fig. 1.

60. J. Puraye, "L'icône byzantine de la cathédrale St. Paul à Liège," *Revue belge d'archéologie et d'histoire de l'art* 9.3 (1939): 193ff.; Grabar 1975, no. 36; and *Splendeur de Byzance* (catalog; Brussels, 1982), no. IC7. The panel measures 34.5 × 29 cm.

61. The panel measures 35 × 26.5 cm. The most important study is P. Rolland, "La Madonne italo-byzantine de Frasnes-les-Buissenal," *Revue belge d'archéologie et d'histoire de l'art* 17 (1947–48): 97ff.; cf. R. Offner, *A critical and historical corpus of Florentine painting* 3.5 (New York, 1947), 56 n. 2 (a stylistic analysis of the panel); D. C. Schorr, *The Devotional Image in Italy during the Fourteenth Century* (New York, 1954), 53 (on Italian examples of the type); M. J. Friedländer, "Über den Zwang zur ikonographischen Tradition in der flämischen Kunst," *Art Quarterly* 1 (1938): 19ff. (on the copies and the example in Kansas City); R. Faille, *Le culte de Notre-Dame de Grâce* (Cambrai, 1971); Kolb 1968, 86; see n. 62 below.

62. G. Passavant, "Zu einigen toskanischen Terrakotta-Madonnen der Frührenaissance," in *Mitteilungen des Florentiner Instituts für Kunstgeschichte* (1988).

63. Sources are in Rolland (see n. 61 above), 99ff. On the copy in Kansas City, cf. Friedländer (see n. 61 above) and E. Panofsky, *Early Netherlandish Painting* (Cambridge, Mass., Harvard University, 1953), 279–80.

64. M. Davies, *Rogier van der Weyden* (London, 1972), 216–17 and fig. 84.

65. G. Noehles, "Studien zur Quattrocentomalerei in Rom" (diss. Münster, 1974), no. 85 and pp. 25ff.; G. S. Hesberg, *A. Romano and His School* (New York, 1980).

66. E. Müntz, in *Gazette des Beaux-Arts* 16 (1877): 98ff.

67. F. Negri Arnoldi, "Madonne giovanilli di A. Romano," *Commentari* 15 (1964): 202ff.;

Noehles (see n. 65 above), nos. 26–39, 78–79, and doc. no. 56; A. Cavallaro, "A. Romano e le confraternite del quattrocento a Roma," *Ricerche per la storia religiosa di Roma* 5 (1984): 335ff. (with specific evidence of the painter's offices, and 346 and fig. 3 on the Virgin panel in S. Lucia del Gonfalone).

68. A. Schmarsow, "Un dipinto di A. Romano a Madrid," *L'Arte* 14 (1911): 118–19; M. Fagiolo and M. L. Madonna (see chap. 11 n. 2), 346; and Cavallaro (see n. 67 above), 347. The dimensions are 94 × 66 cm (or 33 cm each panel).

69. E. D. Howe, "A. Romano, the 'Golden Legend,' and a Madonna of S. Maria Maggiore," *Burlington Magazine* 126, no. 976 (1984): 417–18.

70. Braun 1924. Also cf. the following notes.

71. Cf., with good examples, M. M. Gauthier, "Du tabernacle au retable," *Revue de l'art* 41 (1978): 23ff.

72. Mansi 1901, 23: 791–92. Also cf. M. Hasse, *Der Flügelaltar,* 9th ed. (Dresden, 1941).

73. J. Formigé, *L'abbaye royale de St. Denis* (Paris, 1960), 120ff. with examples from individual chapels. Our example (Cliché des Archives Photographiques der Caisse Nationale des Monuments Historiques, no. MH 167211, in Paris), from a drawing by Percier (Cabinet d'Estampes), comes from the chapel of St. Romain-de-Blaye (Formigé, *L'abbaye royal de St. Denis,* 145–46).

74. E. W. Tristram, *English Medieval Wall Painting: The Thirteenth Century* (Oxford, 1950), 121ff. and pl. 7; F. Wormald, in *Proceedings of the British Academy* 35 (1949): 165–66; and H. Belting, *Die Oberkirche von S. Francesco in Assisi* (Berlin, 1977), 188–89.

75. L. Lefrançois-Pillion, "L'église de St-Thibaut-en-Auxois . . . ," *Gazette des Beaux-Arts* 1 (1922): 137ff. Cf. P. Quarré, "Le portail de St.-Thibaut . . . ," *Bulletin monumental* 123 (1965): 181ff.

76. Frankfurt 1976 (see n. 56 above), 136ff. no. 39. Cf. E. zu Solms-Laubach, "Der Altenberger Altar," *Städel-Jahrbuch* 5 (1926): 33ff.

77. E. Trier, "Der St. Ursula-Altar in Marienstatt," *Marienstätter gesammelte Aufsätze,* 1962, 29ff.; D. L. Ehresmann, "Some Observations on the Role of Liturgy in the Early Winged Altarpiece," *Art Bulletin,* 1982, 359ff. and 364.

78. Decker 1985, 65–66, 81, and 113.

79. Cf. H. Keller, "Der Flügelaltar als Reliquienschrein," in *Festschrift Theodor Müller* (Berlin, 1965), 125ff.

80. Cf. a recent study by Ehresmann (see n. 77 above).

81. E.g., Decker 1985, 70 and 80ff.

82. Cf. ibid., 64 and 91, but in a different sense.

83. Baxandall 1980, 62ff. and 83ff.; Decker 1985, 170.

84. G. Lill, *Hans Leinberger* (Munich, 1942); A. Schädler, "Zur künstlerischen Entwicklung Hans Leinbergers," *Münchner Jahrbuch der bildenden Kunst* 28 (1977): 59ff.; Baxandall 1980, 311–12; and Decker 1985, 213–50.

85. Decker 1985, 250 and 262.

86. C. Altgraf zu Salm, "Neue Forschungen zur Schönen Madonna von Regensburg," *Münchner Jahrbuch der bildenden Kunst* 12 (1962): 49ff.; G. Stahl, "Die Wallfahrt zur Schönen Maria in Regensburg," in *Beiträge zur Geschichte des Bistums Regensburg,* ed. G. Schwaiger and J. Staber (1968), 2:35ff.; A. Hubel, "Die Schöne Maria von Regensburg," in *850 Jahre Kollegiatstift zu den hll. Johannes Baptist und Evangelist in Regensburg,* ed. P. Mai (Munich, 1977); F. Winzinger, "A. Altdorfer," *Münchner Jahrbuch der bildenden Kunst* 25 (1975): 31ff.; Baxandall 1980, 83ff.; Decker 1985, 261ff.

87. Chap. 16b with n. 22.

88. Veste Coburg, Kupferstichkabinett (63.5 × 39.1 cm); cf. Decker 1985, fig. 121.

89. Hamburg 1983, 135.

90. R. Fritz (see n. 59 above), 167 and fig. 6; Altgraf zu Salm (see n. 86 above).

91. See n. 61 above.

92. Decker 1985 has an illustration of this work.

Chapter 20

1. E.g., W. Hofmann in Hamburg 1983, 23ff., with arguments that need further discussion.

2. H. Sedlmayr, *Verlust der Mitte* (Salzburg, 1948).

3. Cf. M. Baxandall 1980, 51ff., with copious quotations.

4. Select references are in Garside 1966, 146ff.; Warnke 1973b, 65ff.; Bredekamp 1975, 231ff. (on the Hussites); Freedberg 1977, 165ff.; Baxandall 1980, 69ff.; Michalski 1984, 70ff.; S. Michalski, *Das Phänomen Bildersturm. Versuch einer Übersicht* (in press). Cf. Phillips 1973; Freedberg 1985; Freedberg 1986, 69ff.

5. *Invokavitpredigten* no. 3 (1522), in Weimar Edition, vol. 10.3, 31f.

6. Warnke 1973, 65ff. with all examples (esp. 80ff.).

7. C. Martin, *St. Pierre, Cathédrale de Genève* (Geneva, 1910), 164–64. The panel was installed in the cathedral in 1835. There was a stone inscription with the same wording in the town wall by the Porte de la Corraterie.

8. Quoted from P. Schmerz and H. D. Schmid, *Reutlingen. Aus der Geschichte einer Stadt* (Reutlingen, 1973), 108. I am indebted to S. Michalski for this quotation.

9. Cf. Lucas of Leyden's engraving of 1514, in Hamburg 1983, no. 9. The catalog contains further illustrations of image breaking and of the idolatry in question (nos. 10–19).

10. See n. 5 above.

11. Nuremberg, Germanisches Nationalmuseum, inv. H 7404. Cf. Hamburg 1983, no. 1; Nuremberg 1983, no. 515; Baxandall 1980, 79ff.

12. Strasbourg, Archives Municipales 5.1, no. 12; Nuremberg 1983, no. 514, and C. C. Christensen, *Art and the Reformation in Germany* (Ohio University Press, 1979), 166–67, containing examples of the situation in Nuremberg.

13. Weimar Edition, vol. 30.1, 224; vol. 51.11, 29ff. (sermon in 1545 on Ps. 8.3), and Table Talk, ibid., vol. 9, no. 6734. On Luther's theology as regards our argument, cf. references in text 40.

14. Panofsky 1969, 216; the letter is in the Oxford complete edition of Erasmus's correspondence, ed. P. S. Allen, vol. 4, no. 1107.7.

15. D. Koepplin and T. Falk, *Lucas Cranach* (Basel, 1974), no. 35. Cf. M. Warnke, *Cranachs Luther* (Frankfurt, 1984), in the "Kunststück" series.

16. A. Bartsch, *Le Peintre-Graveur* 7 (Vienna, 1808), no. 107; *The Illustrated Bartsch* 10, ed. W. L. Strauss (New York, 1981), no. 107; E. Panofsky, *A Dürer,* 2d ed. (Princeton, 1948), 239 and no. 214; Nuremberg 1983, no. 155.

17. Landesbibliothek Gotha, MSA 233, fols. 12–17; F. J. Stopp, "Verbum Domini manet in aeternum: The Dissemination of a Reformation Slogan," in *Essays in German Language, Culture, and Society,* ed. S. S. Prawer (London, 1969), 123ff. and 125.

18. The Dinkelsbühl panel measures 95 × 160 cm; cf. C. Bürckstürmer, *Geschichte der Reformation und Gegenreformation in der ehem. Freien Reichsstadt Dinkelsbühl* (Dinkelsbühl, 1914), 1:65ff.; Schuster 1983, 116 fig. 3; Nuremberg 1983, no. 540.

19. Karel van Mander, *Schilderboeck* (Alkmaar, 1604), fol. 204. Cf. Freedberg 1977, 174.

20. G. Ebeling, "Erwägungen zur Lehre vom Gesetz," in idem, *Wort Glaube,* 2d ed. (1958), 255–56; F. Ohly, "Gesetz und Evangelium,"

in *Schriftenreihe der Westfälischen Wilhelms-Universität Münster*, n.s., 1 (Münster, 1958); W. Joest, *Gesetz und Freiheit* (Göttingen, 1951).

21. Koepplin and Falk (see n. 15 above), 2:505ff., nos. 353–56; J. Wirth, "Le dogme en image: Luther et l'iconographie," *Revue de l'art* 52 (1981): 18; P. K. Schuster, in Hamburg 1983, 333ff. and 356, nos. 474 and 538. See n. 22 below.

22. Luther, *Kirchenpostille*, sermon on the feast of John the Baptist (1522), in Weimar Edition, vol. 10.3, 205ff., quoted by O. Thulin, *Cranach-Altäre der Reformation* (Berlin, 1955), 126ff., with further elaboration on the theme.

23. Thulin (see n. 22 above), 9ff. On the predella, cf. the contemporaneous woodcut by Cranach the Younger of 1546 (Hamburg 1983, no. 69).

24. H. J. Krause, "Zur Ikonographie der protestantischen Schlosskapellen des 16. Jahrhunderts," in *Kunst und Reformation. Kolloquium des C.I.H.A. in Eisenach* (Berlin, 1983), 395ff.; cf. idem, *Sächsische Schloßkapellen der Renaissance* (Berlin, 1982). On the pulpit the true cult of Elijah and the false cult of the priests of Baal was painted *in tabula*. A bronze inscription records the date of consecration. A retable with the Last Supper was added to the altar table only in 1545. Five small paintings with subjects from the Passion and Last Judgment, like the Passion reliefs on the portal, served to "remind and admonish us about the suffering and wounds of Christ," as Luther was apt to put it.

25. Luther, Table Talk, Weimar Edition, no. 4.4787. Cf. Thulin (see n. 22 above), 150.

26. Text 42C; H. Rupprich, *Dürer. Schriftlicher Nachlass* (Berlin, 1956), 1:43 no. 2.

27. Rupprich (see n. 26), 165.

28. Belting 1985, 31ff., with further references.

29. M. Kemp, "From Mimesis to 'Fantasia': The Quattrocento Vocabulary of Creation, Inspiration, and Genius in the Visual Arts," *Viator* 8 (1977): 347ff.

30. *Prediche sopra Ezechiele*, ed. R. Ridolfi (Rome, 1955), 1:343. Cf. R. M. Steinberg, *Fra Girolamo Savonarola: Florentine Art and Renaissance Historiography* (Athens, Ohio, 1976), 48.

31. Vasari, *Le vite*, ed. G. Milanesi (Florence, 1906), 4:383.

32. Leonardo da Vinci, "Trattato della pittura," in *The Literary Works of Leonardo da Vinci*, ed. J. P. Richter (London, 1883; 3d ed., 1970), 1:33, 35.

33. Vasari, (see n. 31 above), 7:437.

34. *Prediche italiane ai Fiorentini*, ed. F. Cognasso, (Perugia, n.d.), 2:161–62.

35. Vasari (see n. 31 above), 7:437.

36. On the Dürer quotation, see n. 26 above. On Bellini's Madonna, cf. H. Belting, "Die gemalte Natur," in *Kunst um 1800 und die Folgen. W. Hofmann zu Ehren* (Munich, 1988), 175 and fig. 2. The painting in the National Gallery is represented throughout the Bellini literature.

37. L. Baldass, *Joos van Cleve, der Meister des Todes Mariä* (Vienna, 1925), 18 and fig. 188. The image comes from the Spiridon Collection in Paris. Cf. K. Baetjer, *European Paintings in the Metropolitan Museum of Art* (New York, 1980), 3:355, no. 32.100.57.

38. Augustine, *De diversis quaestionibus* 83, qu. 74 (*PL* 40, 85). Cf. Düring 1952, 38ff. I am indebted to V. Stoichita for this reference.

39. Leipzig, Museum der bildenden Künste, Graphische Sammlung, inv. N.I.8492: *Kunst der Reformationszeit* (catalog; Berlin, 1983), no. B 65.

40. Rupprich (see n. 26 above), 168.

41. On J. van Scorel, cf. M. J. Friedländer, *Early Netherlandish Painting*, vol. 12 (Leiden, 1975); *Jan van Scorel* (catalog), ed. J. A. L. de Meyere (Utrecht, 1981), with further references. On fig. 288, cf. W. Braunfels et al., *Pintura extranjera* (catalog; Madrid: Prado, 1980), 64 (inv. 2.716, Legado Pablo Bosch, no. 74). On the practice of replicating early Netherlandish painters, cf. L. Silver, "Fountain and Source: A Rediscovered Eyckian Icon," *Pantheon* 41 (1983): 95ff.

42. Kraut 1986, 80ff. Cf. R. Grosshanss, *M. van Heemskerck. Die Gemälde* (Berlin, 1980), 195, and catalog of a 1974 Rennes exhibition (*Le dossier d'un tableau. St-Luc peignant la Vierge de M. van Heemskerck*).

43. Cf. F. Haskell, *Taste and the Antique* (New Haven, 1981).

44. On the history of the reception of the *Sistine Madonna*, cf. E. Schaeffer, *Raffaels Sixtinische Madonna im Erlebnis der Nachwelt* (Leipzig, 1927); M. Putscher, *Die Sixtinische Madonna. Das Werk und seine Wirkung* (Tübingen, 1955); and M. Ebhardt, *Die Deutung der Werke Raffaels in der deutschen Kunstliteratur von Klassik und Romantik* (Baden-Baden, 1972). See n. 48 below with new references.

45. F. Schlegel, "Die Gemälde," in *Athenäum*, Rowohlts Klassiker, Deutsche Literatur (Hamburg, 1969; orig. ed., 1799), 2:55ff.

46. On Wackenroder, cf. the edition by J. F. Unger, *Werke und Briefe* (Heidelberg, 1967), 14ff. On the engraving, cf. J. J. Riepenhausen, *12 Umrisse zum Leben Raphaels von Urbino* (Stutt-

gart, 1834), pl. 8. On the history of the interpretation of the "idea," cf. E. Panofsky, *Idea* (Berlin, 1924; 2d ed., 1960). For stimulating ideas on this topic, I am indebted to a paper by S. Hefele (Munich, 1988).

47. Kraut 1986, 59ff., and Z. Wazbinski, "S. Luca che dipinge la Madonna all'Accademia di Roma," *Artibus et historiae* 12 (1985): 27ff.

48. Most recently, J. K. Eberlein, "The Curtain of Raphael's Sistine Madonna," *Art Bulletin* 65.1 (1983): 61ff., with a survey of the interpretations of the curtain on pp. 75–77. Cf. B. A. Sigel, *Der Vorhang der Sixtinischen Madonna* (Zurich, 1977).

49. See n. 29 above.

50. Cf. Panofsky (see n. 46 above). On the *disegno*, cf. my discussion in *Das Ende der Kunstgeschichte?* (Munich, 1983), 73.

51. Panofsky (see n. 46 above), 32 and 37.

52. Warnke 1968, 61ff.

53. Ibid., 74.

54. Gumpenberg 1657, vols. 1 and 2. Cf. Beissel 1913, 157ff. (the dressing of images), 169ff. (crowning them), and 295. On the crowning, cf. Dejonghe 1969. On the image cult at the time, cf. Mâle 1951, 2:20ff.

55. Gumpenberg 1657, 1:20ff.; evidence regarding S. Maria Maggiore is in Angelis 1621. On copies, cf. O. Karrer, *Der hl. Franz von Borja,*

General der Gesellschaft Jesu, 1510–1572 (Freiburg im Breisgau, 1921), 382–83. Sources are in F. Sacchino, *Historiae Societatis Jesu,* part 3 (Rome, 1649), bk. 5, no. 296, and *Monumenta Historica Societatis Jesu,* fasc. 28 (Madrid, 1910), 3:112–13 no. 734. On Ingolstadt, cf. P. A. Höss, *Pater Jakob Rem S.J.* (Munich, 1953), 29, 90–91, and 208–9.

56. H. Friedel, "Die Cappella Altemps in S. Maria in Trastevere," *Römisches Jahrbuch für Kunstgeschichte* 17 (1978): 92ff.

57. Angelis 1621, 189ff. On the Cappella Paolina, cf. M. C. Doratori, "Gli scultori della Cappella Paolina," *Commentari* 18 (1967): 231ff.; on the altar type, cf. E. Lavagnino et al., *Altari barocchi in Roma* (Rome, 1959); on the idea of the visitation of images by the Holy Spirit, see chap. 4e and n. 83 in that chapter.

58. Warnke 1968, 77ff.; D. Freedberg, in *Münchner Jahrbuch der bildenden Kunst* 32 (1981): 115ff.; Ilse von zur Mühlen, "Rubens und die Gegenreformation am Beispiel der Altarbilder für S. Maria in Vallicella in Rom" (diss. Munich, 1987). On the Oratorians, cf. the recent study by L. Ponnelle and L. Bordet, *St. Philip Neri and the Roman Society of His Times* (London, 1979). On Baronius, cf. C. K. Pullapidilly, *Caesar Baronius: Counter Reformation Historian* (London, 1975).

Bibliography

Achelis, Hans. 1936. *Die Katakomben von Neapel.* Leipzig.

Achimastu-Potamianou, Myrtale. 1984. "A New Anicomic Decoration on Naxos." *Deltion tēs Christianikēs Archaiologikēs Hetaireias* 12: 392ff.

Alexander, Paul Julius. 1953. "The Iconoclastic Council of St. Sophia (815) and Its Definitions." *Dumbarton Oaks Papers* 7:35ff.

——. 1958. *The Patriarch Nicephoros of Constantinople: Ecclesiastical Policy and Image Worship in the Byzantine Empire.* Oxford.

Alföldi, Andreas. 1970. *Die monarchische Repräsentation im römischen Kaiserreich.* Darmstadt.

Alpatov, Michail. 1976. *Le icône russe.* Turin.

Amato, Pietro. 1988. *De vera effigie Mariae. Antiche icone romane.* Rome.

Andaloro, Maria. 1970. "Note sui temi iconografici delle Deesis e dell'Haghiosoritissa." *Rivista dell'Istituto Nazionale d'Archeologìa e storia dell'arte,* n.s., 17:85ff.

Angelis, Paolo de. 1621. *Basilicae S. Mariae de Urbe . . . descriptio. . . .* Rome.

Antonova, Valentina Ivanovna, and Nadezda M. Mneva. 1963. *Drevnerusskoi zivopis. XI–nac. XVIII vv.* (catalog). Moscow: Tretyakov Gallery.

Athens. 1976. *Byzantine Icons of Cyprus* (catalog). Ed. A. Papageorghiou. Benaki Museum.

——. 1985. *Ekthesis gia ta hekato chronica tēs Christianikēs Archaiologikēs Hetaireias* (catalog). Exhibition on the centenary of the foundation of the Christian Archaeological Society.

Babić, Gordana. 1975. "O zivopisanom ukrasu oltarskich preglada" (On the painted ornamentation of altar screens; with French summary). *Zbornik za Likovne Umetnosti* 11:3ff.

——. 1980. *Icônes.* Paris: Editions Princesse.

——. 1988. "Il modello e la replica nell'arte bizantina delle icone." *Arte cristiana* 724:61ff.

Badawy, Alexander, 1978. *Coptic Art and Archaeology.* Cambridge, Mass.: MIT Press.

Bank, Alice. 1977. *Byzantine Art in the Collections of the USSR.* Leningrad.

Barnard, Leslie. 1974. *The Graeco-Roman and Oriental Background of the Iconoclastic Controversy.* Leiden.

——. 1977. "The Theology of Images." In Bryer and Herrin 1977, 7ff.

Barnes, Timothy D. 1981. *Constantine and Eusebius.* Cambridge, Mass.

Baumgart, Fritz. 1935. "Zur geschichtlichen und soziologischen Bedeutung des Tafelbilds." *Deutsche Vierteljahrschrift für Literaturwissenschaft und Geistesgeschichte* 13:378ff.

Baxandall, Michael. 1977. *Die Wirklichkeit der Bilder. Malerei und Erfahrung im Italien des 15. Jahrhunderts.* Frankfurt.

——. 1980. *The Limewood Sculptors of Renaissance Germany.* New Haven.

Baynes, Norman H. 1955a. *Byzantine Studies and Other Essays.* London.

——. 1955b. "The Finding of the Virgin's Robe." In Baynes 1955a, 240ff. Originally published in *Annuaire de l'institut de philologie et d'histoire orientales et slaves* 9 (1949): 87ff.

——. 1955c. "The Icons before Iconoclasm." In Baynes 1955a, 226ff. Originally published in *Harvard Theological Review* 44 (1951): 93ff.

——. 1955d. "The Supernatural Defenders of Constantinople." In Baynes 1955a, 248ff. Originally published in *Analecta Bollandiana* 67 (1949): 165ff.

Beck, Hans Georg. 1959. *Kirche und theologische Literatur im byzantinischen Reich.* Munich.

——. 1975. *Von der Fragwürdigkeit der Ikone.* Sitzungsberichte der Bayerischen Akademie der Wissenschaften. Munich.

Beck, Herbert, and Horst Bredekamp. 1987. "Bilderkult und Bildersturm." In Busch 1987b, 1: 108ff.

Beissel, Stephan. 1913. *Wallfahrten zu unserer Lieben Frau in Legende und Geschichte.* Freiburg im Breisgau.

Belli d'Elia, P., ed. 1988. *Icone di Puglia e Basilicata dal medioevo al settecento* (catalog). Bari.

Belting, Hans. 1970. *Das illuminierte Buch in der spätbyzantinischen Gesellschaft.* Heidelberg.

——. 1981a. *Bild und Publikum im Mittelalter.* Berlin. (Italian version: *L'immagine e il suo pubblico nel medio evo.* Bologna, 1986.)

——. 1981b. "An Image and Its Function in the Liturgy: The Man of Sorrows in Byzantium." *Dumbarton Oaks Papers* 34–35:1ff.

——. 1982a. "The 'Byzantine Madonnas': New Facts about Their Italian Origin and Some Observations on Duccio." *Studies in the History of*

Art of the National Gallery of Washington 12:
7ff.

———, ed. 1982b. *Il medio Oriente e l'Occidente
nell'arte del XIII secolo.* Atti XXIV Congresso
Internazionale Storia dell'Arte 2. Bologna.

———. 1982c. "Die Reaktion der Kunst des 13.
Jahrhunderts auf den Import von Reliquien und
Ikonen." In Belting 1982b, 35ff.

———. 1985. *Giovanni Bellini. Pietà. Ikone und
Bilderzählung in der venezianischen Malerei.*
Frankfurt.

———. 1987a. "Papal Artistic Commissions as
Definitions of the Medieval Church in Rome." In
*Papers in Art History from Pennsylvania State
University* 4.

———. 1987b. "Vom Altarbild zum autonomen
Tafelbild." In Busch 1987b, 1:155ff.

———. 1987c. "Vom Altarbild zur autonomen
Tafelmalerei." In Busch and Schmoock 1987,
128ff.

Belting, Hans, and Christa Belting-Ihm. 1966. "Das
Kreuzbild im 'Hodegos' des Anastasios Sinaites.
Ein Beitrag zur ältesten Darstellung des toten Cru-
cifixus." In *Tortulae* (= *Römische Quartalschrift*
30, supp.), 30ff.

Belting, Hans, Cyril Mango, and Doula Mouriki.
1978. "The Mosaics and Frescoes of St. Mary
Pammakaristos (Fethiye Camii) at Istanbul." In
Dumbarton Oaks Studies 15.

Belting-Ihm, Christa. 1976. *Sub matris tutela. Un-
tersuchungen zur Vorgeschichte der Schutzman-
telmadonna.* Heidelberg.

———. 1987. "Heiligenbild." In *Reallexikon für
Antike und Christentum* 14, cols. 66–96.

Bertelli, Carlo. 1961a. "L'immagine del 'Monaste-
rium Tempuli' dopo il restauro." *Archivum Fra-
trum Praedicatorum* 31:82ff.

———. 1961b. "La Madonna del Pantheon." *Bol-
lettino d'arte* 4.46: 24ff.

———. 1961c. *La Madonna di S. Maria in Traste-
vere.* Rome.

———. 1967. "Icone di Roma." In *Stil und Über-
lieferung in der Kunst des Abendlandes*, Ak-
ten des 21. Internationalen Kunsthistoriker-
Kongresses 1:100ff. Bonn.

———. 1968. "Storia e vicende dell'immagine
edessena a S. Silvestro a Capite a Roma." *Para-
gone* 217 (n.s., 37): 3ff.

———. 1988. "Pittura in Italia durante l'icono-
clasmo: Le icone." *Arte cristiana* 724:45ff.

Bettini, Sergio. 1933. *La pittura di icone cretese-
veneziana e i Madonneri.* Padua.

Bevan, Edwyn. 1940. *Holy Images: An Inquiry into
Idolatry and Image-Worship in Ancient Pagan-
ism and in Christianity.* London.

Blanck, Horst. 1968. "Porträt-Gemälde als Ehren-
denkmäler." *Bonner Jahrbücher* 168:1ff.

Bölten, Johannes. 1937. *Die imago clipeata. Ein
Beitrag zur Portrait- und Typengeschichte.*
Paderborn.

Boskovits, Miklos. 1988. "Immagine e preghiera
nel tardo medioevo: Osservazioni preliminari."
Acte cristiana 724:93ff.

Braun, Josef. 1924. *Der christliche Altar.*

Breckenridge, James Douglas. 1959. *The Numis-
matic Iconography of Justinian II.* New York.

Bredekamp, Horst. 1975. *Kunst als Medium sozi-
aler Konflikt. Bilderkämpfe von der Spätantike
bis zur Hussitenrevolution.* Frankfurt.

Bréhier, Louis. 1938. "Les icônes dans l'histoire de
l'art. Byzance et la Russie." *L'art byzantine chez
les Slaves* 2:150ff.

Brockhaus, H. 1891. *Die Kunst in den Athosklös-
tern.* Leipzig.

Brown, Peter. 1973. "A Dark Age Crisis: Aspects of
the Iconoclastic Controversy." *English Histori-
cal Review* 88:1–34. Reprinted in Brown 1982,
251–301.

———. 1982. *Society and the Holy.* University of
California Press.

Bryer, Anthony, and Judith Herrin, eds. 1977.
Iconoclasm. Birmingham.

Busch, Werner. 1987a. "Die Autonomie der
Kunst." In Busch 1987b, 2:230ff.

———, ed. 1987b. *Funkkolleq Kunst.* 2 vols.
Munich.

Busch, Werner, and Peter Schmoock. 1987. *Kunst.
Die Geschichte ihrer Funktionen.* Weinheim.

Cameron, Alan. 1970. *Claudian: Poetry and Pro-
paganda at the Court of Honorius.* Oxford.

Cameron, Averil. 1978. "The Theotokos in Sixth-
Century Constantinople." *Journal of Theological
Studies* 29:79ff. Reprinted in Cameron 1981.

———. 1979. "The Virgin's Robe." *Byzantion* 49:
42ff. Reprinted in Cameron 1981.

———. 1980. *The Sceptic and the Shroud.* Lon-
don: King's College.

———. 1981. *Continuity and Change in Sixth-
Century Byzantium.* London. Contains "Artistic
Patronage of Justin II" (chap. 12, pp. 62ff.); "Im-
ages of Authority: Elites and Icons" (chap. 13,
pp. 3ff.); "The Sceptic and the Shroud" (chap. 5,
pp. 3ff.); "The Theotokos in Sixth-Century Con-
stantinople" (chap. 16, pp. 79ff.); "The Virgin's
Robe" (chap. 17, pp. 42ff.).

———. 1983. "The History of the Image of Edessa:
The Telling of a Story." In *Okeanos: Essays Pre-
sented to I. Ševčenko*, Harvard Ukrainian Studies
7:80–94. Cambridge, Mass.

Campenhausen, Hans Freiherr von. 1957a. "Die

Bilderfrage als theologisches Problem der alten Kirche." In *Das Gottesbild im Abendland,* ed. W. Schöne et al., 77ff. Witten and Berlin. (English version in H. von Campenhausen. *Tradition and Life in the Early Church.* London, 1968.)

———. 1957. "Zwingli und Luther zur Bilderfrage." In *Das Gottesbild im Abendland,* 139ff.

Capizzi, Carmelo. 1964. *Pantocrator. Saggio d'eseges; letteraria—iconografica.* Orientala Christiana Analecta 170. Rome.

Caraffa, Filippo. 1976. "La processione del SS. Salvatore a Roma e nel Lazio nella notte dell'Assunta." *Lunario romano* 5:127–51.

Carli, Enzo. 1958. *Pittura medievale pisana.* Milan.

Castelnuovo, Enrico, ed. 1985. *La pittura in Italia. Le origini.* Milan.

Cavarnos, Constantine. 1980. *Orthodox Iconography.* Belton, Mass.

Cellini, Pico. 1943. *La Madonna di S. Luca in S. Maria Maggiore.* Rome.

———. 1950. "Una madonna molto antica." *Proporzioni* 3:1ff.

Chastel, André. 1978. "La Véronique." *Revue de l'art,* 71ff.

Chatzidakis, Manolis. 1962. *Icônes de St-Georges des Grecs et de la collection de l'Institut Hellénique de Venise.* Venice.

———. 1972a. "Une icône en mosaïque de Laura." *Jahrbuch der österreichischen Byzantinistik* 21: 73ff.

———. 1972b. *Studies in Byzantine Art and Archaeology.* London.

———. 1976. "L'évolution de l'icône aux 11–13 siècles et la transformation du templon." In *Actes XV. Congrès Internationale d'Études Byzantines* 3:157ff. Athens.

———. 1977a. *Eikones tēs Patmou.* Athens.

———. 1977b. *La peinture des "Madonneri" ou "veneto-crétoise" et sa destination.* Florence.

———. 1978. "Ikonostas." In *Reallexikon der byzantinischen Kunts,* 3:326ff.

Cormack, Robin S. 1969. "The Mosaic Decoration of S. Demetrios, Thessaloniki: A Reexamination in the Light of the Drawings of W. S. George." *Annual of the British School at Athens* 64:17ff.

———. 1977a. "The Arts during the Age of Iconoclasm." In Bryer and Herrin 1977, 35ff.

———. 1977b. "Painting after Iconoclasm." In Bryer and Herrin 1977, 147ff.

———. 1984. "A Crusader Painting of St. George: 'Maniera Greca' or 'lingua franca'?" *Burlington Magazine,* March, 132ff.

———. 1985. *Writing in Gold: Byzantine Society and Its Icons.* London.

———. 1988a. "Icons in the Life of Byzantium." In

Icon 20ff. Baltimore: Walters Art Gallery.

———. 1988b. "Miraculous Icons in Byzantium and Their Powers." *Arte cristiana* 724:55ff.

Cutler, Anthony. 1975. *Transfigurations: Studies in the Dynamics of Byzantine Iconography.* Pennsylvania State University Press.

———. 1984. *The Aristocratic Psalter in Byzantium.* Paris.

Cutler, Anthony, and John W. Nesbitt. 1986. *L'arte bizantina e il suo pubblico.* 2 vols. Turin.

Dawson, George G. 1977. *Healing: Pagan and Christian.* London. 1st ed., 1935.

Decker, Bernhard. 1985. *Das Ende des mittelalterlichen Kultbildes und die Plastik Hans Leinbergers.* Bamberg.

Deichmann, Friedrich Wilhelm. 1983. *Einführung in die christliche Archäologie.* Darmstadt.

Dejonghe, Maurice. 1967. *Les Madones couronnées de Rome.* Paris.

———. 1969. *Roma santuario mariano.* Bologna.

Delbrueck, Richard. 1929. *Consular Diptychen und verwandte Denkmäler.* Berlin.

Delehaye, Hippolyte. 1921. *Deux typika byzantins de l'époque des Paléologues.* Brussels.

Delius, Walter. 1963. *Geschichte der Marienverehrung.* Munich and Basel.

Demus, Otto. 1947a. *Byzantine Mosaic Decoration: Aspects of Monumental Art in Byzantium.* London. 2d ed., 1976.

———. 1947b. "Byzantinische Mosaikminiaturen." *Phaidros* 3:190ff.

———. 1960a. *The Church of San Marco at Venice: Its Architecture and Sculpture.* Washington, D.C.: Dumbarton Oaks.

———. 1960b. "Two Palaeologan Mosaic Icons in the Dumbarton Oaks Collection." *Dumbarton Oaks Papers* 14:87ff.

———. 1965. "Die Rolle der byzantinischen Kunst in Europa." *Jahrbuch der österreichischen byzantinischen Gesellschaft* 14:139ff.

———. 1970. *Byzantine Art and the West.* New York.

———. 1984. *The Mosaics of S. Marco in Venice.* 4 vols. Chicago.

Deuchler, Florens. 1984. *Duccio.* Milan.

Diez, Ernst, and Otto Demus. 1931. *Byzantine Mosaics in Greece.* Harvard University Press.

Djurić, Vojslav J. 1960. "Über den Cin von Chilandar." *Byzantinische Zeitschrift* 53:333ff.

———. 1961. *Icônes de Yougoslavie.* Belgrade.

———. 1976. *Byzantinische Fresken in Jugoslavien.* Munich.

Dmitrievskii, Aleksei A. 1895. *Opisanie liturgiceskich rukopisei.* Kiev. 2d ed., 1917; 3d ed., Hildesheim, 1965.

Dobschütz, Ernst von. 1899. *Christusbilder. Untersuchungen zur christlichen Legende. Texte und Untersuchungen zur Geschichte der altchristlichen Literatur*, n.s., 3. Leipzig.

Downey, Glanville. 1957. *Nikolaos Mesarites: Descriptions of the Church of the Holy Apostles at Constantinople.* Transactions of the American Philosophical Society, n.s., 47.6. Philadelphia.

Dufour Bozzo, Colette. 1974. *Il "Sacro Volto" di Genova.* Rome.

Düring, Walter. 1952. "Imago. Ein Beitrag zur Terminologie und Theologie der römischen Liturgie." *Münchner theologische Studien* 2.5.

Eberlein, Johann Konrad. 1982. *Apparitio regis— revelatio veritatis. Studien zur Darstellung des Vorhangs in der bildenden Kunst von der Spätantike bis zum Ende des Mittelalters.* Wiesbaden.

Ebersolt, Jean. 1951. *Constantinople. Recueil d'études d'archéologie et d'histoire.* Paris.

Egger, Rudolf. 1963. "Spätantikes Bildnis und frühbyzantinische Ikone." *Jahrbuch der österreichischen- byzantinischen Gesellschaft* 11–12: 121ff.

Ehlich, Werner. 1954. *Bild und Rahmen im Altertum.* Leipzig.

———. 1979. *Bilder-Rahmen von der Antike bis zur Romanik.* Dresden.

Elliger, Walter. 1930. *Die Stellung der alten Christen zu den Bildern in den ersten vier Jahrhunderten.* Leipzig.

Epstein, Ann. 1981. "The Middle Byzantine Sanctuary Barrier: Templon or Iconostasis?" *Journal of the British Archaeological Association* 134: 1ff.

Eudokimov, Paul. 1970. *L'art de l'icône. Théologie de la beauté.* Desclée de Brouwer.

Fasola, Umberto M. 1975. *Le catacombe di S. Gemaro a Cepadimonte.* Rome.

Felicetti-Liebenfels, Walter. 1956. *Geschichte der byzantinischen Ikonenmalerei von ihren Anfängen bis zum Ausklang.* Olten.

———. 1972. *Geschichte der russischen Ikonenmalerei in den Grundzügen dargestellt.* Graz. "Iconostasis," 38ff.; "Rubber," 75ff.

Folda, Jaroslav, ed. 1982. *Crusader Art in the Twelfth Century.* BAR International Series 152, British School of Archaeology in Jerusalem. Oxford, 1982.

Forsyth, Ilene H. 1972. *The Throne of Wisdom: Wood Sculptures of the Madonna in Romanesque France.* Princeton.

Frankfurt. 1983. *Spätantikes und frühes Christentum* (catalog). Ed. H. Beck and D. Stutzinger. Liebieghaus.

Freedberg, David. 1977. "The Structure of Byzantine and European Iconoclasm." In Bryer and Herrin 1977, 165ff.

———. 1985. *Iconoclasts and Their Motives.* Maarsen.

———. 1986. "Art and Iconoclasm, 1525–1580: The Case of the Northern Netherlands." In *Kunst voor de Beeldenstorm,* 69ff. Amsterdam.

———. 1988. *Iconoclasm and Painting in the Revolt of the Netherlands, 1566–1609.* Garland Series. New York and London.

———. 1989. *The Power of Images: Studies in the History and Theory of Response.* Chicago.

Frey, Dagobert. 1946. "Der Realitätscharakter des Kunstwerks." In *Kunstwissenschaftliche Grundfragen,* 107ff. Vienna.

Freytag, Richard Lukas. 1985. "Die autonome Theotokosdarstellung der frühen Jahrhunderte." *Beiträge zur Kunstwissenschaft* 5.

Fröhlich, Hans-Martin. 1967. *Ein Bildnis der Schwarzen Muttergottes von Brünn in Aachen.* Veröffentlichungen des bischöflichen Diözesanarchivs Aachen 26. Mönchengladbach.

Frolow, Anatol. 1938. "La 'podea.'" *Byzantion* 13:461ff.

Furlan, Italo. 1979. *Le icone bizantine a mosaico.* Milan.

Galavaris, George. 1970. *Bread and the Liturgy.* Madison.

———. 1981. *The Icon and the Life of the Church.* Leiden.

Gamulin, Grgo. 1983. *The Painted Crucifixes in Croatia.* Zagreb.

Garrison, Edward B. 1949. *Italian Romanesque Panel Painting.* Florence. 2d ed. New York, 1976.

———. 1955–62. *Studies in the History of Mediaeval Italian Painting.* 4 vols. Florence.

Garside, Charles, Jr. 1966. *Zwingli and the Arts.* New Haven.

Geary, Patrick. 1985. "Sacred Commodities: The Circulation of Medieval Relics." In *The Social Life of Things,* ed. A. Appadurai, 169ff. Cambridge.

Geischer, Hans-Jürgen. 1968. *Der byzantinische Bilderstreit.* Gütersloh.

Gerhard, H. P. [pseud. of Heinz Skrobucha]. 1957. *Welt der Ikonen.* Recklinghausen. 4th ed., 1972.

Gero, Stephen. 1973a. *Byzantine Iconoclasm during the Reign of Leo III.* Louvain.

———. 1973b. "The Libri Carolini and the Image Controversy." *Greek Orthodox Theological Review* 18.1–2: 7ff.

———. 1975. "Hypatios of Ephesos on the Cult of Images." In *Christianity, Judaism, and Other*

Greco-Roman Cults: Studies for M. Smith 2:
208ff. Leiden.

———. 1977. *Byzantine Iconoclasm during the Reign of Constantine V.* Louvain.

———. 1981. "The True Image of Christ: Eusebius's Letter to Constantia Reconsidered." *Journal of Theological Studies* 32:460ff.

Goldschmidt, Adolf, and Kurt Weitzmann. 1934. *Die byzantinischen Elfenbeinskulpturen des 10.– 13. Jahrhunderts.* 2 vols. Berlin. 2d ed., 1979.

Gottarelli, Elena. 1976. *I viaggi della Madonna de S. Luca.* Bologna. (about the miraculous image in Bologna)

Grabar, André. 1931. *La Sainte Face de Laon. Le mandylion dans l'art orthodoxe.* Prague.

———. 1936. *L'empereur dans l'art byzantin.* Paris.

———. 1943–46. *Martyrium. Recherches sur le culte des reliques et l'art chrétien antique.* Paris.

———. 1957. *L'iconoclasme byzantin. Dossier archéologique.* Paris. 2d ed., 1984.

———. 1958. *Ampoules de Terre Sainte.* Paris.

———. 1966. *Byzantium from the Death of Theodosius to the Rise of Islam.* London.

———. 1968. *L'art de la fin de l'antiquité et du Moyen Age.* 3 vols. Paris.

———. 1975. *Les revêtements en or et en argent des icônes byzantines du Moyen Age.* Venice.

Graef, Hilda. 1963. *Mary: A History of Doctrine and Devotion.* Vol. 1. London and New York.

Grassi, Luigi. 1941. "La Madonna dell'Ara Coeli e le tradizioni romane del suo tema iconografico." *Rivista archeologica cristiana* 18:76ff.

Guardini, Romano. [ca. 1950]. *Kultbild und Andachtsbild.* Würzburg.

Gumpenberg, Wilhelm. 1657. *Atlas Marianus sive de imaginibus Deiparae per orbem Christianum miracolosis.* Ingolstadt.

Günter, Heinrich. 1949. *Psychologie der Legende. Studien zu einer wissenschaftlichen Heiligengeschichte.* Freiburg.

Gutmann, Joseph, ed. 1977. *The Image and the Word: Confrontations in Judaism, Christianity, and Islam.* Missoula, Mont.

Hager, Hellmut. 1962. *Die Anfänge des italienischen Altarbildes.* Vienna and Munich.

Hallensleben, Horst. 1981. "Zur Frage des byzantinischen Ursprungs der monumentalen Kruzifixe, 'wie die Lateiner sie verehrten.'" In *Festschrift E. Trier,* 7ff. Berlin.

Hamann-MacLean, Richard. 1976. *Grundlegung zu einer Geschichte der mittelalterlichen Monumentalmalerei in Serbien und Makedonien.* Giessen.

Hamann-MacLean, Richard, and Horst Hallensleben. 1963. *Die Monumentalmalerei in Serbien und Makedonien.* Giessen.

Hamburg. 1983. *Luther und die Folgen für die Kunst* (catalog).

Hausherr, Reiner. 1975. "Über die Christus-Johannes-Gruppen." In *Beiträge zur Kunst des Mittelalters. Festschrift Hans Wentzel,* 79ff. Berlin.

Hennephof, Herman. 1969. *Textus byzantini ad iconomachiam pertinentes.* Leiden.

Henry, Patrick, III. 1968. *Theodore of Studios: Byzantine Churchman.* Diss. Yale. Ann Arbor: University Microfilms. "Iconoclastic Controversy," 177ff.

Herrin, Judith. 1983. "Women and the Faith in Icons in Early Christianity." In *Culture, Ideology, and Politics,* ed. R. Samuel and G. Stedman Jones, 56ff. London.

Hoffmann, Konrad. 1983. "Die reformatorische Volksbewegung im Bilderkampf." In Nuremberg 1983, 219ff.

Hofmann, Karl-Martin. 1938. *Philēma hagion.* Gütersloh.

Hofmann, Werner. 1983. "Die Geburt der Moderne aus dem Geist der Religion." In Hamburg 1983, 23ff.

Holl, Karl. 1928. *Gesammelte Aufsätze.* Vol. 2. Tübingen. "The Role of Stylites in the Emergence of Image Veneration" (German, 1907), 388ff.; "Writings of Epiphanius against Image Veneration" (German, 1916), 351ff.

Hueck, Irene. 1967. "Ein Madonnenbild im Dom von Padua." *Mitteilungen des Kunsthistorischen Instituts in Florenz* 13.

———. 1970. "Der Maler der Apostelszenen im Atrium von Alt-St. Peter." *Mitteilungen des Kunsthistorischen Instituts in Florenz* 14:140ff.

Hutter, Irmgard, ed. 1984. *Byzanz und der Westen.* Österreichische Akademie der Wissenschaften, Phil.-hist. Klasse, Sitzungsberichte, 432. Vienna.

Ihm, Christa. 1960. *Die Programme der christlichen Apsismalerei vom 4. bis zur Mitte des 8. Jahrhunderts.* Wiesbaden.

Janin, Raymond. 1953. *Le géographie ecclésiastique de l'empire byzantin;* part 1: *Le siège de Constantinople et le patriarcat œcuménique;* vol. 3: *Les églises et les monastères.* Paris.

———. 1975. *Les églises et les monastères des grands centres byzantins.* Paris.

Jedin, Hubert. 1935. "Entstehung und Tragweite des Trienter Dekrets über die Bilderverehrung." *Theologische Quartalschrift* 116:143ff. and 464ff.

Joksch, Thea. 1978. *Ikonen einer Berliner Privatsammlung*. Berlin.

Kalavrezou-Maxeiner, Joli. 1985. *Byzantine Icons in Steatite*. Vienna.

Kalokyris, K. 1972. *I theotokos is tēn eikonographian*. Salonica.

Kartsonis, Anna D. 1986. *Anastasis: The Making of an Image*. Princeton.

Kazhdan, Alexander. 1973. *Byzanz und seine Kultur*. Berlin.

Kazhdan, Alexander, and Ann Wharton Epstein. 1985. *Change in Byzantine Culture in the Eleventh and Twelfth Centuries*. University of California Press.

Kemp, Wolfgang. 1987. "Kunst wird gesammelt." In Busch 1987b, 2:185ff.

Kermer, Wolfgang. 1967. *Studien zum Diptychon in der sakralen Malerei*. Düsseldorf.

Kitzinger, Ernst. 1934. "Römische Malerei vom Beginn des 7. bis zur Mitte des 8. Jahrhunderts." Diss. Munich.

———. 1940a. *Early Medieval Art in the British Museum*. London.

———. 1940b. *Portraits of Christ*. Harmondsworth: Penguin Books.

———. 1954. "The Cult of Images in the Age before Iconoclasm." *Dumbarton Oaks Papers* 8: 83ff. Reprinted in Kitzinger 1976, 90ff.

———. 1955. "On Some Icons of the Seventh Century." In *Late Classical and Medieval Studies in Honor of A. M. Friend, Jr.*, 132ff. Princeton. Reprinted in Kitzinger 1976, 233ff.

———. 1958. "Byzantine Art in the Period between Justinian and Iconoclasm." In *Berichte zum XI. Internationalen Byzantinistenkongress* 4.1. Munich. Reprinted in Kitzinger 1976, 157ff.

———. 1963. "Some Reflections on Portraiture in Byzantine Art." *Zbornik Radova* (Belgrade) 8.1: 185ff. Reprinted in Kitzinger 1976, 256ff.

———. 1976. *The Art of Byzantium and the Medieval West. Selected Studies*. Ed. W. E. Kleinbauer. Indiana University Press.

———. 1977. *Byzantine Art in the Making: Main Lines of Stylistic Development in Mediterranean Art: Third–Seventh Century*. London.

Klauser, Theodor. 1972. "Rom und der Kult der Gottesmutter Maria." *Jahrbuch für Antike und Christentum* 15:120ff.

Koch, Hugo. 1917. *Die altchristliche Bilderfrage nach den literarischen Quellen*. Göttingen.

Koch, L. 1937–38. "Zur Theologie der Christus-Ikone." *Benediktinische Monatschrift* 19:375ff.; 20:32ff., 168ff., 281ff., 437ff.

Kolb, Karl. 1968. *Eleusa. 2000 Jahre Madonnenbild*. Regensburg.

Kollwitz, Johannes. 1953. *Das Christusbild des 3. Jahrhunderts*. Münster.

———. 1954. "Bild III (christlich)." In *Reallexikon für Antike und Christentum* 2, cols. 318ff.

———. 1957. "Zur Frühgeschichte der Bilderverehrung." In *Das Gottesbild im Abendland*, ed. W. Schöne et al., 57ff. Witten and Berlin.

Kondakov, Nikodim Pavlovic. 1915. *Ikonografia Bogomateri*. 2 vols. St. Petersburg.

Körner, Hans. 1979. *Der früheste deutsche Einblattholzschnitt*. Munich.

Kötting, Bernhard. 1950. *Peregrinatio religiosa. Wallfahrten in der Antike und das Pilgerwesen in der alten Kirche*. Münster.

Kraut, Gisela. 1986. *Lukas malt die Madonna*. Worms.

Krautheimer, Richard. 1965. *Early Christian and Byzantine Architecture*. Harmondsworth: Penguin Books.

———. 1980. *Rome: Profile of a City*. Princeton.

Kreidl-Papadopoulos, Karoline. 1970. "Die Ikonen im Kunsthistorischen Museum in Wien." *Jahrbuch der Kunsthistorischen Sammlungen in Wien* 66:49ff.

Kretzenbacher, Leopold. 1971. *Bilder und Legenden. Erwandertes und erlebtes Bilder-Denken und Bild-Erzählen zwischen Byzanz und dem Abendlande*. Klagenfurt.

———. 1977. *Das verletzte Kultbild*. Bayerische Akademie der Wissenschaften, Phil.-hist. Klasse supp. vol. Munich.

———. 1981. *Schütz- und Bittgebärden der Gottesmutter*. Bayerische Akademie der Wissenschaften, Phil.-hist. Klasse supp. vol. Munich.

Krickelberg-Pütz, Anke A. 1983. "Die Mosaikikone des hl. Nikolaus in Aachen-Burtscheid." *Aachener Kunstblätter . . . ,* 9ff.

Kriss-Rettenbeck, Lenz, and Gerda Möhler, eds. 1984. *Wallfahrt kennt keine Grenzen*. Bayerischen Nationalmuseum Exhibition. Munich.

Krücke, Adolf. 1905. *Der Nimbus und verwandte Attribute in der frühchristlichen Kunst*. Strasbourg. "The Saints and Other Persons" (German), 95ff.

Kruse, Helmut. 1934. *Studien zur offiziellen Geltung des Kaiserbildes im römischen Reiche*. Paderborn.

Labrecque-Pervouchine, Nathalie. 1982. *L'iconostase: Une évolution historique en Russie*. Montreal.

Ladner, Gerhart B. 1940. "Origin and Significance of the Byzantine Iconoclastic Controversy." *Mediaeval Studies* 2:127ff.

———. 1941–84. *Die Papstbildnisse des Altertums und des Mittelalters*. 3 vols. Vatican City.

———. 1953. "The Concept of the Image in the Greek Fathers and the Byzantine Iconoclastic Controversy." *Dumbarton Oaks Papers* 7:1ff. (German version in *Der Mensch als Bild Gottes*, 144ff. Darmstadt, 1969)

———. 1965. *Ad imaginem Dei. The Image of Man in Mediaeval Art*. Latrobe, Pa.

———. 1983. *Images and Ideas in the Middle Ages: Selected Studies in History and Art*. Rome.

Lange, Günter. 1969. *Bild und Wort: Die katechetischen Funktionen des Bildes in der griechischen Theologie des 6. bis 9. Jahrhunderts*. Würzburg.

Lange, Reinhold. 1964. *Die byzantinische Reliefikone*. Recklinghausen.

Lavagnino, Emilio. 1937–38. "La Madonna dell'Ara Coeli e il suo restauro." *Bolletino d'arte*, 529ff.

Lazarev, Victor N. 1959. "La Trinité d'André Roublev." *Gazette Beaux-Arts*, 282ff.ʼ

———. 1967. *Storia della pittura bizantina*. Turin.

———. 1969. *Novgorodian Icon Painting*. Moscow.

———. 1971. *Moscow School of Icon Painting*. Moscow.

Lemerle, Paul. 1947. "Sur la date d'une icône byzantine." *Cahiers archéologiques* 2:129ff. (about a Pantocrator in Leningrad)

———. 1971. *Le premier humanisme byzantin*. Paris.

Lewis, Flora. 1985. "The Veronica: Image, Legend, and Viewer." In *England in the Thirteenth Century*, ed. W. M. Ormrod, 100ff. Nottingham.

Le Liber Pontificalis. 1886ff. Ed. L. M. Duchesne. Paris. 2d ed., 1967.

Lichačeva, Vera D. 1977. *Byzantine Miniature*. Moscow.

L'Orange, Hans Peter. 1965. *Art Forms and Civic Life in the Late Roman Empire*. Princeton.

LP. See Le Liber Pontificalis.

Lucius, Ernst. 1904. *Die Anfänge des Heiligen-Kults und der christlichen Kirche*. Tübingen.

Luck, Georg. 1985. *Arcana Mundi: Magic and the Occult in the Greek and Roman Worlds*. Baltimore.

MacCormack, Sybil C. 1981. *Art and Ceremony in Late Antiquity*. Berkeley.

Maguire, Henry. 1981. *Art and Eloquence in Byzantium*. Princeton.

Majeska, George P. 1984. "Russian Travellers to Constantinople in the Fourteenth and Fifteenth Centuries." In *Dumbarton Oaks Studies, 19*.

Mâle, Emile. 1951. *L'art religieux de la fin du XVI siècle*. 2d ed. Paris.

Mango, Cyril A., ed. 1958. *The Homilies of Photios, Patriarch of Constantinople*. Cambridge: Harvard University Press.

———. 1959. *The Brazen House: A Study of the Vestibule of the Imperial Palace of Constantinople*. Copenhagen.

———. 1962. "Materials for the Study of the Mosaics of St. Sophia at Istanbul." In *Dumbarton Oaks Studies 8*.

———. 1963. "Antique Statuary and the Byzantine Beholder." *Dumbarton Oaks Papers* 17:53ff.

———. 1965. "The Apse Mosaics of St. Sophia at Istanbul." *Dumbarton Oaks Papers* 19:113ff.

———. 1972. *The Art of the Byzantine Empire, 312–1453: Sources and Documents*. Englewood Cliffs, N.J.

———. 1979. "On the History of the Templon and the Martyrion of St. Artemios in Constantinople." *Zograph* 10:40ff.

Mansi, Joannes Dominicus. 1901. *Sacrorum conciliorum nova et amplissima collectio*. Paris. 2d ed., Graz, 1960; originally 1767.

Marangoni, Giovanni. 1747. *Istoria dell'antichissimo oratorio o cappella di S. Lorenzo nel Patriarcato Lateranense*. Rome.

Marcucci, Domenico. 1983. *Santuari mariani d'Italia*. Rome.

Markus, Robert Austin. 1978. "The Cult of Icons in Sixth-Century Gaul." *Journal of Theological Studies* 29:151ff.

Matejcek, Antonin, and J. Myslivec. 1946. "Le Madonne boeme gotiche dei tipi bizantini." *Bolletino Istituto Storico Cecoslovacco* 2:3ff.

Mateos, Juan. 1971. *La célébration de la parole dans la liturgie byzantine*. Rome.

Matthews, Jane T. 1976. "Pantocrator: Title and Image." Ph.D. New York.

Matthiae, Guglielmo. 1966. *La pittura romana del medioeva*. Vol. 2. Rome.

Meiss, Millard. 1951. *Painting in Florence and Siena after the Black Death*. Princeton.

———. 1967. *French Painting in the Time of Jean de Berry: The Late Fourteenth Century and the Patronage of the Duke*. 2 vols. London.

Mensching, Gustav. 1957. *Das Wunder im Glauben und Aberglauben der Völker*. Leiden.

Mercenier, F. 1953. *La prière des églises de rite byzantin*. 3 vols. 2d ed. Gembloux.

Metzger, Cathérine. 1981. *Les ampoules à enlogie du Musée du Louvre*. Paris.

Michalski, Sergiusz. 1984. "Aspekte der protestantischen Bilderfrage." *Idea* 3:65ff.

Miljkovic-Pepek, Petar. 1972. "Deux icônes nouvellement découvertes en Macédoine." *Jahrbuch für österreichische Byzantinistik* 21:203ff.

Moscow. 1977. *Iskusstvo Vizantij v Sobraniach SSSR* (catalog; Byzantine art in the collections of the USSR). 3 vols.

Mouriki, Doula. 1986. "Thirteenth Century Icon Painting in Cyprus." *Griffon*, n.s., 1–2:9–112.

Müller, Paul Johannes. 1978. *Byzantinische Ikonen*. Geneva.

Munoz, Antonio. 1928. *I quadri bizantini della Pinacoteca Vaticana*. Rome.

Murray, C. 1977. "Art and the Early Church." *Journal of Theological Studies* 28:326ff.

Myslivec, Josef. 1947. *Ikona*. Prague.

Nelson, Robert S. 1983. "An Icon at Mt. Sinai and Christian Painting in Muslim Egypt during the Thirteenth and Fourteenth Centuries." *Art Bulletin* 65:201ff.

New York. 1978. *The Age of Spirituality: Late Antique and Early Christian Art* (catalog). Ed. K. Weitzmann. Metropolitan Museum of Art.

Nicol, Donald. M. 1979. *Church and Society in the Last Centuries of Byzantium*. Cambridge University Press.

Nilgen, Ursula. 1977. "Das Fastigium in der Basilica Constantiniana . . ." *Römische Quartalschrift* 72:1ff.

———. 1981. "Maria Regina—ein politischer Kultbildtypus?" *Römisches Jahrbuch für Kunstgeschichte* 19:3ff.

Nordhagen, Per Jonas. 1987. "Icons Designed for the Display of Sumptuous Votive Gifts." In *Festschrift E. Kitzinger (Dumbarton Oaks Papers 41)*, 453ff.

Nuremberg. 1983. *Martin Luther und die Reformation in Deutschland* (catalog).

Olson, Carl, ed. 1985. *The Book of the Goddess Past and Present*. New York.

Onasch, Konrad. 1968. *Die Ikonenmalerei. Grundzüge einer systematischen Darstellung*. Leipzig.

———. 1981. *Liturgie und Kunst der Ostkirche in Stichworten*. Leipzig.

Os, Henk van. 1984. *Sienese Altarpieces, 1215–1460*. Groningen.

Ostrogorsky, Georg. 1929. *Studien zur Geschichte des byzantinischen Bilderstreits*. Breslau. 2d ed., Amsterdam, 1964.

———. 1940. *Geschichte des byzantinischen Staates*. Munich. 2d ed., 1952.

Ostrogorsky, Georg, and Philip Schweinfurth. 1931. "Das Reliquar der Despoten von Epirus." *Seminarium Kondakovianum* 4:165ff.

Ouspensky, Leonid. 1978. *Theology of the Icon*. Crestwood, N.Y.

Ouspensky, Leonid, and Wladimir Lossky. 1952. *Der Sinn der Ikonen*. Berne and Olten.

Pace, Valentino. 1982a. "Armenian Cicilia, Cyprus, Italy, and Sinai Ikons." In Thomas J. Samuelian and Michael E. Stone, *Medieval Armenian Culture*, 291ff. Chico, Calif.: Scholars Press.

———. 1982b. "Italy and the Holy Land: The Case of Apulia." In Folda 1982, 245ff.

———. 1985. "Presenze e influenze cipriote nella pitture duecentesca italiana." *Corsi di cultura sull'arte ravennate e bizantina* 32:259ff.

Pächt, Otto. 1961. "The 'Avignon Diptych' and Its Eastern Ancestry." In *De artibus opuscule XL: Essays in Honor of Erwin Panofsky*, ed. M. Meiss, 402ff. New York.

Pallas, Dimitrios I. 1965. "Die Passion und Bestattung Christi in Byzanz." In *Miscellanea Byzantina Monacensia*, 2. Munich.

———. 1979. "Le ciborium hexagonal de St-Demetrios de Thessalonique." *Zograph* 10:44ff.

Pallucchini, Rodolfo. 1964. *La pittura veneziana del trecento*. Venice.

Panofsky, Erwin. 1969. "Erasmus and the Visual Arts." *Journal of the Warburg and Courtauld Institutes* 32:200ff.

Papageorgiu, Athanasios. 1969. *Icons of Cyprus*. Geneva.

Papageorgiu, Athanasios, and Doula Mouriki. 1976. *Byzantine Icons from Cyprus*. Benaki Museum Exhibition. Athens.

Papageorgiu, Petros N. 1908. "Mnēmeia tēs en Thessalonikē latreias tu megalomartyros Demetriou." *Byzantinische Zeitschrift* 17:321ff., esp. 342ff. and pls. I–IV.

Parlasca, Klaus. 1966. *Mumienporträts und verwandte Denkmäler*. Wiesbaden.

———. 1969–80. *Ritratti di mummie*. Repertorio d'arte dell'Egitto Greco-Romano, ed. A. Adriani, ser. B. 3 vols. Palermo (vol. 1) and Rome (vols. 2–3).

Patrologiae cursus completus, series graeca. 1857–66. 161 vols. Ed. J. P. Migne. Paris. Reprinted Paris, 1977.

Patrologiae cursus completus, series latina. 1841–64. 221 vols. Ed. J. P. Migne. Paris.

Pekary, Thomas. 1985. *Das römische Kaiserbildnis in Staat, Kult, und Gesellschaft*. Berlin.

Pertusi, Agostino. 1960. *Giorgio di Pisidia Poeni*. Vol. 1: *Penegirici Epici*. Studie patristica et byzantina 7. Ettal.

PG. See Patrologiae cursus completus, series graeca.

Phillips, J. 1973. *The Reformation of Images: Destruction of Art in England, 1533–1660*. Berkeley and London.

PL. See Patrologiae cursus completus, series latina.

Radojcic, Svetozar. 1956. "Die serbische Ikonen-

malerei vom 12. Jahrhundert bis zum Jahr 1459." *Jahrbuch der österreichischen-byzantinischen Gesellschaft* 5:61–83.

———. 1957. *Icônes de Serbie et de Macédoine.* Belgrade.

———. 1962. *Ikonen aus Serbien und Makedonien.* Munich.

Reiske, Johann Jakob, ed. 1829–30. *Constantinus VII Porphyrogenetos. De ceremoniis aulae byzantinae.* Corpus scriptorum historiae byzantinae IX.1–2. Bonn.

Rice, D. Talbot. 1937. *The Icons of Cyprus.* London.

———. 1959. *Kunst aus Byzanz.* Munich.

———. 1972. "Cypriot Icons with Plaster Relief Backgrounds." *Jahrbuch für österreichische Byzantinistik* 21:269ff.

Ringbom, Sixten. 1965. *Icon to Narrative.* Turku.

Rizzi, Alberto. 1972. "Le icone bizantine e postbizantine delle chiese veneziane." *Thesaurismata* 9:250ff.

Rösch, Gerhard. 1978. *Onoma Basileos. Studien zum offiziellen Gebrauch der Kaisertitel in spätantiker und frühbyzantinischer Zeit.* Vienna.

Ross, Marvin C. 1962. *Catalogue of the Byzantine and Early Mediaeval Antiquities in the Dumbarton Oaks Collection.* Washington, D.C. 2d ed., 1965.

Rothemund, Boris. 1966. *Handbuch der Ikonenkunst.* 2d ed. Munich.

Rueckert, R. 1957. "Zur Form der byzantinischen Reliquiare." *Münchner Jahrbuch der bildenden Kunst* 8:24ff.

Russo, Eugenio. 1979. "L'affresco di Turtura nel cimitero di Commodilla, l'icona di S. Maria in Trastevere e le piu antiche feste della Madonna a Roma." *Bollettino dell'Istituto storico Italiano per il medio evo e Archivio Muratoriano* 88:35ff.

Sahas, Daniel J. 1986. *Icon and Logos: Sources in Eighth Century Iconoclasm.* Toronto.

Ščepkina, Maria Vjaceslavna. 1977. *Miniatjury Chludovskoj Psaltyri* (The miniatures of the Chludov Psalter). Moscow.

Schaffer, Christa. 1985. *Koimesis. Der Heimgang Mariens. Das Entschlafungsbild in seiner Abhängigkeit von Legende und Theologie.* Regensburg.

Schioppalalba, Johann Baptist. 1767. *In perantiquam sacram tabulam graecam S. Mariae Caritatis Venetiarum ab ampl. Card. Bessarione dona datam dissertatio.* Venice.

Schoenborn, Christoph von. 1976. "L'icône du Christ. Fondements théologiques élaborés entre le Ier et le IIe concile de Nicée (325–787)." *Paradosis* 24.

Schulz, Hans Joachim. 1964. *Die byzantinische Liturgie.* Freiburg im Breisgau.

Schuster, Peter-Klaus. 1983. "Abstraktion, Agitation, und Einfühlung." In Hamburg 1983, 115ff.

Seibt, W. 1983. "Die byzantinischen Bleisiegel der Sammlung Reggiani." *Jahrbuch der österreichischen Byzantinistik* 33:284ff.

Ševčenko, Ihor. 1972. "On Pantoleon the Painter." *Jahrbuch für österreichische Byzantinistik* 21:241ff.

Sheperd, Dorothy G. 1969. "An Icon of the Virgin: A Sixth Century Tapestry Panel from Egypt." *Bulletin of the Cleveland Museum of Art* 56:90ff.

Skrobucha, Heinz. 1975. *Meisterwerke der Ikonenmalerei.* 2d ed. Recklinghausen.

Soteriou, Georg, and Maria Soteriou. 1956–58. *Eikones tēs Monēs Sina* (Icons of the Sinai monastery). Vol. 1: Plates; vol. 2: Texts. Athens.

Spamer, Adolf. 1930. *Das kleine Andachtsbild.* Munich.

Spatharakis, Ioannis. 1981. *Corpus of Dated Greek Illuminated Manuscripts to the Year 1453.* 2 vols. Leiden.

Speck, Paul. 1968. *Theodoros Studites. Jamben auf verschiedene Gegenstände.* Supplementa Byzantina 1. Berlin. "Poems on Images" (German), 175ff.

———. 1978. *Kaiser Konstantin VI. Die Legitimation einer fremden und der Versuch einer eigenen Herrschaft.* Munich.

Stefanescou, J. D. 1932–35. "L'illustration des liturgies dans l'art de Byzance et de l'Orient I." *Annuaire de l'Institut de Philologie et d'Histoire Orientales* 1:21ff.; 3:403ff.

Stichel, Robert H. W. 1982. *Die römische Kaiserstatue am Ausgang der Antike.* Rome.

Stirm, Margarete. 1977. *Die Bilderfrage in der Reformation.* Quellen und Forschungen zur Reformationsgeschichte 45. Gütersloh.

Stubblebine, James H. 1964. *Guido da Siena.* Princeton.

———. 1966. "Byzantine Influences in Thirteenth Century Italian Panel Painting." *Dumbarton Oaks Papers* 20:85ff.

Stylianou, Andreas. 1985. *The Painted Churches of Cyprus.* London.

Stylianou, Andreas, and Judith A. Stylianou. 1964. *The Painted Churches of Cyprus.* Athens.

Tatić-Djurić, Mirjana. 1976. "Eleousa." *Jahrbuch für österreichische Byzantinistik* 25:259ff.

Temple, Richard. 1982. *A Search for Inner Meaning.* London.

Thierry, Nicole. 1979. "La Vierge de tendresse à

l'époque macédonienne." *Zograph* 10:59ff.

———. 1980. "Deux notes à propos du Mandylion." *Zograph* 11.

Thon, Nikolaus. 1979. *Ikone und Liturgie.* Trier.

Tiflis. 1984. *Katalog der mittelalterlichen Emails im Georgischen Staatlichen Museum der Schönen Künste* (catalog).

Treitinger, Oskar. 1938. *Die oströmische Kaiser- und Reichsidee nach ihrer Gestaltung im höfischen Zeremoniell.* Jena.

Tronzo, William. 1988. "Between Icon and the Monumental Decoration of a Church." In *Icon,* 36ff. Baltimore: Walters Art Gallery.

———. 1990. "Apse Decoration, the Liturgy, and the Perception of Art in Medieval Rome." In *Italian Church Decoration of the Middle Ages and Early Renaissance,* ed. W. Tronzo, 167ff. Bologna.

Turner, Victor, and Edith Turner. 1978. *Image and Pilgrimage in Christian Culture: Anthropological Perspectives.* New York: Columbia University Press.

Underwood, Paul A. 1967. *The Kariye Djami.* 4 vols. London.

Valentini, Roberto, and Guiseppe Zucchetti. 1942–46. *Codice topografico della città di Roma.* Vols. 2–3. Rome.

Velmans, Tania. 1978. *La peinture murale byzantine à la fin du moyen Age.* Paris.

———. 1979. "Rayonnement de l'icône au XIIᵉ et au début du XIIIᵉ siècle." In *Actes XV. Congrès International d'Études Byzantines* 1:375ff. Athens.

———. 1983. "L'image de la Déisis dans les églises de Géorgie." *Cahiers archéologiques* 31:129ff. (also on the connection with the Last Judgment).

Verdenius, Willem Jacob. 1962. *Mimesis: Plato's Doctrine of Artistic Imitation and Its Meaning.* Leiden.

Vikan, Gary. 1982. *Byzantine Pilgrimage Art.* Washington, D.C.: Dumbarton Oaks.

———. 1988. "Sacred Image, Sacred Power." In *Icon,* 6ff. Baltimore: Walters Art Gallery.

Volbach, Wolfgang Fritz. 1940–41. "Il Cristo di Sutri e la venerazione del Ss. Salvatore nel Lazio." *Rondiconti della Pontificia Accademia Romana di Archeologia* 17:97–126.

———. 1952. *Elfenbeinarbeiten der Spätantike und des frühen Mittelalters.* 2d ed. Mainz.

———. 1958. *Frühchristliche Kunst. Die Kunst der Spätantike in West- und Ostrom.* Munich.

Walter, Christopher. 1970. *L'iconographie des conciles dans la tradition byzantine.* Paris.

———. 1974. *Ikonen.* Munich and Geneva.

———. 1982. *Art and Ritual of the Byzantine Church.* London. (collection of articles)

Warland, Rainer. 1986. *Das Brustbild Christi. Studien zur spätantiken und frühbyzantinischen Bildgeschichte* (= *Römische Quartalschrift* 41, supp.). Freiburg im Breisgau.

Warnke, Martin. 1968. "Italienische Bildtabernakel bis zum Frühbarock." *Münchner Jahrbuch der bildenden Kunst,* 3d ser., 19:61ff.

———, ed. 1973a. *Bildersturm. Die Zerstörung des Kunstwerks.* Munich.

———. 1973b. "Durchbrochene Geschichte? Die Bilderstürme der Wiedertäufer in Münster." In Warnke 1973a, 65ff.

———. 1984. *Cranachs Luther. Entwürfe für ein Image.* Frankfurt.

Washington, D.C. 1967. *Handbook of the Byzantine Collection* (catalog). Dumbarton Oaks.

Weigelt, Curt H. 1928. "Über die 'mütterliche' Madonna in der italienischen Malerei des 13. Jahrhunderts." *Art Studies* 6:195ff.

Weinreich, Otto. 1929. *Gebet und Wunder.* Stuttgart.

Weis, Adolf. 1958. "Ein vorjustinianischer Ikonentypus in S. Maria Antiqua." *Römisches Jahrbuch für Kunstgeschichte* 8:19ff.

———. 1985. *Die Madonna Platytera. Entwurf für ein Christentum als Bildoffenbarung anhand der Geschichte eines Madonnenthemas.* Königstein im Taunus.

Weitzmann, Kurt. 1963. "Thirteenth Century Crusader Icons on Mt. Sinai." *Art Bulletin* 14:179ff.

———. 1966. "Icon Painting in the Crusader Kingdom." *Dumbarton Oaks Papers* 20:51ff.

———. 1967. "Byzantine Miniature and Icon Painting in the Eleventh Century." In *Proceedings of the XIII Byzantine Congress of Byzantine Studies.* London. Also printed Oxford, 1966.

———. 1976. *The Monastery of Saint Catherine at Mount Sinai: The Icons.* Vol. 1. Princeton University Press.

———. 1978. *The Icon.* New York. (German version: *Die Ikone.* Munich, 1979)

———. 1982. *Studies in the Arts at Sinai.* Princeton University Press.

———. 1983. *The Saint Peter Icon at Dumbarton Oaks.* Washington, D.C.

———. 1984. "Crusader Icons and Maniera Greca." In Hutter 1984, 143ff.

———. 1986. "Icon Programs of the Twelfth and Thirteenth Centuries at Sinai." *Deltion tēs Christianikēs Archaiologikēs Hetaireias* 4.12: 63–116.

Weitzmann, Kurt, with M. Chatzidakis et al. 1965. *Frühe Ikonen.* Vienna and Munich.

———. 1982. *The Icon.* New York.

Wellen, Gherard A. 1961. *Theotokos. Eine ikonographische Abhandlung über das Gottesmutterbild in frühchristlicher Zeit.* Utrecht and Antwerp.

Wenger, Antoine. 1955. *L'assomption de la très Sainte Vierge dans la tradition byzantine du VI^me au X^e siècle.* Paris.

Wessel, Klaus. 1963a. *Die byzantinische Emailkunst.* Recklinghausen.

———. 1963b. *Koptische Kunst. Die Spätantike in Ägypten.* Recklinghausen.

———. 1966. "Bild." In *Reallexikon zur byzantinischen Kunst* (Stuttgart) 1:616ff.

Wessel, Klaus, and Helmut Brenske. 1980. *Ikonen.* Battenberg Antiquitäten Kataloge. Munich.

White, John. 1979. *Duccio: Tuscan Art and the Medieval Workshop.* London.

Willms, Hans. 1935. *Eikon. Eine begriffsgeschichtliche Untersuchung zum Platonismus.* Münster.

Wilpert, Josef. 1903. *Die Malereien der Katakomben Roms.* Freiburg im Breisgau.

———. 1907. "L'Acheropita ossia l'immagine del Salvatore nella Cappella del Sancta Sanctorum." *L'Arte* 10:161ff.

———. 1914–17. *Die römischen Mosaiken und Malereien der kirchlichen Bauten vom IV. bis zum XIII. Jahrhundert.* Vols. 2–4. Freiburg im Breisgau.

Wilson, Ian. 1978. *The Shroud of Turin: The Burial Cloth of Jesus Christ?* Rev. ed. New York: Image Books.

Wlosok, Antonie. 1978. *Römische Kaiserkult.* Darmstadt.

Wolf, Gerhard P. 1990. *Salus Populi Romani: Studien zur Geschichte des römischen Kultbildes im Mittelalter.* Weinheim.

Wolff, Robert L. 1948. "Footnote to an Incident of the Latin Occupation of Constantinople." *Traditio* 16:319ff.

Wright, David H. 1963. "The Earliest Icons in Rome." *Arts Magazine* 38:24ff.

Wulff, Oskar. 1903. *Die Koimesiskirche in Nicäa und ihre Mosaiken.* Strasbourg.

Wulff, Oskar, and Michael Alpatoff. 1925. *Denkmäler der Ikonenmalerei in kunstgeschichtlicher Folge.* Hellerau/Dresden.

Zaloscer, Hilde. 1961. *Porträts aus dem Wüstensand.* Vienna and Munich.

———. 1969. *Vom Mumienbildnis zur Ikone.* Wiesbaden.

———. 1974. *Die Kunst im christlichen Ägypten.* Vienna.

Index of Persons and Places

Index of Subjects

Photo Credits

Ann Arbor, The University of Michigan (Sinai Archives; Courtesy of the Michigan-Princeton-Alexandria Expedition to Mount Sinai) 4, 6, 13, 26, 27, 62, 64, 71, 77, 78, 80, 129, 138, 152, 154, 157–62, 164, 165–68, 174, 178, 205, 227

Aachen, Ann Münchow-Lepper 197

Athens, Byzantinisches Museum 141, 142, 150, 177; M. Chatzidakis 163

Baltimore, Walters Art Gallery 256

Belgrade, G. Babić 103, 106, 148, 169, 170

Berkeley, D. Wright 61, 74

Berlin, Staatliche Museen Preußischer Kulturbesitz 24 (W. Steinkopf), 54, 233, 258, 259, 261

Bologna, Archivio Fotografico d'Arte A. Fillani e Figli 252

Brussels, Institut Royale de Matrimoine Artistique 248, 262a, b

Cambrai (M. Chatelain) X

Cleveland, Cleveland Museum of Art 203, 212

Coburg, Veste Coburg, Kupferstichkabinett 276

Dinkelsbühl, Museum 280

Dortmund, Museum für Kunst und Kulturgeschichte 265

Dresden, Staatliche Kunstsammlungen 290

Durham, N.C., Duke University, Ann Epstein 173

Fermo, Capitulo del Duomo VII

Florence, Alinari 56 (48 623), 76 (Brogi 19 878), 240 (Brogi 6600), 250 (Alinari 5337), 269 (Alinari 1939); Fotostudio Line Mario 232; Kunsthistorisches Institut 206, 210

Frankfurt, FAZ (Barbara Klemm) 133

Geneva, Musée d'Art et d'Histoire 279

Heidelberg, Deckers 216, 217, 219, 226, 228, 230, 238; IX; Klinger 273; Kunsthistorisches Institut 220, 233, 231, 234; R. Reith 124

Kansas City, Mo., Atkins Museum of Fine Arts 267

Kiev, National Museum of Western and Oriental Art 40, 85

London, British Library 247; Courtauld Institute of Art 36, 271; Imperial War Museum 132; The National Gallery 285

Madrid, Prado 268, 288

Mainz, Kunstgeschichtliches Institut der Universität 58; Römisch-Germanisches Zentralmuseum 92

Marburg, Foto Marburg 146, 263, 274

Munich, Bayerische Staatsgemäldesammlungen 53, 201, 211, 277; Bayerisches Landesamt für Denkmalpflege 275; Hirmer 31, 34, 108, 110; H. Körner 257; von zur Mühlen XI

New York, Metropolitan Museum 42, 221, 249, 255, 286; Time-Life 10

Nuremberg, Germanisches Nationalmuseum 281–83

Palermo, Soprintendenza alle Gallerie della Sicilia 151

Paris, Bibliothèque Nationale 46, 47, 156; Écoles des Hautes Études 63; Foto Giraudon 25, 45, 48, 254, IV; Monuments Historiques 270

Perugia, Foto Fiorucci 229

Pisa, Museo Nazionale 3

Princeton, Art Museum 222

Regensburg, Domschatzmuseum—Diözesanmuseum 278

Reichenbach im Vogtland, Bild und Heimat (Kühn) 284

Rennes, Musée des Beaux Arts 289

Rome, Arte Fotografica front plate of color gallery, I, II, V; Bibliotheca Hertziana 23, 134; Deutsches Archäologisches Institut 17, 32, 33, 41, 43; Gabinetto Fotografico Nazionale 5, 6, 66–69, 75, 187, 194, 207, 213, 236; Istituto Centrale per il Catalogo e la Documentazione frontispiece, 8, 70, 190, 192, 193, 195, 292, 294; Richard Krautheimer 65; Barbara Malter 198; Musei Vaticani 2, 15, 16, 18–22, 28, 55, 72, 73a, b, 135, 143, 155, 191; Pontificia Commissione Archeologia Sacra 29, 79; J. Powell 99–102

Siena, Foto Grassi 237; Fabio Lensini 235, 239; Soprintendenza B.A.S. 242, 243, 245, 246, VI (Barellini)

Thessaloniki, Lykides 11

Venice, Böhm 115, 121, 122, 144, 215; Collezione Cini 188; Edizioni Ardo 1, 199; Soprintendenza alle Gallerie 117

Washington, D.C., Dumbarton Oaks Collection 30, 39, 49, 50, 52, 57, 81, 82, 89–91, 94–98, 130, 139, 140, 153, 171, 175, 176; Library of Congress 14; National Gallery of Art 225, 260, VIII

All other photographs are from the author's collection.